Oil Paintings in Public Ownership in
Hampshire

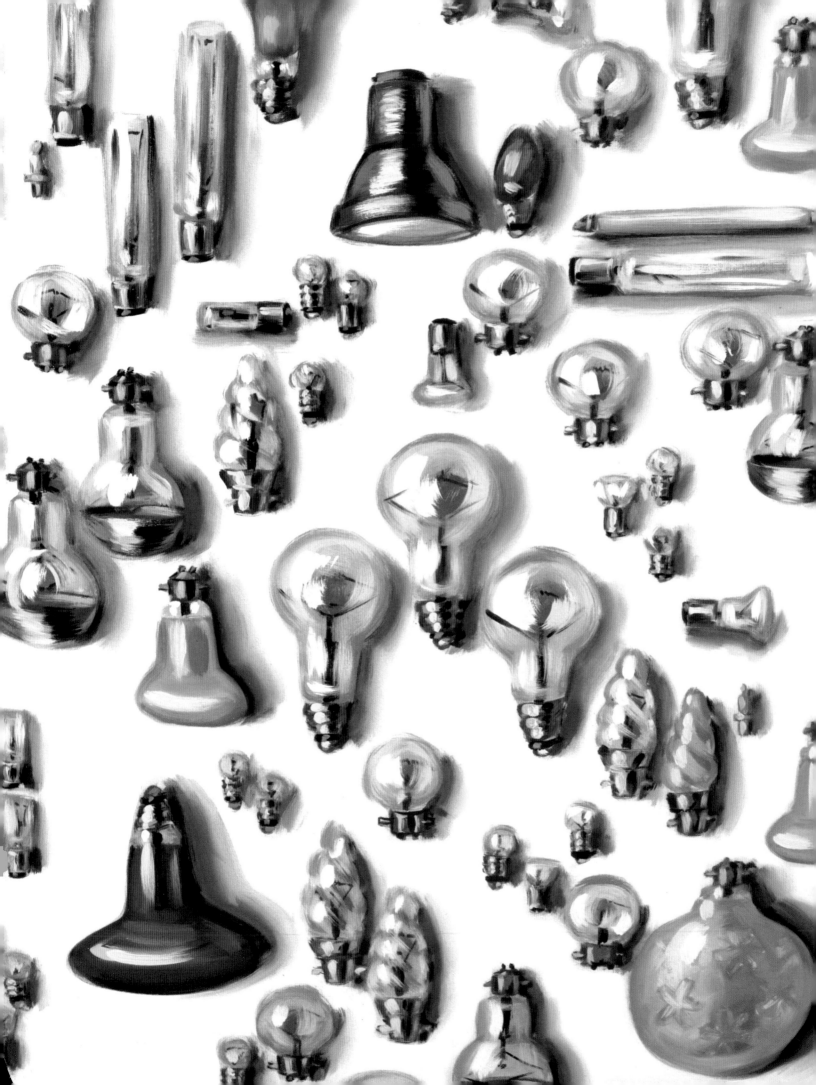

Oil Paintings in Public Ownership in Hampshire

The Public Catalogue Foundation

Andy Ellis, Director
Sonia Roe, Editor
Georgina Dennis, Catalogue Coordinator
Elizabeth Vickers, Photography

First published in 2007 by the Public Catalogue
Foundation, St Vincent House, 30 Orange Street,
London, WC2H 7HH

© 2007 the Public Catalogue Foundation, registered
charity number 1096185. Company limited by
guarantee incorporated in England and Wales
with number 4573564. VAT registration number
833 0131 76. Registered office: The Courtyard,
Shoreham Road, Upper Beeding, Steyning, West
Sussex, BN44 3TN.

We wish to thank the individual artists and all the
copyright holders for their permission to reproduce
the works of art. Exhaustive efforts have been
made to locate the copyright owners of all the
images included within this catalogue and to meet
their requirements. Any omissions or mistakes
brought to our attention will be duly attended to
and corrected in future publications. Owners of
copyright in the paintings illustrated who have
been traced are listed in the Further Information
section.

Photographs of paintings are © the collections that
own them, except where otherwise acknowledged.

Forewords to each collection are © the respective
authors.

**The responsibility for the accuracy of the
information presented in this catalogue lies solely
with the holding collections. Suggestions that
might improve the accuracy of the information
contained in this catalogue should be sent to the
relevant collection and emailed to
info@thepcf.org.uk.**

ISBN 1-904931-16-2 (hardback)
ISBN 1-904931-17-0 (paperback)

Hampshire photography: Elizabeth Vickers

Designed by Jeffery Design, London

Distributed by the Public Catalogue Foundation,
St Vincent House, 30 Orange Street,
London, WC2H 7HH
Telephone 020 7747 5936

**Printed and bound in the UK by Butler and Tanner
Ltd, Frome, Somerset**

Cover image:

Beechey, William 1753–1839
*Admiral Sir Harry Burrard-Neale, 2nd Bt
(1765–1840)* (detail)
Royal Naval Museum, (see p. 191)

Image opposite title page:

Milroy, Lisa b.1959
Lightbulbs (detail), 1991
Portsmouth Museums and Records Service, (see p. 104)

Back cover images (from top to bottom):

Meadus, Eric 1931–1970
Suburban Housing in the Southampton Area, 1968
Hampshire County Council Museums Service, (see p. 283)

Palmer, Garrick b.1933
Circular Form No.14
Portsmouth Museums and Records Service, (see p. 151)

Shayer, William 1788–1879
The Cornfield
Hampshire County Council Museums Service, (see p. 286)

Contents

Following page: Shayer, William, 1788–1879, *Gypsy Encampment in the New Forest* (detail), Hampshire County Council Museums Service (p. 286)

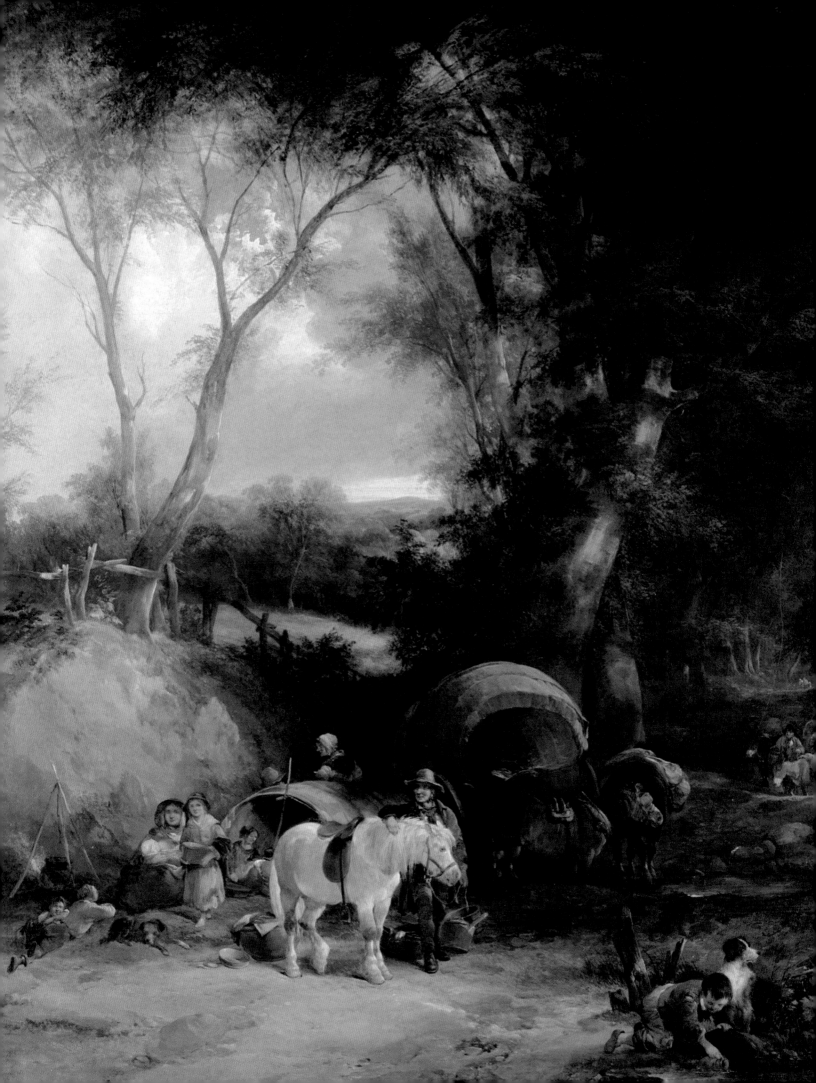

Foreword

If only the public as a whole were allowed to experience the sense of unalloyed fun and pleasure I receive whenever I do a tour of the galleries included in one of our catalogues. If they could share just a portion of the excitement and astonishment I experience on such visits, the galleries would have to ration their visitors.

I should admit, though, that at first glance the galleries on my schedule for the Winchester area did not appear to offer a promising day out. Not many of us would intuitively edge our way towards Middle Wallop for an aesthetic experience at the Museum of Army Flying. Think again. The gliders are utterly wonderful but, tucked away in a tiny gallery upstairs is a small row of portraits which includes a superb portrait of Harry George Hawker (1891–1921) by Ambrose McEvoy: a wonderful, unexpected treat.

There was so much more. A swagger portrait by Henry William Pickersgill and masterly paintings of engagements in the South African war by Thomas Baines at the Royal Greenjackets Museum. Two late sixteenth century paintings, allegedly from Basing House (destroyed by Cromwell), of Semiramis and of Rossa, wife of Suleiman the Magnificent at Hampshire's County Council store, as well as a striking three-quarter length portrait by Gunning King (who merits no entry in Frances Spalding's *Dictionary of Twentieth-Century Painters and Sculptors* and of whose work I would have remained totally unaware until I encountered well over 100 of them in East Sussex).

The lesson of all this might be that galleries should consider cooperating to create multi-venue tours. Even if they had done so, however, I doubt if they would have encountered, as I did, the ghostly, overpainted Maclise painting in Abbey House in Winchester.

As this is the second Hampshire volume, I can do no better than repeat the thanks I proffered in the first catalogue, to the extent that the team responsible is essentially the same. Peter Andreae, has been dedicated and tireless in his campaign to raise funds for both this catalogue and the first volume published earlier this year. Without him our task would have been infinitely more difficult if not impossible. Mrs Mary Fagan and Lord Douro have also been at the fore of the fundraising campaign and deserve my great thanks. Georgie Dennis, our Hampshire Coordinator and Liz Vickers, our photographer, also are due an enormous debt of appreciation for their wonderful work in creating both Hampshire volumes. And, of course, our London publications team of Sonia Roe, Sophie Kullmann and Nickie Murfitt has done an extraordinary job editing and proofreading these works, and generally making them the fine publications they are.

Many have donated generously in support of our work on this catalogue. However, I would like to make particular mention of the vitally important grant made by Hampshire County Council and the support of its Leader, Councillor Ken Thornber CBE. The Council's enthusiasm for our work and its desire to see its paintings revealed in our catalogue is exemplary.

Finally, my thanks go to the curatorial staff in Hampshire whose work underpins this volume. As I am sure everyone will agree, the results as shown in this volume, are glorious.

Fred Hohler, Chairman

The Public Catalogue Foundation

The Public Catalogue Foundation is a registered charity. It is publishing a series of illustrated catalogues of all oil paintings in public ownership in the United Kingdom.

The rationale for this project is that whilst the United Kingdom holds in its public galleries and civic buildings arguably the greatest collection of oil paintings in the world, an alarming four in five of these are not on view. Furthermore, few collections have a complete photographic record of their paintings let alone a comprehensive illustrated catalogue. In short, what is publicly owned is not publicly accessible.

The Public Catalogue Foundation has three aims. First, it intends to create a complete record of the nation's collection of oil, tempera and acrylic paintings in public ownership. Second, it intends to make this accessible to the public through a series of affordable catalogues which will later go online. Finally, it aims to raise funds for the conservation and restoration of paintings in participating collections through the sale of catalogues by these collections.

Collections benefit substantially from the work of the Foundation not least from the digital images that are given to them for free following photography and the increased recognition that the catalogues bring. These substantial benefits come at no financial cost to the collections. The Foundation is funded by a combination of support from individuals, companies, the public sector and charitable trusts.

Financial Supporters

The Public Catalogue Foundation would like to express its profound appreciation to the following organisations and individuals who have made the publication of this catalogue possible and to our two Master Patrons who have led our fundraising campaign in this county.

Donations of £10,000 or more

Hampshire County Council
The Peter Harrison Foundation

The Linbury Trust

Donations of £5,000 or more

Marquess of Douro
Philip Gwyn
National Gallery Trust

Oakmoor Trust
Garfield Weston Foundation

Donations of £1,000 or more

Marcus & Kate Agius
Basingstoke and Deane Borough Council
Sir Christopher Bland
The Charlotte Bonham-Carter
 Charitable Trust
Bramdean Asset Management LLP
The Bulldog Trust
Graeme Cottam & Gloriana Marks de
 Chabris
Coutts Charitable Trust
De La Rue Charitable Trust
Mr Robert Dean
Hobart Charitable Trust
The J. and S. B. Charitable Trust

Lord Lea of Crondall, OBE
Rupert Nabarro
P. F. Charitable Trust
The Pilgrim Trust
Portsmouth City Council
Rathbone Investment Management Ltd
Renaissance South East Hub
Sir Miles & Lady Rivett-Carnac
Smith & Williamson
Strutt and Parker
The Bernard Sunley Charitable
 Foundation
The Thistle Trust
Michael J. Woodhall, FRICS

Other Donations

D. A. Bailey
The Roger Brooke Charitable Trust
Sir James Butler, CBE DL
Sir Jeremiah Colman Gift Trust
Anthony R. C. B. Cooke
Desmond Corcoran
East Hampshire District Council
Freddie Emery-Wallis
Mrs Mary Fagan, JP
Sybilla Jane Flower
The Golden Bottle Trust
Mrs Margaret Hayter
Rear Admiral R. O. Irwin, CB
John Isherwood, CMG
Rose & Gareth Lewis
The Lilian Trust
Mr & Mrs Charles Marriott

Mr & Mrs Nigel McNair Scott
Sir Edwin & Lady Nixon
David M. Norman
Mr & Mrs Charles Parker
Bruce & Lizzie Powell
J. W. Robertson Charitable Trust
Simon Robertson
Leopold de Rothschild Charitable Trust
Alicia Salter
Dr John Sargent
Savills Ltd
Joanna Selbourne
Julian Sheffield
Mr & Mrs Ronald Taylor
Edward & Katherine Wake
Mr & Mrs Hady Wakefield
Winchester City Council

National Supporters

The Bulldog Trust
The John S. Cohen Foundation
Hiscox plc
National Gallery Trust

P. F. Charitable Trust
The Pilgrim Trust
Stavros S. Niarchos Foundation
Garfield Weston Foundation

National Sponsor

Christie's

Acknowledgements

The Public Catalogue Foundation would like to thank the individual artists and copyright holders for their permission to reproduce for free the paintings in this catalogue. Exhaustive efforts have been made to locate the copyright owners of all the images included within this catalogue and to meet their requirements. Copyright credit lines for copyright owners who have been traced are listed in the Further Information section.

The Public Catalogue Foundation would like to express its great appreciation to the following organisations for their great assistance in the preparation of this catalogue:

Bridgeman Art Library
Flowers East
Marlborough Fine Art
National Association of Decorative & Fine Arts Societies (NADFAS)
National Gallery, London
National Portrait Gallery, London
Royal Academy of Arts, London
Tate

The participating collections included in this catalogue would like to express their appreciation to the following individuals and organisations who have contributed so generously to the county's collections and who in many cases continue to do so:

Richard Coventry Baigent
Trustees of the Beneficial School
Mrs A. L. Bonham Carter
Mrs Beryl Bradford
British Hovercraft Corporation
James B. Bundle
Miss Grace Mary Cannon
Miss V. M. M. Cole
Francis Jerome Collins
Miss L. Constant, OBE
Contemporary Art Society
The Corps
Mrs D. H. Davies
The John Downton Trust
Dr N. B. Eales
H. G. Filtness
Mrs Thomas Fleming
Mr E. Prescott Frost
Miss E. Giffard
Richard Lancelyn Green
Mrs E. Hall
Patrick Ernest William Harris

Miss B. Haughton
Miss Rosemary Hewett
Mrs C. M. Leon
Lord Mayor's Office
Barbara Melrose
National Art Collections Fund
 (The Art Fund)
Officers and Staff of the Army
 Physical Training Corps
Bernard Osmond
James Padbury
Mrs Prichard
The Walter Sickert Trust
Mrs H. G. Lynch Staunton
Mrs Ernest Thesiger
Hilary Thomas
Mr R. Thomas
United Services Officer's Club
The Victoria & Albert Museum
 Purchase Grant Fund
Geoffrey Walton
Mrs N. Warburton

Catalogue Scope and Organisation

Medium and Support

The principal focus of this series is oil paintings. However, tempera and acrylic are also included as well as mixed media, where oil is the predominant constituent. Paintings on all forms of support (e.g. canvas, panel, etc.) are included as long as the support is portable. The principal exclusions are miniatures, hatchments or other purely heraldic paintings and wall paintings *in situ*.

Public Ownership

Public ownership has been taken to mean any paintings that are directly owned by the public purse, made accessible to the public by means of public subsidy or generally perceived to be in public ownership. The term 'public' refers to both central government and local government. Paintings held by national museums, local authority museums, English Heritage and independent museums, where there is at least some form of public subsidy, are included. Paintings held in civic buildings such as local government offices, town halls, guildhalls, public libraries, universities, hospitals, crematoria, fire stations and police stations are also included. Paintings held in central government buildings as part of the Government Art Collection and MoD collections are not included in the county-by-county series but should be included later in the series on a national basis.

Geographical Boundaries of Catalogues

The geographical boundary of each county is the 'ceremonial county' boundary. This county definition includes all unitary authorities. Counties that have a particularly large number of paintings are divided between two or more catalogues on a geographical basis.

Criteria for Inclusion

As long as paintings meet the requirements above, all paintings are included irrespective of their condition and perceived quality. However, painting reproductions can only be included with the agreement of the participating collections and, where appropriate, the relevant copyright owner. It is rare that a collection forbids the inclusion of its paintings. Where this is the case and it is possible to obtain a list of paintings, this list is given in the Paintings Without Reproductions section. Where copyright consent is refused, the paintings are also listed in the Paintings Without Reproductions section. All paintings

in collections' stacks and stores are included, as well as those on display. Paintings which have been lent to other institutions, whether for short-term exhibition or long-term loan, are listed under the owner collection. In addition, paintings on long-term loan are also included under the borrowing institution when they are likely to remain there for at least another five years from the date of publication of this catalogue. Information relating to owners and borrowers is listed in the Further Information section.

Layout

Collections are grouped together under their home town. These locations are listed in alphabetical order. In some cases collections that are spread over a number of locations are included under a single owner collection. A number of collections, principally the larger ones, are preceded by curatorial forewords. Within each collection paintings are listed in order of artist surname. Where there is more than one painting by the same artist, the paintings are listed chronologically, according to their execution date.

The few paintings that are not accompanied by photographs are listed in the Paintings Without Reproductions section.

There is additional reference material in the Further Information section at the back of the catalogue. This gives the full names of artists, titles and media if it has not been possible to include these in full in the main section. It also provides acquisition credit lines and information about loans in and out, as well as copyright and photographic credits for each painting. Finally, there is an index of artists' surnames.

Key to Painting Information

Almost all paintings are reproduced in the catalogue. Where this is not the case they are listed in the Paintings Without Reproductions section. Where paintings are missing or have been stolen, the best possible photograph on record has been reproduced. In some cases this may be black and white. Paintings that have been stolen are highlighted with a red border. Some paintings are shown with conservation tissue attached to parts of the painting surface.

Adam, Patrick William 1854–1929
Interior, Rutland Lodge: Vista through Open Doors 1920
oil on canvas 67.3 × 45.7
LEEAG.PA.1925.0671.LACF ☀

Artist name This is shown as surname first. Where the artist is listed on the Getty Union List of Artist Names (ULAN), ULAN's preferred presentation of the name is always given. In a number of cases the name may not be a firm attribution and this is made clear. Where the artist name is not known, a school may be given instead. Where the school is not known, the painter name is listed as *unknown artist*. If the artist name is too long for the space, as much of the name is given as possible followed by (…). This indicates the full name is given at the rear of the catalogue in the Further Information section.

Painting title A painting followed by *(?)* indicates that the title is in doubt. Where the alternative title to the painting is considered to be better known than the original, the alternative title is given in parentheses. Where the collection has not given a painting a title, the publisher does so instead and marks this with an asterisk. If the title is too long for the space, as much of the title is given as possible followed by *(…)* and the full title is given in the Further Information section.

Execution date In some cases the precise year of execution may not be known for certain. Instead an approximate date will be given or no date at all.

Artist dates Where known, the years of birth and death of the artist are given. In some cases one or both dates may not be known with certainty, and this is marked. No date indicates that even an approximate date is not known. Where only the period in which the artist was active is known, these dates are given and preceded with the word *active*.

Medium and support Where the precise material used in the support is known, this is given.

Dimensions All measurements refer to the unframed painting and are given in cm with up to one decimal point. In all cases the height is shown before the width. An (E) is indicated where a painting has not been measured and its size has been calculated by sight only. If the painting is circular, the single dimension is the diameter. If the painting is oval, the dimensions are height and width.

Collection inventory number In the case of paintings owned by museums, this number will always be the accession number. In all other cases it will be a unique inventory number of the owner institution. (P) indicates that a painting is a private loan. Details can be found in the Further Information section. Accession numbers preceded by 'PCF' indicate that the collection did not have an accession number at the time of catalogue production and therefore the number given has been temporarily allocated by the Public Catalogue Foundation. The ☀ symbol indicates that the reproduction is based on a Bridgeman Art Library transparency (go to www.bridgeman.co.uk) or that Bridgeman administers the copyright for that artist.

Facing page: Downton, John, 1906–1991, *Before the Battle* (detail), c.1970, Portsmouth Museums and Records Service, (p. 80)

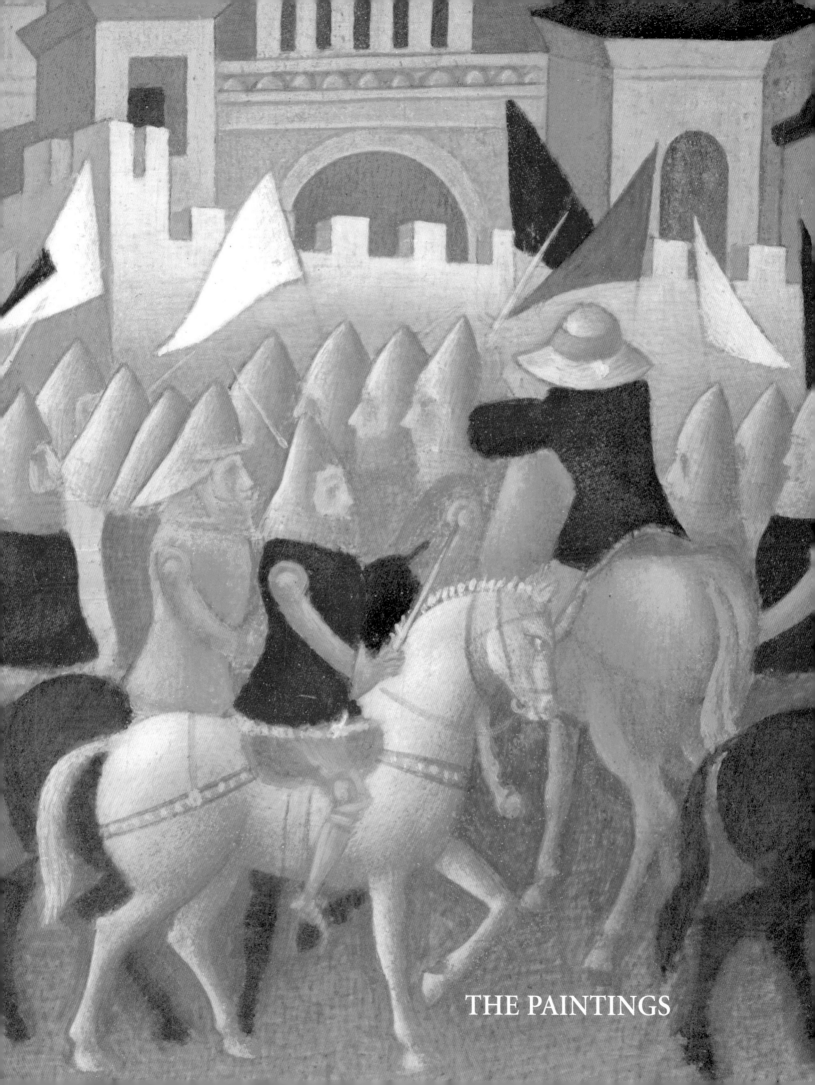

THE PAINTINGS

Army Physical
Training Corps
Museum

Brealey, William Ramsden 1889–1949
Colonel G. N. Dyer, CBE, DSO
oil on canvas 101.6 x 76.2
681

Codner, Maurice Frederick 1888–1958
Colonel C. E. Heathcote, CB, CMC, DSO 1928
oil on canvas 104 x 76.2
495

Lander, John Saint-Hélier 1869–1944
Colonel S. P. Rolt 1905
oil on canvas 78.8 x 66
494

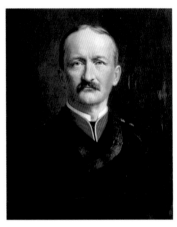

unknown artist
Colonel G. M. Onslow
oil on canvas 66 x 56
493

unknown artist
Colonel Sir George Malcolm Fox (1843–1918)
oil on canvas 101.6 x 81.3
491

unknown artist
Colonel the Honourable J. Scott Napier
oil on canvas 68.6 x 61
492

The Museum of Army Chaplaincy

The Museum of Army Chaplaincy houses the archives and historical relics of the Royal Army Chaplains' Department. Unlike most military museums, it does not include any weapons or ammunition, since the chaplains are non-combatant and their work is to sustain not destroy.

In 1796, a Royal Warrant was issued in which regimental chaplains were abolished, and the first Chaplain-General was appointed in the person of Reverend John Gamble. The collection of portraits of former Chaplain-Generals was established at Bagshot Park, Surrey, around 1950.

One of the highlights of the collection is the painting by Terence Tenison Cuneo, *Presentation of the Victoria Cross to the Reverend Theodore Bayley Hardy, VC, DSO, MC by King George V (1865–1936)*. It was commissioned by the Chaplain-General and chaplains of the Royal Army Chaplains' Department and completed in September 1966. The citation for Hardy's Victoria Cross from the *London Gazette* reads:

'The painting was unveiled by Field Marshall Sir Richard Hull, GCB, DSO, MA, LLD, then Chief of the Defence Staff at a ceremony on 31st May 1967, which was attended by Miss Elizabeth Hardy, the daughter of the Reverend Theodore Bayley Hardy.'

We are grateful to the Public Catalogue Foundation for including our paintings, which we feel deserve to be better known.

Mr David Blake, Curator

Archer, Peter
The Reverend James Harkness, CB, OBE, QHC, MA, Chaplain-General (1987–1995)
1994
oil on canvas 76 x 63.5 (E)
1996.004

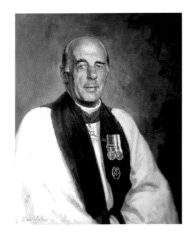

Archer, Peter
The Venerable William Francis Johnston, CB, QHC, MA, Chaplain-General (1980–1987)
1995
oil on canvas 76 x 63.5 (E)
1996.005

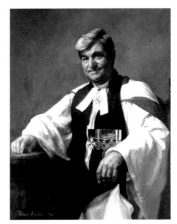

Archer, Peter
The Venerable Peter Mallet, QHC, AKC, Chaplain-General (1974–1980) 1996
oil on canvas 76 x 63.5 (E)
1990.37

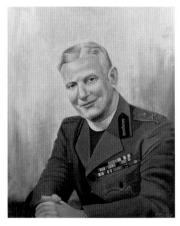

Boughey, Arthur active 1970–1976
*The Reverend Canon Frederick Llewellyn
Hughes, CB, CBE, MC, TD, MA, KHC,
Chaplain-General to the King (…) 1970*
oil on canvas 74.5 x 62 (E)
1988.326.1

Cuneo, Terence Tenison 1907–1996
*Presentation of the Victoria Cross to the
Reverend Theodore Bayley Hardy, VC, DSO,
MC by HM King George V (1865–1936) 1966*
oil on canvas 86 x 116 (E)
1988.26

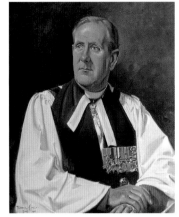

Cuneo, Terence Tenison 1907–1996
*The Reverend Ivan Delacrois Neil, OBE,
Chaplain-General (1960–1966) 1966*
oil on canvas 76 x 63.5 (E)
1988.328.1

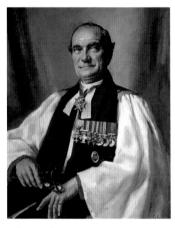

Gilroy, John M. 1898–1985
*The Venerable John Ross Youens, CB, OBE,
MC, Chaplain-General (1966–1974)*
oil on canvas 91.5 x 71 (E)
1990.371

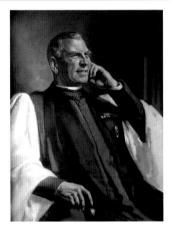

Gilroy, John M. 1898–1985
*The Venerable Victor Joseph Pike, CB, CBE,
Chaplain-General (1951–1960)*
oil on canvas 90 x 71 (E)
1988.327.1

P. W. L.
*St Barbara's Church, Stonecutter's Island, Hong
Kong Harbour c.1984*
acrylic on canvas 61 x 51
2007.001

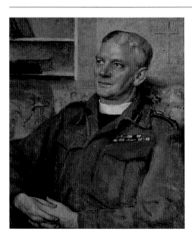

Mason, Arnold 1885–1963
*The Reverend Canon Frederick Llewellyn
Hughes, CB, CBE, MC, TD, MA, KHC,
Chaplain-General to the King (1944–1951)*
oil on canvas 76 x 63.5
1988.314

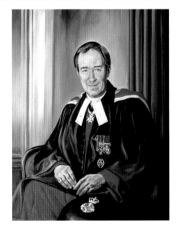

Nye, Shela b.1933
*The Reverend Dr Victor Dobbin CB, MBE,
QHC, DD, Chaplain-General (1995–2000)*
2000
oil on canvas 120 x 80 (E)
2005.2

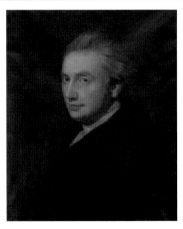

Opie, John (after) 1761–1807
*The Venerable John Owen, Chaplain-General
(1810–1824) 19th C*
oil on canvas 61 x 51
1988.320.1

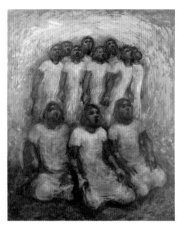

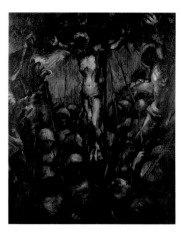

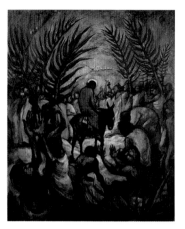

Warren, Stanley 1918–1992
The Black Passion: The Ascension 1959–1960
oil on canvas 115 x 95 (E)
1996.009.6

Warren, Stanley 1918–1992
The Black Passion: The Crucifixion
1959–1960
oil on canvas 115 x 95 (E)
1996.009.4

Warren, Stanley 1918–1992
The Black Passion: The Entry into Jerusalem
1959–1960
oil on canvas 115 x 95 (E)
1996.009.1

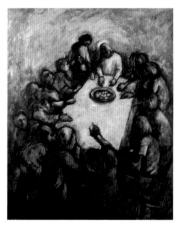

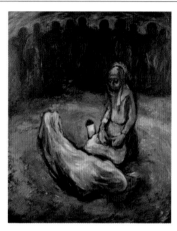

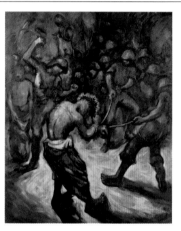

Warren, Stanley 1918–1992
The Black Passion: The Last Supper
1959–1960
oil on canvas 115 x 95 (E)
1996.009.2

Warren, Stanley 1918–1992
The Black Passion: The Pietà 1959–1960
oil on canvas 115 x 95 (E)
1996.009.5

Warren, Stanley 1918–1992
The Black Passion: The Scourging 1959–1960
oil on canvas 115 x 95 (E)
1996.009.3

Wragg, Stephen
Reaping 'His' Harvest
oil on canvas 45 x 60 (E)
1988.332

Test Valley Borough Council

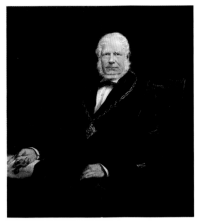

Grant, Henry active 1868–1895
Alderman William Gue (1800–1877) 1877
oil on canvas 200 x 180 (E)
PCF2

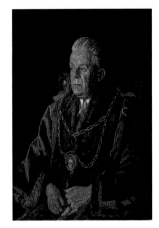

Horton, Percy Frederick 1897–1970
Sydney Robert Bell, Mayor of Andover (1939–1943) 1944
oil on canvas 100 x 75
PCF3

Turner, William
William Turner Senior, Mayor of Andover (1908) c.1908
oil on canvas 200 x 160 (E)
PCF1

Basingstoke and Deane Borough Council

Collins, Louisa
Scenes of Basingstoke 1990
oil on canvas 74 x 100
86

Edney, Ronald Brian 1909–2000
Freedom Ceremony 1968
oil on canvas 60 x 90
79

Edney, Ronald Brian 1909–2000
Basingstoke Skyline
oil on canvas 34.5 x 44.6
5

Hill, Edna
Winchester Street, Overton
oil on canvas 24.8 x 54.8
57

Machin, Iris
Barton's Mill, Old Basing 1990
acrylic on canvas 29.8 x 39.4
42

O'Brien, Marianne
View over Farleigh Hill
oil on canvas 39.7 x 49.6
59

Pearce, Frederick
Old Basing Church 1920
oil on canvas 101 x 126
76

Stanley, Diana 1909–1975
Corner of London Street, Hackwood Road
1967
oil on board 33.7 x 74.4
2

unknown artist
John Burgess Soper JP, Mayor (1888–1889)
c.1895
oil on canvas 55 x 43.2
87

unknown artist early 19th C
Woman and Child
oil on canvas 42 x 52.5
9

unknown artist 19th C
*Charles Shaw Lefevre (d.1823), Recorder of
Basingstoke (1800–1823)*
oil on canvas 74 x 61.2
88

Basingstoke and North Hampshire NHS Foundation Trust

Thorne, Len b.1941
Looking Seaward, the Gannel, Cornwall 1991
acrylic on canvas 38 x 46 (E)
PCF1

National Motor Museum Trust

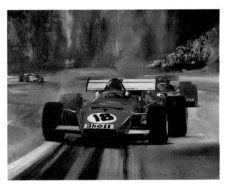

Pears, Dion
Jacky Ickx, Ferrari, Canadian Grand Prix, 1970
1970s
oil on canvas 68.8 x 88.8
TR2149

Bishop's Waltham Museum

unknown artist
Bishop's Waltham Square, after the Removal of the Old Market House c.1840
oil on canvas 30 x 40
BWA 5ii

unknown artist
Bishop's Waltham Square, Showing the Old Market House c.1840
oil on canvas 30 x 40
BWA 5i

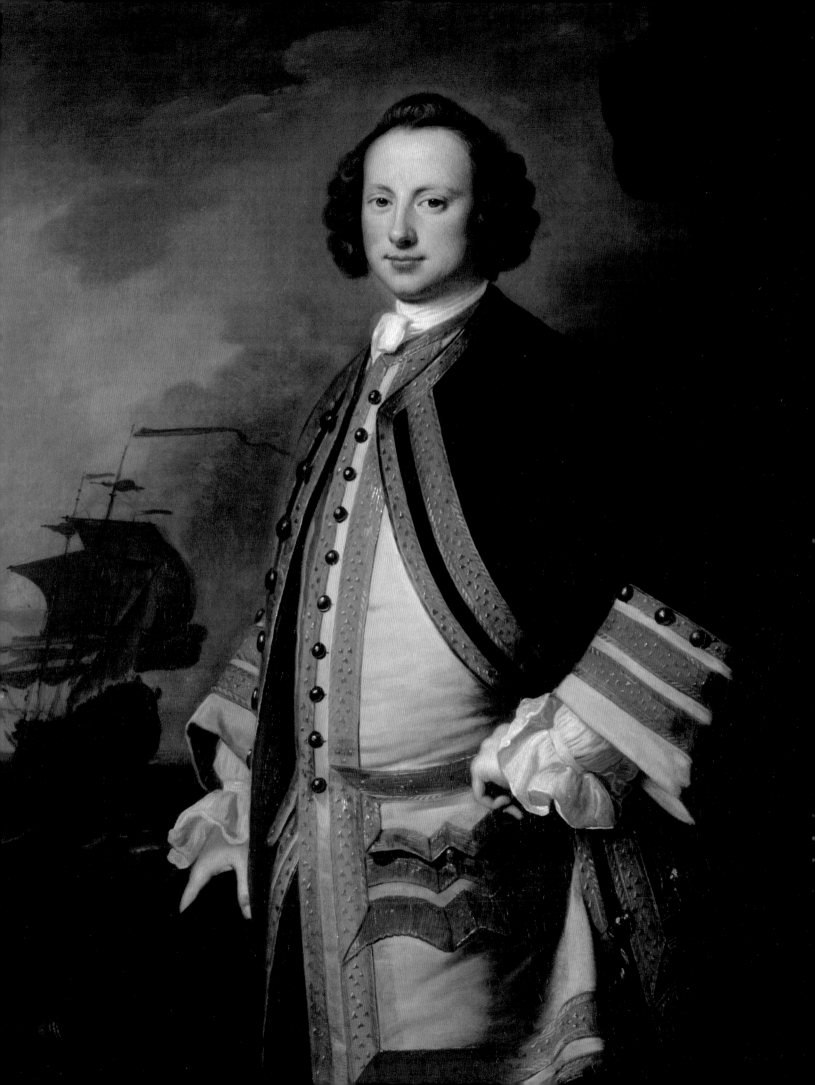

Chawton House Library

Chawton House Library is one of the world's leading centres for the study of the lives and works of women writing in English before 1830. Based on a unique collection that focuses on works by early women writers, it provides the perfect environment for research and study, in a manner that brings to life the social, domestic, economic, cultural and historical contexts in which early English women writers lived and worked. The history of Chawton House itself is interwoven with the family story of perhaps the most famous of all women writers – Jane Austen (1775–1817).

The Knight family had been tenant farmers in Chawton since at least the thirteenth century and by 1578 had prospered sufficiently to buy the manor of Chawton from the descendants of the de Port family that had acquired it after the Norman Conquest. In 1583, John Knight began replacing an earlier medieval building with the house that can be seen today.

The freehold has since remained in the Knight family, though the title has passed laterally and by female descent on several occasions, a matter that has required several heirs to change their surnames to Knight. This last occurred in 1797, when control of the estate passed to Edward Austen, who changed his surname to Knight on taking the legal title in 1812. In 1809, Edward's sister, Jane Austen, moved into Chawton Cottage (formerly the bailiff's house) and began the most prolific period of her writing life, which ended with her death in 1817.

In 1826, the house became the home of Edward's son, also Edward, who lived there until his death in 1879, the title then passing to his son, Montagu, who held the estate until his death in 1914. Inheritance taxes and increased running costs then started a long period of decline, involving the sale of most of the outlying manor and the sub-division of the house into flats.

The decline was halted in 1993 with the sale of a long lease to a new charity established by the American entrepreneur and philanthropist, Sandy Lerner. Ten years later, after extensive conservation work, the house reopened as Chawton House Library.

Chawton House Library's main collection focuses on works written by women in English during the period 1600–1830. The Library holds early editions of works from the period; many of the books in the collection are rare and in some cases even unique. Writers whose work is held in the collection include Penelope Aubin, Aphra Behn, Frances Burney, Maria Edgeworth, Eliza Haywood, Charlotte Lennox, Hannah More, Sydney Owenson, Ann Radcliffe, Mary Robinson, Mary Shelley, Frances Sheridan, Charlotte Smith and Mary Wollstonecraft, and many more both notable and lesser-known writers, as well as a significant number of anonymous works.

The main collection reveals the intricate and richly-woven texture of the literary marketplace during this period. While novels are a strength of the collection, the generic diversity of women's writing is reflected in the holdings of poetry (by writers such as Anne Finch, Felicia Hemans, Lady Mary Montagu, Elizabeth Rowe and Mary Tighe), drama (by the likes of Frances Brooke, Hannah Cowley and Elizabeth Inchbald), published letters (including those of Hester Thrale and Elizabeth Carter), as well as memoirs and autobiographical

Facing page: Hudson, Thomas, 1701–1779, *Admiral Sir George Pocock (1706–1792)* (detail), 1749, Royal Naval Museum, (p. 209)

writing by women such as Charlotte Charke, Mary Robinson and Germaine de Staël, and writing on a whole range of other subjects including history, travel, medicine, botany, cookery and much more. Women also, of course, played a vital part in debates upon female education in this period and the collection contains educational works, advice manuals and children's literature by figures such as Anna Letitia Barbauld, Sarah Trimmer, Priscilla Wakefield and Barbara Hofland. The collection also holds works not necessarily written by women, but pertaining particularly to the lives and experience of women, such as female conduct manuals.

The library also houses the Knight Collection, which is the private library belonging to the Knight family. The Knight Collection was put together over many generations, mainly in the eighteenth and nineteenth centuries. Having been owned by Jane Austen's brother Edward, who was adopted into the Knight family, it was a library known to and used by Jane Austen herself. There have been many changes to this collection since 1900 but it remains a fascinating example of a country house library. The collection is on loan to Chawton House Library from Richard Knight.

Chawton House Library's paintings come from two collections. The Knight Collection comprises family portraits and landscapes, as well as some very interesting Austen-related pieces such as the Wellings silhouette (which is not an oil and therefore not included in this catalogue). The main Library collection focuses on notable women of the period, including the actor Elizabeth Hartley, Lady Mary Wortley Montagu, poet and novelist Amelia Opie by her husband John Opie, and actress, poet and novelist Mary Robinson by John Hoppner.

Heather Shearer, Director

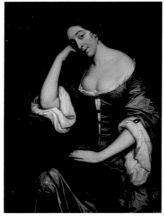

Anderton, Henry (attributed to) 1630–1665
Portrait of a Lady, Three-Quarter Length, Seated, Wearing a Gold Dress with Red Robes
oil on canvas 107 x 84
129

Bascho, H.
*Pink and White Roses**
oil on canvas 47.2 x 62
301

Beale, Mary (circle of) 1633–1699
Portrait of a Lady, Half-Length, in a Brown Dress Trimmed with Lace, in a Sculpted Cartouche
oil on canvas 73.7 x 59
687

Bizard, Jean-Baptiste 1796–1860
George Sand (1804–1876) 1847
oil on canvas 72.4 x 57
84

British (English) School
Sir Roger Lewkenor (?) c.1600
oil on canvas 88.9 x 69
794 (P)

Chamberlin, Mason the elder (attributed to)
1727–1787
Portait of a Lady, probably Elizabeth Hartley
oil on canvas 76.2 x 63.4
686

Cosway, Richard (circle of) 1742–1821
*Portrait of a Lady Seated at a Table Writing a
Letter, possibly Maria Cosway*
oil on panel 21.3 x 17.5
331

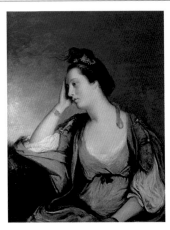

Cotes, Francis (attributed to) 1726–1770
Kitty Fisher
oil on canvas 91.5 x 71
332

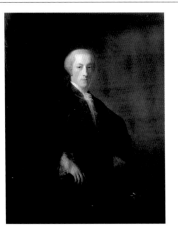

Cotes, Francis (attributed to) 1726–1770
Thomas Knight (d.1794)
oil on canvas 124.3 x 99.2
567 (P)

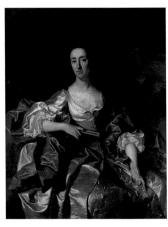

Dahl, Michael I 1656/1659–1743
Jane Knight (1710–1765)
oil on canvas 124.5 x 99
673 (P)

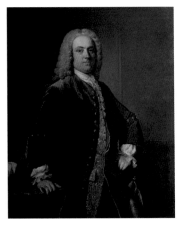

Dahl, Michael I 1656/1659–1743
Thomas Knight (1701–1781)
oil on canvas 124.5 x 99
672 (P)

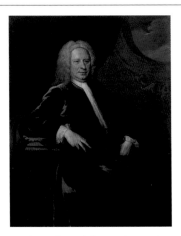

Davison, Jeremiah c.1695–1745
Bulstrode Peachey Knight (d.1735)
oil on canvas 125 x 100.5
563 (P)

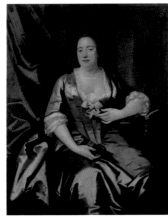

Davison, Jeremiah c.1695–1745
Elizabeth Knight (d.1737)
oil on canvas 125 x 99
564 (P)

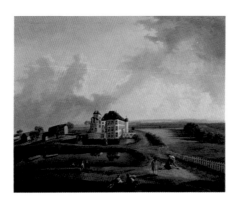

Flemish School late 18th C
Flemish Castle
oil on canvas 75 x 88.5
293

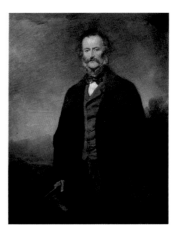

Grant, Francis 1803–1878
Edward Knight II (1794–1879)
oil on canvas 130.9 x 100.9
559 (P)

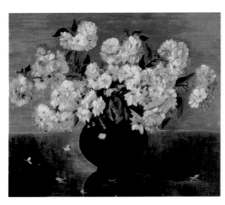

Hissan, T. T.
Pink Floral Bouquet
oil on canvas 53.5 x 64.3
302

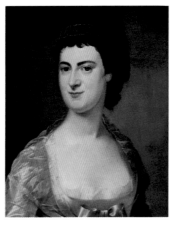

Hoare, William (attributed to) c.1707–1792
Mrs Mary Knowles (1733–1807)
oil on board 53.5 x 44.5
696

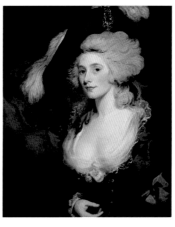

Hoppner, John (attributed to) 1758–1810
Mrs Mary Robinson (1758–1800) as 'Perdita'
oil on canvas 79.4 x 66
207

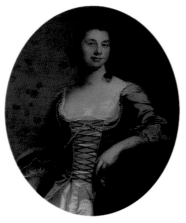

Hudson, Thomas (circle of) 1701–1779
*Portrait of a Lady, Traditionally identified as
Kitty Clive (1711–1785)*
oil on canvas 86.3 x 69.2
797

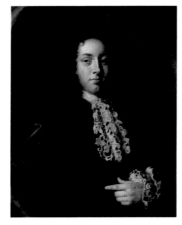

Hysing, Hans (attributed to) 1678–1753
Richard (Martin) Knight (d.1687)
oil on canvas 72.5 x 60
556 (P)

Italian School
*Landscape with Peacock and Peahen, Other
Ornamental Fowl and a Rabbit* c.1800
oil on canvas 101.3 x 137.2
237

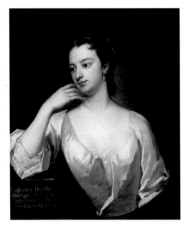

Jervas, Charles c.1675–1739
Lady Mary Wortley Montagu (1689–1762)
oil on canvas 75.5 x 63
206

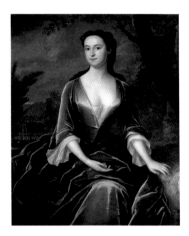

Jervas, Charles c.1675–1739
Portrait of a Lady
oil on canvas 125.3 x 97.3
229

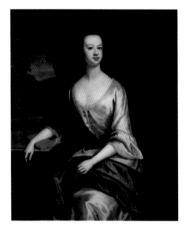

Jervas, Charles (circle of) c.1675–1739
Portrait of a Lady, possibly Eleanor Varney
oil on canvas 120.7 x 100.2
337

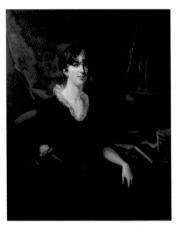

Lawrence, Thomas (circle of) 1769–1830
Portrait of a Lady, Traditionally Identified as
the Novelist Fanny Burney (1752–1840)
oil on canvas 127.6 x 102.3
341

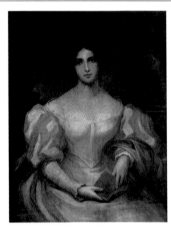

Lawrence, Thomas (follower of) 1769–1830
Portrait of a Lady, Traditionally Identified as
Fanny Kemble (1809–1893)
oil on canvas 111.7 x 86.4
802

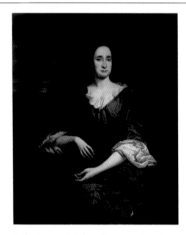

Lely, Peter (style of) 1618–1680
Anne Mynne, Wife of Sir John Lewkenor
oil on canvas 127 x 101
558 (P)

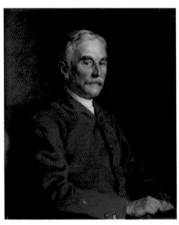

McDonald, Alexander 1839–1921
Montagu G. Knight (1844–1914) 1906
oil on canvas 73.2 x 62.5
568 (P)

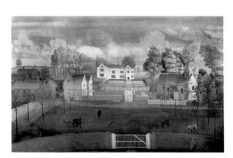

Mellichamp
A View of Chawton c.1740
oil on canvas 133 x 204.4
572 (P)

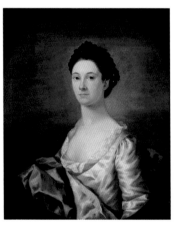

Millar, William active 1751–1775
Diana, Wife of Sir Walter Scott 1758
oil on canvas 75 x 62
338

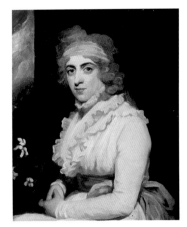

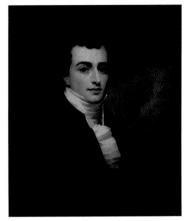

Opie, John 1761–1807
Amelia Alderson Opie (1769–1853), Writer, the Artist's Second Wife
oil on canvas 76.2 x 63.5
294

Preyer, Johann Wilhelm 1803–1889
Vase Filled with Flowers
oil on canvas 57 x 80
212

Raeburn, Henry 1756–1823
Joseph Hume (d.1829)
oil on canvas 76.2 x 63.5
246

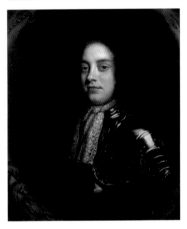

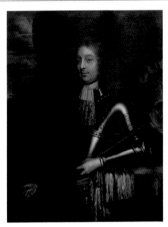

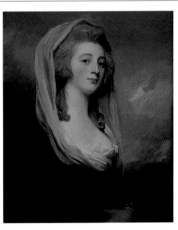

Riley, John (style of) 1646–1691
Christopher (Martin) Knight
oil on canvas 73.5 x 61.8
557 (P)

Riley, John (style of) 1646–1691
Sir Richard Knight (1639–1679)
oil on canvas 127 x 101.5
560 (P)

Romney, George 1734–1802
Charlotte Gunning, later Mrs Stephen Digby
oil on canvas 76.2 x 63.5
295

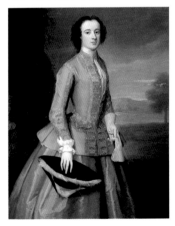

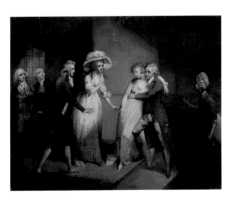

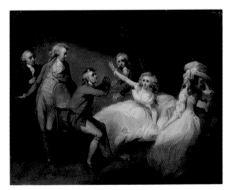

Seemann, Enoch the younger 1694–1744
Portrait of a Lady in a Riding Habit
oil on canvas 124.3 x 99.7
245

Singleton, Henry 1766–1839
*'Camilla Fainting in the Arms of Her Father'
(an illustration of a scene from Fanny Burney's
'Camilla, or a Picture of Youth', published in 1796)*
oil on canvas 35.5 x 44.2
803

Singleton, Henry 1766–1839
*'Camilla Recovering from Her Swoon' (an
illustration of a scene from Fanny Burney's
'Camilla, or a Picture of Youth', published in 1796)*
oil on canvas 35.5 x 44.2
804

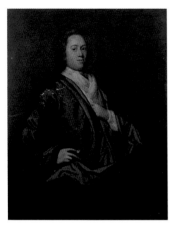

Slaughter, Stephen (style of) 1697–1765
William Woodward Knight
oil on canvas 127.7 x 103
565 (P)

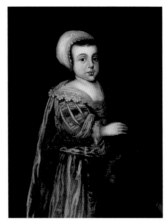

unknown artist
Unknown Boy of the Knight Family c.1635
oil on canvas 72.4 x 54.6
553 (P)

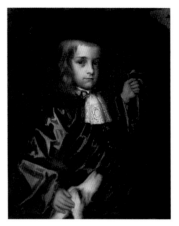

unknown artist
Jonathan Lewkenor (1658–1706)
oil on canvas 72 x 62
561B (P)

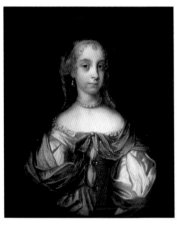

unknown artist
Miss Evelyn Lewkenor
oil on canvas 75.5 x 61.7
562 (P)

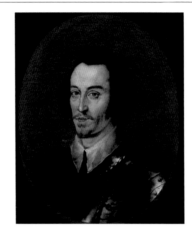

unknown artist
Richard Lewkenor (?)
oil on canvas 58 x 48
554 (P)

unknown artist
Richard Lewkenor (?)
oil on canvas 59 x 47.5
555

unknown artist
Sir Richard Lewkenor (1550–1616)
oil on panel 88.9 x 69
566 (P)

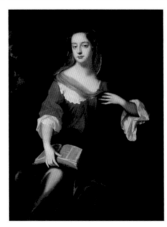

Wissing, Willem (school of) c.1656–1687
Frances, Countess of Scarborough
oil on canvas 123.2 x 97.3
296

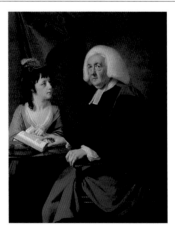

Wright, Joseph of Derby 1734–1797
The Reverend Thomas Wilson (1703–1784)
and Miss Catherine Macaulay (1731–1791)
oil on canvas 127.6 x 101.6
298

Jane Austen's House

Chawton Cottage, now Jane Austen's House Museum, was home to the writer for the last few years of her life. Set in the pretty Hampshire village of Chawton it was here that her genius flourished and she wrote and revised almost all of her major work in this house.

The circumstances in which Jane Austen came to live in Chawton have close links with the oil paintings on display in the house today. A wealthy distant relation, Thomas Knight, had left properties in Kent and Hampshire to Jane's brother, Edward, leaving him a very wealthy man. In 1809 he offered a home on his Chawton estate to his widowed mother and his two unmarried sisters, Cassandra and Jane, and their friend, Martha Lloyd.

Being a modest home, good quality oil paintings are not greatly in evidence. Those that are here all relate to Edward (Austen) Knight and his family. Edward is revealed in considerable splendour in a large full length portrait to celebrate his completion of the Grand Tour. In powdered wig and gold breeches he stands amid classical ruins, very much the young man of property.

We were grateful to the Victoria & Albert Museum Purchase Grant Fund for their help in acquiring a second portrait believed to be of Edward, *Portrait of a Boy in a Blue Coat, possibly Edward Austen,* by an unknown artist. This depicts him in his early teens, with an expression rather typical of his age group, possibly around the time of his 'adoption' by the Knights. In order for him to inherit, under the terms of the Knight estate, he had to leave the Austen family home and take up residence with Thomas Knight and his wife. After they died he was required to take the name of Knight.

Edward was in frequent touch with his birth family and they remained on good terms. His eldest daughter, Fanny Knight, is represented in an oval oil painting when in middle age. A favourite niece of Jane Austen, 'almost another sister', she was the oldest of 11 children. She married into the Knatchbull family. Sadly, in older age, she recalled her famous aunt with more condescension than affection.

We are grateful to the Public Catalogue Foundation for including our paintings, and the opportunity to tell the stories behind them.

Louise West, Education Officer

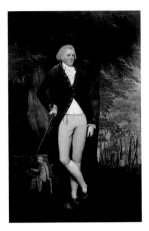

British (English) School 18th C
Edward Austen (1767–1852)
oil on canvas 180 x 110 (E)
CHWJA.JAH 73 (P)

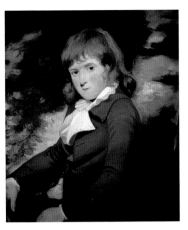

British (English) School 18th C
Portrait of a Boy in a Blue Coat, possibly Edward Austen (1767–1852)
oil on canvas 73.5 x 63
CHWJA.JAH 93

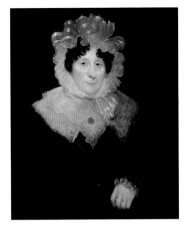

British (English) School 19th C
Susannah Sackree, Nursemaid to Edward Knight's Family at Godmersham Park
oil on canvas 74.5 x 62
CHWJA.JAH 229

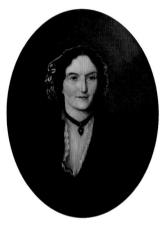

British (English) School mid-19th C
Fanny Knight (later Lady Knatchbull) (b.1793), Jane Austen's Favourite Niece
oil on canvas 67.5 x 56
CHWJA.JAH 33 (P)

unknown artist
Chawton House and Church 1809
oil on canvas 21.5 x 29.5
CHWJA.JAH 37

unknown artist 19th C
'Prowtings', a House Neighbouring Jane Austen's
oil on canvas 17.3 x 24.5
CHWJA.JAH 88

Hampshire Fire and Rescue Service

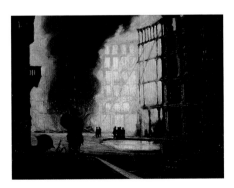

Forby, C. A.
A Quiet Corner in London 1940
oil on canvas roof of a London towing taxi 45 x 60
PCF7

Hancock
At the Scene of the Fire 1970
oil on board 39 x 25
PCF1

Hancock
London in the Blitz
oil on board 25.5 x 45
PCF2

Harland, Bernard d.1981
Threesome 1975
oil on canvas 50 x 75
PCF5

Windebank, Barry
Chariots of Fire 1989
oil on canvas 80 x 100
PCF3

Windebank, Barry
Their Day Done 1989
oil on canvas 80 x 130
PCF4

Windebank, Barry
The Rescue
oil on canvas 100 x 80
PCF6

Emsworth
Museum

Summers, Alan 1926–2006
Ebb Tide at Dawn in Emsworth Harbour
oil on board 29 x 39.5
66

unknown artist 20th C
Lumley Mill, Emsworth, before the Fire in May 1915
oil on canvas 24.5 x 39.5
46

Facing page: Allen, William Herbert, 1863–1943, *A Children's Religious Procession* (detail), Hampshire County Council Museums Service (p. 255)

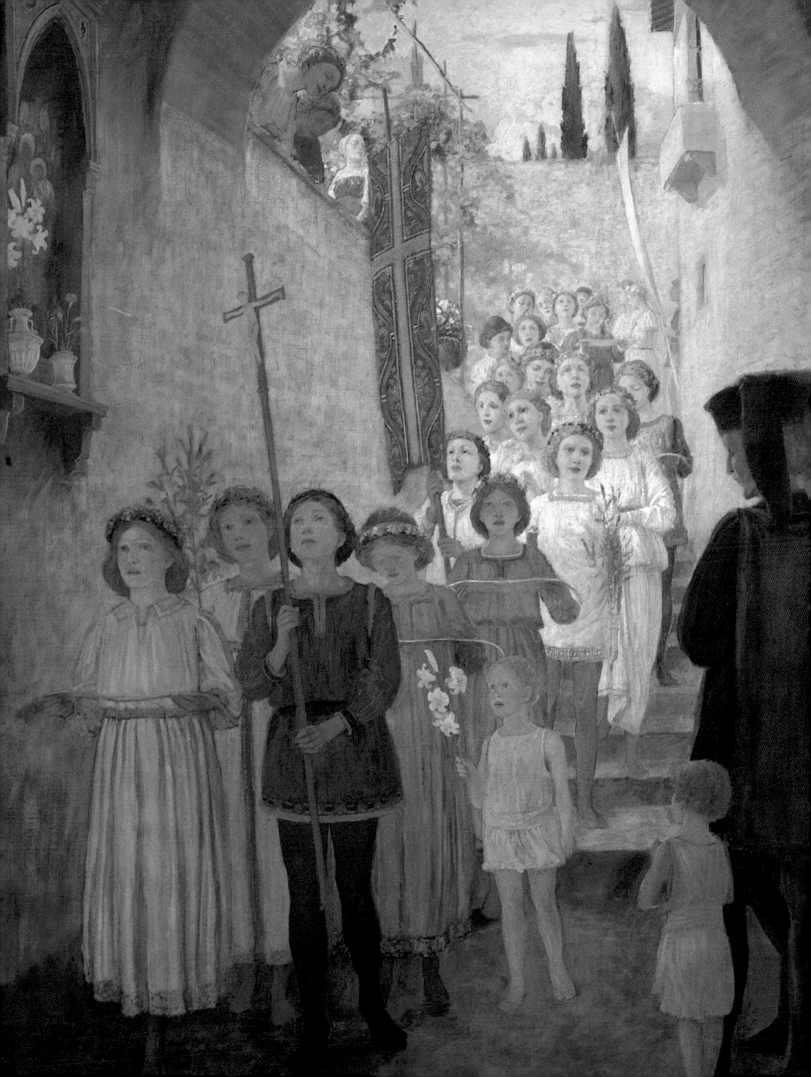

Whitham, Peter 1924–1996
Dolphin Cut c.1990
oil on canvas 29.5 x 39.5
2

Wickham Smith
Warblington Church 1972
oil on board 34 x 44.5
24

Williamson, Richard L. 1916–2003
'Indian Queen' of Emsworth, 1863 1977
oil on board 48.2 x 58.5
11

Fareham Borough Council

Baker, Ted
Cottages and Council Offices 1992
oil on canvas 44 x 59.5
PCF8

Hansford, B. P.
Westbury Manor 1989
oil on canvas 50 x 60 (E)
PCF6

Stone, B. R. active 1962–1988
The 'Mary Rose', 1535 1962
oil on canvas 45 x 55
PCF2

Stone, B. R. active 1962–1988
'HMS Victory' 1988
oil on canvas 44.9 x 54.9
PCF1

Trask, Keith
The 'Red Lion'
oil on board 45 x 60.5
PCF3

unknown artist
Reverend Sir Henry Thompson 1845
oil on canvas 140 x 110
PCF7

unknown artist
Fareham Creek
oil on canvas 87 x 119
PCF4

unknown artist
The Old Mill
oil on canvas 91.2 x 110
PCF5

Royal Armouries, Fort Nelson

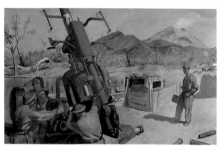

Carr, Henry Marvell 1894–1970
A 3.7 Anti-Aircraft Gun of 393/72 Heavy Anti-Aircraft Regiment, RA, CMF 1944
oil on canvas 81.2 x 130.8
IWM ART LD 4064

Freedman, Barnett 1901–1958
The Gun 1940
oil on canvas 59 x 91.4
IWM ART LD 391

Richards, Albert 1919–1945
Breaking up the Attack, Holland: 25-Pounders of the 15th (Scottish) Division Firing towards Meijel 1944
oil on panel 55.8 x 76.2
IWM ART LD 4825

Rushmoor
Borough Council

Hieronymi, Georg 1914–1993
Oberursel (Taunus), Germany 1989
oil on canvas 58.3 x 47
PCF2

Howard, Ken b.1932
Presentation of Freedom Scrolls on Friday, 29 May 1981 1981
oil on canvas 49.6 x 90
PCF1 🐝

Hart District
Council

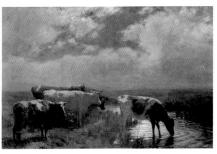

Cuprien, Frank William (attributed to)
1871–1948
Cows Drinking 1914
oil on canvas 118 x 180
PCF3

Jones, Robert M.
A Soldier of Queen Elizabeth's Own Gurkha Rifles on Duty in Kosovo
oil on canvas 74 x 56
PCF2

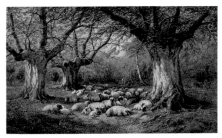

Luker, William II (attributed to) 1867–1947
Sheep in a Wooded Landscape
oil on canvas 74 x 125
PCF1

Fordingbridge Town Council

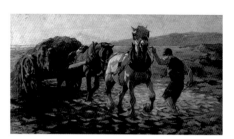

Downs, Edgar 1876–1963
Gathering Kelp 1914
oil on canvas 119 x 192 (E)
PCF2

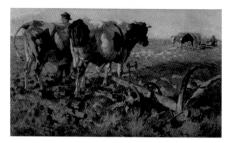

Downs, Edgar 1876–1963
Cattle Ploughing in an Open Landscape
c.1914
oil on canvas 119 x 192 (E)
PCF1

Explosion! The Museum of Naval Firepower

Explosion! The Museum of Naval Firepower holds the national collection of naval weapons and ammunition displayed in the historic buildings of Priddy's Hard, the former naval armament depot for Portsmouth. The collection shows the technical side of naval warfare.

The depiction of great naval battles and warships has always been one of the romantic themes for painters. Weapons, ammunition and the people who made them are seen as a much less romantic topic for high art. Our collection of artwork is necessarily small because of this. Artwork illustrating the themes within our collection is more likely to be pen and ink sketches, posters and postcards and mostly produced in wartime for morale, recruiting or instructional purposes.

We have a few works in oils and acrylics by nationally recognised and local artists. These show the armament service vessels, the workhorses of the armaments world, and the makers and designers of naval armaments. The debt we owe is to the few artists who decided to illustrate the little known and less glamorous side of war. Our greatest thanks go to these artists and their families for the donation of these items to the museum.

Josephine Lawler, Curator

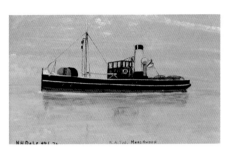

Dale, Norman H.
'NA Tug Marchwood' 1976
oil on canvas 14.5 x 24.8
PH1998.4.6

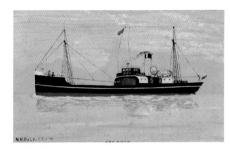

Dale, Norman H.
'NAV Bison' 1976
oil on canvas 15.2 x 25
PH1998.4.7

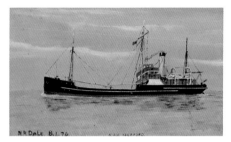

Dale, Norman H.
'NAV Isleford' 1976
oil on canvas 14.5 x 25
PH1998.4.8

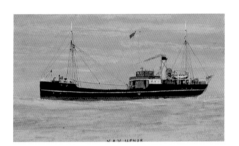

Dale, Norman H.
'NAV Upnor' 1976
oil on canvas 14.3 x 24.8
PH1998.4.9

Silas, Ellis 1883–1972
An Engineer Working at Fort Grange in 1919
c.1919
oil on canvas 54.7 x 45
PH1998.4.56

Royal Navy Submarine Museum

When Britain's first submarine, 'Holland 1', was launched in 1901, few would have guessed that it was to become the nation's most potent weapon. In just over one hundred years, the Royal Navy Submarine Service has progressed from a force with tiny, slow and unwieldy craft capable of firing a torpedo only a few hundred yards, to one with vessels which carry Britain's strategic nuclear deterrent over thousands of miles.

During this time, the perception of the submarine's role has changed totally. At its outset the majority of the Navy considered the Service as 'underhand, unfair and damned un-English'. But in 1943, Winston Churchill proclaimed: 'Of all the branches of men in the Forces there is none which shows more devotion and faces grimmer perils than the submarines'.

Despite this, British submarines and their heroic crews have not entered the consciousness of the general public to the extent of the better known U-boats.

The Royal Navy Submarine Museum has a collection of artefacts and paintings, all of which hold surprising social interest. Therefore we are grateful to the Public Catalogue Foundation for giving us a chance to show our collection to the wider audience we feel it deserves.

Our collection showcases not only professional artists such as Terence Tenison Cuneo, George Fagan Bradshaw and Johne Makin, but also submariners with artistic flare who have ably captured life on board. In addition, the evolution of the submarine can clearly be seen within the paintings. *The Launch of 'HMS Dreadnought'* by Terence Cuneo shows the sheer size of the first nuclear submarine as hundreds crowd to see her with the royal family looking on; a sharp contrast to its earliest predecessor the Holland class, as shown in the painting *'Holland 3'* by H. Collins.

Some of the most important events in submarine history are also portrayed on canvas here. *Well Done 'E.9'* by A. Moore portrays the first ever sinking of a ship by a British submarine. Just days after the loss of the first British warship to a U-boat in 1914, 'HMS E.9' commanded by Lieutenant Max Horton sank the German light cruiser 'Hela'. This picture is an amateur work probably painted close to the event. It illustrates both the popular patriotism of the time and the way submarines gripped the imagination of ordinary people.

The portrait of *Lieutenant Commander Wanklyn* by Harry Morley commemorates the Royal Navy's most successful submarine commander. As Commanding Officer of 'HMS Upholder', Wanklyn sank a record tonnage of enemy shipping from 1940–42. Tragically in April 1942 'Upholder' was lost with all hands on her last patrol before returning to Britain. This portrait was commissioned by the submarine officers of the Ward Room of 'HMS Dolphin' the year after his death. The Admiralty took the very unusual step of publishing a special communiqué praising 'HMS Upholder' and her crew: 'The ship and company are gone, but the example and the inspiration remain.'

Finally, no discussion of our paintings would be complete without taking time to thank our supporters, most prominently the Society of Friends of the Museum, without whom it would have been impossible to purchase Cuneo's *The Launch of 'HMS Dreadnought'*.

Alexandra Geary, Keeper of Artefacts

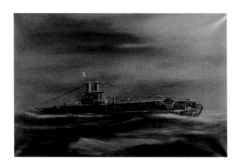

Bampfield, John b.1947
Dawn Patrol
oil on canvas 60 x 90
B24/10/84

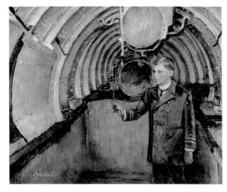

Barnet, Margaret
Lieutenant Arnold Forster
oil on board 40 x 50
B02/05/86

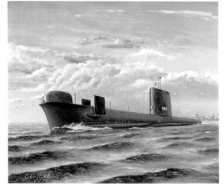

Belling, Colin J.
'HMS Cachalot'
acrylic on board 49.5 x 59.2
B29/04/96

Bennett, H. A.
'HMS K.26'
oil on board 27.5 x 58.5
2002.327.1

Berey, Len b.1916
Chariot Attack on Ship
oil on board 39.5 x 50
B25/13/94E

Berey, Len b.1916
Chariot Going through Net
oil on board 32 x 43
B25/13/94G

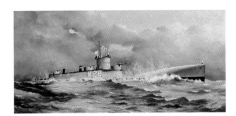

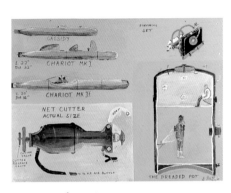

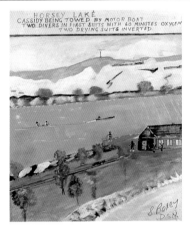

Berey, Len b.1916
Chariots, Net Cutter, Breathing Set and 'Pot'
oil on board 60 x 81.2
B25/13/94C

Berey, Len b.1916
Horsey Lake
oil on board 61.5 x 52
B25/13/94H

Berey, Len b.1916
Submarine Carrying Chariots at Sea
oil on board 41 x 60.5
B25/13/94F

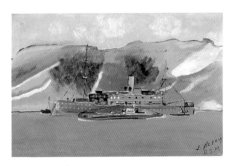

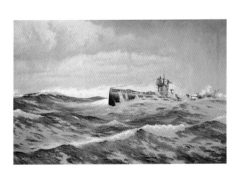

Berey, Len b.1916
T-Boat alongside a Depot Ship
oil on board 40.7 x 61.5
B25/13/94D

Berey, Len b.1916
The First Davis Submerged Escape Apparatus Chamber
oil on board 56 x 30.6
B25/13/94I

Bradshaw, George Fagan 1887–1960
On Patrol (1914–1918) c.1918
oil on canvas 100 x 152
2001.99.1

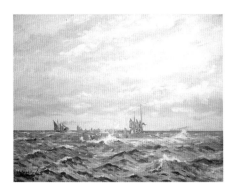

Bradshaw, George Fagan 1887–1960
'HM Submarine C.30'
oil on canvas 53.5 x 71.5
B05/01/68

Bradshaw, George Fagan 1887–1960
'HMS Alecto'
oil on canvas 53.5 x 71.2
B43/05/68

Bradshaw, George Fagan 1887–1960
'HMS/M E.24'
oil on canvas 53.5 x 71.5
2001.14.1

Bradshaw, George Fagan 1887–1960
'HMS/M L.18'
oil on canvas 53.5 x 71
B13/05/68

Bradshaw, George Fagan 1887–1960
'HMS/M XI'
oil on canvas 53.5 x 71.5
B15/02/68

Bradshaw, George Fagan 1887–1960
Sinking of 'U98' (First World War)
oil on board 17.3 x 25 (E)
B35/01/68a

Bradshaw, George Fagan 1887–1960
Sinking of 'U98' (First World War)
oil on board 17.3 x 25 (E)
B35/01/68b

Bradshaw, George Fagan 1887–1960
Sinking of 'U98' (First World War)
oil on board 17.3 x 25 (E)
B35/01/68c

Bradshaw, George Fagan 1887–1960
Sinking of 'U98' (First World War)
oil on board 17.3 x 25 (E)
B35/01/68d

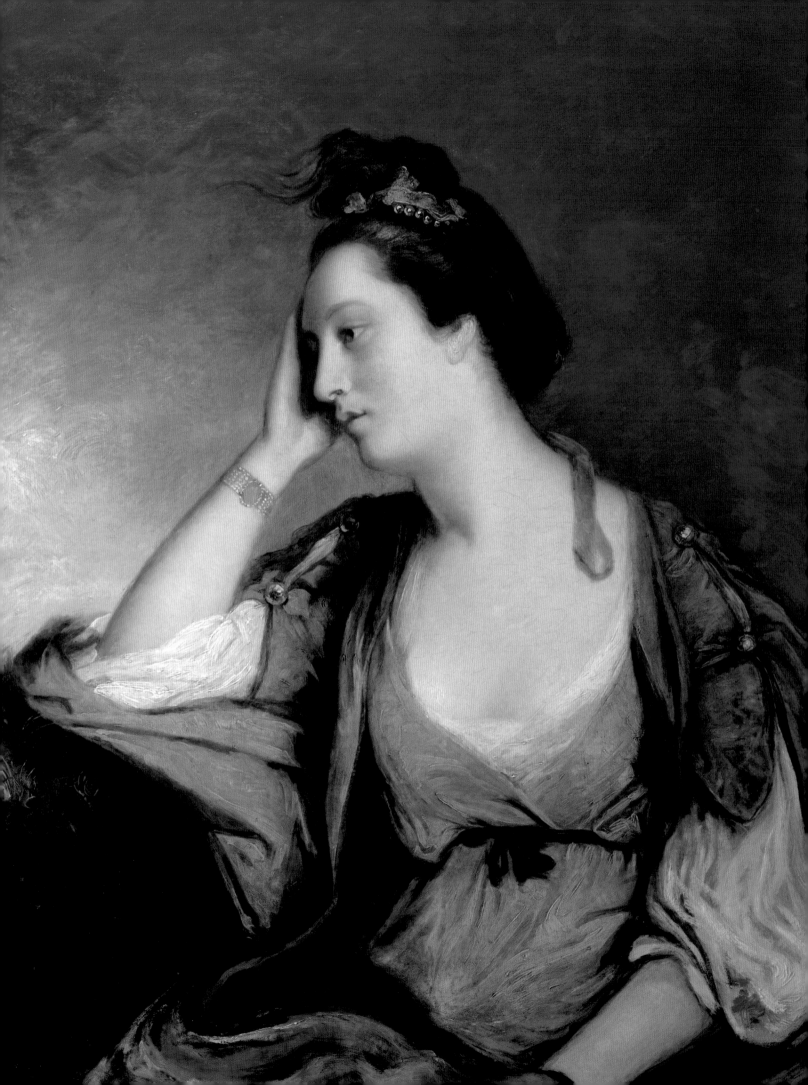

Bradshaw, George Fagan 1887–1960
Submarine and Escort
oil on canvas 52 x 71.5
B09/01/68

Bradshaw, George Fagan 1887–1960
U-Boat at Sunset
oil on canvas 52 x 71
B35/06/68

Bradshaw, George Fagan 1887–1960
U-Boat Sinking Barque by Gunfire
oil on canvas 52.5 x 71.5
B35/07

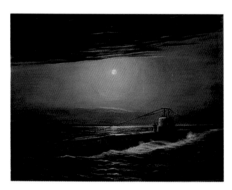

Bray, John
Russian Typhoon Class Submarine
oil on canvas 56.5 x 75.5 (E)
2001.9.1

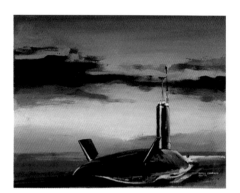

Cameron, Dugald b.1939
'HMS Dreadnought' 1975
oil on board 26.2 x 33.1
B30/01/81 (P)

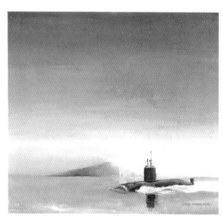

Cameron, Dugald b.1939
'HMS Swiftsure' 1976
oil on board 30.5 x 33
B32/01/76 (P)

Coates-Walker, Christopher
active 1979–1999
Flashback 1979
oil & mixed media on canvas 137 x 200
2001.98.1

Collins, H.
'Holland 3' 1903
oil on board 17.5 x 27.5
2001.1487.1

Cuneo, Terence Tenison 1907–1996
The Launch of 'HMS Dreadnought' 1961
oil on canvas 88 x 136.5
1999.17.1

Facing page: Cotes, Francis (attributed to), 1726–1770, *Kitty Fisher* (detail), Chawton House Library, (p. 13)

Douglas, Penelope
Swiftsure Class Submarine at the Fleet Review
oil on canvas 49 x 75
B32/02/79

Duffy, Owen
'P.228' 1974
oil on board 39.2 x 50.1
2001.87.1

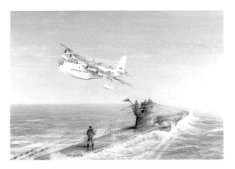

Dyer, Allen G.
Surrender, 1945 1992
acrylic on canvas 49.5 x 72.5
B35/15/96

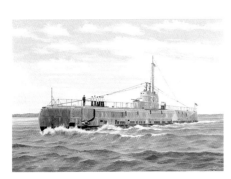

Fisher, Simon b.1944
'HMS Seal' 1998
oil on canvas 34.5 x 50
1998.3.1

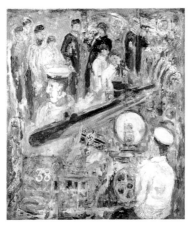

Fleming, George
Sailors and Tin Fishes
oil on canvas 90 x 80
B40/07/97

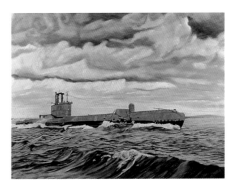

Gittins, D. J. active 1972–1979
'HMS Seadevil' 1972
oil on board 90 x 120
2001.97.1

Grenier, Frank
Patrol under the Ice 1986
oil on canvas 32 x 39.5
B32/12/86

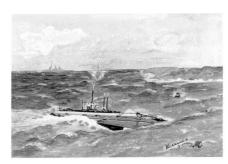

Gunning, M.
'Holland 3'
acrylic on paper 24.5 x 37.5
B02/04/84

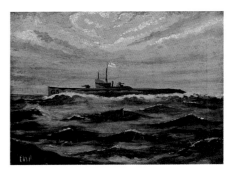

F. W. H.
'HMS G.5'
oil on canvas 23.5 x 30.5
B09/03/83

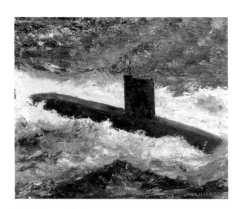

Harrison, G. A.
'HMS Sovereign' 1974 Sea Trials
oil on canvas 50 x 60
2005.26.1

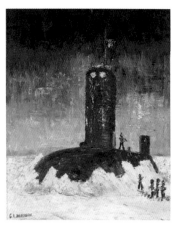

Harrison, G. A.
'HMS Sovereign' in the Arctic
oil on canvas 55 x 45
B32/03/79

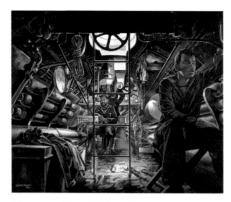

Hunt, Geoffrey William b.1948
Interior of 'Holland I' 1983
oil on canvas 49.5 x 60
B02/03/83

Jacobs, Warwick b.1963
Admiral of the Fleet, the Lord Fieldhouse of
Gosport, GCB, GBE (1928–1992)
acrylic on canvas 60 x 50
2001.1.1

Lukis
'HMS Glasgow' at a Foreign Port
acrylic on canvas 37.4 x 55.6
B33/12/76

Macdonald, Roderick 1921–2001
On the Periscope, 'HMS Renown' 1981
oil on canvas 19 x 24.3
B31/03/82

Macdonald, Roderick 1921–2001
Auxiliary Machinery Room, 'HMS Spartan'
oil on canvas 29.5 x 39.5
B32/07/81

Macdonald, Roderick 1921–2001
Commander Nigel Goodwin, Commanding
Officer, 'HMS Spartan', at Periscope
oil on canvas 39.5 x 29.5
B32/06/81

Macdonald, Roderick 1921–2001
Control Room of 'HMS Renown'
oil on canvas 24.5 x 30
B31/06/82

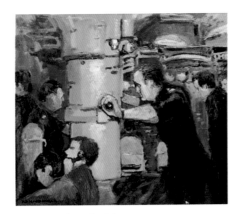

Macdonald, Roderick 1921–2001
Control Room of 'HMS Renown'
oil on canvas 29.2 x 34.2
B31/08/82

Macdonald, Roderick 1921–2001
Control Room of 'HMS Spartan'
oil on canvas 29.5 x 39.5
B32/04/81

Macdonald, Roderick 1921–2001
Control Room of 'HMS Spartan'
oil on canvas 29 x 39.7
B32/05/81

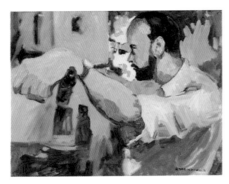

Macdonald, Roderick 1921–2001
Control Room of 'HMS Spartan'
oil on canvas 29 x 39.5
B32/08/81

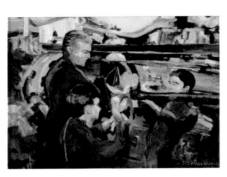

Macdonald, Roderick 1921–2001
Loading Torpedo Tube, 'HMS Renown'
oil on canvas 24.2 x 35
B31/05/82

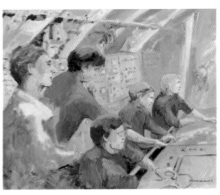

Macdonald, Roderick 1921–2001
Manoeuvring Room of 'HMS Spartan'
oil on canvas 40 x 50
B32/09/81

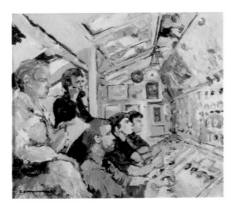

Macdonald, Roderick 1921–2001
Manoeuvring Room of 'HMS Spartan'
oil on canvas 24.5 x 30
B32/11/82

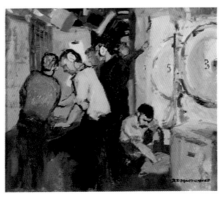

Macdonald, Roderick 1921–2001
Missile Decko of 'HMS Renown'
oil on canvas 24 x 30
B31/04/82

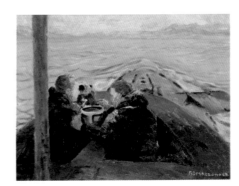

Macdonald, Roderick 1921–2001
Morning Water on the Surface
oil on canvas 29.5 x 40
B31/07/82

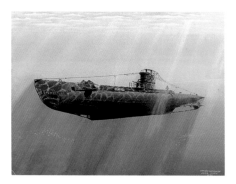

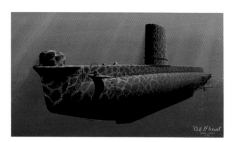

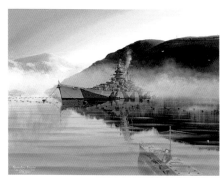

Makin, Johne b.1947
HMS/M Submarine 'Unshaken' 1992
acrylic on canvas 30.5 x 41
2001.44.1

Makin, Johne b.1947
'O & P' Boat 1993
oil on canvas 28.5 x 49.2
2001.105.1

Makin, Johne b.1947
Operation 'Source', 22 September 1943 1993
acrylic on board 41 x 54.5
2001.72.1

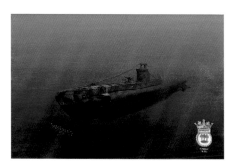

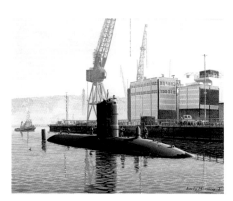

Makin, Johne b.1947
'HMS Upright' 1996
acrylic on board 20.2 x 30.6
B21/04/86

Makin, Johne b.1947
Early Morning 'T', 'HMS/M Triumph'
acrylic on canvas 39 x 49
2001.102.1

Makin, Johne b.1947
Operation 'Principle', Palermo, January 1943
acrylic on board 39.4 x 49.5
B25/12/94

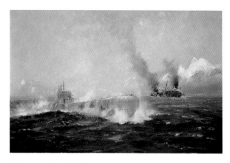

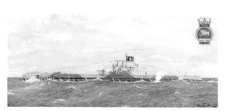

Makin, Johne b.1947
'Torpedo Strike'
oil on board 49.6 x 39.6
2001.25.1

Mason, Frank Henry 1876–1965
Attack on a German Tanker off the Norwegian Coast c.1940
oil on canvas 35.5 x 58.8
2001.3.1

McMurde, H.
'HMS Stygian' P.249 1987
acrylic & pencil on paper 21.2 x 49.2
B24/09/87

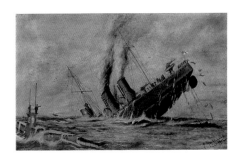

Moore, A.
Well Done HMS 'E.9' 1914
oil on canvas 24 x 39.8
1998.7.1

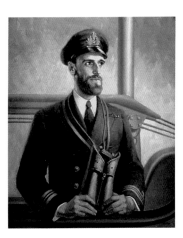

Morley, Harry 1881–1943
Lieutenant Commander Wanklyn 1943
oil on canvas 59.2 x 42
2001.36.1

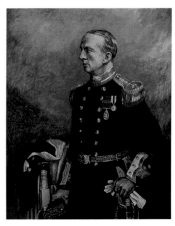

Munday
Commodore S. S. Hall 1955
oil on canvas 126 x 101
2006.32.1

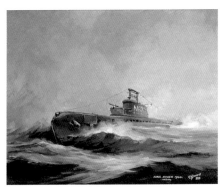

O'Farrel, R. active 1988–1997
HM Submarine 'Rover', India, 1964 1988
oil on board 39.5 x 49.8
B18/01/88

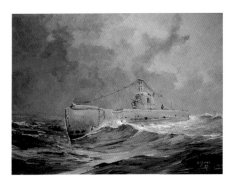

O'Farrel, R. active 1988–1997
HM Submarine 'Porpoise' 1997
oil on card 31.5 x 41.5
2001.90.1

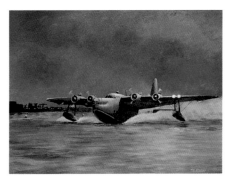

Oswald, T. J.
Night Launch
oil on board 29.5 x 40
2001.1483.1

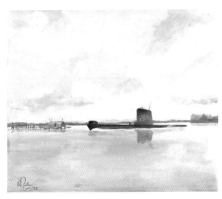

Rinder, P. R. (attributed to)
'Oberon Class' 1965
acrylic on board 45.5 x 55
2001.85.1

Russwurm, G.
'HMS Turbulent' Submerged 1988
acrylic on canvas 14 x 19.5
B23/17/97

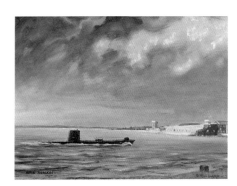

Russwurm, G.
'HMS Sealion'
oil on canvas 29 x 39
B29/03/87

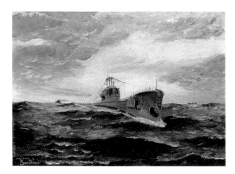

Southcombe, Christopher
HM Submarine 'Alaric'
oil on board 25.2 x 35.3
B26/07/97

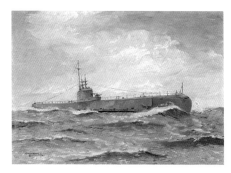

Southcombe, Christopher
HM Submarine 'Rorqual'
oil on board 25.1 x 35.6
B20/02/97

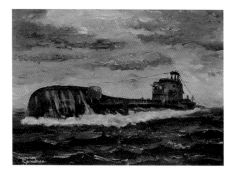

Southcombe, Christopher
HM Submarine 'Thule'
oil on board 25 x 35.2
B23/18/97

Swindlin, N.
Able Seaman John Ford ('HMS Sidon')
oil on canvas 49.5 x 39.3
2004.69.1

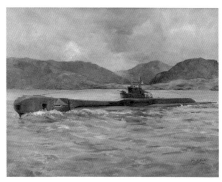

Taylor, John S. active 1932–1939
'HMS Tribune T.76' 1939
oil on canvas 37.5 x 49.5
2001.128.1

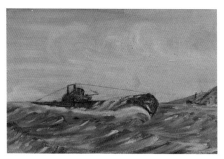

unknown artist
HM Submarine 'Torbay' 1942
oil on canvas 19 x 29
B23/10/84

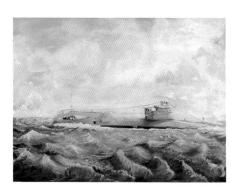

unknown artist
'The Trespasser' 1963
oil on canvas 59 x 80
2001.7.1

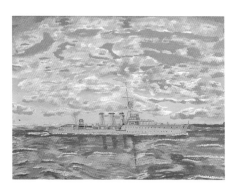

unknown artist
'HMS Inconstant' (depot ship) 1971
oil on board 44 x 59.5
2001.10.1

unknown artist
'C.23' (mounted in lifebelt)
oil on card 22
2001.1235.1

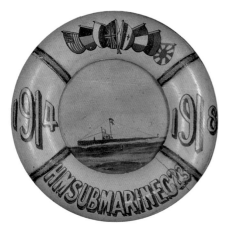

unknown artist
'C.23' (mounted in lifebelt)
oil on card 22
2001.1235.2

unknown artist
Captain C. H. Allen, DSO, Royal Navy
oil on canvas 90 x 59.5
2001.02.1

unknown artist
Commander John Wallace Linton, VC
(1905–1943), 'HMS Turbulent'
oil on board 26 x 15
B23/14/92

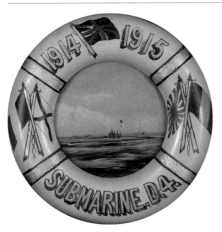

unknown artist
'D.4' (mounted in lifebelt)
oil on card 22
C07/09/82b

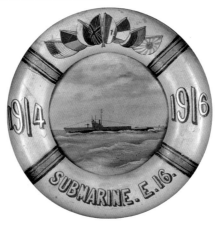

unknown artist
'E.16' (mounted in lifebelt)
oil on card 28
E07/09/94a

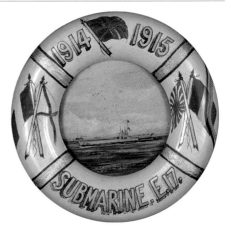

unknown artist
'E.17' (mounted in lifebelt)
oil on card 22
C07/09/82a

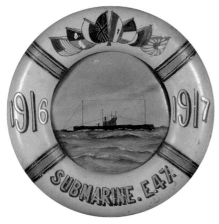

unknown artist
'E.47' (mounted in lifebelt)
oil on card 28
E07/09/94b

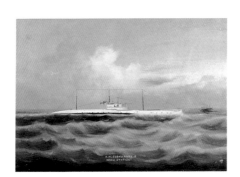

unknown artist
HM Submarine 'L.9' China Station
oil on canvas 39.5 x 56.5
B13/09/79

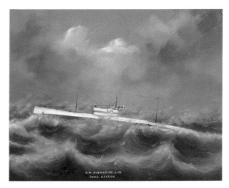

unknown artist
HM Submarine 'L.15' China Station
acrylic on board 38.2 x 48.1
B13/15/84

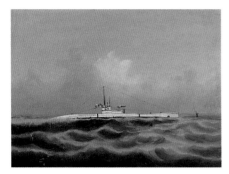

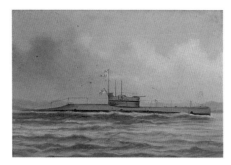

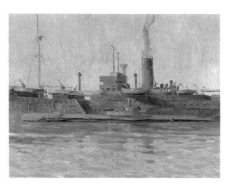

unknown artist
'HMS L.3'
oil on canvas 40.5 x 56
B13/11/80

unknown artist
'L.5'
acrylic on card 16.5 x 25
B13/19/95

unknown artist
'Scorcher' alongside 'Cyclops'
oil on board 29 x 39
2001.59.1

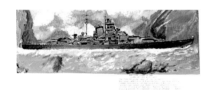

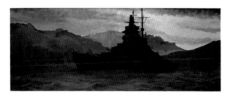

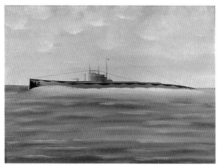

unknown artist
*The Lone 'Queen of the North' and Her
Assailants*
acrylic on paper 40 x 55
B25/12/94A

unknown artist
The 'Tirpitz'
oil on board 73 x 179
B35/02/71

Waldron
HM Submarine 'J.2'
acrylic on board 27.6 x 37.9
2001.1489.1

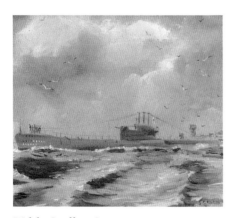

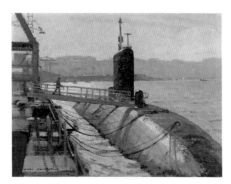

Walsh, Geoffrey C.
'HMS Alliance' Leaving Portsmouth Harbour
oil on board 12 x 14.5
2001.1478.1

Webster, John b.1932
Submarine Berth, Devonport
oil on canvas 44.5 x 59.5
2001.5.1

Wheeler, W. H.
British Submarine 'E.11' 1968
oil on board 46 x 91.2
B07/06/81

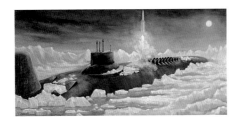

Willoughby, Michael
HM Submarine 'Sealion' 1996
oil on canvas 71.3 x 91.3
2001.96.1

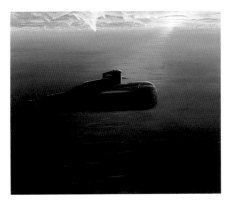

Willoughby, Michael (attributed to)
Lossian Delta Class Submarine (Russian)
oil on canvas 49 x 59
B41/02/87

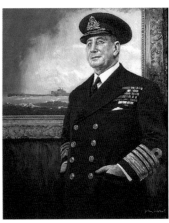

Worsley, John 1919–2000
*Admiral Sir Max Kennedy Horton
(1883–1951)* 1946
oil on canvas 89.5 x 72
2001.39.1

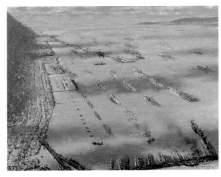

Worsley, John 1919–2000
Gibraltar, 1936 1994
oil on canvas 75 x 100
2001.4.1

Hampshire Constabulary

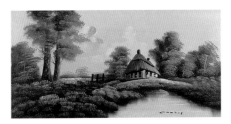

Chalis
House by a Lake with Trees
oil on canvas 43 x 88
PCF2

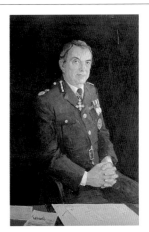

unknown artist
Sir John Hoddinott (c.1945–2001)
oil on canvas 118 x 74
PCF1

Facing page: Hunt, Geoffrey William, b.1948, *Interior of 'Holland I'* (detail), 1983, Royal Navy Submarine Museum, (p. 33)

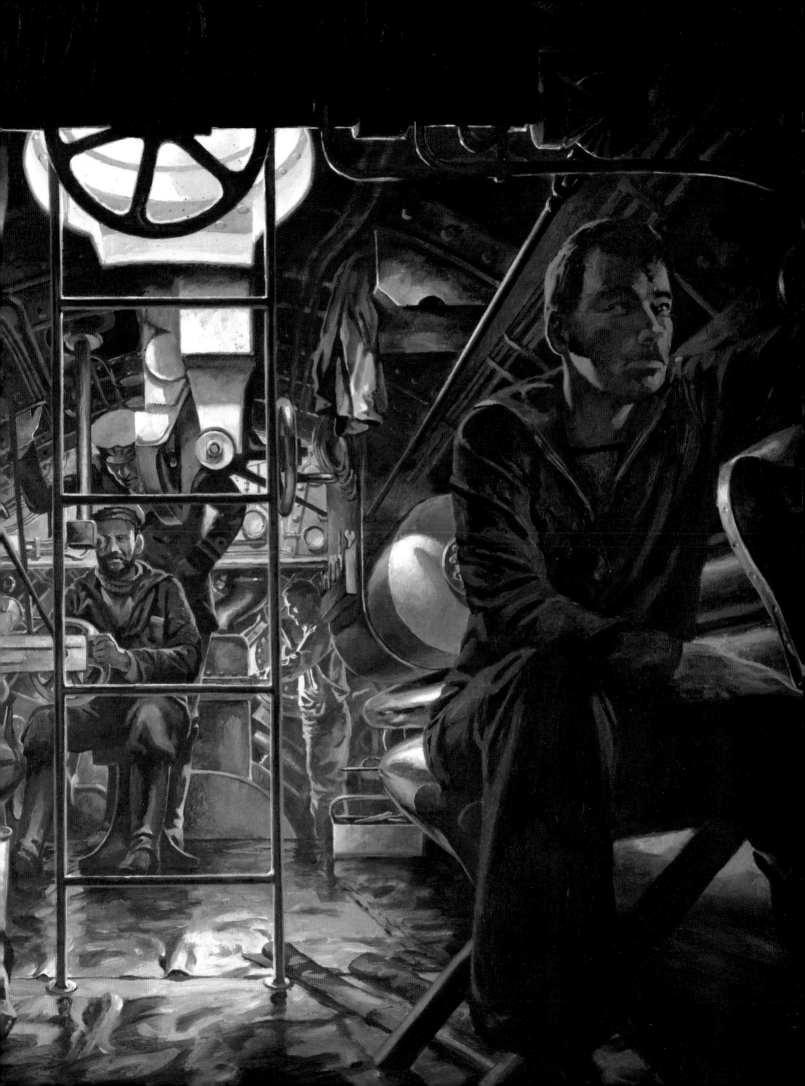

Hartley Wintney
Parish Council

Palmar, Duncan b.1964
Hartley Wintney 2000 AD
oil on canvas 62 x 125.6
1 (P)

Havant Borough
Council

Cowper, Nicholas
Views of Havant 1979
oil on board 120 x 304
PCF1

Phillips, Rex b.1931
Langstone Mill, Havant 1977
oil on canvas 39 x 54
PCF2

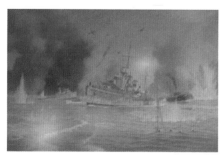

Phillips, Rex b.1931
'HMS Havant' off Dunkirk, May 1940
oil 64 x 90
PCF 3

The Hovercraft Museum Trust

The Hovercraft Museum Trust was set up in 1986, gaining charitable status in 1988. As a new industry (fifty years old in 2008), much original material has survived and nothing pre-dates 1958, when the first hovercraft were made. The collection has mainly been assembled as a result of gifts and donations, with only one commission and two purchases to date. The most famous artist in the collection is Laurence Bagley, whose wonderfully detailed oils of craft in operation are highly sought-after.

Sadly, most of the collection is not included in this catalogue as it is either pencil, watercolour or ink, but we are delighted to be able to show our oils and acrylics to a wider audience. The most interesting are the artist impressions of what they imagined hovercraft to be in the future.

W. J. Agers, Trustee

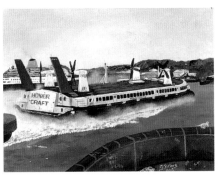

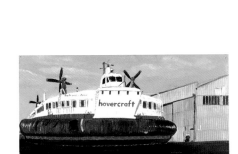

Bagley, Laurence
Westland Fleet 'SR.N5', 'SR.N3' 1966
oil on board 200 x 650 (E)
52

Baxter-Jones, A.
'SR.N4' 1961
acrylic on board 45.5 x 58
5

Briers, Greg b.1959
'SR.N4' Arrives at Dover 2001
acrylic on board 30.5 x 40.5
33

Briers, Greg b.1959
'SR.N4' at Lee-on-Solent 2001
acrylic on board 30.5 x 40.5
34

Cooke, Julian d.2003
Air Bearings Crossbow on the Northern Plateau 1978
acrylic & airbrush on board 31 x 16.5
36

Cooke, Julian d.2003
Air Bearings Crossbow 1979
acrylic & airbrush on board 37.5 x 42.5
37

Cooke, Julian d.2003
Stewardess Flies Crossbow 1979
acrylic & airbrush on board 16.5 x 32.2
38

Cresdee, Keith b.1948
Hovermarine Sidewall 'SES' Hovercraft 1978
acrylic with acetate overlay 40 x 55
24

Cresdee, Keith b.1948
'AP.188' 1985
acrylic on paper 32.5 x 46
25

Goodburn, A.
'BH.7' Logistic Support Craft 1960
acrylic on board 42 x 65.5
15

Goodburn, A.
'SR.N4' 1963
acrylic on board 48.5 x 62
14

Goodman, A.
'BH.7' Welldeck 1966
acrylic on board 29.5 x 37.5
35

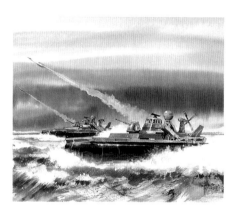

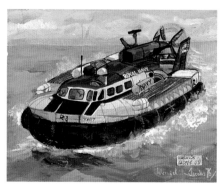

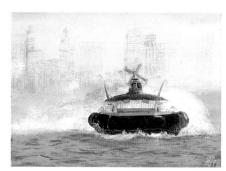

Goodman, A.
'BH.7' Missile Attack 1967
acrylic on board 31 x 38
18

Jacobs, Warwick b.1963
Royal Navy 'RJ XV617' 1976
oil on canvas 20 x 25.5
43

Jacobs, Warwick b.1963
'BH.7' in Manhattan 1977
oil on canvas 25.5 x 35.5
42

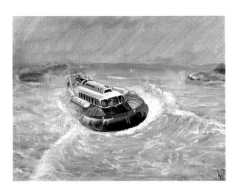

Jacobs, Warwick b.1963
'SR.N6' Amazon Expedition, 1969 1977
oil on canvas 29.5 x 39.5
40

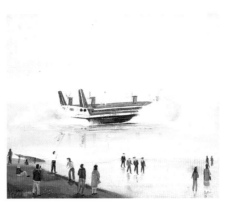

Jacobs, Warwick b.1963
Lord Mountbatten Visits 'SR.N4', Lee-on-Solent 1978
oil on canvas 39 x 46.5
41

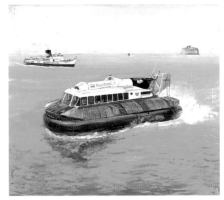

Jacobs, Warwick b.1963
'SR.N6' 130 Hovertravel Solent Crossing 1978
oil on canvas 61 x 71.5
45

Jacobs, Warwick b.1963
Sir Christopher Cockerell (1910–1999) 1990
acrylic & watercolour on paper 44 x 41
50

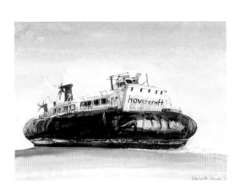

Jacobs, Warwick b.1963
Last Crossing of a Cross Channel Hovercraft, 1 October 2000
acrylic on paper 21.5 x 30
49

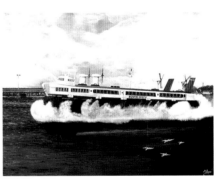

Lyons, M.
Hoverspeed 'Princess Anne'
oil on board 59 x 79
51

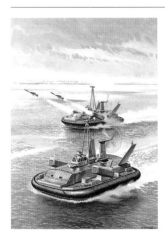

McDonoigh active 1967–1978
'BH.7' Mark 5 1967
acrylic on board 55.5 x 40.5
26

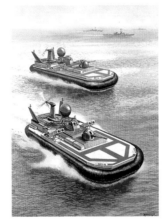

McDonoigh active 1967–1978
'BH.7' Missile Craft Mark 5A 1978
acrylic on board 55.5 x 40
28

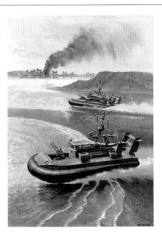

McDonoigh active 1967–1978
'SR.N6' Attack Hovercraft Mark 6 1978
acrylic on board 55.5 x 40
27

Moseley, W. F. active 1961–1962
'SR.N3' 1961
acrylic on board 41 x 66
2

Moseley, W. F. active 1961–1962
'SR.N2' Mark 2 1962
acrylic on board 44 x 53.5
12

Richards, Sam
'SR.N2' 1962
acrylic on board 48 x 65.5
17

Tattersall, Edward
'HM.5' 1975
oil on board 42.5 x 65.5
48

Thorn, Peter active 1961–1985
'SR.N1' 1961
acrylic on paper 35 x 45.5
44

Thorn, Peter active 1961–1985
'BH.7' Stretched Military Craft Mark 5 1978
acrylic on board 37.5 x 57
16

Thorn, Peter active 1961–1985
'Super Santa 4' 1978
acrylic on paper 40.5 x 27.5
46

Thorn, Peter active 1961–1985
'Super Santa 4' 1978
acrylic on paper 40 x 29.5
47

Thorn, Peter active 1961–1985
'BH.7' Mark 5A 1982
acrylic on board 38.5 x 58
9

Thorn, Peter active 1961–1985
'AP.188' Cutaway 1985
acrylic on paper 36.5 x 57
29

Thorn, Peter active 1961–1985
*'BH.88' Hoverspeed Replacement for Channel
Service* 1985
acrylic on board 33 x 47.5
4

Thorn, Peter active 1961–1985
Hover Platform 1985
acrylic on board 36 x 53.5
6

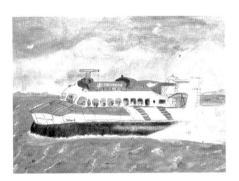

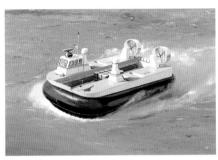

unknown artist
'SR.N6' Seaspeed 'Sea Eagle' 1970
oil on board 25 x 35.2
23

unknown artist
Pindair Projects 1982
acrylic on paper 50 x 32
39

unknown artist
'AP.188' Welldeck Cargo Craft 1985
acrylic on board 37.9 x 56.1
7

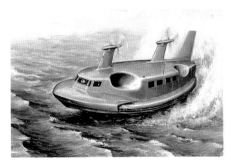

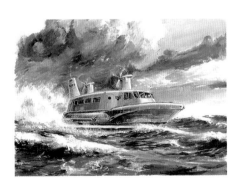

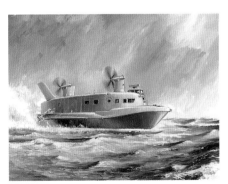

Wrigglesworth, R. P.
'SR.N2' 1960
oil on board 39 x 57.5
8

Wrigglesworth, R. P.
'SR.N2' 1961
acrylic on board 43.5 x 60.5
3

Wrigglesworth, R. P.
'SR.N3' 1961
acrylic on board 43 x 56
1

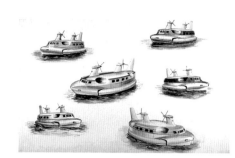

Wrigglesworth, R. P. (attributed to)
Livery Artists' Impressions 1960
acrylic on board 48 x 76
22

Wright, John
'AP.188' Coastguard 1984
acrylic on paper 35 x 51
30

Wright, John
'AP.188' Logistics Support 1984
acrylic on paper 35.5 x 51
31

Wright, John
'AP.188' Patrol Craft 1984
acrylic on paper 34.5 x 51
32

Wright, John
'AP.188' Mine Countermeasure 1985
acrylic on board 38.2 x 57.8
11

Wright, John
'AP.188' Patrol Craft 1985
acrylic on board 37 x 56
10

Wright, John
'AP.188' Military Hovercraft c.1985
acrylic on board 30 x 44.8
13

Wright, John
'AP.188' Military Hovercraft c.1985
acrylic on board 42 x 61.5
20

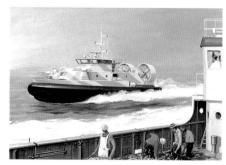

Wright, John
'AP.188' Patrol Craft c.1985
acrylic on board 41 x 59
19

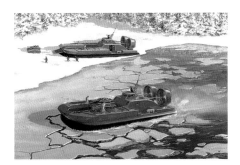

Wright, John
'AP.188' Welldeck in the Arctic c.1985
acrylic on board 38 x 56
21

St Barbe Museum
and Art Gallery

Boycott-Brown, Hugh 1909–1990
Yachts Moored on the Lymington River 1930s
oil on board 28.6 x 39
LMGLM:1994.573

Desmond, Creswell Hartley 1877–1953
Ponies Crossing Boldre Bridge c.1920
oil on canvas 27.2 x 44.3
LMGLM:1995.126

Eastman, Frank S. 1878–1964
John W. Howlett, Founder of Wellworthy and Company, Lymington 1957
oil on canvas 75 x 62.5
LMGLM:1997.455

unknown artist
Harriet King (1823–1862), Daughter of Richard King, Wife of George Inman, as a Young Woman 1840s
oil on canvas 20.1 x 14.6
LMGLM:1999.1.131

New Forest District Council

Brooks, Frank 1854–1937
Edward Penton
oil on canvas 60 x 49.8
PCF3

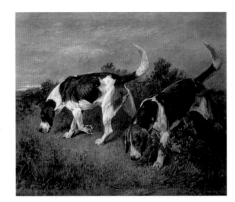

Emms, John 1843–1912
*New Forest Buckhounds: 'Moonstone', 5 Years,
by Bramham Moor Moonstone out of the
Burton Cobweb and 'Challenger', (…)* 1890
oil on canvas 98.5 x 127
PCF2

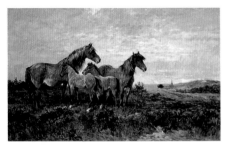

Emms, John 1843–1912
New Forest Ponies 1897
oil on canvas 54.3 x 90.2
PCF1

New Forest Museum and Library

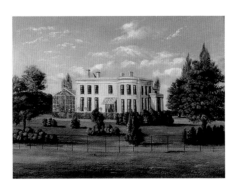

Chalmers, James
Hincheslea House, Brockenhurst 1852
oil on canvas 44.4 x 60
33

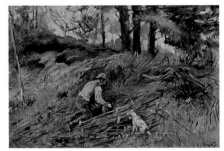

Emms, John 1843–1912
*Ferreting in the New Forest with Terrier
Looking on*
oil on canvas 22 x 34.3
5

Facing page: Britrish (English) School, 18th C, *Edward Austen (1767–1852)* (detail), Jane Austen's House, (p. 19)

Emms, John 1843–1912
Turf Cutting (possibly at Soarley Beaches near Burley)
oil on canvas 25.7 x 37.8
6

Gooch, Thomas active 1750–1803
Thomas Sebright with Three Favourite Hounds Belonging to the New Forest Hunt in a Wooded Landscape 1803
oil on canvas 50 x 61.5
PCF7

Hayes, A.
Burgess Street, Turnpike Gate
oil on canvas 30 x 40
PCF2

Skeats, Leonard Frank 1874–1943
Harry 'Brusher' Mills (1840–1905), New Forest Snake Catcher
oil on canvas 90 x 60
PCF4

Tratt, Richard b.1953
Martin Down, Hampshire 1993
oil on canvas 90.2 x 100.5
PCF1

unknown artist
Mr William Veal of Emery Down, Ringmaster for the New Forest Show for 50 Years 1977
oil on board 49.6 x 39.4
PCF6

unknown artist
Landscape (probably Suffolk)
oil on oak panel 25 x 27 (E)
PCF3

unknown artist
Lawrence Henry Cumberbatch (1827–1885), Deputy Surveyor of the New Forest (1849–1879)
oil on canvas 60 x 50
PCF5 (P)

Wilkinson, Hugh 1850–1948
New Park Farm, Brockenhurst
oil on canvas 28.5 x 45
1

The Museum of Army Flying

The Museum of Army Flying in Middle Wallop has a modest collection of aviation art. The heart of the collection can be seen in the Gorham Room where you can view a display of aircraft designers and engineers. Portraits of Sir Thomas Octave Murdoch Sopwith, alongside the great Sir Richard Fairey, the Honourable Charles Stewart Rolls, Air Vice-Marshal Sir Sefton Brancker, and Harry George Hawker remind us of the early days of flying, with the aid of string and wood.

Many tributes have been made to the Glider Pilot Regiment, none more so than the exciting exploits of the Coup de Main onto the bridge over the Caen Canal, D-Day 6 June 1944. Our visitors can also see the action packed Landing Zones at Arnhem or into the Cold War in the fields of West Germany, with an Army Air Corps Gazelle in support of a Main Battle Tank.

To end our tale, we have a fine example of an air battle over Poole Harbour in the dark days of 1940. Although the collection is only small it depicts in great detail the heroism of the soldiers who went to war by air.

Lieutenant Colonel Derek Armitage, AMA

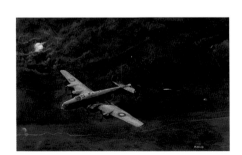

Davis, P.
'Halifax' on Night Flight
oil on board 60 x 97
PCF14

Eastman, Frank S. 1878–1964
Sir George White, Bt (1853–1916) 1953
oil on canvas 60 x 49
PCF2 (P)

Eastman, Frank S. 1878–1964
*Sir Richard Fairey, KT, MBE, FRAeS
(1887–1956)*
oil on canvas 59 x 49
PCF6 (P)

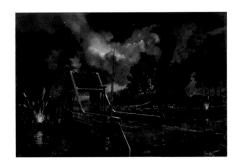

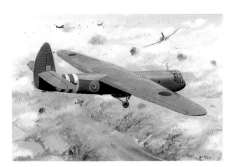

King, Roger
Pegasus Bridge 1984
oil on canvas 60 x 90
PCF12 (P)

Marx, Paul
The Rhine Crossing 1986
oil on canvas 50 x 76
PCF11

McEvoy, Ambrose 1878–1927
Harry George Hawker (1891–1921)
oil on canvas 74.5 x 62
PCF3 (P)

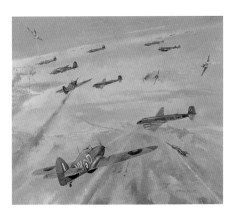

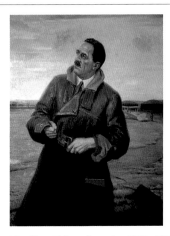

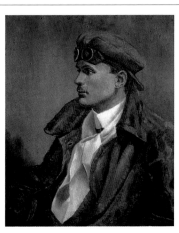

Miller, Edmund b.1929
Chilbolton Pilots over Poole Harbour
oil on canvas 60 x 70
PCF15 (P)

Newling, Edward active 1890–1934
Air Vice-Marshal Sir Sefton Brancker, KCB, AFC (1877–1930)
oil on canvas 125 x 100
PCF1 (P)

Orde, Cuthbert Julian 1888–1968
The Honourable Charles Stewart Rolls (1877–1910)
oil on canvas 75 x 62
PCF5 (P)

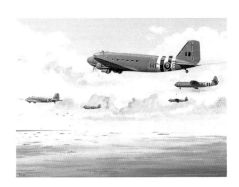

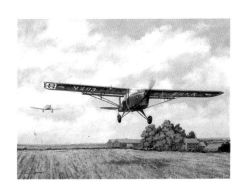

Payne
'Dakotas' Towing 'Horsas'
oil on board 39 x 55
PCF18

Ross, Michael active 1935–1955
Sir Thomas Octave Murdoch Sopwith, CBE (1888–1989)
oil on canvas 90 x 69
PCF4 (P)

Sparkes
Air Racing
oil on canvas 50 x 68.6
PCF9

Steele-Morgan, M. D.
'Horsas' over Pegasus Bridge 1993
oil on canvas 60 x 75
PCF13

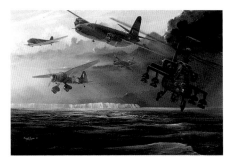

Thompson, Richard E. b.1948
'Then and Now' 1995
acrylic on canvas 60 x 90
PCF16

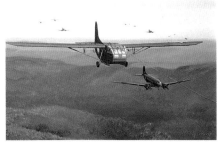

West, Philip b.1956
Glider
acrylic on canvas 49 x 75
PCF10 (P)

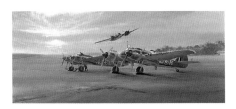

West, Philip b.1956
'Magic Beaus'
acrylic on canvas 60 x 122
PCF17 (P)

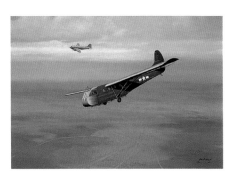

West, Philip b.1956
'Waco' Glider and 'Dakota'
acrylic on canvas 49.5 x 75
PCF7 (P)

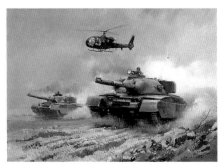

Wootton, Frank 1914–1998
Two 'Chieftain' Tanks and a 'Gazelle'
Helicopter Bonding
oil on canvas 62 x 90
PCF8

East Hampshire
District Council

Carter, George
Landscape with Stile (Summer near
Blackmoor)
oil on canvas 29 x 39
PCF4

Dorling, P.
Bury Court Farm, Bentley 1983
oil on canvas 49 x 59
PCF2

Francis, Charles
Meon Reflections 1987
oil on canvas 44 x 61.5
PCF5

MacKeown, Elizabeth
Vegetable Abstract 1990
oil on canvas 76 x 107
PCF3

Morrison, John
Green Route 1988
oil on canvas 39.8 x 90.5
PCF1

HMS Excellent

In 1829, the hulk 'Excellent' was brought into commission as the first naval gunnery school and its cannons were fired at fixed targets across the mudflats of Portsmouth harbour – as seen in the painting by Henry J. Morgan.

With the expansion of the dockyard over a 28 year period from 1864 when dry docks and basins were constructed, the mud and clay dug out by convict labour was deposited on a mudflat to the north of the harbour known as 'Whale Island'. This mudflat was acquired by 'Excellent' in 1853 for £1,000 to use for rifle practice. With the settling of the deposits by 1883, Commander Percy Scott produced a plan for the construction of a naval gunnery school ashore, and the first building was built on the mudflat (by convict labour) in 1888, and in 1891 when the wardroom (officers' mess) was built, all the officers and ratings moved from the ship 'Excellent' to Whale Island, which was commissioned as 'HMS Excellent' on the 1 May 1891, to become the first naval gunnery school ashore.

Most of the paintings are hung in the beautiful surrounds of the Victorian-built officers' mess. The portrait paintings are of Gunnery Officers who attained the rank of Admiral of the Fleet; these portraits, together with the paintings of naval scenes, were either commissioned, loaned or given to the mess by Gunnery Officers or their families. Should you with to view any of these works, please note that the Museum is open by appointment only.

Paintings of particular interest are those of the 'Queen Charlotte' by Henry J. Morgan, which was the flagship of Lord Howe at the Battle of the Glorious on 1st June 1794. Another painting by D. Leveson shows Lord Howe on board the 'Queen Charlotte' receiving the Sword of Honour from King George III. The 'Queen Charlotte' was out of commission from 1850–1859 when she was commissioned and renamed 'Excellent' and became the last of the gunnery school ships – see the painting *'HMS Excellent' and 'HMS Illustrious'* by Henry J. Morgan.

Probably the painting best known to the general public is the *Head of a Sailor* from 1927 by Arthur David McCormick, being the trademark for the Players Navy Cut cigarettes. The model for the painting was clean-shaven but the beard was added to conform to the original Players Sailor's head trademark. The name on the cap band was originally painted as 'HMS Illustrious'; however, 'HMS Illustrious' was sunk during the First World War and distressed relatives of the 'Illustrious' crew objected to the 'Illustrious' cap band being used on a commercial brand cigarette packet. In 1933, the painting was changed to show 'HMS Excellent' on the cap band.

Lieutenant Commander (Retired) Brian Watts, Curator

Beechey, Richard Brydges 1808–1895
The Spanish Armada Driven out of Calais by Fire 1882
oil on canvas 125 x 182
P20355

Beresford, Frank Ernest 1881–1967
George V (1865–1936) (after Arthur Stockdale Cope) 1937
oil on canvas 75.5 x 62
P11636

Birley, Oswald Hornby Joseph 1880–1952
Admiral of the Fleet Lord Fraser of North Cape, GCB, KBE (1888–1981) 1947
oil on canvas 104 x 79
P20285

H. C.
Lord Howe on Board the 'Queen Charlotte' Bringing His Prize into Spithead, 1794 1804
oil on panel 59.4 x 84.3
P20342

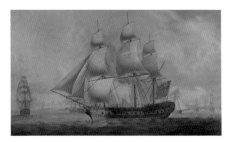

Dodd, R.
The Cuffnells at the Mother Bank 1706
oil on canvas 82 x 143
P13894

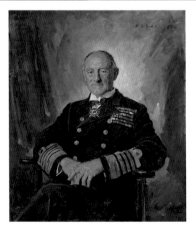

Eves, Reginald Grenville 1876–1941
Admiral of the Fleet Earl Jellicoe, OM, GCB, GCVO (1859–1935) 1934
oil on canvas 112 x 90
P11651

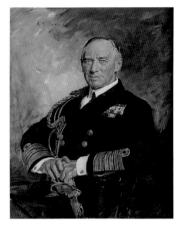

Eves, Reginald Grenville 1876–1941
Admiral of the Fleet Lord Chatfield, PC, GCB,
QM, KCMG, CVO, DCL Oxon, LLD Camb,
DL (1873–1967) 1937
oil on canvas 100 x 75
P20345

Fildes, Denis 1889–1974
Elizabeth II (b.1926) c.1955
oil on canvas 130.5 x 84.4
P20286

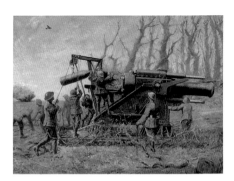

French, R.
Royal Marine Artillery Howitzer in Action,
1914 1921
oil on canvas 75 x 105
RM_01_04_32OM

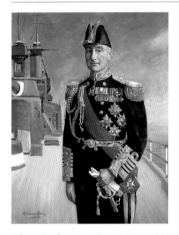

Glen, Graham active 1897–c.1920
Earl Jellicoe (1859–1935) on Deck c.1920
oil on canvas 120.5 x 100.5
P15671

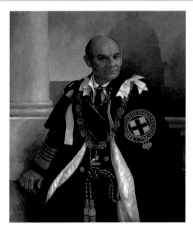

Havers
Admiral of the Fleet Lord Lewin of Greenwich,
KG, GCB, MVO, DSC (1920–1999) 1982
oil on canvas 101 x 80
P22652

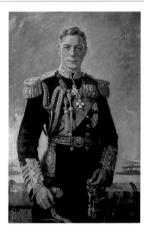

Hodge, Francis Edwin 1883–1949
George VI (1895–1952) 1938
oil on canvas 118 x 76
P20284

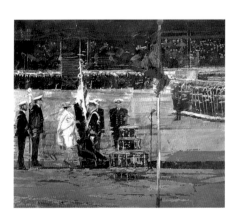

Hogan, S.
Presentation of the Queen's Colour to the
Portsmouth Command 1986
oil on canvas 104 x 120
P23757

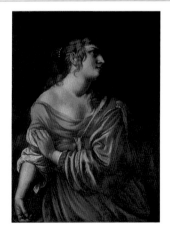

Italian (Venetian) School
St Barbara c.1750
oil on canvas 99.5 x 75.5
EX00327

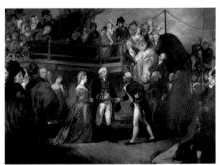

Leveson, D.
Lord Howe Receiving the Sword of Honour
from King George III on 'Queen Charlotte',
1794
oil on canvas 159 x 221
P20290

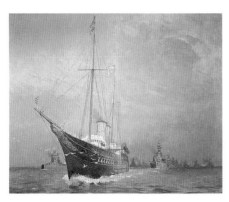

Maxwell, Donald 1877–1936
*The Royal Yacht 'Victoria and Albert' Leading
the Fleet off Weymouth, 1935* c.1935
oil on canvas 100 x 125
P19740

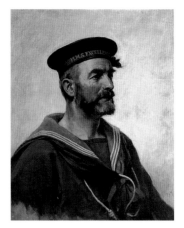

McCormick, Arthur David 1860–1943
Head of a Sailor 1927
oil on canvas 76.3 x 62
P20741

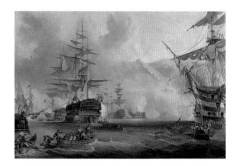

Morgan, Henry J. 1839–1917
'Queen Charlotte' at Algiers, 27 August 1816
1894
oil on canvas 121 x 182
P20289

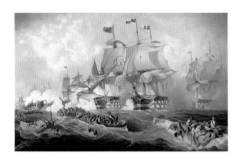

Morgan, Henry J. 1839–1917
*The Glorious First of June, 1794 (after Nicholas
Pocock)* c.1896
oil on canvas 106 x 160
P20356

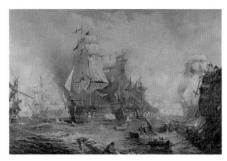

Morgan, Henry J. 1839–1917
*'Breaking the Line' (after William Lionel
Wyllie)* 1906
oil on canvas 120 x 181
P20282

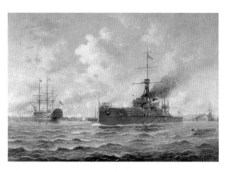

Morgan, Henry J. 1839–1917
'Dreadnought' and 'Victory' at Portsmouth
1907
oil on canvas 80 x 110
P20291

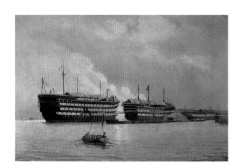

Morgan, Henry J. 1839–1917
'HMS Excellent' and 'HMS Illustrious'
oil on canvas 40 x 60
P20300

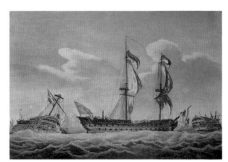

Pocock, Nicholas (after) 1740–1821
'HMS Excellent' Demasted in Harbour
oil on canvas 44.4 x 59
P20339

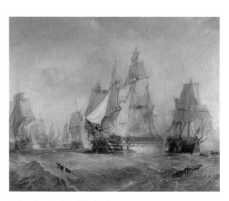

Schetky, John Christian 1778–1874
The Battle of Trafalgar, 21 October 1805
oil on canvas 108.5 x 138.3
P11647

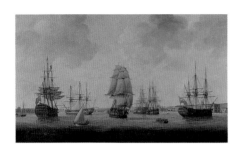

Serres, John Thomas 1759–1825
Portsmouth Harbour at High Tide
oil on canvas 65 x 113
P20281

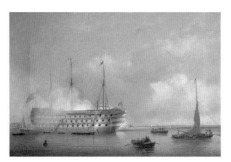

Sharpe, Montagu
'HMS Excellent' 108 Guns 1834–1835
oil on canvas 30.5 x 45.5
P23142

Stubart
Spithead Coronation Review 1953
oil on canvas 87.5 x 227
P26486

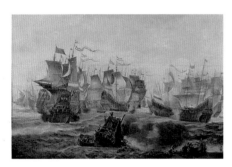

unknown artist
The Dutch and the Danes in Action 1672
oil on panel 59.5 x 91
P20321

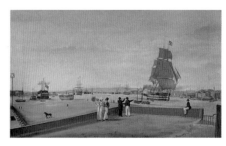

unknown artist 19thC
Man-o-War Leaving Portsmouth Harbour
oil on canvas 49.7 x 85.5
P23123

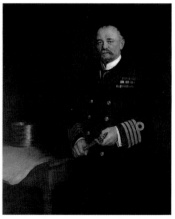

unknown artist
*Captain Percy Scott RN, CVO, CB, LLD
(1853–1924)* 1904
oil on canvas 126 x 121
P11649

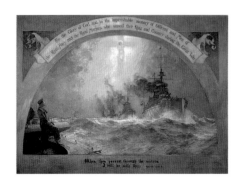

unknown artist
A Memorial to the 1914–1918 War c.1919
oil on canvas 125 x 181
P20358

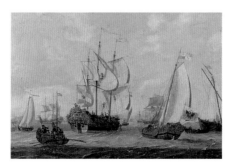

unknown artist
Dutch Shipping in Rotterdam Harbour
oil on panel 59 x 87
P20357

unknown artist
*'HMS Queen Charlotte', afterwards 'HMS
Excellent', Leaving the Hamoaze with HRH
Duke of Clarence on Board, 1825*
oil on panel 59.3 x 89.4
P11650

Facing page: unknown artist, *Major General Coote Manningham (1765–1809)* (detail), The Royal Green Jackets Museum, (p. 317)

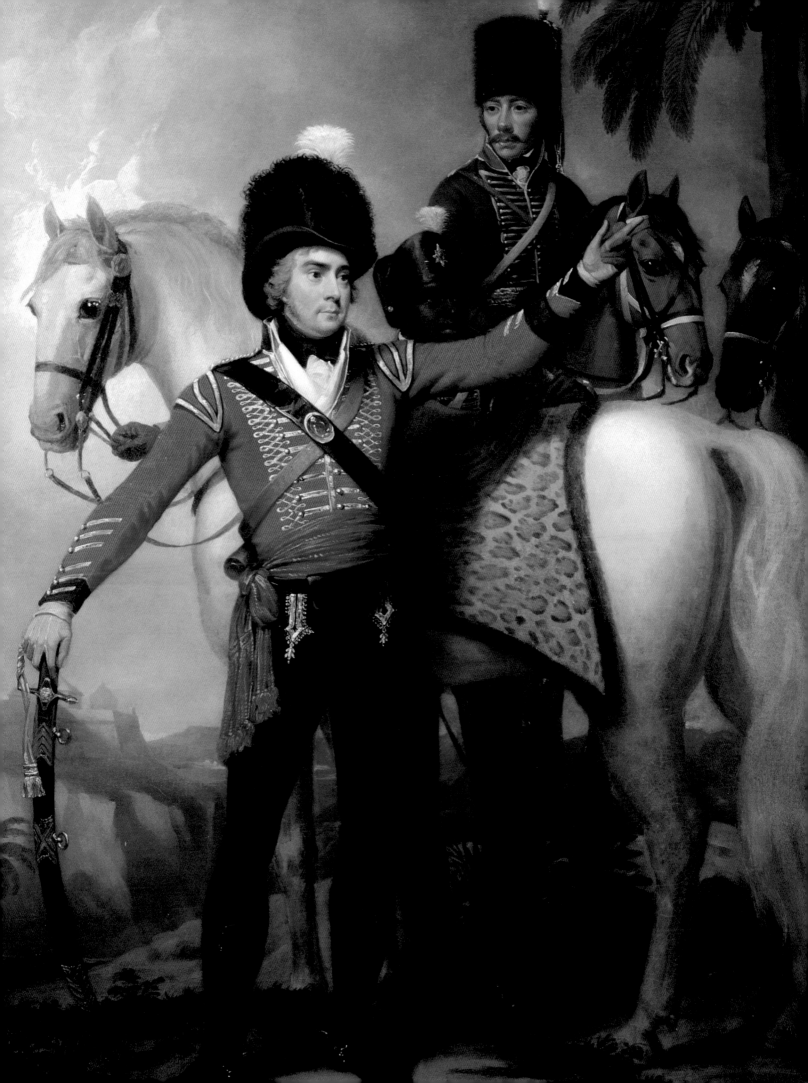

unknown artist
Lord Macartney Entering the River Thames
oil on canvas 81 x 143
P13895

unknown artist
Portmouth Harbour, Man-o-War in the Foreground
oil on canvas 39.5 x 59.8
P20301

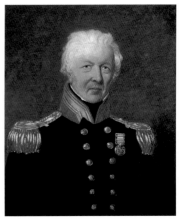

unknown artist
Vice Admiral Walter Lock (1756–1803)
oil on canvas 74.2 x 61.7
P20317

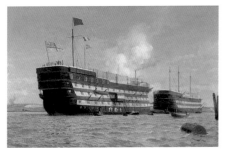

Wells, L. R.
'HMS Excellent' and 'HMS Calcutta' 1891
oil on canvas 94 x 150.5
P20287

Wyllie, William Lionel 1851–1931
The Storming of Zeebrugge Mole, St George's Day, 23 April 1918
oil on canvas 91 x 182
P25965

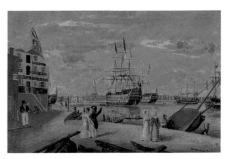

Yarwood, D. E.
Portsmouth Harbour
oil on canvas 44.4 x 67.5
P20326

HMS Victory

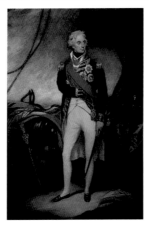

Beechey, William 1753–1839
Horatio Nelson (1758–1805)
oil on paper 58.2 x 41.3
14358

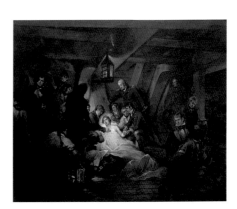

Devis, Arthur William 1762–1822
The Death of Nelson
oil on canvas 116.5 x 124
00626

HMS Warrior
1860

Anderson, J. W.
'HMS Warrior' Drying Her Sails 1861
oil on canvas 60 x 90 (E)
20/99:1

Smitheman, S. Francis b.1927
*'HMS Warrior' Escorting the Royal Yacht
'Victoria and Albert', March 1863*
oil on canvas 60 x 92 (E)
01/1995:1

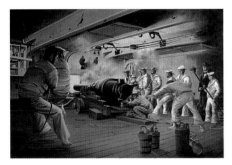

Wigston, John Edwin b.1939
Gun Drill 1985
oil on canvas 60 x 92 (E)
03/2005:1

Wigston, John Edwin b.1939
Stokehold 'HMS Warrior', 1860 1989
oil on canvas 60 x 92 (E)
03/2005:2 (P)

Portsmouth Museums and Records Service

Portsmouth Museums and Records Service was established in 1994 following the amalgamation of the separate Museums and Records Services. There has been a public museum service in Portsmouth since 1896. The original exhibits were drawn from heterogeneous municipal collections, which had accumulated over the centuries, supplemented by loans. The bulk of this collection was destroyed during the great air raid of 10th January 1941. Today's collections have been built up over the last half-century by gift, loan and purchase.

The service now comprises six sites: Portsmouth City Museum & Records Office, D-Day Museum, Southsea Castle, Charles Dickens' Birthplace Museum, Cumberland House Natural History Museum and Eastney Industrial Museum. Paintings are principally exhibited at the City Museum, although works from the collections can be found across many of the sites. Curatorial responsibility for the paintings has been subdivided between different sections of the service.

Paintings held by the Local History Section complement the general aim of the department to focus on the local and social history of Portsmouth. The collection consists of marine and topographical items, works by local artists and portraits of local people. Most of the works have been collected since 1945 following the bombing of the museum in 1941, although a small number did survive the destruction.

Given Portsmouth's maritime history, it is unsurprising that the collection has a particular strength in representations of the harbour and shipping, particularly between 1800 and 1900. Included are well-known maritime artists such as Thomas Luny and William Callcott Knell. Works by contemporary maritime artists are collected to reflect the continued interest in this area.

Prominent marine artists, such as William Lionel Wyllie, are represented as well as local artists such as Edward R. King. The group of 83 works by King, a patient in the local mental hospital, St James', are particularly interesting. Some are the result of a wartime commission by the city's mayor, Sir Denis Daley, to record the destruction suffered during the severe air raids of 1940 and 1941. Others, of the environs of St James', were painted after the war.

The group of paintings by Henry J. Morgan form a unique picture of the career of an individual naval officer, Admiral Giffard, and capture the dramatic changes taking place in ship technology. A small glimpse into another naval career can be gained in the wonderfully naive paintings by Colour Sergeant William Joy from 'HMS Devastation' which was on a mission to find the Indian murderers of two white men, as well as exercise a little 'gunboat diplomacy'.

More recently, the Arthur Conan Doyle Richard Lancelyn Green Bequest has introduced another strand to the collection, with images relating to Sir Arthur Conan Doyle and his famous creation, Sherlock Holmes.

The Art Section was only established in 1968 as an individual section within the museums service and with its own specialist staff. Previously the Antiquities section (later the Local History Section) collected art on behalf of the service. Virtually all fine art works were lost in the bombing in 1941. After the war a decision was taken to concentrate postwar collecting in the area of 'English Taste' rather than to attempt to build up a representative art collection. An immediate appeal after the catastrophic losses brought a number of items into

the collection, individuals and organisations donating items to rebuild Portsmouth's collections. It is through this route that works by Walter Sickert and his circle were donated by the Sickert Trust and works by William Bruce Ellis Ranken were given by Mrs Ernest Thesiger.

Collecting has been most active in the decorative arts field but significant additions of paintings, prints and watercolours have been acquired since the war. Until 1992, primarily English art was being acquired. As far as relatively limited purchase funds allowed, national art movements were represented, and some work by international practitioners was acquired, due to their strong influences on British art.

The Art Section collection is richest in British art of the twentieth century. It has a significant collection of work by artists associated with the St Ives School such as Wilhelmina Barns-Graham, Terry Frost, Patrick Heron, Alfred Wallis and Bryan Wynter. Other artists and makers of this group are represented by watercolours, prints and ceramics.

Another strength is in work by artists of the Bloomsbury Group. Portsmouth has tried to link the fine art collection with the decorative wherever possible by acquiring works that span the disciplines. In this connection, painted furniture by Vanessa Bell, Dora Carrington and Duncan Grant have been major acquisitions. The works by the three artists listed above were all significant commissions at the time of their creation, adding contextual interest to their artistic status.

Strong emphasis has been placed upon acquiring works by artists who were born in the Portsmouth area and who have trained locally or have lived or worked in the area. Work by artists who had other strong associations with the Portsmouth area has also been acquired wherever possible. In this category works by the Cole family – George, George Vicat and Reginald Rex Vicat were acquired. For more recent art practice, work produced by students and tutors at the University of Portsmouth and its predecessor bodies has been a strong theme. Paintings within the ambit of the PCF catalogue in this category come from the artists Derek Boshier, Jessie Brown, Geoff Catlow, John Eatwell, Alan Jefferson, Kevin O'Connor and Garrick Palmer amongst others.

Apart from the gifts given in response to the wartime losses, a number of significant gifts and bequests have enriched the collections. A couple of bequests from local artists Ada Dumas and her friend Eleanor Spyers not only brought examples of their own work but internationally important work, in a variety of different mediums, for example, works by the artist Paul Bril. The daughter of artist Benjamin Haughton (1865–1924) gave 330 works by her father. These are mostly oil paintings and oil sketches of the more remote areas of Kent, Somerset and Devon he loved so much.

Grant aid from the Museums, Libraries and Archives Council Purchase Fund (in its various manifestations) has helped fund many of our purchases. Grant aid and gifts from the Art Fund and the Contemporary Art Society have also added significant items to our collections over the years. In many cases generous grants have enabled us to purchase works but other items have been given by national bodies. The Contemporary Art Society Presentation Scheme has added oils by Justin Knowles, William George Scott and Gary Wragg. The Art Fund has also donated work attributed to such notable artists such as Maerten Fransz. van der Hulst, Adam Elsheimer and Guido Cagnacci.

The Military History Section came into being with the opening of the D-Day Museum in 1984, and one of its main concerns is therefore all aspects of the 1944 Normandy Landings and the subsequent Battle of Normandy. This section also covers the history of Southsea Castle (built on the orders of Henry VIII in 1544) and other aspects of Portsmouth's military history.

The Military History Section administers only a small number of paintings, mainly depicting events in Normandy in 1944 and painted decades later. A number of the paintings in the Local History Section also reflect Portsmouth's military past. For example, the Local History Section includes many depictions of Southsea Castle and other local fortifications, as well as Edward King's paintings of the bomb damage on the city during the Second World War.

The Schools Loan Collection was established as a working collection of original and reproduction specimens and artefacts for educational use. Its collections are lent out to schools in the Portsmouth area providing a valuable outreach tool to support the national curriculum and as a source of inspiration. The collection literally covers subjects from A to Z – art to zoology. The art section of this collection includes original items of decorative art and craft work as well as artists' prints, drawings and paintings. The oil or acrylic paintings are mostly by modern and contemporary British artists, many of whom have a connection with South East Hampshire and West Sussex.

An established system is in place to feed items into the main art collections of the service from the Schools Loan Collection. After being available on loan for five years, an item may be transferred from the Schools Loan Collection to the art collection and formally accessioned into the core collections of the service. That works by such artists as Prunella Clough, Carel Victor Morlais Weight, Orovida Camille Pissarro and Patrick Heron have been transferred to the permanent art collection is a tribute to inspired purchasing by this section in earlier years. A large number of artists' works remain in the collection and are regularly lent out to schools.

Reduced funding for acquisitions has had an impact on our active collecting, but whenever possible our service seeks to extend the existing collection by purchasing or accepting gifts of work that fit our collecting policy. Portsmouth can be proud that such a rich and diverse collection of paintings has been built up since the devastating wartime losses, providing a valuable resource for the people of Portsmouth and visitors to the city.

Rosalinda Hardiman, Museums Collections Manager

Allad, Stanley S.
Lakeside Village (Scene in Surrey)
oil on canvas 60 x 106.5
1950/15/2

Allad, Stanley S.
Windsor Castle
oil on canvas 60.5 x 106
1950/15/1

Allen, G.
Wymering Fields 1907
oil on board 23 x 28
1961/31

Allen, G.
Hilsea
oil on board 23.2 x 30.9
1961/32

Allen, Harry active late 19th C
Charles Dickens, Aged 27 (after Daniel Maclise)
oil on canvas 89 x 67.8
2005/1591

Allen, Harry active late 19th C
Charles Dickens, Aged 45 (after Ary Scheffer)
oil on canvas 67.5 x 54.5
2005/1590

Armstrong, John 1893–1973
The Three Orders of Architecture 1927
tempera on wood 69.4 x 54.4
1984/19

Backhouse, David
Still Life with Flowers
oil on board 37.8 x 27.8
SS22946

Bagley, Laurence
Lone Sailor 1968
oil on canvas 54 x 79.6
1968/122

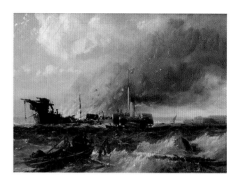

Barker, John Rowland 1911–1959
Portsmouth Future 1959
oil on board 59.5 x 197
1981/422

Barns-Graham, Wilhelmina 1912–2004
Relief II 1967
oil on board 50 x 40
1981/255

Beavis, Richard 1824–1896
Burning of the 'Eastern Monarch' off Fort Monckton
oil on canvas 20 x 28.6
1965/89

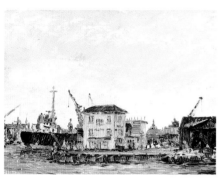

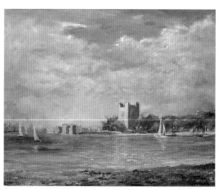

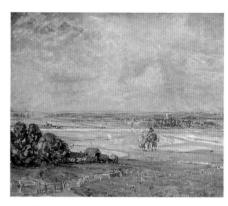

Bernhardt, Geoff
The Bridge Tavern, the Camber
oil on board 29.5 x 40
2005/1086

Blair, Eileen
Portchester Castle, Hampshire
oil on canvas 44.7 x 54.8
1997/1464

Bland, Emily Beatrice 1864–1951
Portchester Castle, Hampshire
oil on board 49.5 x 59.5
2006/1681

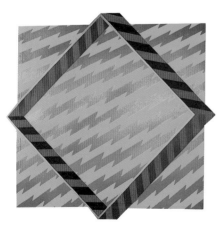

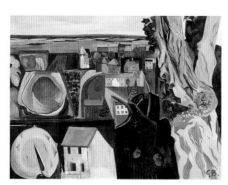

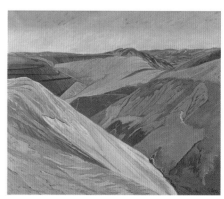

Boshier, Derek b.1937
Set Square 1964
acrylic on card 185.5 x 202.6
1973/936

Bradshaw, Gordon b.1931
County Town c.1970
oil on canvas 88.5 x 121
2003/2545

Bradshaw, Gordon b.1931
View on Plynlimmon 1972
oil on canvas 74 x 89
1972/436

Bradshaw, Gordon b.1931
View on Plynlimmon
oil on canvas 62 x 89
AA278

Bratby, John Randall 1928–1992
Table Top 1955
oil on board 120.8 x 121
1973/401 🐝

Bratby, John Randall 1928–1992
Kitchen II 1966
oil on board 122.3 x 152.3
1980/347 🐝

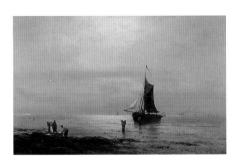

Breanski, Gustave de c.1856–1898
Coastal Scene
oil on canvas 58.5 x 89
1991/213

Bril, Paul 1554–1626
Christ Walking on the Water 1620s
oil on copper 21 x 25
1981/249

Brooker, James A.
*'LCI[S] 527' and 'LCI[S] 525' Landing Free
French Commandos on Sword Beach, 6 June
1944*
oil on board 57.7 x 118.3
1/2/93

Brooks, Frank 1854–1937
Miss Grace Mary Cannon c.1900
oil on canvas 60 x 50
1948/222

Broome, William 1838–1892
*Wreck of 'HMS Eurydice' Being Towed into
Portsmouth Harbour*
oil on canvas 59.1 x 104.4
1979/305

Brown, Jessie 1906–2003
Cactus c.1955
oil on board 49 x 35.8
1973/809

Brown, Jessie 1906–2003
Greetham Street, Portsmouth 1957
oil on board 24 x 34
1971/476

Brown, Jessie 1906–2003
Havant Bypass Construction 1966
oil on canvas 40 x 50
1979/710

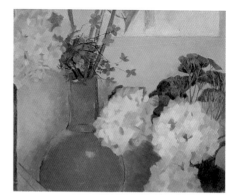

Brown, Jessie 1906–2003
Hydrangeas with Orange Jug c.1970
oil on board 39 x 49
1973/808

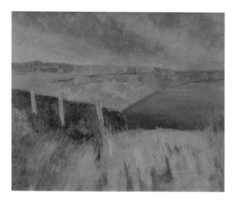

Brown, Jessie 1906–2003
Contractors' Huts
oil on board 30 x 38.5
1973/807

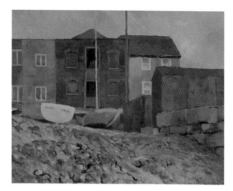

Brown, Jessie 1906–2003
Houses, Old Portsmouth
oil on board 30 x 40
AA256

Brown, Nellie 1900–1970
'Nellie Dean'
oil on canvas 22.4 x 38
2005/842

Browne, J. L. active 1953–1973
Gate to 'HMS Vernon' 1953
oil on board 27 x 38
1975/123

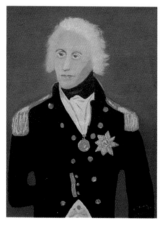

Browne, J. L. active 1953–1973
Admiral Sir Horatio Nelson (1758–1805) 1973
oil on board 39.5 x 29.5
1975/126

Bryant, Henry Charles 1836–1915
Charles Dickens (1812–1870) c.1870
oil on canvas 90 x 70
1984/42

Facing page: unknown artist, *Wrens at Work in the Valve Testing Room, 'HMS Vernon'* (detail), Royal Naval Museum, (p. 224)

Bryant, Henry Charles 1836–1915
Farmyard Scene 1884
oil on canvas 49.4 x 59.4
1950/13/1

Bryant, Henry Charles 1836–1915
*Farmer Kent's Farm, North End (now
Stubbington Avenue, Portsmouth)* 1900
oil on canvas 49.5 x 75
1954/12

Bryant, Henry Charles 1836–1915
Market Vendor
oil on canvas 50 x 41.5
1968/133

Bryant, Henry Charles 1836–1915
Portrait of a Lady
oil on canvas 54.8 x 44.8
1957/63

Bryant, Henry Charles 1836–1915
Sheep on Moorland
oil on canvas 29.7 x 37.6
1979/704

Burn, Gerald Maurice 1862–1945
*Battle Cruiser 'HMS Princess Royal' in the
Floating Dock, Portsmouth*
oil on canvas 89.5 x 135.8
1945/438

Cagnacci, Guido (attributed to) 1601–1681
The Penitent Magdalen 1658
oil on canvas 173.8 x 134.6
1980/679

Callcott, William James active 1843–1896
Portsmouth Harbour from Portsdown Hill
oil on canvas 59 x 82
1946/80

Callcott, William James active 1843–1896
*View from Portsdown Looking towards Portsea
Island*
oil on canvas 69 x 120
1966/43

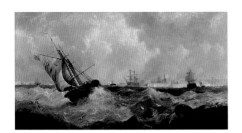

Callow, John 1822–1878
Stiff Breeze off Portsmouth Harbour
oil on canvas 94.8 x 176
1969/423

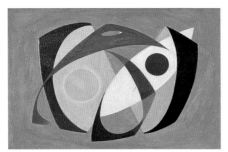

Canty, Jack c.1910–2002
Abstract Painting No.4 1945
oil on canvas 25.5 x 35.4
2002/536

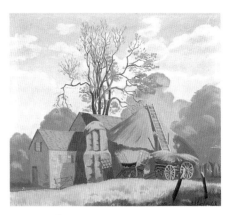

Canty, Jack c.1910–2002
A Farm 1948
oil on canvas 53 x 61
2002/532

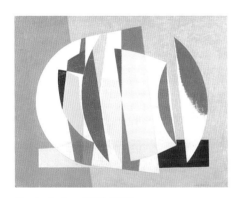

Canty, Jack c.1910–2002
Abstract Painting 1946 1953
oil on board 35.6 x 45.5
2002/537

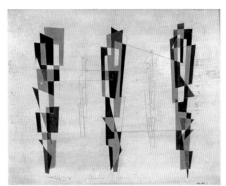

Canty, Jack c.1910–2002
Standing Forms No.2 1955
oil on board 38.3 x 48.7
2002/543

Canty, Jack c.1910–2002
Christmas 1957
oil on board 30.7 x 153
2002/547

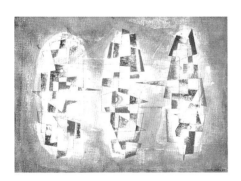

Canty, Jack c.1910–2002
Composition 1957
oil on card 25.5 x 35.3
2002/534

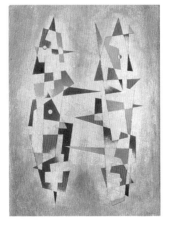

Canty, Jack c.1910–2002
Standing Forms 1957
oil on board 35 x 25
2002/531

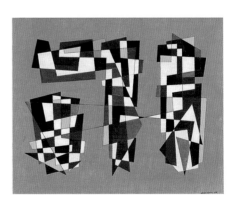

Canty, Jack c.1910–2002
Standing Forms No.5 1957
oil on board 37 x 47
2002/548

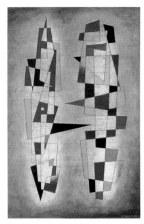

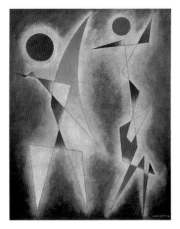

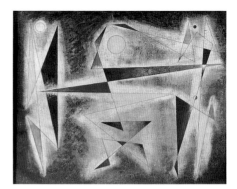

Canty, Jack c.1910–2002
Standing Forms No.10 1957
oil on board 51 x 30.5
2002/546

Canty, Jack c.1910–2002
Combat 1958
oil on board 45 x 35
2002/530

Canty, Jack c.1910–2002
Dancers 1958
oil on board 39 x 49
2002/540

Canty, Jack c.1910–2002
Standing Forms No.3 1958
oil on board 39.4 x 49.4
2002/538

Canty, Jack c.1910–2002
Abstract Forms 1959
oil on board 48.2 x 38.6
2002/542

Canty, Jack c.1910–2002
Forms on a Dark Ground No.3 1985
oil on board 48.5 x 38
2002/533

Canty, Jack c.1910–2002
Abstract
oil on board 25.1 x 35.3
2002/535

Canty, Jack c.1910–2002
Composition (Steamboats)
oil on board 25.5 x 60
2002/541

Canty, Jack c.1910–2002
Expanding Forms
oil on board 45.5 x 121
2002/527

Canty, Jack c.1910–2002
In the Style of Mondrian
oil on board 78.5 x 67.5
2002/529

Canty, Jack c.1910–2002
Point of ...
oil on board 45.2 x 120.5
2002/528

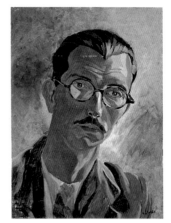

Canty, Jack c.1910–2002
Self Portrait
oil on canvas 39 x 29
2002/539

Carrington, Dora 1893–1932
Scene from the Strachey Gramophone c.1925
oil on wood & metal 50 x 48.5
1986/71/1

Carrington, Dora 1893–1932
Scene from the Strachey Gramophone c.1925
oil on wood & metal 62 x 47.9
1986/71/2

Carrington, Dora 1893–1932
Scene from the Strachey Gramophone c.1925
oil on wood & metal 57 x 46
1986/71/3

Carrington, Dora 1893–1932
Scene from the Strachey Gramophone c.1925
oil on wood & metal 62 x 47.9
1986/71/4

Catlow, Geoff (attributed to) b.1948
Shelves 1970s
acrylic on canvas 65 x 51.5
1984/43

Chambers, George 1803–1840
Entrance to Portsmouth Harbour
oil on canvas 43.9 x 59.6
1964/127

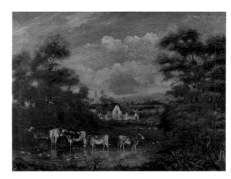

Chesher, Arthur William 1895–1972
Burrell's Traction Engine 1964
oil on board 40 x 55
1973/403

Christian, J. R.
Patrick Ernest William Harris
oil on canvas 82 x 58
1997/1466

Cleall, L.
Goldsmith's (White Farm, Milton) c.1880
oil on canvas 72 x 101
1960/99

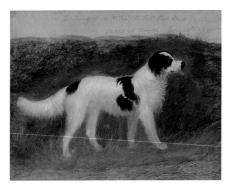

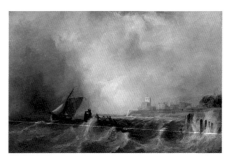

Clough, Prunella 1919–1999
Pond by Chemical Works 1
oil on canvas 62 x 75
1973/404

Cole, George 1810–1883
*'Cato', Property of the Right Honourable Sir
Robert Peel, Bt* 1845
oil on board 24 x 32
1956/29

Cole, George 1810–1883
Entrance to Portsmouth Harbour c.1850
oil on canvas 41 x 62.4
2002/743

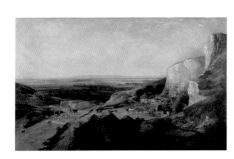

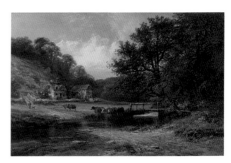

Cole, George 1810–1883
General Yates 1852
oil on canvas 88 x 67.5
1956/30

Cole, George 1810–1883
The London Road, Portsdown Hill 1867
oil on canvas 88.3 x 146.3
1954/3

Cole, George 1810–1883
Cotehele Mill on the Tamar 1871
oil on canvas 49 x 74
1945/362

Cole, George 1810–1883
Hampshire Moorland 1874
oil on canvas 104.5 x 150.5
1945/363

Cole, George 1810–1883
Scene in Hampshire 1878
oil on canvas 59.2 x 90
1945/365

Cole, George 1810–1883
Hampshire Woodland
oil on canvas 104.6 x 149.5
1945/364

Cole, George 1810–1883
Head of George Cole's Second Son
oil on canvas 30 x 29.5
1956/28

Cole, George Vicat 1833–1893
Spring 1865
oil on canvas 64.5 x 100
1945/367

Cole, George Vicat 1833–1893
Near Epsom
oil on canvas 29 x 49
1945/366

Cole, George Vicat 1833–1893
River Scene with Peasants and Cattle
oil on canvas 21.5 x 34.5
1955/1

Cole, Rex Vicat 1870–1940
The Pack Horse Bridge near Bingley
oil on canvas 89 x 116.5
1945/706

Collins, Niamh b.1956
Abstract 1977
oil on canvas 68 x 152
1979/664

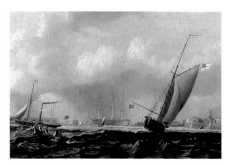

Cooke, Edward William (after) 1811–1880
Shipping off Portsmouth c.1840
oil on canvas 42 x 62.7
1990/76

Cooper, J. C.
Victoria Pier and 'HMS Victory'
oil on canvas 17 x 24.5
1981/391

Copus, M.
Greetings from Southsea (detail) c.1994
oil on canvas 230.5 x 897
H/2006/223

Copus, M.
Victoria Park, Portsmouth (detail) c.1994
oil on canvas 244 x 900
H/2006/222

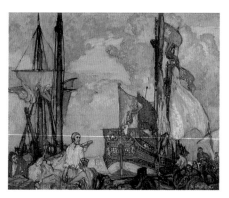

Cox, E. Albert 1876–1955
The Admiral's Galley, 1690 c.1925
oil on board 59 x 74.6
1945/441

Crabbe, Richard 1927–1970
Interlude 1
oil on canvas 144.8 x 143.8
1970/364

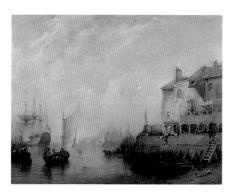

Crawford, Edmund Thornton 1806–1885
Portsmouth Harbour
oil on canvas 89.5 x 116.5
1945/368

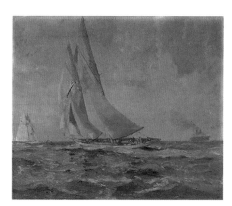

Cribb, Preston 1876–1937
Ocean Racing
oil on canvas 63 x 76
1945/403

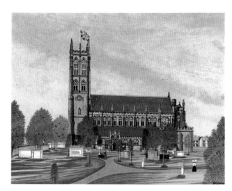

Crow, D.
Kingston Church, Portsmouth
acrylic on card 36 x 46
1971/330

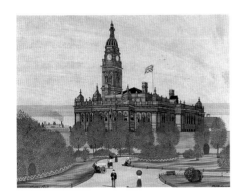

Crow, D.
Town Hall, Portsmouth
acrylic on card 36 x 46
1971/329

Cruikshank, George I 1792–1878
The Library Table
oil on canvas 29.8 x 24.6
1999/616

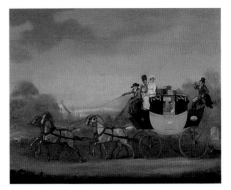

Cruikshank, Isaac Robert (attributed to)
1757–1811
*The Portsmouth Royal Mail near Fareham,
Hampshire*
oil on canvas 54 x 68
1977/274

Dance, Geoffrey b.1930
Admiral Benbow's Farewell to His Wife 1964
oil on board 58.5 x 88.5
1973/407

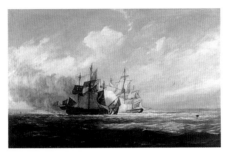

Darby, James Francis 1816–1875
*Action between 'HM Sloop Bonne Citoyenne',
and the French Frigate 'La Furieuse'*
oil on board 57 x 89.6
1986/155

Darby, James Francis 1816–1875
*'HM Sloop Bonne Citoyenne' Taking the
French Frigate 'La Furieuse' in Tow*
oil on board 56.5 x 89.8
1986/156

Deacon, George S. active 1860s–1879
*Portsmouth View from Southsea Common at
Sunset* 1860s
oil on canvas 43 x 73
1981/350

Dixon, James 1887–1970
Ring-Net Fishing, Tory Island 1964
oil on board 54 x 75
1973/410

Dorth, J. E.
Portsmouth Guildhall 1910
oil on canvas 56.5 x 61
1970/420

Dowiss, A. S.
*Entrance Hall** 1930s
oil on canvas 45.5 x 40
SS1209

Downing, George Henry 1878–1940
The Grounds at Leigh Park House, Havant
oil on canvas 111.8 x 86
1953/49 (P)

Downton, John 1906–1991
A Saint c.1963
tempera on linoleum 22 x 22
1998/660

Downton, John 1906–1991
Saint Bartholomew c.1963
tempera on linoleum 22 x 22
1998/659

Downton, John 1906–1991
Before the Battle c.1970
tempera on wood 19 x 14
1998/661

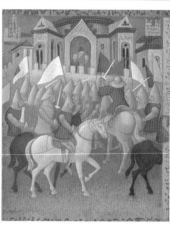

Downton, John 1906–1991
The Siege c.1970
oil on wood 19.7 x 16.9
1998/662

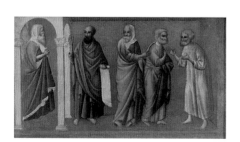

Downton, John 1906–1991
Five Learned Men
tempera on wood 14.5 x 25.5
1998/658

Duchess of Argyll, Louise Caroline Alberta
(attributed to) 1848–1939
Bluejacket, 'HMS Comus'
oil on canvas 73 x 57
1945/443

Dumas, Ada 1868–1950
The Golden-Haired Girl
oil on wood 10 x 8
1979/656

Facing page: Beechey, William, 1753–1839, *Horatio Nelson (1758–1805)* (detail), HMS Victory, (p. 62)

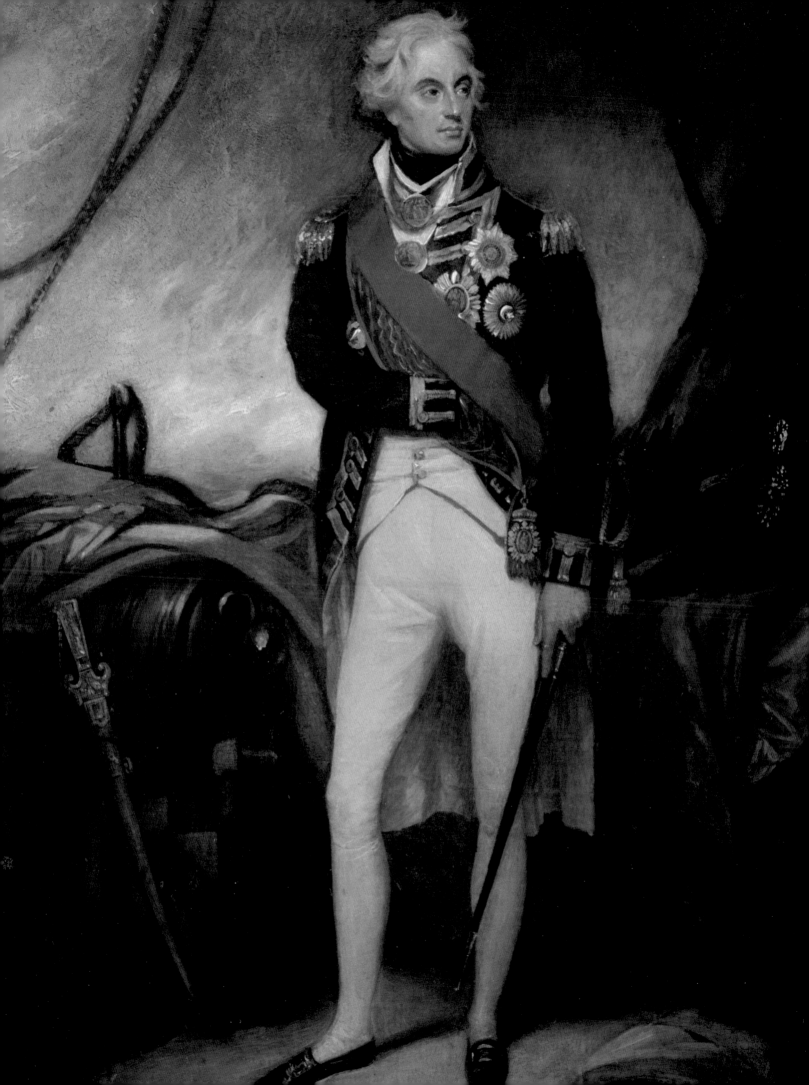

Dunlop, Ronald Ossory 1894–1973
Still Life with Black Bottle 1927
oil on canvas 62 x 73.4
1971/5

Dunlop, Ronald Ossory 1894–1973
Gravesend Shipping
oil on canvas 49 x 59.5
1973/617

Dunlop, Ronald Ossory 1894–1973
View from My Studio Window
oil on canvas 50.5 x 59.5
1971/4

Eatwell, John b.1923
Red Abstract 1968
oil on canvas 121.3 x 136.5
1968/160

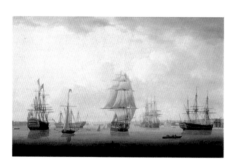

Elliott, Robert J. (attributed to)
c.1790–1849
View of Portsmouth Harbour Looking North
oil on canvas 60.2 x 89.2 (E)
1958/12

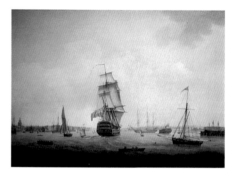

Elliott, Robert J. (attributed to)
c.1790–1849
View of Portsmouth Harbour Looking South
oil on canvas 60 x 89 (E)
1958/11

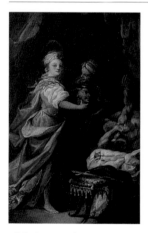

Elsheimer, Adam (attributed to) 1578–1610
Judith and Holofernes
oil on canvas 32.5 x 22.3
1975/212

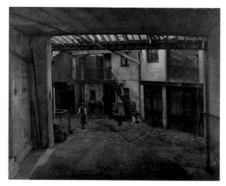

Emmanuel, Frank Lewis 1866–1948
*Dick Turpin's Stable at the Old Grange,
Kensington* 1913
oil on canvas 91.5 x 117
1981/286

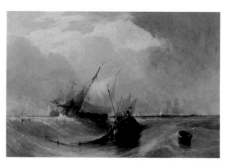

Eubank, John Wilson 1799–1847
The Mouth of the Tyne 1827
oil on canvas 67.5 x 101.2
1968/150

Eurich, Richard Ernst 1903–1992
*Ships of All Nations Assembling off Spithead,
14 June 1953 for Coronation Review by the
Queen, 15 June 1953* 1953
oil on board 21.5 x 120.8
1973/1090 🐝

Everitt, Douglas active c.1970–c.1991
Field in Movement c.1970
oil on board 80.5 x 121.5
2003/2546

Everitt, Douglas active c.1970–c.1991
Dark Abstract c.1991
oil on canvas 197.7 x 152.3
2006/254 (P)

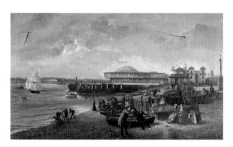

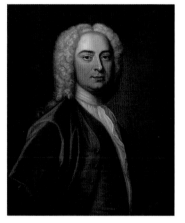

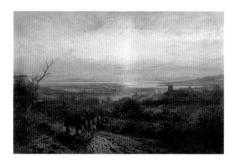

Fayel, B.
View of Southsea Beach with Clarence Pier
oil on canvas 73 x 125.2
2002/736

Fellowes, James c.1690–c.1760
Portrait of a Gentleman
oil on canvas 74.5 x 61
1972/125

Finnie, John 1829–1907
The Meeting of the Mersey and the Weaver
c.1874
oil on canvas 118 x 179.8
1946/203

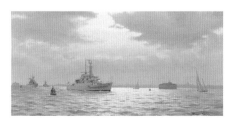

Finnie, John 1829–1907
Sunset at Pangbourne 1878
oil on canvas 90 x 151
1946/202

Fisher, Roger Roland Sutton 1919–1992
Frigates Entering Portsmouth 1980
oil on board 29 x 59.5
2003/2150

Fisher, Roger Roland Sutton 1919–1992
'HMS Frobisher' at Grenada, February 1937
1981
oil on board 24 x 50
2003/2151

Fleming, C.
Alderman C. Dye 1889
oil on canvas 91.5 x 122
1946/74

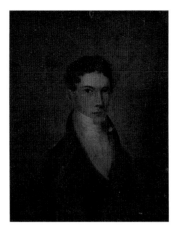

Foorde, William
Portrait of a Young Man (possibly a self portrait) 1778
oil on board 23 x 19.5
1969/270

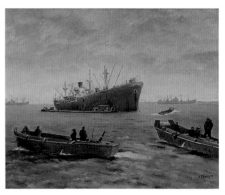

Foulds, Ian
Ready for Going Ashore
oil on canvas 39 x 49.2
2004/3072

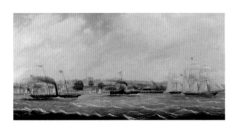

Fowles, Arthur Wellington c.1815–1883
Solent Ferries off Ryde Pier 1850
oil on canvas 36.8 x 74.5
1976/305

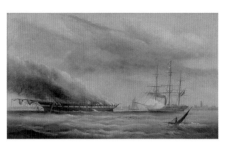

Fowles, Arthur Wellington c.1815–1883
The Frigate 'HMS Falcon' Attempting to Sink by Shelling the Burning Hulk of the Troop Transport, 'Eastern Monarch' 1859
oil on board 36.5 x 45
1976/306

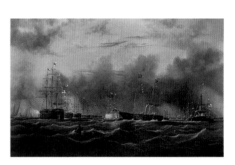

Fowles, Arthur Wellington c.1815–1883
Review of Reserve Fleet, 1878
oil on canvas 148.5 x 234
1969/433

Fox, Mary b.1922
Pagham Harbour
oil on canvas 52 x 75
AA84

Frost, Terry 1915–2003
Ochre and Blue 1958
oil on board 40.5 x 35
1973/892

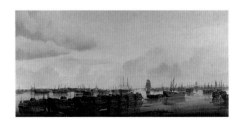

Garneray, Louis (attributed to) 1783–1857
French Prizes in the Harbour c.1800
oil on canvas 50.5 x 103.5
1951/34

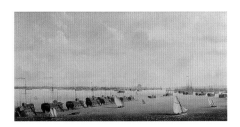

Garneray, Louis (attributed to) 1783–1857
Prison Hulks in Portsmouth Harbour 1810
oil on canvas 38 x 75
1970/439

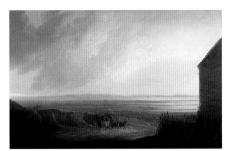

Gilbert, Joseph Francis 1792–1855
View From Hill House 1812
oil on canvas 78.5 x 124
1956/99

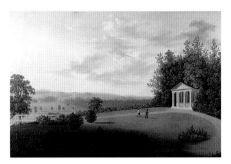

Gilbert, Joseph Francis 1792–1855
The Temple, 28 January 1830 1830
oil on board 60 x 90
1946/67

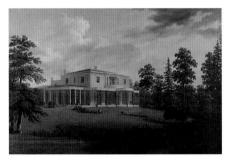

Gilbert, Joseph Francis 1792–1855
Leigh Park House, Havant, from the South-West c.1830
oil on board 60 x 90 (E)
1946/66

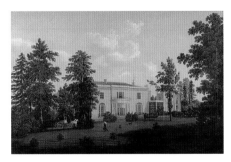

Gilbert, Joseph Francis 1792–1855
Leigh Park House, Havant c.1831
oil on board 60 x 90 (E)
1946/65

Gilbert, Joseph Francis (attributed to)
1792–1855
A Pastoral Scene
oil on canvas 64 x 91
1979/684

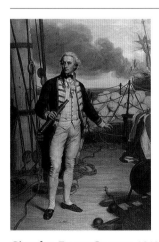

Girardot, Ernest Gustave 1840–1904
Captain John Hutt, RN 1874
oil on canvas 238.5 x 163
1951/39

Goodwin, William Sidney 1833–1916
Horses Hauling Stone at Portland
oil on canvas 61.2 x 91.4
1945/429

Gosse, Laura Sylvia 1881–1968
La marchande de Guimauve
oil on canvas 110.5 x 68
1974/310

Grant, Duncan 1885–1978
Commedia dell'Arte Scene 1924
oil on wood 185 x 97
1984/9

Grant, Keith b.1930
The Volcano in the North 1976
oil on wood 71.5 x 242 x 46.5
1977/743

Grant, Keith b.1930
Pyramid Peak, Jernatt c.1978
acrylic on paper 31.8 x 91.9
1980/346

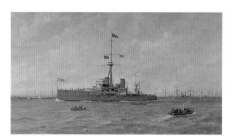

Gregory, George 1849–1938
The Royal Naval Review 1907
oil on canvas 49 x 90
1973/1107

Grone, Ferdinand E. c.1845–1920
A Farm Maid
oil on card 34.9 x 50.6
1979/828

Guthrie, Derek b.1936
St Just 1964
oil on board 58.5 x 82
1973/411

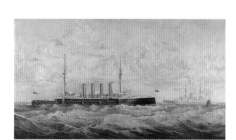

Hall, C. J. active 1900–1903
'HMS Europa' 1900
oil on canvas 49 x 90
1953/81

Hall, C. J. active 1900–1903
'HMS Majestic' 1901
oil on canvas 54 x 38.5
1953/78

Hall, C. J. active 1900–1903
'HMS Majestic' 1901
oil on canvas 26.2 x 52
1953/79

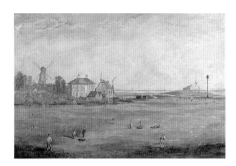

Hall, C. J. active 1900–1903
'HMS Glory' at Malaga 1903
oil on canvas 46 x 87.5
1953/80

Hann, Christopher b.1946
Figure
oil on board 61.2 x 61
1972/223

Hart, Solomon Alexander 1806–1881
The Cricketers, Southsea
oil on canvas 50 x 75
1956/58

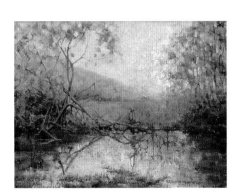

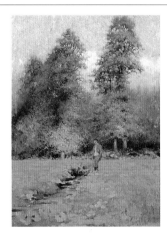

Haughton, Benjamin 1865–1924
*Obscured near Sandhurst, East Kent, 11
October 1890* 1890
oil on board 30.2 x 25.2
1973/244

Haughton, Benjamin 1865–1924
Pool Study 1891
oil on canvas 14 x 19
1973/395

Haughton, Benjamin 1865–1924
Man in a Field by a Stream c.1892
oil on board 38.5 x 29
1973/240

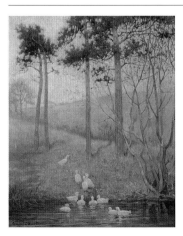

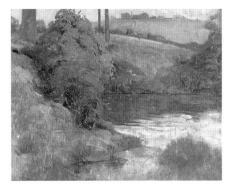

Haughton, Benjamin 1865–1924
October Afternoon 1898
oil on board 28.8 x 25.5
1977/417

Haughton, Benjamin 1865–1924
Country and Skyscape c.1900
oil on board 23.5 x 33.5
1973/144

Haughton, Benjamin 1865–1924
Doctor's Pond, Summerhill c.1900
oil on board 30 x 39
1973/278

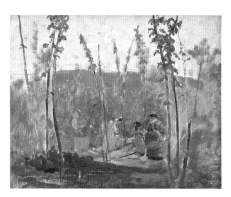

Haughton, Benjamin 1865–1924
February Morning c.1900
oil on board 30 x 38.4
1973/324

Haughton, Benjamin 1865–1924
Picnic in a Clearing, Summerhill c.1900
oil on board 30 x 38.5
1973/238

Haughton, Benjamin 1865–1924
Summerhill c.1900
oil on board 38.5 x 30.5
1973/191

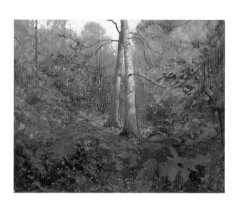

Haughton, Benjamin 1865–1924
Tree Study, Summerhill c.1900
oil on board 44.2 x 33.2
1973/277

Haughton, Benjamin 1865–1924
Woodland Sketch, Summerhill c.1900
oil on board 30 x 39
1973/284

Haughton, Benjamin 1865–1924
The Pool 1901
oil on canvas 125.5 x 112.5
1973/321

Haughton, Benjamin 1865–1924
October Afternoon c.1903
oil on board 15.2 x 23
1973/2

Haughton, Benjamin 1865–1924
Autumn, Weald of Kent 1904
oil on canvas 100 x 113
1973/320

Haughton, Benjamin 1865–1924
Street Scene, Tuscany c.1904
oil on board 34 x 23.5
1973/146

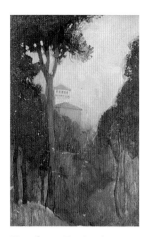

Haughton, Benjamin 1865–1924
Trees and Tower, Tuscany c.1904
oil on board 22.5 x 14.5
1973/97

Haughton, Benjamin 1865–1924
Cornwall 1905
oil on board 15.2 x 22.5
1973/103

Haughton, Benjamin 1865–1924
Rocks on the Cliffs, Newlyn c.1905
oil on board 23 x 34
1973/132

Haughton, Benjamin 1865–1924
Study for 'City of Dreams' 1906
oil on board 23.5 x 34
1973/200

Haughton, Benjamin 1865–1924
Nasturtiums c.1909
oil on board 30.5 x 22.5
1973/131

Haughton, Benjamin 1865–1924
Woodland 1911–1913
oil on board 33.5 x 23.5
1973/142

Haughton, Benjamin 1865–1924
Deserted Orchard 1912
oil on wood 44 x 34
1973/336

Haughton, Benjamin 1865–1924
View in the Vosges 1912
oil on board 24.5 x 33.5
1973/151

Haughton, Benjamin 1865–1924
A Sheltered Farm c.1914
oil on board 44.5 x 33.5
1973/262

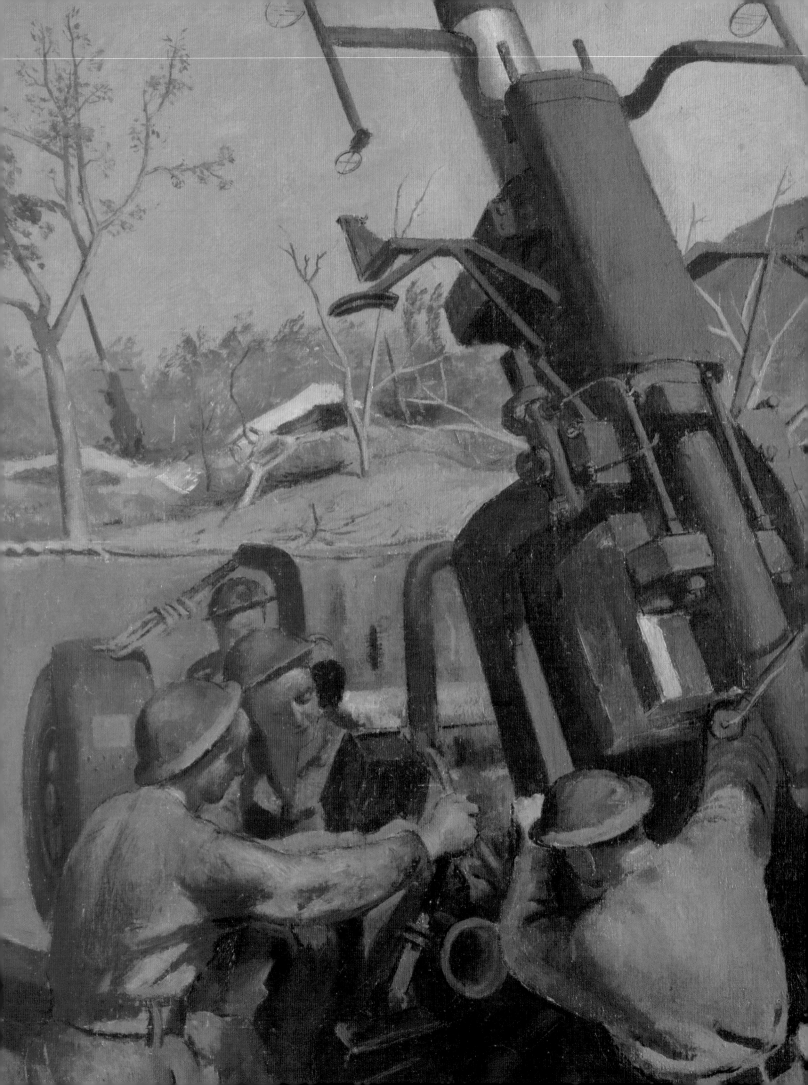

Haughton, Benjamin 1865–1924
Betty 1915
oil on canvas 50.2 x 44.6
1973/378

Haughton, Benjamin 1865–1924
A Garden
oil on board 40 x 31.4
1973/178

Haughton, Benjamin 1865–1924
A Tower Seen through Trees
oil on board 45.6 x 35.1
1973/297

Haughton, Benjamin 1865–1924
A Tree
oil on board 23.8 x 16.2
1973/99

Haughton, Benjamin 1865–1924
A Tree in Woodland
oil on board 24 x 16.1
1973/89

Haughton, Benjamin 1865–1924
A Woman
oil on board 16.5 x 11
1973/104

Haughton, Benjamin 1865–1924
An Upland Farm
oil on board 34.3 x 44.5
1977/420

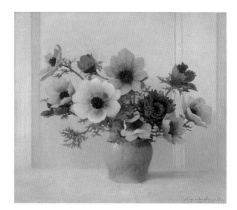

Haughton, Benjamin 1865–1924
Anemones
oil on board 30 x 35.2
1974/348

Haughton, Benjamin 1865–1924
Apple Tree
oil on board 15.7 x 23.5
1973/249

Facing page: Carr, Henry Marvell, 1894–1970, *A 3.7 Anti-Aircraft Gun of 393/72 Heavy Anti-Aircraft Regiment, RA, CMF* (detail), 1944, Royal Armouries, Fort Nelson, (p. 23)

Haughton, Benjamin 1865–1924
April 1912, East Devon
oil on canvas 44.5 x 49.5
1973/368

Haughton, Benjamin 1865–1924
At East Downe
oil on board 35.2 x 45.8
1973/294

Haughton, Benjamin 1865–1924
At the Rose Show
oil on canvas 33.5 x 28.5
1973/328

Haughton, Benjamin 1865–1924
Autumn Wood, East Downe
oil on board 44.5 x 34
1973/343

Haughton, Benjamin 1865–1924
Autumnal Woodland Scene
oil on canvas 75.5 x 60.5
1973/382

Haughton, Benjamin 1865–1924
Beech Bole
oil on board 44.5 x 33
1973/226

Haughton, Benjamin 1865–1924
Beech on the Quantocks
oil on board 34 x 44
1973/223

Haughton, Benjamin 1865–1924
Betty, Aged 12
oil on canvas 49 x 49.2
1973/357

Haughton, Benjamin 1865–1924
Betty Haughton as a Child
oil on canvas 74.5 x 62
1973/391

Haughton, Benjamin 1865–1924
Betty in the Garden
oil on wood 34 x 28
1973/338

Haughton, Benjamin 1865–1924
Birch Tree in a Field
oil on board 34 x 28.5
1973/190

Haughton, Benjamin 1865–1924
Bluebells
oil on board 23.5 x 39.5
1977/421

Haughton, Benjamin 1865–1924
'Breath of Spring'
oil on board 17.4 x 39.9
1977/413

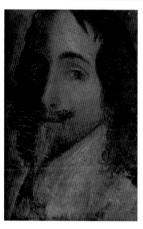

Haughton, Benjamin 1865–1924
Cavalier
oil on board 16 x 10
1977/408

Haughton, Benjamin 1865–1924
Cherry Blossom
oil on board 35 x 25.2
1973/136

Haughton, Benjamin 1865–1924
Cherry Blossom
oil on board 23.8 x 33.4
1973/143

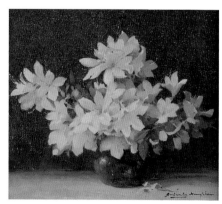

Haughton, Benjamin 1865–1924
Christmas Roses
oil on canvas 30 x 35.5
1974/347

Haughton, Benjamin 1865–1924
Church Graveyard
oil on canvas 48 x 41.5
1973/359

Haughton, Benjamin 1865–1924
Church House Garden, East Downe House
oil on board 34.6 x 25.4
1973/172

Haughton, Benjamin 1865–1924
Churchyard
oil on board 45.8 x 35.9
1973/275

Haughton, Benjamin 1865–1924
Churchyard, East Downe
oil on board 26 x 20
1973/197

Haughton, Benjamin 1865–1924
City of Dreams
oil on board 24 x 34
1977/400

Haughton, Benjamin 1865–1924
Classical Landscape
oil on board 23 x 17.8
1973/87

Haughton, Benjamin 1865–1924
Cliffs and Sea
oil on board 21.8 x 12.9
1973/88

Haughton, Benjamin 1865–1924
Cluster of Flowers
oil on board 35 x 25.3
1973/158

Haughton, Benjamin 1865–1924
Collecting Water, Doctor's Pond, Summerhill
oil on board 30 x 38
1973/185

Haughton, Benjamin 1865–1924
Cornfield with Stooks
oil on canvas 91 x 101
1973/392

Haughton, Benjamin 1865–1924
Cornwall
oil on board 16 x 23.9
1973/92

Haughton, Benjamin 1865–1924
Cornwall
oil on board 16.2 x 23.8
1973/111

Haughton, Benjamin 1865–1924
Cottage Garden
oil on board 55.5 x 60.8
1973/316

Haughton, Benjamin 1865–1924
Cottage in a Copse
oil on board 25.1 x 35.6
1973/216

Haughton, Benjamin 1865–1924
Cottage in a Landscape
oil on board 35 x 40.7
1973/257

Haughton, Benjamin 1865–1924
Cottages on a Hillside
oil on board 33.5 x 44.5
1973/258

Haughton, Benjamin 1865–1924
Country Stream
oil on board 16.3 x 23.7 (E)
1973/123

Haughton, Benjamin 1865–1924
Countryside
oil on board 16.3 x 23.5 (E)
1973/128

Haughton, Benjamin 1865–1924
Countryside
oil on board 25.3 x 35
1973/140

Haughton, Benjamin 1865–1924
Countryside
oil on board 35.2 x 25
1973/152

Haughton, Benjamin 1865–1924
Countryside
oil on board 27 x 29.9
1973/196

Haughton, Benjamin 1865–1924
Countryside
oil on board 24.8 x 35.5
1973/241

Haughton, Benjamin 1865–1924
Countryside with Cottages
oil on board 15.7 x 23.4
1973/110

Haughton, Benjamin 1865–1924
Cypress Trees in Italian Landscape
oil on canvas 10.9 x 16
1973/314

Haughton, Benjamin 1865–1924
Dawn
oil on canvas 59.2 x 64.7
1973/390

Haughton, Benjamin 1865–1924
Dead and Live Tree
oil on board 23 x 16
1977/405

Haughton, Benjamin 1865–1924
Devon
oil on board 24 x 16.3
1973/121

Haughton, Benjamin 1865–1924
Devon Pinewood
oil on board 23.5 x 34.5
1973/335

Haughton, Benjamin 1865–1924
Doctor's Farm
oil on board 12.6 x 21.7
1973/102

Haughton, Benjamin 1865–1924
Doctor's Farm
oil on board 38.5 x 29.8
1973/342

Haughton, Benjamin 1865–1924
Downland
oil on board 23.8 x 33.7
1973/138

Haughton, Benjamin 1865–1924
Downland
oil on board 31.5 x 40
1973/186

Haughton, Benjamin 1865–1924
Downland
oil on board 31.3 x 40
1973/189

Haughton, Benjamin 1865–1924
Downland
oil on board 30 x 38.5
1973/233

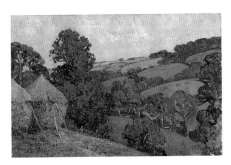

Haughton, Benjamin 1865–1924
Downland
oil on board 38.4 x 30.3
1973/273

Haughton, Benjamin 1865–1924
Downland
oil on board 14.2 x 19.8
1973/349

Haughton, Benjamin 1865–1924
Downland
oil on wood 40 x 61
1973/362

Haughton, Benjamin 1865–1924
East Downe
oil on board 45.7 x 35
1973/231

Haughton, Benjamin 1865–1924
East Downe
oil on canvas 40.7 x 46.8
1973/358

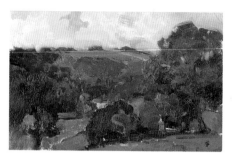

Haughton, Benjamin 1865–1924
East Downe Gate
oil on board 15 x 23.5
1973/90

Haughton, Benjamin 1865–1924
East Downe Wood
oil on board 34 x 43
AA310

Haughton, Benjamin 1865–1924
East Hill, Ottery St Mary
oil on board 34.9 x 45.7
1973/164

Haughton, Benjamin 1865–1924
Ellington, East Yorkshire, Looking towards the Humber
oil on board 23.5 x 45.7
1973/154

Haughton, Benjamin 1865–1924
Evening
oil on board 31.2 x 40
1973/188

Haughton, Benjamin 1865–1924
Eylers
oil on board 45.7 x 35
1973/287

Haughton, Benjamin 1865–1924
Faido
oil on board 15.5 x 22.2
1973/84

Haughton, Benjamin 1865–1924
Farm Buildings and Woodland
oil on board 45 x 35
1973/301

Haughton, Benjamin 1865–1924
Field
oil on board 13 x 21.7
1973/96

Haughton, Benjamin 1865–1924
Field and Trees
oil on canvas 30.5 x 39
1973/373

Haughton, Benjamin 1865–1924
Fields and Village
oil on board 16.1 x 24.3
1973/120/1

Haughton, Benjamin 1865–1924
Florence
oil on wood 15 x 23
1973/127

Haughton, Benjamin 1865–1924
Flowers and Poppy Heads
oil on canvas 61 x 45.7
1973/360

Haughton, Benjamin 1865–1924
Flowers Growing in Rocks
oil on canvas 50 x 45.5
1973/355

Haughton, Benjamin 1865–1924
Flowers in a Garden
oil on board 21.7 x 12.6
1973/250

Haughton, Benjamin 1865–1924
Flowers in a Glass Vase
oil on board 20.6 x 15.4
1973/126

Haughton, Benjamin 1865–1924
Forest Floor
oil on board 16.2 x 24
1973/115

Haughton, Benjamin 1865–1924
Forest Glade
oil on board 45.8 x 35.1
1973/276

Haughton, Benjamin 1865–1924
Foxgloves
oil on board 25.6 x 19.2
1973/117

Haughton, Benjamin 1865–1924
From the Fountain Garden, East Downe
oil on board 35 x 45
1973/166

Haughton, Benjamin 1865–1924
Garden Flower Scene
oil on board 35 x 30
1973/310

Haughton, Benjamin 1865–1924
Garden Flowers
oil on canvas 50.5 x 63.5
1973/384

Haughton, Benjamin 1865–1924
Girl in a Forest Clearing
oil on canvas 45 x 37
1973/303

Haughton, Benjamin 1865–1924
Girl in a Summer Garden
oil on board 24.3 x 16
1973/91

Haughton, Benjamin 1865–1924
Girl in a Wood
oil on board 24.5 x 29.5
1973/187

Facing page: Warren, Stanley, 1918–1992, *The Black Passion: The Entry into Jerusalem* (detail), 1959–1960, The Museum of Army Chaplaincy, (p. 6)

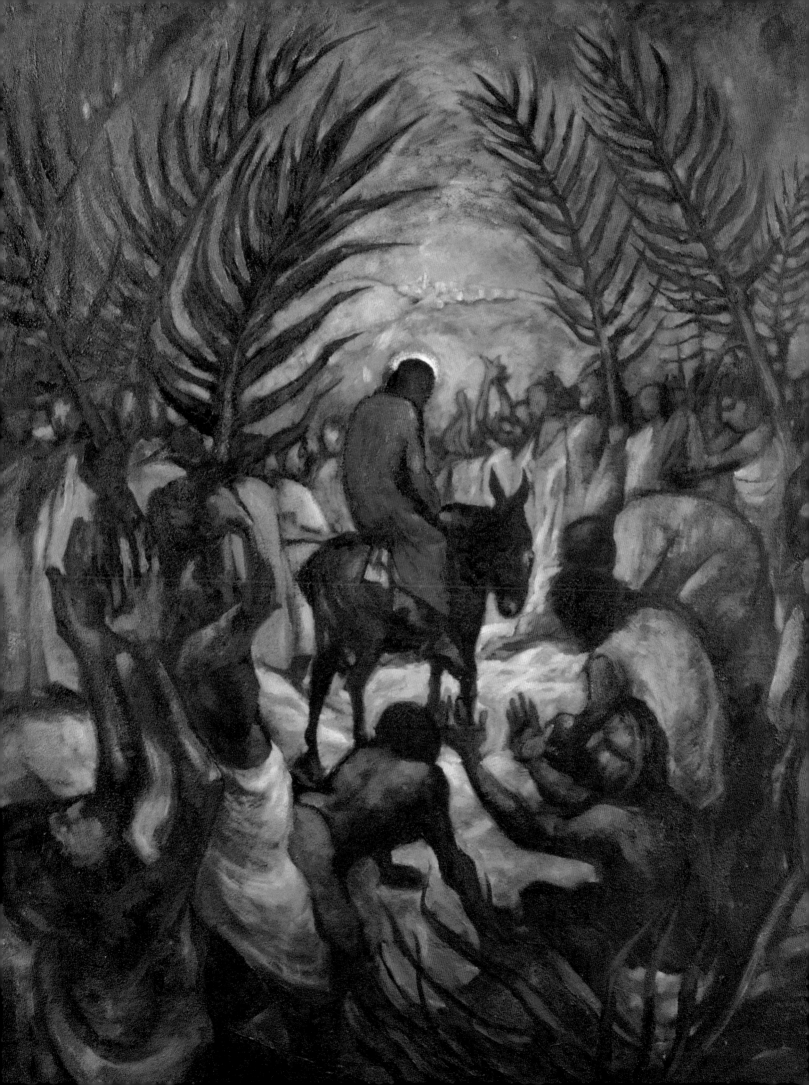

Haughton, Benjamin 1865–1924
Girl Tending a Garden
oil on board 31.3 x 40
1973/236

Haughton, Benjamin 1865–1924
Girl Tending Geese
oil on canvas 50 x 61
1973/371

Haughton, Benjamin 1865–1924
Girl's Head
oil on board 25.6 x 20.7
1973/248

Haughton, Benjamin 1865–1924
Gladioli near a Door
oil on board 40 x 31.5
1973/171

Haughton, Benjamin 1865–1924
Half-Lit Woodland Scene
oil on canvas 49.5 x 62
1973/369

Haughton, Benjamin 1865–1924
Haystack in Hill Country
oil on board 31 x 39.8
1973/237

Haughton, Benjamin 1865–1924
Haystacks
oil on board 24.2 x 35.4
1973/215

Haughton, Benjamin 1865–1924
Haystacks at Dawn
oil on board 25.1 x 35.4
1973/141

Haughton, Benjamin 1865–1924
Hemlock
oil on board 20 x 13
1977/407

Haughton, Benjamin 1865–1924
Hill Country
oil on canvas 49.4 x 75
1973/352

Haughton, Benjamin 1865–1924
Hill Slopes
oil on canvas 34 x 44.5
1973/274

Haughton, Benjamin 1865–1924
Hillside
oil on board 16.2 x 20.4
1973/119

Haughton, Benjamin 1865–1924
Hillside
oil on board 26.2 x 35
1973/209

Haughton, Benjamin 1865–1924
Hillside
oil on board 30.5 x 40
1973/239

Haughton, Benjamin 1865–1924
Hilly Countryside
oil on board 15.6 x 23.5
1973/122

Haughton, Benjamin 1865–1924
Hilly Countryside
oil on board 24.7 x 35.5
1973/160

Haughton, Benjamin 1865–1924
Hop Garden
oil on board 30 x 39
1973/227

Haughton, Benjamin 1865–1924
Houses
oil on board 23.8 x 15.7
1973/252

Haughton, Benjamin 1865–1924
Hydrangeas
oil on board 35.8 x 45.7
1973/167

Haughton, Benjamin 1865–1924
In a Garden in Kent
oil on board 20.5 x 11.5
1973/125

Haughton, Benjamin 1865–1924
In Churchill Wood, North Devon
oil on board 31.3 x 40.6
1973/181

Haughton, Benjamin 1865–1924
Italian Countryside
oil on board 14.5 x 22
1973/112/2

Haughton, Benjamin 1865–1924
Italian Hill Scene
oil on board 31.5 x 40
1973/174

Haughton, Benjamin 1865–1924
Italian Landscape
oil on board 25.5 x 35.4
1973/157

Haughton, Benjamin 1865–1924
Italianate Lakeside
oil on board 23.6 x 16.2
1973/93

Haughton, Benjamin 1865–1924
Italianate Landscape
oil on board 23.8 x 16.2
1973/107

Haughton, Benjamin 1865–1924
Italianate Landscape
oil on board 23.8 x 16.2
1973/112/1

Haughton, Benjamin 1865–1924
Ivy-Clad Tree
oil on board 40.2 x 31.3
1973/272

Haughton, Benjamin 1865–1924
Ivy-Clad Tree
oil on board 45.7 x 34.7
1973/296

Haughton, Benjamin 1865–1924
Jay
oil on board 31.6 x 39.9
1973/184

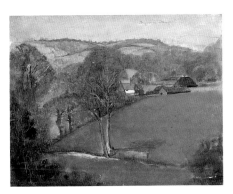

Haughton, Benjamin 1865–1924
Kentish Landscape
oil on board 31.5 x 40.2
1973/282

Haughton, Benjamin 1865–1924
Lady's Wood, Devon
oil on board 35 x 45.6
1973/299

Haughton, Benjamin 1865–1924
Lake and Trees
oil on canvas 76.2 x 60.5
1973/350

Haughton, Benjamin 1865–1924
Lakeland Scene
oil on board 25.1 x 35.5
1973/137

Haughton, Benjamin 1865–1924
Landscape, East Downe
oil on board 44.5 x 33.5
1973/333

Haughton, Benjamin 1865–1924
Landscape with Hayricks
oil on board 35.8 x 45.7
1973/289

Haughton, Benjamin 1865–1924
Landscape with Pond
oil on board 26.5 x 32
1973/308

Haughton, Benjamin 1865–1924
Lilac
oil on board 45.7 x 35
1973/288

Haughton, Benjamin 1865–1924
Lupins and Roses in a Garden
oil on board 40 x 31.7
1973/177

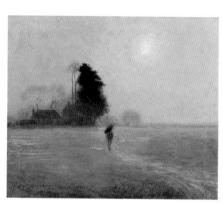

Haughton, Benjamin 1865–1924
Man Crossing a Field at Dusk
oil on canvas 50.5 x 60.5
1973/366

Haughton, Benjamin 1865–1924
Man's Head
oil on board 21 x 16.5
1973/109

Haughton, Benjamin 1865–1924
Marchwood
oil on board 24.2 x 15.9
1973/98

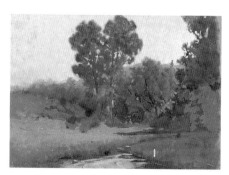

Haughton, Benjamin 1865–1924
Meadow and Woods
oil on board 25 x 35.4
1973/156

Haughton, Benjamin 1865–1924
Misty Woodland
oil on panel 30.5 x 40.6
1973/163

Haughton, Benjamin 1865–1924
Moonlight
oil on board 12.9 x 21.9
1973/251

Haughton, Benjamin 1865–1924
Moonlit Countryside
oil on board 16.2 x 24.1
1973/113

Haughton, Benjamin 1865–1924
Moorland Pond
oil on board 45.8 x 35.1
1973/260

Haughton, Benjamin 1865–1924
Morning Shadows
oil on board 40 x 30.4
1973/169

Haughton, Benjamin 1865–1924
Mountain Landscape
oil on board 45.6 x 34.9
1973/228

Haughton, Benjamin 1865–1924
Mountain Scene
oil on board 23.9 x 15.9
1973/108

Haughton, Benjamin 1865–1924
Narcissi in a Vase
oil on board 40 x 31.2
1973/232

Haughton, Benjamin 1865–1924
North Devon
oil on board 16.3 x 23.5
1973/100

Haughton, Benjamin 1865–1924
North Devon
oil on board 46 x 35
1973/295

Haughton, Benjamin 1865–1924
On East Hill, Ottery St Mary
oil on board 45.8 x 35.2
1973/230

Haughton, Benjamin 1865–1924
On the Cliffs above Mounts Bay, Cornwall
oil on board 35.4 x 24.9
1973/207

Haughton, Benjamin 1865–1924
On the Cliffs at Mounts Bay, Cornwall
oil on board 25.5 x 34.6
1973/207/1

Haughton, Benjamin 1865–1924
On the Quantocks
oil on board 45.8 x 34.7
1973/224

Haughton, Benjamin 1865–1924
On the Quantocks
oil on canvas 49.5 x 62
1973/380

Haughton, Benjamin 1865–1924
Orchard near the Pineta, Viareggio
oil on board 30 x 39.8
1973/175

Haughton, Benjamin 1865–1924
Orchard Sketch
oil on board 22 x 15
1977/410

Haughton, Benjamin 1865–1924
Ottery St Mary
oil on board 35.5 x 25.2
1973/194

Haughton, Benjamin 1865–1924
Ottery St Mary
oil on board 23 x 33.5
1973/323

Haughton, Benjamin 1865–1924
Path through Moorland
oil on board 34.7 x 45.8
1973/259

Haughton, Benjamin 1865–1924
Path through the Woods
oil on board 32.5 x 23.5
1973/243

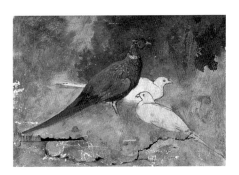

Haughton, Benjamin 1865–1924
Pheasants
oil on board 12.4 x 17.5
1973/313

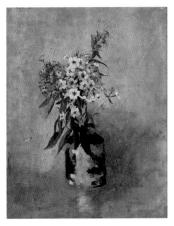

Haughton, Benjamin 1865–1924
Phlox
oil on board 40 x 31.3
1973/285

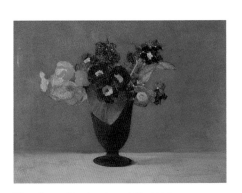

Haughton, Benjamin 1865–1924
Polyanthus
oil on board 23 x 31.5
1973/394

Haughton, Benjamin 1865–1924
Pond amid Woods
oil on wood 60 x 66
1973/364

Haughton, Benjamin 1865–1924
Pond Deep within Wood
oil on canvas 30.5 x 35.5
1973/374

Haughton, Benjamin 1865–1924
Portrait of an Unknown Gentleman's Head
oil on board 60.6 x 50.5
1973/319

Haughton, Benjamin 1865–1924
Pot of Roses
oil on board 35 x 45.5
1973/300

Haughton, Benjamin 1865–1924
Red Sapling by the Sea
oil on board 35.4 x 24.1
1973/139

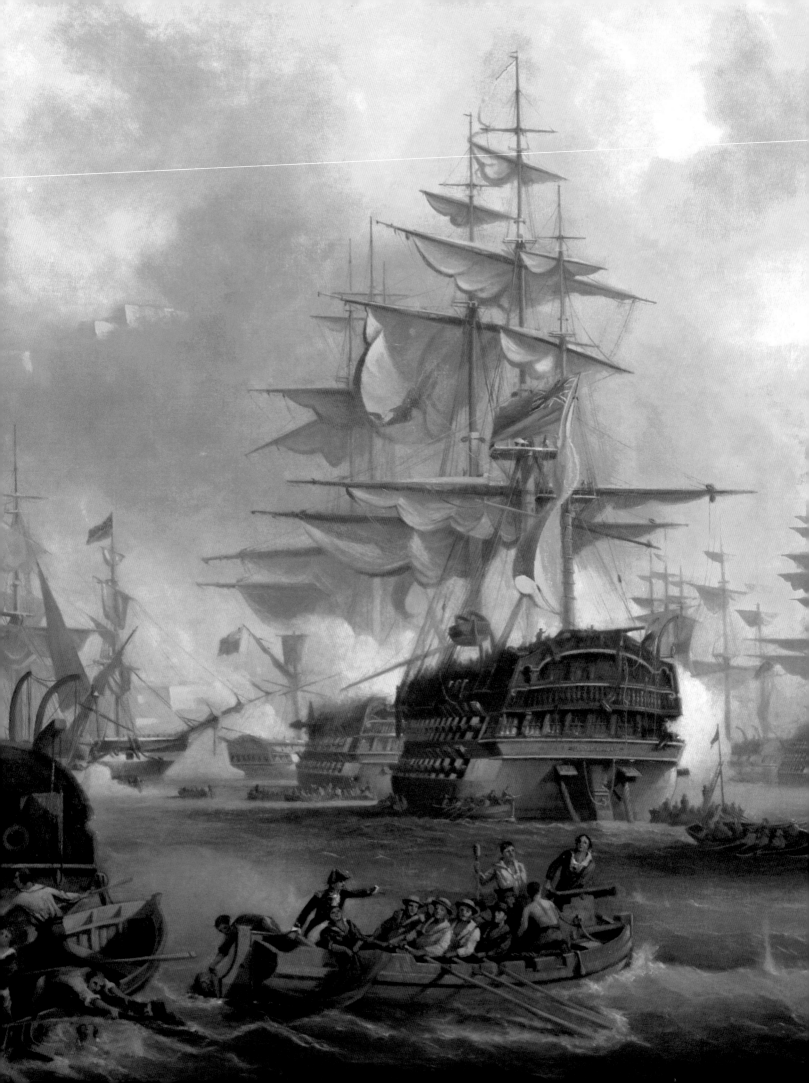

Haughton, Benjamin 1865–1924
Rhododendrons in a Wood
oil on board 33 x 23
1973/341

Haughton, Benjamin 1865–1924
Road to the Moor
oil on wood 15.5 x 24
1973/347

Haughton, Benjamin 1865–1924
Rose Bush
oil on board 15 x 23.5
1973/116

Haughton, Benjamin 1865–1924
Roses
oil on board 45.7 x 35.2
1973/293

Haughton, Benjamin 1865–1924
Rushes in Mediterranean Twilight
oil on canvas 39 x 33.5
1973/309

Haughton, Benjamin 1865–1924
Russet and Gold
oil on canvas 44.8 x 50
1973/367

Haughton, Benjamin 1865–1924
San Mignano, Tuscany
oil on board 34 x 23.8
1973/217

Haughton, Benjamin 1865–1924
Saplings on Hillside
oil on board 44 x 33.5
1973/292

Haughton, Benjamin 1865–1924
Scene with Hunters (unfinished)
oil on board 35.5 x 37.5 (E)
1973/318

Facing page: Morgan, Henry J., 1839–1917, *'Queen Charlotte' at Algiers, 27 August 1816* (detail), 1894, HMS Excellent, (p. 59)

Haughton, Benjamin 1865–1924
Sea and Skyscape
oil on board 23.5 x 34
1973/145

Haughton, Benjamin 1865–1924
Self Portrait
oil on board 40.2 x 30.7
1973/286

Haughton, Benjamin 1865–1924
Sketch at Houndspool
oil on board 39.5 x 30.4
1973/280

Haughton, Benjamin 1865–1924
Sketch for 'Woodland Waters'
oil on board 31.2 x 40
1973/221

Haughton, Benjamin 1865–1924
Sketch for 'Threshing'
oil on board 24 x 34.5
1973/322

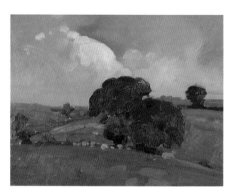

Haughton, Benjamin 1865–1924
Sketch of East Downe
oil on board 30 x 39
1973/234

Haughton, Benjamin 1865–1924
Sketch of Grassland and a Bird's Head
oil on board 17.4 x 39.9
1973/246

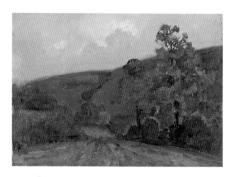

Haughton, Benjamin 1865–1924
Sketch of North Devon
oil on board 25.2 x 35.7
1973/198

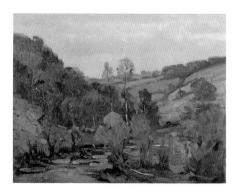

Haughton, Benjamin 1865–1924
Sketch of North Devon
oil on board 31.5 x 40
1973/220

Haughton, Benjamin 1865–1924
Sketch of North Devon Woodland
oil on board 40 x 31.5
1973/229

Haughton, Benjamin 1865–1924
Sketch of Rhododendron Ponticum
oil on board 38 x 30
1973/218

Haughton, Benjamin 1865–1924
Sprig of Flowers with Anemones
oil on board 24.2 x 34.2
1977/402

Haughton, Benjamin 1865–1924
Spring Song
oil on board 35 x 40.5
1977/416

Haughton, Benjamin 1865–1924
Standard Roses in a Garden
oil on canvas 65.6 x 60.5
1973/379

Haughton, Benjamin 1865–1924
Stream in a Woodland Glade
oil on board 35.1 x 45.7
1973/265

Haughton, Benjamin 1865–1924
Study for 'Breath of Spring'
oil on board 28 x 29.5
1973/312

Haughton, Benjamin 1865–1924
Study for 'Breath of Spring'
oil on canvas 49.5 x 36.5
1973/356

Haughton, Benjamin 1865–1924
Study for 'City of Dreams'
oil on board 34 x 23.5
1973/332

Haughton, Benjamin 1865–1924
Study for 'Hush of Evening'
oil on board 26.5 x 31.5
1973/311

Haughton, Benjamin 1865–1924
Study for 'Pastoral'
oil on board 31 x 23
1973/330

Haughton, Benjamin 1865–1924
Study for 'Pastoral'
oil on canvas 63.5 x 71
1973/383

Haughton, Benjamin 1865–1924
Study for 'Pastoral with Woodland Pond'
oil on canvas 41 x 32
1973/375

Haughton, Benjamin 1865–1924
Study of a Beech
oil on board 44.5 x 34
1973/334

Haughton, Benjamin 1865–1924
Study of a Bluebell Wood, Summerhill
oil on board 30.8 x 40
1973/235

Haughton, Benjamin 1865–1924
Study of an Olive Tree
oil on board 24 x 16
1973/106

Haughton, Benjamin 1865–1924
Study of Fir Wood
oil on board 40 x 31.3
1973/170

Haughton, Benjamin 1865–1924
Study of Oak Boles
oil on board 29 x 38
1973/290

Haughton, Benjamin 1865–1924
Study of Roses
oil on board 25 x 33.5
1973/199

Haughton, Benjamin 1865–1924
Summerhill
oil on board 40 x 31.3
1973/279

Haughton, Benjamin 1865–1924
Sun over Downland (recto)
oil on board 16.2 x 23.5
1973/254/1

Haughton, Benjamin 1865–1924
Narcissus and Orchid (verso)
oil on board 23.5 x 16.2
1973/254/2

Haughton, Benjamin 1865–1924
Sundown
oil on board 29.5 x 38.2
1977/411

Haughton, Benjamin 1865–1924
Sunlit Trees
oil on wood 22.5 x 14.5
1973/372

Haughton, Benjamin 1865–1924
Sunlit Wood
oil on board 34.5 x 25.5
1973/147

Haughton, Benjamin 1865–1924
Sunset
oil on board 13 x 21.7
1973/101

Haughton, Benjamin 1865–1924
Sunset behind Trees with Pond
oil on canvas 50 x 62.5
1973/381

Haughton, Benjamin 1865–1924
Sunset over Countryside
oil on board 16.3 x 23.9
1973/130

Haughton, Benjamin 1865–1924
Sunshine and Frost
oil on board 21 x 30
1977/401

Haughton, Benjamin 1865–1924
The Beech Bole
oil on board 11.5 x 21
1977/406

Haughton, Benjamin 1865–1924
The Keeper's Cottage
oil on canvas 40.5 x 75
1973/354

Haughton, Benjamin 1865–1924
The Milking Parlour
oil on board 19 x 24
AA308

Haughton, Benjamin 1865–1924
*The Rhododendron Wood, Betty in Strete
Raleigh Wood*
oil on board 24 x 35
1973/325

Haughton, Benjamin 1865–1924
The Rising Moon, Marchwood
oil on board 33 x 39.5
1973/326

Haughton, Benjamin 1865–1924
The Roof of the World
oil on board 45.7 x 35.1
1973/269

Haughton, Benjamin 1865–1924
The Rookery, Bluebell Time, East Downe
oil on board 35.1 x 45.6
1973/263

Haughton, Benjamin 1865–1924
The Rookery, East Downe
oil on board 45.8 x 35
1973/222

Haughton, Benjamin 1865–1924
The Rookery, East Downe
oil on board 35.3 x 45.8
1973/271

Haughton, Benjamin 1865–1924
The Sid Valley
oil on board 33.5 x 44.5
1973/331

Haughton, Benjamin 1865–1924
Thistle in a Field
oil on board 23.5 x 14.2
1973/120/2

Haughton, Benjamin 1865–1924
Threshing
oil on board 23.8 x 32.7
1977/414

Haughton, Benjamin 1865–1924
Ticino Valley
oil on board 23.8 x 16.5
1973/86

Haughton, Benjamin 1865–1924
Tones for Forest Scene
oil on board 45 x 35.3
1973/317

Haughton, Benjamin 1865–1924
Tree
oil on canvas 106.5 x 50
1973/351

Haughton, Benjamin 1865–1924
Tree against Sky
oil on board 34 x 24
1973/242

Haughton, Benjamin 1865–1924
Tree by a Cottage Door
oil on board 15.8 x 23.5
1973/256

Haughton, Benjamin 1865–1924
Tree by a Stone
oil on board 35.5 x 25
1973/134

Haughton, Benjamin 1865–1924
Tree Felling, East Downe
oil on board 33 x 24
1973/210

Haughton, Benjamin 1865–1924
Tree in a Glade
oil on board 44.5 x 33
1973/267

Haughton, Benjamin 1865–1924
Tree in Autumn
oil on board 31.7 x 40.2
1973/182

Haughton, Benjamin 1865–1924
Tree in Blossom
oil on board 23.7 x 16.3
1973/253

Haughton, Benjamin 1865–1924
Tree in Summer
oil on board 30.2 x 40
1973/192

Haughton, Benjamin 1865–1924
Tree Roots
oil on board 24 x 33
1973/159

Haughton, Benjamin 1865–1924
Trees
oil on board 40.8 x 31.2
1973/179

Haughton, Benjamin 1865–1924
Trees
oil on board 31.6 x 40.1
1973/183

Haughton, Benjamin 1865–1924
Trees and Cornstooks
oil on board 25.2 x 35.4
1973/213

Haughton, Benjamin 1865–1924
Trees and Fields
oil on board 31.9 x 40.1
1973/180

Haughton, Benjamin 1865–1924
Trees and Stream
oil on board 21 x 12
1977/404

Haughton, Benjamin 1865–1924
Trees and Undergrowth
oil on board 35.5 x 25.1
1973/208

Haughton, Benjamin 1865–1924
Trees and Water (unfinished)
oil on canvas 50 x 63
1973/387

Haughton, Benjamin 1865–1924
Trees by a Lake
oil on board 31.2 x 40
1973/176

Haughton, Benjamin 1865–1924
Trees by a Pond
oil on board 15.1 x 23.3
1973/255

Haughton, Benjamin 1865–1924
Trees by a Stream
oil on board 25.1 x 35.1
1973/155

Haughton, Benjamin 1865–1924
Trees in a Cornfield
oil on canvas 62 x 49
1973/389

Haughton, Benjamin 1865–1924
Trees in a Field
oil on board 30.4 x 40.2
1973/165

Haughton, Benjamin 1865–1924
Trees in a Garden
oil on board 34.7 x 25.5
1973/203/1

Haughton, Benjamin 1865–1924
Trees in a Garden
oil on board 32.6 x 24.2
1973/203/2

Haughton, Benjamin 1865–1924
Trees in a Quarry
oil on board 33 x 23
AA309

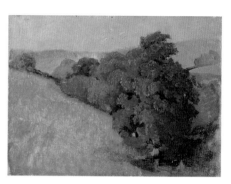

Haughton, Benjamin 1865–1924
Trees in a Valley
oil on board 24 x 32.7
1973/195

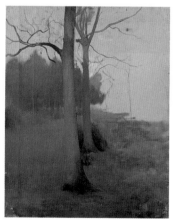

Haughton, Benjamin 1865–1924
Trees in a Winter Landscape
oil on canvas 63.5 x 51
1973/376

Haughton, Benjamin 1865–1924
Trees in a Wood
oil on board 35.1 x 25.3
1973/202

Haughton, Benjamin 1865–1924
Trees in a Woodland
oil on canvas 50 x 63
1973/386

Facing page: Meadus, Eric, 1931–1970, *Vase with Flowers and Bottle* (detail), 1969, Hampshire County Council
Museums Service (p. 283)

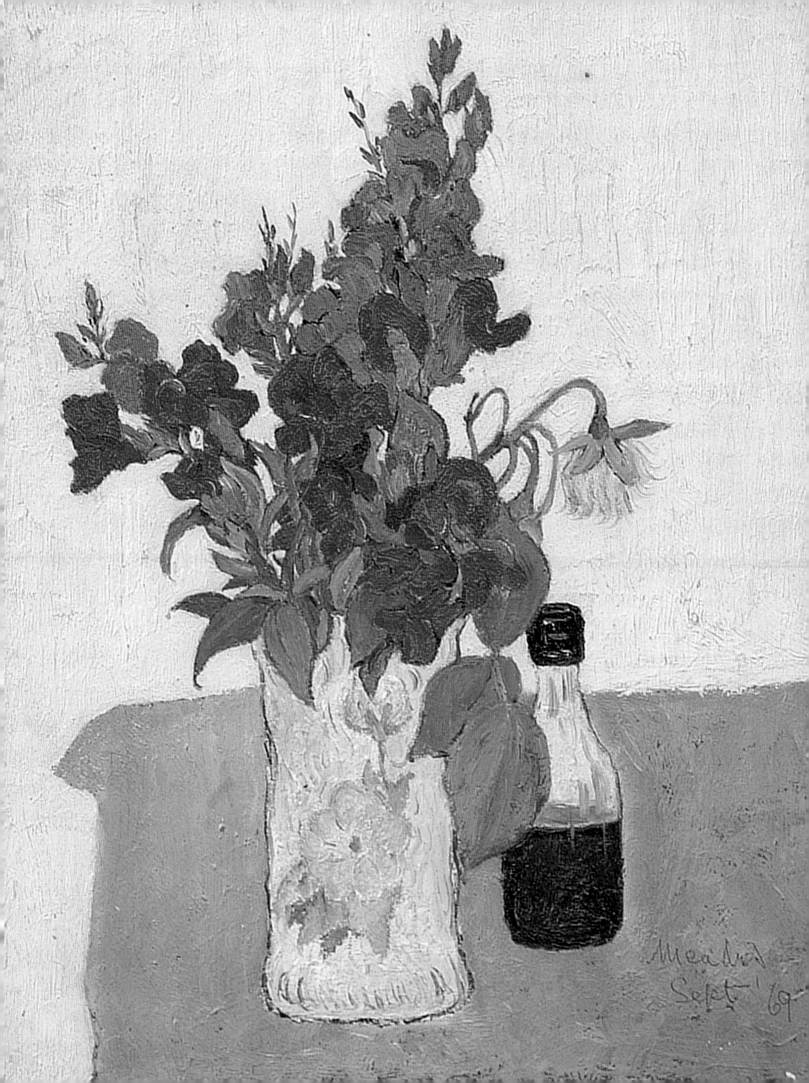

Haughton, Benjamin 1865–1924
Trees in Blossom
oil on board 16 x 23.5
1977/418

Haughton, Benjamin 1865–1924
Trees in Downland
oil on board 35 x 46
1973/266

Haughton, Benjamin 1865–1924
Trees near a Cottage at Sunset
oil on board 45 x 33
1973/268

Haughton, Benjamin 1865–1924
Trees near a Village at Sunset
oil on board 45.6 x 34.7
1973/268/1

Haughton, Benjamin 1865–1924
Trees on a Hill near the Sea
oil on board 34 x 24
1973/193

Haughton, Benjamin 1865–1924
Trees on a Hillside
oil on board 34.7 x 25.5
1973/148

Haughton, Benjamin 1865–1924
Trees on a Hillside
oil on board 32.4 x 24.1
1973/204

Haughton, Benjamin 1865–1924
Trees Reflected in Water
oil on board 21.7 x 12.8
1973/114

Haughton, Benjamin 1865–1924
Two Children Walking
oil on canvas 25 x 20
1973/315

Haughton, Benjamin 1865–1924
Vase of Roses
oil on board 45.7 x 34.5
1973/291

Haughton, Benjamin 1865–1924
Vase of Roses
oil on board 30.5 x 22.8
1973/346

Haughton, Benjamin 1865–1924
Very Early Morning, Hunstead
oil on board 34 x 44.5
1973/168

Haughton, Benjamin 1865–1924
View in Liguria, Bay of La Spezia
oil on board 21.5 x 29
1973/135

Haughton, Benjamin 1865–1924
View in the Quantocks Overlooking the Bristol Channel
oil on board 33 x 42
AA311

Haughton, Benjamin 1865–1924
View near East Downe
oil on board 17.5 x 43
1973/153

Haughton, Benjamin 1865–1924
View over Trees
oil on wood 60.5 x 66
1973/365

Haughton, Benjamin 1865–1924
Village from Hillside
oil on board 38 x 45.5
1973/307

Haughton, Benjamin 1865–1924
Vista between Trees
oil on board 9.5 x 12
1977/403

Haughton, Benjamin 1865–1924
Vosges Landscape
oil on board 25.8 x 34.9
1973/212

Haughton, Benjamin 1865–1924
Wild Roses
oil on board 21.7 x 12.7
1973/124

Haughton, Benjamin 1865–1924
Winter Trees
oil on board 23 x 34
1973/133

Haughton, Benjamin 1865–1924
Woman Drawing Water at a Pond
oil on canvas 46 x 51
1973/377

Haughton, Benjamin 1865–1924
Woman Hanging Out Washing
oil on board 28.2 x 30.7
1973/161

Haughton, Benjamin 1865–1924
Woman in a Churchyard
oil on canvas 63 x 50.5
1973/388

Haughton, Benjamin 1865–1924
Woman in a Conservatory with Roses
oil on board 25.5 x 20
1973/118

Haughton, Benjamin 1865–1924
Woman in a Glade
oil on board 31.2 x 40
1973/225

Haughton, Benjamin 1865–1924
Woman Walking through a Wood
oil on canvas 50.5 x 63.5
1973/385

Haughton, Benjamin 1865–1924
Woman's Head
oil on board 22 x 15.5
1973/247

Haughton, Benjamin 1865–1924
Wood, possibly at East Downe
oil on board 45.8 x 35
1973/173

Haughton, Benjamin 1865–1924
Woodland
oil on board 23.4 x 15
1973/94

Haughton, Benjamin 1865–1924
Woodland
oil on board 16 x 24
1973/95

Haughton, Benjamin 1865–1924
Woodland
oil on board 12.6 x 21.2
1973/105

Haughton, Benjamin 1865–1924
Woodland
oil on board 34.6 x 25.3
1973/150

Haughton, Benjamin 1865–1924
Woodland
oil on board 31.4 x 40
1973/219

Haughton, Benjamin 1865–1924
Woodland
oil on board 46 x 35
1973/264/1

Haughton, Benjamin 1865–1924
Woodland
oil on board 45.5 x 35
1973/264/2

Haughton, Benjamin 1865–1924
Woodland
oil on board 34.8 x 45.7
1973/298

Haughton, Benjamin 1865–1924
Woodland
oil on canvas 60.5 x 45.5
1973/363/1

Haughton, Benjamin 1865–1924
Woodland
oil on canvas 62.5 x 39
1973/363/2

Haughton, Benjamin 1865–1924
Woodland Glade
oil on board 15.9 x 24
1973/85

Haughton, Benjamin 1865–1924
Woodland Glade
oil on board 34.6 x 25.5
1973/205

Haughton, Benjamin 1865–1924
Woodland Glade
oil on canvas 33.5 x 44.5
1977/412

Haughton, Benjamin 1865–1924
Woodland Landscape from Hillside
oil on board 45 x 35.5
1973/304

Haughton, Benjamin 1865–1924
Woodland Path
oil on board 34 x 20
1973/348

Haughton, Benjamin 1865–1924
Woodland Scene
oil on board 40 x 31.2
1973/281

Haughton, Benjamin 1865–1924
Woodland Scene
oil on wood 17 x 12
1973/339

Haughton, Benjamin 1865–1924
Woodland Sketch
oil on board 38.5 x 29.5
1973/327

Haughton, Benjamin 1865–1924
Woodland Stream
oil on canvas 34.5 x 44
1973/305

Haughton, Benjamin 1865–1924
Woodland Study, East Downe
oil on board 34 x 23.5
1973/201

Haughton, Benjamin 1865–1924
Woodland Undergrowth
oil on board 30.5 x 39.9
1973/283

Haughton, Benjamin 1865–1924
Woodland View with Stream
oil on board 30.5 x 30
1973/340

Haughton, Benjamin 1865–1924
Woodland with Hills in the Distance
oil on canvas 75.5 x 50.2
1973/370

Haughton, Benjamin 1865–1924
Yellow Flowers in a Vase
oil on board 35 x 45.5
1973/306

Haughton, Benjamin (attributed to)
1865–1924
Lowland Scenery
oil on board 26 x 35.8
1973/329

Hayman, Patrick 1915–1988
Entry into Jerusalem 1963
oil on canvas 75 x 127
1973/412

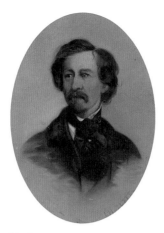

Hazlett, J.
Charles Dickens (1812–1870), as a Young Man
1840s
oil on card 21.2 x 16
2004/3084

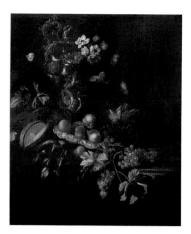

Heem, Cornelis de (attributed to)
1631–1695
Flower Piece
oil on canvas 111 x 95.5
1980/348

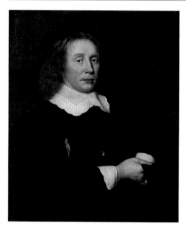

Helst, Bartholomeus van der (attributed to)
1613–1670
Portrait of an Unknown Gentleman
oil on canvas 75 x 62.5
1997/1255

Henri
Chiemsee, Bavaria
oil on paper 21.6 x 30.4
1979/849/2

Heron, Patrick 1920–1999
Red, Yellow, Brown 1964
oil on canvas 74 x 100
1973/413

Hitchens, Ivon 1893–1979
Arched Trees No.2, Late Summer
oil on canvas 50.2 x 104.9
1979/665

Hobbs, Barry
Tricorn 2004
acrylic & ink on paper & plaster 121.8 x 60.5
2004/837/1

Hobbs, Barry
Tricorn 2004
acrylic & ink on paper & plaster 121.8 x 60.9
2004/837/2

Hobbs, Barry
Tricorn 2004
acrylic & ink on paper & plaster 121.8 x 60.6
2004/837/3

Hofland, Thomas Christopher 1777–1843
Hulks in Portsmouth Harbour c.1830
oil on canvas 79 x 132.5
1979/855

Holloway, Denee
Iford Sand Pit 1969
oil on board 62 x 91.5
1970/152

Holloway, Denee
White Sheets
oil on metal & board 71.7 x 97.8
1981/288

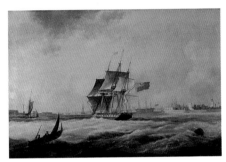

Hornbrook, Thomas Lyde 1780–1850
'HMS Pique' Entering Portsmouth Harbour
c.1840
oil on canvas 57.4 x 68.3
1957/122

Houston, John b.1930
Figures by the Sea, Evening 1966
oil on canvas 28.5 x 39
1981/254

Howard, W. H. active c.1899–1909
H. Kimber, Mayor of Portsmouth c.1899
oil on canvas 89.5 x 69.5
2003/2152

Howard, W. H. active c.1899–1909
Mayor James Baggs 1909
oil on canvas 141 x 110.3
guildhall1

Howsam, Barry
Figure 1969
oil on canvas 44.5 x 34.5
1979/713

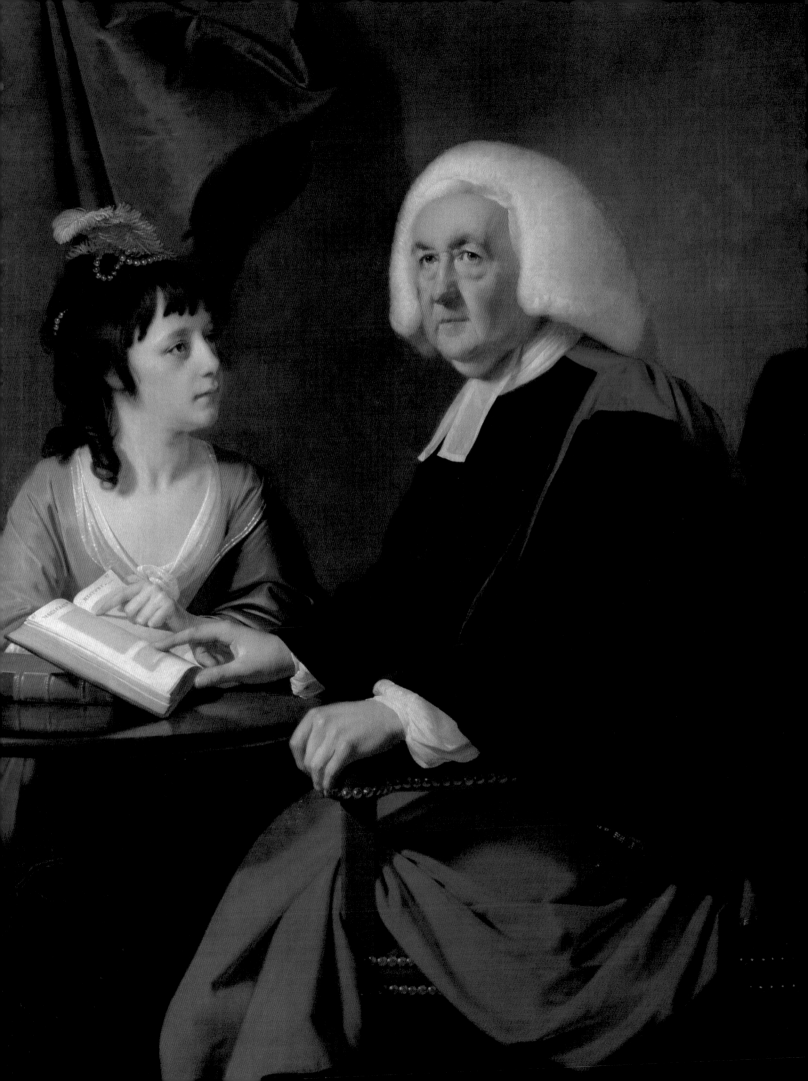

Hudson, John 1829–1897
'Folly of Portsmouth' 1873
oil on canvas 52 x 83
1968/246

Hulst, Maerten Fransz. van der (attributed to)
1605–1645
A River Scene in the Low Countries
oil on wood 34 x 30
1972/592

Irwin, Gwyther b.1931
On a Clear Day 1976
oil on canvas 174.5 x 237.4
1982/356

J. C. N. J.
'Eurydice' from Sandown Bay 1878
oil on board 16.5 x 10.5
1972/727

Jefferson, Alan 1918–2001
Black and White Geometric Abstract 1970s
acrylic on canvas 91.2 x 91.4
1998/675

Jefferson, Alan 1918–2001
Diamond Shaped Abstract 1970s
acrylic & pencil on canvas 126 x 126
1998/674

Jefferson, Alan 1918–2001
Lemon No.25, Oct. 1975 1975
acrylic on canvas 174 x 174
1998/673

Jefferson, Alan 1918–2001
Painting B, 22-3-79 1979
acrylic on canvas 61 x 182.8
1998/672

Jefferson, Alan 1918–2001
Blue Line
acrylic on canvas 76 x 50.5
1998/683

Facing page: Wright, Joseph of Derby, 1734–1797, *The Reverend Thomas Wilson (1703–1784) and Miss Catherine Macaulay (1731–1791)* (detail), Chawton House Library, (p. 17)

Jefferson, Alan 1918–2001
Blue, Violet, Lime and Ochre
acrylic on canvas 76 x 60.7
1998/676

Jefferson, Alan 1918–2001
Canted Corner Geometric Abstract
acrylic on canvas 93.8 x 184
1998/677

Jefferson, Alan 1918–2001
Dark Leaves and Grid
acrylic on canvas 152.7 x 116.2
1998/669

Jefferson, Alan 1918–2001
Green Orb
acrylic on canvas 106 x 84.5
1998/668

Jefferson, Alan 1918–2001
H. B. V. S. 69
acrylic on canvas 164 x 163.5
1998/681

Jefferson, Alan 1918–2001
Leaves and Rainbow
acrylic on canvas 122.2 x 198.8
1998/670

Jefferson, Alan 1918–2001
Lozenge Arch
acrylic on canvas 122.8 x 184.2
1998/678

Jefferson, Alan 1918–2001
On Yellow
acrylic & pencil on canvas 91.6 x 91.5
1998/680

Jefferson, Alan 1918–2001
Orange and Violet
acrylic on canvas 89.8 x 83.8
1998/679

Jefferson, Alan 1918–2001
Pink Orb
acrylic on canvas 45.5 x 35
1998/682

Jefferson, Alan 1918–2001
Soft Five
acrylic on cotton 182.3 x 119.3
1998/671

Jefferson, Alan 1918–2001
Wave
acrylic on cotton 138.6 x 199.8
1972/112

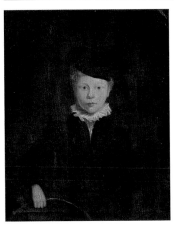

Jerome, James Parker 1810–1883
William Carter Jerome 1831
oil on board 23.5 x 18.8
2000/5

Jerome, James Parker 1810–1883
Ambrosini (Self Portrait) 1832
oil on canvas 60 x 50
2000/13

Jerome, James Parker 1810–1883
Harriet Caroline Augusta Jerome 1840
oil on canvas 60 x 50
2000/12

Jerome, James Parker 1810–1883
Maria Jerome
oil on board 26 x 21.5
2000/6

Jerome, James Parker 1810–1883
*Portrait of an Elderly Gentleman, possibly
Joseph Scarrott Jerome*
oil on board 59 x 45.5
2000/44

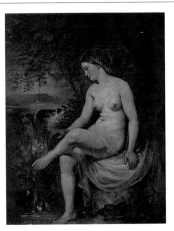

Jerome, James Parker 1810–1883
Seated Female Nude
oil on canvas 61.2 x 49.5
2002/86

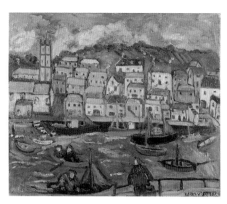

Jewels, Mary 1886–1977
St Ives 1956
oil on canvas 50 x 60
1973/417

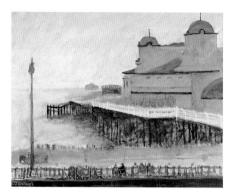

Jonleigh, Leonie active c.1950–1974
South Parade Pier
oil on board 39.5 x 50.5
1980/853

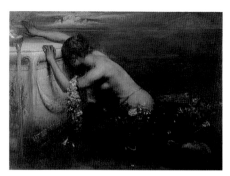

Joy, George William 1844–1925
Laodamia
oil on canvas 107.3 x 153.3
1976/118/1

Joy, William 1803–1867
Beaver Harbour, North End of Vancouver Island 1863
oil on canvas 25 x 40
1971/370

Joy, William 1803–1867
Coronation Bay, North-West End of Vancouver Island 1863
oil on canvas 25 x 40
1971/369

Joy, William 1803–1867
'HMS Devastation' at Fort Rupert, at the West End of Vancouver Island 1863
oil on canvas 27.5 x 43.5
1971/371

Joy, William 1803–1867
'HMS Devastation' Leaving the South-Eastern End of the Johnson's Strait, Vancouver Island 1863
oil on board 28 x 42 (E)
1971/373

Joy, William 1803–1867
Boats of 'HMS Devastation' in Search of Indians, Nootka Sound, Vancouver Island 1864
oil on canvas 28 x 41.5 (E)
1971/372

Joy, William 1803–1867
Town of Nanaimo, Vancouver Island 1865
oil on canvas 33 x 66
1971/375

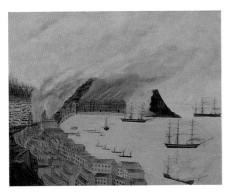

Joy, William 1803–1867
Spanish Fleet Bombarding Valparaiso, March 1866 1866
oil on canvas 36.5 x 47
1971/374

Kasialos, Michael
Pottery Makers
oil on board 54 x 94.5
1974/267

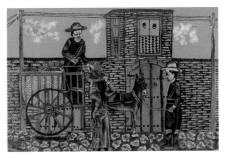

Kasialos, Michael
Travelling Salesman
oil on wood 58.5 x 90.5
1974/268

Kern, Theodor 1900–1969
Absract Yellow, Red and Blue
tempera on paper 55 x 75
AA314

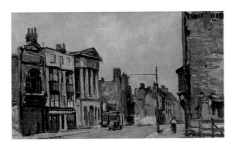

King, Edward R. 1863–1951
High Street and the Old Guildhall 1940–1946
oil on board 32.5 x 58.3
1945/468

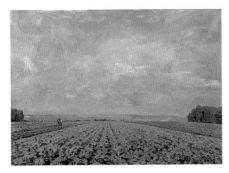

King, Edward R. 1863–1951
Cabbage Field on the Farm at St James' Hospital 1941
oil on canvas 75 x 106
2002/374

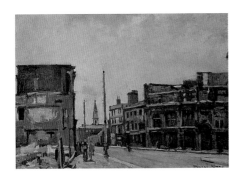

King, Edward R. 1863–1951
Central Hotel, Commercial Road 1941
oil on board 43.5 x 63
1945/454

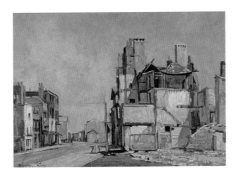

King, Edward R. 1863–1951
High Street, Portsmouth 1941
oil on board 43.5 x 63.5
1945/449

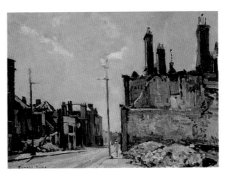

King, Edward R. 1863–1951
High Street, Portsmouth 1941
oil on board 43.5 x 64.2
1945/459

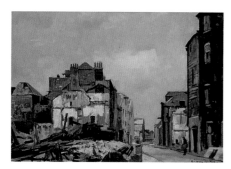

King, Edward R. 1863–1951
Oyster Street, Portsmouth 1941
oil on board 42.8 x 64
1945/447

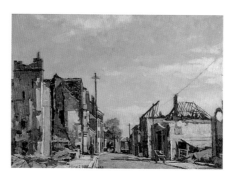

King, Edward R. 1863–1951
Penny Street, Portsmouth 1941
oil on board 43.6 x 63.3
1945/448

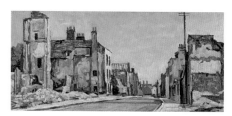

King, Edward R. 1863–1951
St Thomas' Street, Portsmouth 1941
oil on board 26.5 x 58.8
1945/466

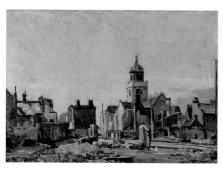

King, Edward R. 1863–1951
The Cathedral from the Ruins in the High Street
1941
oil on board 32.5 x 43
1945/452

King, Edward R. 1863–1951
The Guildhall 1941
oil on board 43.5 x 64
1945/453

King, Edward R. 1863–1951
Cathedral amongst the Ruins in the High Street
c.1941
oil on board 43 x 53
1945/464

King, Edward R. 1863–1951
Elm Grove Baptist Church 1941–1942
oil on board 44.2 x 63.8
1945/472

King, Edward R. 1863–1951
Arundel Street, Portsmouth 1941–1943
oil on board 43.6 x 64
1945/471

King, Edward R. 1863–1951
Commercial Road and Lake Road,
Portsmouth 1941–1943
oil on board 47 x 70.5
1945/470

King, Edward R. 1863–1951
King's Road and Coronation House, Portsmouth
1941–1943
oil on board 43.1 x 58.6
1945/445

King, Edward R. 1863–1951
Palmerston Road, Portsmouth 1941–1943
oil on board 43.2 x 64.2
1945/462

King, Edward R. 1863–1951
Cathedral from High Street 1941–1946
oil on board 45.5 x 64.5
1945/460

King, Edward R. 1863–1951
Commercial Road, Portsmouth 1941–1946
oil on board 43.6 x 64
1945/450

King, Edward R. 1863–1951
*Hampshire and Jubilee Terraces,
Portsmouth* 1941–1946
oil on board 32 x 58
1945/465

King, Edward R. 1863–1951
Hyde Park Corner 1941–1946
oil on board 36.4 x 53
1945/469

King, Edward R. 1863–1951
Palmerston Road, Portsmouth 1941–1946
oil on board 42.5 x 74
1945/461

King, Edward R. 1863–1951
Ruins in Oyster Street, Portsmouth 1941–1946
oil on board 34.2 x 57.7
1945/463

King, Edward R. 1863–1951
*Surrey Street, the Guildhall,
Portsmouth* 1941–1946
oil on board 43 x 63.5
1945/451

King, Edward R. 1863–1951
The Connaught Drill Hall, Stanhope Road,
Portsmouth 1941–1946
oil on board 43 x 63
1945/446

King, Edward R. 1863–1951
High Street, Old Portsmouth 1942
oil on canvas 125.5 x 189
2006/300

King, Edward R. 1863–1951
Cathedral from St Thomas' Street, Old
Portsmouth c.1942
oil on board 44 x 63.5
1945/473

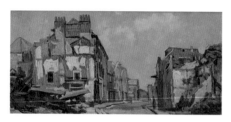

King, Edward R. 1863–1951
Oyster Street, Portsmouth c.1942
oil on board 25 x 55.4
1945/467

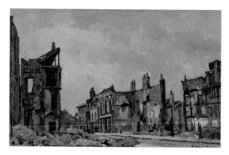

King, Edward R. 1863–1951
Pembroke Road, Portsmouth c.1942
oil on board 45 x 66
1945/455

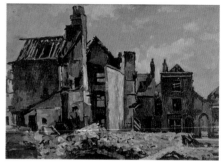

King, Edward R. 1863–1951
Ruins of St Thomas' Street, Portsmouth c.1942
oil on board 44 x 64.3
1945/456

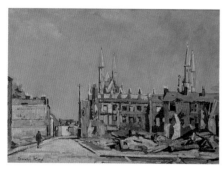

King, Edward R. 1863–1951
St Paul's Road and St Paul's Church,
Portsmouth c.1942
oil on board 44 x 64
1945/457

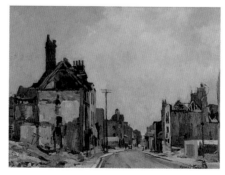

King, Edward R. 1863–1951
St Thomas' Street, Portsmouth c.1942
oil on board 46 x 64
1945/458

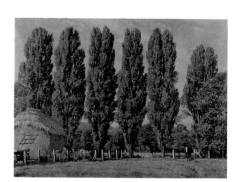

King, Edward R. 1863–1951
The Farm at St James' Hospital 1945
oil on canvas 121 x 163
2002/51

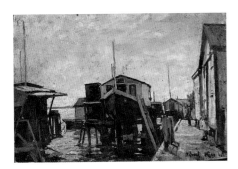

King, Edward R. 1863–1951
*Houseboats at Milton alongside a Quay with a
Girl in Red* 1946
oil on board 43 x 64
1998/12

King, Edward R. 1863–1951
Houseboats at Milton, No.11 1946
oil on card 44.5 x 65
1998/21

King, Edward R. 1863–1951
Houseboats at Milton, No.16 1946
oil on card 35 x 47.1
1998/26

King, Edward R. 1863–1951
Houseboats at Milton, No.21 1946
oil on card 26.5 x 63
1998/31

King, Edward R. 1863–1951
Houseboats at Milton, No.26 c.1946
oil on board 20 x 60.4
1998/36

King, Edward R. 1863–1951
Houseboats at Milton, No.18 1949
oil on wood 33.7 x 54.3
1998/28

King, Edward R. 1863–1951
Houseboats at Milton, No.4 c.1949
oil on card 48 x 61.5
1998/15

King, Edward R. 1863–1951
*A View of the Laundry, St James' Hospital,
Portsmouth* 1950
oil on board 76.5 x 61
1998/1

King, Edward R. 1863–1951
Houseboats at Milton, No.12 1950
oil on board 32 x 61
1998/22

King, Edward R. 1863–1951
Outbuildings at St James' Hospital, No.2 1950
oil on board 61 x 91.5
1998/3

King, Edward R. 1863–1951
Outbuildings at St James' Hospital, No.6 1950
oil on board 50.5 x 75
1998/7

King, Edward R. 1863–1951
Outbuildings at St James' Hospital, No.5
c.1950
oil on board 56 x 81.2
1998/6

King, Edward R. 1863–1951
Outbuildings at St James' Hospital, No.7 1951
oil on board 49.5 x 47.5
1998/8

King, Edward R. 1863–1951
Outbuildings at St James' Hospital, No.10 1951
oil on wood 59 x 80
2002/373

King, Edward R. 1863–1951
*Patients Working on the Farm at St James'
Hospital, No.2* 1951
oil on card 26 x 40.8
1998/42

King, Edward R. 1863–1951
The Grounds of St James' Hospital 1951
oil on wood 79.6 x 59
2002/372

King, Edward R. 1863–1951
Gravel Wharf, Milton Lake, Portsmouth
oil on board 46 x 79
2/2/98

King, Edward R. 1863–1951
Houseboats at Milton, No.3
oil on board 47.5 x 65.5
1998/14

Facing page: Brangwyn, Frank, 1867–1956, *A Balkan Fisherman* (detail), 1890, Hampshire County Council
Museums Service (p. 273)

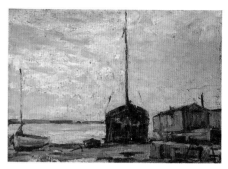

King, Edward R. 1863–1951
Houseboats at Milton, No.5
oil on board 54 x 59.4
1998/16

King, Edward R. 1863–1951
Houseboats at Milton, No.6
oil on board 30.6 x 66.7
1998/17

King, Edward R. 1863–1951
Houseboats at Milton, No.7
oil on board 34.4 x 49
1998/18

King, Edward R. 1863–1951
Houseboats at Milton, No.8
oil on asbestos 25.8 x 57.6
1998/19/1

King, Edward R. 1863–1951
Houseboats at Milton, No.9
oil on asbestos 25.8 x 57.6
1998/19/2

King, Edward R. 1863–1951
Houseboats at Milton, No.10
oil on board 31.5 x 75
1998/20

King, Edward R. 1863–1951
Houseboats at Milton, No.13
oil on board 30.2 x 47.8
1998/23/1

King, Edward R. 1863–1951
Houseboats at Milton, No.14
oil on board 26.5 x 61.5
1998/24

King, Edward R. 1863–1951
Houseboats at Milton, No.15
oil on wood 27.6 x 51.5
1998/25

King, Edward R. 1863–1951
Houseboats at Milton, No.17
oil on board 30.8 x 52.1
1998/27

King, Edward R. 1863–1951
Houseboats at Milton, No.19
oil on wood 30.7 x 67
1998/29

King, Edward R. 1863–1951
Houseboats at Milton, No.20
oil on board 30.8 x 62.7
1998/30

King, Edward R. 1863–1951
Houseboats at Milton, No.22
oil on board 29.8 x 67.7
1998/32

King, Edward R. 1863–1951
Houseboats at Milton, No.23
oil on board 23.9 x 72.5
1998/33

King, Edward R. 1863–1951
Houseboats at Milton, No.24
oil on card 22 x 68.3
1998/34

King, Edward R. 1863–1951
Houseboats at Milton, No.25
oil on board 25.2 x 50.8
1998/35

King, Edward R. 1863–1951
Houseboats at Milton, No.27
oil on board 35 x 46.6
1998/37

King, Edward R. 1863–1951
*Houseboats at Milton with a Dinghy and
Sawhorse in the Foreground*
oil on card 48 x 62
1998/13

King, Edward R. 1863–1951
On Board a Houseboat at Milton
oil on board 30.2 x 47.8
1998/23/2

King, Edward R. 1863–1951
Outbuildings at St James' Hospital, Chimney Smoking
oil on board 59.5 x 76
1998/10

King, Edward R. 1863–1951
Outbuildings at St James' Hospital, No.1
oil on board 46 x 79
1/2/98

King, Edward R. 1863–1951
Outbuildings at St James' Hospital, No.3
oil on board 61 x 84
1998/4

King, Edward R. 1863–1951
Outbuildings at St James' Hospital, No.4
oil on board 60.5 x 76
1998/5

King, Edward R. 1863–1951
Outbuildings at St James' Hospital, No.9
oil on board 46 x 61
1998/11

King, Edward R. 1863–1951
Patients Working on the Farm at St James' Hospital, No.1
oil on card 30.8 x 38.2
1998/38

King, Edward R. 1863–1951
Poplar Trees in the Grounds of St James' Hospital, No.1
oil on card 30.3 x 37.9
1998/39

King, Edward R. 1863–1951
Poplar Trees in the Grounds of St James' Hospital, No.2
oil on card 32.1 x 36.6
1998/40

King, Edward R. 1863–1951
*Poplar Trees in the Grounds of St James'
Hospital, No.3*
oil on card 25 x 35.5
1998/41

King, Edward R. 1863–1951
Self Portrait
oil on board 60.5 x 50.5
1/9/98

King, Edward R. 1863–1951
Self Portrait
oil on board 60.5 x 50.5
2/9/98

King, Edward R. 1863–1951
Sunset with Poplar Trees
oil on card 25.2 x 30.4
1998/45

King, Edward R. 1863–1951
Trees by a Wall
oil on card 30.2 x 37.8
1998/43

King, Edward R. 1863–1951
Two Buildings, possibly in Southsea
oil on card 30.2 x 37.8
1998/44

King, Gunning 1859–1940
Market Day
oil on canvas 69.5 x 89.5
1959/20

King, Roger
D-Day, 6 June 1944 1984
oil on canvas 59.3 x 90
2004/2960

Kingston, Grace active c.1980s–1990s
*A Second World War RAF Mobile Barrage
Balloon Site*
oil on board 39.1 x 49.4
2004/3075

Knell, William Adolphus 1802–1875
'HMS Asia' Leaving Portsmouth Harbour
oil on canvas 99.5 x 125.5
1945/421

Knell, William Callcott b.1830
Collier Brig Running before the Wind in a Fresh Breeze off Sheerness, Looking from Queensborough c.1860
oil on canvas 34.3 x 54.7
1967/326

Knell, William Callcott b.1830
View of Portsmouth from Cowes, Isle of Wight
oil on canvas 34 x 54.6
1967/327

Kneller, Godfrey (attributed to) 1646–1723
Child with Dog and Squirrel
oil on canvas 108.7 x 85.3
1980/677

Knowles, Justin 1935–2004
Pyramid Abstract 1965
oil on canvas 60 x 50.2
1981/248

Ladbrooke, John Berney 1803–1879
Southsea Castle 1850s
oil on canvas 25 x 35
1966/45

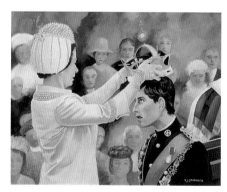

Lancaster, Percy 1878–1951
The Farm Pool
oil on canvas 49.8 x 59.6
1986/177

Lavender, V. J.
Coronation of the Prince of Wales
oil on board 34 x 44
1975/125

Lessore, John b.1939
Garden with Washing Line 1964
oil on board 62 x 45
1973/419

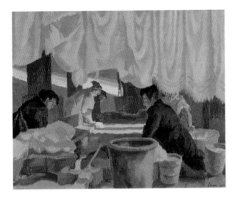

Lessore, Thérèse 1884–1945
Place d'Aix, Marseille 1922
oil on canvas 39.7 x 50
1947/72

Lewis, John Hardwicke 1840–1927
Milton Village c.1900
oil on canvas 39 x 59
1958/7

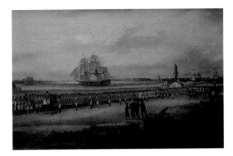

Livesay, Richard 1750–c.1826
Military Review of the Worcestershire Regiment by Major-General Whitelocke on Southsea Common, 1823
oil on canvas 78 x 124
1960/112

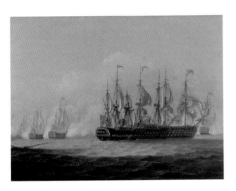

Luny, Thomas 1759–1837
Sir John Jervis and Nelson Defeat the Spaniards off Cape St Vincent 1822
oil on canvas 59.5 x 84.2
1967/325

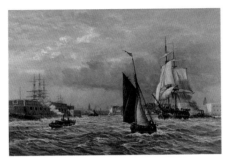

Mason, William Henry active 1858–1917
The Entrance to Portsmouth Harbour 1888
oil on canvas 60 x 90.7
1946/73

Masters, C. H.
Memorial to Those Men of the Portsmouth Borough Police Who Enlisted in the British Army and Who Fell at Ypres
oil on canvas 92 x 67
2004/3464 (P)

Matthews, Peter b.1942
Winter, South Coast (detail)
oil on canvas 65 x 308
1975/182

McCann, O. active 1988–1999
Harry Pound's Yard 1988
oil on board 88.5 x 121.5
1991/85

Miller, Alice A.
A Man of Sorrows
oil on ceramic 18 x 12.9
1972/105

Miller, Alice A.
The 'Madonna della Sedia' (copy after Raphael)
oil on ceramic 12.8 x 7.3
1972/104

Miller, Alice A.
The Virgin Mary
oil on ceramic 12.6 x 7.3
1972/103

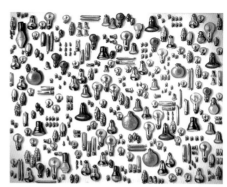

Milroy, Lisa b.1959
Lightbulbs 1991
oil on canvas 203.1 x 259.2
1996/43

Morgan, Henry J. 1839–1917
'HMS Britannia' 1899
oil on canvas 30 x 75
1946/227

Morgan, Henry J. 1839–1917
'HMS Alert', 1875–1876
oil on canvas 34.5 x 79.4
1946/230

Morgan, Henry J. 1839–1917
'HMS Aurora', 1863–1867
oil on canvas 29 x 74.5
1946/228

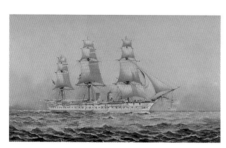

Morgan, Henry J. 1839–1917
'HMS Boadicea', 1892–1894
oil on canvas 34 x 59
1946/233

Morgan, Henry J. 1839–1917
'HMS Bonaventure', 1894–1895
oil on canvas 35 x 59.2
1946/234

Morgan, Henry J. 1839–1917
'HMS Comus', 1899
oil on canvas 29.8 x 75
1946/237

Morgan, Henry J. 1839–1917
'HMS Fox', 1896–1898
oil on canvas 34 x 59
1946/235

Morgan, Henry J. 1839–1917
'HMS Hercules', 1869–1870
oil on canvas 34 x 59.5
1946/229

Morgan, Henry J. 1839–1917
'HMS Penelope', 1885–1887
oil on canvas 34 x 59
1946/231

Morgan, Henry J. 1839–1917
'HMS Trafalgar', 1898
oil on canvas 34 x 59.5 (E)
1946/236

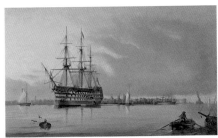

Morgan, Henry J. 1839–1917
'HMS Victory', 1862
oil on canvas 34 x 59 (E)
1946/226

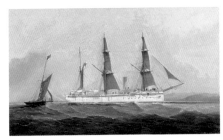

Morgan, Henry J. 1839–1917
'HMS Wanderer', 1887–1891
oil on canvas 35 x 60
1946/232

Munch, Bernard b.1921
Ombrage
oil on paper 30 x 23
AA88

O'Connor, Kevin b.1939
Polar
acrylic on canvas 184 x 184.4
1977/740

Olsson, Albert Julius 1864–1942
Waves Breaking on the Shore
oil on canvas 121.5 x 151.5
1957/139

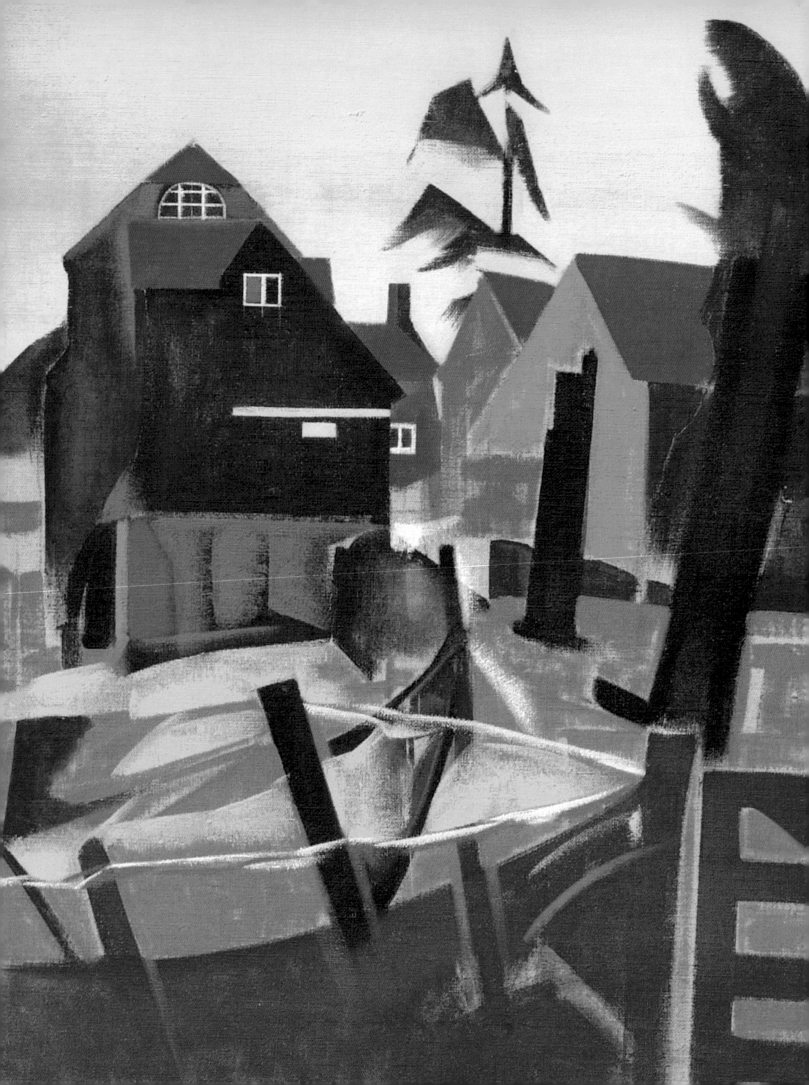

Orsborn, John b.1932
Deep Landscape c.1969
oil on canvas 91 x 121
2003/2547

Orsborn, John b.1932
Medusa c.1971
oil on canvas 115 x 115.6
1981/298

Palmer, Garrick b.1933
Victoria Park, Portsmouth 1956
oil on board 44.2 x 54.2
1956/181

Palmer, Garrick b.1933
The Camber 1966
acrylic on paper 30 x 50.5
1968/69

Palmer, Garrick b.1933
Circular Forms No.18 1972
acrylic on card 53.3 x 76.2
1972/434

Palmer, Garrick b.1933
Circular Form No.14
acrylic on canvas 125.2 x 96
1972/111

Palmer, Garrick b.1933
Standing Form No.11
acrylic on card 44 x 59.2
1972/110

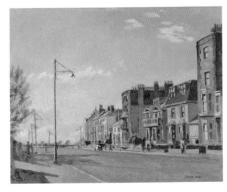

Pare, David 1911–1996
Clarence Parade c.1950
oil on canvas 39 x 49.5
1991/189

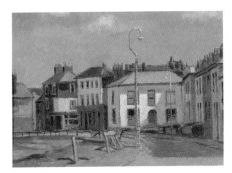

Pare, David 1911–1996
Norfolk Street, 1952
oil on canvas 23 x 34
1953/102

Facing page: Barrett, Maryan E., active 1950–1985, *View of Buildings* (detail), c.1985, Hampshire County Council
Museums Service (p. 271)

Pascoe, Debra b.1956
Footballers 1978
oil on canvas 49.5 x 38.2
SS22945

Pasmore, Victor 1909–1998
Linear Motif 1961
oil on board 69 x 79
1974/265

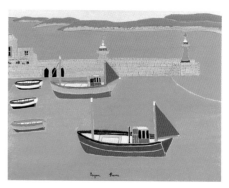

Pearce, Bryan 1929–2007
St Ives from Martins 1962
oil on board 60 x 80
1973/423

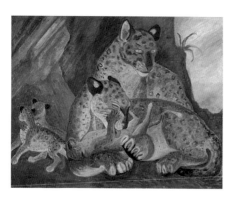

Pissarro, Orovida Camille 1893–1968
Leopard and Family 1958
oil on canvas 68.5 x 89
1973/424

Poate, Richard active 1840s–1870s
Thomas Slade 1853
oil on canvas 76.5 x 63
1945/395/5

Poate, Richard active 1840s–1870s
*Doctor W. C. Engledue, Chairman at the
Banquet Held in September 1856 to Welcome
Home Other Ranks from the (…)* 1856
oil on canvas 57.9 x 83
1959/2

Poate, Richard active 1840s–1870s
*Thomas Batchelor, Treasurer of the Beneficial
Society* 1861
oil on canvas 94 x 78.8
1979/679

Poate, Richard (attributed to)
active 1840s–1870s
*Mr Sergeant Gaselee, MP for Portsmouth
(1865–1868)*
oil on canvas 76.5 x 63.8
1945/395/7

Poate, Richard (attributed to)
active 1840s–1870s
Thomas Batchelor
oil on canvas 90 x 73.5
1945/395/1

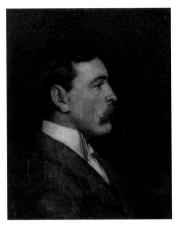

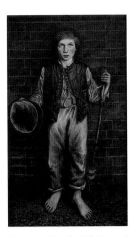

Poole, George Augustus 1861–1932
Benjamin Haughton (1865–1924)
oil on canvas 52.5 x 43.5
1977/450

Proctor, Frederick J. active 1879–1945
'A copper, please' 1879
oil on canvas 90 x 52
1960/84

Proctor, Frederick J. active 1879–1945
The Spirit that Won the War, 1914–1918 1926
oil on canvas 86 x 112
1945/381

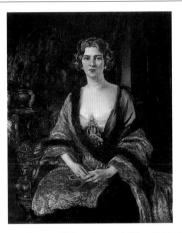

Proctor, Frederick J. active 1879–1945
Gala Press Gang, 1798
oil on canvas 89.5 x 181.3
1945/382

Ranken, William Bruce Ellis 1881–1941
Lady D'Erlanger c.1910
oil on canvas 127 x 100.6
1980/678

Ranken, William Bruce Ellis 1881–1941
Mr and Mrs John V. Templeton 1935
oil on canvas 141.3 x 182.3
1946/223

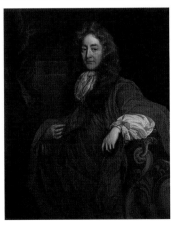

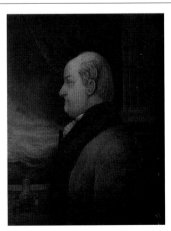

Richards, Ceri Geraldus 1903–1971
Piano 1934
oil on wood 21.5 x 28
1979/1203

Riley, John (attributed to) 1646–1691
Sir Josiah Child, Bt, MP (1630–1699)
oil on canvas 123.6 x 100.5
2000/439

Robbins, W. H.
Sir John Carter
oil on canvas 89 x 69
1945/395/2

Robins, E. active 1882–1902
The Green Post and Boundary Stone at North End 1882
oil on canvas 34 x 57.5
1962/126

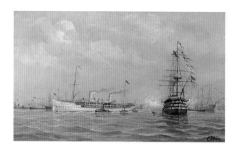

Robins, E. active 1882–1902
Shipping in Portsmouth Harbour 1890s
oil on canvas 29 x 49
1945/476

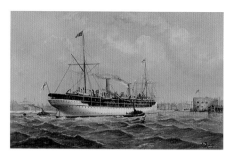

Robins, E. active 1882–1902
'SS Ophir' Entering Portsmouth Harbour
1895–1901
oil on canvas 29.5 x 49.5
1957/124

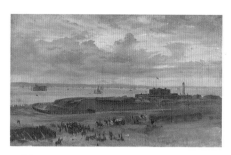

Robins, E. active 1882–1902
Southsea Castle from the East 1900
oil on canvas 46 x 76
1970/430

Robins, E. active 1882–1902
View of the Dockyard and Harbour Looking North 1902
oil on canvas 48.5 x 90
1957/123

Robins, E. active 1882–1902
King George's Gate (Quay Gate)
oil on board 21.6 x 27.4
2005/1250

Robins, E. active 1882–1902
Portchester Castle
oil on board 21 x 33
1955/28

Robins, E. active 1882–1902
'The Old George', London Road, Portsdown
oil on canvas 30 x 41
1976/112

Robins, E. active 1882–1902
'The Old George' Inn, Portsdown Hill
oil on board 14 x 24.5
1981/258

Robins, E. (attributed to)
Pembroke Road Seen through the Defences
oil on canvas 21 x 27
1974/1225

Robins, Henry 1820–1892
Wreck of 'HMS Eurydice' Towed into Portsmouth Harbour, 1 September 1878
oil on canvas 76.2 x 166.5
1974/517

Sainsbury, Timothy b.1935
Under the Outlet 1972
oil on board 122.5 x 89.8
1981/300

Sainsbury, Timothy b.1935
Sacrificial Head
oil on board 122 x 122
1973/78

Saül, Charles b.1943
Boys Swimming with Shark on Coast of Haiti
acrylic on board 49.5 x 60.3
SS22944

Scott, S. J.
Panorama of Portsmouth 1967
oil on board 40.4 x 203
1981/424

Scott, William George 1913–1989
Girl and Blue Table (recto) 1938
oil on canvas 51 x 60.7
1968/104/1

Scott, William George 1913–1989
Breton Village (verso of Girl and Blue Table)
c.1938
oil on canvas 51 x 60.7
1968/104/2

Shaw, Geoff 1892–1970
D-Day, 6 June 1944
oil on canvas 49.5 x 90.3
2003/2020

Shayer, William 1788–1879
Fisher Folk at Brading, Isle of Wight
oil on canvas 67.2 x 88.4
1969/149

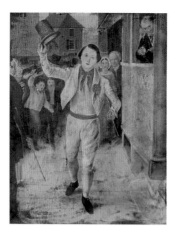

Sheaf, Henry S.
A Walking Race 1839
oil on board 42.5 x 33.5
1968/202

Sheaf, Henry S.
John Pounds Teaching Children in his Workshop
oil on canvas 28 x 26
1945/422

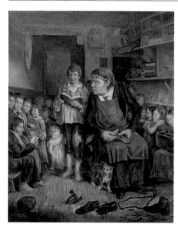

Sheaf, Henry S.
John Pounds Teaching Poor Children
oil on board 48 x 39
2004/822

Shepherd, Thomas Hosmer 1792–1864
View of Southsea Common 1850s
oil on canvas 30.3 x 91.3
1977/275

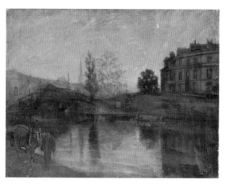

Sickert, Bernard 1863–1932
A Canal Scene
oil on canvas 71 x 91
1979/683

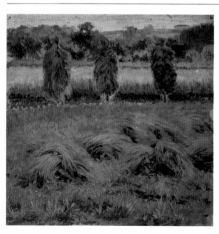

Sickert, Johann Jurgen 1803–1864
Hay Stooks in a Meadow
oil on canvas 34.5 x 35.3
1979/850/1

Sickert, Walter Richard 1860–1942
The Belgian Cocottes (Jeanne et Hélène Dumont)
oil on canvas 49.7 x 39.7
1973/935

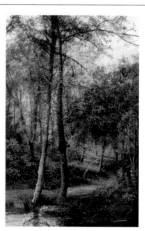

Sinclair, G.
Woodland Path
oil on canvas 74.5 x 49.5
1997/1477

Sinclair, G.
Woodland Stream
oil on canvas 74.5 x 49.5
1997/1476

Smith, Norman
D-Day, Normandy, Lion-sur-Mer
oil on board 59 x 83.5
2004/2966

Smith, Smith 1714–1776
Wooded Landscape
oil on wood 32.5 x 43
1971/8

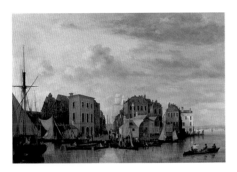

Smyth, William Henry (Admiral)
1788–1865
On the Point, Portsmouth
oil on canvas 83.3 x 121.4
1965/148

Snape, Martin 1853–1930
Portchester Castle
oil on board 19.2 x 31.6
2005/1251

Somerville, Howard 1873–1952
The Chinese Fan
oil on canvas 74.5 x 62
1959/25

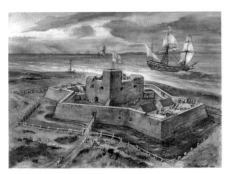

Sorrell, Alan 1904–1974
Southsea Castle, 1578 1970
acrylic on paper 44.4 x 61.7
1971/327

Sparrow, W. G. (Lieutenant Colonel)
Portchester Castle
oil on canvas 30 x 39.5
1958/56

Stanfield, George Clarkson 1828–1878
Coastal Scene
oil on canvas 62.5 x 76.5
1973/704

Steele, Jeffrey b.1931
SG1 27 c.1972
acrylic on canvas 152.7 x 152.5
1974/202

Stephenson, H. W.
'HMS Trincomalee', 1817
oil on board 49 x 59.5
1975/124

Stones, Alan b.1947
Portsmouth 1988
oil on canvas 120 x 151
2005/843

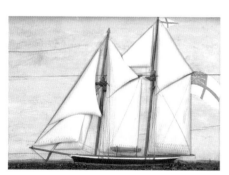

Terry, George Richard
Relief of a Schooner against a Background of the Sea 1870s
oil on wood 34 x 53
1992/186

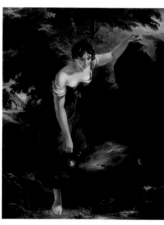

Thomson, Henry 1773–1843
Girl at a Spring (Nature's Fountain)
oil on canvas 177.8 x 145.8
1948/300

Thorn, John active 1838–1864
On the Mole
oil on canvas 59 x 22.5
1997/1438

Thorn, John active 1838–1864
The Cornfield
oil on canvas 59 x 22.5
1997/1437

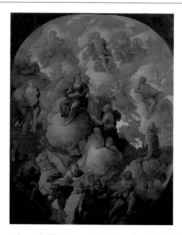

Thornhill, James (circle of) 1675–1734
The Gods on Mount Olympus
oil on canvas 127.7 x 101.5
1975/211

Tindle, David b.1932
Still Life with Gramophone
oil on canvas 56 x 65.5
AA231

Todd, D. C.
The Construction of the New Civic Offices and Central Library, Portsmouth 1974
oil on board 39 x 50
1998/430

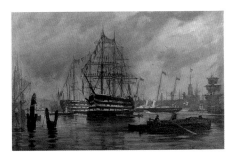

Tollemache, Duff 1859–1936
Portsmouth Harbour from Gosport
oil on canvas 66.9 x 104.5
1959/80

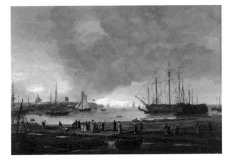

Turner, William 1789–1862
Portsmouth from Gosport
oil on board 69 x 104.5
1978/692

Tutill, George
'Defence Not Defiance' 1896
oil on silk 275.7 x 294.5
1974/1228/1

Tutill, George
'United We Stand, Divided We Fall' 1896
oil on silk 275.7 x 294.5
1974/1228/2

Tuttle, Tony active c.1971–1973
Circles c.1971
acrylic on canvas 101.5 x 101.3
2003/2549

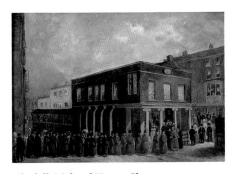

**Ubsdell, Richard Henry Clements
(attributed to)** 1813–1887
The Town Hall, High Street, with Aldermen and Councillors of the (…) after 1800
oil on board 21 x 32
1946/63

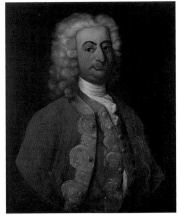

unknown artist
Lieutenant General Campbell, Military Governor of Portsmouth (1731–1737) c.1734
oil on canvas 74.5 x 62.5
1963/17

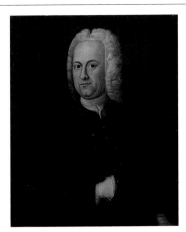

unknown artist
John Hewett of Crofton c.1740
oil on canvas 76 x 63.5
1957/142

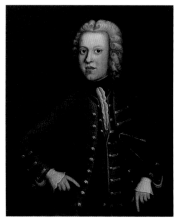

unknown artist
John Hewett II of Purbooke 1740s
oil on canvas 76.7 x 63.5
1957/143

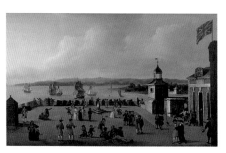

unknown artist early-mid 18th C
The Saluting Platform, Portsmouth in the Reign of Queen Anne
oil on canvas 53 x 90
1974/1233

unknown artist 18th C
Inn and Windmill
oil on canvas 42 x 59.5
1979/722

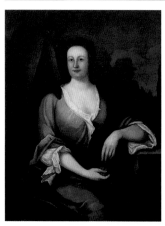

unknown artist mid-late 18th C
Susanna Carter, Wife of Sir John Carter
oil on canvas 122 x 95.4
1958/14

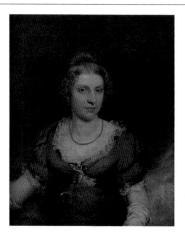

unknown artist
Portrait of a Lady c.1800
oil on canvas 74.5 x 61.8
1997/1468

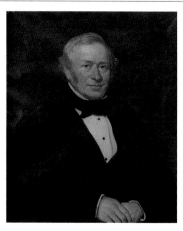

unknown artist
Portrait of an Unknown Gentleman c.1800
oil on canvas 74.3 x 61.7
1997/1467

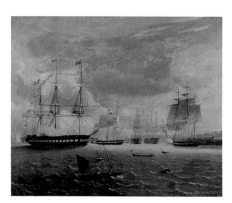

unknown artist
The 'USS Constitution' Entering Portsmouth Harbour 1819
oil on canvas 62.7 x 75
2003/988

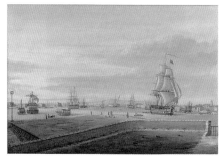

unknown artist
View of Portsmouth Harbour Looking North from Fort Blockhouse c.1820
oil on canvas 44.5 x 67
1994/547

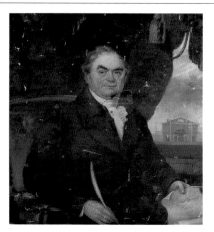

unknown artist
T. Porter Esq. c.1836
oil on canvas 89.5 x 74.5
1945/395/3

Facing page: Christie, Tessa, *Interior of Winchester Cathedral* (detail), c.1970, Winchester Museums Service, (p. 322)

unknown artist
Frigate Entering Portsmouth Harbour 1840
oil on canvas 91 x 123.5
1969/497

unknown artist
William Green of Hollam 1840s
oil on canvas 90 x 70
1957/145

unknown artist
Elizabeth Green, née Hewett c.1842
oil on canvas 91 x 71
1957/144

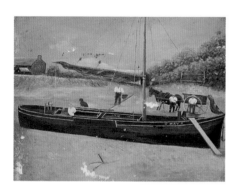

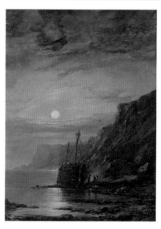

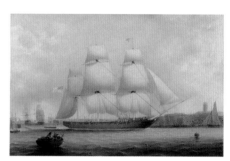

unknown artist
Old Goldsmith Quay, Milton Locks 1870
oil on wood 22.9 x 30.3
1954/30

unknown artist
Moonlit Coast and Wreckers 1871
oil on wood 37 x 27.4
1997/1465

unknown artist early-mid 19th C
*A Royal Naval Vessel Leaving Portsmouth
Harbour*
oil on canvas 44 x 67
1981/283

unknown artist early-mid 19th C
E. Marvin
oil on canvas 76 x 63
1945/395/6

unknown artist 19th C
Coastal Scene
oil on canvas 32 x 75
1945/424

unknown artist 19th C
Masonic Banner Centre
oil on canvas 135.5 x 132
2005/1809/1

unknown artist 19th C
Masonic Banner Centre
oil on canvas 135.5 x 132
2005/1809/2

unknown artist mid-late 19th C
River Estuary and a Castle
oil on canvas 17.5 x 23
1970/107

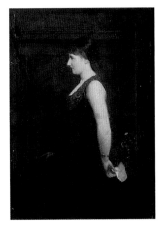

unknown artist late 19th C
Lily Langtry (possibly Dame Clara Butt)
oil on canvas 33.5 x 23.8
1997/1407

unknown artist
*Independent Order of Oddfellows Banner:
'Independent Order of Oddfellows M. U.'*
c.1900
oil on silk 236.5 x 268.5
1977/277/1

unknown artist
*Independent Order of Oddfellows Banner:
'Portsmouth District, Established 1861'* c.1900
oil on silk 236.5 x 268.5
1977/277/2

unknown artist
*London Road Baptist Band of Hope,
Portsmouth Banner: 'God Save the Children'*
c.1900
oil on silk 142 x 181.6
2006/472

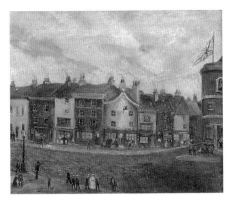

unknown artist
*Queen's Road, Portsea at the Junction with St
James' Street* c.1900
oil on canvas 24.5 x 29.5
1960/76

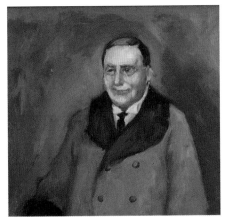

unknown artist
*Charles Augustus Milverton, 'The Worst Man
in London' and 'The King of all the
Blackmailers'* c.1960
oil on board 28.3 x 31.1
2004/1404

unknown artist
*A British Army Officer, Possibly a Governor of
Portsmouth*
oil on canvas 121 x 91
1964/573

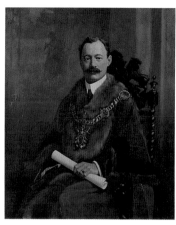

unknown artist
A Mayor of Portsmouth, possibly J. E. Pink
oil on canvas 59.5 x 49.5
1968/357

unknown artist
A Member of the Beneficial Society
oil on canvas 91.2 x 67.8
1979/686

unknown artist
A Seventeenth Century Soldier, from Buckingham House, Portsmouth
oil on wood 34.3 x 12.5
1991/172/3

unknown artist
A Seventeenth Century Soldier, from Buckingham House, Portsmouth
oil on wood 34 x 12.5
1991/172/4

unknown artist
Alderman G. E. Kent, Mayor of Portsmouth (1870–1900)
oil on canvas 89 x 69
1959/77

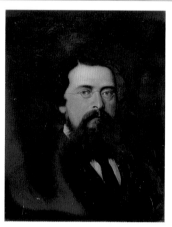

unknown artist
Alderman Richard John Murrell
oil on canvas 57 x 43.5
1959/19

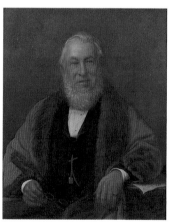

unknown artist
Alderman Ridoutt
oil on canvas 27 x 22
1964/602

unknown artist
Battle of Southsea
oil on paper on board 202
1978/277

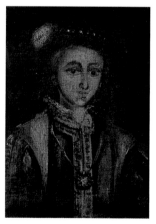

unknown artist
Edward VI (1537–1553)
oil on board 30 x 21.5
1970/403

unknown artist
Entrance to the Camber
oil on canvas 49.5 x 64
1945/431

unknown artist
Fareham Creek, Hampshire
oil on canvas 24 x 34.5
1975/121

unknown artist
First Portsmouth Theatre
oil on canvas 15 x 23
1958/38

unknown artist
Great Salterns Farm, 1851
oil on canvas 36.5 x 52
1999/598

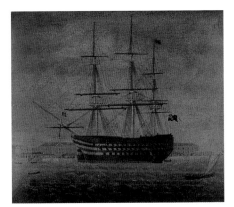

unknown artist
*'HMS Victory' at Moorings in Portsmouth
Harbour*
oil on board 36.5 x 40.5
1971/409

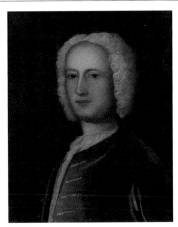

unknown artist
John Carter
oil on canvas 59.5 x 48.5
1958/13

unknown artist
John Pounds
oil on board 45.5 x 58
1955/42

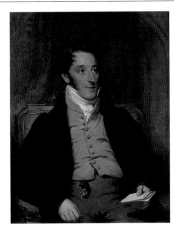

unknown artist
John Spice Hulbert
oil on canvas 90 x 69.8
1981/459

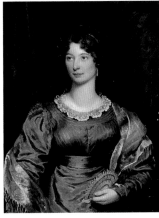

unknown artist
Mary A. Spice Hulbert
oil on canvas 90 x 69.5
1981/460

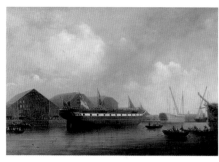

unknown artist
Launch of the Steam Frigate 'HMS Dauntless'
oil on canvas 30.5 x 46
1964/252

unknown artist
Mill by the Water's Edge
oil on canvas 25 x 41
1964/653

unknown artist
Milton Park, 1855
oil on canvas 26.5 x 40
1953/93

unknown artist
Mythological Subject
oil on canvas 120.5 x 126.3
1997/1256

unknown artist
Pembroke Road Seen through the Defences
oil on canvas 50 x 65
1980/682

unknown artist
Portsmouth Harbour, 1850–1900
oil on board 30.5 x 45.5
2005/1436

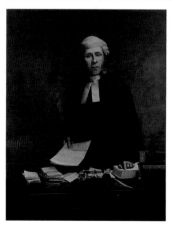

unknown artist
R. W. Ford, Solicitor and Clerk of the Peace,
Portsmouth
oil on canvas 142 x 112
1945/439

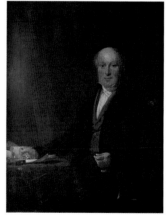

unknown artist
Robert Lawson
oil on canvas 49 x 38
1949/12

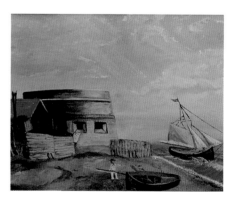

unknown artist
Round Tower
oil on board 12.8 x 16.7
1987/397

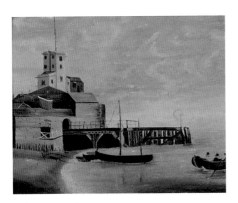

unknown artist
Square Tower
oil on board 13.2 x 16.8
1987/396

unknown artist
Sir Arthur Conan Doyle (1859–1930)
oil on canvas 54.6 x 39.4
2004/1329

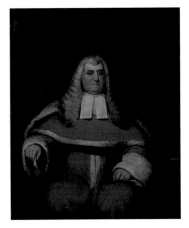

unknown artist
Sir Stephen Gaselee (1882–1943)
oil on canvas 43.2 x 35
1945/395/4

unknown artist
St Mary's Church, Kingston
oil on canvas 21 x 26.5
1964/515

unknown artist
St Mary's Church, Kingston, 1843
oil on board 11.8 x 17.2 (E)
1974/1247

unknown artist
St Mary's Church, Kingston between 1844 and 1887
oil on board 11.8 x 17.5 (E)
1974/1248

unknown artist
The First Semaphore on Southsea Beach, 1795
oil on board 21 x 29
1946/64

unknown artist
The 'Nut' Bar at the Keppel's Head Hotel, Portsmouth, c.1955
oil on board 29.5 x 50
2001/567

unknown artist
The Old Curiosity Shop
oil on canvas 23 x 29.5
2005/1588

unknown artist
The Opening of Fareham Railway Viaduct
oil on board 24.5 x 34.5
1975/120

unknown artist
Theodore Jacobson (d.1772), Architect
oil on canvas 62.6 x 51.2
1973/1057

unknown artist
*View of the Waterfront on the Point from the
Round Tower to the Still and West Public
House*
oil on canvas 49 x 74
1962/19

unknown artist
William Panlet, Former Govenor of Portsmouth
oil on panel 40 x 28.6
1958/130

unknown artist
William Treadgold
oil on paper 57.8 x 45.6
1057A/1/123

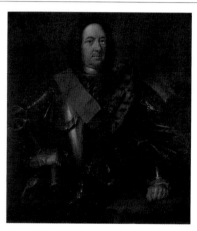

Van de Myer, F. (attributed to)
*Sir Philip Honeywood, Military Governor of
Portsmouth (1740–1752)*
oil on canvas 121 x 111
1969/426

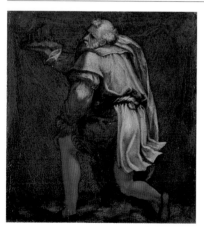

Verdi, Francesco Ubertini (attributed to)
1494–1557
Donor Figure
oil on wood 29 x 27
1975/210/1

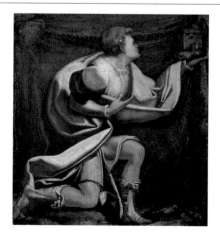

Verdi, Francesco Ubertini (attributed to)
1494–1557
Donor Figure
oil on wood 29 x 27
1975/210/2

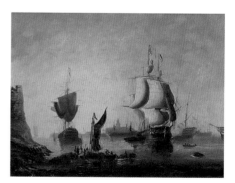

Vernet, Claude-Joseph (attributed to) 1714–
1789
View of a Harbour, possibly Portsmouth
oil on canvas 28 x 38.5
1961/95

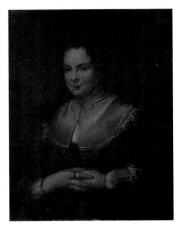

Verspronck, Johannes Cornelisz.
(attributed to) c.1606–1662
Portrait of a Lady
oil on canvas 74 x 59
1945/434

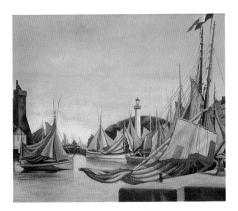

Wadsworth, Edward Alexander 1889–1949
La Rochelle c.1923
tempera on wood & canvas 50 x 59.5
1978/670

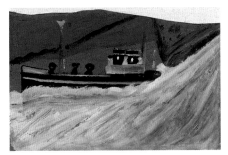

Wallis, Alfred 1855–1942
Boat with Figures 1930–1940
oil on board 22 x 35.7
1973/430

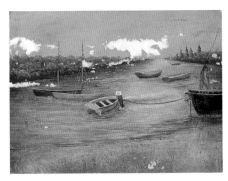

Warburton, N.
Old Canal and Watch House in Trees 1870
oil on wood 22.8 x 30.7
1954/31

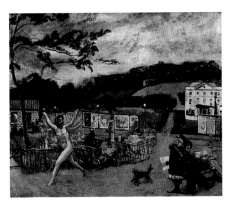

Weight, Carel Victor Morlais 1908–1997
Two Lovers Interrupted by a Sprite c.1938
oil on canvas 62 x 74.6
1974/203

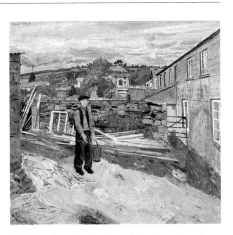

Weight, Carel Victor Morlais 1908–1997
Timber Yard
oil on canvas 54 x 59.6
1973/431

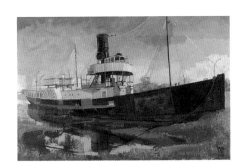

Werge-Hartley, Alan b.1931
The 'Princess Elizabeth'
oil on canvas 60 x 91.5
AA254

Williams, J.
Gad's Hill Place, near Rochester
oil on canvas 24 x 31.5
2005/1589

Wragg, Gary b.1946
Hetty's Painting 1978
oil & acrylic on canvas 177.7 x 169
1986/170

Wright, Peter b.1932
Flower in a Landscape 1965
oil on canvas 79 x 127
1973/432

Wright, Peter b.1932
Dorset Landscape
acrylic on paper 25 x 31.5
AA331

Wyllie, Charles William 1859–1923
Bay of Ambleteuse
oil on board 19 x 35.9
1956/247

Wyllie, William Lionel 1851–1931
A Coastal Scene at Sunset 1872
oil on paper 10.8 x 16.2
1972/426

Wyllie, William Lionel 1851–1931
Old Hulks, Portsmouth 1880
oil on canvas 50 x 75
1964/294

Wyllie, William Lionel 1851–1931
A Castle by a Lake
oil on paper 7.3 x 14.3
1972/425

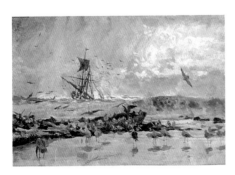

Wyllie, William Lionel 1851–1931
A Ship and Seabirds near the Coast
oil on paper 15.6 x 22.2
1972/427

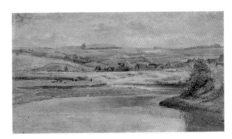

Wyllie, William Lionel 1851–1931
Countryside
oil on paper 13.1 x 23.6
1972/416

Wynter, Bryan 1915–1975
Rilla 1964
oil on canvas 100 x 80
1973/433

Facing page: Canty, Jack, c.1910–2002, *Combat* (detail), 1958, Portsmouth Museums and Records Service, (p. 74)

Zehrer, Rita b.1949
*Abstract** 1998
acrylic on canvas 179.5 x 90
civic office 1

Zehrer, Rita b.1949
*Abstract** 1998
acrylic on canvas 179 x 90
civic office 2

Zehrer, Rita b.1949
*Abstract** 1998
acrylic on canvas 152 x 306
civic office 3

Portsmouth Royal Dockyard Historical Trust

The Portsmouth Royal Dockyard Historical Trust encourages work on all aspects of the Dockyard and is especially concerned with the field of industrial archaeology. The emphasis is therefore on the recording, interpretation, preservation and exhibition of important industrial artefacts and related documents. The Trust defines an industrial artefact as a man-made product employed in the manufacturing process and thus buildings, transport systems and their related equipment all fall within the Trust's purview, as do the working lives of the Dockyard's workforce. An exhibition on the skills and crafts learnt by Dockyard apprentices in their first seven years is on permanent view within the Historic Dockyard.

The paintings shown here form a very small part of the Trust's collection and are not usually on display. The images are all painted by members of the Paint Shop whose job it was to paint insignia, ship's crests and to gild the Royal Yacht, and for the most part they record the Foremen (senior officials) of that particular department.

Brian Patterson, Curator

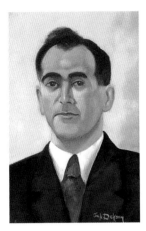

Dickson, Jack
Mr E. A. Rogers, Head of Painters' Shop
(1964–1970)
oil on board 39.4 x 27
2046

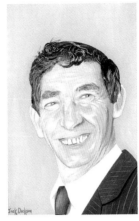

Dickson, Jack
Mr E. G. Bunce, Head of Painters' Shop
(1979–1981)
oil on board 40 x 27
2053

Dickson, Jack
Mr E. R. Goble, Head of Painters' Shop
(1974–1976)
oil on board 40 x 27
2051

Dickson, Jack
Mr F. G. Dominy, Head of Painters' Shop
(1959–1964)
oil on board 40 x 27
2045

Dickson, Jack
Mr H. C. Skeens, Head of Painters' Shop
(1927–1936)
oil on canvas 39.5 x 27
2040

Dickson, Jack
Mr J. E. Quarrington, Head of Painters' Shop
(1981)
oil on canvas 87 x 56.5
2054

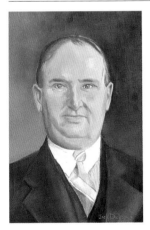

Dickson, Jack
Mr P. V. Jarvis, Head of Painters' Shop (1943–
1949)
oil on board 39.2 x 27
2042

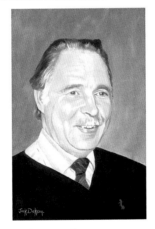

Dickson, Jack
Mr R. D. Rickard, Head of Painters' Shop
(1987)
oil on board 39.5 x 27
2055

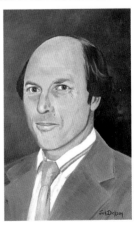

Dickson, Jack
Mr R. W. McLeod, Head of Painters' Shop
(1976–1981)
oil on board 40 x 27
2052

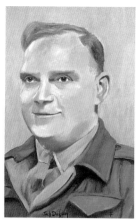

Dickson, Jack
Mr T. E. Skinner, Head of Painters' Shop
(1965–1966)
oil on canvas 39.5 x 26.8
2047

Dickson, Jack
Mr W. G. Gidley, Head of Painters' Shop
(1966–1972)
oil on board 40 x 27
2048

Dickson, Jack (attributed to)
Mr E. Hollingsworth, Head of Painters' Shop
(1972–1974)
oil on canvas 39.5 x 27
2049

Hall, Tom
General Dwight D. Eisenhower (1890–1969)
oil on canvas 44 x 40
1

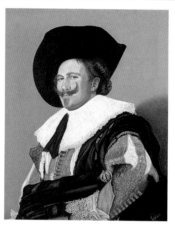

Hall, Tom
The Laughing Cavalier (copy after Frans Hals)
oil on canvas 60 x 48
3475

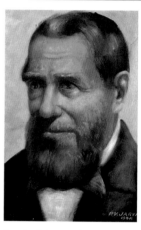

Jarvis, P. V. active 1930–1948
Mr H. Skeens, Head of Painters' Shop
(1859–1866) 1946
oil on board 40 x 27
2033

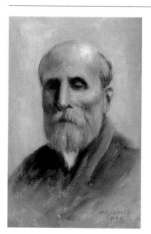

Jarvis, P. V. active 1930–1948
Mr E. J. Lineham, Head of Painters' Shop
(1898–1902) 1948
oil on canvas 39.5 x 27
2037

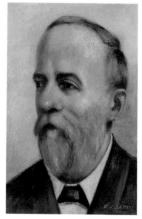

Jarvis, P. V. active 1930–1948
Mr E. Kidd, Head of Painters' Shop
(1902–1910) 1948
oil on canvas 39.5 x 27
2038

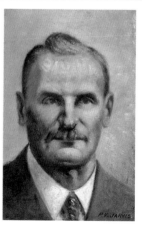

Jarvis, P. V. active 1930–1948
Mr C. B. Mockford, Head of Painters' Shop
(1910–1927)
oil on canvas 40 x 27
3039

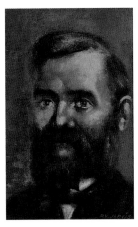

Jarvis, P. V. active 1930–1948
Mr G. Hoile, Head of Painters' Shop
(1866–1881)
oil on canvas 40 x 26.8
2034

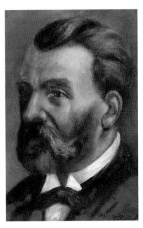

Jarvis, P. V. active 1930–1948
Mr H. C. Skeens, Head of Painters' Shop
(1894–1898)
oil on board 39.4 x 27
2036

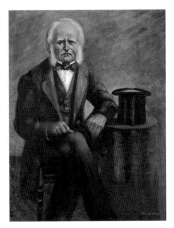

Jarvis, P. V. active 1930–1948
Mr Martin, Head of Painters' Shop
(1948–1959)
oil on canvas 82 x 63.5
2032

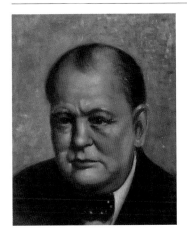

Jarvis, P. V. (attributed to) active 1930–1948
Sir Winston Churchill (1874–1965)
oil on board 57 x 47.5
3471

Johns, M.
Mr G. W. A. Waters, Head of Painters' Shop
(1949–1953)
oil on board 39.5 x 27
2043

unknown artist
*Three Soldiers**
oil on wood 39.5 x 36.8
3657

Royal Marines Museum

The Royal Marines Museum is blessed with not only a large and interesting collection of artwork but also a tremendous building in which to house it. Completed in 1868, the Royal Marine Artillery Barracks at Eastney, Portsmouth, in common with any other military establishment of its type, had an Officer's Mess. This Mess was built and decorated to very high standards and included a large and airy entrance hall with an ornately decorated grand staircase. This led to the Minstrel's Gallery which overlooked the large, lofty Dining Room complete with chandeliers and imposing fireplaces. All of these rooms, and others, have decorative, painted, plasterwork. When, in 1923, the Royal Marine Artillery was combined with the Royal Marine Light Infantry to form the present-day Royal Marines, the building remained unchanged. Many of our paintings were first hung in this very building having been given to, purchased or commissioned by either individual officers or the Mess itself. This building is now ideally suited to displaying the Museum's varied collections – especially its oil paintings, in particular, portraits.

A high proportion of the Museum's collection of oil paintings is on permanent view within these magnificent rooms. They are part of the fabric of the building and certainly provide a dramatic touch to a building that is a very popular choice for wedding receptions, business presentations and other corporate functions and events, as well as being of great interest to our Museum visitors.

Many of the paintings have stories to tell. A very large and imposing painting of Queen Victoria hangs over one of the fireplaces in the Officer's Dining Room. It carries the inscription 'copied from the original of Heinrich Von Angeli by Herman Herkomer, 1887'. Apparently Queen Victoria instructed that this inscription should be added since, upon comparison, it was found that the copy was a better likeness than the original!

Alongside the grand staircase hangs one of only two known equestrian portraits of George III. This was painted by James Northcote (1746–1831), a pupil of and later resident assistant to Sir Joshua Reynolds. A few years ago, thanks to the generous support of the Heritage Lottery and National Art Collections Funds, the Museum was able to acquire, from an auction of works of art belonging to Sir Elton John, a second Northcote portrait. This was painted in 1780–1781, the subject being Lieutenant George Dyer of the Marines, and this now hangs in the Minstrel's Gallery.

Another portrait that hangs in the Minstrel's Gallery is that of Brigadier General F. W. Lumsden, VC, CB, DSO, RMA of the Royal Marine Artillery. This is one of a pair commissioned by the Mess from Helen Donald-Smith in 1920. A man having extraordinary leadership qualities, sense of duty and courage, Lumsden was not only awarded the Victoria Cross, the Distinguished Service Order on four occasions and was appointed Commander of the Bath, but he was also four times 'Mentioned in Despatches'. This painting links well to the series of oil portraits of all Royal Marines who have been awarded the Victoria Cross. These are displayed, above their medal groups, in our magnificent Medal Room. An additional link is to the Lumsden Memorial, which features

prominently in the Museum's Garden of Remembrance and which, each year, becomes the focal point of the Service of Remembrance.

Portraits are only a part of the Museum's collection of oil paintings. Other subjects include battle scenes, ceremonies, ships and exploration with coverage of the eighteenth, nineteenth and twentieth centuries. One of the important aspects of our art collection is that we are able to see events and places before the time of photography and, through a certain group of artists, to see it with an expectancy of fact and accuracy. This group consists of the serving officers and men of the Marines and Royal Marines who sketched, drew and painted, admittedly with varying degrees of talent, what they saw and what they experienced. Whilst the work of the war artist gives the best of both worlds as, for example, the work of Leslie Cole shows, we are as equally proud of the work of the men of our Corps who have provided snapshots from their lives.

Whilst it is very true that 'every picture tells a story', it can be said that there is also a story to tell about every picture. We have provided but a few examples in this short introduction.

The Royal Marines Museum tells the history of one of the world's greatest military units. This is not an idle boast. The men of the current Royal Marines, like their forebears, do not boast, they simply let their actions, their professionalism and their tolerance, both in times of peace and war, speak for themselves – as any of us who have watched their activities in recent times will be aware. We are grateful to the Public Catalogue Foundation and to the Museum's Curatorial staff and volunteers for helping to create this opportunity to show that military museums, as well as those that they represent, are not just about war and death, guns and brutality; they are about people who are as highly trained in providing aid and keeping the peace as they are in winning wars. They also enjoy sport, family life and, as any visit to a Mess will show – art. As has been said on a number of occasions, 'politicians – not soldiers – start wars'. It is the soldiers, or in our case the Royal Marines, who have to win the war and find the peace. They, as much as anyone else, deserve their place in the world to be encapsulated in art.

John Ambler, Pictures and Photographs Librarian

Alleyne, Francis 1750–1815
Portrait of a Lady 1780–1785
oil on canvas 37 x 30
202/98b

Alleyne, Francis 1750–1815
Portrait of an Officer of the Battalion Company of Marines 1780–1785
oil on canvas 37 x 30
202/98a

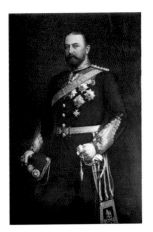

Bambridge, Arthur L. active c.1890–1895
His Royal Highness Alfred Ernest Albert, Duke of Saxe Coburg and Gotha, Duke of Edinburgh (1874–1899), KG, GCB, Admiral (…) c.1890
oil on canvas 152 x 98
010/74

Beer, Percy active 1961–1962
*Lieutenant George Dare Dowell, VC
(1831–1910), Royal Marine Artillery* 1961
oil on board 60 x 50
P/11/14

Beer, Percy active 1961–1962
*Major Francis John William Harvey, VC
(1873–1916), Royal Marine Light Infantry*
oil on board 60 x 50
P/11/21

Beer, Percy (attributed to) active 1961–1962
*Gunner Thomas Wilkinson, VC, Royal Marine
Artillery* 1961
oil on board 60 x 50
P/11/3

Beer, Percy (attributed to) active 1961–1962
*Corporal Thomas Peck Hunter, VC
(1923–1945), Royal Marines* 1962
oil on board 60 x 50
P/11/11

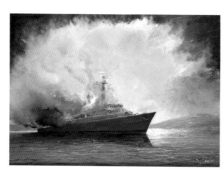

Beetham, Joe active 1982–c.1983
*'HMS Antelope' Explodes off Port San Carlos,
23 May 1982* 1982
oil on canvas 56 x 79
279/82a

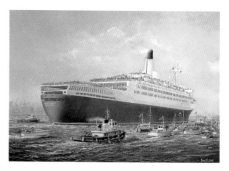

Beetham, Joe active 1982–c.1983
*'Queen Elizabeth II' Returns to Southampton
with Troops from the Falklands* 1982
oil on canvas 57 x 79
348/82f

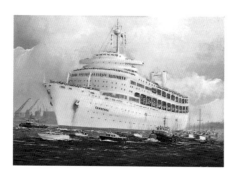

Beetham, Joe active 1982–c.1983
*'SS Canberra' Returns to Southampton, 11 July
1982* 1982
oil on canvas 52 x 71
279/82e

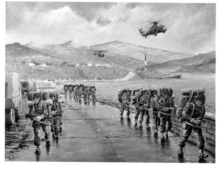

Beetham, Joe active 1982–c.1983
*45th Commanndo Entering Stanley, with Two
Sisters and Mount Kent in the Background, 15
June 1982* 1982
oil on canvas 51.5 x 71.5
348/82h

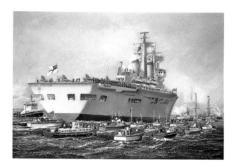

Beetham, Joe active 1982–c.1983
*'HMS Invincible' Arrives Home, Portsmouth,
17 September 1982* c.1982
oil on canvas 57.5 x 79.5
348/82a

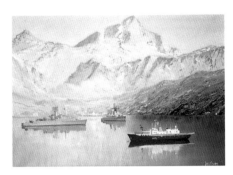

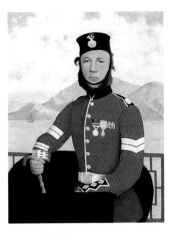

Beetham, Joe active 1982–c.1983
*'HMS Endurance', 'Plymouth' and 'Antrim' at
Grytviken, South Georgia* c.1983
oil on canvas 53 x 78
348/82c

Brown, R. H.
*Corporal William Brown (1820–1899), Royal
Marines (1837–1855), Royal Marine Light
Infantry (1855–1859)* c.1983
oil on hardboard 40 x 30.5
147/82

Cairns, John
On Parade, Singapore 1967
oil on canvas 76.5 x 132
264/05

Chenoweth, Avery
*Lieutenant Colonel Douglas B. Drysdale, Royal
Marines, Commanding 41st Independent
Commando RM in Action, Korea, 1950* 1952
oil on canvas 97 x 84
88/02t

Cole, Leslie 1910–1976
*Royal Marine Commando and Paratrooper
Stretcher-Bearers in Normandy, 1944*
oil on canvas 62 x 92
88/02o

Collinson, Basil
'HMS Repulse', Sunk 10 December 1941
oil on wood 46 x 61
72/95a

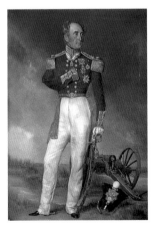

Cunliffe, David active 1826–1855
*General Sir Charles Menzies, KCB, KH, KTS
(1783–1866)*
oil on canvas 54 x 38
290/05

Daubrawa, Henry de active 1825–1861
The Royal Marines 1850
oil on canvas 36 x 33
008/71

Donald-Smith, Helen active 1880–1930
*Brigadier General F. W. Lumsden, VC, CB,
DSO, RMA* 1920
oil on canvas 123 x 83
286/05

Donald-Smith, Helen active 1880–1930
Major General Sir Archibald Paris, KCB
(d.1937) 1920
oil on canvas 127 x 86
287/05

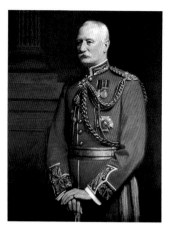

Dujon, J. F. Harrison
General Sir William Thompson Adair, KCB,
Deputy Adjutant General (1907–1911) c.1910
oil on canvas 100 x 78
275/79e

Duke, Dave
Royal Marines on Parade, Malta 1960
oil on canvas 76.5 x 115
265/05

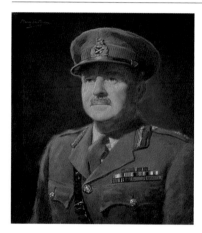

Eastman, Mary active c.1932–1979
Major General A. M. Craig, CB, OBE (1944),
Colonel Commandant, Chatham (1942–1944)
c.1944
oil on canvas 61.5 x 51
132/74

Evans, Lucy active 2000–2001
Team Polar, 2000 2001
oil on canvas 61 x 92
46/01a

Evans, Lucy active 2000–2001
Team Polar, 2000 2001
oil on canvas 25.5 x 30
46/01b

Fuchs, Emil 1866–1929
Edward VII (1841–1910) 1904
oil on canvas 110 x 90
006/74

Gardner, Maurice
Landing Craft Gun 14
oil on canvas 35 x 68
289/05

Gilroy, John M. 1898–1985
The Earl Mountbatten of Burma (1900–1979),
KG, DSO, Life Colonel Commandant Royal
Marines (1965–1979) 1978
oil on hardboard 114 x 77
309/78

Facing page: Allen, William Herbert, 1863–1943, *Market Street, Lucerne* (detail), Hampshire County Council
Museums Service (p. 259)

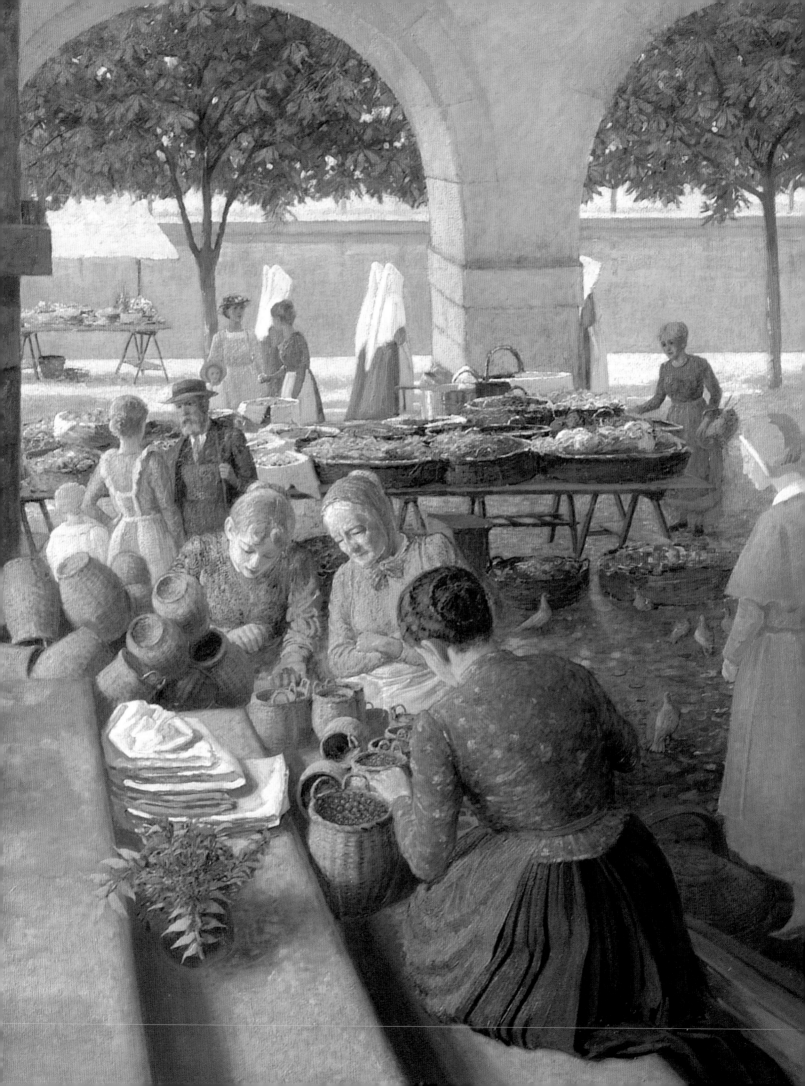

Glazebrook, Hugh de Twenebrokes
1855–1937
His Royal Highness George Frederick Ernest Albert Prince of Wales (…) 1908
oil on canvas 154 x 114
011/74

Goldsmith, W. J. (Major RM)
active 1968–1978
Captain Lewis Stratford Tollemache Halliday, VC (1870–1966), Royal Marine (…) 1968
oil on canvas 60 x 50
288/05

Goldsmith, W. J. (Major RM)
active 1968–1978
Lieutenant H. M. A. Day, Royal Marines Light Infantry, 1918 1978
oil on board 20 x 14
189/78

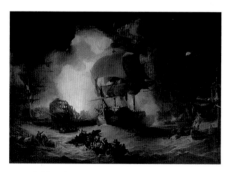

Goodall, John Edward active 1877–1911
The Battle of the Nile c.1903
oil on canvas 190 x 280
19/74

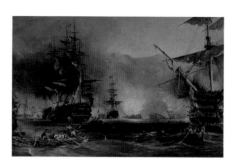

Goodall, John Edward active 1877–1911
The Bombardment of Algiers, 1816 (after George Chambers) c.1903
oil on canvas 230 x 255
20/74

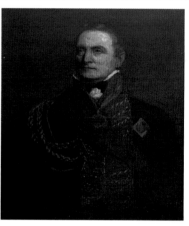

Graves
Major General Thomas Benjamin Adair (served 1794–1843) (after John Jackson) 1913
oil on canvas 106 x 84
275/79c

Halford, J.
Royal Marines Firing a .303 Vickers Machine-Gun on Loan to 'NP8901' from Falkland Islands Defence Force, Back of Wireless (…) 2004
oil on canvas 47 x 63
219/04

Herkomer, Herman 1863–1935
Queen Victoria (1819–1901) (after Heinrich von Angeli) 1887
oil on canvas 340 x 170
009/74

Hill, William
Racing the Storm
oil on canvas 76 x 62
88/02s

Kelly, Robert George 1822–1910
The Boats 'HM Frigates Carysfort' and 'Zebra'
with 50 Royal Marines, Commanded by
Lieutenant R. H. Harrison, Royal (…) 1851
oil on canvas 30 x 44
P/11/38

Lawrence, Thomas 1769–1830
(attributed to) & Morton, Andrew
1802–1845 **(attributed to)**
William IV (1765–1837) 1827
oil on canvas 340 x 170
008/74

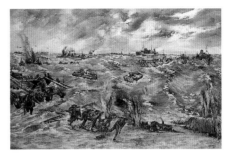

Lockwood, R.
D-Day Landing Craft 1996
oil on canvas 60 x 91.5
267/05

Marchetti, George active 1880s–1912
Colonel Thomas Field Dunscomb Bridge, ADC
to Her Majesty Queen Victoria and His
Majesty King Edward VII (…) 1903
oil on canvas 128 x 92
278/71 (P)

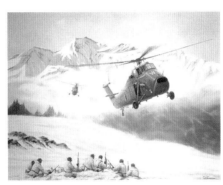

Marchington, Philip
Commando Pick-up c.1982
oil on canvas 74 x 94
158/82

Masi, Phillip
Royal Marines, a Soldier in the Falklands 1983
oil on card 61 x 44
263/05

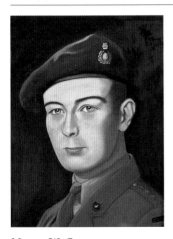

Mason, W. C.
Captain H. O. Huntington-Whiteley, Royal
Marines
oil on canvas 42 x 31
276/83

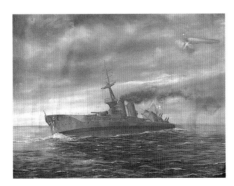

Miller
'HMS Marlborough' at Jutland c.1916
oil on canvas 39 x 50
532/76

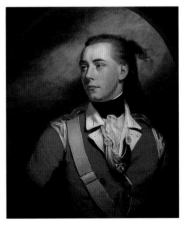

Northcote, James 1746–1831
Lieutenant George Dyer 1780
oil on canvas 77 x 65
612/03

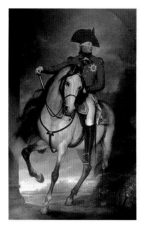

Northcote, James 1746–1831
George III (1738–1820) 1797
oil on canvas 400 x 208
007/74

Oram, L. (Mrs)
United Nations Observation Post in Southern Cyprus, Manned by Royal Marines of 41st Commando Group 1975
oil on canvas 64 x 77
343/99

Payne, James
Boxer Rebellion to Korea, Comradeship between Royal Marines and the USMC 1956
oil on board 71 x 52
262/05

Percy, Herbert Sidney active 1880–1903
Captain James Wood 1886
oil on canvas 92 x 71
310/06

Polivanov, M.
Major Wykeham-Fienes c.1950
oil on canvas 51 x 41
170/73

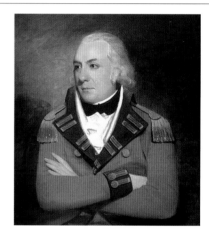

Romney, George (school of) 1734–1802
Unknown Royal Marines Officer c.1802
oil on canvas 74 x 64 (E)
182/74

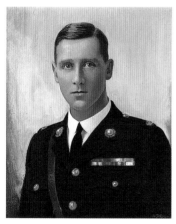

Rowden, W. J.
Captain Edward Bamford, VC, DSO (1887–1938), Royal Marine Light Infantry 1961
oil on board 60 x 50
P/11/9

Shaw, Geoff 1892–1970
Ships at Night
oil on canvas 31.5 x 48
168/96c

Smith, W. E. B. active 1993–1999
Landing Craft Flak 15 1993
oil on wood 46 x 61
150/93

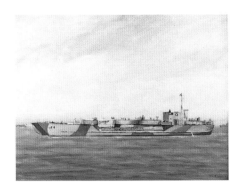

Smith, W. E. B. active 1993–1999
Mk4 Landing Craft Flak 1993
oil on board 46 x 61
103/93

Smith, W. E. B. active 1993–1999
HM Royal Yacht 'Britannia'
oil on canvas 30 x 46
307/99

Stewart, Malcolm 1826–1916
Queen Victoria (1819–1901) (after Heinrich von Angeli) 1907
oil on canvas 115 x 90
13/74

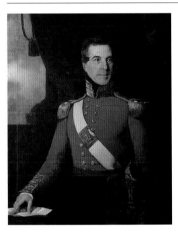

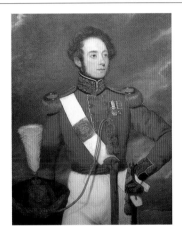

Tait, Robert Scott c.1816–1897
Captain Charles Gray, RM, Author of 'Lays and Lyrics', Published in Scotland, 1841 c.1845
oil on canvas 108 x 90
423/81

Thrayes, J.
Unknown Royal Marines Officer 1831
oil on canvas 100 x 85
P/11/7

Thurgood, T. G.
HM Cruiser 'Vindictive', Assaulted the 'Mole' at Zeebrugge against the Germans, April 1918
1918
oil on canvas 41 x 51
42/99

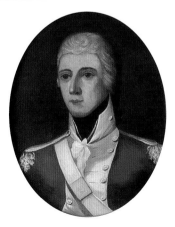

unknown artist
Captain Charles Repington 1755
oil on canvas 123 x 83
421/80

unknown artist
Lieutenant Colonel Benjamin Adair (1755–1794) c.1790
oil on canvas 79 x 66
275/79a

unknown artist
Lieutenant Edward Toomer, RM (1797–1816)
c.1800
oil on canvas 42 x 36.5
228/84

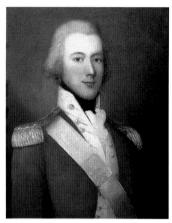

unknown artist
*Captain Charles William Adair, Killed, 'HMS
Victory', Trafalgar, 1805* c.1800–1810
oil on canvas 76 x 63
275/79b

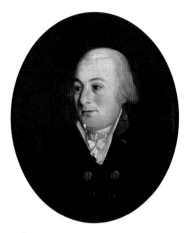

unknown artist
*Possibly Captain Thomas Young, Royal
Marines* c.1805
oil on canvas 57 x 51
84/68

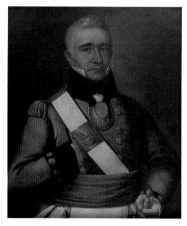

unknown artist
Major Henry Rea 1806
oil on canvas 74 x 62
P/11/27

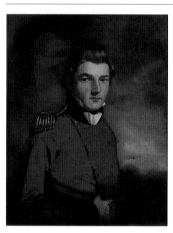

unknown artist
*Possibly Lieutenant John Tatton Brown, Royal
Marines* c.1816
oil on canvas 25 x 20
46/88b

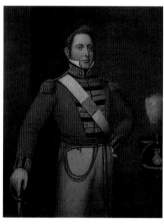

unknown artist
*Lieutenant Colonel Anthony Stransham
(1781–1826)* c.1820
oil on canvas 30.5 x 25.5
P/11/37

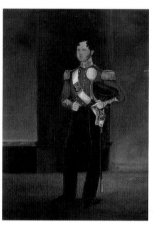

unknown artist
Unknown Royal Marines Officer 1839
oil on canvas 38.3 x 29.5
304/67

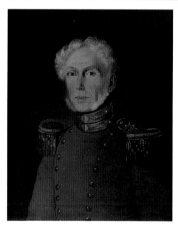

unknown artist
Lieutenant General Thomas Wearing, RM
c.1840
oil on canvas 76 x 62.5
P/11/39

unknown artist
Sergeant Major George Dibben, RM 1847
oil on canvas 78 x 66
32/78

unknown artist
Colour Sergeant F. J. Mills, Royal Marines
c.1854
oil on canvas 76.5 x 64
342/99

unknown artist
General Sir A. B. Stransham, GCB
(1823–1876) c.1860
oil on canvas 94 x 74
P/11/41

unknown artist
Portrait of a Gunner, Royal Marine Artillery
(possibly Gunner Pearce) c.1905
oil on canvas 64.5 x 52
164/79

unknown artist
Major General A. R. Chater, CB, CVO, DSO,
OBE (1896–1979) c.1958
oil on canvas 63 x 52
190/85

unknown artist
Lance Corporal Walter Richard Parker, VC
(1881–1931), Royal Marine Light
Infantry 1961
oil on canvas 60 x 50
P/11/5

unknown artist
Major Frederick William Lumsden, VC, DSO
(1872–1918), Royal Marine Artillery 1961
oil on canvas 60 x 55 (E)
P/11/1

unknown artist
Sergeant Norman Augustus Finch, VC (1890–
1966), Royal Marine Artillery 1961
oil on canvas 60 x 50
P/11/2

unknown artist
Belle Isle, 1761
oil on canvas 127.5 x 229.5
266/05

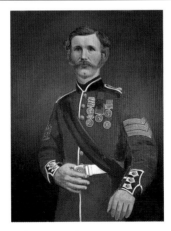

unknown artist
Corporal John Prettyjohns, VC (1823–1887),
Royal Marine Light Infantry
oil on canvas 60 x 50 (E)
P/11/36

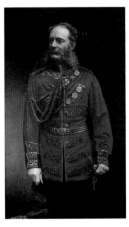

unknown artist
General Sir Charles William Adair, KCB,
Deputy Adjutant General (1878–1883)
oil on canvas 104 x 65
275/79d

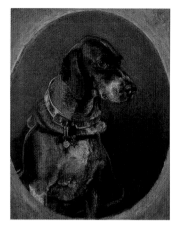

unknown artist
Nell, Adopted by the Royal Marine Artillery in the Early 1880s
oil on canvas 51 x 45
P/4/3

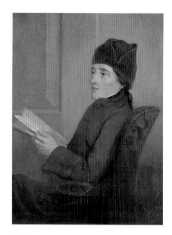

Watson
Lieutenant Colonel David Hepburn (fought at Belle Isle, 1761) c.1780
oil on wood 30.5 x 23
248/76

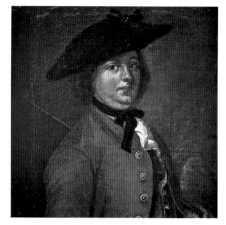

Williamson, Daniel 1783–1843
Hannah Snell (1723–1792) (detail) c.1750
oil on canvas 25.5 x 32
51/88

Young, Mary
The Lying-in-State of Sir Winston Churchill (1874–1965), Westminster Hall c.1965
oil on canvas 85 x 51
104/68

Royal Naval Museum

The sea has always featured largely in British art and our maritime museums are rich in paintings inspired by the element that surrounds us, and which has done so much to shape our history and culture.

Founded in 1911 as the Dockyard Museum, the Royal Naval Museum has gradually expanded as it now covers the whole of naval history. The Museum has always concentrated on the people of the Royal Navy and all its collections reflect this. Among its oil paintings are a significant number of naval portraits, ranging from Thomas Hudson's magnificent study of *Admiral Sir George Pocock (1706–1792)* of 1749, resplendent in the first naval officer's uniform, to studies of ordinary sailors and members of the Women's Royal Naval Service, dating from the Second World War.

The Museum stands alongside 'HMS Victory' in the heart of the old Royal Dockyard at Portsmouth, and as a result Nelson, 'HMS Victory' and Trafalgar have always featured largely in its collections. The Museum houses one of the most important collections of Nelson portraits in the country, featuring works by John Hoppner, Lemuel Francis Abbott, Arthur William Devis and Simon de Koster. Chief among them is the vivid study, *Lord Nelson (1758–1805)*, 1800, by the Austrian court painter Heinrich Füger, now generally agreed to be one of the best likenesses of the great admiral.

The artist most closely associated with the Museum is William Lionel Wyllie. He was fascinated with 'HMS Victory' and took an active role in raising funds for her restoration. His enthusiastic interest also prompted him to paint many pictures recording the restoration and the Museum is fortunate to include a number of these within the collection, including *The Main Yard of 'HMS Victory' Being Crossed*. Wyllie's masterpiece, *Battle of Trafalgar Panorama*, was one of the earliest oils acquired by the Museum in 1929. The gigantic canvas is still displayed in the special annexe built to house the painting, to Wyllie's own design.

In recent years the Museum has sought actively to encourage and promote the work of modern marine artists and has acquired, usually by purchase, paintings by a number of leaders in the field – notably, Geoff Hunt (the current President of the Royal Society of Marine Artists), William Bishop, Rex Phillips and Roger Fisher. The Museum's most significant act of patronage was to commission a large set of paintings in the 1980s depicting key battles in World War Two by former RSMA President, David Cobb. Other works by ordinary sailors, although often quite crude, vividly capture the essence of life at sea.

Although it is by no means the largest maritime art collection in the country, nor the most prestigious, the Royal Naval Museum's oil painting collection is rich, both in the variety of its subject matter and in the span of history that it covers. We are therefore delighted to have this opportunity, thanks to the Public Catalogue Foundation, of making it known to a wider audience.

Dr Colin White, Director

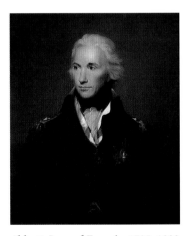

Abbott, Lemuel Francis 1735–1823
Lord Nelson (1758–1805)
oil on canvas 70 x 59.5
1975/1

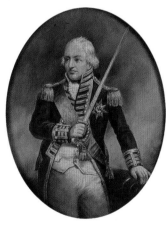

Abbott, Lemuel Francis (after) 1735–1823
Admiral Earl St Vincent
oil on canvas 37 x 29.3
1979/7

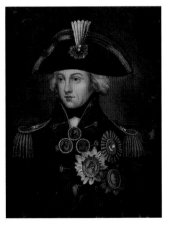

Abbott, Lemuel Francis (after) 1735–1823
Lord Nelson (1758–1805)
oil on glass 35.6 x 33
1973/148

Adams, Bernard 1884–1965
*Vice Admiral Sir Geoffrey Barnard
(1902–1974)*
oil on canvas 70 x 92
1982/259

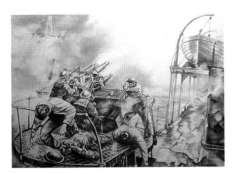

Alcorn-Hender, Michael b.1945
Attack on 'HMS Foylebank' 1982
oil on canvas 52.7 x 75.3
1984/247

Alcorn-Hender, Michael b.1945
*Leading Seaman Jack Mantle (c.1917–
1940)* 1982
oil on board 60 x 47.5
1984/245

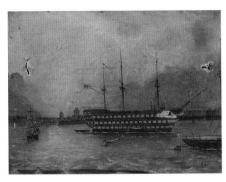

Avery
'HMS Victory' in Portsmouth Harbour, c.1900
oil on canvas 24 x 33.2
1982/783

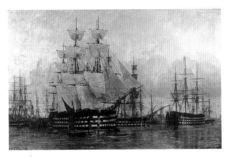

Baden-Powell, Frank Smyth 1850–1933
Ships in Portsmouth Harbour
oil on canvas 166 x 258
PCF24

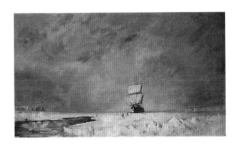

Bailey, Henry (attributed to)
*'HMS Hecla' Searching out the North-West
Passage*
oil on canvas 96.5 x 168
PCF11

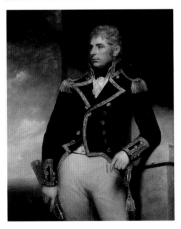

Beechey, William 1753–1839
*Admiral Sir Harry Burrard-Neale, 2nd Bt
(1765–1840)*
oil on canvas 140 x 110
1981/77

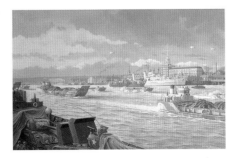

Bishop, William Henry b.1942
Prelude to D-Day 1994
oil on canvas 36.8 x 56.5
1994/154/1

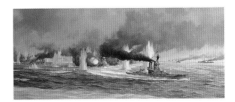

Bishop, William Henry b.1942
Windy Corner, Jutland, 1916
oil on canvas 64 x 133
1986/213

Facing page: Cagnacci, Guido (attributed to), 1601–1681, *The Penitent Magdalen* (detail), 1658, Portsmouth Museums
and Records Service, (p. 72)

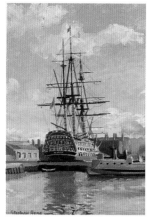

Bone, Stephen 1904–1958
'HMS Victory' in Dry Dock
oil on metal 34 x 24
1997/70

Boyle, Edward
'HMS Charity', Incident off Inchon, September 1950 2004
oil on canvas 44.5 x 59.5
2004/50/1

Braydon, A. F. S.
'HMS Victory' off the South Foreland en route to Portsmouth
tempera on gesso panel 25 x 34
1968/40

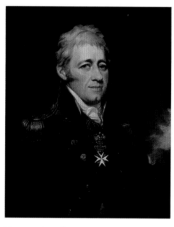

Brown, Mather 1761–1831
Rear Admiral Sir Home Popham (1762–1820)
oil on canvas 73.1 x 61
1999/47

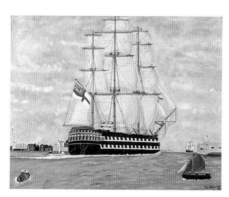

Browne, J. R.
'HMS Edgar' Leaving Portsmouth under Sail
oil on canvas 42 x 55
1975/69

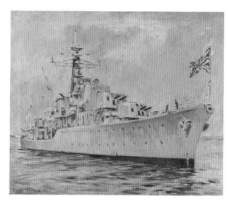

Brunoe, Søren 1916–1994
'HMS Diana' 1955
oil on canvas 49.2 x 59
1986/143

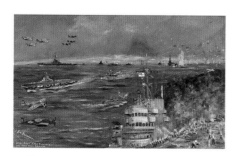

Bullamore, George
848 SQRN 'HMS Formidable'
oil on canvas 50 x 82
PCF12

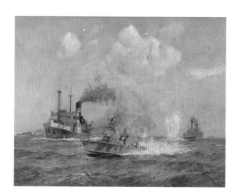

Burgess, Arthur James Wetherall
1879–1957
A Dogfight
oil on copper 45.6 x 60.2
1980/287

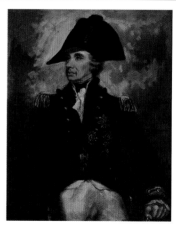

Cadogan, G.
Lord Nelson (1758–1805) (after Arthur William Devis)
oil on canvas 105 x 90 (E)
PCF7

Carmichael, James Wilson 1800–1868
'HMS Victory' Anchored off the Isle of Wight
1847
oil on canvas 148 x 202
1973/76

Carter, P. T.
'HMS Birmingham' in the Second World War
oil on canvas 35 x 55
1980/204

Casey, Ron
'Bismarck' in the Denmark Strait 1981
oil on board 35.2 x 51.8
1982/825

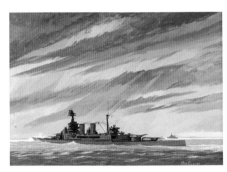

Casey, Ron
Last Hours of the 'Hood' 1981
oil on board 45 x 60 (E)
1982/824

Chowdhury, I. A.
'Appreciating the situation'
oil on canvas 59 x 50
1985/196

Clout, Harry
Channel Attack, August 1940
oil on canvas 29.5 x 43.5
1978/12

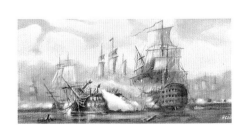

Clout, Harry
*Naval Warfare**
oil on board 28 x 58.1
1978/11

Cobb, Charles David b.1921
Biscay Anti U-Boat Patrol c.1940
oil on canvas 49.4 x 75
1978/334

Cobb, Charles David b.1921
*Gulf War, H Hour; Twelve Royal Navy
Minesweepers Complete Their Task* 1991
oil on board 39 x 74
1995/93

Cobb, Charles David b.1921
A Sea Harrier
oil on board 25.6 x 40.4
1992/179/7 (P)

Cobb, Charles David b.1921
Admiral Ramsay Reviewing the Fleet before D-Day
oil on board 64 x 94
1977/310

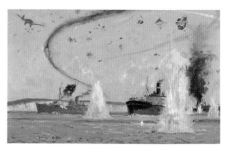

Cobb, Charles David b.1921
Air Attack by Luftwaffe on Channel Convoy
oil on board 29 x 49.3
1978/161

Cobb, Charles David b.1921
Allied Landings in North Africa, November 1942
oil on canvas 44.5 x 65
1980/273

Cobb, Charles David b.1921
Artillery at Mount Kent
oil on board 25.6 x 40.4
1992/179/7 (P)

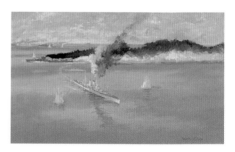

Cobb, Charles David b.1921
Battle of the Java Sea, 27 February 1942
oil on board 29.2 x 49
1982/433

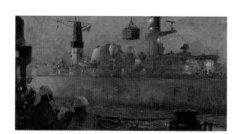

Cobb, Charles David b.1921
'Blazer' Refuelling at Sea from Fort Grange
oil on canvas 33.5 x 64.3
1994/198/1

Cobb, Charles David b.1921
Bomb Attack Sinks 'Cornwall' and 'Dorsetshire'
oil on board 44.5 x 64.7
1982/427

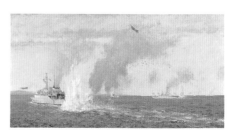

Cobb, Charles David b.1921
Bombardment of Port Stanley Airstrip, 1 May 1982
oil on board 39.6 x 75
1984/696

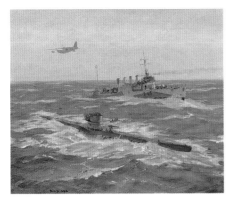

Cobb, Charles David b.1921
Capture Intact of U-Boat '570'
oil on canvas 29.5 x 60
1978/327

Cobb, Charles David b.1921
Carrier Aircraft Attack, Sabang, 19 April 1944
oil on board 29.4 x 49
1982/429

Cobb, Charles David b.1921
Defence of a Russian Convoy
oil on board 29.4 x 49.5
1978/333

Cobb, Charles David b.1921
Dunkirk Operation 'Dynamo', 26 May–4 June 1940
oil on board 40 x 75 (E)
1982/426

Cobb, Charles David b.1921
Escort Carrier 'HMS Nairana' Stalked Unsuccessfully by U-Boat 502, 1 February 1944
oil on board 29.5 x 49
1982/432

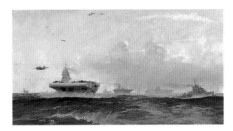

Cobb, Charles David b.1921
Fast Carrier Task Group Operating off the Japanese Mainland, July 1945
oil on canvas 40 x 74
1982/437

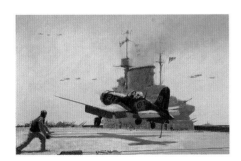

Cobb, Charles David b.1921
Fleet Air Arm Corsair Landing on
oil on canvas 64 x 84
1982/431

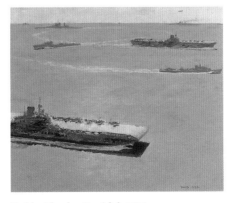

Cobb, Charles David b.1921
Formation of the British Pacific Fleet, 1944
oil on board 49.6 x 59.5
1982/438

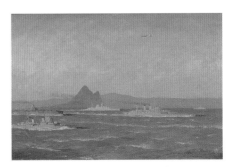

Cobb, Charles David b.1921
Gibraltar-Based Force H
oil on canvas 49 x 75
1980/262

Cobb, Charles David b.1921
Harpoon Convoy
oil on canvas 29.5 x 49.5
1980/277

Cobb, Charles David b.1921
*'HMS Dianthus' and Convoy in Winter
Atlantic Gale*
oil on board 44.5 x 64.8
1978/326

Cobb, Charles David b.1921
*HMS Gloucester' on the Armilla Patrol
Escorting a Convoy of Container Ships through
the Strait of Hormuz*
oil on board 48.8 x 74.5
1991/200

Cobb, Charles David b.1921
*'HMS Gloucester', 'USS Missouri', 'USS Adroit',
'HMS Ledbury', 'HMS Dulverton', 'HMS
Cattistock' and 'HMS Atherton'*
oil on board 53 x 89
1995/93

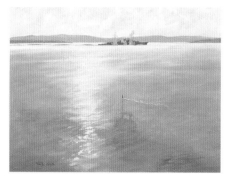

Cobb, Charles David b.1921
*'HMS Submarine Trenchant' Sinks the Cruiser
'Ashigara', 8 June 1945*
oil on canvas 44.5 x 59.5
1982/436

Cobb, Charles David b.1921
'HMS Upholder' Attacking Italian Troopships
oil on board 29.5 x 49.6
1980/268

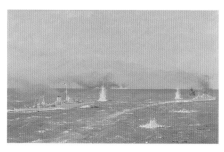

Cobb, Charles David b.1921
*'HMS Warspite' with Destroyers at the Second
Battle of Narvik, 13 April 1940*
oil on canvas 64 x 84 (E)
1978/163

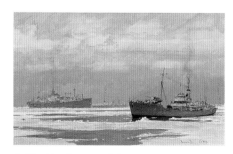

Cobb, Charles David b.1921
*'HMT Ayrshire' and Ships from 'PQ17' in the
Ice Pack, 5–7 July 1942*
oil on canvas 29.5 x 49
1982/434

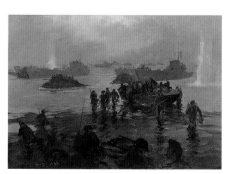

Cobb, Charles David b.1921
Invasion of Sicily
oil on board 61 x 80
1980/274

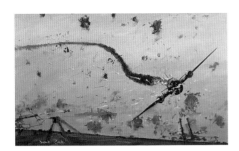

Cobb, Charles David b.1921
Japanese Kamikaze Suicide Attacks on Ships
oil on board 29.5 x 49.6
1982/430

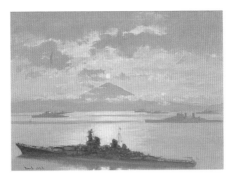

Cobb, Charles David b.1921
Japanese Surrender, Tokyo Bay
oil on board 39.4 x 59.4
PCF16

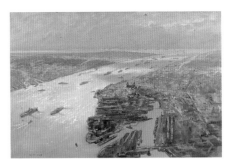

Cobb, Charles David b.1921
Liverpool, Nerve Centre for the Battle of the Atlantic
oil on canvas 59 x 89.5
1978/328

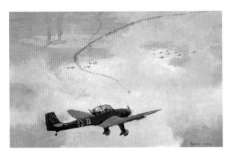

Cobb, Charles David b.1921
Malta under Air Attack by Junkers 87 Dive Bombers
oil on board 45 x 65
1980/272

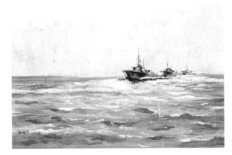

Cobb, Charles David b.1921
Motor Torpedo Boats
oil on board 25.5 x 38
1985/180

Cobb, Charles David b.1921
Mount Kent
oil on board 25.6 x 40.4
1992/179/7 (P)

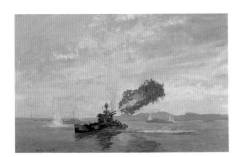

Cobb, Charles David b.1921
North African Inshore Squadron, 1940–1943
oil on canvas 34.5 x 54.5
1980/269

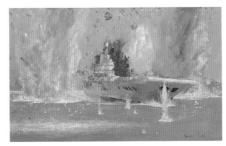

Cobb, Charles David b.1921
Operation 'Excess', 'Illustrious' under Air Attack, 19 January 1941
oil on canvas 45 x 65
1980/266

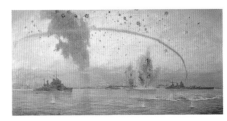

Cobb, Charles David b.1921
Pedestal Convoy to Malta
oil on canvas 77 x 130
1980/271

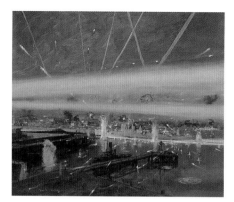

Cobb, Charles David b.1921
St Nazaire Raid, 27–28 March 1942
oil on canvas 49 x 59.8
1978/329

Cobb, Charles David b.1921
Salerno, 'HM Submarine Shakespeare' Acting as a Marker for Invasion Fleet, 9 September 1943
oil on board 49.5 x 75
1980/275

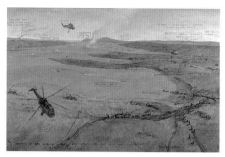

Cobb, Charles David b.1921
Sketch for 'San Carlos Water'
oil on board 60 x 110 (E)
1984/335

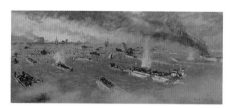

Cobb, Charles David b.1921
Sword Beach, Ouistreham, D-Day, 6 June 1944
oil on canvas 37.5 x 88
1982/439

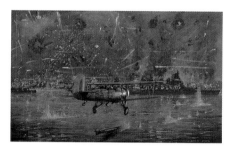

Cobb, Charles David b.1921
Taranto Harbour, Swordfish from 'Illustrious' Cripple the Italian Fleet, 11 November 1940
oil on canvas 44 x 75
1980/264

Cobb, Charles David b.1921
The 1943 Climax of the Atlantic Convoy War No.1
oil on board 29.4 x 49.5
1978/331

Cobb, Charles David b.1921
The 1943 Climax of the Atlantic Convoy War No.2
oil on canvas 45 x 65
1978/332

Cobb, Charles David b.1921
The Battle of Cape Matapan, 29 March 1941
oil on board 49 x 80
1980/265

Cobb, Charles David b.1921
The Capture of Madagascar
oil on canvas 45 x 65
1982/428

Cobb, Charles David b.1921
The 'Channel Dash', 12–13 February 1942
oil on canvas 44 x 65
1978/330

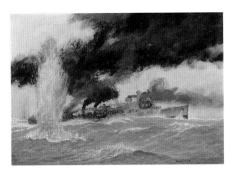

Cobb, Charles David b.1921
*The Destroyer 'HMS Glowworm' Rams the
German Cruiser 'Admiral Hipper', 8 April 1940*
oil on canvas 44 x 64.5
1982/435

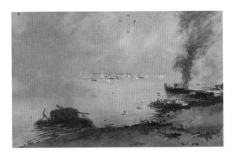

Cobb, Charles David b.1921
The Dieppe Raid
oil on canvas 29.3 x 45
1978/325

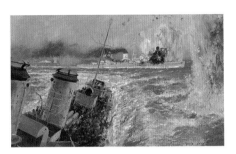

Cobb, Charles David b.1921
The Evacuation of Crete
oil on board 44.5 x 74.6
1980/261

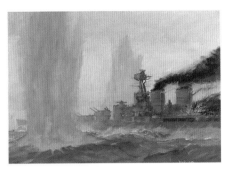

Cobb, Charles David b.1921
The Last Moments of the 'Hood'
oil on canvas 44.8 x 64.9
1978/324

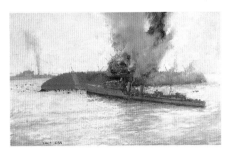

Cobb, Charles David b.1921
The Loss of 'HMS Eagle'
oil on board 39.5 x 49.5
1980/270

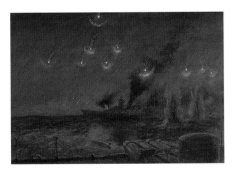

Cobb, Charles David b.1921
*The Sinking of the 'Scharnhorst', 26 December
1943*
oil on board 44.1 x 64.5
1978/162

Cobb, Charles David b.1921
The Surrender of Italy
oil on canvas 34.6 x 54.9
1980/276

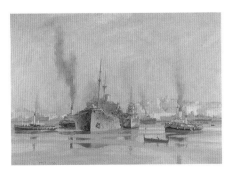

Cobb, Charles David b.1921
The Tanker 'Ohio'
oil on canvas 44.5 x 65
1980/263

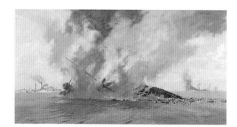

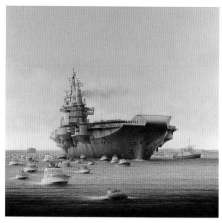

Cobb, Charles David b.1921
Torpedo Planes Sink 'Repluse' and 'Prince of Wales', 10 December 1941
oil on board 39.5 x 75
PCF15

Cobb, Charles David b.1921
Yomping
oil on board 25.6 x 40.4
1992/179/7 (P)

Coole, Brian b.1939
'HMS Hermes' Homecoming
oil on board 100 x 105
2002/25

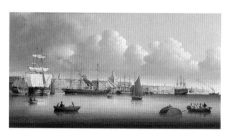

Coole, Brian b.1939
'HMS Warrior' in Portsmouth Harbour
oil on board 46 x 89
2001/112

Coole, Brian b.1939
San Carlos Water
oil on board 45 x 64.5
2002/26

Coole, Brian b.1939
'SS Uganda', Hospital Ship
oil on board 45.1 x 65
2002/27

Coupe, Marshall
'HMS Royal Sovereign'
oil on canvas 36 x 52
1976/45

Dawson, Montague J. 1895–1973
'HMS Skate'
oil on canvas 59 x 38.5
1987/342

Deakins, Cyril Edward 1916–2002
'HMS Albrighton'
oil on board 35 x 60
1982/425

Facing page: Wollen, William Barnes, 1857–1936, *The Scouts* (detail), 1905, Horsepower: The Museum of The King's Royal Hussars, (p. 306)

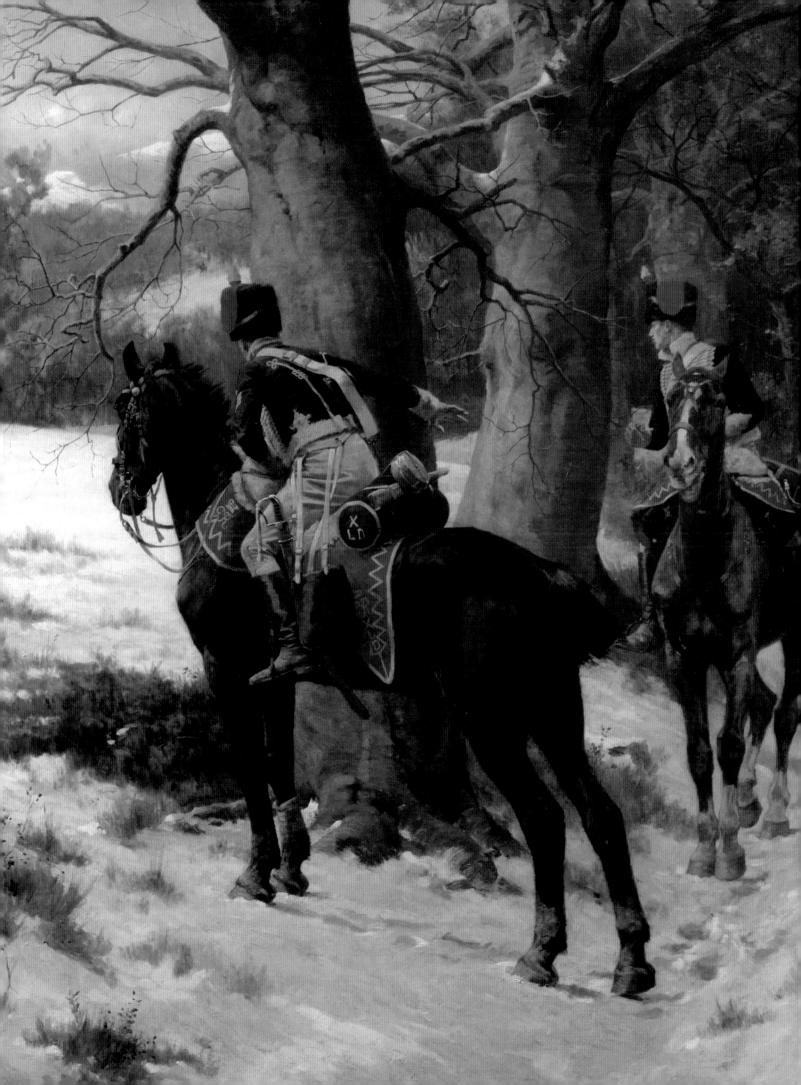

D'Esposito
Ship Portrait 1896
oil on canvas 15 x 30 (E)
PCF6

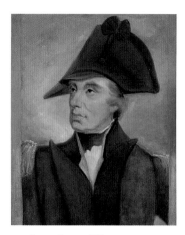

Devis, Arthur William 1762–1822
Lord Nelson (1758–1805) (after Arthur Devis)
oil on canvas 92 x 82
1988/116/4

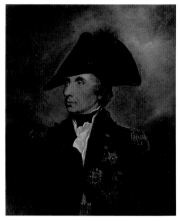

Devis, Arthur William 1762–1822
Sketch of Lord Nelson (1758–1805)
oil on canvas 90 x 70 (E)
2000/45/1

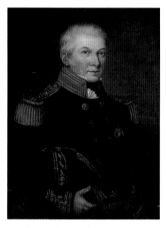

Devis, Arthur William 1762–1822
Vice Admiral Page
oil on canvas 90 x 70 (E)
2000/45/2

Dominy, John
'HMS Argonaut'
oil on canvas 39.2 x 49.4
1983/453

Dominy, John
'HMS Endurance' and 'HMS Plymouth'
oil on canvas 40 x 50 (E)
1983/452

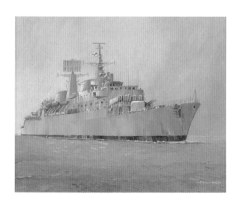

Dominy, John
'HMS Glamorgan'
oil on board 39.1 x 49.2
1983/449

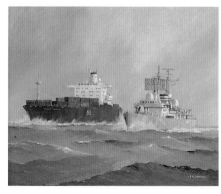

Dominy, John
'HMS Glasgow' and Atlantic Conveyor
oil on board 39 x 48.5
1983/455

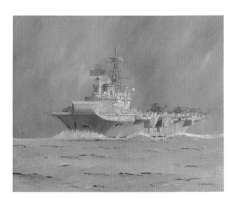

Dominy, John
'HMS Hermes'
oil on board 40 x 50 (E)
1983/456

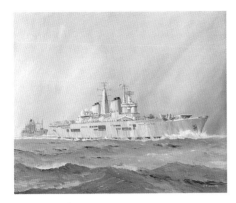

Dominy, John
'HMS Invincible'
oil on board 40 x 50 (E)
1983/454

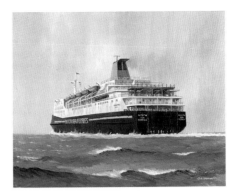

Dominy, John
'MV Norland'
oil on canvas 40 x 50 (E)
1983/445

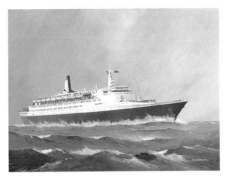

Dominy, John
'Queen Elizabeth II'
oil on canvas 53.3 x 68.6
1983/457

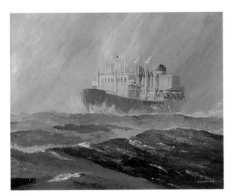

Dominy, John
'RFA Tidespring'
oil on board 39 x 49.5
1983/450

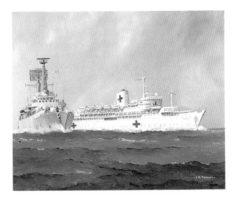

Dominy, John
'SS Uganda' and 'HMS Amtrim'
oil on board 43.2 x 58.4
1983/446

Dominy, John
'The Europic' Ferry
oil on board 39 x 49.5
1983/448

Dominy, John
The Ferry 'Nordic'
oil on board 43.2 x 58.4
1983/444

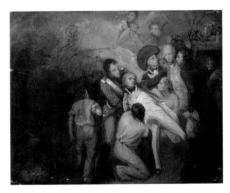

Drummond, Samuel 1765–1844
Nelson Carried Below
oil on canvas 60 x 76
1967/2

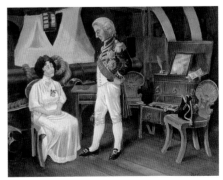

Eames, F. A. R.
The Admiral and His Lady
oil on board 64 x 70 (E)
1991/311

Eleck, J.
'HMS Hood' 1920
oil on canvas 24.5 x 61
1991/214/3

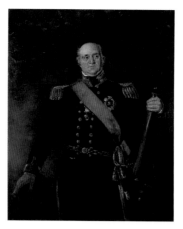

Evans, Richard 1784–1871
Admiral Thomas Hardy (1769–1839)
oil on canvas 30 x 15 (E)
1960/46

Fisher, Roger Roland Sutton 1919–1992
'HMS London', Evening in the Gulf
oil on canvas 24 x 34 (E)
1992/59

Fisher, Roger Roland Sutton 1919–1992
*Red Cross Squadron Entering the Ascension
Island during the South Atlantic Campaign*
oil on canvas 19 x 39.5
1987/197/1

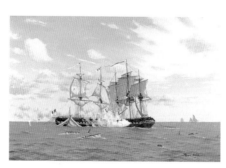

Fisher, Roger Roland Sutton 1919–1992
*The Action between 'HMS Nymphe', French
5th Rate (Captured, 10 August 1780), and the
French 'Cleopatre', 18 June 1793*
oil on canvas 50 x 80 (E)
1989/437/1

Foxlee, S.
Portrait of a Wren 1945
oil on board 33 x 25
1981/352

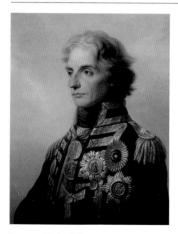

Füger, Heinrich 1751–1818
Lord Nelson (1758–1805) 1800
oil on canvas 77 x 54
1973/77

Füger, Heinrich (after) 1751–1818
Lord Nelson (1758–1805)
oil on canvas 180 x 70 (E)
PCF23

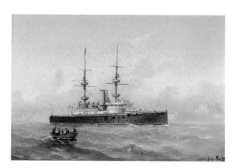

Galea, Luigi 1847–1917
'HMS Royal Sovereign' off Malta 1901
oil on board 29 x 39
1982/1572

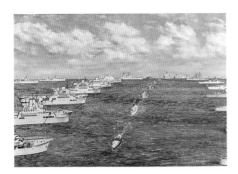

Garbutt, P. E.
Coronation Fleet Review 1953
oil on canvas 70.5 x 100
1981/221

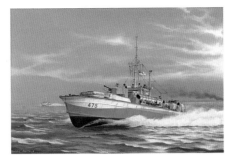

Garland, Harold active 1986–1988
Motor Torpedo Boat '475'
oil on canvas 60 x 75 (E)
1989/157

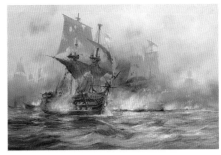

Geidel, Gerhard b.1925
'HMS Victory' at Trafalgar
oil on canvas 49 x 79
1989/186

Gittins, D. J.
'HMS Peterel' Arriving in Chunking, August 1932 1979
acrylic on board 51 x 75
1986/623/3

Gunn, Philip active 1973–1976
Holy Stoning 1973
acrylic on board 40 x 55
1979/46

Gunn, Philip active 1973–1976
Naval Recruits Joining 'Impregnable' 1973
acrylic on board 55 x 40
1979/43

Gunn, Philip active 1973–1976
Sailor Boy's Dressing Room 1973
acrylic on board 40 x 55
1979/47

Gunn, Philip active 1973–1976
Scamper at the Assembly Bugle 1973
acrylic on board 40 x 55
1979/44

Gunn, Philip active 1973–1976
'Up All Hammocks' 1973
acrylic on board 40.1 x 54.7
1979/45

Gunn, Philip active 1973–1976
Assault on the Fort 1974
acrylic on board 39.5 x 54.4
1979/66

Gunn, Philip active 1973–1976
Coaling Ship 1974
acrylic on board 39.5 x 54.5
1979/54

Gunn, Philip active 1973–1976
Coaling Ship by Baskets 1974
acrylic on board 39.7 x 54.2
1979/63

Gunn, Philip active 1973–1976
Coaling Ship on Board 1974
acrylic on board 39.8 x 54
1979/64

Gunn, Philip active 1973–1976
Duty Cooks of the Mess 1974
acrylic on board 39.5 x 54.2
1979/60

Gunn, Philip active 1973–1976
Housing the Top Mast 1974
acrylic on board 54.2 x 39.8
1979/62

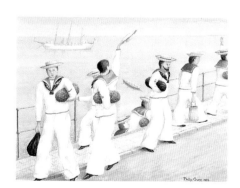

Gunn, Philip active 1973–1976
Landing in No.6 Hats 1974
acrylic on board 39.5 x 54.2
1979/50

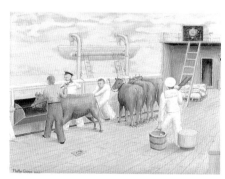

Gunn, Philip active 1973–1976
Livestock on Board 1974
acrylic on board 39.6 x 54.1
1979/59

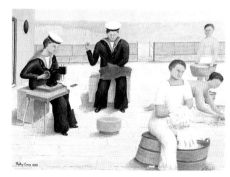

Gunn, Philip active 1973–1976
Make and Mend Day 1974
acrylic on board 39.8 x 54.3
1979/52

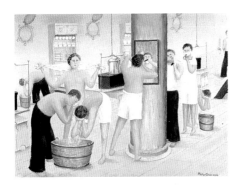

Gunn, Philip active 1973–1976
Mess Deck 'T' 1974
acrylic on board 39.5 x 54.3
1979/53

Gunn, Philip active 1973–1976
Sailmaking Class 1974
acrylic on board 40.2 x 54.8
1979/48

Gunn, Philip active 1973–1976
Sailor's Sunday Best 1974
acrylic on board 38.8 x 27.3
1979/49

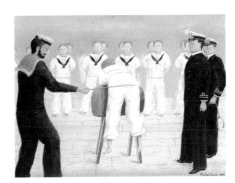

Gunn, Philip active 1973–1976
Stokehold Work 1974
acrylic on board 39.5 x 54
1979/57

Gunn, Philip active 1973–1976
Tarring the Top Galant Stay 1974
acrylic on board 54.5 x 39.6
1979/58

Gunn, Philip active 1973–1976
The Cane 1974
acrylic on board 39.5 x 54.5
1979/56

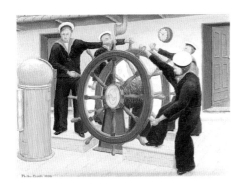

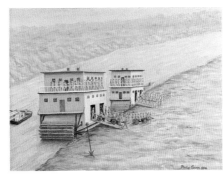

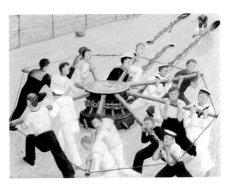

Gunn, Philip active 1973–1976
The Wheel 1974
acrylic on board 39.5 x 54.5
1979/55

Gunn, Philip active 1973–1976
Transport for Troops 1974
acrylic on board 39.8 x 54.2
1979/67

Gunn, Philip active 1973–1976
Weighing Anchor 1974
acrylic on board 39.5 x 54.4
1979/51

Gunn, Philip active 1973–1976
'Fate of my first command' 1975
acrylic on board 40 x 54.8
1979/72

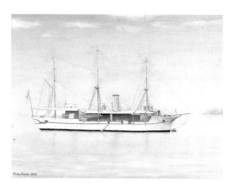

Gunn, Philip active 1973–1976
'HMS Clic' 1975
acrylic on board 40 x 54.5
1979/74

Gunn, Philip active 1973–1976
Malaria Victim 1975
acrylic on board 40 x 54.8
1979/71

Gunn, Philip active 1973–1976
Presentation of the Medal 1975
acrylic on board 40 x 54.6
1979/73

Gunn, Philip active 1973–1976
'A sailor he would be' 1976
acrylic on board 55.5 x 40
PCF20

Gunn, Philip active 1973–1976
The Hammock Problems 1976
acrylic on board 40.5 x 55
1979/75

Gunn, Philip active 1973–1976
'A valiant deed'
acrylic on board 39.8 x 54.2
1979/69

Gunn, Philip active 1973–1976
Naval Boarding Unit
acrylic on board 39.6 x 54
1979/68

Gunn, Philip active 1973–1976
Rum Tub Crows Nest
acrylic on board 54.2 x 39.6
1979/61

Gunn, Philip active 1973–1976
The Mine Capture Mesh
acrylic on board 39.7 x 54
1979/65

Hogan, David 1924–1997
'HMS Warspite' off Sydney, March 1942
oil on canvas 19.5 x 37.5
1986/227

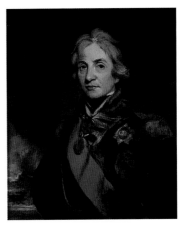

Hoppner, John 1758–1810
Lord Nelson (1758–1805)
oil on canvas 76 x 63
1992/407

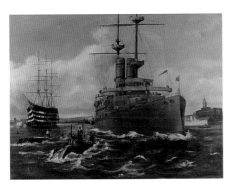

Howards
'A' Class Submarines and a Warship, possibly Royal Sovereign Class, 1905 1906
oil on canvas 30 x 40 (E)
1980/318

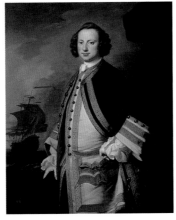

Hudson, Thomas 1701–1779
Admiral Sir George Pocock (1706–1792) 1749
oil on canvas 125 x 99.5
1986/482

Hunt, Geoffrey William b.1948
Desolation Island
oil on canvas 43.5 x 33
1989/239

Hunt, Geoffrey William b.1948
Far Side of the World
oil on board 43.5 x 33
1989/244

Hunt, Geoffrey William b.1948
Fortune of War
oil on board 43.5 x 33
1989/240

Hunt, Geoffrey William b.1948
'HMS Surprise'
oil on board 43.5 x 33
1989/237

Hunt, Geoffrey William b.1948
Letter of Marque
oil on canvas 43.5 x 33
1989/246

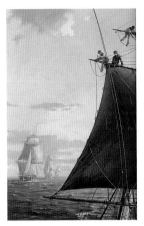

Hunt, Geoffrey William b.1948
Master and Commander
oil on board 61 x 46
1989/235

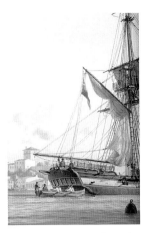

Hunt, Geoffrey William b.1948
Mauritius Command
oil on canvas 43.5 x 33
1989/238

Hunt, Geoffrey William b.1948
Post Captain
oil on canvas 43.5 x 33
1989/236

Hunt, Geoffrey William b.1948
Reverse of the Medal
oil on board 43.5 x 33
1989/245

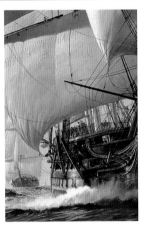

Hunt, Geoffrey William b.1948
The Ionian Mission
oil on canvas 43.5 x 33
1989/242

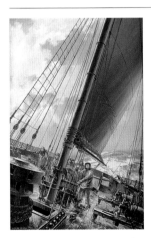

Hunt, Geoffrey William b.1948
The Surgeon's Mate
oil on canvas 43.5 x 33
1989/241

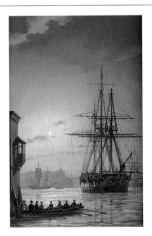

Hunt, Geoffrey William b.1948
Treasons Harbour
oil on canvas 43.5 x 33
1989/243

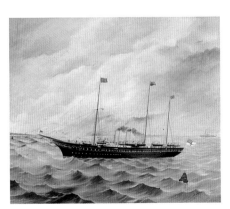

Jeram, J.
'HMY Victoria and Albert'
oil on canvas 50 x 60
1973/346

Facing page: Allen, William Herbert, 1863–1943, *Sacred Cantata Performed in Stapleford Church, near Salisbury* (detail),
Hampshire County Council Museums Service (p. 265)

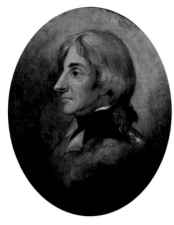

Koster, Simon de 1767–1831
Lord Nelson (1758–1805)
oil on canvas 72.5 x 64
1967/5

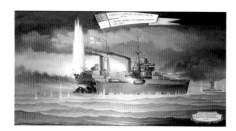

Leskinov
'HMS Edinburgh'
oil on canvas 79 x 114
1993/110/1

Leskinov
50th Anniversary of Russian Convoys
oil on canvas 94.2 x 145.7
1993/110/2

Lowe, Arthur 1866–1940
'HMS Armadale Castle'
oil on canvas 29.3 x 44.5
1988/66/1

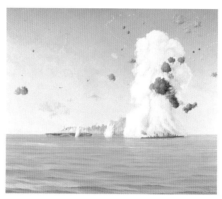

Lumsden
'HMS Phoebe' Giving Cover to 'HMS Imdomitable', 1940 1973
oil on board 63 x 75
1978/85

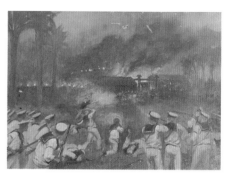

Lund, Niels Møller 1863–1916
Attack on the Japanese Battery at Shimonoseki by a Naval Brigade, September 1864 1900
oil on canvas 37 x 52
1990/147

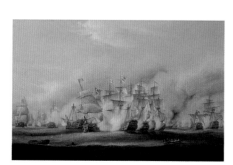

Luny, Thomas 1759–1837
The Battle of Trafalgar, 21 October 1805
oil on canvas 98 x 141
1973/65

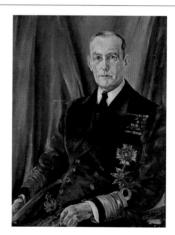

MacDermott, Beatrice
Admiral Sir John Edelsten
oil on canvas 91.5 x 75.7
1983/106

Mason, Frank Henry 1876–1965
The 'Flapper' on the Gingwera River, German East Africa, 1916
oil on board 35 x 26
1983/947

Maycock, J. E.
'Defence' ('Defiance')
oil on canvas 46 x 31.5
1979/116

Maycock, J. E.
The Battle of Heligoland Bight, 28 August 1914
oil on canvas 24.3 x 36.7
1979/117

Maycock, J. E.
The Sinking of 'Blücher', 24 January 1915
oil on canvas 24.5 x 36.8
1979/118

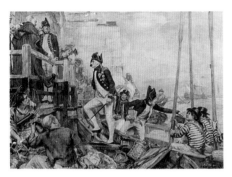

McCormick, Arthur David 1860–1943
Lord Nelson Arriving at Portsmouth from Spithead
oil on canvas 42 x 59
1969/12

Meadows, John Hardy b.1912
Western Approaches during the Battle of the Atlantic
acrylic on board 44.5 x 66.8
1990/25

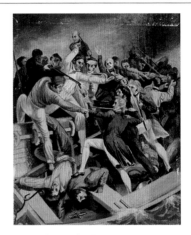

Mertall, R. (after)
Boat Action in the Bay of Cadiz, 1797
oil on board 25 x 18 (E)
1978/160

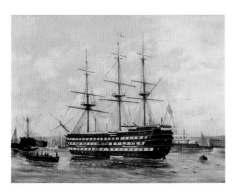

Moss, T.
'HMS Victory' 1880s
oil on canvas 50.8 x 66
1965/19

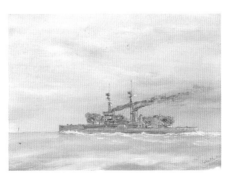

Moulton, John
'HMS Bellerophon'
acrylic on board 24.5 x 34.5
1984/50

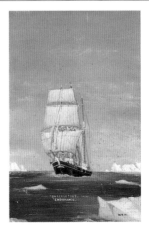

W. E. N.
Sir Ernest Shackleton's Exploration Ship 'Endurance' under Sail amongst Icebergs
oil on board 38.5 x 28.5
1985/301

Needell, Philip G. 1886–1974
Serbian Relief Fund Concert, April 1916 1916
oil on board 53 x 43
1978/306

Needell, Philip G. 1886–1974
'HMS Almanzora' and Convoy at Sunrise, 1917
oil on canvas 18 x 52 (E)
1977/229

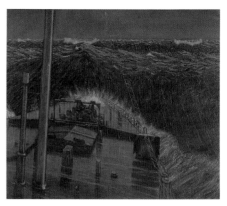

Needell, Philip G. 1886–1974
The Northern Patrol
oil on canvas 53 x 63
1977/228

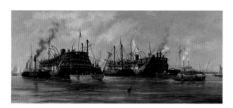

Nibbs, Richard Henry 1816–1893
The Raising of 'HMS Eurydice'
oil on canvas 51 x 121.5
1954/43

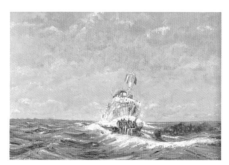

Panter, Brian
'Aconit' Ramming 'U32'
oil on canvas 40 x 60
1993/200

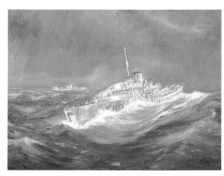

Panter, Brian
'HMS Bluebell'
oil on canvas 55 x 75 (E)
1986/471/1

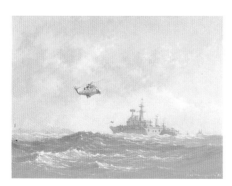

Phillips, Rex b.1931
'HMS Hermes'
oil on canvas 40.6 x 50.8
1983/470

Phillips, Rex b.1931
'HMS Warrior' off the Isle of Wight during Her First Commission
oil on canvas 58 x 72
1984/651

Phillips, Rex b.1931
San Carlos Anchorage under Attack, 'Canberra' Survives the Day, 21 May 1982
oil on board 34 x 44.5
1983/471

Phillips, Rex b.1931
The 'Sheffield' is Hit
oil on board 44 x 54.5
1984/136

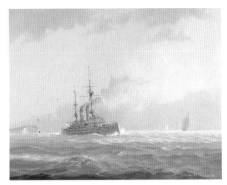

Phillips, Rex b.1931
*View of a King Edward VII Class Battleship,
Steaming off 'The Needles', c.1903*
oil on canvas 38.5 x 48
PCF5

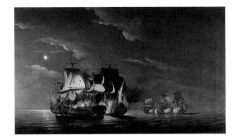

Pocock, Nicholas 1740–1821
The Battle of Flamborough Head, 1779
oil on canvas 104 x 163
1981/41

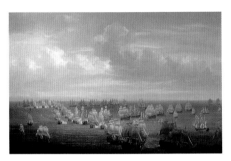

Pocock, Nicholas 1740–1821
The Battle of Trafalgar, 21 October 1805
oil on canvas 118 x 180
1982/95

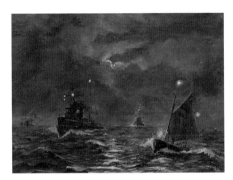

Poignard
HM Ships Passing a Fleet of Drifters, 1912
oil on board 30 x 40 (E)
1981/1093

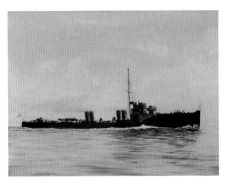

Poignard
'HMS Cherwell', 1912–1913
oil on board 23 x 32
1981/1089

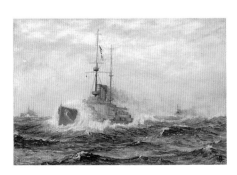

Poignard
'HMS Prince of Wales' in the Bay, 1911
oil on board 29.2 x 39.4
1981/1091

Poignard
HMTB No.110, 1912
oil on canvas 34 x 29
1981/1087

Poignard
HMTB No.110 Entering Portsmouth Harbour
oil on canvas 34 x 29
1981/1088

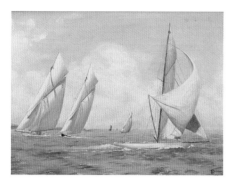

Poignard
'J' Class Yachts in the Solent, 1911–1912
oil on canvas 30 x 40 (E)
1981/1094

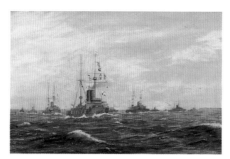

Poignard
*The Atlantic Fleet Entering Portland Harbour,
1910*
oil on board 29.2 x 45.3
1981/1092

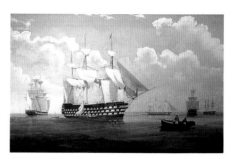

Poulson, T. R.
*HM Ships 'Pique', 'Vanguard', 'Daphne',
'Queen' and 'Vernon'* 1847
oil on canvas 110 x 140 (E)
1964/24

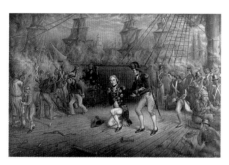

Proctor, Frederick J. active 1879–1945
Nelson Shot
oil on canvas 91.3 x 136.4
PCF19

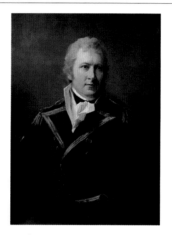

Raeburn, Henry Macbeth 1860–1947
George Duff (1764–1805)
oil on canvas 87.5 x 66.3
1990/185 (P)

Rawlings, Les
HRH Prince Charles (b.1948) 1979
oil on canvas 74.2 x 49.5
1980/150

Righton, Fred
'Bismarck' under Attack
oil on hardboard 30 x 60
1992/424

Robins, E. active 1882–1902
*Troopship 'Seraphis' Leaving Portsmouth
Harbour*
oil on canvas 50 x 75
1963/91

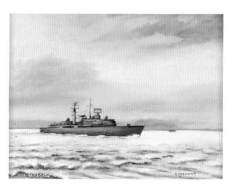

Russwurm, G.
*'HMS Glasgow', Launched Swan Hunter,
Wallsend-on-Tyne, 14 April 1976*
oil on board 30 x 40
1984/605

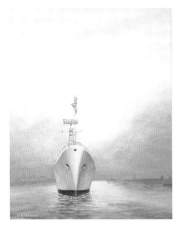

Russwurm, G.
'Journey's End'
oil on canvas 50 x 39
1984/603

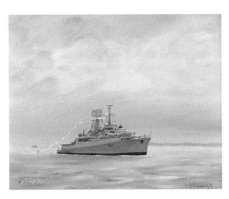

Russwurm, G.
Paying off of 'HMS Antrim', 18 April 1984
oil on board 27.2 x 35.5
1984/606

Russwurm, G.
Salute to Portsmouth
oil on canvas 39.5 x 49.8
1984/604

Russwurm, G.
The Last Voyage of 'HMS Bulwark'
oil on canvas 30.5 x 40.8
1985/363

Serres, Dominic 1722–1793
Ships on a Lee Shore
oil on canvas 80.5 x 109.5
1952/83

Shaw, Geoff 1892–1970
'HMNZS Achilles', Cruiser, Built by Cammell Laird, Launched 1 September 1932
oil on canvas 47 x 90
1982/522

Shaw, Geoff 1892–1970
The Battle of the North Cape, 26 December 1943
oil on canvas 43 x 89
1992/207/1

Shkolny, Valentin
Brotherhood of Sailors 1991
oil on canvas 70.4 x 80
1993/153/1

Shkolny, Valentin
'May the dead rest in peace' 1991
oil on canvas 71 x 80.3
1993/153/2

Shkolny, Valentin
'O Lord' 1991
oil on canvas 77.3 x 77
1993/153/3

Smith, W. E. B.
'NM LCF15' Sunk, Operation 'Brassard' 1993
oil on canvas 49 x 74
PCF9

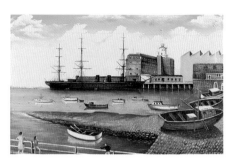

Stechman, Ron
'HMS Warrior' at Her Berth in Portsmouth
oil on canvas 60 x 94
1984/134

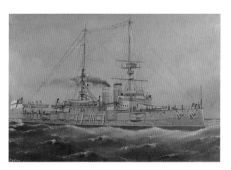

Stephens, H. E.
'HMS Britannia'
oil on canvas 49 x 74.4
1981/281

Tait, W. S.
HRH Prince of Wales (b.1948)
oil on board 45 x 34.5
1981/284 (P)

Terry, John
Firing of Gun on Board 'HMS Victory'
oil on canvas 60 x 131
1979/32

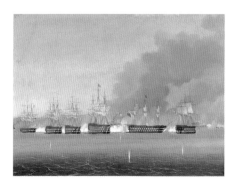

unknown artist
The Bombardment of Acre, 3 November 1840 1841
oil on canvas 39 x 53
1973/384

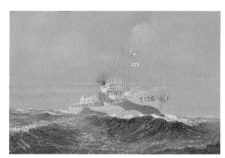

unknown artist
'HMS Olive' 1943
oil on board 25 x 38
1989/598/2

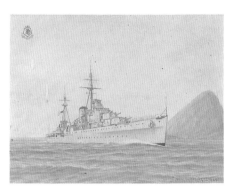

unknown artist
'HMS Ajax' 1946
oil on board 29.5 x 39.2
1990/301/1

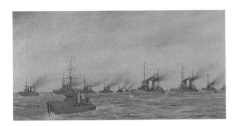

unknown artist 20th C
The Surrender of the German Fleet at Scapa,
21 November 1918
oil on board 29.5 x 60
1980/114

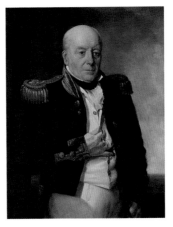

unknown artist
Admiral Charles William Paterson (1756–1841)
oil on canvas 90 x 70
1986/509/1 (P)

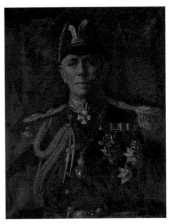

unknown artist
Admiral of the Fleet, Sir George Astley
Callaghan (1852–1920)
oil on canvas 80 x 64
1988/408/12

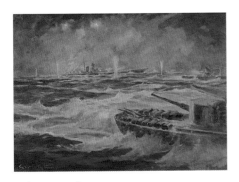

unknown artist
Attack by Destroyers on German Battleship
'Scharnhorst'
oil on canvas 66 x 90 (E)
1988/497/1

unknown artist
Battle Scene
oil on canvas 100 x 250 (E)
PCF22

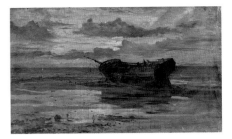

unknown artist
Beached Hulk at Sunset
oil on canvas 55 x 98
PCF13

unknown artist
Boatswain Robert Mackenzie (b.1792)
oil on canvas 76 x 60
1981/188

unknown artist
Captain C. Maud, DSO, DSC
oil on canvas 50 x 42
1980/180

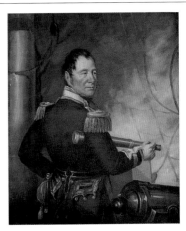

unknown artist
Captain Edward Johnston
oil on canvas 45 x 38
1960/47

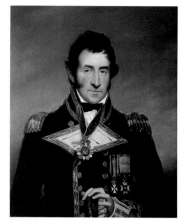

unknown artist
Captain John Coode, CB (d.1858)
oil on canvas 77 x 64
1988/355

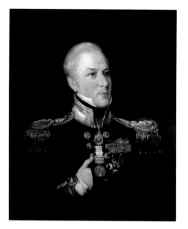

unknown artist
Captain William Henderson
oil on canvas 76 x 62.3
1978/190

unknown artist
*Harbour Scene**
oil on canvas 38 x 57
1973/383

unknown artist
'HMS Amphitrite', c.1890
oil on canvas 42 x 56
2001/83

unknown artist
'HMS Beagle', 'HMS Swallow', 'Basilisk' and 'Flora'
oil on canvas 45.5 x 60.5
1980/147

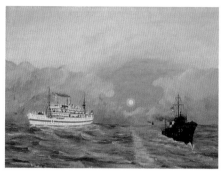

unknown artist
'HMS Garthcastle'
oil on canvas 26.6 x 36.7
1980/213

unknown artist
'HMS Sabre'
oil on canvas 49.5 x 64.8
1985/199

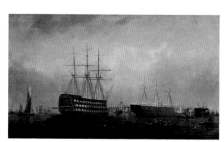

unknown artist
'HMS Victory'
oil on canvas 63.5 x 96.5
1973/332

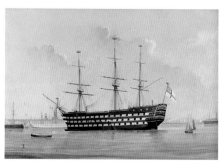

unknown artist
'HMS Victory'
oil on canvas 45 x 65
1984/558

Facing page: Leveson, D., *Lord Howe Receiving the Sword of Honour from King George III on 'Queen Charlotte', 1794* (detail),
HMS Excellent, (p. 58)

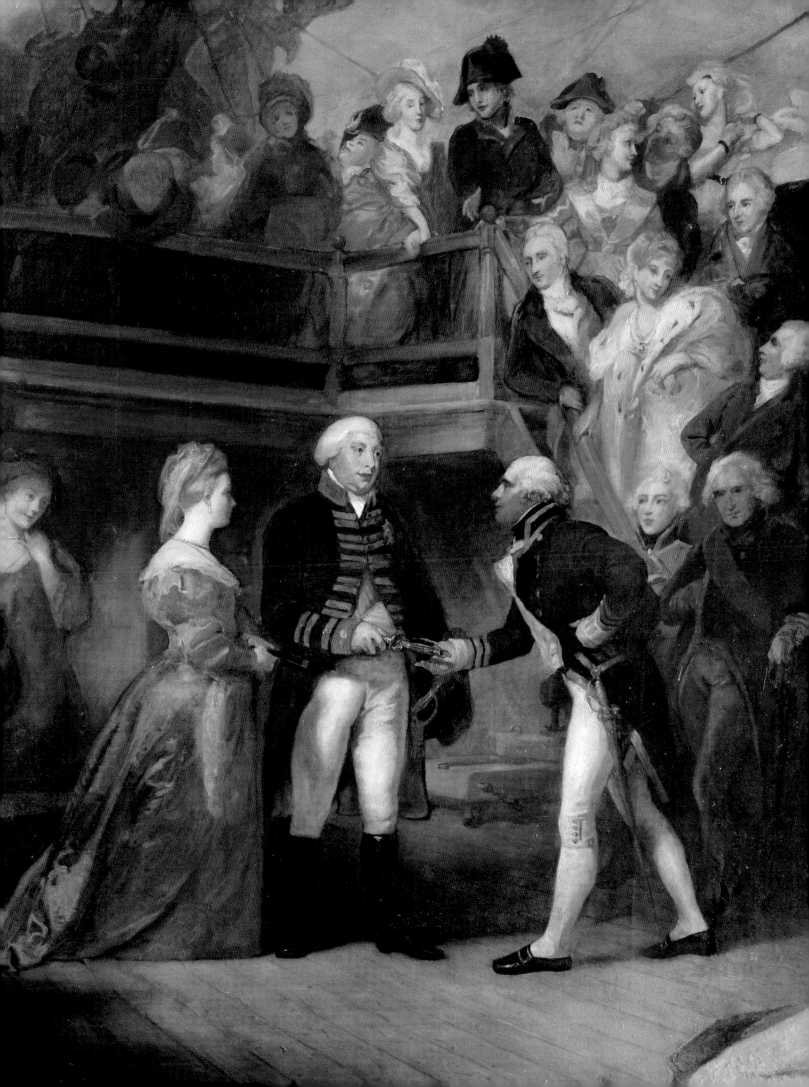

unknown artist
Horatia Nelson (1801–1881)
oil on canvas 90 x 70
1988/116/5

unknown artist
Katharine Furse (1875–1952)
oil on canvas 50 x 30 (E)
1993/448

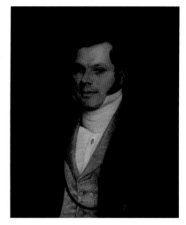

unknown artist
Lieutenant Kelly Nazer
oil on canvas 44.3 x 35.7
1984/29

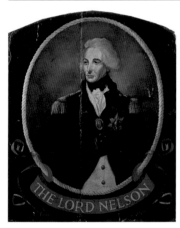

unknown artist
Lord Nelson (1758–1805)
oil on metal 110 x 90 (E)
1973/125

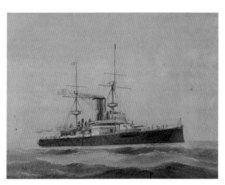

unknown artist
Majestic Type Battleship
oil on canvas 36.5 x 49.3
PCF14

unknown artist
Midshipman Arthur Vladimir Wevill
oil on canvas 72.4 x 59.7
1985/316/1

unknown artist
Mrs Samuel Bird Cook
oil on board 60 x 50
1983/1299

unknown artist
'MV Seaforth Clansman'
acrylic on canvas 150 x 87.9
1987/196

unknown artist
Naval Chaplain Arthur Price Hill
oil on canvas 61 x 49
1986/571

unknown artist
Nelson Tray
oil on paper 40 x 60
1973/239

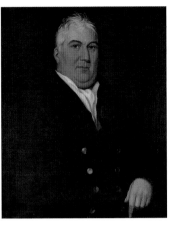

unknown artist
Rear Admiral George Morris
oil on canvas 75 x 65 (E)
1990/83/1

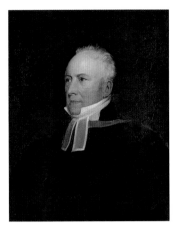

unknown artist
Reverend Dr Samuel Cole
oil on canvas 75 x 59
1977/264

unknown artist
Sail and Steam
oil on canvas 34 x 40
1980/146

unknown artist
Saling Ships in Portsmouth Harbour
oil on canvas 66 x 104
PCF17

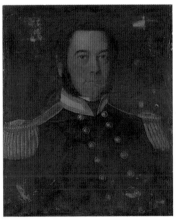

unknown artist
Samuel Bird Cook, RN
oil on board 60.5 x 50
1983/1298

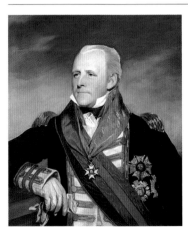

unknown artist
Sir Charles Vinicombe Penrose (1759–1830)
oil on canvas 80 x 65
1988/356

unknown artist
*Sir Edward Hamilton Wearing a Small King's
Gold Medal for the Recapture of 'Hermione' by
Surprise, 25 October 1799*
oil on canvas 74 x 61
1984/333/1

unknown artist
Sir John Leeke
oil on canvas 44 x 34.3
1980/174

unknown artist
The Attack by a Naval Brigade on the Japanese Battery at Shimonoseki, September 1864
oil on canvas 36.5 x 49.3
1990/148

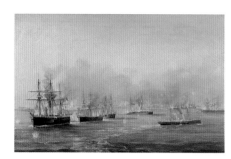

unknown artist
The Bombardment of Alexandria
oil on canvas 41 x 64
1977/307

unknown artist
The Parsonage at Burnham Thorpe
oil on canvas 31 x 42
1972/101 (P)

unknown artist
Troopship 'Tamar'
oil on canvas 44.4 x 58.5
1975/65

unknown artist
Wren Entwistle
oil on canvas 49.5 x 39.5
1990/276

unknown artist
Wrens at Work in the Valve Testing Room, 'HMS Vernon'
oil on canvas 35 x 45 (E)
PCF2

Wilkinson, Norman 1878–1971
The Dover Patrol
oil & watercolour on paper 36 x 51
1985/359/1

Wood, Jennings
Armistice Parade, Constantinople 1919
oil on canvas 36.8 x 53.3
1987/134

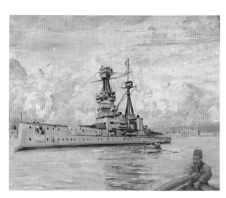

Wood, Jennings
The Flagship 'HMS Superb' 1919
oil on board 39.4 x 48.3
1987/133

Wood, Jennings
The Hanging of Turks in the Streets of Constantinople before the Armistice of 1918
1919
oil on canvas 45.7 x 40.6
1987/135

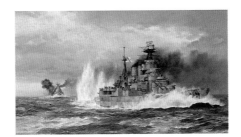

Wright, Paul
Empire Day, 1941
oil on board 69 x 120
1982/440

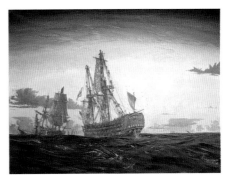

Wyllie, Harold 1880–1973
'Close of Day'
oil on canvas 73.8 x 100.2
1964/20

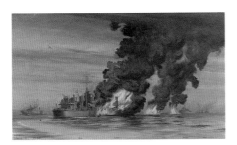

Wyllie, Harold 1880–1973
'HMS Whitley' Coming to the Rescue of 'MV Inverlane', Badly Damaged and on Fire after the Convoy Entered a Mine Field (…)
oil on canvas 51.8 x 99.8
1988/100

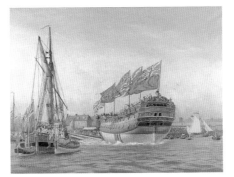

Wyllie, Harold 1880–1973
Launch of the 'Agamemnon', Buckler's Hard, 1781
oil on canvas 90.5 x 117
1964/19

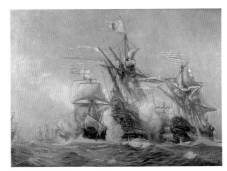

Wyllie, Harold 1880–1973
The Armada
oil on canvas 160 x 223
1983/995

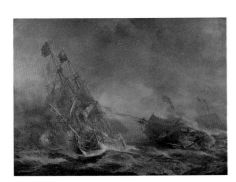

Wyllie, Harold 1880–1973
The Battle of Quiberon Bay, 20 November 1759
oil on canvas 162 x 219
1983/1001

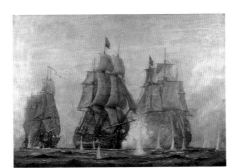

Wyllie, Harold 1880–1973
The Battle of St Vincent, 14 February 1797
oil on canvas 275 x 485 (E)
1983/1000

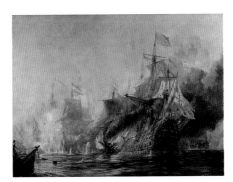

Wyllie, Harold 1880–1973
The Battle of Sole Bay, 28 May 1672
oil on canvas 160 x 220
1983/996

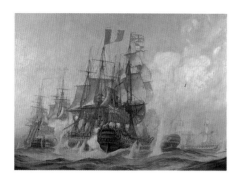

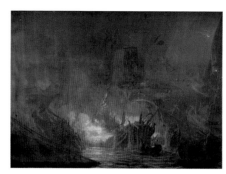

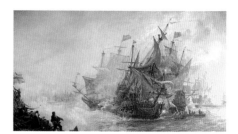

Wyllie, Harold 1880–1973
The First of June, 1794
oil on canvas 275 x 482.6
1983/999

Wyllie, Harold 1880–1973
The Nile
oil on canvas 155.5 x 219
1983/994

Wyllie, William Lionel 1851–1931
The Battle of North Foreland, June 1653 1900
oil on canvas 151 x 273.3
PCF1

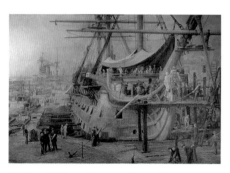

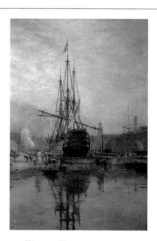

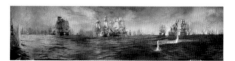

Wyllie, William Lionel 1851–1931
The Restoration of 'HMS Victory' 1925
oil on canvas 123.7 x 183.5
1975/64

Wyllie, William Lionel 1851–1931
The Main Yard of 'HMS Victory' Being Crossed
1928
oil on canvas 225 x 152
1968/20

Wyllie, William Lionel 1851–1931
The Battle of Trafalgar Panorama 1931
oil on canvas 355 x 1260
1984/560

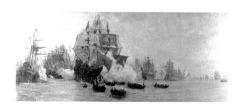

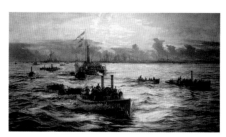

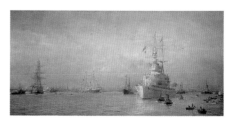

Wyllie, William Lionel 1851–1931
The Battle of Gravelines, 29 July 1588
oil on canvas 68 x 153
PCF21

Wyllie, William Lionel 1851–1931
Liberty Men Landing from Spithead
oil on canvas 88.9 x 150.9
1968/14

Wyllie, William Lionel 1851–1931
'Renown' Leaving Portsmouth Harbour
oil on canvas 60 x 121
1968/16

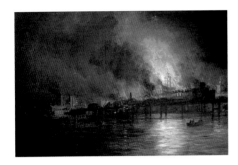

Wyllie, William Lionel 1851–1931
Semaphore Tower on Fire
oil on canvas 89 x 150 (E)
1981/37

Wyllie, William Lionel 1851–1931
The 'Gloucester Hulk' at Chatham
oil on canvas 96.5 x 162.5 (E)
1968/17

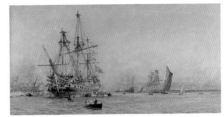

Wyllie, William Lionel 1851–1931
Wooden Warships on the Medway (Man O'War at Anchor)
oil on canvas 59.8 x 120.5
2003/65

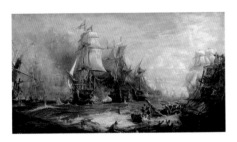

Wyllie, William Lionel (after) 1851–1931
The Battle of Trafalgar, 21 October 1805
oil on canvas 230 x 320
1983/997

Zinkeisen, Doris Clare 1898–1991
Dame Vera Laughton Mathews
oil on canvas 111.8 x 86.2
1991/198

University of Portsmouth

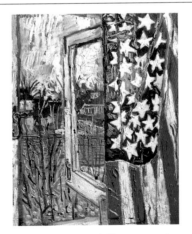

Bratby, John Randall 1928–1992
From the Coach House Window, Curtained with a 45 Star Flag 1966
oil on canvas 67 x 54.2
PCF1 ✲

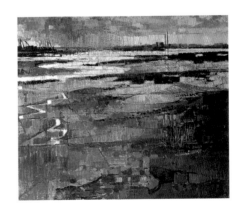

Folkes, Peter L. b.1923
Storm over Southampton from Redbridge No.1
oil on canvas 49.2 x 59.6
PCF3

unknown artist 20th C
Abstract
oil on canvas 175 x 275 (E)
PCF2

Romsey Town Council

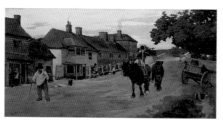

Biddlecombe, Walter active 1874–1902
Mainstone Looking toward Romsey
oil on canvas 64 x 132
PCF4

Crossley, Harley b.1936
The Massed Bands and Corps of Drums of the Wessex Regiment Prince of Wales Division, Romsey, 13 June 1983 1987
oil on canvas 49.5 x 74.7
PCF9

Kneller, Godfrey (attributed to) 1646–1723
Sir William Petty (1623–1687), Political Economist, Inventor, Scientist and Founder Member of the Royal Society
oil on canvas 76 x 60
PCF7

Le Nost, Alain b.1936
Paimpol Harbour 1983
oil on canvas 31 x 44
PCF3

Oxford, Tom
George Mackrell in Mayoral Robes
oil on board 54 x 35
PCF2

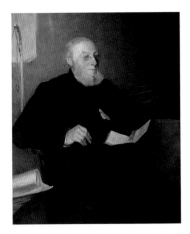

Rands, Sarah E. 1834–1904
Reverend Edward Lyon Berthon (1813–1899),
Vicar of Romsey (1860–1892)
oil on canvas 111.5 x 90
PCF10

Rawlings, Leo 1918–1990
Japanese Prisoner of War, Burma 1939–1946
oil, axel grease & jungle pigments 60 x 50
PCF8

Stark, Dwight V.
Admiral the Viscount Mountbatten of Burma,
KG, PC, GMSI, GCVO, KCB, DSO (1900–
1971), High Steward and First (…) c.1946
oil on canvas 112 x 77
PCF6

Swamy, S. N. active 1950–1960
Lady Edwina Mountbatten (1901–1960) 1960
oil on canvas 75 x 54
PCF5

Woolway, George Richard 1879–1961
Edward VII (1841–1910) 1901–1911
oil on canvas 170 x 120
PCF1

Gilbert White's House & The Oates Museum

Gilbert White was born in 1720 and was educated in Basingstoke by Thomas Wharton, professor of poetry at Oxford, before studying at Oriel College, Oxford. He followed his grandfather and uncle into the church and from an early age took a close interest in the natural world around him.

White is best known for the book *The Natural History and Antiquities of Selborne*. This was a compilation of his letters written to Thomas Pennant and Daines Barrington, both leading naturalists of the day. In the letters, White discussed his observations and theories about flora and fauna in a charming and immediate way. The book is one of the most published in the English language and it has not been out of print since its first publication in 1789.

When Gilbert White died in 1793, his house passed to his brothers and it remained in the ownership of the White family until the 1840s. It then had

a number of private owners until 1953, when the last private owner of the house died.

A public appeal was launched to save the house for the nation, with the intention of raising enough money to purchase the house and set up an endowment fund. Both would then be handed over to the National Trust, which would undertake to open the house to the public. However, the appeal did not raise sufficient funds to purchase the house until Robert Washington Oates came forward. He had set up a fund in memory of his family and a joint Gilbert White and Oates Memorial Trust was created to run the house as a museum.

Today, the Museum commemorates both Gilbert White and the Oates family under the overall theme of 'Exploring the Natural World'. The majority of the paintings in the Trust's ownership derive from the Oates family collection, with about a third relating to the White family of Selborne. The White family paintings are displayed as part of room settings within the part of the house which Gilbert White would have known in the eighteenth century, while the Oates family pictures are displayed in the Oates Museum in the Victorian part of the house.

The core of the house dates back to the seventeenth century. Gilbert White added the Great Parlour and in 1794, a year after his brother's death, Benjamin White built the dining room, now the tea parlour. Professor Bell, who bought the house in 1844, added a library. Extensive alterations were then made by successive owners up to, and including the last private owner, Colonel Bibby, at the beginning of the twentieth century.

An old and complicated building such as this requires constant and costly attention. The house has grown piece-meal and now boasts no less than 17 roofs, most of which needed re-tiling. Much of the exterior brickwork, stonework and woodwork needed attention. The interior of the house was also in need of work to the electrical wiring and heating systems.

Gilbert White's house is a Grade I listed building with a fascinating history. It is of great architectural interest in its own right but it is also important as the home of a great pioneer in the study of natural history. The recently completed restoration work will ensure that the heritage enshrined in the building will be safeguarded.

We are vesry grateful to the Public Catalogue Foundation for enabling us to make this part of our collection accessible to a wider audience.

Maria Newbery, Director

Facing page: Bizard, Jean-Baptiste, 1796–1860, *George Sand (1804–1876)* (detail), 1847, Chawton House Library, (p. 13)

Barber, Gordon W.
High Wood, Selborne
oil on canvas 24.5 x 34.5
1994.517

Barber, Gordon W.
St Mary's Church
oil on canvas 29.5 x 39 (E)
1994.522

Barber, Gordon W.
Yew Hedge in Gilbert White's Garden
oil on canvas 29.5 x 39 (E)
1994.523

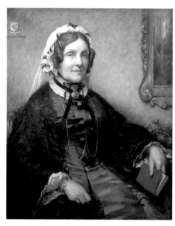

Calkin, Lance 1859–1936
Anna Maria Oates (1799–1870)
oil on canvas 74.7 x 62
1994.583

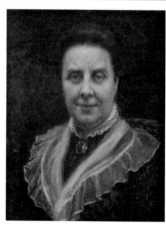

Calkin, Lance 1859–1936
Emma Francis Oates
oil on canvas 34 x 29
1994.576

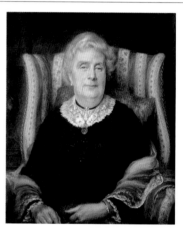

Calkin, Lance 1859–1936
Emma Franks Oates
oil on canvas 76 x 63.5
1994.546

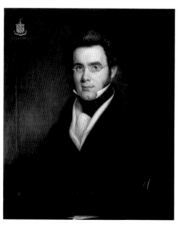

Calkin, Lance 1859–1936
Hibbert Oates (1797–1840)
oil on canvas 74.7 x 61.9
1994.365

Holroyd, John Newman active 1909–1947
Robert Washington Oates (1874–1958) 1947
oil on canvas 70.7 x 60.5
2006.6

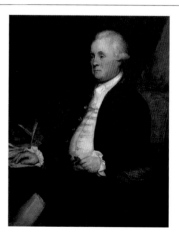

Robinson, Thomas b. before 1770–1810
Thomas White (1724–1797)
oil on canvas 105.5 x 90
1994.30 (P)

Seaby, Allen William 1867–1953
Landscape 1912
oil on canvas 20.2 x 27.6
2006.2

Seaby, Allen William 1867–1953
The Wakes
oil on canvas 36.8 x 26.5
2006.1

Swann, E.
Frank Oates, OBE (1890–1945) 1945
oil on canvas 75 x 57.5
1994.366

unknown artist
A Church, possibly Selborne
oil on canvas 24.5 x 30.2
1994.518

unknown artist
Anne Ford
oil on canvas 71.8 x 59
1994.36 (P)

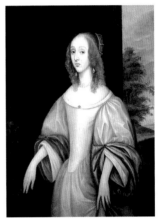

unknown artist
Anne White (1693–1739)
oil on canvas 104.5 x 84.3
1994.35 (P)

unknown artist
Charles George Oates (1844–1901)
oil on canvas 74.5 x 62
1994.264

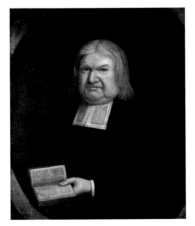

unknown artist
Edmund Yalden (1727–1779)
oil on canvas 73 x 60.5
1994.31

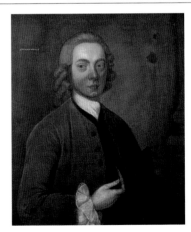

unknown artist
Edward Grace Junior
oil on canvas 73.2 x 62
1994.536

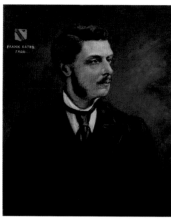

unknown artist
Frank Oates, FRGS (1840–1875)
oil on canvas 75 x 57.5
1994.368

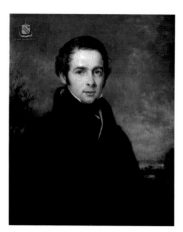

unknown artist
George Hibbert Oates (1791–1837)
oil on canvas 74.9 x 62
2006.8

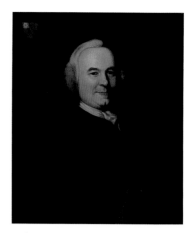

unknown artist
George Oates (1717–1779)
oil on canvas 75 x 62.2
1994.254

unknown artist
Gilbert White Memorial Wood
oil on canvas 42 x 55
1994.547

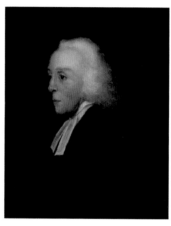

unknown artist
John White
oil on canvas 30.3 x 24.4
2006.7 (P)

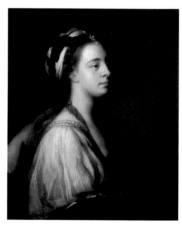

unknown artist
Katherine Battie
oil on canvas 74.5 x 62.5
2006.5 (P)

unknown artist
Kissing on the Strand
oil on canvas 22 x 29.5
1994.306

unknown artist
Lawrence Oates (1880–1912)
oil on canvas 74 x 62
1994.364

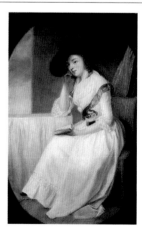

unknown artist
Mary White (1759–1833)
oil on canvas 58.3 x 37.3
2006.4 (P)

unknown artist
Mr Bennett
oil on panel 56 x 45.5
1994.530a

unknown artist
Mrs Bennett
oil on panel 56 x 45.5
1994.530b

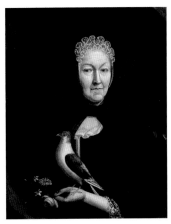

unknown artist
Mrs Hannah Yalden
oil on canvas 73 x 60.5
1994.32

unknown artist
Portrait of a Lady
oil on canvas 73 x 59.2
1994.38

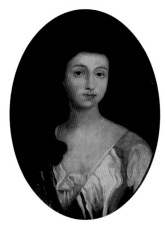

unknown artist
Rebecca Snooke (1694–1780)
oil on canvas 62.3 x 45.7
2006.3

unknown artist
Reverend Gilbert White (1720–1793)
oil on canvas 73.5 x 61
PCF6

unknown artist
Reverend Thomas Holt
oil on canvas 73.5 x 60.5
1994.37 (P)

unknown artist
Robert Oates (1827–1921)
oil on canvas 70 x 54.7
1994.537

unknown artist
Samuel Oates (1722–1789)
oil on canvas 79 x 61.8
1994.540

unknown artist
Selborne from the Hanger
oil on canvas 65.5 x 40
1994.598

unknown artist
The Gates of the Diogryth
oil on canvas 90 x 62.2
1994.531

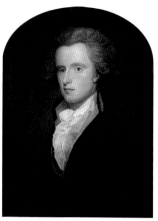

unknown artist
Thomas Holt-White (1763–1841)
oil on canvas 71.5 x 53
1994.40 (P)

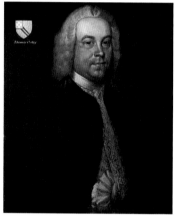

unknown artist
Thomas Oates (1710–1750)
oil on canvas 73.6 x 61.5
1994.538

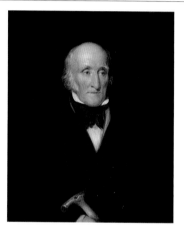

Wood, John 1801–1870
Thomas Holt-White (1763–1841), Aged 77
oil on canvas 75 x 62
1994.39 (P)

Hampshire County Council's Contemporary Art Collection

Hampshire County Council began its collection of contemporary art and craft approximately 20 years ago. In a bold move, significant British artists' work was confidently collected from high profile auction houses and dealers. Bridget Riley, David Hockney, Henry Moore, Victor Pasmore and John Piper to name a few. Officers were building a collection of works from nationally important artists. For affordability, the work favoured was predominantly prints and so much of the County's collection is unfortunately not featured here in this catalogue. But many of those early purchases comprise a series of local scenes by Annabel Gault, skyscapes by Brendan Neiland, a Hampshire field by Robert Buhler and two other smaller works by David Morgan and David Atkins.

The purpose was then, as it is today, to enhance the working environment for staff and create a more welcoming place to visit. The works are located in

County Council offices rather than a gallery and are on view for the staff and visitors who use those spaces. The impact of placing quality original visual art and craft in ordinary offices is recognised as highly important. Investing in the collection is also seen as an investment in the Council's staff, creating a high quality and inspiring working environment. An opportunity to create themed exhibitions has arisen with the building of a new gallery in the Winchester Discovery Centre. These exhibitions will be organised by a curatorial team and will enable a wider public to enjoy the artworks.

Currently the collecting policy is to invest locally, in the rich pool of artists, craft makers and galleries Hampshire has to offer. By supporting Hampshire artists or organisations, the County Council supports the local cultural economy and raises the profile and awareness of locally based talent and resources.

Most recently, new works have eagerly been purchased from artists such as Kathy Ramsay Carr, Nick Andrew and Peter Joyce. Hampshire locals like Christine Hughes and Margaret McLellan from the New Forest were discovered by researchers, and hundreds of other visitors, at annual open studio events, whereas artists such as Masako Tobita and Andy Waite were found in local galleries. These examples are just some of the strong works giving colour, variety and value to the collection.

Functional bespoke craft in daily use, site specific sculpture, prints and paintings form a 300-piece strong collection situated in offices and County sites across Hampshire. Roughly one third of the collection consists of the paintings illustrated in this catalogue. The County Council is immensely proud of how the collection has developed and is delighted to be part of this record of works in public collections.

Janet Mein, Head of the Arts Service

Andrew, Nick b.1957
Acer
acrylic on paper 30.4 x 40.6
14

Andrew, Nick b.1957
Anthra
acrylic on paper 36 x 36
311

Andrew, Nick b.1957
Beorna
acrylic on paper 36 x 36
310

Andrew, Nick b.1957
Millefolia
acrylic & oil on paper 70 x 71.4
225

Andrew, Nick b.1957
Rilla
acrylic & oil on paper 71 x 72
224

Atkins, David b.1964
Summer Storm c.1997
oil on board 16 x 18.6
15

Barnes, Catherine b.1947
Hill Barn
oil on canvas 91.8 x 91.8
210

Barnes, Catherine b.1947
Hill Village
oil on canvas 35.2 x 47.4
212

Barnes, Catherine b.1947
Looking Outwards
oil on canvas 91 x 96.4 (E)
233

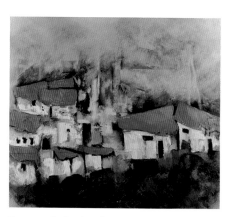

Barnes, Catherine b.1947
Out of the City
oil on canvas 106.4 x 121.6
213

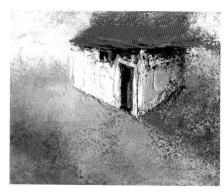

Barnes, Catherine b.1947
Vermillion Mountain Hut
oil on canvas 35.4 x 45.6
211

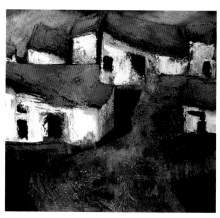

Barnes, Catherine b.1947
Village Life
oil on canvas 71 x 76
209

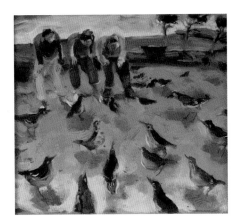

Bealing, Nicola b.1963
The Bird Island
oil on board 18 x 20
182

Beaugié, Kate b.1975
Wiltshire Winter
oil on board 46.7 x 118
283

Becket, Mike b.1946
Left-Handed Guitarist
acrylic on board 25.8 x 22.7
183

Bray, Jill
Confrontation
oil on canvas 76.4 x 101.4
19

Buhler, Robert 1916–1989
Corner of a Field, Hampshire
oil on board 34 x 44.1
24 🐝

Burrows, Bev b.1955
Arish Mell and Flowers Barrow
acrylic on canvas 59 x 44.5
196

Burrows, Bev b.1955
Footpath at Pinnacle Rock
acrylic on canvas 44.5 x 60
197

Burrows, Bev b.1955
Kimmeridge
acrylic on canvas 59 x 44
198

Burrows, Bev b.1955
Rocky Shore at Mudeford
acrylic on canvas 44 x 59
199

Butterworth, John b.1962
Voyager No.1
mixed media on handmade paper 42 x 47.4
25

Chisholm, Josephine b.1955
Arc de Triomphe, Paris
mixed media on paper 34.2 x 24.8
241

Crabbe, Richard 1927–1970
Gulf Thanksgiving, Portsmouth
oil on canvas 104.2 x 120
37

Crabbe, Richard 1927–1970
Sailors at a Thanksgiving Parade
oil on board 37 x 22.4
35

Crowther, Patricia b.1965
Cape Forms
oil on board 14.4 x 14.2
274

Crowther, Patricia b.1965
Circle with Ochre
oil on board 14.4 x 14.4
277

Crowther, Patricia b.1965
Porthmeor Elements
oil on board 14.2 x 14.6
275

Crowther, Patricia b.1965
Porthmeor Forms
oil on board 14.4 x 14.8
276

Crowther, Patricia b.1965
Porthmeor Rain
oil on board 14.4 x 14.6
278

Facing page: Goodall, John Edward, active 1877–1891, *The Battle of the Nile* (detail), c.1930, Royal Marines Museum, (p. 182)

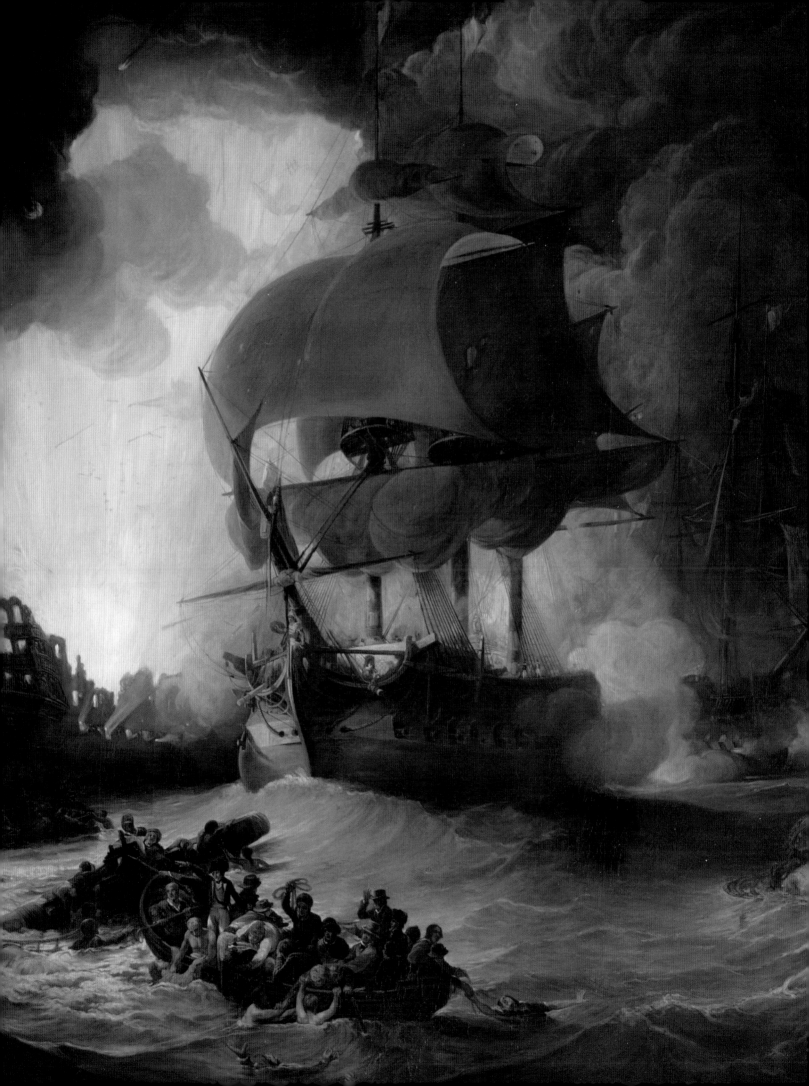

Dworok, Peter b.1950
Derwentwater
oil on board 58 x 13
316

Dworok, Peter b.1950
Ullswater
oil on board 58 x 12.5
317

Eurich, Richard Ernst 1903–1992
Breakwater
oil on board 45 x 60
214 🐞

Eurich, Richard Ernst 1903–1992
Rain and Rainbow
oil on board 30.4 x 40.6
187 🐞

Flesseman, Meinke b.1966
Untitled
mixed media on canvas 90 x 137
312

Flesseman, Meinke b.1966
Untitled
mixed media on canvas 67.5 x 68
313

Gault, Annabel b.1952
Butser Hill, Morning, November 1994
oil on paper 73 x 83.2
51

Gault, Annabel b.1952
Butser Hill II, November 1993
oil on board 17.5 x 24.6
45

Gault, Annabel b.1952
North from Butser Hill II, November 1994
oil on paper 38 x 46.4
52

Gault, Annabel b.1952
North from Butser Hill III, December 1994
oil on paper 100 x 112
53

Gault, Annabel b.1952
Path on Butser, Afternoon, June 1994
oil on paper 15.4 x 20.4
47

Gault, Annabel b.1952
View from Cross Dykes, November 1993
oil on paper 17.6 x 20
44

Gault, Annabel b.1952
West from Butser Hill, Morning, November 1994
oil on paper 25.8 x 27.4
48

Goodman, Claire b.1963
Tree Reflections
oil on canvas 61 x 45.8
281

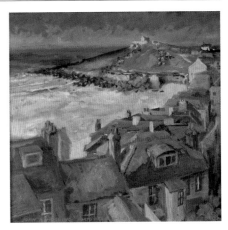

Hosking, John b.1952
Porthmeor, St Ives
oil on board 24 x 25
181

Hughes, Christine b.1946
Christchurch Harbour No.1
oil on board 16.5 x 27
261

Hughes, Christine b.1946
Christchurch Harbour No.2
oil on board 16.5 x 27
261

Hughes, Christine b.1946
Cornish Coast
oil on canvas 86 x 86.5
265

243

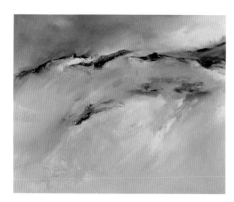

Hughes, Christine b.1946
High Buzzard Knot
oil on canvas 92.2 x 112
242

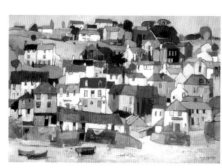

Huntly, Moira b.1932
Port Isaac, Cornwall
acrylic on board 52.4 x 77.6
284

Joyce, Peter b.1964
Near the Bill
acrylic on paper 70 x 23.4
289

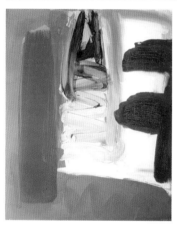

Knowles, Stuart b.1948
Study (Untitled), 1993 (from the 'Sea, Stone, Moon' series)
oil on paper 43.8 x 36.2
80

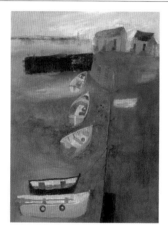

Launder, June b.1954
Old Fishguard
acrylic on paper 38 x 28
292

Marsland, Derek b.1957
Field and Trees
oil on canvas 40 x 112
314

Marsland, Derek b.1957
Oak at Sunset
oil on canvas 30 x 60
315

McLellan, Margaret b.1952
Ancestral Gold
oil on canvas 38 x 38.5
288

McLellan, Margaret b.1952
Ancient Farmland V
acrylic & Japanese lace paper on board
40 x 40.5
287

McLellan, Margaret b.1952
Interior St Andrew's (Winterborne Tomson)
mixed media on board 61 x 81.2
285

McLellan, Margaret b.1952
Morning Portland
acrylic & conté crayon on board 23 x 23
286

Morgan, David b.1947
Mudeford Quay
oil on board 17.8 x 24.8
88

Neiland, Brendan b.1941
Cloud Study I
acrylic on paper 31 x 31
90

Neiland, Brendan b.1941
Cloud Study II
acrylic on paper 31 x 31
91

Neiland, Brendan b.1941
Cloud Study III
acrylic on paper 31 x 31
92

Neiland, Brendan b.1941
Cloud Study IV
acrylic on paper 31 x 31
93

Neiland, Brendan b.1941
Cloud Study V
acrylic on paper 21 x 47.6
94

O'Keeffe, Noelle b.1961
Small Tapestry Pond
oil on canvas 30.4 x 30.4
291

Perrett, Angela b.1946
Crevice
mixed media on board 78 x 55.4
255

Perrett, Angela b.1946
Shell Shore VI
mixed media on board 38 x 37.8
256

Perrett, Angela b.1946
Shell Shore X
mixed media on board 57 x 57
257

Plowman, Chris b.1952
Big Wheel
mixed media on paper 17 x 23
178

Plowman, Chris b.1952
Small House
mixed media on paper 19 x 23
179

Ramsay Carr, Kathy b.1952
Harmony West
oil on canvas 76 x 76.1
307

Ramsay Carr, Kathy b.1952
Sky Glas
oil on canvas 75.8 x 76
306

Robertson, Gillian b.1952
Denial
oil on canvas 102 x 198
244

Robertson, Gillian b.1952
Seeing Her
oil on canvas 101.4 x 152.6
243

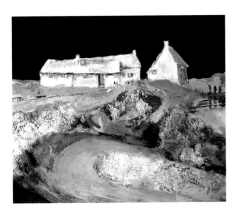

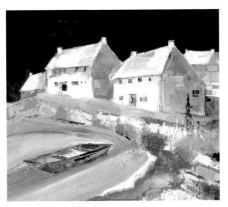

Sey, Eileen b.1941
Cornish Fishing Village
acrylic on board 28.2 x 33.2 (E)
280

Sey, Eileen b.1941
Cottage by the Sea
acrylic on board 28.2 x 33.2 (E)
279

Smitt, A.
An Island near the Shore
oil on paper 25.6 x 76.2
222

Tarr, Deborah b.1966
Rose Room V
oil on canvas 76 x 68
186

Taylor, Frank b.1946
The Pilgrimage
mixed media on canvas 72.4 x 87.6
216

Tobita, Masako b.1954
All of a Sudden
oil on canvas 89 x 89
254

Tobita, Masako b.1954
Bow out, out
oil on canvas 80 x 80
269

Tobita, Masako b.1954
October Morning
oil on canvas 60 x 70.2
267

Tobita, Masako b.1954
Silent Move
oil on canvas 80 x 80.4
268

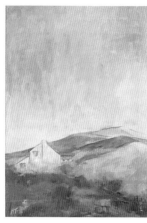

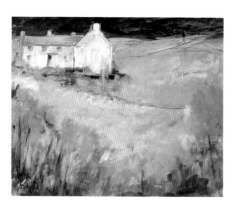

Triffitt, Mary
Cheynhall
acrylic on board 48.1 x 34.2
245

Triffitt, Mary
Cornish Farmhouse
acrylic on board 44.4 x 54.6
236

Triffitt, Mary
Golden Landscape
acrylic on paper 32 x 34.5
251

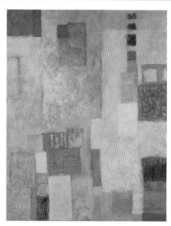

Triffitt, Mary
Lone Barn
acrylic on canvas 34.8 x 53.8
237

Vyvyan, Angela b.1929
City Gardens
oil on canvas 75.6 x 60.8
239

Vyvyan, Angela b.1929
City Park IV
oil on board 46 x 66
238

Vyvyan, Angela b.1929
Path to the Shore No.1
oil on board 46.2 x 66
240

Waite, Andy b.1954
Blue Field
oil on canvas 30 x 30
324

Waite, Andy b.1954
Green Lake
oil on canvas 31 x 31
321

Waite, Andy b.1954
Lake
oil on canvas 30 x 30
323

Waite, Andy b.1954
Park
oil on canvas 30 x 30
322

Wallbridge, Tina Bird b.1960
Cathedral/College
acrylic on canvas 51.2 x 20.2
282

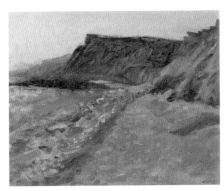

Wallbridge, Tina Bird b.1960
Tower Arts
acrylic on canvas 118 x 45
294

Wallbridge, Tina Bird b.1960
West Hill
acrylic on canvas (set of 4) 104 x 104
308

Woolley, James
Barton Cliffs
oil on board 19.4 x 24.2
250

Woolley, James
Highcliffe Barbeques
oil on board 19.4 x 24.2
248

Woolley, James
Incoming Tide
oil on board 24.4 x 19.2
247

Woolley, James
Langton Ledges
oil on board 19.2 x 24
249

Woolley, James
September Sea
oil on board 23.6 x 18.4
246

Hampshire County Council Museums Service

Hampshire County Council's Museums Service had its beginnings in the nineteenth century, when the townspeople of Alton founded a Mechanics Institute and Library, and later added a Museum for the benefit of local people. Later foundations at Christchurch, with the Red House Museum begun by Herbert Druitt, and at Basingstoke where the Willis Museum is named after its first curator, were brought together under the umbrella of the Hampshire County Council and formed the core of the Museums Service.

The Service owns a relatively small but important collection of Hampshire related material, dating from the early 1600s to the present day. The collection has grown steadily over the past 35 years, and while the greater part consists of works in watercolour or pencil, there are a significant number of works in oil included in the present catalogue.

Hampshire is fortunate in having not only a rich and varied landscape, but also a coastline which offers both views across creeks and estuaries, man-made ports and harbours that are home to both naval and merchant shipping. All these aspects of local life are recorded in the art collection, although the interpretation may be very different. William Shayer's *Gypsy Encampment in the New Forest* is a typically sentimental representation of a travelling family. The works of William Herbert Allen, by contrast, while capable of representing romantic rural scenes as in *Pastoral, Sheep in the Meadows, Farnham*, are always set in the present day. Allen saw himself as recording a vanishing way of life on the Surrey/Hampshire border in the period between the two World Wars, and his paintings, though very gentle and inspired by deep affection for the landscape, are rigorous representations of a world that was about to disappear. Over 6,000 paintings, drawings and sketches were bequeathed to the Curtis Museum in Alton in 1943, and now form part of the county collection.

While Allen's main occupation was as Director of Farnham College of Art, the little town of Petersfield was, for many years, the hub of a small artistic community founded by an East End medical practitioner, Dr Harry Roberts.

Facing page: Vyvyan, Angela, b.1929, *City Gardens* (detail), Hampshire County Council's Contemporary Art Collection, (p. 248)

Roberts' daughter, Hazel, married George Marston, the artist on Shackleton's 1915 expedition to the Antarctic, who painted both *Self Portrait* and *Antarctic Sea and LandscapeView*. By far the best known member of the group however was Flora Twort, a particularly skilled artist in pastel, but who also worked in watercolour, and to a lesser extent in oil. Flora recorded the life of Petersfield from her studio above the bookshop she ran with two friends, later sketching and painting the estuary and harbour at Langstone where she lived at Langstone Mill. Like Allen, Flora was very aware of the huge social and political changes that were occurring throughout the first half of the twentieth century, and of the effect of change on the town. In 1964 she said 'No doubt we have gained a lot in 40 years – these pictures are reminders of some of the things we have lost.' Flora continued to paint until almost the end of her life, recording scenes such as *Pontoon at Heath Lake, Petersfield*. When she died in 1985 she bequeathed not only a collection of her works but her studio in Petersfield to Hampshire County Council. The Flora Twort Gallery now displays an exhibition of her works, selected from the collection in our care and changed on a regular basis.

Like Flora Twort, Martin Snape's work was thought worthy of exhibition at the Royal Academy. Born in Gosport in 1857, Snape was a prolific and accomplished topographical artist who took advantage of the local railway system to travel into the Meon Valley to paint. His best loved scenes, however, are those that record Gosport, Portsmouth and the local coastline, such as the painting of *The Hard, Gosport.*

A view that is very much less known today, but which has considerable modern resonance, is the view of *Prison Hulks in Portsmouth Harbour* painted in the early years of the nineteenth century by Louis Garneray. Less than half a century later, Edwin Weedon's painting of *The Launching of 'HMS Royal Sovereign' at Portsmouth, 25 April 1857*, expresses an altogether more uplifting and patriotic representation of the local coast and its shipping.

Like many other museums, Hampshire acquires its collections with the assistance of a number of different agencies, and is immensely grateful for the support it has received over the years from the Victoria & Albert Museum Purchase Grant Fund, the National Art Collections Fund, the Heritage Lottery Fund, and private donors.

One of our most important acquisitions in recent years, purchased with the assistance of the Heritage Lottery Fund, was the archive of Frederick Bowker, a local solicitor in the nineteenth century who acted on behalf of the Tichborne family during the Tichborne Trials. The case concerned a young man, Roger Tichborne, supposedly lost at sea, and the appearance more than a decade later of a man from the Australian Outback, claiming to be the missing heir. Until 1996 the case was the longest in British legal history and had huge social and political implications. *The Tichborne Trial* by Frederick Sargent, shows the Tichborne Claimant at the second trial for perjury, at which he was found guilty and sentenced to 14 years imprisonment. An Act of Parliament was passed immediately afterwards confirming the right of Roger Tichborne's infant nephew to the family title and estates; a second Act made it an offence to impersonate anybody with a view to acquiring money or property. The problems of identity theft today make the painting, and the story of the Tichborne Trials, hugely relevant, and the museums service has received several

expressions of interest in the Tichborne archive from museums both at home and overseas.

Making material accessible is a problem for most museums today, with collections that have outstripped the gallery space available, and increasing pressure on funds for conservation, restoration and collections management. Hampshire Museums Service has taken the decision to make as much of our fine and decorative art as possible available online and has a number of projects in hand to that end. We welcome the opportunity to work with the Public Catalogue Foundation and the potential thus afforded to make our collections accessible to a wider public.

Alastair Penfold, Head of Collections

Allan, Christina active 1884–1900
Place Mill and Priory
oil on canvas 39 x 59
FA2006.546

Allan, Christina active 1884–1900
The Mill at Christchurch
oil on canvas 34.5 x 53
FA2006.556

Allan, Christina active 1884–1900
Village and Bridge at Iford
oil on canvas 29 x 49.5
FA2006.552

Allan, Stanley Larpent 1867–1947
The Havant to Emsworth Road, Looking East towards the Green Pond and Forge
oil on canvas 39.2 x 59.2
FA1993.2

Allan, Stanley Larpent 1867–1947
The Portsmouth to London Road, Looking North to the Village of Waterlooville with St George's Church to the Left
oil on canvas 39.5 x 59.5
FA1993.1

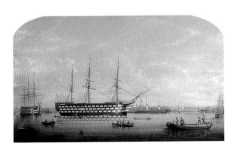

Atkins, William Edward 1842–1910
'Victory'
oil on canvas 102 x 176
FA2007.70

Allen, William Herbert 1863–1943
Male Model 1888
oil on canvas 80.5 x 56
ACM1943.346.782.17

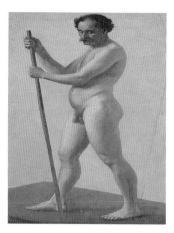

Allen, William Herbert 1863–1943
Male Model 1888
oil on canvas 80.5 x 56
ACM1943.346.782.18

Allen, William Herbert 1863–1943
Still Life Studies 1888
oil on canvas 75 x 50
ACM1943.346.782.15

Allen, William Herbert 1863–1943
Still Life Studies 1888
oil on canvas 50 x 75.5
ACM1943.346.782.16

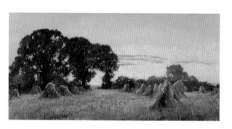

Allen, William Herbert 1863–1943
Stooked Corn in Pale Sunlight 1907
oil on canvas 30.5 x 61
ACM1943.346.134

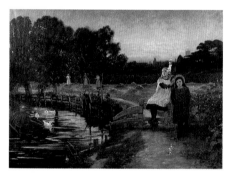

Allen, William Herbert 1863–1943
Haymaking at Dusk, Farnham Water Meadows
c.1916
oil on canvas 114 x 160
ACM1943.346.33

Allen, William Herbert 1863–1943
Chantel de la Flechère c.1929
tempera on prepared gesso panel 47 x 25
ACM1943.346.88

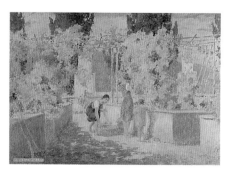

Allen, William Herbert 1863–1943
Grape Picking in Italy 1930s
tempera on prepared gesso wooden board
37.5 x 54
ACM1943.346.107

Allen, William Herbert 1863–1943
La Giona, Lake Maggiore 1930s
oil on canvas 56.5 x 112
ACM1943.346.27

Allen, William Herbert 1863–1943
In the Tuileries Gardens c.1932
tempera on prepared gesso wooden board
47 x 61.5
ACM1943.346.594

Allen, William Herbert 1863–1943
The Fold c.1932
tempera on prepared gesso wooden board
56 x 65.5
ACM1943.346.29

Allen, William Herbert 1863–1943
*The Oratorio, Sacred Cantata Performed in
Farnham Parish Church* c.1932
tempera on prepared gesso panel 46 x 81
ACM1943.346.21

Allen, William Herbert 1863–1943
The Tuileries c.1932
tempera on prepared gesso wooden board
43 x 59.5
ACM1943.346.592

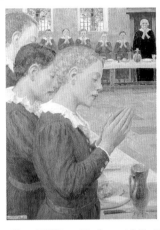

Allen, William Herbert 1863–1943
Grace, These Creatures Bless c.1939
tempera on prepared gesso wooden board
56 x 42
ACM1943.346.17

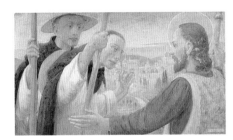

Allen, William Herbert 1863–1943
Sarmarole c.1939
tempera on prepared gesso wooden board
46.5 x 82
ACM1943.346.16

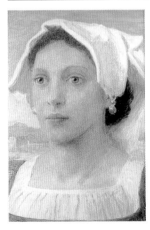

Allen, William Herbert 1863–1943
A Breton Peasant Girl
tempera on prepared gesso wooden board
34.5 x 24.5
ACM1943.346.8

Allen, William Herbert 1863–1943
A Chapel in the Mountains
oil on canvas 51 x 30.5
ACM1943.346.130

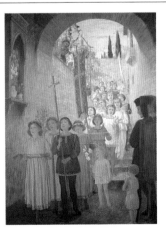

Allen, William Herbert 1863–1943
A Children's Religious Procession
oil on canvas 122 x 91.5
ACM1943.346.69

Allen, William Herbert 1863–1943
A Country Walk
oil on canvas 41 x 30.5
FA1997.84

Allen, William Herbert 1863–1943
A Hop Kiln
oil on canvas 51 x 30.5
ACM1943.346.82

Allen, William Herbert 1863–1943
A Quiet Backwater
oil on canvas 57 x 48
ACM1943.346.142

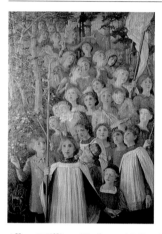

Allen, William Herbert 1863–1943
A Religious Procession
oil on canvas 160 x 114
ACM1943.346.4

Allen, William Herbert 1863–1943
A Windmill
oil on canvas 91.5 x 71
ACM1943.346.49

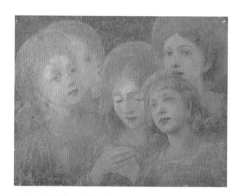

Allen, William Herbert 1863–1943
Angels
oil on canvas 39.5 x 51
FA1997.87

Allen, William Herbert 1863–1943
Birch Trees
oil on canvas 33 x 43
ACM1943.346.131

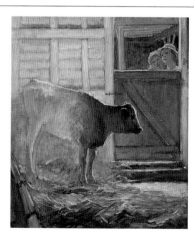

Allen, William Herbert 1863–1943
Calf in a Shed, Stovold's Farm
oil on canvas 46 x 41
ACM1943.346.115

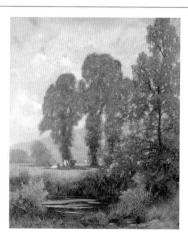

Allen, William Herbert 1863–1943
Cattle beneath Elms
oil on canvas 76.5 x 63.5
ACM1943.346.124

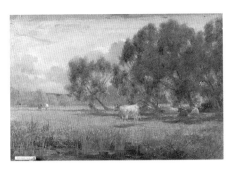

Allen, William Herbert 1863–1943
Cattle in the Water Meadow
oil on canvas 51 x 76
ACM1943.346.152

Allen, William Herbert 1863–1943
Choir Boys Singing
oil on canvas 30.5 x 51
ACM1943.346.154

Allen, William Herbert 1863–1943
Continental Street Scene
oil on canvas 61 x 40.5
ACM1943.346.146

Allen, William Herbert 1863–1943
Corn Stooks, Farnham
oil on canvas 91.5 x 121
FA2006.603

Allen, William Herbert 1863–1943
Corn Stooks, Farnham
oil on canvas 49.5 x 55
FA2006.614

Allen, William Herbert 1863–1943
Corn Stooks in Sunlight
oil on canvas 58 x 48
ACM1943.346.141

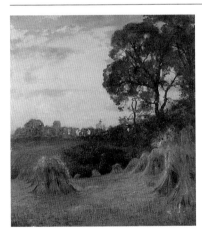

Allen, William Herbert 1863–1943
Corn Stooks in the Sunset
oil on canvas 56 x 51
ACM1943.346.118

Allen, William Herbert 1863–1943
Corn Stooks, possibly Crooksbury Hill
oil on canvas 45.5 x 61
FA2006.613

Allen, William Herbert 1863–1943
Country Scene
oil on canvas 53.5 x 43
ACM1943.346.79

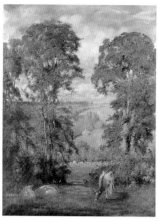

Allen, William Herbert 1863–1943
Cow Grazing in Landscape
oil on canvas 90 x 69
FA2006.608

Allen, William Herbert 1863–1943
Cows for Milking
oil on canvas 67 x 114
FA2006.609

Allen, William Herbert 1863–1943
Cows Watering beneath Bradford-on-Avon
tempera & pencil on prepared gesso wooden
board 37.5 x 58
ACM1943.346.792

Allen, William Herbert 1863–1943
Dante (1265–1321)
oil on canvas 51 x 41
FA1997.77

Allen, William Herbert 1863–1943
Fiesole, Florence, Val d'Arno
oil on canvas 68.5 x 114
ACM1943.346.59

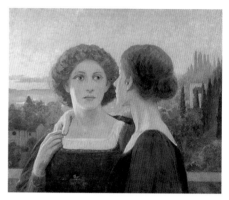

Allen, William Herbert 1863–1943
Friendship
oil on canvas 54.5 x 65
ACM1943.346.12

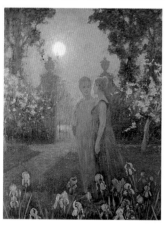

Allen, William Herbert 1863–1943
Friendship
oil on canvas 93 x 73
FA1997.75

Allen, William Herbert 1863–1943
Garden with Sundial
oil on panel 35.5 x 25.5
ACM1943.346.101

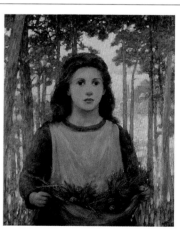

Allen, William Herbert 1863–1943
Girl Gathering Fir Cones
oil on canvas 64 x 54
ACM1943.346.116

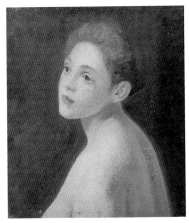

Allen, William Herbert 1863–1943
Girl with Bare Shoulders against a Reddish Background
oil on canvas 41 x 35.5
ACM1943.346.138

Allen, William Herbert 1863–1943
Haystacks in the Moonlight
oil on canvas 30.5 x 51
FA1997.76

Allen, William Herbert 1863–1943
Hillside at Fiesole, Florence, Val d'Arno, Italy
oil on canvas 56.5 x 112
ACM1943.346.750

Allen, William Herbert 1863–1943
In the Bourne
oil on cardboard 46.5 x 36
ACM1943.346.93

Allen, William Herbert 1863–1943
Leading the Cow
oil on canvas 52 x 37
ACM1943.346.132

Allen, William Herbert 1863–1943
Leading the Flock at Dusk
oil on canvas 38 x 28
FA1997.85

Allen, William Herbert 1863–1943
Market Scene, Lucerne
oil on canvas 119 x 95
FA2006.611

Allen, William Herbert 1863–1943
Marshland on the Edge of the Wood
oil on panel 35.5 x 25.5
ACM1943.346.102

Allen, William Herbert 1863–1943
Milkmaid and Cow in Landscape
oil on canvas 92 x 122.5
FA2006.604

Allen, William Herbert 1863–1943
Milkmaid, Mount Orgueil, Jersey
oil on canvas 52 x 37
ACM1943.346.106

Allen, William Herbert 1863–1943
Monk on Monastery Balcony
oil on canvas 37.5 x 54.5
FA2006.607

Allen, William Herbert 1863–1943
Musing beside the Water Fountain
tempera on prepared gesso wooden board
47 x 61
ACM1943.346.794

Allen, William Herbert 1863–1943
Near Tilford Mill, Waverley
oil on canvas 54.5 x 75
ACM1943.346.121

Allen, William Herbert 1863–1943
Pastoral, Sheep in the Meadows, Farnham
oil on canvas 30.5 x 46
ACM1943.346.84

Allen, William Herbert 1863–1943
Pond in the Woods
oil on canvas 76 x 46
ACM1943.346.139

Allen, William Herbert 1863–1943
Portrait of a Boy
oil on canvas 31 x 23
ACM1943.346.90

Allen, William Herbert 1863–1943
Portrait of a Child in a White Dress
oil on board 29 x 23
ACM1943.346.87

Allen, William Herbert 1863–1943
Portrait of a Girl against an Orange Tree
oil on canvas 40.5 x 30.5
ACM1943.346.156

Facing page: Anderton, Henry (attributed to), 1630–1665, *Portrait of a Lady Three-Quarter Length, Seated, Wearing a Gold Dress with Red Robes* (detail), Chawton House Library, (p. 12)

Allen, William Herbert 1863–1943
Portrait of a Girl against an Orange Tree
oil on canvas 43 x 33
FA1997.89

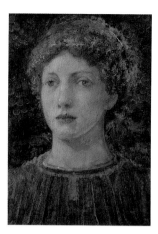

Allen, William Herbert 1863–1943
Portrait of a Girl amongst Grapes
oil on canvas 38 x 28
ACM1943.346.111

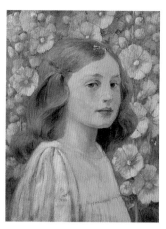

Allen, William Herbert 1863–1943
Portrait of a Girl amongst Hollyhocks
oil on canvas 40.5 x 30.5
ACM1943.346.158

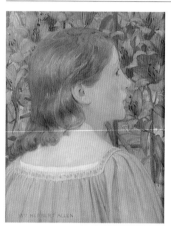

Allen, William Herbert 1863–1943
Portrait of a Girl amongst Lilies
oil on canvas 38 x 30.5
ACM1943.346.162

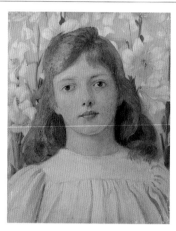

Allen, William Herbert 1863–1943
Portrait of a Girl amongst Madonna Lilies
oil on canvas 40.5 x 30.5
ACM1943.346.160

Allen, William Herbert 1863–1943
Portrait of a Girl amongst Purple Delphiniums
oil on canvas 46 x 36
ACM1943.346.6

Allen, William Herbert 1863–1943
Portrait of a Girl Carrying St John's Wort
oil on canvas 61 x 51
ACM1943.346.117

Allen, William Herbert 1863–1943
Portrait of a Girl in a Green Dress
oil on canvas 30 x 25
FA1997.81

Allen, William Herbert 1863–1943
Portrait of a Girl in a Red Dress
oil on canvas 48.5 x 37
ACM1943.346.54

Allen, William Herbert 1863–1943
Portrait of a Girl in a White Dress
oil on canvas 40.5 x 30.5
ACM1943.346.105

Allen, William Herbert 1863–1943
Portrait of a Girl in a White Pinafore
oil on canvas 40.5 x 30.5
ACM1943.346.159

Allen, William Herbert 1863–1943
Portrait of a Girl Wearing a Light Blue Dress
oil on canvas 30.5 x 25.5
ACM1943.346.113

Allen, William Herbert 1863–1943
Portrait of a Girl with a Garland of Roses in Her Hair
oil on canvas 40.5 x 30.5
FA1997.93

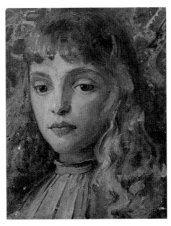

Allen, William Herbert 1863–1943
Portrait of a Girl with a Grey Dress
oil on board 29 x 23
ACM1943.346.91

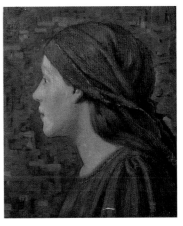

Allen, William Herbert 1863–1943
Portrait of a Girl with a Scarf on Her Head
oil on canvas 32.5 x 27
ACM1943.346.155

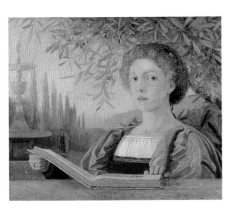

Allen, William Herbert 1863–1943
Portrait of a Girl with an Open Book
oil on canvas 54.5 x 65
ACM1943.346.119

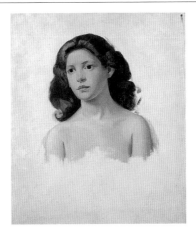

Allen, William Herbert 1863–1943
Portrait of a Girl with Bare Shoulders
oil on canvas 57.5 x 49
ACM1943.346.137

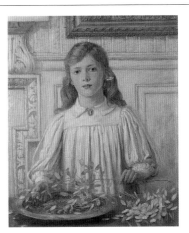

Allen, William Herbert 1863–1943
Portrait of a Girl with Honesty
oil on canvas 76 x 63.5
ACM1943.346.60

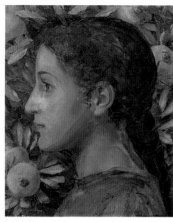

Allen, William Herbert 1863–1943
Portrait of a Girl with Medlars
oil on canvas 30.5 x 25.5
ACM1943.346.112

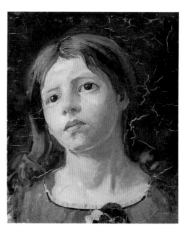

Allen, William Herbert 1863–1943
Portrait of a Girl with Pansies
oil on canvas 30.5 x 25.5
ACM1943.346.110

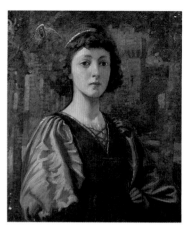

Allen, William Herbert 1863–1943
Portrait of a Girl with Peacock Feather
oil on canvas 64 x 54.5
ACM1943.346.52

Allen, William Herbert 1863–1943
Portrait of a Girl with Primroses
oil on canvas 40.5 x 30.5
ACM1943.346.161

Allen, William Herbert 1863–1943
Portrait of a Girl with White Cravat
oil on canvas 35.5 x 30.5
FA1997.83

Allen, William Herbert 1863–1943
Portrait of a Young Girl Wearing a Brooch of Irises
oil on cardboard 47.5 x 40
ACM1943.346.83

Allen, William Herbert 1863–1943
Portrait of a Young Girl with a Ribbon in her Hair
oil on canvas 51 x 40.5
ACM1943.346.78

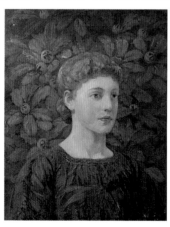

Allen, William Herbert 1863–1943
Portrait of a Young Girl with Medlars
oil on canvas 54 x 43
ACM1943.346.100

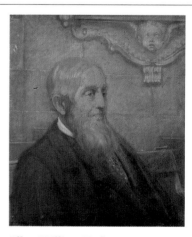

Allen, William Herbert 1863–1943
Portrait of an Elderly Man in Farnham Parish Church
oil on canvas 65.5 x 56
FA1997.88

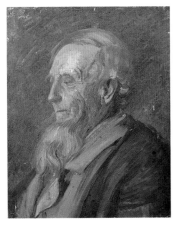

Allen, William Herbert 1863–1943
Portrait of an Old Man
oil on canvas 51 x 40.5
ACM1943.346.97

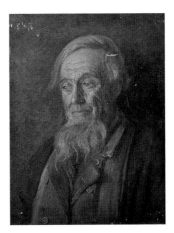

Allen, William Herbert 1863–1943
Portrait of an Old Man
oil on canvas 53.5 x 43
ACM1943.346.98

Allen, William Herbert 1863–1943
Quesnoy, Picardy
oil on canvas 46 x 58.5
ACM1943.346.144

Allen, William Herbert 1863–1943
Sacred Cantata Performed in Stapleford Church, near Salisbury
tempera on prepared gesso wooden board
54 x 77
ACM1943.346.797

Allen, William Herbert 1863–1943
Sailing at Dusk, Saint-Valery-sur-Somme
oil on canvas 76.5 x 63.5
ACM1943.346.48

Allen, William Herbert 1863–1943
Selborne Common
oil on canvas 54.5 x 75
ACM1943.346.125

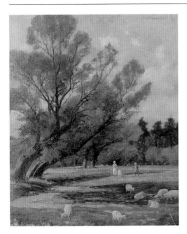

Allen, William Herbert 1863–1943
Sheep Grazing in Landscape
oil on canvas 55 x 46
FA2006.610

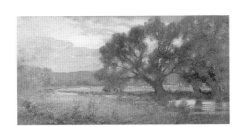

Allen, William Herbert 1863–1943
Sheep Grazing in the Meadows, Farnham
oil on canvas 30.5 x 61
ACM1943.346.133

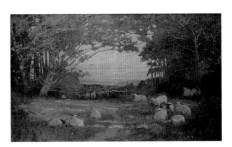

Allen, William Herbert 1863–1943
Sheep in the Meadow
oil on canvas 68.5 x 114.5
ACM1943.346.37

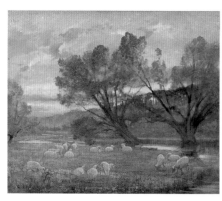

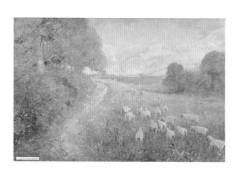

Allen, William Herbert 1863–1943
Sheep in the Meadows, Farnham
oil on canvas 49 x 59
ACM1943.346.147

Allen, William Herbert 1863–1943
Sheep on a Hillside
oil on canvas 51 x 76
ACM1943.346.151

Allen, William Herbert 1863–1943
Shepherdess amongst Blossom
oil on canvas 51 x 40
ACM1943.346.99

Allen, William Herbert 1863–1943
Snailslynch Kilns by the Wey, Farnham
oil on canvas 30.5 x 61
ACM1943.346.135

Allen, William Herbert 1863–1943
Still Life with Mandolin, Pot and Chair
oil on canvas 122 x 81
ACM1943.346.41

Allen, William Herbert 1863–1943
Stooked Corn at Sunset
oil on canvas 30.5 x 61
ACM1943.346.136

Allen, William Herbert 1863–1943
Stooked Corn in Sunshine and Shade
oil on canvas 46 x 51
ACM1943.346.149

Allen, William Herbert 1863–1943
Stooked Corn, toward the End of the Day
oil on canvas 30.5 x 40.5
ACM1943.346.80

Allen, William Herbert 1863–1943
Sun Effects through Trees
oil on canvas 76.5 x 63.5
ACM1943.346.128

Allen, William Herbert 1863–1943
Sunlight on Stooked Corn
oil on canvas 46 x 61
ACM1943.346.148

Allen, William Herbert 1863–1943
Sunlight Reflected in Water
oil on canvas 75 x 54
ACM1943.346.126

Allen, William Herbert 1863–1943
Sunset across the Common
oil on canvas 36 x 46
ACM1943.346.95

Allen, William Herbert 1863–1943
Sunset, Driving the Flock
oil on canvas 27 x 40.5
ACM1943.346.104

Allen, William Herbert 1863–1943
Sunset over the Valley
oil on canvas 36 x 47
ACM1943.346.94

Allen, William Herbert 1863–1943
The Descent from the Cross
oil on canvas 165 x 124
ACM1943.346.5

Allen, William Herbert 1863–1943
The Minstrel
oil on canvas 75.5 x 55
ACM1943.346.127

Allen, William Herbert 1863–1943
The Recital
oil on canvas 30.5 x 51
ACM1943.346.81

Allen, William Herbert 1863–1943
The Shepherd Leading His Flock
oil on canvas 46 x 41
FA1997.82

Allen, William Herbert 1863–1943
The Stream
oil on canvas 65.5 x 121.5
ACM1943.346.58

Allen, William Herbert 1863–1943
The Visitation
oil on canvas 114.5 x 81.5
ACM1943.346.35

Allen, William Herbert 1863–1943
Women Walking along a Walled Lane
oil on canvas 51 x 39.5
ACM1943.346.96

Allen, William Herbert 1863–1943
Woodland Scene with Lone Figure
oil on canvas 78 x 65
FA1997.95

Allen, William Herbert 1863–1943
Work on the Land, Farnham
oil on canvas 33 x 43
FA2006.612

Allen, William Herbert 1863–1943
Worker Carrying a Scythe with His Daughter
oil on panel 35.5 x 25.5
ACM1943.346.92

G. C. B.
*The Seat of Admiral Sir Harry Burrard-Neale,
Walhampton House, Boldre, New Forest*
oil on panel 15 x 23
FA1992.128

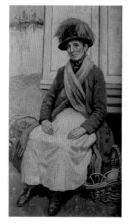

Baker, S. A.
Gypsy Flower Seller 1920s
oil on canvas 69 x 39.5
FA1998.102

Ball, Wilfred Williams 1853–1917
Coastal Scene at Sunset
oil on canvas 25.5 x 45
FA2006.498

Ball, Wilfred Williams 1853–1917
Coastal Scene with Lighthouse
oil on canvas 38 x 60
FA2006.499

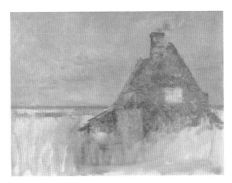

Ball, Wilfred Williams 1853–1917
Cottage in a Rural Setting
oil on canvas 24.5 x 33
FA2006.497

Ball, Wilfred Williams 1853–1917
Cottage in a Rural Setting
oil on canvas 36.5 x 54
FA2006.502

Ball, Wilfred Williams 1853–1917
Cottage with Children Picking Flowers
oil on canvas 37 x 54
FA2006.503

Ball, Wilfred Williams 1853–1917
Cottages near Shore Line
oil on canvas 30 x 49
FA2006.500

Ball, Wilfred Williams 1853–1917
View of Stanpit, near Christchurch
oil on canvas 31 x 39
FA2006.495

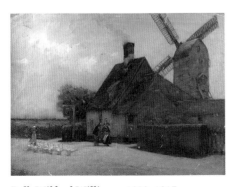

Ball, Wilfred Williams 1853–1917
Windmill and Geese
oil on canvas 50 x 65
FA2006.501

Ball, Wilfred Williams (attributed to)
1853–1917
Farmyard Scene with Poultry
oil on canvas 37 x 55
FA2006.496

Barker, Geoffrey Alan 1881–1959
View from the Garden of Miss M. Jolliffe,
Christchurch 1950
oil on canvas 52.5 x 97
FA1990.2

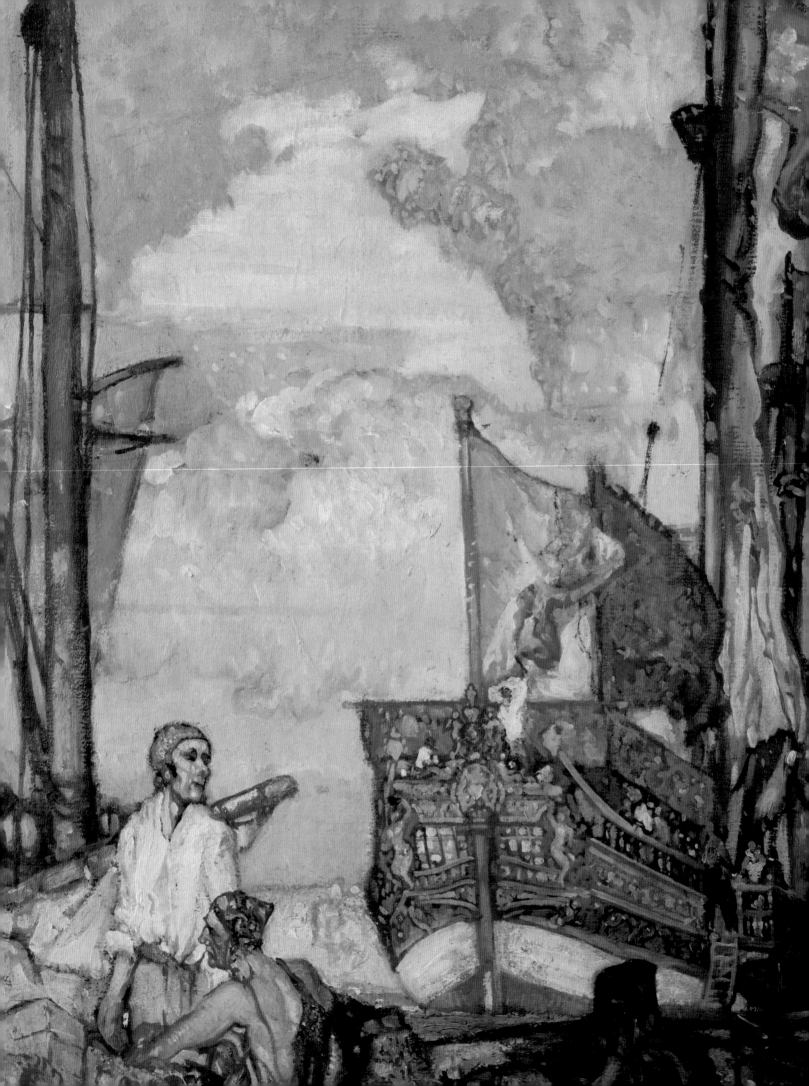

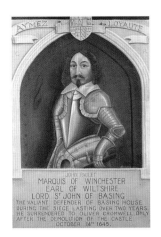

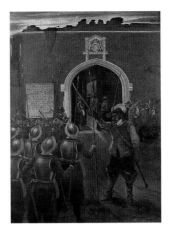

Barnes, Ernest W. 1880–1960
John Paulet, Marquis of Winchester (1598–1675) 1920
oil on plywood 75.5 x 49.8
BWM1960.291

Barnes, Ernest W. 1880–1960
The Lighting of Basing House, 1645 1920
oil on plywood 85.5 x 64.5
BWM1960.292

Barrett, Maryan E. active 1950–1985
Timber Barn c.1985
oil on canvas 46 x 61
FA1995.33.14

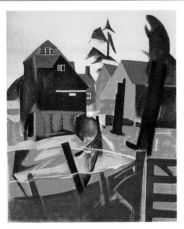

Barrett, Maryan E. active 1950–1985
Unfinished Study of Buildings and Cars
c.1985
oil on canvas 61 x 51
FA1995.33.15

Barrett, Maryan E. active 1950–1985
View of Buildings c.1985
oil on canvas 56 x 46
FA1995.33.18

Barrett, Maryan E. active 1950–1985
View of Petersfield c.1985
oil on canvas 51.5 x 102
FA1995.33.1

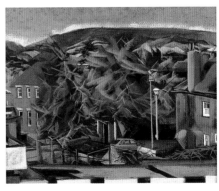

Barrett, Maryan E. active 1950–1985
View of Petersfield c.1985
oil on canvas 51.5 x 102
FA1995.33.2

Barrett, Maryan E. active 1950–1985
View of Petersfield c.1985
oil on canvas 51.5 x 102
FA1995.33.16

Barrett, Maryan E. active 1950–1985
View of Petersfield c.1985
oil on canvas 43 x 52
FA1995.33.17

Facing page: Cox, E. Albert, 1876–1955, *The Admiral's Galley, 1690* (detail), c.1925, Portsmouth Museums and Records Service, (p. 78)

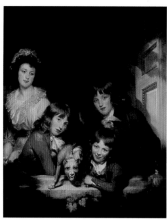

Beechey, William 1753–1839
Family Portrait
oil on canvas 180 x 120 (E)
FA2006.602

Bell, Arthur George 1849–1916
Autumn Scene, Hengistbury Head from Southbourne
oil on canvas 30 x 42 (E)
FA2006.548

Bell, Arthur George 1849–1916
Lane near Burton
oil on canvas 42 x 30 (E)
FA2006.557

Bell, Arthur George 1849–1916
River Scene
oil on canvas 62 x 92
FA1993.119

Bell, Arthur George 1849–1916
Rural Scene
oil on wood 25.3 x 46
FA2006.193

Bell, Arthur George 1849–1916
Sheep Grazing on Hengistbury Head
oil on canvas 30 x 42 (E)
FA2006.558

Bell, Arthur George 1849–1916
Sheep on Hengistbury Head
oil on canvas 76 x 127
CRH1968.14

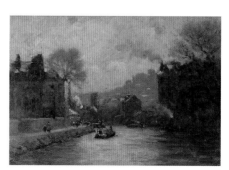

Bell, Arthur George 1849–1916
Silver Light, City Smoke, a View of the River Avon at Bradford-on-Avon
oil on canvas 25 x 35.5
FA2006.555

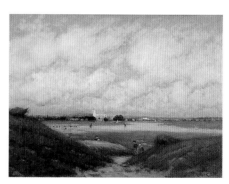

Bell, Arthur George 1849–1916
View of Christchurch Priory from Warren Head, Christchurch
oil on canvas 52 x 69
FA2006.493

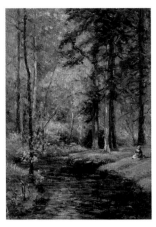

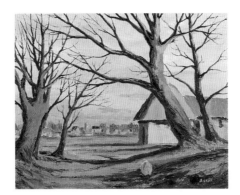

Bell, Arthur George 1849–1916
Woodland River Scene
oil on plywood 35 x 25.5
FA1993.59

Bissill, George William 1896–1973
Hurstbourne Tarrant 1939
oil on canvas 40.5 x 51
FA1976.30

Brangwyn, Frank 1867–1956
A Balkan Fisherman 1890
oil on canvas 30 x 20.5
FA2006.549 ※

Breanski, Alfred de 1852–1928
Horseman and Bridge at the Gap of Dunloe, Killarney
oil on paper 15.8 x 38.5
FA2006.165

British (English) School
C. A. Mornewick Junior c.1835
oil on canvas 90 x 75
FA2004.131

Bryan, Charles Stanley Coles
active 1937–1956
Yacht 'Endeavour' Racing in the Solent 1946
oil on canvas 62.5 x 74.6
GOS1982.90

Bryan, Charles Stanley Coles
active 1937–1956
Botley Flour Mill Loading Barn 1955
oil on canvas 44 x 59
FA1995.38.1

Bryan, Charles Stanley Coles
active 1937–1956
The Yacht Beacon 1956
oil on canvas 50 x 65 (E)
FA1995.38.4

Bryan, Charles Stanley Coles
active 1937–1956
Ashley Dancing Academy
oil on canvas 100 x 127
GOS1980.45

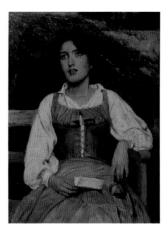

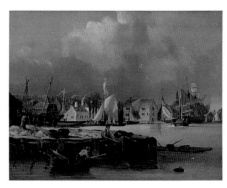

Bryan, Charles Stanley Coles
active 1937–1956
No.2 Boatyard, Botley Reech, River Hamble
oil on canvas 43 x 58
FA1995.38.2

Burgess, John Bagnold 1830–1897
Portrait of a Young Woman with a Love Letter
oil on board 35 x 25
FA1993.109

Burrard, Harry active c.1850–1876
View of Lymington Quay c.1850
oil on canvas 16 x 22
FA1976.14.1

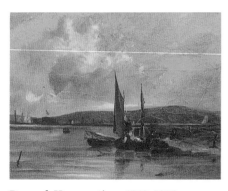

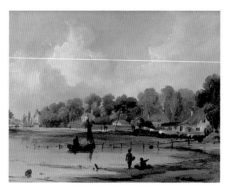

Burrard, Harry active c.1850–1876
View of Lymington Quay c.1876
oil on canvas 17.1 x 22.6
FA1976.38

Burrard, Harry
View of Lymington Harbour Area
active c.1850–1876
oil on canvas 16 x 22
FA1976.14.2

C. M. C.
Lake Scene
oil on cardboard 11 x 16.5
FA1993.92

Cave, William 1737–1813
Summer Evening; the Coach (after Philip James de Loutherbourg) 1806
oil on canvas 75 x 152
ACM1931.20

Chambers, George 1803–1840
'The Royal George' Leaving Southampton Water with George IV on Board c.1829
oil on board 25 x 39
FA1990.25

Clark, G.
Penshurst, Kent c.1800
oil on canvas 22 x 44
GOS1978.101

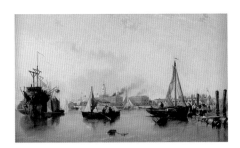

Cole, George 1810–1883
*Entrance to Portsmouth Harbour with British
Man of War* 1838
oil on canvas 31 x 52
FA1989.10

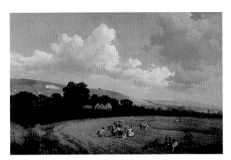

Collins, Alfred active 1850–1882
Portsdown Hill from Portsmouth c.1850
oil on canvas 34.7 x 53.5
FA2001.73

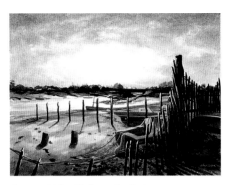

Cooper, John Hubert b.1912
View of Anglesey Creek
acrylic on canvas 43 x 57.5 (E)
GOS1982.89.9

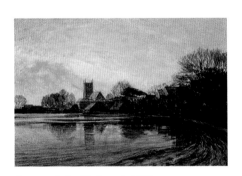

Cooper, John Hubert b.1912
View of Anglesey Creek
acrylic on canvas 37 x 57
GOS1982.89.10

Cooper, John Hubert b.1912
View of Haslar Creek
acrylic on canvas 43 x 57 (E)
GOS1982.89.11

Cope, Arthur Stockdale 1857–1940
*Thomas George Baring, Earl of Northbrook
(1826–1904)*
oil on canvas 133.8 x 109
FA2001.35

Couling, Paula b.1930
*View of Christchurch Priory with Boats
Moored on River Avon* 1970s
oil on canvas 40 x 70 (E)
FA2006.269

Crofts, Ernest 1847–1911
Cromwell at the Storming of Basing House
oil on canvas 149.8 x 203.2
FA2004.143

Crossley, Harley b.1936
*Cunard White Star 'RMS Aquitania', Leaving
Royal Pier, Southampton, 1948* c.1994
oil on canvas 49 x 75
FA1996.25 🐝

Curtis
Crusader Fighting a Turk on Horseback
oil on canvas 20.5 x 30.6
FA1982.1.2

Curtis
Medieval Knights in Armour Fighting on Horseback
oil on canvas 20.5 x 30.6
FA1982.1.1

G. D.
The Winchester to Farnham Stage or Mail Coach c.1820
oil on canvas 40 x 58
FA1996.46

Darnell, Dorothy active 1904–1922
Study of a Female Figure
oil on canvas 60 x 40
ACM1961.199

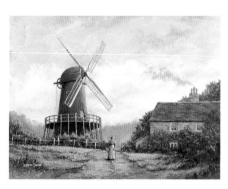

Davidson, Laurence
Retrospective View of Bursledon Windmill, Hampshire, 1890s c.1999
oil on canvas 46 x 61
FA1999.164

Davies, Mary
Dead Bird 1970
oil on canvas 44.5 x 44.5 (E)
FA1993.100

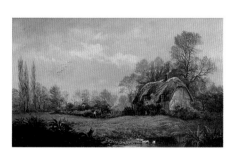

Davis, Arthur Henry c.1847–1895
Ibsley near Ringwood
oil on canvas 25 x 40 (E)
FA2006.553

Davis, Arthur Henry c.1847–1895
View of Christchurch Priory
oil on board 21.5 x 17.8
FA2006.232

Davis, Arthur Henry (attributed to)
c.1847–1895
View of Blackwater Ferry on the River Stour, Dorset
oil on board 14.1 x 22.3
FA2006.233

Dee
'828' at Barry Island
acrylic on board 63.5 x 94
FA2007.73

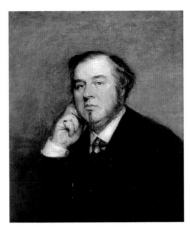

Dickinson, Lowes Cato 1819–1908
George Sclater Booth, Lord Basing (1826–1894), First Chairman of Hampshire County Council (1889–1894)
oil on canvas 95 x 70 (E)
FA1993.20

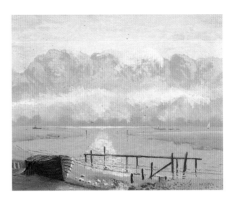

Ditch, A. H. active 1959–1965
Hillhead (?) c.1960
oil on canvas 21 x 27
FA1988.29.3

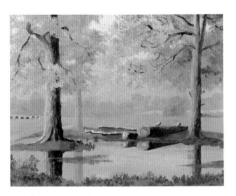

Ditch, A. H. active 1959–1965
Park Lane, Fareham
oil on canvas 20 x 26
FA1988.29.1

Ditch, A. H. active 1959–1965
View of Cams Hall Farm, Fareham
oil on canvas 32 x 48
FA1988.29.2

Dring, William D. 1904–1990
Sir C. L. Chute, Chairman of Hampshire County Council (1938–1955) 1948
oil on canvas 151 x 120.5
FA2001.39

Durham, F.
View from Smugglers Lane, Christchurch
oil on canvas 24 x 34
CRH1958.56

Durman, Alan 1905–1963
Artwork for Southern Railways Poster
oil on board 97 x 60
FA2006.8

Elliot, Thomas active 1790–1810
British Man of War and Other Shipping in Portsmouth Harbour c.1790
oil on canvas 24 x 32 (E)
FA1993.10

Elliott, Richard
The Wreck of the 'Herman Julius' c.1838
oil on canvas 25 x 39
CRH1956.106

Elwes, Simon 1902–1975
Mrs Violet Stuart Wortley (1866–1953) c.1950
oil on canvas 56 x 46
FA2002.1

Fenelly, J.
Farmyard Scene 1849
oil on cardboard 41 x 60
CRH1963.24

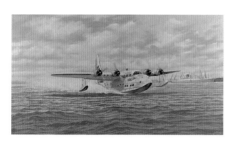

Fisher, Simon b.1944
*BOAC Flying Boat 'Somerset' Taking off on
Last Scheduled Flying Boat Service from
Southampton Water* c.1980
oil on canvas 49.5 x 90
FA1997.27

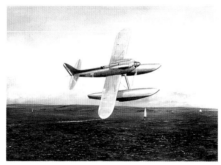

Gage, R. E.
*Schneider Trophy Seaplane 'No.7' Flying over
the Solent*
oil on canvas 51 x 71
FA1996.45

Garland, Valentine Thomas 1840–1914
Cams Mill, Fareham c.1880
oil on canvas 50 x 76
FA1986.5

Garneray, Louis 1783–1857
Prison Hulks in Portsmouth Harbour c.1810
oil on canvas 52.5 x 103.5
FA1996.24

Gibson, Anthony
Royal Yacht
oil on canvas 59.3 x 88.3
FA2007.74

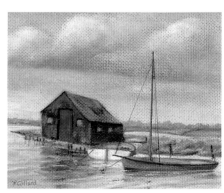

Gillard, Frank
*Boathouse which Once Housed a Gun Punt
Belonging to Tom Parham, near Harts Farm,
Bedhampton, Hampshire, prior to 1939*
oil on hardboard 17 x 21.5
FA1990.21

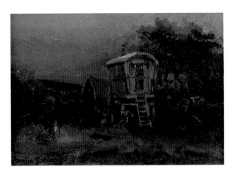

Goddard, Amelia active 1890–1920s
Gypsy Caravan in New Forest at Dusk 1920s
oil on canvas 13.3 x 18
FA2006.51

Goddard, Amelia active 1890–1920s
Gypsy Child
oil on canvas 33 x 26
FA2006.619

Grant, William d.1982
Self Portrait c.1975
oil on board 59.1 x 49.1
FA1993.16.1

Gregory, H.
Holy Ghost Chapel Ruins, Basingstoke c.1875
oil on canvas 28 x 33
FA2002.648

Gregory, H.
Young Hounds
oil on canvas 49 x 39
BWM1960.253

Gregory, J. W. active mid-to early 19th C
Holy Ghost Chapel Ruins, Basingstoke 1829
oil on canvas 43 x 54
FA1993.80

Hanneman, Adriaen (circle of) c.1601–1671
The Wife of the First Duke of Bolton (d.1653?)
oil on canvas 76.2 x 63.5
FA1998.202

Hansford, B. P.
Fareham Mill
oil on canvas 49.5 x 84
FA2004.128

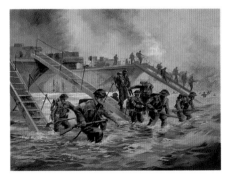

Harrison, Terry b.1951
*Commemorating the Anniversary of the D-Day
Landings, Normandy Beach, 6 June 1944* 1994
oil on canvas 45.5 x 61
R1997.56.1

Hemwell, G.
Mount Everest 1920
oil on canvas 60 x 47.5
FA2006.504

Herdman, Robert 1829–1888
*Charles Shaw-Lefevre, First Viscount Eversley
(1794–1888), in the Uniform of the Hampshire
Carabiniers* 1875
oil on canvas 126 x 100
FA1993.25

Heymans, Casimir b.c.1895
Old Iford c.1920
oil on canvas 25 x 40 (E)
FA2006.551

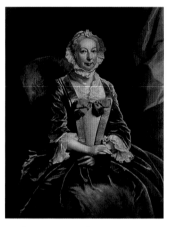

Highmore, Joseph 1692–1780
Mrs Iremonger of Wherwell Priory c.1745
oil on canvas 122.4 x 97.3
FA1994.27

Holst, Laurits Bernhard 1848–1934
Breaking Waves
oil on canvas 23.5 x 37.5
FA2006.547

Houghton, Philip active 1909–1922
Springtime at Swan Hill 1910s
oil on board 46 x 38
FA1997.91

Jones, Douglas
The Constables' House and Priory c.1890
oil on canvas 34 x 55
FA2006.554

Kinch, Hayter 1767–1844
*The Upper Quay Area of Fareham Creek,
Looking South from Cams Mill* c.1824
oil on canvas 88 x 107
FA1993.33

King, Gunning 1859–1940
Portrait Study of a Girl
oil on canvas 159 x 73.5
FA2004.136

Facing page: Romney, George, 1734–1802, *Charlotte Gunning, later Mrs Stephen Digby* (detail), Chawton House Library, (p. 16)

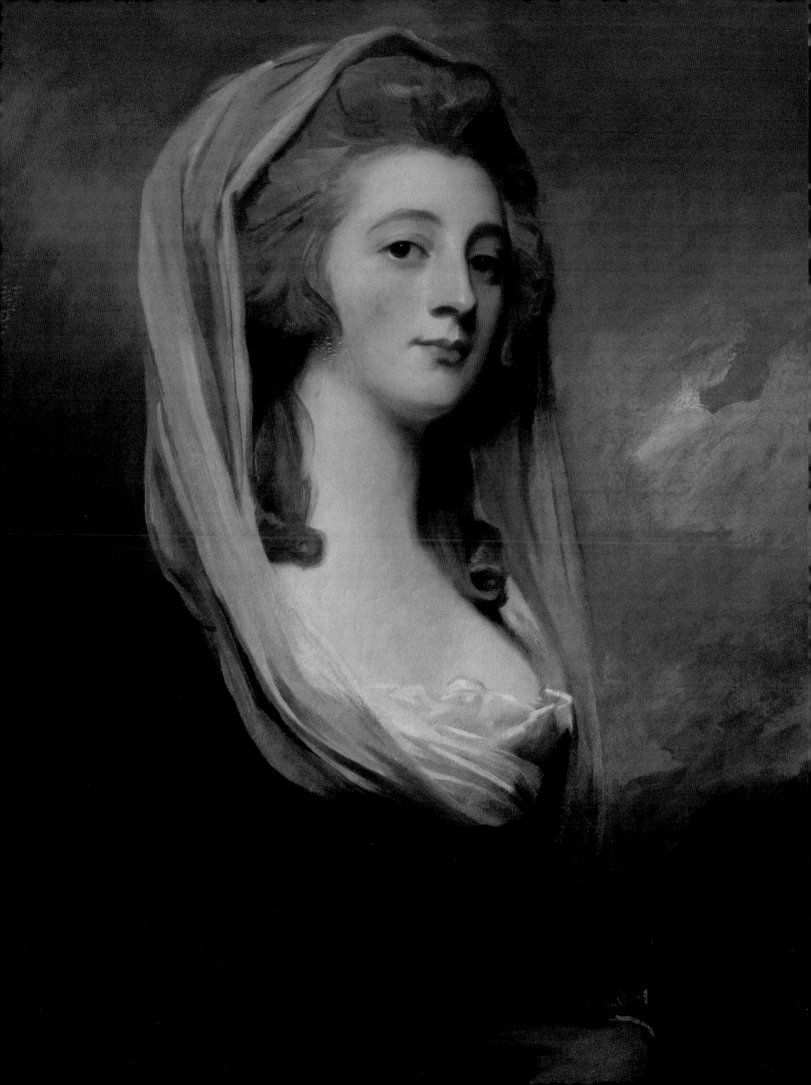

W. E. L.
View of Iford Bridge and Cottages,
Christchurch 1895
oil on canvas 15.1 x 20.1
FA2006.492

Lander, John Saint-Hélier 1869–1944
Canon Charles Theobald (b.1831) c.1907
oil on canvas 99.8 x 82.5
FA2001.36

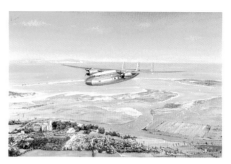

Lee, T. W.
Airspeed Ambassador Flying over Christchurch,
May 1951 1998
oil on canvas 49.6 x 75.2
FA1999.122

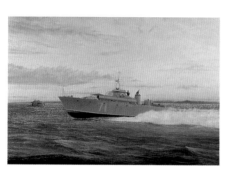

Lee, T. W.
Motor Torpedo Boat 'MTB71' on Patrol in the
Solent, off Hampshire, Second World War,
1942–1943 1998
oil on canvas 49 x 73
FA1999.123

Lucas, John 1807–1874
The First Duke of Wellington (1769–1852) in
Old Age 1840s
oil on canvas 138 x 106
FA1990.18.2

Lucas, John 1807–1874
Duke of Wellington, KG, in the Uniform of the
Lord Lieutenant of Hampshire 1841
oil on canvas 230 x 158
FA1993.28

Marston, George 1882–1940
Antarctic Sea and Landscape c.1930
oil on canvas 33.5 x 48
FA2006.12

Marston, George 1882–1940
Self Portrait 1939
oil on canvas 51 x 41
FA1997.4

Mason, Samuel
Charles Heath (1740–1810) 1804
oil on canvas 30.5 x 24
KD1997.209

McCannell, William Otway 1883–1969
River Fantasy 1920s
oil on canvas 71 x 86.5
FA1997.94

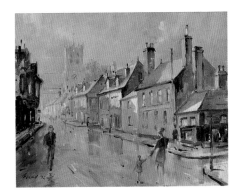

Mead active 1972–1975
Street Scene, Christchurch 1972
oil on canvas 39.5 x 49.5
FA1993.110

Mead active 1972–1975
Street Scene, Christchurch 1975
oil on canvas 39.5 x 50
FA1993.116

Meadus, Eric 1931–1970
*Railway Station, possibly Woolston,
Southampton* 1964
oil on canvas 49 x 53
FA1992.2.12

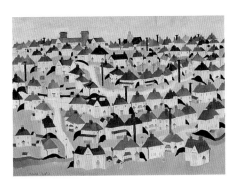

Meadus, Eric 1931–1970
Suburban Housing in the Southampton Area
1968
oil on board 43.5 x 59.1
FA1992.2.13

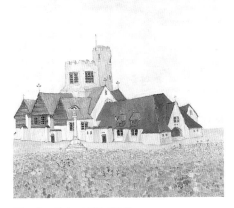

Meadus, Eric 1931–1970
Church of St Alban, Swaythling, Southampton
1969
oil on board 43 x 49
FA1992.2.5

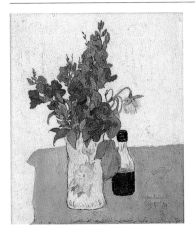

Meadus, Eric 1931–1970
Vase with Flowers and Bottle 1969
oil on board 31 x 26
FA1992.2.1

Monnier, Jean b.1933
A Marina
oil on canvas 49.2 x 99.8
FA2007.75

Moore, Y.
*'Cat and Fiddle' Public House near
Christchurch, Dorset* 1906
oil on board 20.3 x 30.3
FA2006.129

Morgan, Owen Frederick active 1896–1926
W. H. Curtis (1880–1957) 1926
oil on canvas 34 x 30
ACM1963.179

Myall, John
'828' at Eastleigh Works
acrylic on board 54.6 x 84
FA2007.71

Nasmyth, Patrick 1787–1831
A View in Hampshire 1826
oil on canvas 50 x 70
FA1993.36

Nickless
Gosport Pontoon and the Semaphore Tower, Portsmouth 1967
oil on canvas 49.5 x 74.9
GOS1986.124

Nickless
'HMS Dolphin', Gosport and the Round Tower, Portsmouth 1967
oil on canvas 49.3 x 74.5
GOS1986.123

Pether, Abraham 1756–1812
God's House Tower by Moonlight
oil on canvas 49.5 x 76
FA1991.28

Pike, Sidney 1846–1907
The Priory and Constable's House
oil on canvas 29 x 75
FA2006.550

Pike, Sidney 1846–1907
View of Christchurch Harbour
oil on board 45 x 65.5
FA2006.123

Pollard, Chris
First Train through Eastleigh
acrylic on board 51 x 81 (E)
FA2007.72

Polly, D. M.
View of East Cliff, Bournemouth 1902
oil on wood 24.5 x 32.7
FA2006.122

Richmond, George 1809–1896
Sir William Heathcote, Bt (1801–1881) 1870
oil on canvas 110 x 82
FA1993.21

Rogers, A. J.
View of West Street, Fareham, Hampshire, by Thackeray's House c.1980
oil on board 28 x 51
FA1990.118.2

Rogers, A. J.
West Street, Fareham, by Lloyds Bank c.1980
oil on board 33.5 x 43.5
FA1990.118.1

Salisbury, Frank O. 1874–1962
Sir Alexander MacLean 1945
oil on canvas 110 x 84
FA2001.30

Sancha, Carlos Luis 1920–2001
Lord Portchester, Chairman of Hampshire County Council (1973–1977) c.1975
oil on canvas 75 x 62
FA2006.507

Sargent, Frederick 1837–1899
The Tichborne Trial
oil on canvas 100 x 125
FA2005.237.1

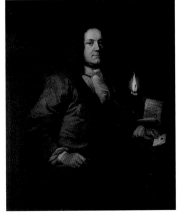

Schalcken, Godfried 1643–1706
John Acton, Solicitor of Basingstoke
oil on canvas 124.7 x 99.7
FA1988.15

Seabrooke, Elliot 1886–1950
Bucklers Hard Estuary c.1935
oil on board 59.5 x 87.5
FA2004.135

Serres, Dominic 1722–1793
*View from Portsdown Hill Overlooking
Portsmouth Harbour* c.1778
oil on canvas 73 x 133
FA1991.22

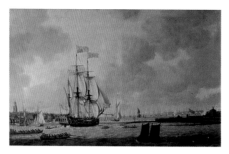

Serres, Dominic 1722–1793
British Warship Leaving Portsmouth Harbour
oil on canvas 35 x 56
FA1991.47

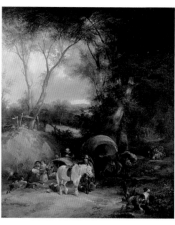

Shayer, William 1788–1879
Gypsy Encampment in the New Forest
oil on canvas 95 x 80
FA1996.21

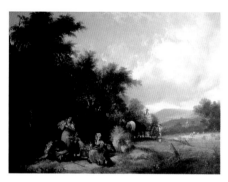

Shayer, William 1788–1879
The Cornfield
oil on canvas 70 x 97
FA1996.20

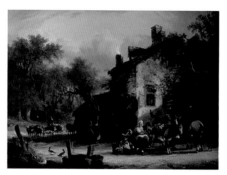

Shayer, William 1788–1879
The Rabbit Seller
oil on canvas 70 x 100
FA1993.12

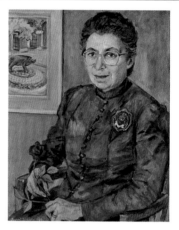

Shepherd, Rupert 1909–1992
Councillor Mrs Sue Bartlett 1990
oil on canvas 74 x 58.5
FA2006.505

Sinkinson, Frederick
Abstract Coastal Scene
oil on canvas 33 x 33
FA2006.617

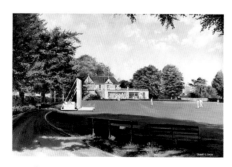

Smith, Stuart C.
May's Bounty, Basingstoke
oil on canvas 58 x 84
FA2006.632

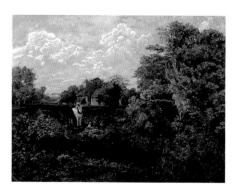

Snape, Martin 1853–1930
St Mary's Church, Rowner, Gosport 1874
oil on canvas 46 x 60.5
GOS1974.212.170

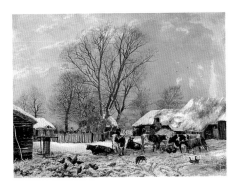

Snape, Martin 1853–1930
Farmyard Scene 1875
oil on canvas 47 x 63.5
GOS1974.212.125

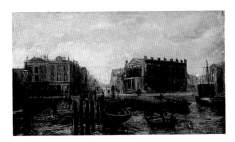

Snape, Martin 1853–1930
The Hard, Gosport 1880
oil on canvas 33.5 x 61
GOS1974.212.190

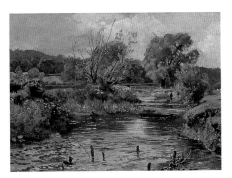

Snape, Martin 1853–1930
Fly Fishing on the River Meon c.1900
oil on panel 24.5 x 35
FA1989.11.1

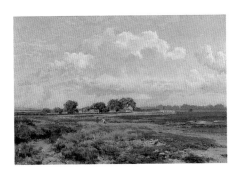

Snape, Martin 1853–1930
Itchenor, Hampshire c.1900
oil on canvas 24.5 x 37
FA1994.24

Snape, Martin 1853–1930
The River Meon c.1900
oil on panel 28 x 48
FA1989.11.2

Snape, Martin 1853–1930
The Hard, Gosport 1919
oil on canvas 59.5 x 90
GOS1974.212.157

Snape, Martin 1853–1930
Emsworth Fair
oil on canvas 58 x 78
GOS1974.212.122

Snape, Martin 1853–1930
Forton Creek, Gosport
oil on canvas 98 x 126
GOS1974.212.165

Snape, Martin 1853–1930
Grange Farm
oil on canvas 58.5 x 78.6
GOS1974.212.127

Snape, Martin 1853–1930
Haslar Creek
oil on canvas 33.3 x 48
GOS1987.197

Snape, Martin 1853–1930
Rural Landscape
oil on canvas 47 x 64
GOS1974.212.163

Snape, Martin 1853–1930
Rural Landscape
oil on canvas 28.2 x 47.4
GOS1986.108.2

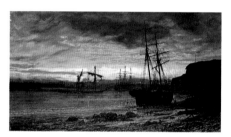

Snape, Martin 1853–1930
Ships at Sunset
oil on canvas 56 x 102 (E)
GOS1974.212.123

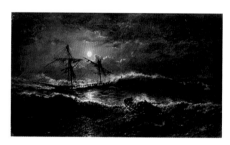

Snape, Martin 1853–1930
Storm at Sea
oil on canvas 56 x 102 (E)
GOS1974.212.134

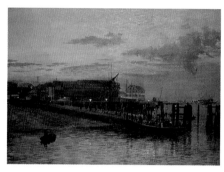

Snape, Martin 1853–1930
The Hard, Gosport
oil on canvas 70 x 98.5
GOS1974.212.126

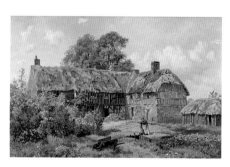

Snape, Martin 1853–1930
The Old Manor House, Bedhampton
oil on canvas 31.1 x 50
FA2006.622

Snape, Martin 1853–1930
The Oldest Oak in the Greenwood
oil on canvas 97 x 70
FA1998.260

Snape, Martin 1853–1930
Winter Highland Scene
oil on canvas 57.5 x 78.2
GOS1974.212.156

Snape, William H. 1862–1904
Landscape c.1887
oil on canvas 53 x 29
GOS1974.212.153

Snape, William H. 1862–1904
Seascape c.1887
oil on canvas 39.3 x 54.3
GOS1974.212.149

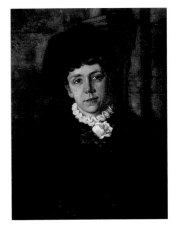

Snape, William H. 1862–1904
One of the Snape Family 1889
oil on canvas 44.6 x 34.5
GOS1974.212.166

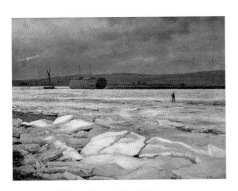

Snape, William H. 1862–1904
Frozen Harbour Scene 1895
oil on canvas 38.7 x 54.2
GOS1974.212.121

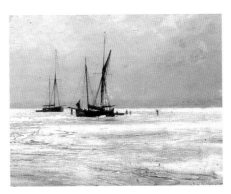

Snape, William H. 1862–1904
Harbour Scene 1895
oil on canvas 29.4 x 38
GOS1974.212.85

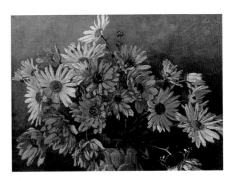

Snape, William H. 1862–1904
Still Life, Vase of Flowers 1899
oil on canvas 26.4 x 36.5
GOS1974.212.159

Snape, William H. 1862–1904
Gamekeeper in the Wild Grounds
oil on canvas 64.4 x 85
GOS1974.212.135

Snape, William H. 1862–1904
Landscape
oil on canvas 20.7 x 28
GOS1974.212.154

Snape, William H. 1862–1904
Marsh Scene
oil on canvas 44.5 x 34.5
GOS1976.292

Snape, William H. 1862–1904
Portrait of a Child Selling Flowers
oil on canvas 59.4 x 49.2
GOS1974.212.137

Spencelayh, Charles 1865–1958
Portrait of a Small Girl Standing with a Doll c.1910
oil on canvas 125 x 75
CRH1964.86 (P) ☀

Spooner, Charles Sydney 1862–1938
Portchester Castle 1886
oil on canvas 64 x 90
FA1992.6

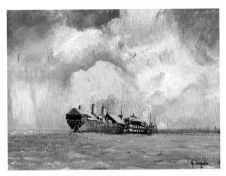

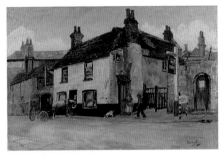

Steers, F. A.
Lee Breton Farmhouse, Lee-on-the-Solent 1950
oil on paper 50 x 67.5
GOS1998.2.1

Swayne, H.
Hulks off Hardway, Gosport c.1960
oil on canvas 25.5 x 35
GOS1987.165

Thirlwall
The Plough, Alton 1945
oil on canvas 51 x 72
FA1993.67

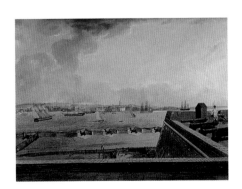

Tuke, Henry Scott 1858–1929
Cabin Boy
oil on board 32 x 22.5
FA1998.305

Turner, Daniel d.1801
View of Gosport
oil on canvas 39 x 53.5
FA1997.23

Twort, Flora 1893–1985
Mrs Jane Twort 1928
oil on canvas 60 x 50
FA1985.3.55

Facing page: Marks, Henry Stacey, 1829–1898, *The Odd Volume* (detail), 1894, Winchester Museums Service, (p. 324)

Twort, Flora 1893–1985
At Twilight with the Swans
oil on panel 37 x 49.6
FA1985.3.51

Twort, Flora 1893–1985
Dr W. J. D. Twort as a Young Man
oil on panel 50.5 x 40.5
FA1985.3.56

Twort, Flora 1893–1985
Figures on the Beach
oil on wood 32.8 x 40.5
FA2004.56

Twort, Flora 1893–1985
Girl by Water (recto)
oil on plywood 25 x 35
FA2005.27

Twort, Flora 1893–1985
Pontoon at Heath Lake, Petersfield (verso)
oil on plywood 25 x 35
FA2005.27a

Twort, Flora 1893–1985
Morning by the Lake
oil on plywood 30.5 x 40
FA2005.29

Twort, Flora 1893–1985
Pontoon at Heath Lake, Petersfield
oil on plywood 30 x 40
FA2005.28

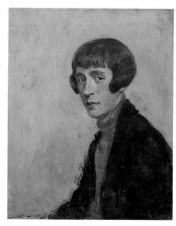

Twort, Flora 1893–1985
Portrait of Lady
oil on canvas 56.1 x 46.1
FA1985.3.52

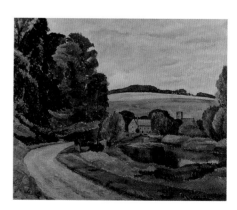

Tyson, Kathleen 1898–c.1982
Middle Woodford, Wiltshire
oil on canvas 62 x 75
FA1993.113

unknown artist late 16th C
Rossa, Wife of Suleiman the Magnificent
oil on board 77 x 53.5
FA2006.620

unknown artist late 16th C
Semiramis
oil on board 77 x 53.5
FA2006.621

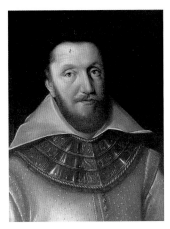

unknown artist
Sir David Norton, Southwark c.1620
oil on canvas 57.1 x 44.4
FA1988.38

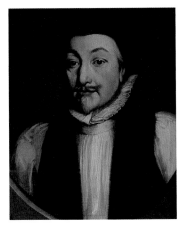

unknown artist
Portrait of a Bishop c.1650
oil on canvas 73.8 x 64
FA2001.38

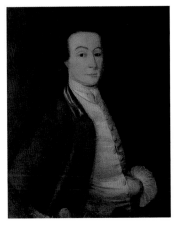

unknown artist
Portrait of a Man in Early Middle Age 1750s
oil on canvas 65.5 x 53
FA1996.11

unknown artist
*View of Winchester with the Militia Camp in
the Foreground* 1759
oil on canvas 91.5 x 155.5
FA1993.23

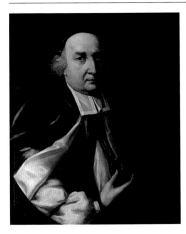

unknown artist
Portrait of a Bishop c.1775
oil on canvas 73.8 x 64
FA2001.34

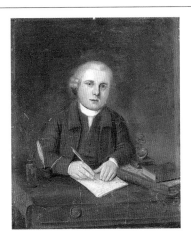

unknown artist 18th C
*William Curtis (1746–1799), Botanist, Writing
at His Table*
oil on copper 30 x 24
AOC892

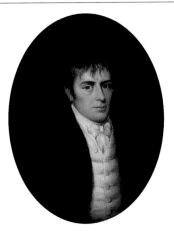

unknown artist
Thomas Heath (1781–1842) 1800
oil on canvas 30.5 x 24
KD1997.210

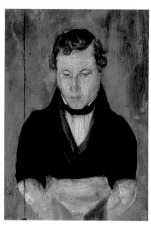

unknown artist
Ambrose Tucker c.1820
oil on board 36.5 x 26.5
FA2006.491

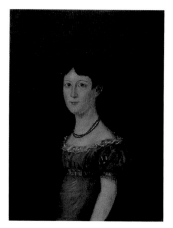

unknown artist
Portrait of a Young Girl in a Blue Dress, a Member of the Barney Family, Fareham 1820s
oil on canvas 21 x 18
FA2006.625

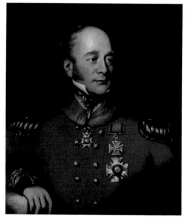

unknown artist
The Honourable Sir Hercules Packenham, Military Governor of the Portsmouth Garrison c.1830
oil on canvas 76.2 x 61
FA1988.39

unknown artist
Domones Butchers' Shop, Castle Street, Christchurch 1830s
oil on board 24 x 30
FA1998.304

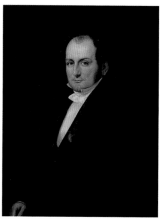

unknown artist
Abraham Crowley (1795–1864) c.1835
oil on canvas 93 x 70
FA1986.3.1

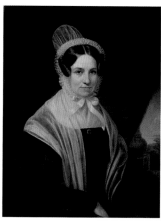

unknown artist
Charlotte Crowley (1801–1892) c.1835
oil on canvas 93 x 70
FA1986.3.2

unknown artist
Charles Sedgefield Crowley (1797–1868), Husband of Emma Curtis c.1838
oil on canvas 93 x 70
FA1986.3.3

unknown artist
Emma Crowley, née Curtis c.1838
oil on canvas 93 x 70
FA1986.3.4

unknown artist
Maria Humphrey of Salisbury, Wiltshire, Wife of Thomas Heath, Mayor of Andover c.1838
oil on canvas 89.3 x 68.5
KD1997.228

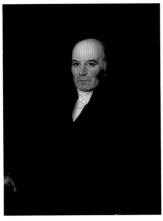

unknown artist
Thomas Heath (1781–1842), Mayor of
Andover, Hampshire (1837–1838) c.1838
oil on canvas 89.3 x 68.5
KD1997.229

unknown artist
View of Christchurch Priory from Wick,
Christchurch c.1840
oil on canvas 28 x 40 (E)
FA2006.494

unknown artist
Benny Reid, Christchurch 1842
oil on board 28 x 18
FA1998.308

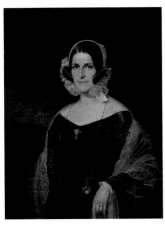

unknown artist
Elizabeth Curtis (1806–1900) c.1845
oil on canvas 93 x 70
FA1986.3.5

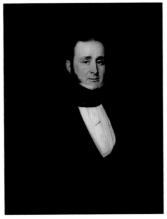

unknown artist
Henry Crowley (1793–1864), Husband of
Elizabeth Curtis c.1845
oil on canvas 93 x 70
FA1986.3.6

unknown artist
Abraham Crowley (1796–1864) c.1850
oil on canvas 39 x 28
FA1998.254

unknown artist
Charlotte Crowley, née Curtis (1801–1892),
Wife of Abraham Crowley c.1850
oil on canvas 39 x 28
FA1998.255

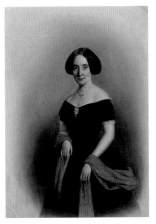

unknown artist
Portrait of a Lady with a Red Shawl 1850s
oil on canvas 43 x 32
FA1993.75

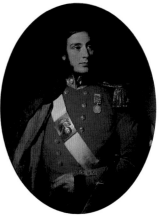

unknown artist
Edward William Packenham, from a Grenadier
Corps of a Fusilier Regiment, Wearing the
Crimea Medal with Bars (…) c.1855
oil on canvas 111.8 x 86.4
FA1993.19

unknown artist
St Mary's Church and Cottages, Basingstoke
c.1870
oil on board 23 x 27
BWM1960.302

unknown artist
The Alton Postman's Dog c.1870
oil on board 12 x 20
HCMS1970.428

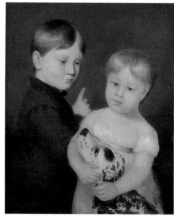

unknown artist
*Portrait of a Small Boy and Girl with a Dog,
possibly Hugh Curtis and His Sister* 1870s
oil on canvas 65 x 53.5
FA1996.10

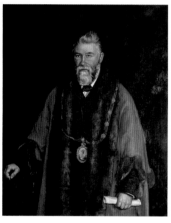

unknown artist
Thomas Mason Kingdon in Mayoral Robes
c.1887
oil on canvas 157 x 136
BWM1966.1332

unknown artist
St Mary's Church, Basing 1892
oil on canvas 52 x 41
FA2006.627

unknown artist early 19th C
*View of Christchurch Priory from Warren
Point*
oil on board 22 x 30
FA2001.40

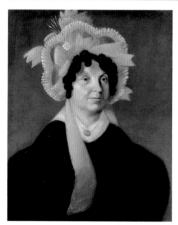

unknown artist 19th C
Mrs Isabell Watts
oil on canvas 74 x 61
FA1990.26

unknown artist late 19th C
Basingstoke Canal
oil on board 22 x 32
FA1993.53

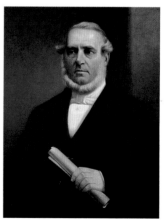

unknown artist late 19th C
Portrait of a Man Holding a Scroll
oil on canvas 116 x 95.5
FA2001.37

unknown artist
Reverend John Barney (1883–1960) as a Boy,
Fareham 1900
oil on canvas 84 x 60
FA2006.624

unknown artist
Ashdell Rustic Bridge, Alton c.1910
oil on canvas 30 x 46
ACM1965.29

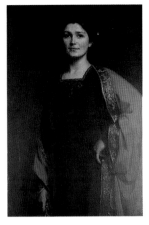

unknown artist
Portrait of a Woman in a Black and Red Dress
c.1910
oil on canvas 104 x 70
FA1998.103

unknown artist
A Church, possibly St Michael's, Basingstoke
1915
oil on canvas 36 x 48
FA2006.628

unknown artist
Alderman Sir William Purdie Treloar, Bt
(1843–1923) 1917
oil on canvas 89 x 72
FA2001.26

unknown artist
Gosport Ferry in Portsmouth Harbour c.1930
oil on cardboard 40 x 29
GOS1985.28

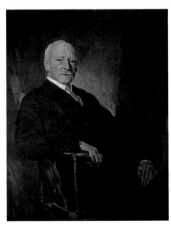

unknown artist
Sir William Wyndham Portal (1850–1931)
1931
oil on canvas 108 x 89
FA1993.27

unknown artist
Two Peasant Women with a Donkey 1965
oil on canvas 29 x 33
FA2006.626

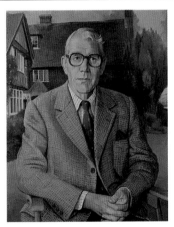

unknown artist
Sir Lynton White, Chairman of Hampshire
County Council (1977–1985) c.1980
oil on canvas 79.5 x 64
FA2006.506

unknown artist
A View of Christchurch Priory, Constable's House across the Mill Stream
oil on board 14.4 x 23.4
FA2006.293

unknown artist
Belle Vue Hotel, Lee-on-Solent
oil on canvas 30.5 x 46
FA1976.36

unknown artist
Bury House
oil on canvas 31 x 41
GOS1974.212.130

unknown artist
Christchurch Abbey from the Ferry
oil on canvas 31 x 51
FA1993.57

unknown artist
City Scene
oil on board 34 x 49
FA1993.86

unknown artist
Coastal Path
oil on canvas 23 x 30
FA1993.91

unknown artist
Compton Village near Winchester
oil on board 35 x 25
FA1993.107

unknown artist
Cottages at Bury Cross, Gosport
oil on canvas 28 x 40
GOS1976.294

unknown artist
Family Group, c.1840–1860
oil on canvas 62 x 52
HCMS1970.905

unknown artist
Gosport Iron Foundry
oil on canvas 40 x 51
GOS1987.152.2

unknown artist
John Richard Gregson in the Old Town Hall
oil on canvas 61 x 65
GOS1985.404

unknown artist
Lady Rose, Sandhills, Mudeford
oil on canvas 18.2 x 17.8
FA1998.302

unknown artist
Landscape
oil on canvas 17 x 51
FA2006.631

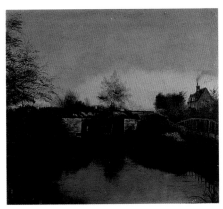

unknown artist
Lock on Basingstoke Canal
oil on canvas 44 x 50
FA2006.629

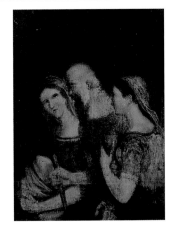

unknown artist
Lot and His Daughters
oil on canvas 33.4 x 26
FA1982.1.3

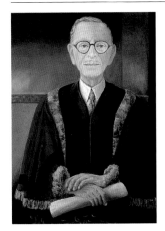

unknown artist
Mr Willis (1877–1970)
oil on canvas 24.5 x 19
FA1993.97

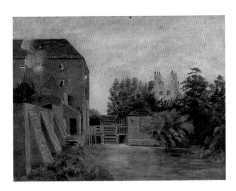

unknown artist
Old Mill House, Bedhampton
oil on canvas 49.5 x 60.2
HV2006.4

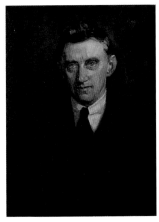

unknown artist
Portrait of a Gentleman
oil on canvas 62 x 46
FA1993.60

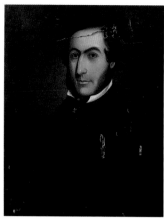

unknown artist
Portrait of a Gentleman
oil on canvas 65 x 51
FA1993.61

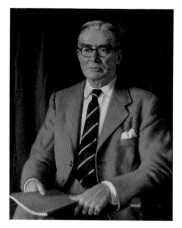

unknown artist
Portrait of a Gentleman
oil on canvas 90 x 69
FA2006.630

unknown artist
River Scene
oil on canvas 20 x 26 (E)
FA1993.82

unknown artist
St Mary's Church, Andover
oil on canvas 19.4 x 24.2
FA2006.601

unknown artist
The Grove, Gosport
oil on canvas 25 x 35
GOS1982.88

unknown artist
The Hard and High Street, Gosport
oil on canvas 29.6 x 45.1
GOS1981.75

unknown artist
The Old Mill, Christchurch
oil on board 27 x 24.7
FA2006.289

unknown artist
Town Square with Colonnade
oil on canvas 32 x 52 (E)
FA2006.606

unknown artist
Yacht Racing, c.1900
oil on canvas 66 x 109
GOS1985.402

Facing page: King, Gunning, 1859–1940, *Market Day* (detail), Portsmouth Museums and Records Service, (p. 145)

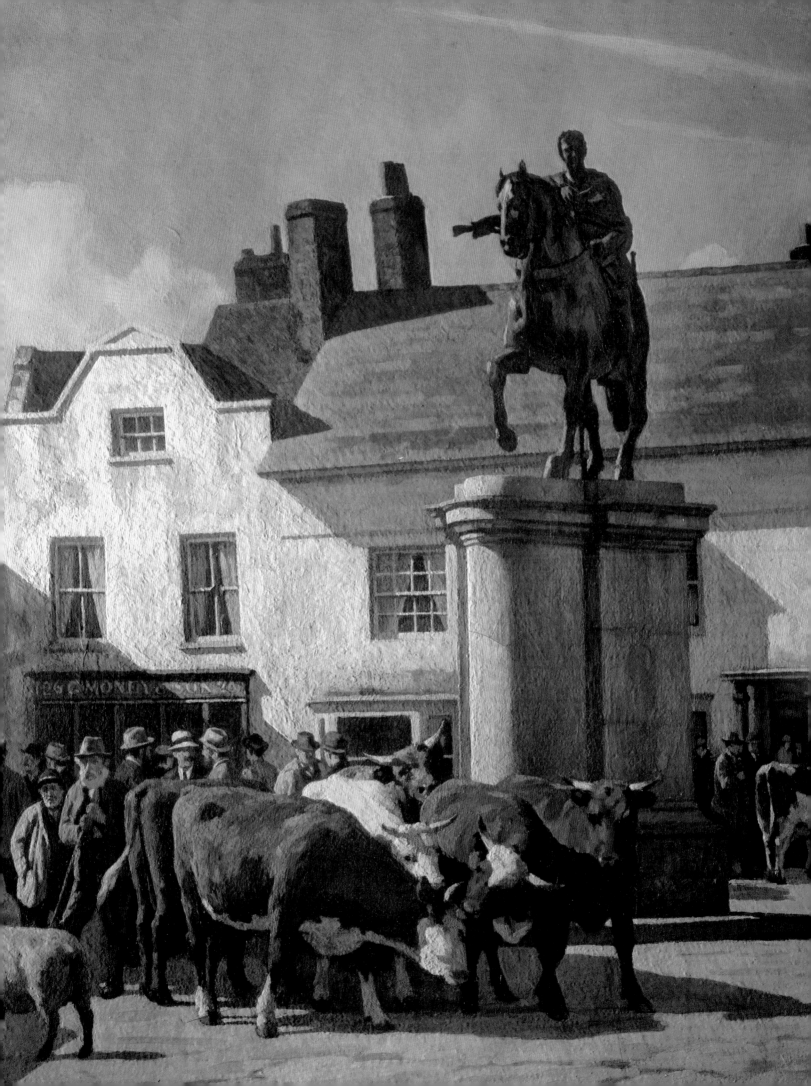

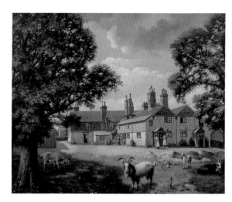

Van der Weegen, F. active 1912–1928
Eggars Grammar School, Alton 1912
oil on canvas 33 x 51
ACM1960.29

Van der Weegen, F. active 1912–1928
View of Anstey Lane, Alton 1913
oil on canvas 78 x 63
ACM1960.30

Van der Weegen, F. active 1912–1928
View of Cottages in Alton 1914
oil on canvas 67 x 82
ACM1960.28

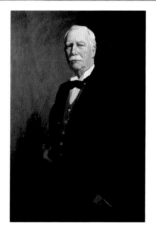

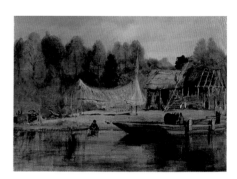

Van der Weegen, F. active 1912–1928
*Road Leading into Alton from the Upper
Windows of Eggar's Grammar School* 1916
oil on board 43 x 33
ACM1960.27

Watt, George Fiddes 1873–1960
*Francis George Baring, Second Earl of
Northbrook (1850–1929), Chairman of
Hampshire County Council (1907–1927)* c.1922
oil on canvas 112 x 76
FA1993.22

Watts, Frederick W. 1800–1862
On the River Itchen
oil on board 28 x 39.5
FA1993.37

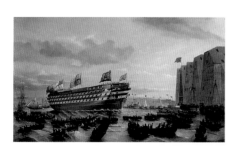

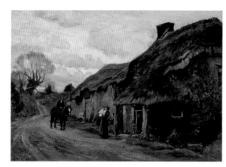

Weedon, Edwin 1819–1873
*The Launching of 'HMS Royal Sovereign' at
Portsmouth, 25 April 1857*
oil on canvas 69.4 x 120.2
FA2006.107

Whitehead, M. E.
Cottages at Throop
oil on canvas 29 x 44
CRH1964.10

Williams, E.
*View of Cams Mill and Delme Arms Public
House* c.1910
oil on canvas 39.5 x 44.8
FA2006.489

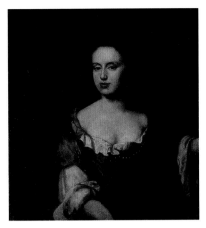

Wissing, Willem c.1656–1687
Lady Catherine Shuckburgh of Hinton Ampner, Hampshire 1675
oil on canvas 81.5 x 74
FA1989.16.2

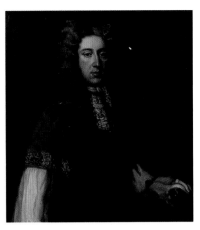

Wissing, Willem c.1656–1687
Sir Charles Shuckburgh of Hinton Ampner, Hampshire
oil on canvas 82 x 74.5
FA1989.16.1

Woods, Chris
Bodmin at Ropley, West Country Class Locomotive No.34016 on the Watercress Line near Alton 1991
oil on canvas 51 x 76
FA1991.43

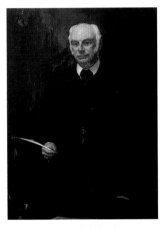

Wortley, Archibald J. Stuart 1849–1905
Melville Portal (1818–1904) 1895
oil on canvas 114 x 84
FA1993.26

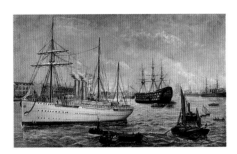

Wright, E. A.
The Royal Yacht and 'HMS Victory'
oil on canvas 71 x 121.2
GOS1985.403

Wright, Jack
Landscape 1958
oil on canvas 18 x 23
FA2006.618

Horsepower: The Museum of the King's Royal Hussars

Horsepower, the recently refurbished museum of the King's Royal Hussars, tells the story of an English cavalry regiment from 1715 to the present day. The Museum is situated in Peninsula Barracks in the centre of Winchester and is one of six military museums that form Winchester's Military Museums, accessible on their website, www.winchestermilitarymuseums.co.uk. As the only cavalry museum in the region, Horsepower tells the story of the mounted soldier, firstly on horses, but for the last 75 years in armoured cars and tanks.

The displays include impressive life-size models, interactive exhibits, a variety of memorabilia such as medals, swords, uniforms and musical instruments, as well as maps and pictures. Soon after starting a visit to the Museum, the painting *The Scouts* by William Barnes Wollen is seen. This portrays two 10th Hussars during the Peninsula War observing from the cover of trees the approach of a French mounted patrol. Although painted long after the event, the picture captures the spirit of the cavalry soldier on reconnaissance.

The paintings displayed include a wide range of subjects from important generals of former years such as *Major General Sir John Douglas*, who commanded the 11th Hussars at the Charge of the Light Brigade, to National Cadet Officers such as *Sergeant Major Kilvert*, who also rode in that charge. The scenery of South Africa during the Boer War is brought to life in *The Race for the Kopje* by Godfrey Douglas Giles that shows an incident near the Modder River. Giles also painted *The Charge at El Teb, Sudan,* having been present himself. This painting is displayed above a showcase that contains many objects included in the picture, such as spears, a sword and a shield.

More recent paintings include two pictures of the 10th Hussars Guidon Parade, *Auld Lang Syne, 1961 (10th Hussar Guidon Parade)* and *10th Royal Hussar Guidon Parade March Past HRH Duke of Gloucester, Colonel-in-Chief* by Joan Wanklyn and the 11th Hussars Guidon Parade in 1965, *Presentation of the Guidon to HM Queen Mother, 1965, (11th Hussars),* by Terence Tenison Cuneo.

The Museum recently purchased, with the assistance of Resource and the Victoria & Albert Museum Purchase Grant Fund '*The Girls We Left Behind', the Departure of a Troop of 11th Hussars for India* by Thomas Jones Barker. This depicts the touching scene of a mounted troop of 11th Hussars leaving an English village on their departure for India in 1866.

A number of the paintings included are on loan from the regiment, The King's Royal Hussars, and are sometimes returned for their use. In addition, an important portrait of *Field Marshall Julian Byng, 1st Viscount Byng of Vymy,* painted by Philip Alexius de László, is on loan from the National Portrait Gallery. He served in every rank from 1883 to 1919 and was first in action with the 10th Hussars at El Teb in 1884.

Major P. J. C. Beresford (Retired), Honorary Curator

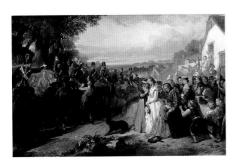

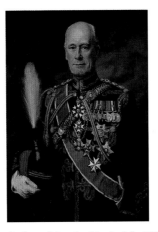

Barker, Thomas Jones 1815–1882
*'The Girls We Left Behind', the Departure of a
Troop of 11th Hussars for India* 1866
oil on canvas 69.5 x 107
1797

Codner, Maurice Frederick 1888–1958
General Sir Charles Gairdner (1898–1983)
1951
oil on canvas 90 x 69
1258

Cuneo, Terence Tenison 1907–1996
*Presentation of the Guidon by HM Queen
Mother, 1965 (11th Hussars)*
oil on canvas 100 x 140
612

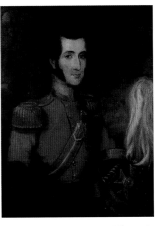

Giles, Godfrey Douglas 1857–1941
Charge at El Teb, Sudan 1884
oil on canvas 96 x 170
628

Giles, Godfrey Douglas 1857–1941
The Race for the Kopje 1902
oil on canvas 75 x 125
613

Gwatkin, Joshua Reynolds active 1831–1851
Samuel Fisher, 11th Light Dragoons 1840
oil on canvas 90 x 70
2123

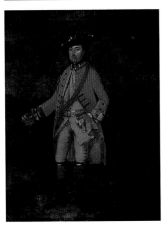

Hall, John 1739–1797
*Captain Edward Hall, Earl of Ancrams
Dragoons* 1762
oil on canvas 42 x 33
1568

László, Philip Alexius de 1869–1937
*Field Marshall Julian Byng, 1st Viscount Byng
of Vymy* 1933
oil on canvas 120 x 92

G. M.
HRH Duke of Gloucester 1928
oil on canvas 53 x 45
1441

unknown artist
*Lieutenant General Charles Vane, Lord Stewart
(later Marquis of Londonderry)* c.1870
oil on canvas 59 x 48
604

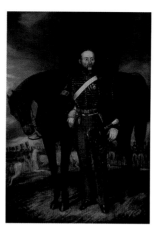

unknown artist
Sergeant Major Kilvert c.1870
oil on canvas 79 x 56
720

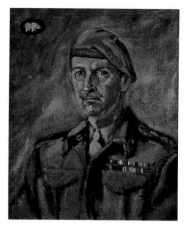

unknown artist
Major General John Coombe 1940s
oil on hessian 58 x 49
1016

Wanklyn, Joan active 1956–1994
Auld Lang Syne (10th Hussar Guidon Parade)
1961
oil on canvas 72 x 100 (E)
611

Wanklyn, Joan active 1956–1994
*10th Royal Hussar Guidon Parade March Past
HRH Duke of Gloucester, Colonel-in-Chief*
1961
oil on canvas 72 x 100 (E)
610

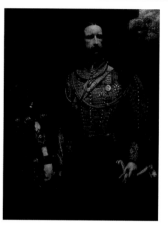

Winterhalter, Franz Xaver 1805–1875
Major General Sir John Douglas
oil on canvas 132 x 100
1053

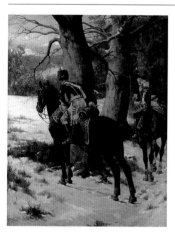

Wollen, William Barnes 1857–1936
The Scouts 1905
oil on canvas 142 x 114
996

The Adjutant General's Corps Museum

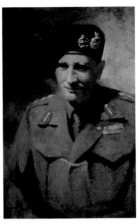

Cremona, Emanuel Vincent 1919–1987
*Field Marshall Montgomery of Alamein
(1887–1976)* 1944
oil on canvas 94 x 67.2
2004.1781

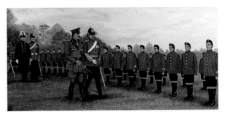

A. G. J.
*Royal Hibernian Military School Prize Giving
Day, 1911* 1980
oil on canvas 35 x 74
2004.0353

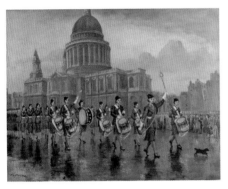

Lytton, Neville Stephen 1879–1951
Auxiliary Territorial Service Band c.1943
oil on canvas 74.5 x 90.5
2004.3535

The Gurkha Museum

Britain has had a unique relationship with Nepal, beginning with war between the two countries from 1814–1815. The deep feeling of mutual respect and admiration between the British and their adversaries resulted in a peace treaty where a large number of Gurkhas were permitted to volunteer for service in the East India Company's Army. These volunteers formed the first regiments of the Gurkha Brigade, and Britain's friendship with Nepal stems from this time, a country which has proved a staunch ally ever since and has become our 'oldest ally' in Asia.

The Gurkha Museum, Winchester, covers the Gurkha and Nepal, his homeland, and describes the main chapters of Gurkha military history from 1815 to the present day.

Crossing the Tigris, Mesopotamia, 23 February 1917 shows the 1st Battalion 2nd King Edward's Own Gurkha Rifles being rowed across the river by men of the 1st/4th Battalion, the Hampshire Regiment and was painted c.1960 by Lionel D. R. Edwards (1878–1966).

More recent acquisitions include two oil paintings of *HM Queen Elizabeth II* and *HRH The Duke of Edinburgh* by Denis Fildes (1889–1974), and oil paintings of *HRH The Prince of Wales* by Michael Noakes (b.1933) and *HRH Princess Mary, The Princess Royal* by Leonard Boden (1911–1999).

A painting of a scene during the Borneo Confrontation entitled *The Action at Labis* by Terence Tenison Cuneo (1907–1996) depicts the 10th Gurkha Rifles on operations in 1964 against Indonesian parachute troops in Western Malaysia. The painting is a tribute to the Company Commander, Major Richard Haddow who was killed in the encounter.

The Museum has been assisted on two occasions by Resource and the Victoria & Albert Museum Purchase Grant Fund to buy two watercolours and by the Friends of the Museum to enable many other acquisitions over the past 14 years. Without such help we, as an independent museum, would not be able to acquire such fine artwork to show to the public.

Lastly, the Museum is most grateful to the Public Catalogue Foundation for the reproduction of our paintings which will provide information to a wider audience.

Major Gerald Davies, Curator

Beadle, James Prinsep 1863–1947
General Frederick Young (1786–1874), Who Raised and Commanded the Sirmoor Battalion (later King Edward VII's Own (…) 1928
oil on canvas 60 x 50
1995.05.11 (P)

Boden, Leonard 1911–1999
HRH Princess Mary, the Princess Royal (1897–1965) c.1958
oil on canvas 125 x 100
2006.02.02 (P)

Cousins, Derek b.1928
Field Marshal the Lord Bramall of Bushfield, KG, GCB, OBE, MC, JP (b.1923), Colonel 2nd King Edward VII's Own Gurkhas (…) 1983
oil on canvas 99.5 x 75
1995.04.31 (P)

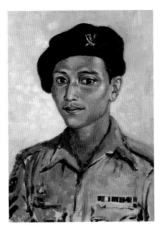

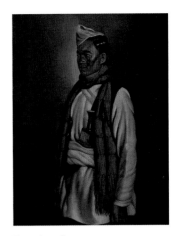

Cuneo, Terence Tenison 1907–1996
The Action at Labis
oil on canvas 100 x 125
2006.02.05 (P)

Doig, Desmond 1921–1983
*Naik Dilbahadur Rana, Orderly to Major
Geoffrey Maycock of the 5th Royal Gurkha
Rifles (Frontier Force)* c.1946
oil on canvas 55.5 x 41
196.02.06

Douglas, G.
*Gurkha Mangale Limbu, Supper in '68:
Gurhka Field Squadron in Traditional
Dress* c.1960
oil on canvas 44.5 x 34.7
1994.03.17

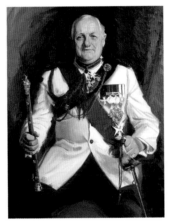

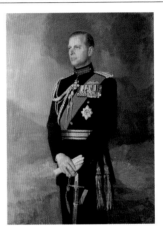

Edwards, Lionel D. R. 1878–1966
*Crossing the Tigris, Mesopotamia, 23 February
1917* c.1960
oil on canvas 69.3 x 90
1995.04.32 (P)

Festing, Andrew b.1941
*Field Marshal Sir John Lyon Chapple, GCB,
CBE, MA, DL, Colonel 2nd King Edward VII's
Own Gurkhas (The Sirmoor Rifles) (…)*
oil on canvas 100 x 76.7
2006.02.01 (P)

Fildes, Denis 1889–1974
HRH The Duke of Edinburgh (b.1921) c.1952
oil on canvas 124.5 x 91.5
2006.02.03

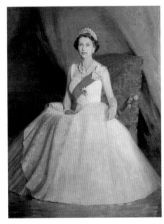

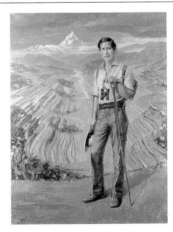

Fildes, Denis 1889–1974
HM Queen Elizabeth II (b.1926) c.1959
oil on canvas 167 x 127
2006.02.04 (P)

Noakes, Michael b.1933
HRH The Prince of Wales (b.1948) 1982–
1983
oil on canvas 156 x 121
1995.04.30 (P)

Ram, Jayun active 1824–c.1840
*Captain John Fisher (1802–1846), Killed in
Action while Commanding the 6th Sirmoor
(Rifle) Battalion (…)* c.1840
oil on canvas 75.5 x 60.3
1995.02.03

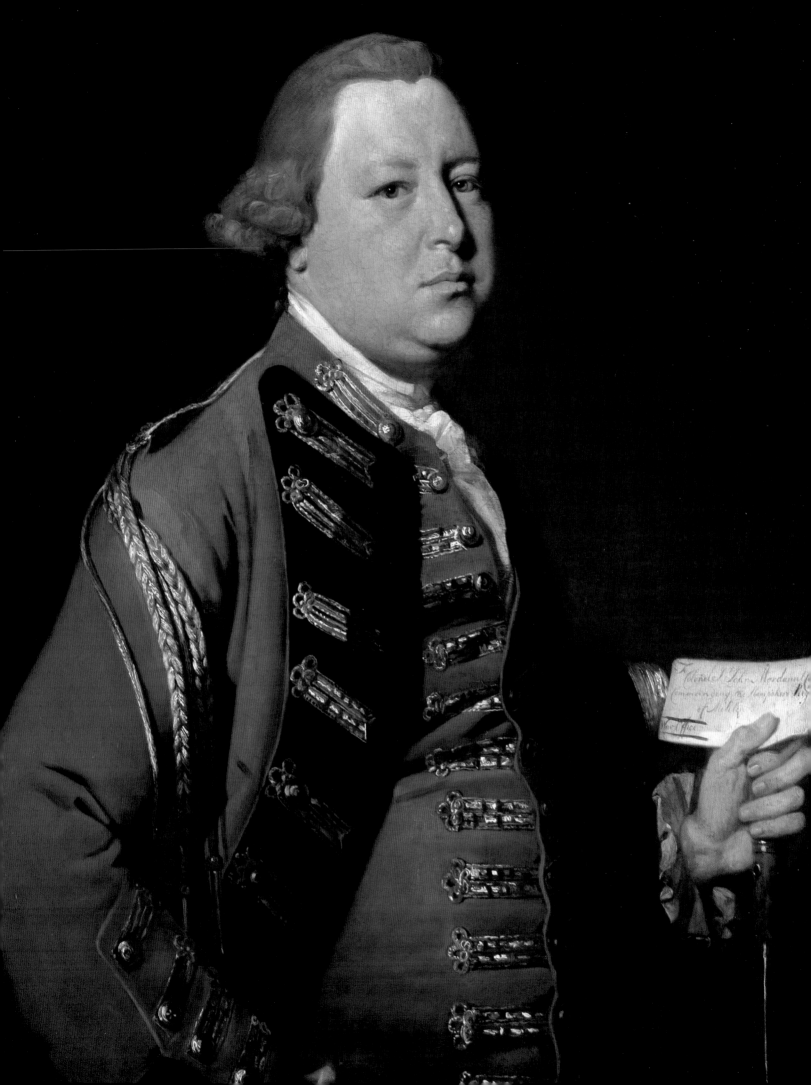

Sheldon, Harry 1923–2002
*A Young Garhwali Man in Traditional
Dress* c.1946
oil on canvas 54.6 x 44.5
2002.03.37

unknown artist
*Lance Corporal Bhimlal Thapa DCM, 1st
Battalion 2nd King Edward VII's Own Gurkha
Rifles (The Sirmoor Rifles)* c.1951
oil on canvas 57 x 46
1998.03.42 (P)

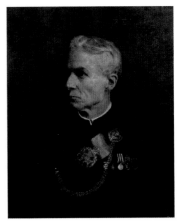

unknown artist
*General John Adam Tytler, VC, CB (1825–
1880)*
oil on canvas 69.5 x 55.5
2005.03.30

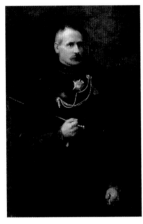

unknown artist
*Major General Sir Charles H. Powell, KCB,
Colonel 1st King George V's Own Gurkha
Rifles (1916–1943)*
oil on canvas 150 x 82
2003.07.01

The Light Infantry
Museum

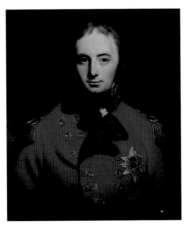

Birley, Oswald Hornby Joseph 1880–1952
Sir John Moore, KB (1761–1809) 1927
oil on canvas 74 x 62 (E)
PCF1

Facing page: unknown artist, *Colonel Mordaunt Cope Commanding the Hampshire Militia* (detail), The Royal Hampshire
Regiment Museum, (p. 318)

The Royal Green Jackets Museum

A picture, it is said, is often worth a thousand words, and from the perspective of the military historian or museum visitor, it is often a crucial aid to gaining an understanding of how a commander may have appeared to his men or of what the battlefield may have looked like. This is especially so in the years before the Crimean War (1854–1856), after which photography became more commonplace, providing images, over time, of equal and often greater historical rather than aesthetic value.

The Royal Green Jackets Museum is fortunate to own a number of oil paintings which pre-date the era of photography and supplement the written record with handsome portraits of regimental figures, some of national renown, and of scenes depicting the actions in which the Regiment and its antecedents were involved. Among them is a splendid painting by an unknown artist of Major General Coote Manningham, who is revered by the Regiment as the founder of The Rifle Brigade in 1800. Other valuable portraits from an historical perspective include paintings of a number of the Regiment's commanders at the Battle of Waterloo, including John Colborne, later Field Marshal Lord Seaton, who, when in command of the 52nd and with his Regiment, administered the decisive flanking attack that routed the French Imperial Guard and ensured Allied victory. Among the battle scenes are five admirable and little-known oils by Thomas Baines (1820–1875) of engagements in which the 1st Battalion, The Rifle Brigade, took part during the war in South Africa in 1852. All these and more are included in the Public Catalogue Foundation's excellent listing of the Museum's paintings, which the Museum Trustees hope will increase the public's awareness of their existence and lead visitors to Hampshire and its residents wishing to view for themselves the treasures on their doorstep.

We are indebted to the Public Catalogue Foundation for initiating this project and for the images that it has spawned.

Lieutenant-General Sir Christopher Wallace, Chairman

Atkinson, John Augustus 1775–1833
Lieutenant Colonel Macleod at Badajoz
oil on canvas 28 x 34
922

Aylward, James D. Vine d.1917
The Morning of Waterloo
oil on board 18.5 x 28
1930a

Baines, Thomas 1820–1875
Camp Scene
oil on board 27 x 40
1270d

Baines, Thomas 1820–1875
*Captain Lord Russel's Coy with a Six-Pounder
Detachment of the Royal Artillery Skirmish
against the Kaffirs*
oil on board 42.5 x 64
1270b

Baines, Thomas 1820–1875
*Landing in Surf at Algoa Bay, Cape of Good
Hope, 30 March 1852*
oil on board 27 x 39
1270c

Baines, Thomas 1820–1875
River Crossing
oil on board 26 x 38.5
1270a

Baines, Thomas 1820–1875
*The Battalion Embarks at Dover on HM
Steamship 'Magaera' on 2 January 1852*
oil on board 26.5 x 39.5
1270e

Béjar Novella, Pablo Antonio 1869–1920
Prince Maurice of Battenburg (1891–1914)
1915
oil on canvas 127 x 101.5
77

Bodley, Josselin 1893–1974
Polygon Wood, Ypres 1915
oil on canvas 62.5 x 51.5
130a

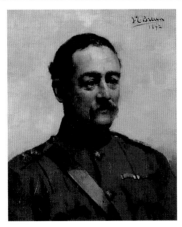

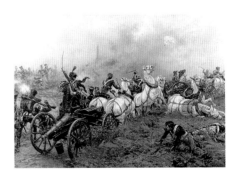

Bodley, Josselin 1893–1974
Shelley Farm, St Eloi 1915
oil on canvas 52 x 44
130b

Breun, John Ernest 1862–1921
Lieutenant Colonel Hutton 1892
oil on canvas 59.5 x 49
799

Crofts, Ernest 1847–1911
*The Capture of a French Battery by the 52nd
Regiment at Waterloo* 1896
oil on canvas 155 x 193
1929

Fildes, Denis 1889–1974
General Sir David Lathbury, GCB, DSO, MBE (1906–1978)
oil on canvas 126 x 90
867

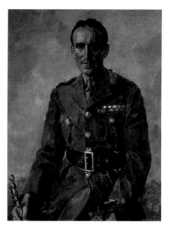

Green, Kenneth 1905–1986
General Sir Bernard Paget (1887–1961) 1964
oil on canvas 90 x 70
1119

Hollebone, Sarah
General Sir Montagu Stopford, GCB, KBE, DSO, MC
oil on canvas 99.8 x 74
1420

Holt, Herbert 1891–1978
Brigadier General Henry Bouquet (1719–1765) (after John Wollaston)
oil on canvas 75.5 x 63
149

Jones, George 1786–1869
Captain George Napier
oil on board 21 x 25
1066

Kitson, Ethel M. active 1920–1972
Cromac Square, Londonderry 1972
oil on canvas 44.5 x 60
1960

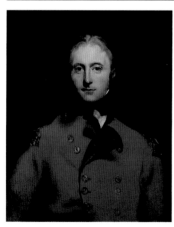

Lawrence, Thomas 1769–1830
Sir John Moore (1761–1809)
oil on linen 74.5 x 62
1035

Lawson, Cecil active 1913–1923
Iron Bridge at Lucknow
oil on board 24 x 32.5
1936

Miles, John C. active 1839–1850
Lieutenant Edward Welch Eversley 1850
oil on canvas 74 x 43.5
527

Moseley, Henry 1798–1866
Lieutenant General Sir Henry Smith
(1805–1837)
oil on canvas 75 x 62
1362

Pickersgill, Henry William 1782–1875
Major General Sir George Ridout Bingham
(1777–1833) (detail)
oil on canvas 224 x 144.5
117

Risdon, A. W.
Rifleman Tom Plunkett (after N. Payne)
oil on canvas 28.3 x 49
1925

Trotter, John (attributed to)
active 1756–1792
Lieutenant Colonel George Etherington (served
with the 60th, 1756–1787)
oil on canvas 54 x 68
1918

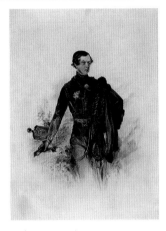

unknown artist
Captain Francis Charteris Fletcher (served
1846–1864)
oil on paper 44 x 34
558

unknown artist
Captain Isaac R. D'Arcy
oil on board 29 x 19
420

unknown artist
Colonel John Philip Hunt, CB (1799–1814)
oil on canvas 71 x 60
782

unknown artist
Colonel Thomas Lawrence Smith (1792–1877)
oil on canvas 72 x 60
1369 (P)

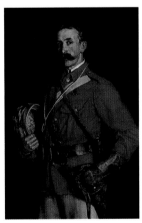

unknown artist
Colonel Willoughby Verner (d.1943)
oil on canvas 110.5 x 74.2
1581

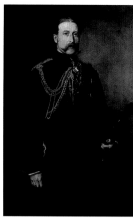

unknown artist
Duke of Connaught (d.1942)
oil on canvas 129 x 85
352

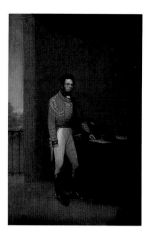

unknown artist
Governor General Sir George Prevost (1767–1816)
oil on canvas 60 x 40
1187

unknown artist
John Colborne, 1st Baron Seaton (1778–1863)
oil on canvas 90 x 70
1310

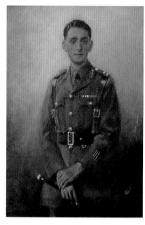

unknown artist
Lieutenant Anthony Francis Macleod Paget (1924–1945)
oil on canvas 42.5 x 30.5
1118

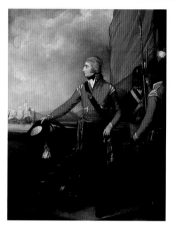

unknown artist
Lieutenant Colonel Boyd Manningham
oil on canvas 94 x 73.5
942b

unknown artist
Lieutenant Colonel James Fullerton (d.1834)
oil on canvas 75 x 62
577

unknown artist
Lieutenant Colonel W. Humbley (served with the Rifle Brigade, 1807–1854)
oil on canvas 71 x 47
774

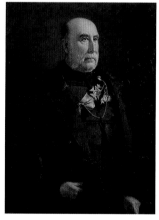

unknown artist
Lieutenant General Robert Beaufoy Hawley (1821–1898)
oil on canvas 87 x 67
711

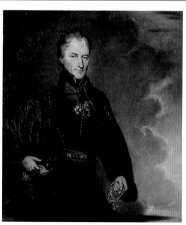

unknown artist
Lieutenant General Sir Thomas Beckwith (d.1831)
oil on paper 34.5 x 30
88

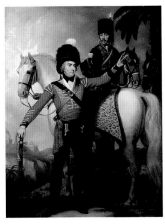

unknown artist
*Major General Coote Manningham
(1765–1809)*
oil on canvas 92 x 73
942a

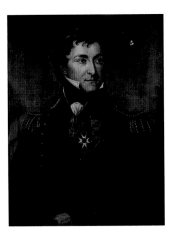

unknown artist
*Major General Sir Alexander Cameron of
Inverailort (1770–1850)*
oil on canvas 80.5 x 62
268

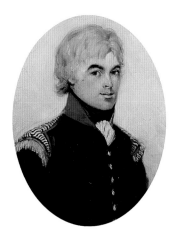

unknown artist
Robert Craufurd (1764–1812)
oil on board 21 x 16
392

unknown artist
Russian Icon
tempera on linen 11 x 9.5
1730

unknown artist
The Honourable Henry Robert Molyneux
oil on canvas 22 x 17
1020

The Royal
Hampshire
Regiment
Museum

Cuneo, Terence Tenison 1907–1996
Tebourba Gap 1980
oil on canvas 98 x 135
PCF7

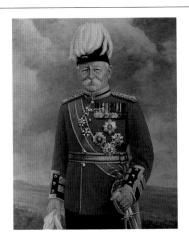

Holroyd, John Newman active 1909–1947
*General Sir Richard Haking (1862–
1945)* 1938
oil on canvas 90 x 60.5
PCF2

Stadden, Charles & Wilcox, Leslie Arthur
1904–1982
Presentation of the Colours to 1st Battalion, by Earl Mountbatten of Burma (...)
oil on canvas 75 x 125
PCF4

unknown artist
Ceremony of the Presentation of the Colours of the 4th/5th Battalion, the Hampshire Regiment, by Earl Mountbatten of Burma (...)
oil on canvas 39 x 88
PCF5

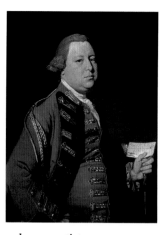

unknown artist
Colonel Mordaunt Cope Commanding the Hampshire Militia
oil on canvas 88.5 x 68.5
PCF3

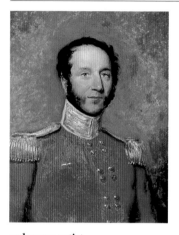

unknown artist
Major John Rutledge Kell, 37th Foot (1825–1836)
oil on canvas 29 x 23.3
PCF9

Waring, Dawn
The Battle of Minden, 1 August 1759 1993
oil on canvas 104 x 171
PCF1

Wilcox, Leslie Arthur 1904–1982
D-Day, 6 June 1944
oil on canvas 71 x 98
PCF6

Wilcox, Leslie Arthur 1904–1982
Monte Cassino
oil on canvas 60 x 105
PCF8

Winchester Museums Service

Winchester Museums Service cares for a collection of around 1,600 works of art, including 76 oils, mainly of a topographical nature which belong to Winchester City Council. The majority of the pictures are views of Winchester and the surrounding district, though the collection does include a number of scenes of places outside the district. The oldest topographical picture is a view of Winchester from the south-west in 1759 and shows an encampment of Hessian troops outside the city.

As well as the topographical scenes the collection also contains some portraits. These include local MPs, mayors, local gentry, civic dignitaries, city benefactors and patrons, including Charles I and Charles II. The earliest portrait, that of Ralph Lamb a cousin of the then Mayor of Winchester, was painted in 1554, probably to commemorate his attendance that year at the wedding of Queen Mary and King Philip in Winchester. Lamb is best known locally as a benefactor of St John's Hospital, a local alms charity.

The collection includes pictures by nationally known artists such as Frederick Appleyard, Peter Lely, John Opie, George Arnald, William Sidney Cooper and Frank O. Salisbury. However, the remit of the Museums Service's collection policy ensures that local artists, both professional and amateur, are also well represented.

The majority of the art collection is kept at the Museums Service headquarters where they can be viewed by appointment, but around a third of the oils are hung on the walls of Winchester Guildhall and the Mayor's official residence, Abbey House. Once a year a selection of pictures are exhibited, including some of the oil paintings.

The collection includes many bequests, donations and purchases, and the city has a policy of acquiring new pictures both contemporary and historical. A number of pictures have been purchased with the help of both the Victoria & Albert Museum Purchase Grant Fund and the Art Fund. The most recent accession was made during the compilation of the Hampshire catalogue and was painted in 1997 by Tobias Till, the artist son of the retiring Dean of Winchester Cathedral.

Ross Turle, Curator of Recent History

Appleyard, Frederick 1874–1963
*The Devil's Pool, Glen Trool, Galloway,
Scotland* c.1920
oil on panel 29.6 x 39.6
A.1644

Appleyard, Frederick 1874–1963
*The Merrick Group and River Dee, Galloway,
Scotland* c.1920
oil on panel 27.6 x 38
A.1645

Appleyard, Frederick 1874–1963
Geoffrey Walton as a Young Boy 1922
oil on board 33.6 x 24.2
A.1637

Appleyard, Frederick 1874–1963
View over Lovington House c.1925
oil on canvas 29.4 x 39.7
A.1646

Appleyard, Frederick 1874–1963
Itchen Valley Landscape with Figure c.1930
oil on canvas 29.1 x 39.6
A.1636

Appleyard, Frederick 1874–1963
*Avington Park, Looking North towards Itchen
Down* c.1935
oil on panel 29.5 x 39.5
A.1647

Appleyard, Frederick 1874–1963
Garden at Lane End, Itchen Stoke c.1935
oil on canvas 28 x 37
A.1635

Appleyard, Frederick 1874–1963
*Moonrise over the River Itchen from just below
Itchen Stoke* c.1935
oil on panel 29.8 x 40
A.1648

Appleyard, Frederick 1874–1963
The Ford at Chilland, Martyr Worthy c.1935
oil on panel 28.7 x 39.5
A.1649

Facing page: Bealing, Nicola, b.1963, *The Bird Island* (detail), Hampshire County Council's Contemporary
Art Collection, (p. 239)

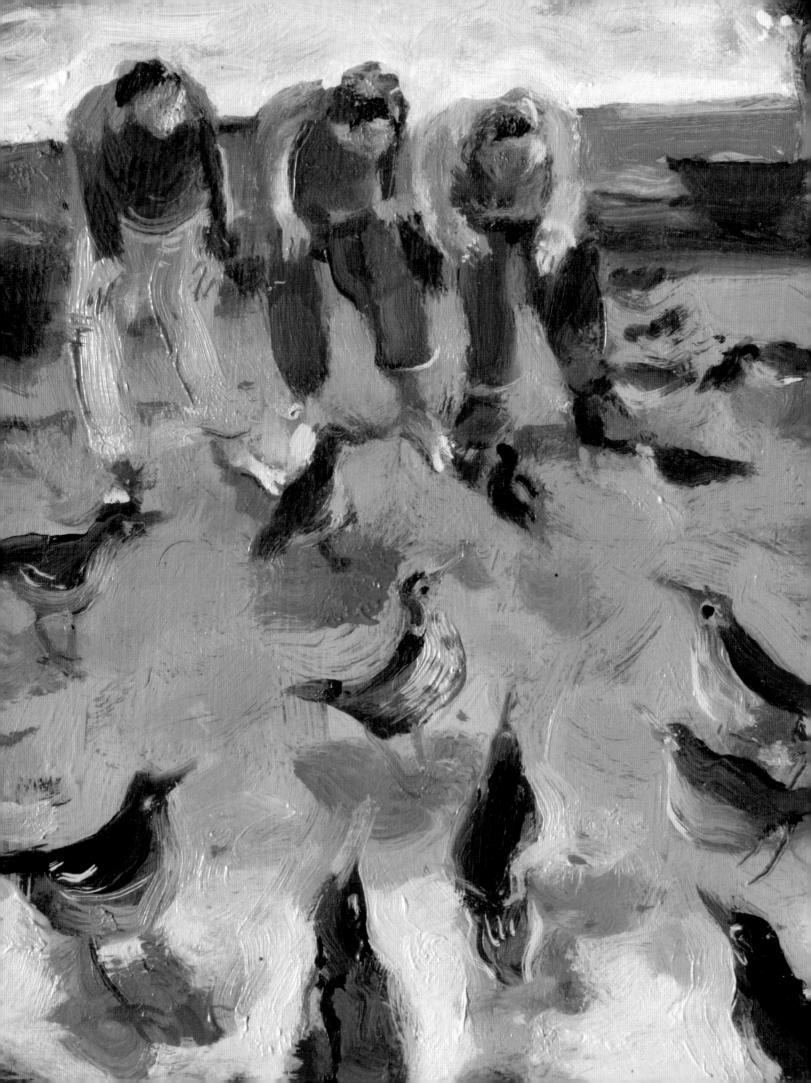

Appleyard, Frederick 1874–1963
Itchen Abbas Church c.1940
oil on canvas 17 x 25
A.1617

Appleyard, Frederick 1874–1963
Landscape with Trees c.1940
oil on canvas 29 x 38.5
A.1521

Appleyard, Frederick 1874–1963
Village Green, Itchen Stoke c.1940
oil on canvas 31.5 x 51.5
A.1520

Arnald, George 1763–1841
Cromwell's Troops Entering Winchester from the South c.1810
oil on canvas 135 x 235
A.1577

Baigent, Richard 1799–1881
Boys Going to Hills c.1840
oil on canvas 24.2 x 30
A.1535

Bird
Richard Baigent (1799–1881) 1836
oil on canvas 73.7 x 61
A.208

Christie, Tessa
Interior of Winchester Cathedral c.1970
oil on board 54.3 x 45.4
A.252

Cooper, William Sidney 1854–1927
Tanquerary Island, Kent 1903
oil on canvas 100 x 150
A.1506

Darley, William Henry active 1836–1850
Head of Christ 1840
oil on canvas 20.2 x 15.1
A.268

Darley, William Henry active 1836–1850
Louisa Baigent 1841
oil on canvas 73.7 x 61
A.207

Delamorte
Versailles, the Garden Front c.1940
oil on canvas 53 x 64
A.201

Donaldson, Andrew Brown 1840–1919
King Alfred and the Danes c.1890
oil on canvas 93.5 x 182
A.1234

Dyck, Anthony van (copy after) 1599–1641
John Paulet (1598–1675), Fifth Marquis of
Winchester, Defender of Basing c.1670
oil on canvas 190 x 150
A.1503

Griffier, Jan II active 1738–1773
Winchester from the South-West with an
Encampment in the Foreground 1759
oil on canvas 78.6 x 147.6
A.192

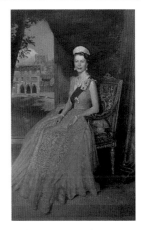

Halliday, Edward Irvine 1902–1984
Queen Elizabeth II (b.1926) 1957
oil on canvas 200 x 136
A.1500

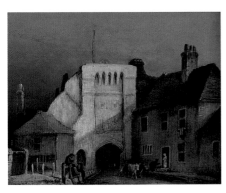

Hart, Thomas Gray 1797–1881
Westgate from the West c.1820
oil on canvas 27 x 34.5
A.1622

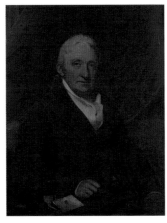

Heathcote, Thornhill B. active 1880–1890
Richard Harpur 1886
oil on canvas 89.5 x 69
A.231

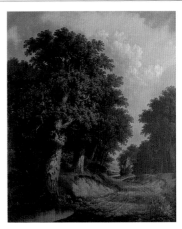

Ladbrooke, John Berney 1803–1879
Landscape with Trees, Cottage, Winding Lane
and Pond c.1840
oil on canvas 95.2 x 81
A.205

Ladbrooke, Robert 1770–1842
Landscape with Trees, Cattle, and Stream
c.1800
oil on canvas 66 x 90.2
A.204

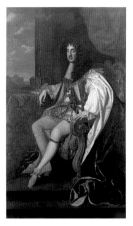

Lely, Peter 1618–1680
King Charles II (1630–1685) c.1680
oil on canvas 300 x 150
A.1495

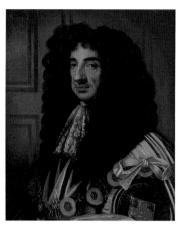

Lely, Peter (after) 1618–1680
King Charles II (1630–1685) c.1700
oil on canvas 72.4 x 59.7
A.195

Liddell, George
Edward Page Clowser (1795–1860) 1852
oil on canvas 89.4 x 70
A.229

Locke, Henry Edward 1862–1925
*Statue of King Alfred (849–899) in the
Broadway* 1904
oil on canvas 101.6 x 68.6
A.214

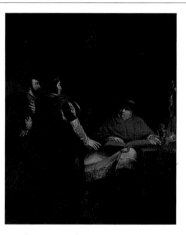

Maclise, Daniel 1806–1870
*Cardinal Wolsey Refusing to Deliver up the
Seals of His Office* c.1850
oil on canvas 95.2 x 80
A.203

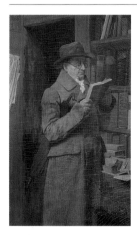

Marks, Henry Stacey 1829–1898
The Odd Volume 1894
oil on canvas 67.3 x 40.6
A.197

Merrick, Emily M. b.1842
*Richard Moss (1823–1905), MP for
Winchester* c.1890
oil on canvas 66.3 x 53.3
A.1477

Moore, Annie Osborne active 1888–1909
Alderman Thomas Stopher (1837–1926) 1909
oil on canvas 97 x 74.5
A.1233

Mornewick, Charles Augustus
active c.1826–1874
The First Viscount Eversley, Charles Shaw-Lefevre (1794–1888) 1857
oil on canvas 180 x 150
A.1505

Opie, John 1761–1807
Lady Elizabeth Woodville Pleading for Her Children before Edward IV (detail) 1798
oil on canvas 249 x 198
A.286

Osmond, Edward 1900–1981
Eight Acres Corner on the Avington-Littledown Road c.1930
oil on panel 25.9 x 34.2
A.1650

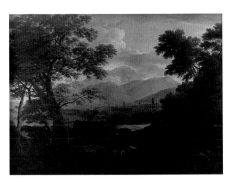

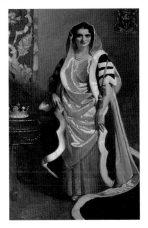

Reinagle, Ramsay Richard 1775–1862
Landscape in Italy 1802
oil on canvas 198.1 x 243.8
A.285

Salisbury, Frank O. 1874–1962
Marchioness of Winchester (1902–1995) 1956
oil on canvas 200 x 107
A.1232

Sparkes, T. Roy active c.1960–1989
Cheyney Court c.1960
oil on canvas 16.6 x 25.9
A.236

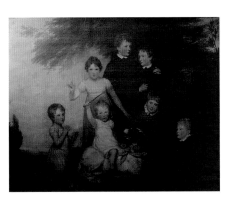

Sparkes, T. Roy active c.1960–1989
College Hall, Winchester College c.1960
oil on canvas 34.1 x 47.7
A.235

Sparkes, T. Roy active c.1960–1989
The Old Chesil Rectory c.1971
oil on canvas 15.8 x 26
A.234

Stewardson, Thomas 1781–1859
The Children of the 13th Marquess c.1812
oil on canvas 190 x 240
A.1554 (P)

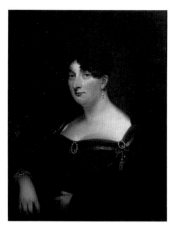

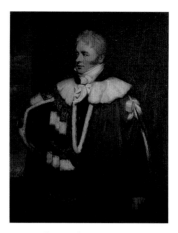

Stewardson, Thomas 1781–1859
*Anne, Wife of the 13th Marquess of Winchester
(b. before 1785–1841)* c.1815
oil on canvas 74 x 62
A.1553 (P)

Stewardson, Thomas 1781–1859
*Charles Paulet (1764–1843), 13th Marquess of
Winchester* c.1815
oil on canvas 129 x 94
A.1552 (P)

Till, Tobias b.1969
Footbridge 1997
oil on canvas 44.8 x 54.8
A.1695

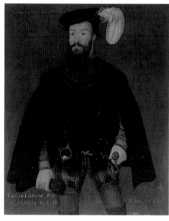

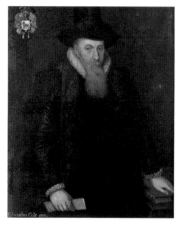

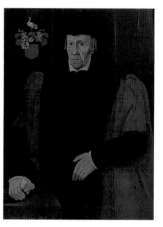

unknown artist
Ralph Lamb (1518–1558) 1554
oil on board 42 x 33.5
A.196

unknown artist
Edward Cole (d.1617) c.1600
oil on canvas 135 x 110
A.1501

unknown artist
Sir Thomas White (1492–1567) c.1600
oil on panel 84 x 62
A.1498

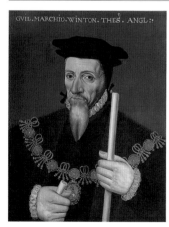

unknown artist
*Sir William Paulet (c.1483–1572), First
Marquis of Winchester* c.1600
oil on panel 90 x 65
A.1491

unknown artist
George Pemerton c.1650
oil on canvas 135 x 110
A.1502

unknown artist
King Charles I (1600–1649) c.1650
oil on canvas 300 x 150
A.1493

unknown artist
King Charles II (1630–1685) c.1680
oil on canvas 300 x 150
A.1497

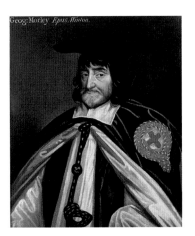

unknown artist
George Morley, DD (1597–1684) c.1700
oil on canvas 90 x 75
A.1492

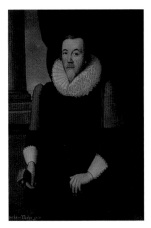

unknown artist
Lancelot Thorpe (b.c.1532) c.1700
oil on canvas 155 x 110
A.1499

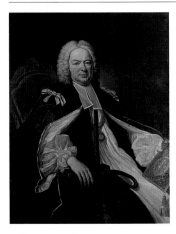

unknown artist
*Bishop Sherlock (1677–1761), Bishop of
Salisbury* c.1750
oil on canvas 123 x 95.5
A.1231

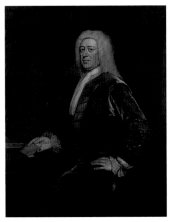

unknown artist
Colonel Brydges of Avington (1678–1751)
c.1750
oil on canvas 165 x 115
A.1494

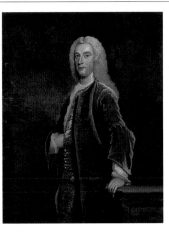

unknown artist
Sir Paulet St John, Bt (1704–1780) c.1750
oil on canvas 165 x 115
A.1496

unknown artist
*Classical Landscape with Ruined Building,
River and Pastoral Scene* c.1780
oil on canvas 89.8 x 137.8
A.194

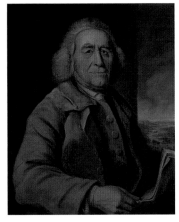

unknown artist
James Cooke c.1780
oil on canvas 74 x 60.5
A.1504

unknown artist
Woodland Scene c.1780
oil on canvas 97.5 x 120.3
A.187

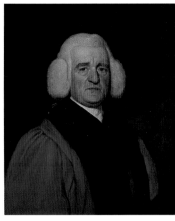

unknown artist
John Doswell (1740–1792), Mayor of Winchester c.1800
oil on canvas 76.5 x 63.5
A.1479

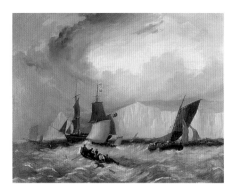

unknown artist
Seascape with Sailing Ships and White Cliffs c.1800
oil on canvas 68.6 x 89.2
A.189

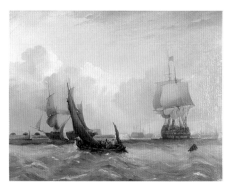

unknown artist
Seascape with Sailing Ships near Harbour c.1800
oil on canvas 68.6 x 89.2
A.188

unknown artist
The Westgate from the East c.1800
oil on canvas 52.7 x 67
A.140

unknown artist
Portrait of a Young Man c.1850
oil on canvas 29.5 x 24.2
A.198

unknown artist
Viscount Eversley, GCB (1794–1888), Aged 91 c.1880
oil on board 59.4 x 43.2
A.193

unknown artist
Winchester from the South c.1880
oil on canvas 40.7 x 61
A.206

unknown artist
Alderman Thomas Stopher (1837–1926) c.1910
oil on canvas 50 x 39.7
A.1667

unknown artist
The Old Chesil Rectory c.1960
oil on canvas 19.7 x 25
A.603

unknown artist
Alderman John Silver
oil on canvas 75 x 65.5
A.226

Walton, Henry 1875–1969
Old Wooden Bridge over the River Itchen
c.1930
oil on canvas 24.7 x 31.6
A.1639

Walton, Henry 1875–1969
Trees in Avington Park c.1930
oil on canvas 25.8 x 38.4
A.1638

Young, Tobias c.1755–1824
Winchester from the South 1803
oil on canvas 74 x 91
A.1654

GVIL. MARCHIO. WINTON. THES̃. ANGL :*

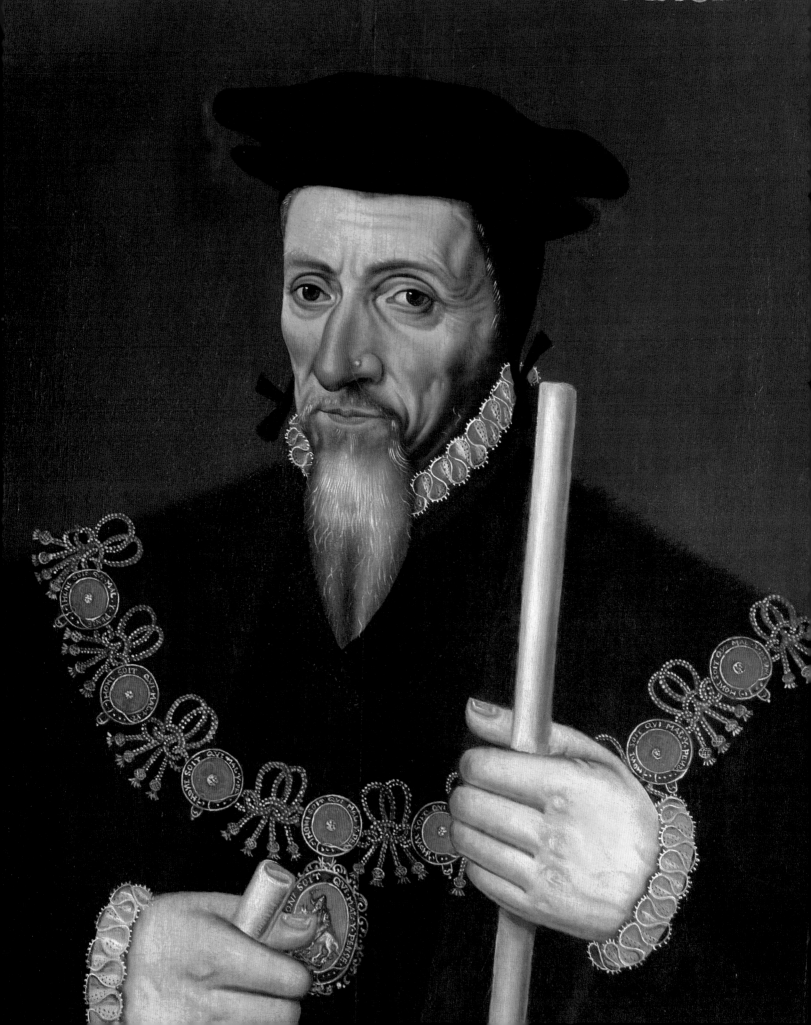

Paintings Without Reproductions

This section lists all the paintings that have not been included in the main pages of the catalogue. They were excluded as it was not possible to photograph them for this project. Additional information relating to acquisition credit lines or loan details is also included. For this reason the information below is not repeated in the Further Information section.

Royal Navy Submarine Museum

Langdale, D., *Submarine 'P.271'*, oil, B40/02/86, donated, 1986, on loan to a nuclear submarine base

K. M., *Chariot and Two Charioteers*, 122 x 122, oil on board, 2001.1091.1, untraced find, not available at the time of photography

The Museum of Army Flying

Michel, Girard b.1939, *View of Pegasus Bridge**, 1993, 97 x 70, oil on canvas, not available at the time of photography

Pearce, Ray A. b.1937, *Horsas Landing on Renkum Heath Near Arnhem, 1400 Hours, 17 September 1944*, 1994, 90 x 65, oil on canvas, not available at the time of photography

Royal Naval Museum

Cobb, Charles David b.1921, *Lynx Helicopter from the 'MV Stena'*, 45 x 60 (E), oil on canvas, 1992/143/1, on loan from a private individual, not available at the time of photography

Cobb, Charles David b.1921, *The Battle of Sirte, 22 March 1942*, 44 x 65, oil on board, 1980/267, purchased, 1980, not available at the time of photography

Dominy, John, *'HMS Antelope'*, *1972*, 40 x 50 (E), oil on canvas, 1983/451, gift, 1983, not available at the time of photography

Dominy, John, *'SS Canberra' and Assault Ships during the Falklands Campaign, 1982*, 40 x 50, oil on canvas, 1983/447, gift, 1983, not available at the time of photography

Fisher, Roger Roland Sutton 1919–1992, *'HMS Endurance 1967' at Grytviken in South Georgia during the Falklands Campaign, 1982*, 24 x 34, oil on canvas, 1983/468, purchased, 1983, not available at the time of photography

Gunn, Phillip active 1973–1976, *Sailors in Board*, 39.6 x 54.5, acrylic on board, 1979/70, purchased, 1979, not available at the time of photography

Lucy, Charles 1814–1873, *Lord Nelson (1758–1805)*, 193 x 150.5, oil on canvas, 1993/372, acquired, 1993, not available at the time of photography

Phillips, Rex b.1931, *'HMS Illustrious' under Air Attack in Malta*, 65 x 90, oil on canvas, 1991/199, purchased, 1991, not available at the time of photography

Phillips, Rex b.1931, *'HMS Warrior' off Portland, 1865*, 49.5 x 59.5, oil on canvas, 1984/651, purchased, 1984, not available at the time of photography

unknown artist, *Captain William Hutcheson Hall Holding a Presentation Sword Given to Him by the Crew of 'HMS Nemesis', 1839*, 120 x 90, oil on canvas, 1986/301, on loan from a private individual, not available at the time of photography

unknown artist, *'HMS Vernon'*, 63.5 x 50.8, oil on glass, 2001/82, gift, 2001, not available at the time of photography

unknown artist, *Nelson with Laurel Motif*, 50.8 x 38.1, oil on panel, 1967/12, gift through Grant in Aid, 1967, not available at the time of photography

unknown artist, *Ships in Heavy Seas in Portsmouth Harbour, c.1830*, oil on canvas, 1989/590, gift, 1989, not available at the time of photography

unknown artist, *Sir Robert Oliver, Superintendent, Indian Navy*, 50 x 60, oil on canvas, 1986/302, on loan from a private individual, not available at the time of photography

unknown artist, *The Sinking of 'HMS Waverley', Paddle Minesweeper by German Aircraft, 29 May 1940, during the Evacuation of Dunkirk*, 68.6 x 58.4, oil on canvas, 1986/114/1, gift, 1986, not available at the time of photography

The Mary Rose Trust

Bishop, William Henry, *The Warship 'Mary Rose'*, c.1988, 54 x 82, oil on canvas, E193, commissioned, 1983

McKee, Alice b.1954, *Alexander McKee OBE*, 1997, 80 x 67, acrylic on canvas, 1986/301, on loan from the artist, not available at the time of photography

Maile, Ben, *The Long Wait*, 76 x 101, oil on canvas, E138, gift

Maile, Ben, *The 'Mary Rose' 1545*, 100 x 79, oil on canvas, E48, gift

Maile, Ben, *Recovery Day*, 95 x 75, oil on canvas, E139, gift

Facing page: unknown artist, *Sir William Paulet (c.1483–1572), First Marquis of Winchester* (detail), c.1600, Winchester Museums Service, (p. 326)

331

Further Information

The paintings listed in this section have additional information relating to one or more of the five categories outlined below. This extra information is only provided where it is applicable and where it exists. Paintings listed in this section follow the same order as in the illustrated pages of the catalogue.

I	The full name of the artist if this was too long to display in the illustrated pages of the catalogue. Such cases are marked in the catalogue with a (…).
II	The full title of the painting if this was too long to display in the illustrated pages of the catalogue. Such cases are marked in the catalogue with a (…).
III	Acquisition information or acquisition credit lines as well as information about loans, copied from the records of the owner collection.
IV	Artist copyright credit lines where the copyright owner has been traced. Exhaustive efforts have been made to locate the copyright owners of all the images included within this catalogue and to meet their requirements. Any omissions or mistakes brought to our attention will be duly attended to and corrected in future publications.
V	The credit line of the lender of the transparency if the transparency has been borrowed. Bridgeman images are available subject to any relevant copyright approvals from the Bridgeman Art Library at www.bridgeman.co.uk

Army Physical Training Corps Museum

Brealey, William Ramsden 1889–1949, *Colonel G. N. Dyer, CBE, DSO*, presented by officers and staff of the Army Physical Training Corps, 1969
Codner, Maurice Frederick 1888–1958, *Colonel C. E. Heathcote, CB, CMC, DSO*, presented by officers of the Army Physical Training Corps, 1969
Lander, John Saint-Hélier 1869–1944, *Colonel S. P. Rolt*, presented by officers and army gymnastics staff, 1969
unknown artist *Colonel G. M. Onslow*, presented by officers and army gymnastics staff, 1969
unknown artist *Colonel Sir George Malcolm Fox (1843–1918)*, presented by the sitter's daughter, Mrs Marion Ward, 1958
unknown artist *Colonel the Honourable J. Scott Napier*, presented by officers and army gymnastics staff, 1969

The Museum of Army Chaplaincy

Archer, Peter *The Reverend James Harkness, CB, OBE, QHC, MA, Chaplain-General (1987–1995)*, gift, 1996
Archer, Peter *The Venerable William Francis Johnston, CB, QHC, MA, Chaplain-General (1980–1987)*, gift, 1996
Archer, Peter *The Venerable Peter Mallet, QHC, AKC, Chaplain-*

General (1974–1980), gift, 1996
Boughey, Arthur active 1970–1976, *The Reverend Canon Frederick Llewellyn Hughes, CB, CBE, MC, TD, MA, KHC, Chaplain-General to the King (1944–1951)*, gift, 1988
Cuneo, Terence Tenison 1907–1996, *Presentation of the Victoria Cross to the Reverend Theodore Bayley Hardy, VC, DSO, MC by HM King George V (1865–1936)*, gift, 1988, © reproduced with kind permission of the Cuneo estate
Cuneo, Terence Tenison 1907–1996, *The Reverend Ivan Delacrois Neil, OBE, Chaplain-General (1960–1966)*, gift, 1988, © reproduced with kind permission of the Cuneo estate
Gilroy, John M. 1898–1985, *The Venerable John Ross Youens, CB, OBE, MC, Chaplain-General (1966–1974)*, gift, 1990
Gilroy, John M. 1898–1985, *The Venerable Victor Joseph Pike, CB, CBE, Chaplain-General (1951–1960)*, gift, 1988
P. W. L. *St Barbara's Church, Stonecutter's Island, Hong Kong Harbour*, gift from the Reverend Robin Laird, 2006
Mason, Arnold 1885–1963, *The Reverend Canon Frederick Llewellyn Hughes, CB, CBE, MC, TD, MA, KHC, Chaplain-General to the King (1944–1951)*, gift, 1988
Nye, Shela b.1933, *The Reverend Dr Victor Dobbin CB, MBE, QHC, DD, Chaplain-General (1995–2000)*, gift, 2005, © the artist
Opie, John (after) 1761–1807, *The Venerable John Owen, Chaplain-*

General (1810–1824), gift, 1988
Warren, Stanley 1918–1992, *The Black Passion: The Ascension*, gift from Mrs Prichard, 1996
Warren, Stanley 1918–1992, *The Black Passion: The Crucifixion*, gift from Mrs Prichard, 1996
Warren, Stanley 1918–1992, *The Black Passion: The Entry into Jerusalem*, gift from Mrs Prichard, 1996
Warren, Stanley 1918–1992, *The Black Passion: The Last Supper*, gift from Mrs Pritchard, 1996
Warren, Stanley 1918–1992, *The Black Passion: The Pietà*, gift from Mrs Prichard, 1996
Warren, Stanley 1918–1992, *The Black Passion: The Scourging*, gift from Mrs Prichard, 1996
Wragg, Stephen *Reaping 'His' Harvest*, gift from the artist, 1996

Test Valley Borough Council

Grant, Henry active 1868–1895, *Alderman William Gue (1800–1877)*
Horton, Percy Frederick 1897–1970, *Sydney Robert Bell, Mayor of Andover (1939–1943)*
Turner, William *William Turner Senior, Mayor of Andover (1908)*

Basingstoke and Deane Borough Council

Collins, Louisa *Scenes of Basingstoke*, presented to Councillor K. G. Chapman, Mayor of Basingstoke and Deane (1992–1993)

Edney, Ronald Brian 1909–2000, *Freedom Ceremony*, presented to the Borough by RAF Odiham to commemorate the conferment of the freedom to the Borough, © the artist's estate
Edney, Ronald Brian 1909–2000, *Basingstoke Skyline*, © the artist's estate
Hill, Edna *Winchester Street, Overton*
Machin, Iris *Barton's Mill, Old Basing*
O'Brien, Marianne *View over Farleigh Hill*, purchased, 1993
Pearce, Frederick *Old Basing Church*
Stanley, Diana 1909–1975, *Corner of London Street, Hackwood Road*
unknown artist *John Burgess Soper JP, Mayor (1888–1889)*, presented to the Aldermen and Burgesses of Basingstoke by the sitter's daughters, 1895
unknown artist early 19th C, *Woman and Child*
unknown artist 19th C, *Charles Shaw Lefevre (d.1823), Recorder of Basingstoke (1800–1823)*

Basingstoke and North Hampshire NHS Foundation Trust

Thorne, Len b.1941, *Looking Seaward, the Gannel, Cornwall*, gift from the artist

National Motor Museum Trust

Pears, Dion *Jacky Ickx, Ferrari, Canadian Grand Prix, 1970*, bequeathed, 2001

Bishop's Waltham Museum

unknown artist *Bishop's Waltham Square, after the Removal of the Old Market House*, bequeathed by James Padbury, 1898
unknown artist *Bishop's Waltham Square, Showing the Old Market House*, bequeathed by James Padbury, 1898

Chawton House Library

Anderton, Henry (attributed to) 1630–1665, *Portrait of a Lady, Three-Quarter Length, Seated, Wearing a Gold Dress with Red Robes*, purchased from Sotheby's, 1995
Bascho, H. *Pink and White Roses**, purchased, 1998
Beale, Mary (circle of) 1633–1699, *Portrait of a Lady, Half-Length, in a Brown Dress Trimmed with Lace, in a Sculpted Cartouche*, purchased from Christie's, 2003
Bizard, Jean-Baptiste 1796–1860, *George Sand (1804–1876)*, purchased, 1993
British (English) School *Sir Roger Lewkenor (?)*, on loan from Richard Knight
Chamberlin, Mason the elder (attributed to) 1727–1787, *Portrait of a Lady, probably Elizabeth*

Hartley, purchased from Christie's, 2004

Cosway, Richard (circle of) 1742–1821, *Portrait of a Lady Seated at a Table Writing a Letter, possibly Maria Cosway*, purchased, 1997

Cotes, Francis (attributed to) 1726–1770, *Kitty Fisher*, purchased from Butterfield & Butterfield, 1996

Cotes, Francis (attributed to) 1726–1770, *Thomas Knight (d.1794)*, on loan from Richard Knight

Dahl, Michael I 1656/1659–1743, *Jane Knight (1710–1765)*, on loan from Richard Knight

Dahl, Michael I 1656/1659–1743, *Thomas Knight (1701–1781)*, on loan from Richard Knight

Davison, Jeremiah c.1695–1745, *Bulstrode Peachey Knight (d.1735)*, on loan from Richard Knight

Davison, Jeremiah c.1695–1745, *Elizabeth Knight (d.1737)*, on loan from Richard Knight

Flemish School late 18th C, *Flemish Castle*, purchased from Sotheby's New York, 1993

Grant, Francis 1803–1878, *Edward Knight II (1794–1879)*, on loan from Richard Knight

Hissan, T. T. *Pink Floral Bouquet*, purchased, 1998

Hoare, William (attributed to) c.1707–1792, *Mrs Mary Knowles (1733–1807)*, purchased from Christie's, 2004

Hoppner, John (attributed to) 1758–1810, *Mrs Mary Robinson (1758–1800) as 'Perdita'*, purchased from Sotheby's New York, 1995

Hudson, Thomas (circle of) 1701–1779, *Portrait of a Lady, Traditionally identified as Kitty Clive (1711–1785)*, purchased from Christie's, 2006

Hysing, Hans (attributed to) 1678–1753, *Richard (Martin) Knight (d.1687)*, on loan from Richard Knight

Italian School *Landscape with Peacock and Peahen, Other Ornamental Fowl and a Rabbit*, purchased from Sotheby's New York, 1992

Jervas, Charles c.1675–1739, *Lady Mary Wortley Montagu (1689–1762)*, purchased from Sotheby's, 1995

Jervas, Charles c.1675–1739, *Portrait of a Lady*, purchased from Sotheby's New York, 1992

Jervas, Charles (circle of) c.1675–1739, *Portrait of a Lady, possibly Eleanor Varney*, purchased from Christie's East, New York, 1997

Lawrence, Thomas (circle of) 1769–1830, *Portrait of a Lady, Traditionally Identified as the Novelist Fanny Burney (1752–1840)*, purchased from Christie's, 2001

Lawrence, Thomas (follower of) 1769–1830, *Portrait of a Lady, Traditionally Identified as Fanny Kemble (1809–1893)*, purchased from Christie's, 2006

Lely, Peter (style of) 1618–1680, *Anne Mynne, Wife of Sir John Lewkenor*, on loan from Richard Knight

McDonald, Alexander 1839–1921, *Montagu G. Knight (1844–1914)*, on loan from Richard Knight

Mellichamp *A View of Chawton*, on loan from Richard Knight

Millar, William active 1751–1775, *Diana, Wife of Sir Walter Scott*, purchased from Sotheby's, 1996

Opie, John 1761–1807, *Amelia Alderson Opie (1769–1853), Writer, the Artist's Second Wife*, purchased from Sotheby's New York, 1996

Preyer, Johann Wilhelm 1803–1889, *Vase Filled with Flowers*, purchased, 1995

Raeburn, Henry 1756–1823, *Joseph Hume (d.1829)*, purchased from Sotheby's New York, 1996

Riley, John (style of) 1646–1691, *Christopher (Martin) Knight*, on loan from Richard Knight

Riley, John (style of) 1646–1691, *Sir Richard Knight (1639–1679)*, on loan from Richard Knight

Romney, George 1734–1802, *Charlotte Gunning, later Mrs Stephen Digby*, purchased from Christie's, 1996

Seemann, Enoch the younger 1694–1744, *Portrait of a Lady in a Riding Habit*, purchased from Sotheby's New York, 1993

Singleton, Henry 1766–1839, *'Camilla Fainting in the Arms of Her Father' (an illustration of a scene from Fanny Burney's 'Camilla, or a Picture of Youth', published in 1796)*, purchased from Christie's, 2005

Singleton, Henry 1766–1839, *'Camilla Recovering from Her Swoon' (an illustration of a scene from Fanny Burney's 'Camilla, or a Picture of Youth', published in 1796)*, purchased from Christie's, 2005

Slaughter, Stephen (style of) 1697–1765, *William Woodward Knight*, on loan from Richard Knight

unknown artist *Unknown Boy of the Knight Family*, on loan from Richard Knight

unknown artist *Jonathan Lewkenor (1658–1706)*, on loan from Richard Knight

unknown artist *Miss Evelyn Lewkenor*, on loan from Richard Knight

unknown artist *Richard Lewkenor (?)*, on loan from Richard Knight

unknown artist *Richard Lewkenor (?)*, on loan from Richard Knight

unknown artist *Sir Richard Lewkenor (1550–1616)*, on loan from Richard Knight

Wissing, Willem (school of) c.1656–1687, *Frances, Countess of Scarborough*, purchased from Christie's New York, 1996

Wright, Joseph of Derby 1734–1797, *The Reverend Thomas Wilson (1703–1784) and Miss Catherine Macaulay (1731–1791)*, purchased from Christie's, 1996

Jane Austen's House

British (English) School 18th C, *Edward Austen (1767–1852)*, on loan from the Jane Austen Society

British (English) School 18th C, *Portrait of a Boy in a Blue Coat, possibly Edward Austen (1767–1852)*, purchased with the assistance of the Victoria & Albert Museum Purchase Grant Fund, 2002

British (English) School 19th C, *Susannah Sackree, Nursemaid to Edward Knight's Family at Godmersham Park*, gift, 1994

British (English) School mid-19th C, *Fanny Knight (later Lady Knatchbull) (b.1793), Jane Austen's Favourite Niece*, on loan from an anonymous individual

unknown artist *Chawton House and Church*, presented by Mrs Beryl Bradford, 1951

unknown artist 19th C, *'Prowtings', a House Neighbouring Jane Austen's*, presented by Mrs Beryl Bradford, 1952

Hampshire Fire and Rescue Service

Forby, C. A. *A Quiet Corner in London*, donated

Hancock *At the Scene of the Fire*, donated

Hancock *London in the Blitz*, donated

Harland, Bernard d.1981, *Threesome*, gift from the artist's widow

Windebank, Barry *Chariots of Fire*

Windebank, Barry *Their Day Done*

Windebank, Barry *The Rescue*, presented, 1981

Emsworth Museum

Summers, Alan 1926–2006, *Ebb Tide at Dawn in Emsworth Harbour*, donated by Mr and Mrs R. Morgan, c.1990, © the artist's estate

unknown artist 20th C, *Lumley Mill, Emsworth, before the Fire in May 1915*, presented by Arthur Jones, 1994

Whitham, Peter 1924–1996, *Dolphin Cut*, donated by Mrs Beryl Whitam, the artist's widow, 1997

Wickham Smith *Warblington Church*, donated by Mrs A. Byerley, 2004

Williamson, Richard L. 1916–2003, *'Indian Queen' of Emsworth, 1863*, donated by the artist, 1992, © the artist's estate

Fareham Borough Council

Baker, Ted *Cottages and Council Offices*

Hansford, B. P. *Westbury Manor*

Stone, B. R. active 1962–1988, *The*

'Mary Rose', 1535

Stone, B. R. active 1962–1988, *'HMS Victory'*

Trask, Keith *The 'Red Lion'*

unknown artist *Reverend Sir Henry Thompson*

unknown artist *Fareham Creek*

unknown artist *The Old Mill*

Royal Armouries, Fort Nelson

Carr, Henry Marvell 1894–1970, *A 3.7 Anti-Aircraft Gun of 393/72 Heavy Anti-Aircraft Regiment, RA, CMF*, on loan from the Imperial War Museum, © crown copyright

Freedman, Barnett 1901–1958, *The Gun*, on loan from the Imperial War Museum, © crown copyright

Richards, Albert 1919–1945, *Breaking up the Attack, Holland: 25-Pounders of the 15th (Scottish) Division Firing towards Meijel*, on loan from the Imperial War Museum, © crown copyright

Rushmoor Borough Council

Hieronymi, Georg 1914–1993, *Oberursel (Taunus), Germany*, presented to the Borough Council, 1989

Howard, Ken b.1932, *Presentation of Freedom Scrolls on Friday, 29 May 1981*, presented, 1982, © the artist/www.bridgeman.co.uk

Hart District Council

Cuprien, Frank William (attributed to) 1871–1948, *Cows Drinking*

Jones, Robert M. *A Soldier of Queen Elizabeth's Own Gurkha Rifles on Duty in Kosovo*

Luker, William II (attributed to) 1867–1947, *Sheep in a Wooded Landscape*, presented to Fleet Urban District Council by Mrs Freda M. Donada, 1967

Fordingbridge Town Council

Downs, Edgar 1876–1963, *Gathering Kelp*, acquired, 1952

Downs, Edgar 1876–1963, *Cattle Ploughing in an Open Landscape*, acquired, 1952

Explosion! The Museum of Naval Firepower

Dale, Norman H. *'NA Tug Marchwood'*, gift

Dale, Norman H. *'NAV Bison'*, gift

Dale, Norman H. *'NAV Isleford'*, gift

Dale, Norman H. *'NAV Upnor'*, gift

Silas, Ellis 1883–1972, *An Engineer Working at Fort Grange in 1919*, gift

Royal Navy Submarine Museum

Bampfield, John b.1947, *Dawn Patrol*, donated, 1984

Barnet, Margaret *Lieutenant Arnold Forster*, donated, 1986

Belling, Colin J. *'HMS Cachalot'*, donated, 1996

Bennett, H. A. *'HMS K.26'*, donated, 2002

Berey, Len b.1916, *Chariot Attack on Ship*, donated, 1994, © the artist

Berey, Len b.1916, *Chariot Going through Net*, donated, 1994, © the artist

Berey, Len b.1916, *Chariots, Net Cutter, Breathing Set and 'Pot'*, donated, 1994, © the artist

Berey, Len b.1916, *Horsey Lake*, donated, 1994, © the artist

Berey, Len b.1916, *Submarine Carrying Chariots at Sea*, donated, 1994, © the artist

Berey, Len b.1916, *T-Boat alongside a Depot Ship*, donated, 1994, © the artist

Berey, Len b.1916, *The First Davis Submerged Escape Apparatus Chamber*, donated, 1994, © the artist

Bradshaw, George Fagan 1887–1960, *On Patrol (1914–1918)*, transferred, 1998, © the artist's estate

Bradshaw, George Fagan 1887–1960, *'HM Submarine C.30'*, donated, 1968, © the artist's estate

Bradshaw, George Fagan 1887–1960, *'HMS Alecto'*, donated, 1968, © the artist's estate

Bradshaw, George Fagan 1887–1960, *'HMS/M E.24'*, donated, 1968, © the artist's estate

Bradshaw, George Fagan 1887–1960, *'HMS/M L.18'*, donated, 1968, © the artist's estate

Bradshaw, George Fagan 1887–1960, *'HMS/M XI'*, donated, 1968, © the artist's estate

Bradshaw, George Fagan 1887–1960, *Sinking of 'U98' (First World War)*, untraced find, © the artist's estate

Bradshaw, George Fagan 1887–1960, *Sinking of 'U98' (First World War)*, untraced find, © the artist's estate

Bradshaw, George Fagan 1887–1960, *Sinking of 'U98' (First World War)*, untraced find, © the artist's estate

Bradshaw, George Fagan 1887–1960, *Sinking of 'U98' (First World War)*, untraced find, © the artist's estate

Bradshaw, George Fagan 1887–1960, *Submarine and Escort*, donated, 1968, © the artist's estate

Bradshaw, George Fagan 1887–1960, *U-Boat at Sunset*, donated, 1968, © the artist's estate

Bradshaw, George Fagan 1887–1960, *U-Boat Sinking Barque by Gunfire*, donated, © the artist's estate

Bray, John *Russian Typhoon Class Submarine*, purchased, 1987

Cameron, Dugald b.1939, *'HMS Dreadnought'*, on loan from the artist, © the artist

Cameron, Dugald b.1939, *'HMS Swiftsure'*, on loan from the artist, © the artist

Coates-Walker, Christopher active 1979–1999, *Flashback*, untraced find

Collins, H. *'Holland 3'*, untraced find

Cuneo, Terence Tenison 1907–1996, *The Launch of 'HMS Dreadnought'*, purchased, 1999, © reproduced with kind permission of the Cuneo estate

Douglas, Penelope *Swiftsure Class Submarine at the Fleet Review*, purchased, 1979

Duffy, Owen *'P.228'*, transferred, 1998

Dyer, Allen G. *Surrender, 1945*, donated, 1996

Fisher, Simon b.1944, *'HMS Seal'*, presented by Mr Timothy Smith, 1998, © the artist

Fleming, George *Sailors and Tin Fishes*, donated, 1997

Gittins, D. J. active 1972–1979, *'HMS Seadevil'*, transferred, 1998

Grenier, Frank *Patrol under the Ice*, purchased, 1986

Gunning, M. *'Holland 3'*, donated, 1984

F. W. H. *'HMS G.5'*, donated, 1983

Harrison, G. A. *'HMS Sovereign' 1974 Sea Trials*, donated, 2005

Harrison, G. A. *'HMS Sovereign' in the Arctic*, donated, 1979

Hunt, Geoffrey William b.1948, *Interior of 'Holland I'*, purchased, 1983, © the artist

Jacobs, Warwick b.1963, *Admiral of the Fleet, the Lord Fieldhouse of Gosport, GCB, GBE (1928–1992)*, untraced find

Lukis *'HMS Glasgow' at a Foreign Port*, donated, 1976

Macdonald, Roderick 1921–2001, *On the Periscope, 'HMS Renown'*, purchased, 1982

Macdonald, Roderick 1921–2001, *Auxiliary Machinery Room, 'HMS Spartan'*, purchased, 1981

Macdonald, Roderick 1921–2001, *Commander Nigel Goodwin, Commanding Officer, 'HMS Spartan', at Periscope*, purchased, 1981

Macdonald, Roderick 1921–2001, *Control Room of 'HMS Renown'*, purchased, 1982

Macdonald, Roderick 1921–2001, *Control Room of 'HMS Renown'*, purchased, 1982

Macdonald, Roderick 1921–2001, *Control Room of 'HMS Spartan'*, donated, 1981

Macdonald, Roderick 1921–2001, *Control Room of 'HMS Spartan'*, purchased, 1981

Macdonald, Roderick 1921–2001, *Control Room of 'HMS Spartan'*, purchased, 1981

Macdonald, Roderick 1921–2001, *Loading Torpedo Tube, 'HMS Renown'*, purchased, 1982

Macdonald, Roderick 1921–2001,

Manoeuvring Room of 'HMS Spartan', purchased, 1981

Macdonald, Roderick 1921–2001, *Manoeuvring Room of 'HMS Spartan'*, purchased, 1982

Macdonald, Roderick 1921–2001, *Missile Deck of 'HMS Renown'*, purchased, 1982

Macdonald, Roderick 1921–2001, *Morning Water on the Surface*, purchased, 1982

Makin, Johne b.1947, *HMS/M Submarine 'Unshaken'*, purchased, © the artist

Makin, Johne b.1947, *'O & P' Boat*, untraced find, © the artist

Makin, Johne b.1947, *Operation 'Source', 22 September 1943*, commissioned , © Royal Navy Submarine Museum

Makin, Johne b.1947, *'HMS Upright'*, untraced find, © the artist

Makin, Johne b.1947, *Early Morning 'T', 'HMS/M Triumph'*, purchased, © the artist

Makin, Johne b.1947, *Operation 'Principle', Palermo, January 1943*, purchased, 1994, © the artist

Makin, Johne b.1947, *'Torpedo Strike'*, donated, 1989, © the artist

Mason, Frank Henry 1876–1965, *Attack on a German Tanker off the Norwegian Coast*, donated

McMurde, H. *'HMS Stygian' P.249*, donated, 1987

Moore, A. *Well Done 'HMS E.9'*, transferred, 1998

Morley, Harry 1881–1943, *Lieutenant Commander Wanklyn*, on loan from the Royal Navy Trophy Centre, © the artist's estate

Munday *Commodore S. S. Hall*, on loan from the Royal Navy Trophy Centre

O'Farrel, R. active 1988–1997, *HMS Submarine 'Rover' India, 1964*, donated, 1988

O'Farrel, R. active 1988–1997, *HM Submarine 'Porpoise'*, donated, 1997

Oswald, T. J. *Night Launch*, untraced find

Rinder, P. R. (attributed to) *'Oberon Class'*, transferred, 1998

Russwurm, G. *'HMS Turbulent' Submerged*, donated, 1997

Russwurm, G. *'HMS Sealion'*, untraced find

Southcombe, Christopher *HM Submarine 'Alaric'*, donated, 1997

Southcombe, Christopher *HM Submarine 'Rorqual'*, donated, 1997

Southcombe, Christopher *HM Submarine 'Thule'*, donated, 1997

Swindlin, N. *Able Seaman John Ford ('HMS Sidon')*, donated, 2004

Taylor, John S. active 1932–1939, *'HMS Tribune T.76'*, donated, 2000

unknown artist *HM Submarine 'Torbay'*, donated, 1984

unknown artist *'The Trespasser'*, transferred, 1998

unknown artist *'HMS Inconstant' (depot ship)*, untraced find

unknown artist *'C.23 (mounted in lifebelt)*, donated, 1998

unknown artist *'C.23 (mounted in*

lifebelt), donated, 1998

unknown artist *Captain C. H. Allen, DSO, Royal Navy*, transferred, 1998

unknown artist *Commander John Wallace Linton, VC (1905–1943), 'HMS Turbulent'*, donated, 1992

unknown artist *'D.4' (mounted in lifebelt)*, untraced find

unknown artist *'E.16' (mounted in lifebelt)*, donated, 1994

unknown artist *'E.17' (mounted in lifebelt)*, untraced find

unknown artist *'E.47' (mounted in lifebelt)*, donated, 1994

unknown artist *HM Submarine 'L.9' China Station*, donated, 1976

unknown artist *HM Submarine 'L.15' China Station*, donated, 1984

unknown artist *'HMS L.3'*, transferred, 1980

unknown artist *'L.5'*, donated, 1995

unknown artist *'Scorcher' alongside 'Cyclops'*, on loan from the Royal Navy Trophy Centre

unknown artist *The Lone 'Queen of the North' and Her Assailants*, donated, 1994

unknown artist *The 'Tirpitz'*, donated, 1971

Waldron *HM Submarine 'J.2'*, untraced find

Walsh, Geoffrey C. *'HMS Alliance' Leaving Portsmouth Harbour*, untraced find

Webster, John b.1932, *Submarine Berth, Devonport*, donated, 2000

Wheeler, W. H. *British Submarine 'E.11'*, donated, 1981

Willoughby, Michael *HM Submarine 'Sealion'*, purchased

Willoughby, Michael (attributed to) *Lossian Delta Class Submarine (Russian)*, purchased, 1987

Worsley, John 1919–2000, *Admiral Sir Max Kennedy Horton (1883–1951)*, transferred, 1998, © the artist's estate

Worsley, John 1919–2000, *Gibraltar, 1936*, untraced find, © the artist's estate

Hampshire Constabulary

Chalis *House by a Lake with Trees*, possibly acquired from the Police College, Bishops Waltham and moved to the Hamble site, 1988

unknown artist *Sir John Hoddinott (c.1945–2001)*, gift, c.2000,

Hartley Wintney Parish Council

Palmar, Duncan b.1964, *Hartley Wintney 2000 AD*, on loan from the Rotary Club of Hart © Hartley Wintney Parish Council

Havant Borough Council

Cowper, Nicholas *Views of Havant*

Phillips, Rex b.1931, *Langstone*

Mill, Havant, presented by E. S. M. Chadwick, 1977, © the artist

Phillips, Rex b.1931, *'HMS Havant' off Dunkirk, May 1940*, purchased with the assistance of the Royal British Legion (Hayling Island Branch), the Royal Naval Association (Waterlooville Branch), the Hayling Island Naval Association and the Royal Air Force Association (Hayling Island Branch), © the artist

The Hovercraft Museum Trust

Bagley, Laurence *Westland Fleet 'SR.N5', 'SR.N3'*, gift from the British Hovercraft Corporation, 1993, © Hovercraft Museum Trust

Baxter-Jones, A. *'SR.N4'*, gift from the British Hovercraft Corporation, 1989, © Hovercraft Museum Trust

Briers, Greg b.1959, *'SR.N4' Arrives at Dover*, gift, 1991, © Hovercraft Museum Trust

Briers, Greg b.1959, *'SR.N4' at Lee-on-Solent*, gift, 2001, © Hovercraft Museum Trust

Cooke, Julian d.2003, *Air Bearings Crossbow on the Northern Plateau*, gift from the artist's widow, 2003, © Hovercraft Museum Trust

Cooke, Julian d.2003, *Air Bearings Crossbow*, gift from the artist's widow, 2003, © Hovercraft Museum Trust

Cooke, Julian d.2003, *Stewardess Flies Crossbow*, gift from the artist's widow, 2003, © Hovercraft Museum Trust

Cresdee, Keith b.1948, *Hovermarine Sidewall 'SES' Hovercraft*, gift, 1991, © Hovercraft Museum Trust

Cresdee, Keith b.1948, *'AP.188'*, gift, 1991, © Hovercraft Museum Trust

Goodburn, A. *'BH.7' Logistic Support Craft*, gift from the British Hovercraft Corporation, 1991, © Hovercraft Museum Trust

Goodburn, A. *'SR.N4'*, gift from the British Hovercraft Corporation, 1991, © Hovercraft Museum Trust

Goodman, A. *'BH.7' Welldeck*, gift, 2001, © Hovercraft Museum Trust

Goodman, A. *'BH.7' Missile Attack*, gift, 1991, © Hovercraft Museum Trust

Jacobs, Warwick b.1963, *Royal Navy 'RJ XV617'*, gift, 1986, © the artist

Jacobs, Warwick b.1963, *'BH.7' in Manhattan*, gift, 1986, © the artist

Jacobs, Warwick b.1963, *'SR.N6' Amazon Expedition, 1969*, gift, 1986, © the artist

Jacobs, Warwick b.1963, *Lord Mountbatten Visits 'SR.N4', Lee-on-Solent*, gift, 1986, © the artist

Jacobs, Warwick b.1963, *'SR.N6' 130 Hovertravel Solent Crossing*, gift, 1986, © the artist

Jacobs, Warwick b.1963, *Sir Christopher Cockerell (1910–1999)*,

commissioned, 1990, © the artist

Jacobs, Warwick b.1963, *Last Crossing of a Cross Channel Hovercraft, 1 October 2000*, gift, 2001, © the artist

Lyons, M. *Hoverspeed 'Princess Anne'*

McDonoigh active 1967–1978, *'BH.7' Mark 5*, gift, 1991, © Hovercraft Museum Trust

McDonoigh active 1967–1978, *'BH.7' Missile Craft Mark 5A*, gift, 1991, © Hovercraft Museum Trust

McDonoigh active 1967–1978, *SR.N6' Attack Hovercraft Mark 6*, gift, 1991, © Hovercraft Museum Trust

Moseley, W. F. active 1961–1962, *'SR.N3'*, gift from the British Hovercraft Corporation, 1989, © Hovercraft Museum Trust

Moseley, W. F. active 1961–1962, *'SR.N2' Mark 2*, gift from the British Hovercraft Corporation, 1991, © Hovercraft Museum Trust

Richards, Sam *'SR.N2'*, gift from the artist's daughter, 2006, © Hovercraft Museum Trust

Tattersall, Edward *'HM.5'*, © Hovercraft Museum Trust

Thorn, Peter active 1961–1985, *'SR.N1'*, gift, 1986, © Hovercraft Museum Trust

Thorn, Peter active 1961–1985, *BH.7' Stretched Military Craft Mark 5*, gift from the British Hovercraft Corporation, 1991, © Hovercraft Museum Trust

Thorn, Peter active 1961–1985, *'Super Santa 4'*, purchased, 1985, © Hovercraft Museum Trust

Thorn, Peter active 1961–1985, *'Super Santa 4'*, purchased, 1985, © Hovercraft Museum Trust

Thorn, Peter active 1961–1985, *'BH.7' Mark 5A*, gift from the British Hovercraft Corporation, 1991, © Hovercraft Museum Trust

Thorn, Peter active 1961–1985, *'AP.188' Cutaway*, gift, 1991, © Hovercraft Museum Trust

Thorn, Peter active 1961–1985, *'BH.88' Hoverspeed Replacement for Channel Service*, gift from the British Hovercraft Corporation, 1989, © Hovercraft Museum Trust

Thorn, Peter active 1961–1985, *Hover Platform* , gift from the British Hovercraft Corporation, 1989, © Hovercraft Museum Trust

unknown artist *'SR.N6' Seaspeed 'Sea Eagle'*, gift, 2000, © Hovercraft Museum Trust

unknown artist *Pindair Projects*, gift from Mike Pinder, 1989, © Hovercraft Museum Trust

unknown artist *'AP.188' Welldeck Cargo Craft*, gift from the British Hovercraft Corporation, 1991, © Hovercraft Museum Trust

Wrigglesworth, R. P. *'SR.N2'*, gift from the British Hovercraft Corporation, 1991, © Hovercraft Museum Trust

Wrigglesworth, R. P. *'SR.N2'*, gift from the British Hovercraft Corporation, 1989, © Hovercraft Museum Trust

Wrigglesworth, R. P. '*SR.N3*', gift from the British Hovercraft Corporation, 1989, © Hovercraft Museum Trust

Wrigglesworth, R. P. (attributed to) *Livery Artists' Impressions*, gift, 1991, © Hovercraft Museum Trust

Wright, John '*AP.188*' *Coastguard*, gift, 1991, © Hovercraft Museum Trust

Wright, John '*AP.188*' *Logistics Support*, gift, 1991, © Hovercraft Museum Trust

Wright, John '*AP.188*' *Patrol Craft*, gift, 1991, © Hovercraft Museum Trust

Wright, John '*AP.188*' *Mine Countermeasure*, gift from the British Hovercraft Corporation, 1991, © Hovercraft Museum Trust

Wright, John '*AP.188*' *Patrol Craft*, gift from the British Hovercraft Corporation, 1991, © Hovercraft Museum Trust

Wright, John '*AP.188*' *Military Hovercraft*, gift from the British Hovercraft Corporation, 1991, © Hovercraft Museum Trust

Wright, John '*AP.188*' *Military Hovercraft*, gift, 1991, © Hovercraft Museum Trust

Wright, John '*AP.188*' *Patrol Craft*, gift, 1991, © Hovercraft Museum Trust

Wright, John '*AP.188*' *Welldeck in the Arctic*, gift, 1991, © Hovercraft Museum Trust

St Barbe Museum and Art Gallery

Boycott-Brown, Hugh 1909–1990, *Yachts Moored on the Lymington River*, gift, 1994

Desmond, Creswell Hartley 1877–1953, *Ponies Crossing Boldre Bridge*, gift, 1995

Eastman, Frank S. 1878–1964, *John W. Howlett, Founder of Wellworthy and Company, Lymington*, gift, 1997

unknown artist *Harriet King (1823–1862), Daughter of Richard King, Wife of George Inman, as a Young Woman*, gift, 1999

New Forest District Council

Brooks, Frank 1854–1937, *Edward Penton*, acquired, 1919

Emms, John 1843–1912, *New Forest Buckhounds: 'Moonstone', 5 Years, by Bramham Moor Moonstone out of the Burton Cobweb and 'Challenger', 3 Years, by Bramham Moor Coroner out of the Haricot*, acquired, 1953

Emms, John 1843–1912, *New Forest Ponies*, acquired, 1953

New Forest Museum and Library

Chalmers, James *Hincheslea House, Brockenhurst*, gift

Emms, John 1843–1912, *Ferreting in the New Forest with Terrier Looking on*, purchased from Ann Coles

Emms, John 1843–1912, *Turf Cutting (possibly at Soarley Beaches near Burley)*, purchased from Ann Coles

Gooch, Thomas active 1750–1803, *Thomas Sebright with Three Favourite Hounds Belonging to the New Forest Hunt in a Wooded Landscape*

Hayes, A. *Burgess Street, Turnpike Gate*

Skeats, Leonard Frank 1874–1943, *Harry 'Brusher' Mills (1840–1905), New Forest Snake Catcher*

Tratt, Richard b.1953, *Martin Down, Hampshire*, © the artist

unknown artist *Mr William Veal of Emery Down, Ringmaster for the New Forest Show for 50 Years*, gift from Mrs N. King of Totton

unknown artist *Landscape (probably Suffolk)*, gift from Daphne and Hugh Taylor of Victoria, British Columbia, Canada, to the New Forest Ninth Century Trust, 2004

unknown artist *Lawrence Henry Cumberbatch (1827–1885), Deputy Surveyor of the New Forest (1849–1879)*, on loan from a private lender

Wilkinson, Hugh 1850–1948, *New Park Farm, Brockenhurst*, purchased from Ann Coles

The Museum of Army Flying

Davis, P. '*Halifax*' *on Night Flight*, gift

Eastman, Frank S. 1878–1964, *Sir George White, Bt (1853–1916)*, on loan from an anonymous individual

Eastman, Frank S. 1878–1964, *Sir Richard Fairey, KT, MBE, FRAeS (1887–1956)*, on loan from an anonymous individual

King, Roger *Pegasus Bridge*, on loan from an anonymous individual

Marx, Paul *The Rhine Crossing*, gift

McEvoy, Ambrose 1878–1927, *Harry George Hawker (1891–1921)*, on loan from an anonymous individual

Miller, Edmund b.1929, *Chilbolton Pilots over Poole Harbour*, on loan from an anonymous individual, © the artist

Newling, Edward active 1890–1934, *Air Vice-Marshal Sir Sefton Brancker, KCB, AFC (1877–1930)*, on loan from an anonymous individual

Orde, Cuthbert Julian 1888–1968, *The Honourable Charles Stewart Rolls (1877–1910)*, on loan from an anonymous individual

Payne '*Dakotas*' *Towing* '*Horsas*', gift

Ross, Michael active 1935–1955, *Sir Thomas Octave Murdoch Sopwith, CBE (1888–1989)*, on loan

from an anonymous individual

Sparkes *Air Racing*, gift, 1990

Steele-Morgan, M. D. '*Horsas*' *over Pegasus Bridge*, gift

Thompson, Richard E. b.1948, '*Then and Now*', gift, 1998

West, Philip b.1956, *Glider*, on loan from an anonymous individual, © the artist

West, Philip b.1956, '*Magic Beaus*', on loan from an anonymous individual, © the artist

West, Philip b.1956, '*Waco*' *Glider and* '*Dakota*', on loan from an anonymous individual, © the artist

Wootton, Frank 1914–1998, *Two 'Chieftain' Tanks and a 'Gazelle' Helicopter Bonding*, gift, © the artist's estate

East Hampshire District Council

Carter, George *Landscape with Stile (Summer near Blackmoor)*, purchased, 1993

Dorling, P. *Bury Court Farm, Bentley*, purchased, 1983

Francis, Charles *Meon Reflections*, purchased, 1987

MacKeown, Elizabeth *Vegetable Abstract*, purchased, 1990

Morrison, John *Green Route*, purchased, 1988

HMS Excellent

Beechey, Richard Brydges 1808–1895, *The Spanish Armada Driven out of Calais by Fire*, on loan from the Royal Navy Trophy Centre

Beresford, Frank Ernest 1881–1967, *George V (1865–1936) (after Arthur Stockdale Cope)*, on loan from the Royal Navy Trophy Centre

Birley, Oswald Hornby Joseph 1880–1952, *Admiral of the Fleet Lord Fraser of North Cape, GCB, KBE (1888–1981)*, on loan from the Royal Navy Trophy Centre, © the artist's estate

H. C. *Lord Howe on Board the 'Queen Charlotte' Bringing His Prize into Spithead, 1794*, on loan from the Royal Navy Trophy Centre

Dodd, R. *The Cuffnells at the Mother Bank*, on loan from the Royal Navy Trophy Centre

Eves, Reginald Grenville 1876–1941, *Admiral of the Fleet Earl Jellicoe, OM, GCB, GCVO (1859–1935)*, on loan from the Royal Navy Trophy Centre

Eves, Reginald Grenville 1876–1941, *Admiral of the Fleet Lord Chatfield, PC, GCB, QM, KCMG, CVO, DCL Oxon, LLD Camb, DL (1873–1967)*, on loan from the Royal Navy Trophy Centre

Fildes, Denis 1889–1974, *Elizabeth II (b.1926)*, on loan from the Royal Navy Trophy Centre

French, R. *Royal Marine Artillery Howitzer in Action, 1914*, on loan

from the Royal Marine Corps

Glen, Graham active 1897–c.1920, *Earl Jellicoe (1859–1935) on Deck*, on loan from the Royal Navy Trophy Centre

Havers *Admiral of the Fleet Lord Lewin of Greenwich, KG, GCB, MVO, DSC (1920–1999)*, on loan from the Royal Navy Trophy Centre

Hodge, Francis Edwin 1883–1949, *George VI (1895–1952)*, on loan from the Royal Navy Trophy Centre

Hogan, S. *Presentation of the Queen's Colour to the Portsmouth Command*, on loan from the Royal Navy Trophy Centre

Italian (Venetian) School *St Barbara*, presented by the Church of St Barbara by Reverend W. B. Atherton, probably 1962

Leveson, D. *Lord Howe Receiving the Sword of Honour from King George III on 'Queen Charlotte', 1794*, on loan from the Royal Navy Trophy Centre

Maxwell, Donald 1877–1936, *The Royal Yacht 'Victoria and Albert' Leading the Fleet off Weymouth, 1935*, on loan from the Royal Navy Trophy Centre

McCormick, Arthur David 1860–1943, *Head of a Sailor*, on loan from the Royal Navy Trophy Centre

Morgan, Henry J. 1839–1917, '*Queen Charlotte' at Algiers, 27 August 1816*, on loan from the Royal Navy Trophy Centre

Morgan, Henry J. 1839–1917, *The Glorious First of June, 1794 (after Nicholas Pocock)*, on loan from the Royal Navy Trophy Centre

Morgan, Henry J. 1839–1917, '*Breaking the Line' (after William Lionel Wyllie)*, on loan from the Royal Navy Trophy Centre

Morgan, Henry J. 1839–1917, '*Dreadnought' and 'Victory' at Portsmouth*, on loan from the Royal Navy Trophy Centre

Morgan, Henry J. 1839–1917, '*HMS Excellent' and 'HMS Illustrious*', on loan from the Royal Navy Trophy Centre

Pocock, Nicholas (after) 1740–1821, '*HMS Excellent' Demasted in Harbour*, on loan from the Royal Navy Trophy Centre

Schetky, John Christian 1778–1874, *The Battle of Trafalgar, 21 October 1805*, on loan from the Royal Navy Trophy Centre

Serres, John Thomas 1759–1825, *Portsmouth Harbour at High Tide*, on loan from the Royal Navy Trophy Centre

Sharpe, Montagu '*HMS Excellent' 108 Guns*, on loan from the Royal Navy Trophy Centre

Stubart *Spithead Coronation Review*, on loan from the Royal Navy Trophy Centre

unknown artist *19th C , The Dutch and the Danes in Action*, on loan from the Royal Navy Trophy Centre

unknown artist *Man-o-War Leaving Portsmouth Harbour*, on loan from the Royal Navy Trophy Centre

unknown artist *Captain Percy Scott RN, CVO, CB, LLD (1853–1924)*, on loan from the Royal Navy Trophy Centre

unknown artist *A Memorial to the 1914–1918 War*, on loan from the Royal Navy Trophy Centre

unknown artist *Dutch Shipping in Rotterdam Harbour*, on loan from the Royal Navy Trophy Centre

unknown artist '*HMS Queen Charlotte', afterwards 'HMS Excellent', Leaving the Hamoaze with HRH Duke of Clarence on Board, 1825*, on loan from the Royal Navy Trophy Centre

unknown artist *Lord Macartney Entering the River Thames*, on loan from the Royal Navy Trophy Centre

unknown artist *Portsmouth Harbour, Man-o-War in the Foreground*, on loan from the Royal Navy Trophy Centre

unknown artist *Vice Admiral Walter Lock (1756–1803)*, on loan from the Royal Navy Trophy Centre

Wells, L. R. '*HMS Excellent' and 'HMS Calcutta*', on loan from the Royal Navy Trophy Centre

Wyllie, William Lionel 1851–1931, *The Storming of Zeebrugge Mole, St George's Day, 23 April 1918*, on loan from the Royal Navy Trophy Centre

Yarwood, D. E. *Portsmouth Harbour*, on loan from the Royal Navy Trophy Centre

HMS Victory

Beechey, William 1753–1839, *Horatio Nelson (1758–1805)*, on loan from the Royal Navy Trophy Centre

Devis, Arthur William 1762–1822, *The Death of Nelson*, on loan from the Royal Navy Trophy Centre

HMS Warrior 1860

Anderson, J. W. '*HMS Warrior' Drying Her Sails*, gift

Smitheman, S. Francis b.1927, '*HMS Warrior' Escorting the Royal Yacht 'Victoria and Albert', March 1863*, © the artist

Wigston, John Edwin b.1939, *Gun Drill*, presented, 2005, © the artist

Wigston, John Edwin b.1939, *Stokehold 'HMS Warrior', 1860*, on loan from the artist, © the artist

Portsmouth Museums and Records Service

Allad, Stanley S. *Lakeside Village (Scene in Surrey)*, gift from James B. Bundle, 1950

Allad, Stanley S. *Windsor Castle*,

gift from James B. Bundle, 1950

Allen, G. *Wymering Fields*, purchased from Mrs L. Banks, 1961

Allen, G. *Hilsea*, purchased from Mrs L. Banks, 1961

Allen, Harry active late 19th C, *Charles Dickens, Aged 27 (after Daniel Maclise)*, gift from J. C. Parkinson, JP, DL, 1968

Allen, Harry active late 19th C, *Charles Dickens, Aged 45 (after Ary Scheffer)*, gift from J. Cousins Lawrence, 1968

Armstrong, John 1893–1973, *The Three Orders of Architecture*, purchased from Browse & Darby, 1984, © the artist's estate

Backhouse, David *Still Life with Flowers*, transferred from Bristol Museums Service, 2006

Bagley, Laurence *Lone Sailor*, purchased from Corrall Publicity Ltd, 1968

Barker, John Rowland 1911–1959, *Portsmouth Future*, gift from the Lord Mayor's Office, 1981

Barns-Graham, Wilhelmina 1912–2004, *Relief II*, purchased from Penwith Gallery, 1981, © by courtesy of the Barns-Graham Charitable Trust

Beavis, Richard 1824–1896, *Burning of the 'Eastern Monarch' off Fort Monckton*, purchased from Norman Marks, 1965

Bernhardt, Geoff *The Bridge Tavern, the Camber*, gift from Hilary Thomas, 2004

Blair, Eileen *Portchester Castle, Hampshire*, bequeathed by Patrick Ernest William Harris, 1997

Bland, Emily Beatrice 1864–1951, *Portchester Castle, Hampshire*, presented by Mrs Lesley Lewis through the National Art Collections Fund, 2006

Boshier, Derek b.1937, *Set Square*, purchased from the artist, 1973

Bradshaw, Gordon b.1931, *County Town*, purchased from D. M. Nesbit and Co., 2003

Bradshaw, Gordon b.1931, *View on Plynlimmon*, purchased from the artist, 1972

Bradshaw, Gordon b.1931, *View on Plynlimmon*, purchased from the Education Picture Fund, 1972

Bratby, John Randall 1928–1992, *Table Top*, transferred from the Schools' Loans Service, 1973, © the artist's estate/www.bridgeman.co.uk

Bratby, John Randall 1928–1992, *Kitchen II*, purchased from the artist, 1967, © the artist's estate/www.bridgeman.co.uk

Breanski, Gustave de c.1856–1898, *Coastal Scene*, gift from Mrs M. M. Goodchild, 1991

Bril, Paul 1554–1626, *Christ Walking on the Water*, bequeathed by Miss E. M. Spyers, 1950

Brooker, James A. *LCI[S] 527' and 'LCI[S] 525' Landing Free French Commandos on Sword Beach, 6 June 1944*, gift from the artist, 1993

Brooks, Frank 1854–1937, *Miss Grace Mary Cannon*, bequeathed by Miss Grace Mary Cannon, 1948

Broome, William 1838–1892, *Wreck of 'HMS Eurydice' Being Towed into Portsmouth Harbour*, purchased from Sotheby's with the assistance of the Victoria & Albert Museum Purchase Grant Fund, 1979

Brown, Jessie 1906–2003, *Cactus*, purchased from the artist, 1973

Brown, Jessie 1906–2003, *Greetham Street, Portsmouth*, purchased from the artist, 1971

Brown, Jessie 1906–2003, *Havant Bypass Construction*, transferred from the Schools' Loans Service, 1979

Brown, Jessie 1906–2003, *Hydrangeas with Orange Jug*, purchased from the artist, 1973

Brown, Jessie 1906–2003, *Contractors' Huts*, purchased from the artist, 1973

Brown, Jessie 1906–2003, *Houses, Old Portsmouth*, purchased from the Portsmouth Theatre Royal Society, 1972

Brown, Nellie 1900–1970, *'Nellie Dean'*, found in store, 2005

Browne, J. L. active 1953–1973, *Gate to 'HMS Vernon'*, gift from the United Services Officer's Club, 1975

Browne, J. L. active 1953–1973, *Admiral Sir Horatio Nelson (1758–1805)*, gift from the United Services Officer's Club, 1975

Bryant, Henry Charles 1836–1915, *Charles Dickens (1812–1870)*, found in store, 1984

Bryant, Henry Charles 1836–1915, *Farmyard Scene*, bequeathed by William Hugh Bonner, 1950

Bryant, Henry Charles 1836–1915, *Farmer Kent's Farm, North End (now Stubbington Avenue, Portsmouth)*, gift from Dr R. H. Emmett, 1954

Bryant, Henry Charles 1836–1915, *Market Vendor*, gift from the Lord Mayor's Office, 1968

Bryant, Henry Charles 1836–1915, *Portrait of a Lady*, gift from Miss E. Musselwhite, 1957

Bryant, Henry Charles 1836–1915, *Sheep on Moorland*, purchased, 1979

Burn, Gerald Maurice 1862–1945, *Battle Cruiser 'HMS Princess Royal' in the Floating Dock, Portsmouth*, gift from the artist, 1945

Cagnacci, Guido (attributed to) 1601–1681, *The Penitent Magdalen*, transferred from a former museum in Portsmouth

Callcott, William James active 1843–1896, *Portsmouth Harbour from Portsdown Hill*, gift from Vincent R. Wintle,1946

Callcott, William James active 1843–1896, *View from Portsdown Looking towards Portsea Island*, purchased from Mrs D. A. Pervin, 1966

Callow, John 1822–1878, *Stiff Breeze off Portsmouth Harbour*, purchased from Mrs K. Bailey, 1969

Canty, Jack c.1910–2002, *Abstract Painting No.4*, bequeathed by the artist, 2002

Canty, Jack c.1910–2002, *A Farm*, bequeathed by the artist, 2002

Canty, Jack c.1910–2002, *Abstract Painting 1946*, bequeathed by the artist, 2002

Canty, Jack c.1910–2002, *Standing Forms No.2*, bequeathed by the artist, 2002

Canty, Jack c.1910–2002, *Christmas*, bequeathed by the artist, 2002

Canty, Jack c.1910–2002, *Composition*, bequeathed by the artist, 2002

Canty, Jack c.1910–2002, *Standing Forms*, bequeathed by the artist, 2002

Canty, Jack c.1910–2002, *Standing Forms No.5*, bequeathed by the artist, 2002

Canty, Jack c.1910–2002, *Standing Forms No.10*, bequeathed by the artist, 2002

Canty, Jack c.1910–2002, *Combat*, bequeathed by the artist, 2002

Canty, Jack c.1910–2002, *Dancers*, bequeathed by the artist, 2002

Canty, Jack c.1910–2002, *Standing Forms No.3*, bequeathed by the artist, 2002

Canty, Jack c.1910–2002, *Abstract Forms*, bequeathed by the artist, 2002

Canty, Jack c.1910–2002, *Forms on a Dark Ground No.3*, bequeathed by the artist, 2002

Canty, Jack c.1910–2002, *Abstract*, bequeathed by the artist, 2002

Canty, Jack c.1910–2002, *Composition (Steamboats)*, bequeathed by the artist, 2002

Canty, Jack c.1910–2002, *Expanding Forms*, bequeathed by the artist, 2002

Canty, Jack c.1910–2002, *In the Style of Mondrian*, bequeathed by the artist, 2002

Canty, Jack c.1910–2002, *Point of …*, bequeathed by the artist, 2002

Canty, Jack c.1910–2002, *Self Portrait*, bequeathed by the artist, 2002

Carrington, Dora 1893–1932, *Scene from the Strachey Gramophone*, purchased from Sotheby's, 1986

Carrington, Dora 1893–1932, *Scene from the Strachey Gramophone*, purchased from Sotheby's, 1986

Carrington, Dora 1893–1932, *Scene from the Strachey Gramophone*, purchased from Sotheby's, 1986

Carrington, Dora 1893–1932, *Scene from the Strachey Gramophone*, purchased from Sotheby's, 1986

Catlow, Geoff (attributed to) b.1948, *Shelves*, found in store, 1984

Chambers, George 1803–1840, *Entrance to Portsmouth Harbour*, purchased, 1964

Chesher, Arthur William 1895–1972, *Burrell's Traction Engine*, transferred from the Schools' Loans Service

Christian, J. R. *Patrick Ernest William Harris*, bequeathed by Patrick Ernest William Harris, 1997

Cleall, L. *Goldsmith's (White Farm, Milton)*, purchased from J. Kellaway, 1960

Clough, Prunella 1919–1999, *Pond by Chemical Works 1*, transferred from the Schools' Loans Service, 1973, © estate of Prunella Clough 2007. All Rights Reserved DACS.

Cole, George 1810–1883, *'Cato', Property of the Right Honourable Sir Robert Peel, Bt*, bequeathed by Miss V. M. M. Cole, 1956

Cole, George 1810–1883, *Entrance to Portsmouth Harbour*, purchased, 1987–1988

Cole, George 1810–1883, *General Yates*, bequeathed by Miss V. M. M. Cole, 1956

Cole, George 1810–1883, *The London Road, Portsdown Hill*, found in store, 1954

Cole, George 1810–1883, *Cotehele Mill on the Tamar*, purchased from Messrs Mitchell, 1945

Cole, George 1810–1883, *Hampshire Moorland*, purchased from Messrs Mitchell, 1945

Cole, George 1810–1883, *Scene in Hampshire*, purchased from Messrs Mitchell, 1945

Cole, George 1810–1883, *Hampshire Woodland*, purchased, 1945

Cole, George 1810–1883, *Head of George Cole's Second Son*, bequeathed by Miss V. M. M. Cole, 1956

Cole, George Vicat 1833–1893, *Spring*, purchased, 1945

Cole, George Vicat 1833–1893, *Near Epsom*, purchased, 1945

Cole, George Vicat 1833–1893, *River Scene with Peasants and Cattle*, purchased from Miss Isabel McHugh, 1955

Cole, Rex Vicat 1870–1940, *The Pack Horse Bridge near Bingley*, purchased, 1945

Collins, Niamh b.1956, *Abstract*, purchased from the Hiscock Gallery, 1979, © the artist

Cooke, Edward William (after) 1811–1880, *Shipping off Portsmouth*, purchased from Sotheby's, 1990

Cooper, J. C. *Victoria Pier and 'HMS Victory'*, gift from Miss M. Bevis, 1981

Copus, M. *Greetings from Southsea (detail)*, commissioned, 1995

Copus, M. *Victoria Park, Portsmouth (detail)*, commissioned, 1995

Cox, E. Albert 1876–1955, *The Admiral's Galley, 1690*, gift from the artist, 1945

Crabbe, Richard 1927–1970, *Interlude 1*, gift(?) from Portsmouth Cathedral, 1971

Crawford, Edmund Thornton 1806–1885, *Portsmouth Harbour*, purchased from the Parker Gallery, 1945

Cribb, Preston 1876–1937, *Ocean Racing*, gift from Mrs E. Cribb, 1945

Crow, D. *Kingston Church, Portsmouth*, purchased from G. T. King, 1971

Crow, D. *Town Hall, Portsmouth*, purchased from G. T. King, 1971

Cruikshank, George I 1792–1878, *The Library Table*, gift from Mrs J. Cochrane, 1999

Cruikshank, Isaac Robert (attributed to) 1757–1811, *The Portsmouth Royal Mail near Fareham, Hampshire*, purchased from the Old Hall Gallery with the assistance of the Victoria & Albert Museum Purchase Grant Fund, 1977

Dance, Geoffrey b.1930, *Admiral Benbow's Farewell to His Wife*, transferred from the Schools' Loans Service, 1973

Darby, James Francis 1816–1875, *Action between 'HM Sloop Bonne Citoyenne', and the French Frigate 'La Furieuse'*, gift from Miss L. Constant, OBE, 1986

Darby, James Francis 1816–1875, *'HM Sloop Bonne Citoyenne' Taking the French Frigate 'La Furieuse' in Tow*, gift from Miss L. Constant, OBE, 1986

Deacon, George S. active 1860s–1879, *Portsmouth View from Southsea Common at Sunset*, gift from D. Smith Stretton, 1981

Dixon, James 1887–1970, *Ring-Net Fishing, Tory Island*, transferred from the Schools' Loans Service, 1973

Dorth, J. E. *Portsmouth Guildhall*, purchased from Mr Sayers, 1970

Dowiss, A. S. *Entrance Hall**, bequeathed by G. W. J. Chambers, 1980

Downing, George Henry 1878–1940, *The Grounds at Leigh Park House, Havant*, on loan from Mrs H. Peel

Downton, John 1906–1991, *A Saint*, gift from the John Downton Trust, 1998

Downton, John 1906–1991, *Saint Bartholomew*, gift from the John Downton Trust, 1998

Downton, John 1906–1991, *Before the Battle*, gift from R. S. Lesney, via the John Downton Trust, 1998

Downton, John 1906–1991, *The Siege*, gift from the John Downton Trust, 1998

Downton, John 1906–1991, *Five Learned Men*, gift from the John Downton Trust, 1998

Duchess of Argyll, Louise Caroline Alberta (attributed to) 1848–1939, *Bluejacket, 'HMS Comus'*, gift from HRH Prince Michael, Duke of Kent, 1945

Dumas, Ada 1868–1950, *The Golden-Haired Girl*, gift from Miss M. E. Spyers, 1979

Dunlop, Ronald Ossory 1894–1973, *Still Life with Black Bottle*, purchased from D. M. Nesbit and Co., 1971

Dunlop, Ronald Ossory 1894–1973, *Gravesend Shipping*, purchased from Bryan Heath (Fine Art) Ltd, 1973

Dunlop, Ronald Ossory 1894–1973, *View from My Studio Window*, purchased from the artist, 1971

Eatwell, John b.1923, *Red Abstract*, purchased from Portsmouth College of Art, 1968

Elliott, Robert J. (attributed to) c.1790–1849, *View of Portsmouth Harbour Looking North*, purchased from Miss E. Giffard, 1958

Elliott, Robert J. (attributed to) c.1790–1849, *View of Portsmouth Harbour Looking South*, purchased from Miss E. Giffard, 1958

Elsheimer, Adam (attributed to) 1578–1610, *Judith and Holofernes*, gift from the National Art Collections Fund, 1975

Emmanuel, Frank Lewis 1866–1948, *Dick Turpin's Stable at the Old Grange, Kensington*, gift from Gerald Emanuel, 1981

Eubank, John Wilson 1799–1847, *The Mouth of the Tyne*, gift from the Lord Mayor's Office, 1968

Eurich, Richard Ernst 1903–1992, *Ships of All Nations Assembling off Spithead, 14 June 1953 for Coronation Review by the Queen, 15 June 1953*, purchased from Werner Haub, 1973, © courtesy of the artist's estate/www.bridgeman.co.uk

Everitt, Douglas active c.1970–c.1991, *Field in Movement*, purchased from the Hiscock Gallery, 2003

Everitt, Douglas active c.1970–c.1991, *Dark Abstract*, on loan from the artist

Fayel, B. *View of Southsea Beach with Clarence Pier*, bequeathed by John Rodney Gordon Slight via Bond Pearce, 2002

Fellowes, James c.1690–c.1760, *Portrait of a Gentleman*, gift from Mrs J. Haslegrave, 1972

Finnie, John 1829–1907, *The Meeting of the Mersey and the Weaver*, gift from Mrs E. Hall, 1946

Finnie, John 1829–1907, *Sunset at Pangbourne*, gift from Mrs E. Hall, 1946

Fisher, Roger Roland Sutton 1919–1992, *Frigates Entering Portsmouth*, purchased from D. M. Nesbit and Co., 2003, © the artist's estate

Fisher, Roger Roland Sutton 1919–1992, *'HMS Frobisher' at Grenada, February 1937*, purchased from D. M. Nesbit and Co., 2003, © the artist's estate

Fleming, C. *Alderman C. Dye*, gift from A. A. Dye, 1946

Foorde, William *Portrait of a Young Man (possibly a self portrait)*, gift from Mr E. A. Grove, 1969

Foulds, Ian *Ready for Going Ashore*, gift from British SHAEF Veterans Association, 2004

Fowles, Arthur Wellington c.1815–1883, *Solent Ferries off Ryde Pier*, purchased from the Hampshire Gallery with the assistance of the Victoria & Albert Museum Purchase Grant Fund, 1976

Fowles, Arthur Wellington c.1815–1883, *The Frigate 'HMS Falcon' Attempting to Sink by Shelling the Burning Hulk of the Troop Transport, 'Eastern Monarch'*, purchased from the Hampshire Gallery with the assistance of the Victoria & Albert Museum Purchase Grant Fund, 1976

Fowles, Arthur Wellington c.1815–1883, *Review of Reserve Fleet, 1878*, purchased from P. H. Smith, 1969

Fox, Mary b.1922, *Pagham Harbour*, purchased from the Trentham Gallery, 1967

Frost, Terry 1915–2003, *Ochre and Blue*, purchased from Mr A. C. Sewler, 1973, © the artist's estate

Garneray, Louis (attributed to) 1783–1857, *French Prizes in the Harbour*, purchased from C. Marshall Spink, 1951

Garneray, Louis (attributed to) 1783–1857, *Prison Hulks in Portsmouth Harbour*, purchased from Harding and Goadsby with the assistance of the Victoria & Albert Museum Purchase Grant Fund, 1970

Gilbert, Joseph Francis 1792–1855, *View From Hill House*, purchased from G. Dowing, 1956

Gilbert, Joseph Francis 1792–1855, *The Temple, 28 January 1830*, gift from Mrs H. G. Lynch Staunton, 1946

Gilbert, Joseph Francis 1792–1855, *Leigh Park House, Havant, from the South-West*, gift from Mrs H. G. Lynch Staunton, 1946

Gilbert, Joseph Francis 1792–1855, *Leigh Park House, Havant*, gift from Mrs H. G. Lynch Staunton, 1946

Gilbert, Joseph Francis (attributed to) 1792–1855, *A Pastoral Scene*, purchased, 1979

Girardot, Ernest Gustave 1840–1904, *Captain John Hutt, RN*, gift from J. G. Hutt, 1951

Goodwin, William Sidney 1833–1916, *Horses Hauling Stone at Portland*, found in store, 1945

Gosse, Laura Sylvia 1881–1968, *La marchande de Guimauve*, gift from the Walter Sickert Trust, 1948, © the artist's estate/www.bridgeman.co.uk

Grant, Duncan 1885–1978, *Commedia dell'Arte Scene*, purchased from the Mayor Gallery with the assistance of the Victoria & Albert Museum Purchase Grant Fund, 1984, © 1978 estate of Duncan Grant

Grant, Keith b.1930, *The Volcano in the North*, purchased from the artist, 1977, © the artist

Grant, Keith b.1930, *Pyramid Peak, Jernatt*, purchased from the artist, 1980, © the artist

Gregory, George 1849–1938, *The Royal Naval Review*, purchased from Denys Brook Hart with the assistance of the Victoria & Albert Museum Purchase Grant Fund, 1973

Grone, Ferdinand E. c.1845–1920, *A Farm Maid*, found in store, 1979

Guthrie, Derek b.1936, *St Just*, transferred from the Schools' Loans Service, 1973, © the artist

Hall, C. J. active 1900–1903, *'HMS Europa'*, gift from Mr E. Prescott Frost, 1953

Hall, C. J. active 1900–1903, *'HMS Majestic'*, gift from Mr E. Prescott Frost, 1953

Hall, C. J. active 1900–1903, *'HMS Majestic'*, gift from Mr E. Prescott Frost, 1953

Hall, C. J. active 1900–1903, *'HMS Glory' at Malaga*, gift from Mr E. Prescott Frost, 1953

Hann, Christopher b.1946, *Figure*, purchased from the Hiscock Gallery, 1972

Hart, Solomon Alexander 1806–1881, *The Cricketers, Southsea*, gift from Miss A. C. Coles, 1956

Haughton, Benjamin 1865–1924, *Obscured near Sandhurst, East Kent, 11 October 1890*, gift from Miss B. Haughton, 1973

Haughton, Benjamin 1865–1924, *Pool Study*, gift from Miss B. Haughton, 1973

Haughton, Benjamin 1865–1924, *Man in a Field by a Stream*, gift from Miss B. Haughton, 1973

Haughton, Benjamin 1865–1924, *October Afternoon*, bequeathed by Miss B. Haughton, 1977

Haughton, Benjamin 1865–1924, *Country and Skyscape*, gift from Miss B. Haughton, 1973

Haughton, Benjamin 1865–1924, *Doctor's Pond, Summerhill*, gift from Miss B. Haughton, 1973

Haughton, Benjamin 1865–1924, *February Morning*, gift from Miss B. Haughton, 1973

Haughton, Benjamin 1865–1924, *Picnic in a Clearing, Summerhill*, gift from Miss B. Haughton, 1973

Haughton, Benjamin 1865–1924, *Summerhill*, gift from Miss B. Haughton, 1973

Haughton, Benjamin 1865–1924, *Tree Study, Summerhill*, gift from Miss B. Haughton, 1973

Haughton, Benjamin 1865–1924, *Woodland Sketch, Summerhill*, gift from Miss B. Haughton, 1973

Haughton, Benjamin 1865–1924, *The Pool*, gift from Miss B. Haughton, 1973

Haughton, Benjamin 1865–1924, *October Afternoon*, gift from Miss B. Haughton, 1973

Haughton, Benjamin 1865–1924, *Autumn, Weald of Kent*, gift from Miss B. Haughton, 1973

Haughton, Benjamin 1865–1924, *Street Scene, Tuscany*, gift from Miss B. Haughton, 1973

Haughton, Benjamin 1865–1924, *Trees and Tower, Tuscany*, gift from Miss B. Haughton, 1973

Haughton, Benjamin 1865–1924, *Cornwall*, gift from Miss B. Haughton, 1973

Haughton, Benjamin 1865–1924, *Rocks on the Cliffs, Newlyn*, gift from Miss B. Haughton, 1973

Haughton, Benjamin 1865–1924, *Study for 'City of Dreams'*, gift from Miss B. Haughton, 1973

Haughton, Benjamin 1865–1924, *Nasturtiums*, gift from Miss B. Haughton, 1973

Haughton, Benjamin 1865–1924, *Woodland*, gift from Miss B. Haughton, 1973

Haughton, Benjamin 1865–1924, *Deserted Orchard*, gift from Miss B. Haughton, 1973

Haughton, Benjamin 1865–1924, *View in the Vosges*, gift from Miss B. Haughton, 1973

Haughton, Benjamin 1865–1924, *A Sheltered Farm*, gift from Miss B. Haughton, 1973

Haughton, Benjamin 1865–1924, *Betty*, gift from Miss B. Haughton, 1973

Haughton, Benjamin 1865–1924, *A Garden*, gift from Miss B. Haughton, 1973

Haughton, Benjamin 1865–1924, *A Tower Seen through Trees*, gift from Miss B. Haughton, 1973

Haughton, Benjamin 1865–1924, *A Tree*, gift from Miss B. Haughton, 1973

Haughton, Benjamin 1865–1924, *A Tree in Woodland*, gift from Miss B. Haughton, 1973

Haughton, Benjamin 1865–1924, *A Woman*, gift from Miss B. Haughton, 1973

Haughton, Benjamin 1865–1924, *An Upland Farm*, bequeathed by Miss B. Haughton, 1977

Haughton, Benjamin 1865–1924, *Anemones*, bequeathed by Miss B. Haughton, 1974

Haughton, Benjamin 1865–1924, *Apple Tree*, gift from Miss B. Haughton, 1973

Haughton, Benjamin 1865–1924, *April 1912, East Devon*, gift from Miss B. Haughton, 1973

Haughton, Benjamin 1865–1924, *At East Downe*, gift from Miss B. Haughton, 1973

Haughton, Benjamin 1865–1924, *At the Rose Show*, gift from Miss B. Haughton, 1973

Haughton, Benjamin 1865–1924, *Autumn Wood, East Downe*, gift from Miss B. Haughton, 1973

Haughton, Benjamin 1865–1924, *Autumnal Woodland Scene*, gift from Miss B. Haughton, 1973

Haughton, Benjamin 1865–1924, *Beech Bole*, gift from Miss B. Haughton, 1973

Haughton, Benjamin 1865–1924, *Beech on the Quantocks*, gift from Miss B. Haughton, 1973

Haughton, Benjamin 1865–1924, *Betty, Aged 12*, gift from Miss B. Haughton, 1973

Haughton, Benjamin 1865–1924, *Betty Haughton as a Child*, gift from Miss B. Haughton, 1973

Haughton, Benjamin 1865–1924, *Cornwall*, gift from Miss B. Haughton, 1973

Haughton, Benjamin 1865–1924, *Betty in the Garden*, gift from Miss B. Haughton, 1973

Haughton, Benjamin 1865–1924, *Birch Tree in a Field*, gift from Miss B. Haughton, 1973

Haughton, Benjamin 1865–1924, *Bluebells*, bequeathed by Miss B. Haughton, 1977

Haughton, Benjamin 1865–1924, *'Breath of Spring'*, bequeathed by Miss B. Haughton, 1977

Haughton, Benjamin 1865–1924, *Cavalier*, bequeathed by Miss B. Haughton, 1977

Haughton, Benjamin 1865–1924, *Cherry Blossom*, gift from Miss B. Haughton, 1973

Haughton, Benjamin 1865–1924, *Cherry Blossom*, gift from Miss B. Haughton, 1973

Haughton, Benjamin 1865–1924, *Christmas Roses*, bequeathed by Miss B. Haughton, 1974

Haughton, Benjamin 1865–1924, *Church Graveyard*, gift from Miss B. Haughton, 1973

Haughton, Benjamin 1865–1924, *Church House Garden, East Downe House*, gift from Miss B. Haughton, 1973

Haughton, Benjamin 1865–1924, *Churchyard*, gift from Miss B. Haughton, 1973

Haughton, Benjamin 1865–1924, *Churchyard, East Downe*, gift from Miss B. Haughton, 1973

Haughton, Benjamin 1865–1924, *City of Dreams*, bequeathed by Miss B. Haughton, 1977

Haughton, Benjamin 1865–1924, *Classical Landscape*, gift from Miss B. Haughton, 1973

Haughton, Benjamin 1865–1924, *Cliffs and Sea*, gift from Miss B. Haughton, 1973

Haughton, Benjamin 1865–1924, *Cluster of Flowers*, gift from Miss B. Haughton, 1973

Haughton, Benjamin 1865–1924, *Collecting Water, Doctor's Pond, Summerhill*, gift from Miss B. Haughton, 1973

Haughton, Benjamin 1865–1924, *Cornfield with Stooks*, gift from Miss B. Haughton, 1973

Haughton, Benjamin 1865–1924, *Cornwall*, gift from Miss B. Haughton, 1973

Haughton, Benjamin 1865–1924, *Cornwall*, gift from Miss B. Haughton, 1973

Haughton, Benjamin 1865–1924, *Cottage Garden*, gift from Miss B. Haughton, 1973

Haughton, Benjamin 1865–1924, *Cottage in a Copse*, gift from Miss B. Haughton, 1973

Haughton, Benjamin 1865–1924, *Cottage in a Landscape*, gift from Miss B. Haughton, 1973

Haughton, Benjamin 1865–1924, *Cottages on a Hillside*, gift from Miss B. Haughton, 1973

Haughton, Benjamin 1865–1924, *Country Stream*, gift from Miss B. Haughton, 1973

Haughton, Benjamin 1865–1924, *Countryside*, gift from Miss B.

Haughton, 1973

Haughton, Benjamin 1865–1924, *Countryside*, gift from Miss B. Haughton, 1973

Haughton, Benjamin 1865–1924, *Countryside*, gift from Miss B. Haughton, 1973

Haughton, Benjamin 1865–1924, *Countryside*, gift from Miss B. Haughton, 1973

Haughton, Benjamin 1865–1924, *Countryside*, gift from Miss B. Haughton, 1973

Haughton, Benjamin 1865–1924, *Countryside with Cottages*, gift from Miss B. Haughton, 1973

Haughton, Benjamin 1865–1924, *Cypress Trees in Italian Landscape*, gift from Miss B. Haughton, 1973

Haughton, Benjamin 1865–1924, *Dawn*, gift from Miss B. Haughton, 1973

Haughton, Benjamin 1865–1924, *Dead and Live Tree*, bequeathed by Miss B. Haughton, 1977

Haughton, Benjamin 1865–1924, *Devon*, gift from Miss B. Haughton, 1973

Haughton, Benjamin 1865–1924, *Devon Pinewood*, gift from Miss B. Haughton, 1973

Haughton, Benjamin 1865–1924, *Doctor's Farm*, gift from Miss B. Haughton, 1973

Haughton, Benjamin 1865–1924, *Doctor's Farm*, gift from Miss B. Haughton, 1973

Haughton, Benjamin 1865–1924, *Downland*, gift from Miss B. Haughton, 1973

Haughton, Benjamin 1865–1924, *Downland*, gift from Miss B. Haughton, 1973

Haughton, Benjamin 1865–1924, *Downland*, gift from Miss B. Haughton, 1973

Haughton, Benjamin 1865–1924, *Downland*, gift from Miss B. Haughton, 1973

Haughton, Benjamin 1865–1924, *Downland*, gift from Miss B. Haughton, 1973

Haughton, Benjamin 1865–1924, *Downland*, gift from Miss B. Haughton, 1973

Haughton, Benjamin 1865–1924, *East Downe*, gift from Miss B. Haughton, 1973

Haughton, Benjamin 1865–1924, *East Downe*, gift from Miss B. Haughton, 1973

Haughton, Benjamin 1865–1924, *East Downe Gate*, gift from Miss B. Haughton, 1973

Haughton, Benjamin 1865–1924, *East Downe Wood*, on loan from the Art Department, Portsmouth Museums and Records Service

Haughton, Benjamin 1865–1924, *East Hill, Ottery St Mary*, gift from Miss B. Haughton, 1973

Haughton, Benjamin 1865–1924, *Ellington, East Yorkshire, Looking Towards the Humber*, gift from Miss B. Haughton, 1973

Haughton, Benjamin 1865–1924, *Evening*, gift from Miss B. Haughton, 1973

Haughton, Benjamin 1865–1924, *Eylers*, gift from Miss B. Haughton, 1973

Haughton, Benjamin 1865–1924, *Faido*, gift from Miss B. Haughton, 1973

Haughton, Benjamin 1865–1924, *Farm Buildings and Woodland*, gift from Miss B. Haughton, 1973

Haughton, Benjamin 1865–1924, *Field*, gift from Miss B. Haughton, 1973

Haughton, Benjamin 1865–1924, *Field and Trees*, gift from Miss B. Haughton, 1973

Haughton, Benjamin 1865–1924, *Fields and Village*, gift from Miss B. Haughton, 1973

Haughton, Benjamin 1865–1924, *Florence*, gift from Miss B. Haughton, 1973

Haughton, Benjamin 1865–1924, *Flowers and Poppy Heads*, gift from Miss B. Haughton, 1973

Haughton, Benjamin 1865–1924, *Flowers Growing in Rocks*, gift from Miss B. Haughton, 1973

Haughton, Benjamin 1865–1924, *Flowers in a Garden*, gift from Miss B. Haughton, 1973

Haughton, Benjamin 1865–1924, *Flowers in a Glass Vase*, gift from Miss B. Haughton, 1973

Haughton, Benjamin 1865–1924, *Forest Floor*, gift from Miss B. Haughton, 1973

Haughton, Benjamin 1865–1924, *Forest Glade*, gift from Miss B. Haughton, 1973

Haughton, Benjamin 1865–1924, *Foxgloves*, gift from Miss B. Haughton, 1973

Haughton, Benjamin 1865–1924, *From the Fountain Garden, East Downe*, gift from Miss B. Haughton, 1973

Haughton, Benjamin 1865–1924, *Garden Flower Scene*, gift from Miss B. Haughton, 1973

Haughton, Benjamin 1865–1924, *Garden Flowers*, gift from Miss B. Haughton, 1973

Haughton, Benjamin 1865–1924, *Girl in a Forest Clearing*, gift from Miss B. Haughton, 1973

Haughton, Benjamin 1865–1924, *Girl in a Summer Garden*, gift from Miss B. Haughton, 1973

Haughton, Benjamin 1865–1924, *Girl in a Wood*, gift from Miss B. Haughton, 1973

Haughton, Benjamin 1865–1924, *Girl Tending a Garden*, gift from Miss B. Haughton, 1973

Haughton, Benjamin 1865–1924, *Girl Tending Geese*, gift from Miss B. Haughton, 1973

Haughton, Benjamin 1865–1924, *Girl's Head*, gift from Miss B. Haughton, 1973

Haughton, Benjamin 1865–1924, *Gladioli near a Door*, gift from Miss B. Haughton, 1973

Haughton, Benjamin 1865–1924, *Half-Lit Woodland Scene*, gift from

Miss B. Haughton, 1973

Haughton, Benjamin 1865–1924, *Haystack in Hill Country*, gift from Miss B. Haughton, 1973

Haughton, Benjamin 1865–1924, *Haystacks*, gift from Miss B. Haughton, 1973

Haughton, Benjamin 1865–1924, *Haystacks at Dawn*, gift from Miss B. Haughton, 1973

Haughton, Benjamin 1865–1924, *Hemlock*, bequeathed by Miss B. Haughton, 1977

Haughton, Benjamin 1865–1924, *Hill Country*, gift from Miss B. Haughton, 1973

Haughton, Benjamin 1865–1924, *Hill Slopes*, gift from Miss B. Haughton, 1973

Haughton, Benjamin 1865–1924, *Hillside*, gift from Miss B. Haughton, 1973

Haughton, Benjamin 1865–1924, *Hillside*, gift from Miss B. Haughton, 1973

Haughton, Benjamin 1865–1924, *Hillside*, gift from Miss B. Haughton, 1973

Haughton, Benjamin 1865–1924, *Hilly Countryside*, gift from Miss B. Haughton, 1973

Haughton, Benjamin 1865–1924, *Hilly Countryside*, gift from Miss B. Haughton, 1973

Haughton, Benjamin 1865–1924, *Hop Garden*, gift from Miss B. Haughton, 1973

Haughton, Benjamin 1865–1924, *Houses*, gift from Miss B. Haughton, 1973

Haughton, Benjamin 1865–1924, *Hydrangeas*, gift from Miss B. Haughton, 1973

Haughton, Benjamin 1865–1924, *In a Garden in Kent*, gift from Miss B. Haughton, 1973

Haughton, Benjamin 1865–1924, *In Churchill Wood, North Devon*, gift from Miss B. Haughton, 1973

Haughton, Benjamin 1865–1924, *Italian Countryside*, gift from Miss B. Haughton, 1973

Haughton, Benjamin 1865–1924, *Italian Hill Scene*, gift from Miss B. Haughton, 1973

Haughton, Benjamin 1865–1924, *Italian Landscape*, gift from Miss B. Haughton, 1973

Haughton, Benjamin 1865–1924, *Italianate Lakeside*, gift from Miss B. Haughton, 1973

Haughton, Benjamin 1865–1924, *Italianate Landscape*, gift from Miss B. Haughton, 1973

Haughton, Benjamin 1865–1924, *Italianate Landscape*, gift from Miss B. Haughton, 1973

Haughton, Benjamin 1865–1924, *Ivy-Clad Tree*, gift from Miss B. Haughton, 1973

Haughton, Benjamin 1865–1924, *Ivy-Clad Tree*, gift from Miss B. Haughton, 1973

Haughton, Benjamin 1865–1924, *Jay*, gift from Miss B. Haughton, 1973

Haughton, Benjamin 1865–1924, *Kentish Landscape*, gift from Miss

B. Haughton, 1973

Haughton, Benjamin 1865–1924, *Lady's Wood, Devon*, gift from Miss B. Haughton, 1973

Haughton, Benjamin 1865–1924, *Lake and Trees*, gift from Miss B. Haughton, 1973

Haughton, Benjamin 1865–1924, *Lakeland Scene*, gift from Miss B. Haughton, 1973

Haughton, Benjamin 1865–1924, *Landscape, East Downe*, gift from Miss B. Haughton, 1973

Haughton, Benjamin 1865–1924, *Landscape with Hayricks*, gift from Miss B. Haughton, 1973

Haughton, Benjamin 1865–1924, *Landscape with Pond*, gift from Miss B. Haughton, 1973

Haughton, Benjamin 1865–1924, *Lilac*, gift from Miss B. Haughton, 1973

Haughton, Benjamin 1865–1924, *Lupins and Roses in a Garden*, gift from Miss B. Haughton, 1973

Haughton, Benjamin 1865–1924, *Man Crossing a Field at Dusk*, gift from Miss B. Haughton, 1973

Haughton, Benjamin 1865–1924, *Man's Head*, gift from Miss B. Haughton, 1973

Haughton, Benjamin 1865–1924, *Marchwood*, gift from Miss B. Haughton, 1973

Haughton, Benjamin 1865–1924, *Meadow and Woods*, gift from Miss B. Haughton, 1973

Haughton, Benjamin 1865–1924, *Misty Woodland*, gift from Miss B. Haughton, 1973

Haughton, Benjamin 1865–1924, *Moonlight*, gift from Miss B. Haughton, 1973

Haughton, Benjamin 1865–1924, *Moonlit Countryside*, gift from Miss B. Haughton, 1973

Haughton, Benjamin 1865–1924, *Moorland Pond*, gift from Miss B. Haughton, 1973

Haughton, Benjamin 1865–1924, *Morning Shadows*, gift from Miss B. Haughton, 1973

Haughton, Benjamin 1865–1924, *Mountain Landscape*, gift from Miss B. Haughton, 1973

Haughton, Benjamin 1865–1924, *Mountain Scene*, gift from Miss B. Haughton, 1973

Haughton, Benjamin 1865–1924, *Narcissi in a Vase*, gift from Miss B. Haughton, 1973

Haughton, Benjamin 1865–1924, *North Devon*, gift from Miss B. Haughton, 1973

Haughton, Benjamin 1865–1924, *North Devon*, gift from Miss B. Haughton, 1973

Haughton, Benjamin 1865–1924, *On East Hill, Ottery St Mary*, gift from Miss B. Haughton, 1973

Haughton, Benjamin 1865–1924, *On the Cliffs above Mounts Bay, Cornwall*, gift from Miss B. Haughton, 1973

Haughton, Benjamin 1865–1924, *On the Cliffs at Mounts Bay, Cornwall*, gift from Miss B. Haughton, 1973

Haughton, Benjamin 1865–1924, *On the Quantocks*, gift from Miss B. Haughton, 1973

Haughton, Benjamin 1865–1924, *On the Quantocks*, gift from Miss B. Haughton, 1973

Haughton, Benjamin 1865–1924, *Orchard near the Pineta, Viareggio*, gift from Miss B. Haughton, 1973

Haughton, Benjamin 1865–1924, *Orchard Sketch*, bequeathed by Miss B. Haughton, 1977

Haughton, Benjamin 1865–1924, *Ottery St Mary*, gift from Miss B. Haughton, 1973

Haughton, Benjamin 1865–1924, *Ottery St Mary*, gift from Miss B. Haughton, 1973

Haughton, Benjamin 1865–1924, *Path through Moorland*, gift from Miss B. Haughton, 1973

Haughton, Benjamin 1865–1924, *Path through the Woods*, gift from Miss B. Haughton, 1973

Haughton, Benjamin 1865–1924, *Pheasants*, gift from Miss B. Haughton, 1973

Haughton, Benjamin 1865–1924, *Phlox*, gift from Miss B. Haughton, 1973

Haughton, Benjamin 1865–1924, *Polyanthus*, gift from Miss B. Haughton, 1973

Haughton, Benjamin 1865–1924, *Pond amid Woods*, gift from Miss B. Haughton, 1973

Haughton, Benjamin 1865–1924, *Pond Deep within Wood*, gift from Miss B. Haughton, 1973

Haughton, Benjamin 1865–1924, *Portrait of an Unknown Gentleman's Head*, gift from Miss B. Haughton, 1973

Haughton, Benjamin 1865–1924, *Pot of Roses*, gift from Miss B. Haughton, 1973

Haughton, Benjamin 1865–1924, *Red Sapling by the Sea*, gift from Miss B. Haughton, 1973

Haughton, Benjamin 1865–1924, *Rhododendrons in a Wood*, gift from Miss B. Haughton, 1973

Haughton, Benjamin 1865–1924, *Road to the Moor*, gift from Miss B. Haughton, 1973

Haughton, Benjamin 1865–1924, *Rose Bush*, gift from Miss B. Haughton, 1973

Haughton, Benjamin 1865–1924, *Roses*, gift from Miss B. Haughton, 1973

Haughton, Benjamin 1865–1924, *Rushes in Mediterranean Twilight*, gift from Miss B. Haughton, 1973

Haughton, Benjamin 1865–1924, *Russet and Gold*, gift from Miss B. Haughton, 1973

Haughton, Benjamin 1865–1924, *San Mignano, Tuscany*, gift from Miss B. Haughton, 1973

Haughton, Benjamin 1865–1924, *Saplings on Hillside*, gift from Miss B. Haughton, 1973

Haughton, Benjamin 1865–1924, *Scene with Hunters (unfinished)*, gift from Miss B. Haughton, 1973

Haughton, Benjamin 1865–1924, *Sea and Skyscape*, gift from Miss B.

Haughton, 1973

Haughton, Benjamin 1865–1924, *Self Portrait*, gift from Miss B. Haughton, 1973

Haughton, Benjamin 1865–1924, *Sketch at Houndspool*, gift from Miss B. Haughton, 1973

Haughton, Benjamin 1865–1924, *Sketch for 'Woodland Waters'*, gift from Miss B. Haughton, 1973

Haughton, Benjamin 1865–1924, *Sketch for 'Threshing'*, gift from Miss B. Haughton, 1973

Haughton, Benjamin 1865–1924, *Sketch of East Downe*, gift from Miss B. Haughton, 1973

Haughton, Benjamin 1865–1924, *Sketch of Grassland and a Bird's Head*, gift from Miss B. Haughton, 1973

Haughton, Benjamin 1865–1924, *Sketch of North Devon*, gift from Miss B. Haughton, 1973

Haughton, Benjamin 1865–1924, *Sketch of North Devon*, gift from Miss B. Haughton, 1973

Haughton, Benjamin 1865–1924, *Sketch of North Devon Woodland*, gift from Miss B. Haughton, 1973

Haughton, Benjamin 1865–1924, *Sketch of Rhododendron Ponticum*, gift from Miss B. Haughton, 1973

Haughton, Benjamin 1865–1924, *Sprig of Flowers with Anemones*, bequeathed by Miss B. Haughton, 1977

Haughton, Benjamin 1865–1924, *Spring Song*, bequeathed by Miss B. Haughton, 1977

Haughton, Benjamin 1865–1924, *Standard Roses in a Garden*, gift from Miss B. Haughton, 1973

Haughton, Benjamin 1865–1924, *Stream in a Woodland Glade*, gift from Miss B. Haughton, 1973

Haughton, Benjamin 1865–1924, *Study for 'Breath of Spring'*, gift from Miss B. Haughton, 1973

Haughton, Benjamin 1865–1924, *Study for 'Breath of Spring'*, gift from Miss B. Haughton, 1973

Haughton, Benjamin 1865–1924, *Study for 'City of Dreams'*, gift from Miss B. Haughton, 1973

Haughton, Benjamin 1865–1924, *Study for 'Hush of Evening'*, gift from Miss B. Haughton, 1973

Haughton, Benjamin 1865–1924, *Study for 'Pastoral'*, gift from Miss B. Haughton, 1973

Haughton, Benjamin 1865–1924, *Study for 'Pastoral'*, gift from Miss B. Haughton, 1973

Haughton, Benjamin 1865–1924, *Study for 'Pastoral with Woodland Pond'*, gift from Miss B. Haughton, 1973

Haughton, Benjamin 1865–1924, *Study of a Beech*, gift from Miss B. Haughton, 1973

Haughton, Benjamin 1865–1924, *Study of a Bluebell Wood, Summerhill*, gift from Miss B. Haughton, 1973

Haughton, Benjamin 1865–1924, *Study of an Olive Tree*, gift from Miss B. Haughton, 1973

Haughton, Benjamin 1865–1924,

Study of Fir Wood, gift from Miss B. Haughton, 1973

Haughton, Benjamin 1865–1924, *Study of Oak Boles*, gift from Miss B. Haughton, 1973

Haughton, Benjamin 1865–1924, *Study of Roses*, gift from Miss B. Haughton, 1973

Haughton, Benjamin 1865–1924, *Summerhill*, gift from Miss B. Haughton, 1973

Haughton, Benjamin 1865–1924, *Sun over Downland (recto)*, gift from Miss B. Haughton, 1973

Haughton, Benjamin 1865–1924, *Narcissus and Orchid (verso)*, gift from Miss B. Haughton, 1973

Haughton, Benjamin 1865–1924, *Sundown*, bequeathed by Miss B. Haughton, 1977

Haughton, Benjamin 1865–1924, *Sunlit Trees*, gift from Miss B. Haughton, 1973

Haughton, Benjamin 1865–1924, *Sunlit Wood*, gift from Miss B. Haughton, 1973

Haughton, Benjamin 1865–1924, *Sunset*, gift from Miss B. Haughton, 1973

Haughton, Benjamin 1865–1924, *Sunset behind Trees with Pond*, gift from Miss B. Haughton, 1973

Haughton, Benjamin 1865–1924, *Sunset over Countryside*, gift from Miss B. Haughton, 1973

Haughton, Benjamin 1865–1924, *Sunshine and Frost*, bequeathed by Miss B. Haughton, 1977

Haughton, Benjamin 1865–1924, *The Beech Bole*, bequeathed by Miss B. Haughton, 1977

Haughton, Benjamin 1865–1924, *The Keeper's Cottage*, gift from Miss B. Haughton, 1973

Haughton, Benjamin 1865–1924, *The Milking Parlour*, on loan from the Art Department, Portsmouth Museums and Records Service

Haughton, Benjamin 1865–1924, *The Rhododendron Wood, Betty in Strete Raleigh Wood*, gift from Miss B. Haughton, 1973

Haughton, Benjamin 1865–1924, *The Rising Moon, Marchwood*, gift from Miss B. Haughton, 1973

Haughton, Benjamin 1865–1924, *The Roof of the World*, gift from Miss B. Haughton, 1973

Haughton, Benjamin 1865–1924, *The Rookery, Bluebell Time, East Downe*, gift from Miss B. Haughton, 1973

Haughton, Benjamin 1865–1924, *The Rookery, East Downe*, gift from Miss B. Haughton, 1973

Haughton, Benjamin 1865–1924, *The Rookery, East Downe*, gift from Miss B. Haughton, 1973

Haughton, Benjamin 1865–1924, *The Sid Valley*, gift from Miss B. Haughton, 1973

Haughton, Benjamin 1865–1924, *Thistle in a Field*, gift from Miss B. Haughton, 1973

Haughton, Benjamin 1865–1924, *Threshing*, bequeathed by Miss B. Haughton, 1977

Haughton, Benjamin 1865–1924,

Ticino Valley, gift from Miss B. Haughton, 1973

Haughton, Benjamin 1865–1924, *Tones for Forest Scene*, gift from Miss B. Haughton, 1973

Haughton, Benjamin 1865–1924, *Tree*, gift from Miss B. Haughton, 1973

Haughton, Benjamin 1865–1924, *Tree against Sky*, gift from Miss B. Haughton, 1973

Haughton, Benjamin 1865–1924, *Tree by a Cottage Door*, gift from Miss B. Haughton, 1973

Haughton, Benjamin 1865–1924, *Tree by a Stone*, gift from Miss B. Haughton, 1973

Haughton, Benjamin 1865–1924, *Tree Felling, East Downe*, gift from Miss B. Haughton, 1973

Haughton, Benjamin 1865–1924, *Tree in a Glade*, gift from Miss B. Haughton, 1973

Haughton, Benjamin 1865–1924, *Tree in Autumn*, gift from Miss B. Haughton, 1973

Haughton, Benjamin 1865–1924, *Tree in Blossom*, gift from Miss B. Haughton, 1973

Haughton, Benjamin 1865–1924, *Tree in Summer*, gift from Miss B. Haughton, 1973

Haughton, Benjamin 1865–1924, *Tree Roots*, gift from Miss B. Haughton, 1973

Haughton, Benjamin 1865–1924, *Trees*, gift from Miss B. Haughton, 1973

Haughton, Benjamin 1865–1924, *Trees*, gift from Miss B. Haughton, 1973

Haughton, Benjamin 1865–1924, *Trees and Cornstooks*, gift from Miss B. Haughton, 1973

Haughton, Benjamin 1865–1924, *Trees and Fields*, gift from Miss B. Haughton, 1973

Haughton, Benjamin 1865–1924, *Trees and Stream*, bequeathed by Miss B. Haughton, 1977

Haughton, Benjamin 1865–1924, *Trees and Undergrowth*, gift from Miss B. Haughton, 1973

Haughton, Benjamin 1865–1924, *Trees and Water (unfinished)*, gift from Miss B. Haughton, 1973

Haughton, Benjamin 1865–1924, *Trees by a Lake*, gift from Miss B. Haughton, 1973

Haughton, Benjamin 1865–1924, *Trees by a Pond*, gift from Miss B. Haughton, 1973

Haughton, Benjamin 1865–1924, *Trees by a Stream*, gift from Miss B. Haughton, 1973

Haughton, Benjamin 1865–1924, *Trees in a Cornfield*, gift from Miss B. Haughton, 1973

Haughton, Benjamin 1865–1924, *Trees in a Field*, gift from Miss B. Haughton, 1973

Haughton, Benjamin 1865–1924, *Trees in a Garden*, gift from Miss B. Haughton, 1973

Haughton, Benjamin 1865–1924, *Trees in a Garden*, gift from Miss B. Haughton, 1973

Haughton, Benjamin 1865–1924,

Trees in a Quarry, on loan from the Art Department, Portsmouth Museums and Records Service

Haughton, Benjamin 1865–1924, *Trees in a Valley*, gift from Miss B. Haughton, 1973

Haughton, Benjamin 1865–1924, *Trees in a Winter Landscape*, gift from Miss B. Haughton, 1973

Haughton, Benjamin 1865–1924, *Trees in a Wood*, gift from Miss B. Haughton, 1973

Haughton, Benjamin 1865–1924, *Trees in a Woodland*, gift from Miss B. Haughton, 1973

Haughton, Benjamin 1865–1924, *Trees in Blossom*, bequeathed by Miss B. Haughton, 1977

Haughton, Benjamin 1865–1924, *Trees in Downland*, gift from Miss B. Haughton, 1973

Haughton, Benjamin 1865–1924, *Trees near a Cottage at Sunset*, gift from Miss B. Haughton, 1973

Haughton, Benjamin 1865–1924, *Trees near a Village at Sunset*, gift from Miss B. Haughton, 1973

Haughton, Benjamin 1865–1924, *Trees on a Hill near the Sea*, gift from Miss B. Haughton, 1973

Haughton, Benjamin 1865–1924, *Trees on a Hillside*, gift from Miss B. Haughton, 1973

Haughton, Benjamin 1865–1924, *Trees on a Hillside*, gift from Miss B. Haughton, 1973

Haughton, Benjamin 1865–1924, *Trees Reflected in Water*, gift from Miss B. Haughton, 1973

Haughton, Benjamin 1865–1924, *Two Children Walking*, gift from Miss B. Haughton, 1973

Haughton, Benjamin 1865–1924, *Vase of Roses*, gift from Miss B. Haughton, 1973

Haughton, Benjamin 1865–1924, *Vase of Roses*, gift from Miss B. Haughton, 1973

Haughton, Benjamin 1865–1924, *Very Early Morning, Hunstead*, gift from Miss B. Haughton, 1973

Haughton, Benjamin 1865–1924, *View in Liguria, Bay of La Spezia*, gift from Miss B. Haughton, 1973

Haughton, Benjamin 1865–1924, *View in the Quantocks Overlooking the Bristol Channel*, on loan from the Art Department, Portsmouth Museums and Records Service

Haughton, Benjamin 1865–1924, *View near East Downe*, gift from Miss B. Haughton, 1973

Haughton, Benjamin 1865–1924, *View over Trees*, gift from Miss B. Haughton, 1973

Haughton, Benjamin 1865–1924, *Village from Hillside*, gift from Miss B. Haughton, 1973

Haughton, Benjamin 1865–1924, *Vista between Trees*, bequeathed by Miss B. Haughton, 1977

Haughton, Benjamin 1865–1924, *Vosges Landscape*, gift from Miss B. Haughton, 1973

Haughton, Benjamin 1865–1924, *Wild Roses*, gift from Miss B. Haughton, 1973

Haughton, Benjamin 1865–1924,

Winter Trees, gift from Miss B. Haughton, 1973

Haughton, Benjamin 1865–1924, *Woman Drawing Water at a Pond*, gift from Miss B. Haughton, 1973

Haughton, Benjamin 1865–1924, *Woman Hanging Out Washing*, gift from Miss B. Haughton, 1973

Haughton, Benjamin 1865–1924, *Woman in a Churchyard*, gift from Miss B. Haughton, 1973

Haughton, Benjamin 1865–1924, *Woman in a Conservatory with Roses*, gift from Miss B. Haughton, 1973

Haughton, Benjamin 1865–1924, *Woman in a Glade*, gift from Miss B. Haughton, 1973

Haughton, Benjamin 1865–1924, *Woman Walking through a Wood*, gift from Miss B. Haughton, 1973

Haughton, Benjamin 1865–1924, *Woman's Head*, gift from Miss B. Haughton, 1973

Haughton, Benjamin 1865–1924, *Wood, possibly at East Downe*, gift from Miss B. Haughton, 1973

Haughton, Benjamin 1865–1924, *Woodland*, gift from Miss B. Haughton, 1973

Haughton, Benjamin 1865–1924, *Woodland*, gift from Miss B. Haughton, 1973

Haughton, Benjamin 1865–1924, *Woodland*, gift from Miss B. Haughton, 1973

Haughton, Benjamin 1865–1924, *Woodland*, gift from Miss B. Haughton, 1973

Haughton, Benjamin 1865–1924, *Woodland*, gift from Miss B. Haughton, 1973

Haughton, Benjamin 1865–1924, *Woodland*, gift from Miss B. Haughton, 1973

Haughton, Benjamin 1865–1924, *Woodland*, gift from Miss B. Haughton, 1973

Haughton, Benjamin 1865–1924, *Woodland Glade*, gift from Miss B. Haughton, 1973

Haughton, Benjamin 1865–1924, *Woodland Glade*, gift from Miss B. Haughton, 1973

Haughton, Benjamin 1865–1924, *Woodland Glade*, bequeathed by Miss B. Haughton, 1977

Haughton, Benjamin 1865–1924, *Woodland Landscape from Hillside*, gift from Miss B. Haughton, 1973

Haughton, Benjamin 1865–1924, *Woodland Path*, gift from Miss B. Haughton, 1973

Haughton, Benjamin 1865–1924, *Woodland Scene*, gift from Miss B. Haughton, 1973

Haughton, Benjamin 1865–1924, *Woodland Scene*, gift from Miss B. Haughton, 1973

Haughton, Benjamin 1865–1924, *Woodland Sketch*, gift from Miss B. Haughton, 1973

Haughton, Benjamin 1865–1924, *Woodland Stream*, gift from Miss B. Haughton, 1973

Haughton, Benjamin 1865–1924, *Woodland Study, East Downe*, gift from Miss B. Haughton, 1973

Haughton, Benjamin 1865–1924, *Woodland Undergrowth*, gift from Miss B. Haughton, 1973

Haughton, Benjamin 1865–1924, *Woodland View with Stream*, gift from Miss B. Haughton, 1973

Haughton, Benjamin 1865–1924, *Woodland with Hills in the Distance*, gift from Miss B. Haughton, 1973

Haughton, Benjamin 1865–1924, *Yellow Flowers in a Vase*, gift from Miss B. Haughton, 1973

Haughton, Benjamin (attributed to) 1865–1924, *Lowland Scenery*, gift from Miss B. Haughton, 1973

Hayman, Patrick 1915–1988, *Entry into Jerusalem*, transferred from the Schools' Loans Service, 1973, © DACS 2007

Hazlett, J. *Charles Dickens (1812–1870), as a Young Man*, found in store, 2004

Heem, Cornelis de (attributed to) 1631–1695, *Flower Piece*, found in store, 1980

Helst, Bartholomeus van der (attributed to) 1613–1670, *Portrait of an Unknown Gentleman*, bequeathed by Patrick Ernest William Harris, 1997

Henri *Chiemsee, Bavaria*, gift from the Walter Sickert Trust, 1947

Heron, Patrick 1920–1999, *Red, Yellow, Brown*, transferred from the Schools' Loans Service, 1973, © estate of Patrick Heron 2007/DACS 2007

Hitchens, Ivon 1893–1979, *Arched Trees No.2, Late Summer*, purchased from Jack Canty, 1979, © Ivon Hitchens' estate/Jonathan Clark & Co.

Hobbs, Barry *Tricorn*, purchased from the artist, 2004

Hobbs, Barry *Tricorn*, purchased from the artist, 2004

Hobbs, Barry *Tricorn*, purchased from the artist, 2004

Hofland, Thomas Christopher 1777–1843, *Hulks in Portsmouth Harbour*, purchased from D. Macleau with the assistance of the Victoria & Albert Museum Purchase Grant Fund, 1979

Holloway, Denee *Iford Sand Pit*, purchased from the Duff Gallery, 1970

Holloway, Denee *White Sheets*, purchased from the Duff Gallery, 1970

Hornbrook, Thomas Lyde 1780–1850, *'HMS Pique' Entering Portsmouth Harbour*, gift from Mrs H. Griffith Williams, 1957

Houston, John b.1930, *Figures by the Sea, Evening*, purchased from the Mercury Gallery, 1981

Howard, W. H. active c.1899–1909,

H. Kimber, Mayor of Portsmouth, purchased from D. M. Nesbit and Co., 2003

Howard, W. H. active c.1899–1909, *Mayor James Baggs*, purchased

Howsam, Barry *Figure*, transferred from the Schools' Loans Service, 1979

Hudson, John 1829–1897, *'Folly of Portsmouth'*, purchased from Mr Percy Beer, 1968

Hulst, Maerten Fransz. van der (attributed to) 1605–1645, *A River Scene in the Low Countries*, gift from the National Art Collections Fund, 1972

Irwin, Gwyther b.1931, *On a Clear Day*, gift from Mr M. Bendon, 1982, © the artist

J. C. N. J. *'Eurydice' from Sandown Bay*, purchased from Mr J. G. Beer, 1972

Jefferson, Alan 1918–2001, *Black and White Geometric Abstract*, gift from the artist, 1998

Jefferson, Alan 1918–2001, *Diamond Shaped Abstract*, gift from the artist, 1998

Jefferson, Alan 1918–2001, *Lemon No.25, Oct. 1975*, gift from the artist, 1998

Jefferson, Alan 1918–2001, *Painting B, 22-3-79*, gift from the artist, 1998

Jefferson, Alan 1918–2001, *Blue Line*, gift from the artist, 1998

Jefferson, Alan 1918–2001, *Blue, Violet, Lime and Ochre*, gift from the artist, 1998

Jefferson, Alan 1918–2001, *Canted Corner Geometric Abstract*, gift from the artist, 1998

Jefferson, Alan 1918–2001, *Dark Leaves and Grid*, gift from the artist, 1998

Jefferson, Alan 1918–2001, *Green Orb*, gift from the artist, 1998

Jefferson, Alan 1918–2001, *H. B. V. S. 69*, gift from the artist, 1998

Jefferson, Alan 1918–2001, *Leaves and Rainbow*, gift from the artist, 1998

Jefferson, Alan 1918–2001, *Lozenge Arch*, gift from the artist, 1998

Jefferson, Alan 1918–2001, *On Yellow*, gift from the artist, 1998

Jefferson, Alan 1918–2001, *Orange and Violet*, gift from the artist, 1998

Jefferson, Alan 1918–2001, *Pink Orb*, gift from the artist, 1998

Jefferson, Alan 1918–2001, *Soft Five*, gift from the artist, 1998

Jefferson, Alan 1918–2001, *Wave*, purchased from the artist, 1972

Jerome, James Parker 1810–1883, *William Carter Jerome*, bequeathed by Francis Jerome Collins, 2000

Jerome, James Parker 1810–1883, *Ambrosini (Self Portrait)*, bequeathed by Francis Jerome Collins, 2000

Jerome, James Parker 1810–1883, *Harriet Caroline Augusta Jerome*, bequeathed by Francis Jerome Collins, 2000

Jerome, James Parker 1810–1883, *Maria Jerome*, bequeathed by

Francis Jerome Collins, 2000

Jerome, James Parker 1810–1883, *Portrait of an Elderly Gentleman, possibly Joseph Scarrott Jerome*, bequeathed by Francis Jerome Collins, 2000

Jerome, James Parker 1810–1883, *Seated Female Nude*, bequeathed by Mr R. C. A. Collins, 2002

Jewels, Mary 1886–1977, *St Ives*, transferred from the Schools' Loans Service, 1973

Jonleigh, Leonie active c.1950–1974, *South Parade Pier*, purchased from J. Hudson Lyons, 1980

Joy, George William 1844–1925, *Laodamia*, purchased from Commander V. Clark, 1976

Joy, William 1803–1867, *Beaver Harbour, North End of Vancouver Island*, gift from H. G. Filtness, 1971

Joy, William 1803–1867, *Coronation Bay, North-West End of Vancouver Island*, gift from H. G. Filtness, 1971

Joy, William 1803–1867, *'HMS Devastation' at Fort Rupert, at the West End of Vancouver Island*, gift from H. G. Filtness, 1971

Joy, William 1803–1867, *'HMS Devastation' Leaving the South-Eastern End of the Johnson's Strait, Vancouver Island*, gift from H. G. Filtness, 1971

Joy, William 1803–1867, *Boats of 'HMS Devastation' in Search of Indians, Nootka Sound, Vancouver Island*, gift from H. G. Filtness, 1971

Joy, William 1803–1867, *Town of Nanaimo, Vancouver Island*, gift from H. G. Filtness, 1971

Joy, William 1803–1867, *Spanish Fleet Bombarding Valparaiso, March 1866*, gift from H. G. Filtness, 1971

Kasialos, Michael *Pottery Makers*, transferred from the Schools' Loans Service

Kasialos, Michael *Travelling Salesman*, transferred from the Schools' Loans Service, 1974

Kern, Theodor 1900–1969, *Abstract Yellow, Red and Blue*, gift from Frida Kern

King, Edward R. 1863–1951, *High Street and the Old Guildhall*, purchased from the artist, 1945

King, Edward R. 1863–1951, *Cabbage Field on the Farm at St James' Hospital*, gift from Barbara Melrose, 2002

King, Edward R. 1863–1951, *Central Hotel, Commercial Road*, purchased from the artist, 1945

King, Edward R. 1863–1951, *High Street, Portsmouth*, purchased from the artist, 1945

King, Edward R. 1863–1951, *High Street, Portsmouth*, purchased from the artist, 1945

King, Edward R. 1863–1951, *Oyster Street, Portsmouth*, purchased from the artist, 1945

King, Edward R. 1863–1951, *Penny Street, Portsmouth*, purchased from the artist, 1945

King, Edward R. 1863–1951, *St Thomas' Street, Portsmouth*, purchased from the artist, 1945

King, Edward R. 1863–1951, *The Cathedral from the Ruins in the High Street*, purchased from the artist, 1945

King, Edward R. 1863–1951, *The Guildhall*, purchased from the artist, 1945

King, Edward R. 1863–1951, *Cathedral amongst the Ruins in the High Street*, purchased from the artist, 1945

King, Edward R. 1863–1951, *Elm Grove Baptist Church*, purchased from the artist, 1945

King, Edward R. 1863–1951, *Arundel Street, Portsmouth*, purchased from the artist, 1945

King, Edward R. 1863–1951, *Commercial Road and Lake Road, Portsmouth*, purchased from the artist, 1945

King, Edward R. 1863–1951, *King's Road and Coronation House, Portsmouth*, purchased from the artist, 1945

King, Edward R. 1863–1951, *Palmerston Road, Portsmouth*, purchased from the artist, 1945

King, Edward R. 1863–1951, *Cathedral from High Street*, purchased from the artist, 1945

King, Edward R. 1863–1951, *Commercial Road, Portsmouth*, purchased from the artist, 1945

King, Edward R. 1863–1951, *Hampshire and Jubilee Terraces, Portsmouth*, purchased from the artist, 1945

King, Edward R. 1863–1951, *Hyde Park Corner*, purchased from the artist, 1945

King, Edward R. 1863–1951, *Palmerston Road, Portsmouth*, purchased from the artist, 1945

King, Edward R. 1863–1951, *Ruins in Oyster Street, Portsmouth*, purchased from the artist, 1945

King, Edward R. 1863–1951, *Surrey Street, the Guildhall, Portsmouth*, purchased from the artist, 1945

King, Edward R. 1863–1951, *The Connaught Drill Hall, Stanhope Road, Portsmouth*, purchased from the artist, 1945

King, Edward R. 1863–1951, *High Street, Old Portsmouth*, found in store, probably 1945

King, Edward R. 1863–1951, *Cathedral from St Thomas' Street, Old Portsmouth*, purchased from the artist, 1945

King, Edward R. 1863–1951, *Oyster Street, Portsmouth*, purchased from the artist, 1945

King, Edward R. 1863–1951, *Pembroke Road, Portsmouth*, purchased from the artist, 1945

King, Edward R. 1863–1951, *Ruins of St Thomas' Street, Portsmouth*, purchased from the artist, 1945

King, Edward R. 1863–1951, *St Paul's Road and St Paul's Church, Portsmouth*, purchased from the artist, 1945

King, Edward R. 1863–1951, *St Thomas' Street, Portsmouth*, purchased from the artist, 1945

King, Edward R. 1863–1951, *The Farm at St James' Hospital*, gift from St James' Hospital, 2002

King, Edward R. 1863–1951, *Houseboats at Milton alongside a Quay with a Girl in Red*, found in store, 1998

King, Edward R. 1863–1951, *Houseboats at Milton, No.11*, found in store, 1998

King, Edward R. 1863–1951, *Houseboats at Milton, No.16*, found in store, 1998

King, Edward R. 1863–1951, *Houseboats at Milton, No.21*, found in store, 1998

King, Edward R. 1863–1951, *Houseboats at Milton, No.26*, found in store, 1998

King, Edward R. 1863–1951, *Houseboats at Milton, No.18*, found in store, 1998

King, Edward R. 1863–1951, *Houseboats at Milton, No.4*, found in store, 1998

King, Edward R. 1863–1951, *A View of the Laundry, St James' Hospital, Portsmouth*, found in store, 1998

King, Edward R. 1863–1951, *Houseboats at Milton, No.12*, found in store, 1998

King, Edward R. 1863–1951, *Outbuildings at St James' Hospital, No.2*, found in store, 1998

King, Edward R. 1863–1951, *Outbuildings at St James' Hospital, No.6*, found in store, 1998

King, Edward R. 1863–1951, *Outbuildings at St James' Hospital, No.5*, found in store, 1998

King, Edward R. 1863–1951, *Outbuildings at St James' Hospital, No.7*, found in store, 1998

King, Edward R. 1863–1951, *Outbuildings at St James' Hospital, No.10*, gift from Barbara Melrose, 2002

King, Edward R. 1863–1951, *Patients Working on the Farm at St James' Hospital, No.2*, found in store, 1998

King, Edward R. 1863–1951, *The Grounds of St James' Hospital*, gift from Barbara Melrose, 2002

King, Edward R. 1863–1951, *Gravel Wharf, Milton Lake, Portsmouth*, found in store, 1998

King, Edward R. 1863–1951, *Houseboats at Milton, No.3*, found in store, 1998

King, Edward R. 1863–1951, *Houseboats at Milton, No.5*, found in store, 1998

King, Edward R. 1863–1951, *Houseboats at Milton, No.6*, found in store, 1998

King, Edward R. 1863–1951, *Houseboats at Milton, No.7*, found in store, 1998

King, Edward R. 1863–1951, *Houseboats at Milton, No.8*, found in store, 1998

King, Edward R. 1863–1951, *Houseboats at Milton, No.9*, found

in store, 1998

King, Edward R. 1863–1951, *Houseboats at Milton, No.10*, found in store, 1998

King, Edward R. 1863–1951, *Houseboats at Milton, No.13*, found in store, 1998

King, Edward R. 1863–1951, *Houseboats at Milton, No.14*, found in store, 1998

King, Edward R. 1863–1951, *Houseboats at Milton, No.15*, found in store, 1998

King, Edward R. 1863–1951, *Houseboats at Milton, No.17*, found in store, 1998

King, Edward R. 1863–1951, *Houseboats at Milton, No.19*, found in store, 1998

King, Edward R. 1863–1951, *Houseboats at Milton, No.20*, found in store, 1998

King, Edward R. 1863–1951, *Houseboats at Milton, No.22*, found in store, 1998

King, Edward R. 1863–1951, *Houseboats at Milton, No.23*, found in store, 1998

King, Edward R. 1863–1951, *Houseboats at Milton, No.24*, found in store, 1998

King, Edward R. 1863–1951, *Houseboats at Milton, No.25*, found in store, 1998

King, Edward R. 1863–1951, *Houseboats at Milton, No.27*, found in store, 1998

King, Edward R. 1863–1951, *Houseboats at Milton with a Dinghy and Sawhorse in the Foreground*, found in store, 1998

King, Edward R. 1863–1951, *On Board a Houseboat at Milton*, found in store, 1998

King, Edward R. 1863–1951, *Outbuildings at St James' Hospital, Chimney Smoking*, found in store, 1998

King, Edward R. 1863–1951, *Outbuildings at St James' Hospital, No.1*, found in store, 1998

King, Edward R. 1863–1951, *Outbuildings at St James' Hospital, No.3*, found in store, 1998

King, Edward R. 1863–1951, *Outbuildings at St James' Hospital, No.4*, found in store, 1998

King, Edward R. 1863–1951, *Outbuildings at St James' Hospital, No.9*, found in store, 1998

King, Edward R. 1863–1951, *Patients Working on the Farm at St James' Hospital, No.1*, found in store, 1998

King, Edward R. 1863–1951, *Poplar Trees in the Grounds of St James' Hospital, No.1*, found in store, 1998

King, Edward R. 1863–1951, *Poplar Trees in the Grounds of St James' Hospital, No.2*, found in store, 1998

King, Edward R. 1863–1951, *Poplar Trees in the Grounds of St James' Hospital, No.3*, found in store, 1998

King, Edward R. 1863–1951, *Self Portrait*, found in store, 1998

King, Edward R. 1863–1951, *Self Portrait*, found in store, 1998

King, Edward R. 1863–1951, *Sunset with Poplar Trees*, found in store, 1998

King, Edward R. 1863–1951, *Trees by a Wall*, found in store, 1998

King, Edward R. 1863–1951, *Two Buildings, possibly in Southsea*, found in store, 1998

King, Gunning 1859–1940, *Market Day*, transferred from the Guildhall Sub-Committee, 1959

King, Roger *D-Day, 6 June 1944*, gift from Gieves and Hawkes Ltd, 1984

Kingston, Grace active c.1980s–1990s, *A Second World War RAF Mobile Barrage Balloon Site*, gift from Mrs Eileen Hollidge, 2004, © Portsmouth City Council

Knell, William Adolphus 1802–1875, *'HMS Asia' Leaving Portsmouth Harbour*, gift from Miss Dorothy Hannington, 1945

Knell, William Callcott b.1830, *Collier Brig Running before the Wind in a Fresh Breeze off Sheerness, Looking from Queensborough*, purchased from Mrs E. Ellis, 1967

Knell, William Callcott b.1830, *View of Portsmouth from Cowes, Isle of Wight*, purchased from Mrs E. Ellis, 1967

Kneller, Godfrey (attributed to) 1646–1723, *Child with Dog and Squirrel*, transferred from Portsmouth Museum, 1980

Knowles, Justin 1935–2004, *Pyramid Abstract*, gift from the Contemporary Art Society, 1981

Ladbrooke, John Berney 1803–1879, *Southsea Castle*, purchased from Percy Beer Antiques Ltd, 1966

Lancaster, Percy 1878–1951, *The Farm Pool*, gift from the C. H. Clark Will Trust, 1986

Lavender, V. J. *Coronation of the Prince of Wales*, gift from the United Services Officer's Club, 1975

Lessore, John b.1939, *Garden with Washing Line*, transferred from the Schools' Loans Service, 1973, © the artist

Lessore, Thérèse 1884–1945, *Place d'Aix, Marseille*, gift from the Walter Sickert Trust, 1947, © the artist's estate

Lewis, John Hardwicke 1840–1927, *Milton Village*, purchased from Mrs L. M. Stupple, 1958

Livesay, Richard 1750–c.1826, *Military Review of the Worcestershire Regiment by Major-General Whitelocke on Southsea Common, 1823*, purchased from M. Barnard with the assistance of the Victoria & Albert Museum Purchase Grant Fund, 1960

Luny, Thomas 1759–1837, *Sir John Jervis and Nelson Defeat the Spaniards off Cape St Vincent*, purchased from Mrs E. Ellis, 1967

Mason, William Henry active 1858–1917, *The Entrance to Portsmouth Harbour*, purchased from F. Guymer, 1946

Masters, C. H. *Memorial to Those Men of the Portsmouth Borough Police Who Enlisted in the British Army and Who Fell at Ypres*, on loan from Mr John Masters

Matthews, Peter b.1942, *Winter, South Coast (detail)*, purchased from the Arnolfini Gallery with the assistance of the Victoria & Albert Museum Purchase Grant Fund, 1975

McCann, O. active 1988–1999, *Harry Pound's Yard*, purchased from the artist, 1999

Miller, Alice A. *A Man of Sorrows*, purchased from D. M. Nesbit and Co., 1972

Miller, Alice A. *The 'Madonna della Sedia' (copy after Raphael)*, purchased from D. M. Nesbit and Co., 1972

Miller, Alice A. *The Virgin Mary*, purchased from D. M. Nesbit and Co., 1972

Milroy, Lisa b.1959, *Lightbulbs*, gift from the Contemporary Art Society, 1996, © the artist

Morgan, Henry J. 1839–1917, *'HMS Britannia'*, gift from Miss E. Giffard, 1946

Morgan, Henry J. 1839–1917, *'HMS Alert', 1875–1876*, gift from Miss E. Giffard, 1946

Morgan, Henry J. 1839–1917, *'HMS Aurora', 1863–1867*, gift from Miss E. Giffard, 1946

Morgan, Henry J. 1839–1917, *'HMS Boadicea', 1892–1894*, gift from Miss E. Giffard, 1946

Morgan, Henry J. 1839–1917, *'HMS Bonaventure', 1894–1895*, gift from Miss E. Giffard, 1946

Morgan, Henry J. 1839–1917, *'HMS Comus', 1899*, gift from Miss E. Giffard, 1946

Morgan, Henry J. 1839–1917, *'HMS Fox', 1896–1898*, gift from Miss E. Giffard, 1946

Morgan, Henry J. 1839–1917, *'HMS Hercules', 1869–1870*, gift from Miss E. Giffard, 1946

Morgan, Henry J. 1839–1917, *'HMS Penelope', 1885–1887*, gift from Miss E. Giffard, 1946

Morgan, Henry J. 1839–1917, *'HMS Trafalgar', 1898*, gift from Miss E. Giffard, 1946

Morgan, Henry J. 1839–1917, *'HMS Victory', 1862*, gift from Miss E. Giffard, 1946

Morgan, Henry J. 1839–1917, *'HMS Wanderer', 1887–1891*, gift from Miss E. Giffard, 1946

Munch, Bernard b.1921, *Ombrage*, purchased from Anthony Dawson, 1968

O'Connor, Kevin b.1939, *Polar*, purchased from the artist, 1977

Olsson, Albert Julius 1864–1942, *Waves Breaking on the Shore*, gift from Mrs J. Olsson, 1957

Orsborn, John b.1932, *Deep Landscape*, purchased from the artist, 2003

Orsborn, John b.1932, *Medusa*, transferred from the Schools' Loans Service, 1981

Palmer, Garrick b.1933, *Victoria Park, Portsmouth*, purchased from the artist, 1956, © the artist

Palmer, Garrick b.1933, *The Camber*, purchased from the City Archives Department, 1968 (?), © the artist

Palmer, Garrick b.1933, *Circular Forms No.18*, purchased from the Hiscock Gallery, 1972, © the artist

Palmer, Garrick b.1933, *Circular Form No.14*, purchased from the artist, 1972, © the artist

Palmer, Garrick b.1933, *Standing Form No.11*, purchased from the artist, 1972, © the artist

Pare, David 1911–1996, *Clarence Parade*, purchased from D. M. Nesbit and Co., 1999, © the artist's estate

Pare, David 1911–1996, *Norfolk Street, 1952*, purchased from F. D. E. Pane, 1953, © the artist's estate

Pascoe, Debra b.1956, *Footballers*, transferred from Bristol Museums Service, 2006, © the artist

Pasmore, Victor 1909–1998, *Linear Motif*, transferred from the Schools' Loans Service, 1974, © the estate of Victor Pasmore, courtesy of Marlborough Fine Art (London) Limited

Pearce, Bryan 1929–2007, *St Ives from Martins*, transferred from the Schools' Loans Service, 1973, © the estate of Bryan Pearce/licensed by DACS, 2007

Pissarro, Orovida Camille 1893–1968, *Leopard and Family*, transferred from the Schools' Loans Service, 1973, © the trustees of the estate of Orovida Pissarro

Poate, Richard active 1840s–1870s, *Thomas Slade*, gift from the trustees of the Beneficial School, 1945

Poate, Richard active 1840s–1870s, *Doctor W. C. Engledue, Chairman at the Banquet Held in September 1856 to Welcome Home Other Ranks from the Crimea, Proposing the Royal Toast*, gift from Mrs N. Gunn, 1959

Poate, Richard active 1840s–1870s, *Thomas Batchelor, Treasurer of the Beneficial Society*, transferred from the Local History Department, 1979

Poate, Richard (attributed to) active 1840s–1870s, *Mr Sergeant Gaselee, MP for Portsmouth (1865–1868)*, gift from the trustees of the Beneficial School, 1945

Poate, Richard (attributed to) active 1840s–1870s, *Thomas Batchelor*, gift from the trustees of the Beneficial School, 1945

Poole, George Augustus 1861–1932, *Benjamin Haughton (1865–1924)*, bequeathed by Miss B. Haughton, 1977

Proctor, Frederick J. active 1879–1945, *'A copper, please'*, gift from Mr W. A. Mew, 1960

Proctor, Frederick J. active 1879–1945, *The Spirit that Won the War, 1914–1918*, gift from the artist, 1945

Proctor, Frederick J. active 1879–1945, *Gala Press Gang, 1798*, gift from the artist, 1945

Ranken, William Bruce Ellis 1881–1941, *Lady D'Erlanger*, gift from Mrs Ernest Thesiger, 1980

Ranken, William Bruce Ellis 1881–1941, *Mr and Mrs John V. Templeton*, gift from Mrs Ernest Thesiger, 1946

Richards, Ceri Geraldus 1903–1971, *Piano*, purchased from Monika Kinley with the assistance of the Victoria & Albert Museum Purchase Grant Fund, 1979, © estate of Ceri Richards/DACS 2007

Riley, John (attributed to) 1646–1691, *Sir Josiah Child, Bt, MP (1630–1699)*, purchased from Historial Portraits with the assistance of the MLA/Victoria & Albert Museum Purchase Grant Fund, 2000

Robbins, W. H. *Sir John Carter*, gift from the trustees of the Beneficial School, 1945

Robins, E. active 1882–1902, *The Green Post and Boundary Stone at North End*, purchased from Radford Antiques, 1962

Robins, E. active 1882–1902, *Shipping in Portsmouth Harbour*, gift from Captain H. T. Barnett, 1945

Robins, E. active 1882–1902, *'SS Ophir' Entering Portsmouth Harbour*, gift from Miss F. MacMillen, 1957

Robins, E. active 1882–1902, *Southsea Castle from the East*, purchased from Olive Brown, 1970

Robins, E. active 1882–1902, *View of the Dockyard and Harbour Looking North*, purchased from Miss F. MacMillen, 1957

Robins, E. active 1882–1902, *King George's Gate (Quay Gate)*, gift from Hilary Thomas, 2004

Robins, E. active 1882–1902, *Portchester Castle*, gift from H. J. Ridout, 1955

Robins, E. active 1882–1902, *The Old George', London Road, Portsdown*, gift from Miss A. E. Hoar, 1976

Robins, E. active 1882–1902, *'The Old George' Inn, Portsdown Hill*, gift from Mrs Brading, 1981

Robins, E. (attributed to) *Pembroke Road Seen through the Defences*, bequeathed by Mr L. W. Prior, 1974

Robins, Henry 1820–1892, *Wreck of 'HMS Eurydice' Towed into Portsmouth Harbour, 1 September 1878*, purchased from Christie, Manson and Woods with the assistance of the Victoria & Albert Museum Purchase Grant Fund, 1974

Sainsbury, Timothy b.1935, *Under the Outlet*, purchased from the artist, 1981, © the artist

Sainsbury, Timothy b.1935, *Sacrificial Head*, bequeathed by Miss Grace Mary Cannon, 1973, © the artist

Saül, Charles b.1943, *Boys Swimming with Shark on Coast of Haiti*, transferred from Bristol Museums Service, 2006

Scott, S. J. *Panorama of Portsmouth*, purchased from Mr S. L. Scott, 1981

Scott, William George 1913–1989, *Girl and Blue Table (recto)*, gift from the Contemporary Art Society, 1968, © 2007 estate of William Scott

Scott, William George 1913–1989, *Breton Village (verso of Girl and Blue Table)*, gift from the Contemporary Art Society, 1968, © 2007 estate of William Scott

Shaw, Geoff 1892–1970, *D-Day, 6 June 1944*, purchased from the Parker Gallery, 1984

Shayer, William 1788–1879, *Fisher Folk at Brading, Isle of Wight*, purchased from Neville Payne Antiques, 1969

Sheaf, Henry S. *A Walking Race*, purchased from Mr Percy Beer, 1968

Sheaf, Henry S. *John Pounds Teaching Children in his Workshop*, purchased from D. Bendall, 1945

Sheaf, Henry S. *John Pounds Teaching Poor Children*, gift from the Lord Mayor's Office via the City Archivist, 2004

Shepherd, Thomas Hosmer 1792–1864, *View of Southsea Common*, purchased from the Rutland Gallery with the assistance of the Victoria & Albert Museum Purchase Grant Fund, 1977

Sickert, Bernard 1863–1932, *A Canal Scene*, found in store, 1979

Sickert, Johann Jurgen 1803–1864, *Hay Stooks in a Meadow*, gift from the Walter Sickert Trust, 1947

Sickert, Walter Richard 1860–1942, *The Belgian Cocottes (Jeanne et Hélène Dumont)*, purchased from Miss Blyth with the assistance of the Victoria & Albert Museum Purchase Grant Fund and the National Art Collections Fund, 1973, © estate of Walter R. Sickert/DACS 2007

Sinclair, G. *Woodland Path*, bequeathed by Patrick Ernest William Harris, 1997

Sinclair, G. *Woodland Stream*, bequeathed by Patrick Ernest William Harris, 1997

Smith, Norman *D-Day, Normandy, Lion-sur-Mer*, gift from Mr D. Dwyer

Smith, Smith 1714–1776, *Wooded Landscape*, purchased from D. M. Nesbit and Co., 1971

Smyth, William Henry (Admiral) 1788–1865, *On the Point, Portsmouth*, purchased from Mr M. Bernard, 1965

Snape, Martin 1853–1930, *Portchester Castle*, gift from Hilary Thomas, 2004

Somerville, Howard 1873–1952, *The Chinese Fan*, transferred from the Guildhall Sub-Committee, 1959

Sorrell, Alan 1904–1974, *Southsea Castle, 1578*, purchased from the artist, 1971, © the artist's estate

Sparrow, W. G. (Lieutenant Colonel) *Portchester Castle*, gift from Mrs Davies, 1958

Stanfield, George Clarkson 1828–1878, *Coastal Scene*, transferred from Bognor Regis Museum, 1973

Steele, Jeffrey b.1931, *SG1 27*, purchased from the artist with the assistance of the Victoria & Albert Museum Purchase Grant Fund, 1974

Stephenson, H. W. *'HMS Trincomalee', 1817*, gift from the United Services Officer's Club, 1975

Stones, Alan b.1947, *Portsmouth*, transferred from Portsmouth Library Service, 2005

Terry, George Richard *Relief of a Schooner against a Background of the Sea*, gift from Richard W. Savage, 1992

Thomson, Henry 1773–1843, *Girl at a Spring (Nature's Fountain)*, gift from Mr A. L. Nicholson via the National Art Collections Fund, 1948

Thorn, John active 1838–1864, *On the Mole*, bequeathed by Patrick Ernest William Harris, 1997

Thorn, John active 1838–1864, *The Cornfield*, bequeathed by Patrick Ernest William Harris, 1997

Thornhill, James (circle of) 1675–1734, *The Gods on Mount Olympus*, gift from the National Art Collections Fund, 1975

Tindle, David b.1932, *Still Life with Gramophone*, purchased from the Piccadilly Gallery, 1970, © the artist

Todd, D. C. *The Construction of the New Civic Offices and Central Library, Portsmouth*, purchased from D. M. Nesbit and Co., 1998

Tollemache, Duff 1859–1936, *Portsmouth Harbour from Gosport*, purchased from Reverend A. Grey,1959

Turner, William 1789–1862, *Portsmouth from Gosport*, purchased from Christie's with the assistance of the Victoria & Albert Museum Purchase Grant Fund and the National Art Collections Fund, 1978

Tutill, George *'Defence Not Defiance'*, gift from Mr A. Page, 1874

Tutill, George *'United We Stand, Divided We Fall'*, gift from Mr A. Page, 1874

Tuttle, Tony active c.1971–1973, *Circles*, purchased from the artist, 1973

Ubsdell, Richard Henry Clements (attributed to) 1813–1887, *The Town Hall, High Street, with Aldermen and Councillors of the Corporation in Procession*, gift from Mrs C. M. Leon, 1946

unknown artist *Lieutenant General Campbell, Military Governor of Portsmouth (1731–1737)*, purchased from R. W. Christopher, 1962

unknown artist *John Hewett of Crofton*, gift from Miss Rosemary Hewett, 1957

unknown artist *John Hewett II of Purbooke*, gift from Miss Rosemary Hewett, 1957

unknown artist early-mid 18th C, *The Saluting Platform, Portsmouth in the Reign of Queen Anne*, purchased from the Parker Gallery with the assistance of the Victoria & Albert Museum Purchase Grant Fund, 1974

unknown artist 18th C, *Inn and Windmill*, purchased, 1979

unknown artist mid-late 18th C, *Susanna Carter, Wife of Sir John Carter*, gift from Mrs A. L. Bonham Carter, 1958

unknown artist *Portrait of a Lady*, bequeathed by Patrick Ernest William Harris, 1997

unknown artist *Portrait of an Unknown Gentleman*, bequeathed by Patrick Ernest William Harris, 1997

unknown artist *The 'USS Constitution' Entering Portsmouth Harbour*, purchased, 2003

unknown artist *View of Portsmouth Harbour Looking North from Fort Blockhouse*, purchased from the Parker Gallery with the assistance of the Victoria & Albert Museum Purchase Grant Fund, 1994

unknown artist *T. Porter Esq.*, gift from the trustees of the Beneficial School, 1945

unknown artist *Frigate Entering Portsmouth Harbour*, gift from Reverend R. J. S. Chamberlain, 1969

unknown artist *William Green of Hollam*, gift from Miss Rosemary Hewett, 1957

unknown artist *Elizabeth Green, née Hewett*, gift from Miss Rosemary Hewett, 1957

unknown artist *Old Goldsmith Quay, Milton Locks*, gift from Mrs N. Warburton, 1954

unknown artist *Moonlit Coast and Wreckers*, bequeathed by Patrick Ernest William Harris, 1997

unknown artist early-mid 19th C, *A Royal Naval Vessel Leaving Portsmouth Harbour*, purchased from Philips, 1981

unknown artist early-mid 19th C, *E. Marvin*, gift from the trustees of the Beneficial School, 1945

unknown artist 19th C, *Coastal Scene*, found in store, 1945

unknown artist 19th C, *Masonic Banner Centre*, found in store, 2005

unknown artist 19th C, *Masonic Banner Centre*, found in store, 2005

unknown artist mid-late 19th C, *River Estuary and a Castle*, purchased from Derek Davis, 1970

unknown artist late 19th C, *Lily Langtry (possibly Dame Clara Butt)*, bequeathed by Patrick Ernest William Harris, 1997

unknown artist *Independent Order of Oddfellows Banner: 'Independent Order of Oddfellows M. U.'*, gift from Mr S. C. Lethbridge, 1977

unknown artist *Independent Order of Oddfellows Banner: 'Portsmouth District, Established 1861'*, gift from Mr S. C. Lethbridge, 1977

unknown artist *London Road Baptist Band of Hope, Portsmouth Banner: 'God Save the Children'*, gift from the London Road Baptist Church, 2002

unknown artist *Queen's Road, Portsea at the Junction with St James' Street*, purchased from F. Lloyd, 1960

unknown artist *Charles Augustus Milverton, 'The Worst Man in London' and 'The King of all the Blackmailers'*, bequeathed by Richard Lancelyn Green, 2004

unknown artist *A British Army Officer, Possibly a Governor of Portsmouth*, found in store, 1964

unknown artist *A Mayor of Portsmouth, possibly J. E. Pink*, purchased from Mr G. Taylor, 1968

unknown artist *A Member of the Beneficial Society*, transferred from the Local History Department, 1979

unknown artist *A Seventeenth Century Soldier, from Buckingham House, Portsmouth*, gift from Mr R. Thomas, 1999

unknown artist *A Seventeenth Century Soldier, from Buckingham House, Portsmouth*, gift from Mr R. Thomas, 1999

unknown artist *Alderman G. E. Kent, Mayor of Portsmouth (1870–1900)*, gift from Blake, Lapthorn, Roberts and Rea, 1959

unknown artist *Alderman Richard John Murrell*, gift from Walter Edward Gattens, 1959

unknown artist *Alderman Ridoutt*, gift from Mr G. White, 1964

unknown artist *Battle of Southsea*, gift from Mr M. H. R. Jones, 1978

unknown artist *Edward VI (1537–1553)*, purchased from D. M. Nesbit and Co.,1970

unknown artist *Entrance to the Camber*, found in store, 1945

unknown artist *Fareham Creek, Hampshire*, purchased from D. M. Nesbit and Co., 1975

unknown artist *First Portsmouth Theatre*, gift from Mrs W. H. Aylen, 1958

unknown artist *Great Salterns Farm, 1851*, purchased from Bell Fine Art, 1999

unknown artist *'HMS Victory' at Moorings in Portsmouth Harbour*, gift from Mrs G. Dowling, 1971

unknown artist *John Carter*, gift from Mrs A. L. Bonham Carter, 1958

unknown artist *John Pounds*, gift from Mrs Mansbridge, 1955

unknown artist *John Spice Hulbert*, transferred from the Royal Naval Museum, 1981

unknown artist *Mary A. Spice Hulbert*, transferred from the Royal Naval Museum, 1981

unknown artist *Launch of the Steam Frigate 'HMS Dauntless'*, found in store, 1964

unknown artist *Mill by the Water's Edge*, found in store, 1964

unknown artist *Milton Park, 1855*, gift from J. Stares, 1953

unknown artist *Mythological Subject*, bequeathed by Patrick Ernest William Harris, 1997

unknown artist *Pembroke Road Seen through the Defences*, gift from Mrs Clark, 1980

unknown artist *Portsmouth Harbour, 1850–1900*

unknown artist *R. W. Ford, Solicitor and Clerk of the Peace, Portsmouth*, found in store, 1945

unknown artist *Robert Lawson*, gift from Miss Baldock, 1949

unknown artist *Round Tower*, gift from Dr N. B. Eales, 1987

unknown artist *Square Tower*, gift from Dr N. B. Eales, 1987

unknown artist *Sir Arthur Conan Doyle (1859–1930)*, bequeathed by Richard Lancelyn Green, 2004

unknown artist *Sir Stephen Gaselee (1882–1943)*, gift from the trustees of the Beneficial School, 1945

unknown artist *St Mary's Church, Kingston*, found in store, 1964

unknown artist *St Mary's Church, Kingston, 1843*, gift from Mrs D. H. Davies, 1974

unknown artist *St Mary's Church, Kingston between 1844 and 1887*, gift from Mrs D. H. Davies, 1974

unknown artist *The First Semaphore on Southsea Beach, 1795*, gift from Mrs C. M. Leon, 1946

unknown artist *The 'Nut' Bar at the Keppel's Head Hotel, Portsmouth, c.1955*, gift from Miss M. N. McCaw, 2001

unknown artist *The Old Curiosity Shop*, gift from Major Henry Lyon, VO

unknown artist *The Opening of Fareham Railway Viaduct*, purchased from D. M. Nesbit and Co., 1975

unknown artist *Theodore Jacobson (d.1772), Architect*, purchased from the Godolphin Gallery, 1973

unknown artist *View of the Waterfront on the Point from the Round Tower to the Still and West Public House*, purchased from R. W. Christopher, 1962

unknown artist *William Panlet, Former Govenor of Portsmouth*, purchased from N. C. E. Ashton, 1958

unknown artist *William Treadgold*, on loan

Van de Myer, F. (attributed to) *Sir Philip Honeywood, Military Governor of Portsmouth (1740–1752)*, purchased from M. Knoedler and Co. Ltd, 1969

Verdi, Francesco Ubertini (attributed to) 1494–1557, *Donor Figure*, gift from the National Art Collections Fund, 1975

Verdi, Francesco Ubertini (attributed to) 1494–1557, *Donor Figure*, gift from the National Art Collections Fund, 1975

Vernet, Claude-Joseph (attributed to) 1714–1789, *View of a Harbour, possibly Portsmouth*, purchased from C. G. Saunders, 1961

Verspronck, Johannes Cornelisz. (attributed to) c.1606–1662, *Portrait of a Lady*, found in store, 1945

Wadsworth, Edward Alexander 1889–1949, *La Rochelle*, purchased from the Mayor Gallery with the assistance of the Victoria & Albert Museum Purchase Grant Fund, 1978, © estate of Edward Wadsworth/DACS 2007

Wallis, Alfred 1855–1942, *Boat with Figures*, transferred from the Schools' Loans Service, 1973, DACS

Warburton, N. *Old Canal and Watch House in Trees*, gift from Mrs N. Warburton, 1954

Weight, Carel Victor Morlais 1908–1997, *Two Lovers Interrupted by a Sprite*, purchased from the Fieldborne Galleries with the assistance of the Victoria & Albert Museum Purchase Grant Fund, 1974, © the estate of the artist

Weight, Carel Victor Morlais 1908–1997, *Timber Yard*, transferred from the Schools' Loans Service, 1973, © the estate of the artist

Werge-Hartley, Alan b.1931, *The 'Princess Elizabeth'*, purchased from the Hiscock Gallery, 1971

Williams, J. *Gad's Hill Place, near Rochester*, found in store, 1968

Wragg, Gary b.1946, *Hetty's Painting*, gift from the Contemporary Art Society, 1986, © the artist

Wright, Peter b.1932, *Flower in a Landscape*, transferred from the Schools' Loans Service, 1973, © the artist

Wright, Peter b.1932, *Dorset Landscape*, purchased from the Hiscock Gallery, 1974, © the artist

Wyllie, Charles William 1859–1923, *Bay of Ambleteuse*, purchased from Miss F. Pryor, 1956

Wyllie, William Lionel 1851–1931, *A Coastal Scene at Sunset*, found in store

Wyllie, William Lionel 1851–1931, *Old Hulks, Portsmouth*, purchased from Reverend J. F. Gerrard, 1964

Wyllie, William Lionel 1851–1931, *A Castle by a Lake*, found in store

Wyllie, William Lionel 1851–1931, *A Ship and Seabirds near the Coast*, found in store

Wyllie, William Lionel 1851–1931, *Countryside*, found in store

Wynter, Bryan 1915–1975, *Rilla*, transferred from the Schools' Loans Service, 1973, © estate of Bryan Wynter/DACS 2007

Zehrer, Rita b.1949, *Abstract**, on loan from the Council, © the artist

Zehrer, Rita b.1949, *Abstract**, on loan from the Council, © the artist

Zehrer, Rita b.1949, *Abstract**, on loan from the Council, © the artist

Portsmouth Royal Dockyard Historic Trust

Dickson, Jack *Mr E. A. Rogers, Head of Painters' Shop (1964–1970)*

Dickson, Jack *Mr E. G. Bunce, Head of Painters' Shop (1979–1981)*

Dickson, Jack *Mr E. R. Goble, Head of Painters' Shop (1974–1976)*

Dickson, Jack *Mr F. G. Dominy, Head of Painters' Shop (1959–1964)*

Dickson, Jack *Mr H. C. Skeens, Head of Painters' Shop (1927–1936)*

Dickson, Jack *Mr J. E. Quarrington, Head of Painters' Shop (1981)*

Dickson, Jack *Mr P. V. Jarvis, Head of Painters' Shop (1943–1949)*

Dickson, Jack *Mr R. D. Rickard, Head of Painters' Shop (1987)*

Dickson, Jack *Mr R. W. McLeod, Head of Painters' Shop (1976–1981)*

Dickson, Jack *Mr T. E. Skinner, Head of Painters' Shop (1965–1966)*

Dickson, Jack *Mr W. G. Gidley, Head of Painters' Shop (1966–1972)*

Dickson, Jack (attributed to) *Mr E. Hollingsworth, Head of Painters' Shop (1972–1974)*

Hall, Tom *General Dwight D. Eisenhower (1890–1969)*

Hall, Tom *The Laughing Cavalier (copy after Frans Hals)*

Jarvis, P. V. active 1930–1948, *Mr H. Skeens, Head of Painters' Shop (1859–1866)*

Jarvis, P. V. active 1930–1948, *Mr E. J. Lineham, Head of Painters' Shop (1898–1902)*

Jarvis, P. V. active 1930–1948, *Mr E. Kidd, Head of Painters' Shop (1902–1910)*

Jarvis, P. V. active 1930–1948, *Mr C. B. Mockford, Head of Painters' Shop (1910–1927)*

Jarvis, P. V. active 1930–1948, *Mr G. Hoile, Head of Painters' Shop (1866–1881)*

Jarvis, P. V. active 1930–1948, *Mr H. C. Skeens, Head of Painters' Shop (1894–1898)*

Jarvis, P. V. active 1930–1948, *Mr Martin, Head of Painters' Shop (1948–1959)*

Jarvis, P. V. (attributed to) *Sir Winston Churchill (1874–1965)*

Johns, M. *Mr G. W. A. Waters, Head of Painters' Shop (1949–1953)*

unknown artist *Three Soldiers**

Royal Marines Museum

Alleyne, Francis 1750–1815, *Portrait of a Lady*, purchased, 1998

Alleyne, Francis 1750–1815, *Portrait of an Officer of the Battalion Company of Marines*, purchased, 1998

Bambridge, Arthur L. active c.1890–1895, *His Royal Highness Alfred Ernest Albert, Duke of Saxe Coburg and Gotha, Duke of Edinburgh (1874–1899), KG, GCB, Admiral of the Fleet (1893), Honorary Colonel of the Royal Marines (1883)*, gift from the Corps, 1974, photo credit: Trustees of the Royal Marines Museum

Beer, Percy active 1961–1962, *Lieutenant George Dare Dowell, VC (1831–1910), Royal Marine Artillery*, commissioned, photo credit: Trustees of the Royal Marines Museum

Beer, Percy active 1961–1962, *Major General Sir Archibald Paris, KCB (d.1937)*, gift from the Corps, 1974, photo credit: Trustees of the Royal Marines Museum

Beer, Percy active 1961–1962, *Major Francis John William Harvey, VC (1873–1916), Royal Marine Light Infantry*, commissioned, photo credit: Trustees of the Royal Marines Museum

Beer, Percy (attributed to) active 1961–1962, *Gunner Thomas Wilkinson, VC, Royal Marine Artillery*, commissioned, photo credit: Trustees of the Royal Marines Museum

Beer, Percy (attributed to) active 1961–1962, *Corporal Thomas Peck Hunter, VC (1923–1945), Royal Marines*, commissioned, photo credit: Trustees of the Royal Marines Museum

Beetham, Joe active 1982–c.1983, *'HMS Antelope' Explodes off Port San Carlos, 23 May 1982*, gift from the artist, 1982

Beetham, Joe active 1982–c.1983, *'Queen Elizabeth II' Returns to Southampton with Troops from the Falklands*, gift from the artist, 1982

Beetham, Joe active 1982–c.1983, *'SS Canberra' Returns to Southampton, 11 July 1982*, gift from the artist, 1982

Beetham, Joe active 1982–c.1983, *45th Commanndo Entering Stanley, with Two Sisters and Mount Kent in the Background, 15 June 1982*, gift from the artist, 1982

Beetham, Joe active 1982–c.1983, *'HMS Invincible' Arrives Home, Portsmouth, 17 September 1982*, gift from the artist, 1982

Beetham, Joe active 1982–c.1983, *'HMS Endurance', 'Plymouth' and 'Antrim' at Grytviken, South Georgia*, gift from the artist, 1982

Brown, R. H. *Corporal William Brown (1820–1899), Royal Marines (1837–1855), Royal Marine Light Infantry (1855–1859)*, gift, 1982

Cairns, John *On Parade, Singapore*, gift from the Corps, 2004

Chenoweth, Avery *Lieutenant Colonel Douglas B. Drysdale, Royal Marines, Commanding 41st Independent Commando RM in Action, Korea, 1950*, gift from the Corps, 2002

Cole, Leslie 1910–1976, *Royal Marine Commando and Paratrooper Stretcher-Bearers in Normandy, 1944*, gift from the Corps, 2002, photo credit: Trustees of the Royal Marines Museum

Collinson, Basil *'HMS Repulse', Sunk 10 December 1941*, gift, 1995

Cunliffe, David active 1826–1855, *General Sir Charles Menzies, KCB, KH, KTS (1783–1866)*, gift, photo credit: Trustees of the Royal Marines Museum

Daubrawa, Henry de active 1825–1861, *The Royal Marines*, purchased, 1971

of the Royal Marines Museum

Donald-Smith, Helen active 1880–1930, *Brigadier General F. W. Lumsden, VC, CB, DSO, RMA*, gift from the Corps, 1974, photo credit: Trustees of the Royal Marines Museum

Donald-Smith, Helen active 1880–1930, *Major General Sir Archibald Paris, KCB (d.1937)*, gift from the Corps, 1974, photo credit: Trustees of the Royal Marines Museum

Dujon, J. F. Harrison *General Sir William Thompson Adair, KCB, Deputy Adjutant General (1907–1911)*, gift, 1979, photo credit: Trustees of the Royal Marines Museum

Duke, Dave *Royal Marines on Parade, Malta*, gift from the Corps, 2004

Eastman, Mary active c.1932–1979, *Major General A. M. Craig, CB, OBE (1944), Colonel Commandant, Chatham (1942–1944)*, gift from the Imperial War Museum

Evans, Lucy active 2000–2001, *Team Polar, 2000*, commissioned, 2000

Evans, Lucy active 2000–2001, *Team Polar, 2000*, commissioned, 2000

Fuchs, Emil 1866–1929, *Edward VII (1841–1910)*, gift from the Corps, 1974

Gardner, Maurice *Landing Craft Gun 14*, gift from the artist

Gilroy, John M. 1898–1985, *The Earl Mountbatten of Burma (1900–1979), KG, DSO, Life Colonel Commandant Royal Marines (1965–1979)*, gift from the artist, 1978

Glazebrook, Hugh de Twenebrokes 1855–1937, *His Royal Highness George Frederick Ernest Albert Prince of Wales (1865–1936), KG, Colonel-in-Chief of the Royal Marines*, gift from the Corps, 1974, photo credit: Trustees of the Royal Marines Museum

Goldsmith, W. J. (Major RM) active 1968–1978, *Captain Lewis Stratford Tollemache Halliday, VC (1870–1966), Royal Marine Light Infantry*, commissioned

Goldsmith, W. J. (Major RM) active 1968–1978, *Lieutenant H. M. A. Day, Royal Marines Light Infantry, 1918*, commissioned

Goodall, John Edward active 1877–1911, *The Battle of the Nile*, gift from the Corps, 1974

Goodall, John Edward active 1877–1911, *The Bombardment of Algiers, 1816 (after George Chambers)*, gift from the Corps, 1974

Graves *Major General Thomas Benjamin Adair (served 1794–1843) (after John Jackson)*, gift, 1979

Halford, J. *Royal Marines Firing a .303 Vickers Machine-Gun on Loan to 'NP8901' from Falkland Islands Defence Force, Back of Wireless Ridge, Moody Brook*, gift from the artist, 2004

Herkomer, Herman 1863–1935,

Queen Victoria (1819–1901) (after Heinrich von Angeli), gift from the Corps, 1974

Hill, William *Racing the Storm*, gift from the Corps, 2002

Kelly, Robert George 1822–1910, *The Boats 'HM Frigates Carysfort' and 'Zebra' with 50 Royal Marines, Commanded by Lieutenant R. H. Harrison, Royal Marines, Attacking the Castle of Tortosa, 25 September 1840*, purchased

Lawrence, Thomas 1769–1830 (attributed to) & Morton, Andrew 1802–1845 (attributed to) *William IV (1765–1837)*, gift from the Corps, 1974, photo credit: Trustees of the Royal Marines Museum

Lockwood, R. *D-Day Landing Craft*, gift from the Corps, 2004

Marchetti, George active 1880s–1912, *Colonel Thomas Field Dunscomb Bridge, ADC to Her Majesty Queen Victoria and His Majesty King Edward VII, Commandant Depot Royal Marines*, on permanent loan from a private lender, photo credit: Trustees of the Royal Marines Museum

Marchington, Philip *Commando Pick-up*, commissioned, 1982

Masi, Phillip *Royal Marines, a Soldier in the Falklands*, gift from the Corps, 2004

Mason, W. C. *Captain H. O. Huntington-Whiteley, Royal Marines*, gift from the artist, 1983

Miller *'HMS Marlborough' at Jutland*, gift, 1976

Northcote, James 1746–1831, *Lieutenant George Dyer*, purchased, 2003, photo credit: Trustees of the Royal Marines Museum

Northcote, James 1746–1831, *George III (1738–1820)*, gift from the Corps, 1974, photo credit: Trustees of the Royal Marines Museum

Oram, L. (Mrs) *United Nations Observation Post in Southern Cyprus, Manned by Royal Marines of 41 Commando Group*, gift, 1999

Payne, James *Boxer Rebellion to Korea, Comradeship between Royal Marines and the USMC*, gift from the Corps, 2004

Percy, Herbert Sidney active 1880–1903, *Captain James Wood*, gift, 2006

Polivanov, M. *Major Wykeham-Fienes*, gift, 1973

Romney, George (school of) 1734–1802, *Unknown Royal Marines Officer*, purchased, 1974

Rowden, W. J. *Captain Edward Bamford, VC, DSO (1887–1938), Royal Marine Light Infantry*, commissioned, photo credit: Trustees of the Royal Marines Museum

Shaw, Geoff 1892–1970, *Ships at Night*, gift, 1996

Smith, W. E. B. active 1993–1999, *Landing Craft Flak 15*, gift from the artist

Smith, W. E. B. active 1993–1999, *Mk4 Landing Craft Flak*, gift from the artist

343

Smith, W. E. B. active 1993–1999, *HM Royal Yacht 'Britannia'*, gift from the artist, 1999

Stewart, Malcolm 1826–1916, *Queen Victoria (1819–1901) (after Heinrich von Angeli)*, gift from the Corps, 1974

Tait, Robert Scott c.1816–1897, *Captain Charles Gray, RM, Author of 'Lays and Lyrics', Published in Scotland, 1841*, purchased, 1981

Thrayes, J. *Unknown Royal Marines Officer*, believed to be a gift from the Corps, possibly 1974, photo credit: Trustees of the Royal Marines Museum

Thurgood, T. G. *HM Cruiser 'Vindictive', Assaulted the 'Mole' at Zeebrugge against the Germans, April 1918*, purchased, 1999

unknown artist *Captain Charles Repington*, purchased, 1980

unknown artist *Lieutenant Colonel Benjamin Adair (1755–1794)*, gift, 1979, photo credit: Trustees of the Royal Marines Museum

unknown artist *Lieutenant Edward Toomer, RM (1797–1816)*, purchased, 1984

unknown artist *Captain Charles William Adair, Killed, 'HMS Victory', Trafalgar, 1805*, gift, 1979

unknown artist *Possibly Captain Thomas Young, Royal Marines*, gift from the Royal Naval College, Greenwich, 1968

unknown artist *Major Henry Rea*, gift from the Corps, 1959, photo credit: Trustees of the Royal Marines Museum

unknown artist *Possibly Lieutenant John Tatton Brown, Royal Marines*, bequeathed

unknown artist *Lieutenant Colonel Anthony Stransham (1781–1826)*, gift from the Corps, 1965

unknown artist *Unknown Royal Marines Officer*, believed to be a gift from the Corps, possibly 1974

unknown artist *Lieutenant General Thomas Wearing, RM*, believed to be a gift from the Corps, possibly 1974

unknown artist *Sergeant Major George Dibben, RM*, purchased, 1978

unknown artist *Colour Sergeant F. J. Mills, Royal Marines*, purchased, 1999

unknown artist *General Sir A. B. Stransham, GCB (1823–1876)*, gift from the Corps, 1959, photo credit: Trustees of the Royal Marines Museum

unknown artist *Portrait of a Gunner, Royal Marine Artillery (possibly Gunner Pearce)*, gift, 1979

unknown artist *Major General A. R. Chater, CB, CVO, DSO, OBE (1896–1979)*, gift, 1985

unknown artist *Lance Corporal Walter Richard Parker, VC (1881–1931), Royal Marine Light Infantry*, commissioned, photo credit: Trustees of the Royal Marines Museum

unknown artist *Major Frederick William Lumsden, VC, DSO (1872–1918), Royal Marine Artillery*, commissioned

unknown artist *Sergeant Norman Augustus Finch, VC (1890–1966), Royal Marine Artillery*, commissioned, photo credit: Trustees of the Royal Marines Museum

unknown artist *Belle Isle, 1761*, gift from the Corps, 2004

unknown artist *Corporal John Prettyjohns, VC (1823–1887), Royal Marine Light Infantry*, commissioned, photo credit: Trustees of the Royal Marines Museum

unknown artist *General Sir Charles William Adair, KCB, Deputy Adjutant General (1878–1883)*, gift, 1979

unknown artist *Nell, Adopted by the Royal Marine Artillery in the Early 1880s*, gift from the Corps, 1957

Watson *Lieutenant Colonel David Hepburn (fought at Belle Isle, 1761)*, gift from the Corps, 1976

Williamson, Daniel 1783–1843, *Hannah Snell (1723–1792) (detail)*, on permanent loan from the National Trust, photo credit: Trustees of the Royal Marines Museum

Young, Mary *The Lying-in-State of Sir Winston Churchill (1874–1965), Westminster Hall*, gift from the Corps, 1968, photo credit: Trustees of the Royal Marines Museum

Royal Naval Museum

Abbott, Lemuel Francis 1735–1823, *Lord Nelson (1758–1805)*, on loan from a private individual

Abbott, Lemuel Francis (after) 1735–1823, *Admiral Earl St Vincent*, purchased, 1979

Abbott, Lemuel Francis (after) 1735–1823, *Lord Nelson (1758–1805)*, gift, 1973

Adams, Bernard 1884–1965, *Vice Admiral Sir Geoffrey Barnard (1902–1974)*, gift, 1982

Alcorn-Hender, Michael b.1945, *Attack on 'HMS Foylebank'*, commissioned by Fred Walden, gift, 1984, © the artist

Alcorn-Hender, Michael b.1945, *Leading Seaman Jack Mantle (c.1917–1940)*, commissioned by Fred Walden, gift, 1984, © the artist

Avery *'HMS Victory' in Portsmouth Harbour, c.1900*, gift, 1982

Baden-Powell, Frank Smyth 1850–1933, *Ships in Portsmouth Harbour*

Bailey, Henry (attributed to) *HMS Hecla' Searching out the North-West Passage*

Beechey, William 1753–1839, *Admiral Sir Harry Burrard-Neale, 2nd Bt (1765–1840)*, purchased, 1981

Bishop, William Henry b.1942, *Prelude to D-Day*, purchased, 1994

Bishop, William Henry b.1942, *Windy Corner, Jutland, 1916*,

purchased, 1986

Bone, Stephen 1904–1958, *'HMS Victory' in Dry Dock*, © the artist's estate

Boyle, Edward *'HMS Charity', Incident off Inchon, September 1950*

Braydon, A. F. S. *'HMS Victory' off the South Foreland en route to Portsmouth*, gift, 1968

Brown, Mather 1761–1831, *Rear Admiral Sir Home Popham (1762–1820)*, gift, 1999

Browne, J. R. *HMS Edgar' Leaving Portsmouth under Sail*, gift, 1975

Brunoe, Søren 1916–1994, *'HMS Diana'*, gift, 1986, © DACS 2007

Bullamore, George *848 SQRN 'HMS Formidable'*

Burgess, Arthur James Wetherall 1879–1957, *A Dogfight*, gift, 1980, © the artist's estate

Cadogan, G. *Lord Nelson (1758–1805) (after Arthur William Devis)*

Carmichael, James Wilson 1800–1868, *'HMS Victory' Anchored off the Isle of Wight*, gift, 1973

Carter, P. T. *'HMS Birmingham' in the Second World War*, gift, 1980

Casey, Ron *'Bismarck' in the Denmark Strait*, gift, 1982

Casey, Ron *Last Hours of the 'Hood'*, gift, 1982

Chowdhury, I. A. *'Appreciating the situation'*, gift, 1985

Clout, Harry *Channel Attack, August 1940*, gift, 1978

Clout, Harry *Naval Warfare**, gift, 1978

Cobb, Charles David b.1921, *Biscay Anti U-Boat Patrol*, purchased, 1978, © the artist

Cobb, Charles David b.1921, *Gulf War, H Hour; Twelve Royal Navy Minesweepers Complete Their Task*, purchased, 1995, © the artist

Cobb, Charles David b.1921, *A Sea Harrier*, on loan from a private individual, © the artist

Cobb, Charles David b.1921, *Admiral Ramsay Reviewing the Fleet before D-Day*, acquired, 1977, © the artist

Cobb, Charles David b.1921, *Air Attack by Luftwaffe on Channel Convoy*, purchased, 1978, © the artist

Cobb, Charles David b.1921, *Allied Landings in North Africa, November 1942*, purchased, 1980, © the artist

Cobb, Charles David b.1921, *Artillery at Mount Kent*, on loan from a private individual, © the artist

Cobb, Charles David b.1921, *Battle of the Java Sea, 27 February 1942*, purchased, 1982, © the artist

Cobb, Charles David b.1921, *'Blazer' Refuelling at Sea from Fort Grange*, purchased, 1994, © the artist

Cobb, Charles David b.1921, *Bomb Attack Sinks 'Cornwall' and 'Dorsetshire'*, purchased, 1982, © the artist

Cobb, Charles David b.1921, *Bombardment of Port Stanley Airstrip, 1 May 1982*, purchased, 1984, © the artist

Cobb, Charles David b.1921, *Capture Intact of U-Boat '570'*, purchased, 1978, © the artist

Cobb, Charles David b.1921, *Carrier Aircraft Attack, Sabang, 19 April 1944*, purchased, 1982, © the artist

Cobb, Charles David b.1921, *Defence of a Russian Convoy*, acquired, 1978, © the artist

Cobb, Charles David b.1921, *Dunkirk Operation 'Dynamo', 26 May–4 June 1940*, purchased, 1982, © the artist

Cobb, Charles David b.1921, *Escort Carrier 'HMS Nairana' Stalked Unsuccessfully by U-Boat 502, 1 February 1944*, purchased, 1982, © the artist

Cobb, Charles David b.1921, *Fast Carrier Task Group Operating off the Japanese Mainland, July 1945*, purchased, 1982, © the artist

Cobb, Charles David b.1921, *Fleet Air Arm Corsair Landing on*, purchased, 1982, © the artist

Cobb, Charles David b.1921, *Formation of the British Pacific Fleet, 1944*, purchased, 1982, © the artist

Cobb, Charles David b.1921, *Gibraltar-Based Force H*, purchased, 1980, © the artist

Cobb, Charles David b.1921, *Harpoon Convoy*, purchased, 1980, © the artist

Cobb, Charles David b.1921, *'HMS Dianthus' and Convoy in Winter Atlantic Gale*, purchased, 1978, © the artist

Cobb, Charles David b.1921, *'HMS Gloucester' on the Armilla Patrol Escorting a Convoy of Container Ships through the Strait of Hormuz*, gift, 1991, © the artist

Cobb, Charles David b.1921, *'HMS Gloucester', 'USS Missouri', 'HMS Ledbury', 'HMS Dulverton', 'HMS Cattistock' and 'HMS Atherton'*, acquired, 1995, © the artist

Cobb, Charles David b.1921, *'HMS Submarine Trenchant' Sinks the Cruiser 'Ashigara', 8 June 1945*, purchased, 1982, © the artist

Cobb, Charles David b.1921, *'HMS Upholder' Attacking Italian Troopships*, purchased, 1980, © the artist

Cobb, Charles David b.1921, *'HMS Warspite' with Destroyers at the Second Battle of Narvik, 13 April 1940*, purchased, 1978, © the artist

Cobb, Charles David b.1921, *'HMT Ayrshire' and Ships from 'PQ17' in the Ice Pack, 5–7 July 1942*, purchased, 1982, © the artist

Cobb, Charles David b.1921, *Invasion of Sicily*, purchased, 1980, © the artist

Cobb, Charles David b.1921, *Japanese Kamikaze Suicide Attacks on Ships*, purchased, 1982, © the artist

Cobb, Charles David b.1921, *Japanese Surrender, Tokyo Bay*, © the artist

Cobb, Charles David b.1921, *Liverpool, Nerve Centre for the Battle of the Atlantic*, purchased, 1978, © the artist

Cobb, Charles David b.1921, *Malta under Air Attack by Junkers 87 Dive Bombers*, purchased, 1980, © the artist

Cobb, Charles David b.1921, *Motor Torpedo Boats*, gift, 1985, © the artist

Cobb, Charles David b.1921, *Mount Kent*, on loan from a private individual, © the artist

Cobb, Charles David b.1921, *North African Inshore Squadron, 1940–1943*, purchased, 1980, © the artist

Cobb, Charles David b.1921, *Operation 'Excess', 'Illustrious' under Air Attack, 19 January 1941*, purchased, 1980, © the artist

Cobb, Charles David b.1921, *Pedestal Convoy to Malta*, purchased, 1980, © the artist

Cobb, Charles David b.1921, *St Nazaire Raid, 27–28 March 1942*, purchased, 1978, © the artist

Cobb, Charles David b.1921, *Salerno, 'HM Submarine Shakespeare' Acting as a Marker for Invasion Fleet, 9 September 1943*, purchased, 1980, © the artist

Cobb, Charles David b.1921, *Sketch for 'San Carlos Water'*, acquired, 1984, © the artist

Cobb, Charles David b.1921, *Sword Beach, Ouistreham, D-Day, 6 June 1944*, purchased, 1982, © the artist

Cobb, Charles David b.1921, *Taranto Harbour, Swordfish from 'Illustrious' Cripple the Italian Fleet, 11 November 1940*, purchased, 1980, © the artist

Cobb, Charles David b.1921, *The 1943 Climax of the Atlantic Convoy War No.1*, purchased, 1978, © the artist

Cobb, Charles David b.1921, *The 1943 Climax of the Atlantic Convoy War No.2*, purchased, 1978, © the artist

Cobb, Charles David b.1921, *The Battle of Cape Matapan, 29 March 1941*, purchased, 1980, © the artist

Cobb, Charles David b.1921, *The Capture of Madagascar*, purchased, 1982, © the artist

Cobb, Charles David b.1921, *The 'Channel Dash', 12–13 February 1942*, purchased, 1978, © the artist

Cobb, Charles David b.1921, *The Destroyer 'HMS Glowworm' Rams the German Cruiser 'Admiral Hipper', 8 April 1940*, purchased, 1982, © the artist

Cobb, Charles David b.1921, *The Dieppe Raid*, purchased, 1978, © the artist

Cobb, Charles David b.1921, *The Evacuation of Crete*, purchased, 1980, © the artist

Cobb, Charles David b.1921, *The Last Moments of the 'Hood'*, purchased, 1978, © the artist

Cobb, Charles David b.1921, *The Loss of 'HMS Eagle'*, purchased,

1980, © the artist

Cobb, Charles David b.1921, *The Sinking of the 'Scharnhorst', 26 December 1943*, acquired, 1978, © the artist

Cobb, Charles David b.1921, *The Surrender of Italy*, purchased, 1980, © the artist

Cobb, Charles David b.1921, *The Tanker 'Ohio'*, purchased, 1980, © the artist

Cobb, Charles David b.1921, *Torpedo Planes Sink 'Repulse' and 'Prince of Wales', 10 December 1941*, purchased, © the artist

Cobb, Charles David b.1921, *Yomping*, on loan from a private individual, © the artist

Coole, Brian b.1939, *'HMS Hermes' Homecoming*, purchased through Grant in Aid, 2002

Coole, Brian b.1939, *'HMS Warrior' in Portsmouth Harbour*, purchased through Grant in Aid, 2001

Coole, Brian b.1939, *San Carlos Water*, gift through Grant in Aid, 2002

Coole, Brian b.1939, *'SS Uganda', Hospital Ship*, gift through Grant in Aid, 2002

Coupe, Marshall *'HMS Royal Sovereign'*, gift, 1976

Dawson, Montague J. 1895–1973, *'HMS Skate'*, gift, 1987, © the artist's estate

Deakins, Cyril Edward 1916–2002, *'HMS Albrighton'*, gift, 1982, © the artist's estate

D'Esposito *Ship Portrait*

Devis, Arthur William 1762–1822, *Lord Nelson (1758–1805) (after Arthur Devis)*, gift, 1988

Devis, Arthur William 1762–1822, *Sketch of Lord Nelson (1758–1805)*, gift, 2000

Devis, Arthur William 1762–1822, *Vice Admiral Page*, acquired, 2000

Dominy, John *'HMS Argonaut'*, gift, 1983

Dominy, John *'HMS Endurance' and 'HMS Plymouth'*, gift, 1983

Dominy, John *'HMS Glamorgan'*, gift, 1983

Dominy, John *'HMS Glasgow' and Atlantic Conveyor*, gift, 1983

Dominy, John *'HMS Hermes'*, gift, 1983

Dominy, John *'HMS Invincible'*, gift, 1983

Dominy, John *'MV Norland'*, gift, 1983

Dominy, John *'Queen Elizabeth II'*, gift, 1983

Dominy, John *'RFA Tidespring'*, gift, 1983

Dominy, John *'SS Uganda' and 'HMS Amtrim'*, gift, 1983

Dominy, John *'The Europic' Ferry*, gift, 1983

Dominy, John *The Ferry 'Nordic'*, gift, 1983

Drummond, Samuel 1765–1844, *Nelson Carried Below*, gift through Grant in Aid, 1967

Eames, F. A. R. *The Admiral and His Lady*, gift, 1991

Eleck, J. *'HMS Hood'*, gift, 1991

Evans, Richard 1784–1871, *Admiral Thomas Hardy (1769–1839)*, gift, 1960

Fisher, Roger Roland Sutton 1919–1992, *HMS London', Evening in the Gulf*, purchased, 1992

Fisher, Roger Roland Sutton 1919–1992, *Red Cross Squadron Entering the Ascension Island during the South Atlantic Campaign*, gift, 1987, © the artist's estate

Fisher, Roger Roland Sutton 1919–1992, *The Action between 'HMS Nymphe', French 5th Rate (Captured, 10 August 1780), and the French 'Cleopatre', 18 June 1793*, purchased, 1989, © the artist's estate

Foxlee, S. *Portrait of a Wren*, gift, 1981

Füger, Heinrich 1751–1818, *Lord Nelson (1758–1805)*, gift, 1973

Füger, Heinrich (after) 1751–1818, *Lord Nelson (1758–1805)*

Galea, Luigi 1847–1917, *'HMS Royal Sovereign' off Malta*, purchased, 1982

Garbutt, P. E. *Coronation Fleet Review, 1953*, purchased, 1953

Garland, Harold active 1986–1988, *Motor Torpedo Boat '475'*, gift, 1989

Geidel, Gerhard b.1925, *'HMS Victory' at Trafalgar*, gift through Grant in Aid, 1989

Gittins, D. J. active 1972–1979, *'HMS Peterel' Arriving in Chunking, August 1932*, gift, 1986

Gunn, Philip active 1973–1976, *Holy Stoning*, purchased, 1979

Gunn, Philip active 1973–1976, *Naval Recruits Joining 'Impregnable'*, purchased, 1979

Gunn, Philip active 1973–1976, *Sailor Boy's Dressing Room*, purchased, 1979

Gunn, Philip active 1973–1976, *Scamper at the Assembly Bugle*, purchased, 1979

Gunn, Philip active 1973–1976, *'Up All Hammocks'*, purchased, 1979

Gunn, Philip active 1973–1976, *Assault on the Fort*, purchased, 1979

Gunn, Philip active 1973–1976, *Coaling Ship*, purchased, 1979

Gunn, Philip active 1973–1976, *Coaling Ship by Baskets*, purchased, 1979

Gunn, Philip active 1973–1976, *Coaling Ship on Board*, purchased, 1979

Gunn, Philip active 1973–1976, *Duty Cooks of the Mess*, purchased, 1979

Gunn, Philip active 1973–1976, *Housing the Top Mast*, purchased, 1979

Gunn, Philip active 1973–1976, *Landing in No.6 Hats*, purchased, 1979

Gunn, Philip active 1973–1976, *Livestock on Board*, purchased, 1979

Gunn, Philip active 1973–1976, *Make and Mend Day*, purchased, 1979

Gunn, Philip active 1973–1976, *Mess Deck 'T'*, purchased, 1979

Gunn, Philip active 1973–1976, *Sailmaking Class*, purchased, 1979

Gunn, Philip active 1973–1976, *Sailor's Sunday Best*, purchased, 1979

Gunn, Philip active 1973–1976, *Stokehold Work*, purchased, 1979

Gunn, Philip active 1973–1976, *Tarring the Top Galant Stay*, purchased, 1979

Gunn, Philip active 1973–1976, *The Cane*, purchased, 1979

Gunn, Philip active 1973–1976, *The Wheel*, purchased, 1979

Gunn, Philip active 1973–1976, *Transport for Troops*, purchased, 1979

Gunn, Philip active 1973–1976, *Weighing Anchor*, purchased, 1979

Gunn, Philip active 1973–1976, *'Fate of my first command'*, purchased, 1979

Gunn, Philip active 1973–1976, *'HMS Clic'*, purchased, 1979

Gunn, Philip active 1973–1976, *Malaria Victim*, purchased, 1979

Gunn, Philip active 1973–1976, *Presentation of the Medal*, purchased, 1979

Gunn, Philip active 1973–1976, *'A sailor he would be'*, acquired, 1979

Gunn, Philip active 1973–1976, *The Hammock Problems*, purchased, 1979

Gunn, Philip active 1973–1976, *'A valiant deed'*, purchased, 1979

Gunn, Philip active 1973–1976, *Naval Boarding Unit*, purchased, 1979

Gunn, Philip active 1973–1976, *Rum Tub Crows Nest*, purchased, 1979

Gunn, Philip active 1973–1976, *The Mine Capture Mesh*, purchased, 1979

Hogan, David 1924–1997, *'HMS Warspite' off Sydney, March 1942*, purchased, 1986

Hoppner, John 1758–1810, *Lord Nelson (1758–1805)*, purchased, 1992

Howards *'A' Class Submarines and a Warship, possibly Royal Sovereign Class, 1905*, purchased, 1980

Hudson, Thomas 1701–1779, *Admiral Sir George Pocock (1706–1792)*, purchased, 1986

Hunt, Geoffrey William b.1948, *Desolation Island*, purchased, 1989, © the artist

Hunt, Geoffrey William b.1948, *Far Side of the World*, purchased, 1989, © the artist

Hunt, Geoffrey William b.1948, *Fortune of War*, purchased, 1989, © the artist

Hunt, Geoffrey William b.1948, *'HMS Surprise'*, purchased, 1989, © the artist

Hunt, Geoffrey William b.1948, *Letter of Marque*, purchased, 1989, © the artist

Hunt, Geoffrey William b.1948, *Master and Commander*, purchased, 1989, © the artist

Hunt, Geoffrey William b.1948,

**Mauritius Command*, purchased, 1989, © the artist

Hunt, Geoffrey William b.1948, *Post Captain*, purchased, 1989, © the artist

Hunt, Geoffrey William b.1948, *Reverse of the Medal*, purchased, 1989, © the artist

Hunt, Geoffrey William b.1948, *The Ionian Mission*, purchased, 1989, © the artist

Hunt, Geoffrey William b.1948, *The Surgeon's Mate*, purchased, 1989, © the artist

Hunt, Geoffrey William b.1948, *Treasons Harbour*, purchased, 1989, © the artist

Jerman, J. *'HMY Victoria and Albert'*, gift, 1973

Koster, Simon de 1767–1831, *Lord Nelson (1758–1805)*, gift, 1967

Leskinov *'HMS Edinburgh'*, acquired, 1993

Leskinov *50th Anniversary of Russian Convoys*, acquired, 1993

Lowe, Arthur 1866–1940, *'HMS Armadale Castle'*, gift, 1988

Lumsden *'HMS Phoebe' Giving Cover to 'HMS Imdomitable', 1940*, gift through Grant in Aid, 1978

Lund, Niels Møller 1863–1916, *Attack on the Japanese Battery at Shimonoseki by a Naval Brigade, September 1864*, purchased, 1990

Luny, Thomas 1759–1837, *The Battle of Trafalgar, 21 October 1805*, gift, 1973

MacDermott, Beatrice *Admiral Sir John Edelsten*, gift, 1983

Mason, Frank Henry 1876–1965, *The 'Flapper' on the Gingwera River, German East Africa*

Maycock, J. E. *'Defence' ('Defiance')*, gift, 1979

Maycock, J. E. *The Battle of Heligoland Bight, 28 August 1914*, gift, 1979

Maycock, J. E. *The Sinking of 'Blücher', 24 January 1915*, gift, 1979

McCormick, Arthur David 1860–1943, *Lord Nelson Arriving at Portsmouth from Spithead*, transferred, 1969

Meadows, John Hardy b.1912, *Western Approaches during the Battle of the Atlantic*, purchased, 1990

Mertall, R. (after) *Boat Action in the Bay of Cadiz, 1797*, gift, 1978

Moss, T. *'HMS Victory'*, gift, 1965

Moulton, John *'HMS Bellerophon'*, gift, 1984

W. E. N. *Sir Ernest Shackleton's Exploration Ship 'Endurance' under Sail amongst Icebergs*, gift, 1985

Needell, Philip G. 1886–1974, *Serbian Relief Fund Concert, April 1916*, gift, 1978

Needell, Philip G. 1886–1974, *'HMS Almanzora' and Convoy at Sunrise, 1917*, gift, 1977

Needell, Philip G. 1886–1974, *The Northern Patrol*, gift, 1977

Nibbs, Richard Henry 1816–1893, *The Raising of 'HMS Eurydice'*, purchased, 1954

Panter, Brian *'Aconit' Ramming*

**'U32'*, purchased, 1993

Panter, Brian *'HMS Bluebell'*, purchased, 1986

Phillips, Rex b.1931, *'HMS Hermes'*, purchased, 1983, © the artist

Phillips, Rex b.1931, *'HMS Warrior' off the Isle of Wight during Her First Commission*, purchased, 1984, © the artist

Phillips, Rex b.1931, *San Carlos Anchorage under Attack, 'Canberra' Survives the Day, 21 May 1982*, purchased, 1983, © the artist

Phillips, Rex b.1931, *The 'Sheffield' is Hit*, purchased, 1984, © the artist

Phillips, Rex b.1931, *View of a King Edward VII Class Battleship, Steaming off 'The Needles', c.1903*, © the artist

Pocock, Nicholas 1740–1821, *The Battle of Flamborough Head, 1779*, purchased, 1981

Pocock, Nicholas 1740–1821, *The Battle of Trafalgar, 21 October 1805*, purchased, 1982

Poignard *HM Ships Passing a Fleet of Drifters, 1912*, gift, 1981

Poignard *'HMS Cherwell', 1912–1913*, gift, 1981

Poignard *'HMS Prince of Wales' in the Bay, 1911*, gift, 1981

Poignard *HMTB No.110, 1912*, gift, 1981

Poignard *HMTB No.110 Entering Portsmouth Harbour*, gift, 1981

Poignard *'J' Class Yachts in the Solent, 1911–1912*, gift, 1981

Poignard *The Atlantic Fleet Entering Portland Harbour, 1910*, gift, 1981

Poulson, T. R. *HM Ships 'Pique', 'Vanguard', 'Daphne', 'Queen' and 'Vernon'*, gift, 1964

Proctor, Frederick J. active 1879–1945, *Nelson Shot*

Raeburn, Henry Macbeth 1860–1947, *George Duff (1764–1805)*, on loan from a private individual

Rawlings, Les *HRH Prince Charles (b.1948)*, purchased, 1980

Righton, Fred *'Bismarck' under Attack*, gift, 1992

Robins, E. active 1882–1902, *Troopship 'Seraphis' Leaving Portsmouth Harbour*, acquired, 1963

Russwurm, G. *'HMS Glasgow', Launched Swan Hunter, Wallsend-on-Tyne, 14 April 1976*, gift, 1984

Russwurm, G. *'Journey's End'*, gift, 1984

Russwurm, G. *Paying off of 'HMS Antrim', 18 April 1984*, gift, 1984

Russwurm, G. *Salute to Portsmouth*, gift, 1984

Russwurm, G. *The Last Voyage of 'HMS Bulwark'*, gift, 1985

Serres, Dominic 1722–1793, *Ships on a Lee Shore*, gift, 1952

Shaw, Geoff 1892–1970, *'HMNZS Achilles', Cruiser, Built by Laird, Launched 1 September 1932*, purchased, 1982

Shaw, Geoff 1892–1970, *The Battle of the North Cape, 26 December 1943*, purchased, 1992

Shkolny, Valentin *Brotherhood of Sailors*

Shkolny, Valentin 'May the dead rest in peace', acquired, 1993
Shkolny, Valentin 'O Lord', acquired, 1993
Smith, W. E. B. 'NM LCF15' Sunk, Operation 'Brassard'
Stechman, Ron 'HMS Warrior' at Her Berth in Portsmouth, gift, 1984
Stephens, H. E. 'HMS Britannia', gift, 1981
Tait, W. S. HRH Prince of Wales (b.1948), on loan from a private individual
Terry, John Firing of Gun on Board 'HMS Victory', gift, 1979
unknown artist The Bombardment of Acre, 3 November 1840, gift, 1973
unknown artist 'HMS Olive', gift, 1989
unknown artist 'HMS Ajax', gift, 1990
unknown artist 20th C, The Surrender of the German Fleet at Scapa, 21 November 1918, gift, 1980
unknown artist Admiral Charles William Paterson (1756–1841), on loan from a private individual
unknown artist Admiral of the Fleet, Sir George Astley Callaghan (1852–1920), gift, 1988
unknown artist Attack by Destroyers on German Battleship 'Scharnhorst', gift, 1988
unknown artist Battle Scene
unknown artist Beached Hulk at Sunset
unknown artist Boatswain Robert Mackenzie (b.1792), gift, 1981
unknown artist Captain C. Maud, DSO, DSC, gift, 1980
unknown artist Captain Edward Johnston, gift, 1960
unknown artist Captain John Coode, CB (d.1858), gift, 1988
unknown artist Captain William Henderson, gift, 1978
unknown artist Harbour Scene*
unknown artist 'HMS Amphitrite', c.1890, gift, 2001
unknown artist HMS Beagle', 'HMS Swallow', 'Basilisk' and 'Flora', gift, 1980
unknown artist 'HMS Garthcastle', gift, 1980
unknown artist 'HMS Sabre', gift, 1985
unknown artist 'HMS Victory', gift, 1973
unknown artist 'HMS Victory', purchased, 1984
unknown artist Horatia Nelson (1801–1881), gift, 1988
unknown artist Katharine Furse (1875–1952), acquired, 1993
unknown artist Lieutenant Kelly Nazer, gift, 1984
unknown artist Lord Nelson (1758–1805), acquired, 1973
unknown artist Majestic Type Battleship
unknown artist Midshipman Arthur Vladimir Wevill, purchased, 1985
unknown artist Mrs Samuel Bird Cook, gift, 1983
unknown artist 'MV Seaforth Clansman', gift, 1987

unknown artist Naval Chaplain Arthur Price Hill, bequeathed, 1986
unknown artist Nelson Tray, acquired, 1973
unknown artist Rear Admiral George Morris, gift, 1990
unknown artist Reverend Dr Samuel Cole, gift 1977
unknown artist Sail and Steam, gift, 1980
unknown artist Saling Ships in Portsmouth Harbour
unknown artist Samuel Bird Cook, RN, gift, 1983
unknown artist Sir Charles Vinicombe Penrose (1759–1830), gift, 1988
unknown artist Sir Edward Hamilton Wearing a Small King's Gold Medal for the Recapture of 'Hermione' by Surprise, 25 October 1799, purchased, 1984
unknown artist Sir John Leeke, gift, 1980
unknown artist The Attack by a Naval Brigade on the Japanese Battery at Shimonoseki, September 1864, purchased, 1990
unknown artist The Bombardment of Alexandria, gift, 1977
unknown artist The Parsonage at Burnham Thorpe, on loan from a private individual
unknown artist Troopship 'Tamar', gift, 1975
unknown artist Wren Entwistle, acquired, 1990
unknown artist Wrens at Work in the Valve Testing Room, 'HMS Vernon'
Wilkinson, Norman 1878–1971, The Dover Patrol, purchased, 1985, © the Norman Wilkinson estate
Wood, Jennings Armistice Parade, Constantinople, gift, 1987
Wood, Jennings The Flagship 'HMS Superb', gift, 1987
Wood, Jennings The Hanging of Turks in the Streets of Constantinople before the Armistice of 1918, gift, 1987
Wright, Paul Empire Day, 1941, gift, 1982
Wyllie, Harold 1880–1973, 'Close of Day', gift, 1964, © the artist's estate
Wyllie, Harold 1880–1973, 'HMS Whitley' Coming to the Rescue of 'MV Inverlane', Badly Damaged and on Fire after the Convoy Entered a Mine Field in the North Sea, 14 December 1939, gift, 1988, © the artist's estate
Wyllie, Harold 1880–1973, Launch of the 'Agamemnon', Buckler's Hard, 1781, gift, 1964, © the artist's estate
Wyllie, Harold 1880–1973, The Armada, gift, 1983, © the artist's estate
Wyllie, Harold 1880–1973, The Battle of Quiberon Bay, 20 November 1759, gift, 1983, © the artist's estate
Wyllie, Harold 1880–1973, The Battle of St Vincent, 14 February 1797, gift, 1983, © the artist's estate
Wyllie, Harold 1880–1973, The Battle of Sole Bay, 28 May 1672,

gift, 1983, © the artist's estate
Wyllie, Harold 1880–1973, The First of June, 1794, gift, 1983, © the artist's estate
Wyllie, Harold 1880–1973, The Nile, gift, 1983, © the artist's estate
Wyllie, William Lionel 1851–1931, The Battle of North Foreland, June 1653
Wyllie, William Lionel 1851–1931, The Restoration of 'HMS Victory', on loan from the National Maritime Museum
Wyllie, William Lionel 1851–1931, The Main Yard of 'HMS Victory' Being Crossed, purchased, 1968
Wyllie, William Lionel 1851–1931, The Battle of Trafalgar Panorama, acquired, 1929
Wyllie, William Lionel 1851–1931, The Battle of Gravelines, 29 July 1588
Wyllie, William Lionel 1851–1931, Liberty Men Landing from Spithead, purchased, 1968
Wyllie, William Lionel 1851–1931, 'Renown' Leaving Portsmouth Harbour, purchased, 1968
Wyllie, William Lionel 1851–1931, Semaphore Tower on Fire, purchased, 1981
Wyllie, William Lionel 1851–1931, The 'Gloucester Hulk' at Chatham, purchased, 1968
Wyllie, William Lionel 1851–1931, Wooden Warships on the Medway (Man O'War at Anchor), gift, 2003
Wyllie, William Lionel (after) 1851–1931, The Battle of Trafalgar, 21 October 1805, gift, 1983
Zinkeisen, Doris Clare 1898–1991, Dame Vera Laughton Mathews, purchased, 1991, © the artist's estate

University of Portsmouth

Bratby, John Randall 1928–1992, From the Coach House Window, Curtained with a 45 Star Flag, purchased, 1960s, © the artist's estate/www.bridgeman.co.uk
Folkes, Peter L. b.1923, Storm over Southampton from Redbridge No.1, purchased, 1960s, © the artist
unknown artist 20th C, Abstract, gift from a student of the University, c.1977

Romsey Town Council

Biddlecombe, Walter active 1874–1902, Mainstone Looking toward Romsey
Crossley, Harley b.1936, The Massed Bands and Corps of Drums of the Wessex Regiment Prince of Wales Division, Romsey, 13 June 1983, gift to the Borough of Romsey by Councillor Peter Ruston, 1987, © the artist/www.bridgeman.co.uk
Kneller, Godfrey (attributed to) 1646–1723, Sir William Petty (1623–1687), Political Economist, Inventor, Scientist and Founder

Member of the Royal Society, presented to the Borough of Romsey by John Gore Esq., CVO, of Rogate, Sussex, 1947
Le Nost, Alain b.1936, Paimpol Harbour, gift on the twinning of Romsey with Paimpol, 1983
Oxford, Tom George Mackrell in Mayoral Robes
Rands, Sarah E. 1834–1904, Reverend Edward Lyon Berthon (1813–1899), Vicar of Romsey (1860–1892)
Rawlings, Leo 1918–1990, Japanese Prisoner of War, Burma, gift from Earl Mountbatten, © the artist's estate
Stark, Dwight V. Admiral the Viscount Mountbatten of Burma, KG, PC, GMSI, GCVO, KCB, DSO (1900–1971), High Steward and First Freeman of Romsey
Swamy, S. N. active 1950–1960, Lady Edwina Mountbatten (1901–1960), bequeathed by J. Nehru, Prime Minister of India after her death, 1960
Woolway, George Richard 1879–1961, Edward VII (1841–1910)

Gilbert White's House & The Oates Museum

Barber, Gordon W. High Wood, Selborne
Barber, Gordon W. St Mary's Church
Barber, Gordon W. Yew Hedge in Gilbert White's Garden
Calkin, Lance 1859–1936, Anna Maria Oates (1799–1870), gift, 1954
Calkin, Lance 1859–1936, Emma Francis Oates, gift, 1958
Calkin, Lance 1859–1936, Emma Franks Oates, gift, 1958
Calkin, Lance 1859–1936, Hibbert Oates (1797–1840), gift, 1954
Holroyd, John Newman active 1909–1947, Robert Washington Oates (1874–1958), gift, 1958
Robinson, Thomas b. before 1770–1810, Thomas White (1724–1797), on loan from an anonymous individual
Seaby, Allen William 1867–1953, Landscape, acquired, 1963
Seaby, Allen William 1867–1953, The Wakes, acquired, 1963
Swann, E. Frank Oates, OBE (1890–1945), gift, 1954
unknown artist A Church, possibly Selborne
unknown artist Anne Ford, on loan from an anonymous individual
unknown artist Anne White (1693–1739), on loan from an anonymous individual
unknown artist Charles George Oates (1844–1901), gift, 1958
unknown artist Edmund Yalden (1727–1779), gift, 1963
unknown artist Edward Grace Junior, gift, 1954
unknown artist Frank Oates, FRGS (1840–1875), gift, 1954

unknown artist George Hibbert Oates (1791–1837), gift, 1958
unknown artist George Oates (1717–1779), gift, 1958
unknown artist Gilbert White Memorial Wood
unknown artist John White, on loan from an anonymous individual
unknown artist Katherine Battie, on loan from an anonymous individual
unknown artist Kissing on the Strand, gift, 1958
unknown artist Lawrence Oates (1880–1912), gift, 1958
unknown artist Mary White (1759–1833), on loan from an anonymous individual
unknown artist Mr Bennett, gift, 1957
unknown artist Mrs Bennett, gift, 1957
unknown artist Mrs Hannah Yalden, gift, 1963
unknown artist Portrait of a Lady
unknown artist Rebecca Snooke (1694–1780), gift, 2001
unknown artist Reverend Gilbert White (1720–1793), on loan from the National Trust
unknown artist Reverend Thomas Holt, on loan from an anonymous individual
unknown artist Robert Oates (1827–1921), gift, 1958
unknown artist Samuel Oates (1722–1789), gift, 1954
unknown artist Selborne from the Hanger
unknown artist The Gates of the Diogryth, gift, 1958
unknown artist Thomas Holt-White (1763–1841), on loan from an anonymous individual
unknown artist Thomas Oates (1710–1750), gift, 1954
Wood, John 1801–1870, Thomas Holt-White (1763–1841), Aged 77, on loan from an anonymous individual

Hampshire County Council's Contemporary Art Collection

Andrew, Nick b.1957, Acer, purchased, 1994, © the artist
Andrew, Nick b.1957, Anthra, purchased, 2006, © the artist
Andrew, Nick b.1957, Beorna, purchased, 2006, © the artist
Andrew, Nick b.1957, Millefolia, purchased, 1998, © the artist
Andrew, Nick b.1957, Rilla, purchased, 1998, © the artist
Atkins, David b.1964, Summer Storm, purchased, 1994, © the artist
Barnes, Catherine b.1947, Hill Barn, purchased, 2001
Barnes, Catherine b.1947, Hill Village, purchased, 2001
Barnes, Catherine b.1947, Looking Outwards, purchased, 2002
Barnes, Catherine b.1947, Out of the City, purchased, 2001
Barnes, Catherine b.1947,

Vermillion Mountain Hut, purchased, 2001

Barnes, Catherine b.1947, *Village Life*, purchased, 2001

Bealing, Nicola b.1963, *The Bird Island*, purchased, 1996, © the artist

Beaugié, Kate b.1975, *Wiltshire Winter*, purchased, 2004

Becket, Mike b.1946, *Left-Handed Guitarist*, purchased, 1996, © the artist

Bray, Jill *Confrontation*, purchased, 1992

Buhler, Robert 1916–1989, *Corner of a Field, Hampshire*, purchased, 1994, © the artist's estate/www. bridgeman.co.uk

Burrows, Bev b.1955, *Arish Mell and Flowers Barrow*, purchased, 2000, © the artist

Burrows, Bev b.1955, *Footpath at Pinnacle Rock*, purchased, 2000, © the artist

Burrows, Bev b.1955, *Kimmeridge*, purchased, 2000, © the artist

Burrows, Bev b.1955, *Rocky Shore at Mudeford*, purchased, 2000, © the artist

Butterworth, John b.1962, *Voyager No.1*, purchased, 1992

Chisholm, Josephine b.1955, *Arc de Triomphe, Paris*, purchased, 2003, © the artist

Crabbe, Richard 1927–1970, *Gulf Thanksgiving, Portsmouth*, purchased, 1992

Crabbe, Richard 1927–1970, *Sailors at a Thanksgiving Parade*, purchased, 1992

Crowther, Patricia b.1965, *Cape Forms*, purchased, 2004, © the artist

Crowther, Patricia b.1965, *Circle with Ochre*, purchased, 2004, © the artist

Crowther, Patricia b.1965, *Porthmeor Elements*, purchased, 2004, © the artist

Crowther, Patricia b.1965, *Porthmeor Forms*, purchased, 2004, © the artist

Crowther, Patricia b.1965, *Porthmeor Rain*, purchased, 2004, © the artist

Dworok, Peter b.1950, *Derwentwater*, purchased, 2006, © the artist

Dworok, Peter b.1950, *Ullswater*, purchased, 2006, © the artist

Eurich, Richard Ernst 1903–1992, *Breakwater*, purchased, 1997, © the artist's estate/www.bridgeman.co.uk

Eurich, Richard Ernst 1903–1992, *Rain and Rainbow*, purchased, 1997, © the artist's estate/www. bridgeman.co.uk

Flesseman, Meinke b.1966, *Untitled*, purchased, 2006

Flesseman, Meinke b.1966, *Untitled*, purchased, 2006

Gault, Annabel b.1952, *Butser Hill, Morning, November 1994*, purchased, 1995, © the artist

Gault, Annabel b.1952, *Butser Hill II, November 1993*, purchased, 1995, © the artist

Gault, Annabel b.1952, *North from*

Gault, Annabel b.1952, *Butser Hill II, November 1994*, purchased, 1995, © the artist

Gault, Annabel b.1947, *North from Butser Hill III, December 1994*, purchased, 1995, © the artist

Gault, Annabel b.1952, *Path on Butser, Afternoon, June 1994*, purchased, 1995, © the artist

Gault, Annabel b.1952, *View from Cross Dykes, November 1993*, purchased, 1995, © the artist

Gault, Annabel b.1952, *West from Butser Hill, Morning, November 1994*, purchased, 1995, © the artist

Goodman, Claire b.1963, *Tree Reflections*, purchased, 2004, © the artist

Hosking, John b.1952, *Porthmeor, St Ives*, purchased, 1996, © the artist

Hughes, Christine b.1946, *Christchurch Harbour No.1*, purchased, 2003, © the artist

Hughes, Christine b.1946, *Christchurch Harbour No.2*, purchased, 2003, © the artist

Hughes, Christine b.1946, *Cornish Coast*, purchased, 2003, © the artist

Hughes, Christine b.1946, *High Buzzard Knot*, purchased, 2003, © the artist

Huntly, Moira b.1932, *Port Isaac, Cornwall*, purchased, 2004, © the artist

Joyce, Peter b.1964, *Near the Bill*, purchased, 2005, © the artist

Knowles, Stuart b.1948, *Study (Untitled) 1993 (from 'Sea, Stone, Moon' series)*, purchased, 1994, © the artist

Launder, June b.1954, *Old Fishguard*, purchased, 2005, © the artist

Marsland, Derek b.1957, *Field and Trees*, purchased, 2006, © the artist

Marsland, Derek b.1957, *Oak at Sunset*, purchased, 2006, © the artist

McLellan, Margaret b.1952, *Ancestral Gold*, purchased, 2004, © the artist

McLellan, Margaret b.1952, *Ancient Farmland V*, purchased, 2004, © the artist

McLellan, Margaret b.1952, *Interior St Andrew's (Winterborne Tomson)*, purchased, 2004, © the artist

McLellan, Margaret b.1952, *Morning Portland*, purchased, 2004, © the artist

Morgan, David b.1947, *Mudeford Quay*, purchased, 1994

Neiland, Brendan b.1941, *Cloud Study I*, purchased, 1994, © the artist

Neiland, Brendan b.1941, *Cloud Study II*, purchased, 1994, © the artist

Neiland, Brendan b.1941, *Cloud Study III*, purchased, 1994, © the artist

Neiland, Brendan b.1941, *Cloud Study IV*, purchased, 1994, © the artist

Neiland, Brendan b.1941, *Cloud Study V*, purchased, 1994, © the artist

O'Keeffe, Noelle b.1961, *Small Tapestry Pond*, purchased, 2005, © the artist

Perrett, Angela b.1946, *Crevice*, purchased, 2003, © the artist

Perrett, Angela b.1946, *Shell Shore VI*, purchased, 2003, © the artist

Perrett, Angela b.1946, *Shell Shore X*, purchased, 2003, © the artist

Plowman, Chris b.1952, *Big Wheel*, purchased, 1996, © the artist

Plowman, Chris b.1952, *Small House*, purchased, 1996, © the artist

Ramsay Carr, Kathy b.1952, *Harmony West*, purchased, 2005

Ramsay Carr, Kathy b.1952, *Sky Glas*, purchased, 2005

Robertson, Gillian b.1952, *Denial*, purchased, 2003, © the artist

Robertson, Gillian b.1952, *Seeing Her*, purchased, 2003, © the artist

Sey, Eileen b.1941, *Cornish Fishing Village*, purchased, 2004, © the artist

Sey, Eileen b.1941, *Cottage by the Sea*, purchased, 2004, © the artist

Smitt, A. *An Island near the Shore*

Tarr, Deborah b.1966, *Rose Room V*, purchased, 1997

Taylor, Frank b.1946, *The Pilgrimage*, purchased, 1996, © the artist

Tobita, Masako b.1954, *All of a Sudden*, purchased, 2004, © the artist

Tobita, Masako b.1954, *Bow out, out*, purchased, 2004, © the artist

Tobita, Masako b.1954, *October Morning*, purchased, 2004, © the artist

Tobita, Masako b.1954, *Silent Move*, purchased, 2004, © the artist

Triffitt, Mary *Cheynhall*, purchased, 2003

Triffitt, Mary *Cornish Farmhouse*, purchased, 2003

Triffitt, Mary *Golden Landscape*, purchased, 2003

Triffitt, Mary *Lone Barn*, purchased, 2003

Vyvyan, Angela b.1929, *City Gardens*, purchased, 2003, © the artist

Vyvyan, Angela b.1929, *City Park IV*, purchased, 2003, © the artist

Vyvyan, Angela b.1929, *Path to the Shore No.1*, purchased, 2003, © the artist

Waite, Andy b.1954, *Blue Field*, purchased, 2006, © the artist

Waite, Andy b.1954, *Green Lake*, purchased, 2006, © the artist

Waite, Andy b.1954, *Lake*, purchased, 2006, © the artist

Waite, Andy b.1954, *Park*, purchased, 2006, © the artist

Wallbridge, Tina Bird b.1960, *Cathedral/College*, purchased, 2004, © the artist

Wallbridge, Tina Bird b.1960, *Tower Arts*, commissioned, 2005, © the artist

Wallbridge, Tina Bird b.1960, *West Hill*, commissioned, 2005, © the artist

Woolley, James *Barton Cliffs*, purchased, 2003

Woolley, James *Highcliffe Barbeques*, purchased, 2003

Woolley, James *Incoming Tide*, purchased, 2003

Woolley, James *Langton Ledges*, purchased, 2003

Woolley, James *September Sea*, purchased, 2003

Hampshire County Council Museums Service

Allan, Christina active 1884–1900, *Place Mill and Priory*, untraced find

Allan, Christina active 1884–1900, *The Mill at Christchurch*, untraced find

Allan, Christina active 1884–1900, *Village and Bridge at Iford*, gift

Allan, Stanley Larpent 1867–1947, *The Havant to Emsworth Road, Looking East towards the Green Pond and Forge*, purchased, 1992

Allan, Stanley Larpent 1867–1947, *The Portsmouth to London Road, Looking North to the Village of Waterlooville with St George's Church to the Left*, purchased, 1992

Atkins, William Edward 1842–1910, *'Victory'*, untraced find

Allen, William Herbert 1863–1943, *Male Model*, bequeathed, 1943, © the artist's estate

Allen, William Herbert 1863–1943, *Male Model*, bequeathed, 1943, © the artist's estate

Allen, William Herbert 1863–1943, *Still Life Studies*, bequeathed, 1943, © the artist's estate

Allen, William Herbert 1863–1943, *Still Life Studies*, bequeathed, 1943, © the artist's estate

Allen, William Herbert 1863–1943, *Stooked Corn in Pale Sunlight*, bequeathed, 1943, © the artist's estate

Allen, William Herbert 1863–1943, *Haymaking at Dusk, Farnham Water Meadows*, bequeathed, 1943, © the artist's estate

Allen, William Herbert 1863–1943, *Chantel de la Flechère*, bequeathed, 1943, © the artist's estate

Allen, William Herbert 1863–1943, *Grape Picking in Italy*, bequeathed, 1943, © the artist's estate

Allen, William Herbert 1863–1943, *La Giona, Lake Maggiore*, bequeathed, 1943, © the artist's estate

Allen, William Herbert 1863–1943, *In the Tuileries Gardens*, bequeathed, 1943, © the artist's estate

Allen, William Herbert 1863–1943, *The Fold*, bequeathed, 1943, © the artist's estate

Allen, William Herbert 1863–1943, *The Oratorio, Sacred Cantata Performed in Farnham Parish Church*, bequeathed, 1943, © the artist's estate

Allen, William Herbert 1863–

Allen, William Herbert 1863–1943, *The Tuileries*, bequeathed, 1943, © the artist's estate

Allen, William Herbert 1863–1943, *Grace, These Creatures Bless*, bequeathed, 1943, © the artist's estate

Allen, William Herbert 1863–1943, *Sarmarole*, bequeathed, 1943, © the artist's estate

Allen, William Herbert 1863–1943, *A Breton Peasant Girl*, bequeathed, 1943, © the artist's estate

Allen, William Herbert 1863–1943, *A Chapel in the Mountains*, bequeathed, 1943, © the artist's estate

Allen, William Herbert 1863–1943, *A Children's Religious Procession*, bequeathed, 1943, © the artist's estate

Allen, William Herbert 1863–1943, *A Country Walk*, bequeathed, 1943, © the artist's estate

Allen, William Herbert 1863–1943, *A Hop Kiln*, bequeathed, 1943, © the artist's estate

Allen, William Herbert 1863–1943, *A Quiet Backwater*, bequeathed, 1943, © the artist's estate

Allen, William Herbert 1863–1943, *A Religious Procession*, bequeathed, 1943, © the artist's estate

Allen, William Herbert 1863–1943, *A Windmill*, bequeathed, 1943, © the artist's estate

Allen, William Herbert 1863–1943, *Angels*, bequeathed, 1943, © the artist's estate

Allen, William Herbert 1863–1943, *Birch Trees*, bequeathed, 1943, © the artist's estate

Allen, William Herbert 1863–1943, *Calf in a Shed, Stovold's Farm*, bequeathed, 1943, © the artist's estate

Allen, William Herbert 1863–1943, *Cattle beneath Elms*, bequeathed, 1943, © the artist's estate

Allen, William Herbert 1863–1943, *Cattle in the Water Meadow*, bequeathed, 1943, © the artist's estate

Allen, William Herbert 1863–1943, *Choir Boys Singing*, bequeathed, 1943, © the artist's estate

Allen, William Herbert 1863–1943, *Continental Street Scene*, bequeathed, 1943, © the artist's estate

Allen, William Herbert 1863–1943, *Corn Stooks, Farnham*, bequeathed, 1943, © the artist's estate

Allen, William Herbert 1863–1943, *Corn Stooks, Farnham*, bequeathed, 1943, © the artist's estate

Allen, William Herbert 1863–1943, *Corn Stooks in Sunlight*, bequeathed, 1943, © the artist's estate

Allen, William Herbert 1863–1943, *Corn Stooks in the Sunset*,

bequeathed, 1943, © the artist's estate

Allen, William Herbert 1863–1943, *Corn Stooks, possibly Crooksbury Hill*, bequeathed, 1943, © the artist's estate

Allen, William Herbert 1863–1943, *Country Scene*, bequeathed, 1943, © the artist's estate

Allen, William Herbert 1863–1943, *Cow Grazing in Landscape*, bequeathed, 1943, © the artist's estate

Allen, William Herbert 1863–1943, *Cows for Milking*, bequeathed, 1943, © the artist's estate

Allen, William Herbert 1863–1943, *Cows Watering beneath Bradford-on-Avon*, bequeathed, 1943, © the artist's estate

Allen, William Herbert 1863–1943, *Dante (1265–1321)*, bequeathed, 1943, © the artist's estate

Allen, William Herbert 1863–1943, *Fiesole, Florence, Val d'Arno*, bequeathed, 1943, © the artist's estate

Allen, William Herbert 1863–1943, *Friendship*, bequeathed, 1943, © the artist's estate

Allen, William Herbert 1863–1943, *Friendship*, bequeathed, 1943, © the artist's estate

Allen, William Herbert 1863–1943, *Garden with Sundial*, bequeathed, 1943, © the artist's estate

Allen, William Herbert 1863–1943, *Girl Gathering Fir Cones*, bequeathed, 1943, © the artist's estate

Allen, William Herbert 1863–1943, *Girl with Bare Shoulders against a Reddish Background*, bequeathed, 1943, © the artist's estate

Allen, William Herbert 1863–1943, *Haystacks in the Moonlight*, bequeathed, 1943, © the artist's estate

Allen, William Herbert 1863–1943, *Hillside at Fiesole, Florence, Val d'Arno, Italy*, bequeathed, 1943, © the artist's estate

Allen, William Herbert 1863–1943, *In the Bourne*, bequeathed, 1943, © the artist's estate

Allen, William Herbert 1863–1943, *Leading the Cow*, bequeathed, 1943, © the artist's estate

Allen, William Herbert 1863–1943, *Leading the Flock at Dusk*, bequeathed, 1943, © the artist's estate

Allen, William Herbert 1863–1943, *Market Scene, Lucerne*, bequeathed, 1943, © the artist's estate

Allen, William Herbert 1863–1943, *Marshland on the Edge of the Wood*, bequeathed, 1943, © the artist's estate

Allen, William Herbert 1863–1943, *Milkmaid and Cow in Landscape*, bequeathed, 1943, © the artist's estate

Allen, William Herbert 1863–1943, *Milk Maid, Mount Orgueil, Jersey*, bequeathed, 1943, © the artist's estate

Allen, William Herbert 1863–1943, *Monk on Monastery Balcony*, bequeathed, 1943, © the artist's estate

Allen, William Herbert 1863–1943, *Musing beside the Water Fountain*, bequeathed, 1943, © the artist's estate

Allen, William Herbert 1863–1943, *Near Tilford Mill, Waverley*, bequeathed, 1943, © the artist's estate

Allen, William Herbert 1863–1943, *Pastoral, Sheep in the Meadows, Farnham*, bequeathed, 1943, © the artist's estate

Allen, William Herbert 1863–1943, *Pond in the Woods*, bequeathed, 1943, © the artist's estate

Allen, William Herbert 1863–1943, *Portrait of a Boy*, bequeathed, 1943, © the artist's estate

Allen, William Herbert 1863–1943, *Portrait of a Child in a White Dress*, bequeathed, 1943, © the artist's estate

Allen, William Herbert 1863–1943, *Portrait of a Girl against an Orange Tree*, bequeathed, 1943, © the artist's estate

Allen, William Herbert 1863–1943, *Portrait of a Girl against an Orange Tree*, bequeathed, 1943, © the artist's estate

Allen, William Herbert 1863–1943, *Portrait of a Girl amongst Grapes*, bequeathed, 1943, © the artist's estate

Allen, William Herbert 1863–1943, *Portrait of a Girl amongst Hollyhocks*, bequeathed, 1943, © the artist's estate

Allen, William Herbert 1863–1943, *Portrait of a Girl amongst Lilies*, bequeathed, 1943, © the artist's estate

Allen, William Herbert 1863–1943, *Portrait of a Girl amongst Madonna Lilies*, bequeathed, 1943, © the artist's estate

Allen, William Herbert 1863–1943, *Portrait of a Girl amongst Purple Delphiniums*, bequeathed, 1943, © the artist's estate

Allen, William Herbert 1863–1943, *Portrait of a Girl Carrying St John's Wort*, bequeathed, 1943, © the artist's estate

Allen, William Herbert 1863–1943, *Portrait of a Girl in a Green Dress*, bequeathed, 1943, © the artist's estate

Allen, William Herbert 1863–1943, *Portrait of a Girl in a Red Dress*, bequeathed, 1943, © the artist's estate

Allen, William Herbert 1863–1943, *Portrait of a Girl in a White Dress*, bequeathed, 1943, © the artist's estate

Allen, William Herbert 1863–1943, *Portrait of a Girl in a White Pinafore*, bequeathed, 1943, © the artist's estate

Allen, William Herbert 1863–1943, *Portrait of a Girl Wearing a Light Blue Dress*, bequeathed, 1943, © the artist's estate

Allen, William Herbert 1863–1943, *Portrait of a Girl with a Garland of Roses in Her Hair*, bequeathed, 1943, © the artist's estate

Allen, William Herbert 1863–1943, *Portrait of a Girl with a Grey Dress*, bequeathed, 1943, © the artist's estate

Allen, William Herbert 1863–1943, *Portrait of a Girl with a Scarf on Her Head*, bequeathed, 1943, © the artist's estate

Allen, William Herbert 1863–1943, *Portrait of a Girl with an Open Book*, bequeathed, 1943, © the artist's estate

Allen, William Herbert 1863–1943, *Portrait of a Girl with Bare Shoulders*, bequeathed, 1943, © the artist's estate

Allen, William Herbert 1863–1943, *Portrait of a Girl with Honesty*, bequeathed, 1943, © the artist's estate

Allen, William Herbert 1863–1943, *Portrait of a Girl with Medlars*, bequeathed, 1943, © the artist's estate

Allen, William Herbert 1863–1943, *Portrait of a Girl with Pansies*, bequeathed, 1943, © the artist's estate

Allen, William Herbert 1863–1943, *Portrait of a Girl with Peacock Feather*, bequeathed, 1943, © the artist's estate

Allen, William Herbert 1863–1943, *Portrait of a Girl with Primroses*, bequeathed, 1943, © the artist's estate

Allen, William Herbert 1863–1943, *Portrait of a Girl with White Cravat*, bequeathed, 1943, © the artist's estate

Allen, William Herbert 1863–1943, *Portrait of a Young Girl Wearing a Brooch of Irises*, bequeathed, 1943, © the artist's estate

Allen, William Herbert 1863–1943, *Portrait of a Young Girl with a Ribbon in her Hair*, bequeathed, 1943, © the artist's estate

Allen, William Herbert 1863–1943, *Portrait of a Young Girl with Medlars*, bequeathed, 1943, © the artist's estate

Allen, William Herbert 1863–1943, *Portrait of an Elderly Man in Farnham Parish Church*, bequeathed, 1943, © the artist's estate

Allen, William Herbert 1863–1943, *Portrait of an Old Man*, bequeathed, 1943, © the artist's estate

Allen, William Herbert 1863–1943, *Portrait of an Old Man*, bequeathed, 1943, © the artist's estate

Allen, William Herbert 1863–1943, *Quesnoy, Picardy*, bequeathed, 1943, © the artist's estate

Allen, William Herbert 1863–1943, *Sacred Cantata Performed in Stapleford Church, near Salisbury*, bequeathed, 1943, © the artist's estate

Allen, William Herbert 1863–1943, *Sailing at Dusk, Saint-Valery-sur-Somme*, bequeathed, 1943, © the artist's estate

Allen, William Herbert 1863–1943, *Selborne Common*, bequeathed, 1943, © the artist's estate

Allen, William Herbert 1863–1943, *Sheep Grazing in Landscape*, bequeathed, 1943, © the artist's estate

Allen, William Herbert 1863–1943, *Sheep Grazing in the Meadows, Farnham*, bequeathed, 1943, © the artist's estate

Allen, William Herbert 1863–1943, *Sheep in the Meadow*, bequeathed, 1943, © the artist's estate

Allen, William Herbert 1863–1943, *Sheep in the Meadows, Farnham*, bequeathed, 1943, © the artist's estate

Allen, William Herbert 1863–1943, *Sheep on a Hillside*, bequeathed, 1943, © the artist's estate

Allen, William Herbert 1863–1943, *Shepherdess amongst Blossom*, bequeathed, 1943, © the artist's estate

Allen, William Herbert 1863–1943, *Snailslynch Kilns by the Wey, Farnham*, bequeathed, 1943, © the artist's estate

Allen, William Herbert 1863–1943, *Still Life with Mandolin, Pot and Chair*, bequeathed, 1943, © the artist's estate

Allen, William Herbert 1863–1943, *Stooked Corn at Sunset*, bequeathed, 1943, © the artist's estate

Allen, William Herbert 1863–1943, *Stooked Corn in Sunshine and Shade*, bequeathed, 1943, © the artist's estate

Allen, William Herbert 1863–1943, *Stooked Corn, toward the End of the Day*, bequeathed, 1943, © the artist's estate

Allen, William Herbert 1863–1943, *Sun Effects through Trees*, bequeathed, 1943, © the artist's estate

Allen, William Herbert 1863–1943, *Sunlight on Stooked Corn*, bequeathed, 1943, © the artist's estate

Allen, William Herbert 1863–1943, *Sunlight Reflected in Water*, bequeathed, 1943, © the artist's estate

Allen, William Herbert 1863–1943, *Sunset across the Common*, bequeathed, 1943, © the artist's estate

Allen, William Herbert 1863–1943, *Sunset, Driving the Flock*, bequeathed, 1943, © the artist's estate

Allen, William Herbert 1863–

1943, *Sunset over the Valley*, bequeathed, 1943, © the artist's estate

Allen, William Herbert 1863–1943, *The Descent from the Cross*, bequeathed, 1943, © the artist's estate

Allen, William Herbert 1863–1943, *The Minstrel*, bequeathed, 1943, © the artist's estate

Allen, William Herbert 1863–1943, *The Recital*, bequeathed, 1943, © the artist's estate

Allen, William Herbert 1863–1943, *The Shepherd Leading His Flock*, bequeathed, 1943, © the artist's estate

Allen, William Herbert 1863–1943, *The Stream*, bequeathed, 1943, © the artist's estate

Allen, William Herbert 1863–1943, *The Visitation*, bequeathed, 1943, © the artist's estate

Allen, William Herbert 1863–1943, *Women Walking along a Walled Lane*, bequeathed, 1943, © the artist's estate

Allen, William Herbert 1863–1943, *Woodland Scene with Lone Figure*, bequeathed, 1943, © the artist's estate

Allen, William Herbert 1863–1943, *Work on the Land, Farnham*, bequeathed, 1943, © the artist's estate

Allen, William Herbert 1863–1943, *Worker Carrying a Scythe with His Daughter*, bequeathed, 1943, © the artist's estate

G. C. B. *The Seat of Admiral Sir Harry Burrard-Neale, Walhampton House, Boldre, New Forest*, untraced find

Baker, S. A. *Gypsy Flower Seller*, untraced find

Ball, Wilfred Williams 1853–1917, *Coastal Scene at Sunset*, untraced find

Ball, Wilfred Williams 1853–1917, *Coastal Scene with Lighthouse*, untraced find

Ball, Wilfred Williams 1853–1917, *Cottage in a Rural Setting*, untraced find

Ball, Wilfred Williams 1853–1917, *Cottage in a Rural Setting*, untraced find

Ball, Wilfred Williams 1853–1917, *Cottage with Children Picking Flowers*, untraced find

Ball, Wilfred Williams 1853–1917, *Cottages near Shore Line*, untraced find

Ball, Wilfred Williams 1853–1917, *View of Stanpit, near Christchurch*, untraced find

Ball, Wilfred Williams 1853–1917, *Windmill and Geese*, untraced find

Ball, Wilfred Williams (attributed to) 1853–1917, *Farmyard Scene with Poultry*, untraced find

Barker, Geoffrey Alan 1881–1959, *View from the Garden of Miss M. Jolliffe, Christchurch*, bequeathed, 1990

Barnes, Ernest W. 1880–1960, *John Paulet, Marquis of Winchester (1598–1675)*, gift, 1960

Barnes, Ernest W. 1880–1960, *The Lighting of Basing House, 1645*, gift, 1960

Barrett, Maryan E. active 1950–1985, *Timber Barn*, gift, 1995

Barrett, Maryan E. active 1950–1985, *Unfinished Study of Buildings and Cars*, gift, 1995

Barrett, Maryan E. active 1950–1985, *View of Buildings*, gift, 1995

Barrett, Maryan E. active 1950–1985, *View of Petersfield*, gift, 1995

Barrett, Maryan E. active 1950–1985, *View of Petersfield*, gift, 1995

Barrett, Maryan E. active 1950–1985, *View of Petersfield*, gift, 1995

Barrett, Maryan E. active 1950–1985, *View of Petersfield*, gift, 1995

Beechey, William 1753–1839, *Family Portrait*, accepted in lieu of tax

Bell, Arthur George 1849–1916, *Autumn Scene, Hengistbury Head from Southbourne*, gift

Bell, Arthur George 1849–1916, *Lane near Burton*, gift

Bell, Arthur George 1849–1916, *River Scene*

Bell, Arthur George 1849–1916, *Rural Scene*, untraced find

Bell, Arthur George 1849–1916, *Sheep Grazing on Hengistbury Head*, gift

Bell, Arthur George 1849–1916, *Sheep on Hengistbury Head*, gift, 1968

Bell, Arthur George 1849–1916, *Silver Light, City Smoke, a View of the River Avon at Bradford-on-Avon*, untraced find

Bell, Arthur George 1849–1916, *View of Christchurch Priory from Warren Head, Christchurch*, untraced find

Bell, Arthur George 1849–1916, *Woodland River Scene*

Bissill, George William 1896–1973, *Hurstbourne Tarrant*, purchased, 1976

Brangwyn, Frank 1867–1956, *A Balkan Fisherman*, untraced find, © the artist's estate/www.bridgeman.co.uk

Breanski, Alfred de 1852–1928, *Horseman and Bridge at the Gap of Dunloe, Killarney*, untraced find

British (English) School *C. A. Mornewick Junior*, untraced find

Bryan, Charles Stanley Coles active 1937–1956, *Yacht 'Endeavour' Racing in the Solent*, gift, 1984

Bryan, Charles Stanley Coles active 1937–1956, *Botley Flour Mill Loading Barn*, gift, 1995

Bryan, Charles Stanley Coles active 1937–1956, *The Yacht Beacon*, gift, 1995

Bryan, Charles Stanley Coles active 1937–1956, *Ashley Dancing Academy*, gift, 1980

Bryan, Charles Stanley Coles active 1937–1956, *No.2 Boatyard, Botley Reech, River Hamble*, gift, 1995

Burgess, John Bagnold 1830–1897, *Portrait of a Young Woman with a Love Letter*, untraced find

Burrard, Harry active c.1850–1876, *View of Lymington Quay*, untraced find

Burrard, Harry active c.1850–1876, *View of Lymington Quay*, purchased, 1976

Burrard, Harry active c.1850–1876, *View of Lymington Harbour Area*, untraced find

C. M. C. *Lake Scene*, untraced find

Cave, William 1737–1813, *Summer Evening; the Coach (after Philip James de Loutherbourg)*, gift, 1931

Chambers, George 1803–1840, *'The Royal George' Leaving Southampton Water with George IV on Board*, purchased, 1990

Clark, G. *Penshurst, Kent*, gift, 1976

Cole, George 1810–1883, *Entrance to Portsmouth Harbour with British Man of War*, purchased, 1989

Collins, Alfred active 1850–1882, *Portsdown Hill from Portsmouth*, purchased, 2000

Cooper, John Hubert b.1912, *View of Anglesey Creek*, purchased, 1982

Cooper, John Hubert b.1912, *View of Anglesey Creek*, purchased, 1982

Cooper, John Hubert b.1912, *View of Haslar Creek*, purchased, 1982

Cope, Arthur Stockdale 1857–1940, *Thomas George Baring, Earl of Northbrook (1826–1904)*, untraced find

Couling, Paula b.1930, *View of Christchurch Priory with Boats Moored on River Avon*, untraced find, © the artist

Crofts, Ernest 1847–1911, *Cromwell at the Storming of Basing House*, on loan from Leeds City Art Gallery

Crossley, Harley b.1936, *Cunard White Star 'RMS Aquitania', Leaving Royal Pier, Southampton, 1948*, purchased, 1996, © the artist/www.bridgeman.co.uk

Curtis *Crusader Fighting a Turk on Horseback*, gift, 1982

Curtis *Medieval Knights in Armour Fighting on Horseback*, gift, 1982

G. D. *The Winchester to Farnham Stage or Mail Coach*, purchased, 1996

Darnell, Dorothy active 1904–1922, *Study of a Female Figure*, gift, 1961

Davidson, Laurence *Retrospective View of Bursledon Windmill, Hampshire, 1890s*, purchased, 1999

Davies, Mary *Dead Bird*, untraced find

Davis, Arthur Henry c.1847–1895, *Ibsley near Ringwood*, untraced find

Davis, Arthur Henry c.1847–1895, *View of Christchurch Priory*, untraced find

Davis, Arthur Henry (attributed to) c.1847–1895, *View of Blackwater Ferry on the River Stour, Dorset*, untraced find

Dee *'828' at Barry Island*

Dickinson, Lowes Cato 1819–1908, *George Sclater Booth, Lord Basing (1826–1894), First Chairman of Hampshire County Council (1889–1894)*, gift, 1987

Ditch, A. H. active 1959–1965, *Hillhead (?)*, gift, 1988

Ditch, A. H. active 1959–1965, *Park Lane, Fareham*, gift, 1988

Ditch, A. H. active 1959–1965, *View of Cams Hall Farm, Fareham*, gift, 1988

Dring, William D. 1904–1990, *Sir C. L. Chute, Chairman of Hampshire County Council (1938–1955)*, untraced find, © the artist's estate/www.bridgeman.co.uk

Durham, F. *View from Smugglers Lane, Christchurch*, gift, 1958

Durman, Alan 1905–1963, *Artwork for Southern Railways Poster*, purchased, 1997

Elliot, Thomas active 1790–1810, *British Man of War and Other Shipping in Portsmouth Harbour*, purchased, 1992

Elliott, Richard *The Wreck of the 'Herman Julius'*, gift, 1956

Elwes, Simon 1902–1975, *Mrs Violet Stuart Wortley (1866–1953)*, gift, 2002

Fenelly, J. *Farmyard Scene*, gift, 1963

Fisher, Simon b.1944, *BOAC Flying Boat 'Somerset' Taking off on Last Scheduled Flying Boat Service from Southampton Water*, untraced find, © the artist

Gage, R. E. *Schneider Trophy Seaplane 'No.7' Flying over the Solent*, gift, 1996

Garland, Valentine Thomas 1840–1914, *Cams Mill, Fareham*, purchased, 1986

Garneray, Louis 1783–1857, *Prison Hulks in Portsmouth Harbour*, purchased, 1996

Gibson, Anthony *Royal Yacht*

Gillard, Frank *Boathouse which Once Housed a Gun Punt Belonging to Tom Parham, near Harts Farm, Bedhampton, Hampshire, prior to 1939*, gift, 1990

Goddard, Amelia active 1890–1920s, *Gypsy Caravan in New Forest at Dusk*, untraced find at Red House Museum, Christchurch, Dorset

Goddard, Amelia active 1890–1920s, *Gypsy Child*

Grant, William d.1982, *Self Portrait*, gift, 1992

Gregory, H. *Holy Ghost Chapel Ruins, Basingstoke*, untraced find

Gregory, H. *Young Hounds*, gift, 1960

Gregory, J. W. *Holy Ghost Chapel, Basingstoke*

Hanneman, Adriaen (circle of) c.1601–1671, *The Wife of the First Duke of Bolton (d.1653?)*, purchased, 1997

Hansford, B. P. *Fareham Mill*, gift, 2004

Harrison, Terry b.1951, *Commemorating the Anniversary of the D-Day Landings, Normandy Beach, 6 June 1944*, gift, 1996, © the artist

Hemwell, G. *Mount Everest*, untraced find

Herdman, Robert 1829–1888, *Charles Shaw-Lefevre, First*

Viscount Eversley (1794–1888), in the Uniform of the Hampshire Carabiniers, untraced find

Heymans, Casimir b.c.1895, *Old Iford*, gift

Highmore, Joseph 1692–1780, *Mrs Iremonger of Wherwell Priory*, purchased, 1993

Holst, Laurits Bernhard 1848–1934, *Breaking Waves*, gift

Houghton, Philip active 1909–1922, *Springtime at Swan Hill*, bequeathed, 1943

Jones, Douglas *The Constables' House and Priory*, untraced find

Kinch, Hayter 1767–1844, *The Upper Quay Area of Fareham Creek, Looking South from Cams Mill*, purchased, 1993

King, Gunning 1859–1940, *Portrait Study of a Girl*, untraced find

W. E. L. *View of Iford Bridge and Cottages, Christchurch*, untraced find

Lander, John Saint-Hélier 1869–1944, *Canon Charles Theobald (b.1831)*, untraced find

Lee, T. W. *Airspeed Ambassador Flying over Christchurch, May 1951*, purchased, 1999

Lee, T. W. *Motor Torpedo Boat 'MTB71' on Patrol in the Solent, off Hampshire, Second World War, 1942–1943*, purchased, 1999

Lucas, John 1807–1874, *The First Duke of Wellington (1769–1852) in Old Age*, untraced find

Lucas, John 1807–1874, *Duke of Wellington, KG, in the Uniform of the Lord Lieutenant of Hampshire*, untraced find

Marston, George 1882–1940, *Antarctic Sea and Landscape*, purchased, 1998, © the artist's estate

Marston, George 1882–1940, *Self Portrait*, purchased, 1997, © the artist's estate

Mason, Samuel *Charles Heath (1740–1810)*, gift

McCannell, William Otway 1883–1969, *River Fantasy*, bequeathed, 1943

Mead active 1972–1975, *Street Scene, Christchurch*

Mead active 1972–1975, *Street Scene, Christchurch*

Meadus, Eric 1931–1970, *Railway Station, possibly Woolston, Southampton*, gift, 1992, © the artist's estate

Meadus, Eric 1931–1970, *Suburban Housing in the Southampton Area*, gift, 1992, © the artist's estate

Meadus, Eric 1931–1970, *Church of St Alban, Swaythling, Southampton*, gift, 1992, © the artist's estate

Meadus, Eric 1931–1970, *Vase with Flowers and Bottle*, gift, 1992, © the artist's estate

Monnier, Jean b.1933, *A Marina*

Moore, Y. *'Cat and Fiddle' Public House near Christchurch, Dorset*, untraced find

Morgan, Owen Frederick active 1896–1926, *W. H. Curtis (1880–*

1957), gift, 1963

Myall, John *'828' at Eastleigh Works*

Nasmyth, Patrick 1787–1831, *A View in Hampshire*, purchased, 1993

Nickless *Gosport Pontoon and the Semaphore Tower, Portsmouth*, gift, 1982

Nickless *'HMS Dolphin', Gosport and the Round Tower, Portsmouth*, gift, 1982

Pether, Abraham 1756–1812, *God's House Tower by Moonlight*, purchased, 1991

Pike, Sidney 1846–1907, *The Priory and Constable's House*, untraced find

Pike, Sidney 1846–1907, *View of Christchurch Harbour*, untraced find

Pollard, Chris *First Train through Eastleigh*

Polly, D. M. *View of East Cliff, Bournemouth*, untraced find

Richmond, George 1809–1896, *Sir William Heathcote, Bt (1801–1881)*, untraced find

Rogers, A. J. *View of West Street, Fareham, Hampshire, by Thackeray's House*, gift, 1990

Rogers, A. J. *West Street, Fareham, by Lloyds Bank*, gift, 1990

Salisbury, Frank O. 1874–1962, *Sir Alexander MacLean*, gift, 1998, © the estate of Frank O. Salisbury/DACS 2007

Sancha, Carlos Luis 1920–2001, *Lord Portchester, Chairman of Hampshire County Council (1973–1977)*, untraced find

Sargent, Frederick 1837–1899, *The Tichborne Trial*, purchased, 2004

Schalcken, Godfried 1643–1706, *John Acton, Solicitor of Basingstoke*, purchased, 1988

Seabrooke, Elliot 1886–1950, *Bucklers Hard Estuary*, untraced find

Serres, Dominic 1722–1793, *View from Portsdown Hill Overlooking Portsmouth Harbour*, purchased, 1991

Serres, Dominic 1722–1793, *British Warship Leaving Portsmouth Harbour*, purchased, 1991

Shayer, William 1788–1879, *Gypsy Encampment in the New Forest*, purchased, 1991

Shayer, William 1788–1879, *The Cornfield*, purchased, 1991

Shayer, William 1788–1879, *The Rabbit Seller*, purchased, 1992

Shepherd, Rupert 1909–1992, *Councillor Mrs Sue Bartlett*, untraced find

Sinkinson, Frederick *Abstract Coastal Scene*

Smith, Stuart C. *May's Bounty, Basingstoke*

Snape, Martin 1853–1930, *St Mary's Church, Rowner, Gosport*, gift, 1984

Snape, Martin 1853–1930, *Farmyard Scene*, gift, 1984

Snape, Martin 1853–1930, *The Hard, Gosport*, gift, 1984

Snape, Martin 1853–1930, *Fly*

Fishing on the River Meon, purchased, 1989

Snape, Martin 1853–1930, *Itchenor, Hampshire*, untraced find

Snape, Martin 1853–1930, *The River Meon*, purchased, 1989

Snape, Martin 1853–1930, *The Hard, Gosport*, gift, 1984

Snape, Martin 1853–1930, *Emsworth Fair*, gift, 1984

Snape, Martin 1853–1930, *Forton Creek, Gosport*, gift, 1984

Snape, Martin 1853–1930, *Grange Farm*, gift, 1984

Snape, Martin 1853–1930, *Haslar Creek*, bequeathed, 1987

Snape, Martin 1853–1930, *Rural Landscape*, gift, 1984

Snape, Martin 1853–1930, *Rural Landscape*, gift, 1986

Snape, Martin 1853–1930, *Ships at Sunset*, gift, 1984

Snape, Martin 1853–1930, *Storm at Sea*, gift, 1984

Snape, Martin 1853–1930, *The Hard, Gosport*, gift, 1984

Snape, Martin 1853–1930, *The Old Manor House, Bedhampton*, purchased

Snape, Martin 1853–1930, *The Oldest Oak in the Greenwood*, gift, 1998

Snape, Martin 1853–1930, *Winter Highland Scene*, gift, 1984

Snape, William H. 1862–1904, *Landscape*, gift, 1984

Snape, William H. 1862–1904, *Seascape*, gift, 1984

Snape, William H. 1862–1904, *One of the Snape Family*, gift, 1984

Snape, William H. 1862–1904, *Frozen Harbour Scene*, gift, 1984

Snape, William H. 1862–1904, *Harbour Scene*, gift, 1984

Snape, William H. 1862–1904, *Still Life, Vase of Flowers*, gift, 1984

Snape, William H. 1862–1904, *Gamekeeper in the Wild Grounds*, gift, 1984

Snape, William H. 1862–1904, *Landscape*, gift, 1984

Snape, William H. 1862–1904, *Marsh Scene*, gift, 1976

Snape, William H. 1862–1904, *Portrait of a Child Selling Flowers*, gift, 1984

Spencelayh, Charles 1865–1958, *Portrait of a Small Girl Standing with a Doll*, on loan from an anonymous individual, © the artist's estate/www.bridgeman.co.uk

Spooner, Charles Sydney 1862–1938, *Portchester Castle*, purchased, 1992

Steers, F. A. *Lee Breton Farmhouse, Lee-on-the-Solent*, gift, 1998

Swayne, H. *Hulks off Hardway, Gosport*, untraced find

Thirlwall *The Plough, Alton*, untraced find

Tuke, Henry Scott 1858–1929, *Cabin Boy*, untraced find

Turner, Daniel d.1801, *View of Gosport*, untraced find

Twort, Flora 1893–1985, *Mrs Jane Twort*, bequeathed, 1985

Twort, Flora 1893–1985, *At*

Twilight with the Swans, bequeathed, 1985

Twort, Flora 1893–1985, *Dr W. J. D. Twort as a Young Man*, bequeathed, 1985

Twort, Flora 1893–1985, *Figures on the Beach*, bequeathed, 2004

Twort, Flora 1893–1985, *Girl by Water (recto)*, bequeathed, 1985

Twort, Flora 1893–1985, *Pontoon at Heath Lake, Petersfield (verso)*, bequeathed, 1985

Twort, Flora 1893–1985, *Morning by the Lake*, bequeathed, 2005

Twort, Flora 1893–1985, *Pontoon at Heath Lake, Petersfield*, bequeathed, 2005

Twort, Flora 1893–1985, *Portrait of Lady*, bequeathed, 1985

Tyson, Kathleen 1898–c.1982, *Middle Woodford, Wiltshire*, untraced find

unknown artist *Sir David Norton, Southwark*

unknown artist *Portrait of a Bishop*, untraced find

unknown artist *Portrait of a Man in Early Middle Age*, untraced find

unknown artist *View of Winchester with the Militia Camp in the Foreground*

unknown artist *Portrait of a Bishop*, untraced find

unknown artist 18th C, *William Curtis (1746–1799), Botanist, Writing at His Table*, gift, 1945

unknown artist *Thomas Heath (1781–1842)*, untraced find

unknown artist *Ambrose Tucker*, untraced find

unknown artist *Portrait of a Young Girl in a Blue Dress, a Member of the Barney Family, Fareham*

unknown artist *The Honourable Sir Hercules Packenham, Military Governor of the Portsmouth Garrison*, purchased, 1988

unknown artist *Domones Butchers' Shop, Castle Street, Christchurch*, untraced find

unknown artist *Abraham Crowley (1795–1864)*, gift, 1986

unknown artist *Charlotte Crowley (1801–1892)*, gift, 1986

unknown artist *Charles Sedgefield Crowley (1797–1868), Husband of Emma Curtis*, gift, 1986

unknown artist *Emma Crowley, née Curtis*, gift, 1986

unknown artist *Maria Humphrey of Salisbury, Wiltshire, Wife of Thomas Heath, Mayor of Andover*, untraced find

unknown artist *Thomas Heath (1781–1842), Mayor of Andover, Hampshire (1837–1838)*, untraced find

unknown artist *View of Christchurch Priory from Wick, Christchurch*, untraced find

unknown artist *Benny Reid, Christchurch*, untraced find

unknown artist *Elizabeth Curtis (1806–1900)*, gift, 1986

unknown artist *Henry Crowley (1793–1864), Husband of Elizabeth Curtis*, gift, 1986

unknown artist *Abraham Crowley*

(1796–1864), gift, 1998

unknown artist *Charlotte Crowley, née Curtis (1801–1892), Wife of Abraham Crowley*, gift, 1998

unknown artist *Portrait of a Lady with a Red Shawl*

unknown artist *Edward William Packenham, from a Grenadier Corps of a Fusilier Regiment, Wearing the Crimea Medal with Bars for Balaclava, Inkerman and Alma*, purchased, 1988

unknown artist *St Mary's Church and Cottages, Basingstoke*, gift, 1960

unknown artist *The Alton Postman's Dog*, gift, 1970

unknown artist *Portrait of a Small Boy and Girl with a Dog, possibly Hugh Curtis and His Sister*, untraced find

unknown artist *Thomas Mason Kingdon in Mayoral Robes*, gift, 1966

unknown artist *St Mary's Church, Basing*

unknown artist early 19th C, *View of Christchurch Priory from Warren Point*, gift, 2001

unknown artist 19th C, *Mrs Isabell Watts*, gift, 1990

unknown artist late 19th C, *Basingstoke Canal*, untraced find

unknown artist late 19th C, *Portrait of a Man Holding a Scroll*, untraced find

unknown artist *Reverend John Barney (1883–1960) as a Boy, Fareham*

unknown artist *Ashdell Rustic Bridge, Alton*, purchased, 1965

unknown artist *Portrait of a Woman in a Black and Red Dress*, untraced find

unknown artist *A Church, possibly St Michael's, Basingstoke*

unknown artist *Alderman Sir William Purdie Treloar, Bt (1843–1923)*, gift, 2001

unknown artist *Gosport Ferry in Portsmouth Harbour*, gift, 1985

unknown artist *Sir William Wyndham Portal (1850–1931)*, untraced find

unknown artist *Two Peasant Women with a Donkey*

unknown artist *Sir Lynton White, Chairman of Hampshire County Council (1977–1985)*, untraced find

unknown artist *A View of Christchurch Priory, Constable's House across the Mill Stream*, untraced find

unknown artist *Belle Vue Hotel, Lee-on-Solent*, gift, 1976

unknown artist *Bury House*, gift, 1984

unknown artist *Christchurch Abbey from the Ferry*

unknown artist *City Scene*

unknown artist *Coastal Path*

unknown artist *Compton Village near Winchester*, untraced find

unknown artist *Cottages at Bury Cross, Gosport*, gift, 1984

unknown artist *Family Group, c.1840–1860*, gift, 1970

unknown artist *Gosport Iron Foundry*, gift, 1987

unknown artist *John Richard Gregson in the Old Town Hall*, gift, 1985

unknown artist *Lady Rose, Sandhills, Mudeford*, untraced find

unknown artist *Landscape*

unknown artist *Lock on Basingstoke Canal*

unknown artist *Lot and His Daughters*

unknown artist *Mr Willis (1877–1970)*, untraced find

unknown artist *Old Mill House, Bedhampton*, untraced find

unknown artist *Portrait of a Gentleman*

unknown artist *Portrait of a Gentleman*

unknown artist *Portrait of a Gentleman*

unknown artist *Portrait of a Lady, possibly a Member of the Paulet Family*

unknown artist *Portrait of a Lady, possibly a Member of the Paulet Family*

unknown artist *River Scene*

unknown artist *St Mary's Church, Andover*

unknown artist *The Grove, Gosport*, purchased, 1984

unknown artist *The Hard and High Street, Gosport*, bequeathed, 1981

unknown artist *The Old Mill, Christchurch*, untraced find

unknown artist *Town Square with Colonnade*

unknown artist *Yacht Racing, c.1900*, gift, 1985

Van der Weegen, F. active 1912–1928, *Eggars Grammar School, Alton*, gift, 1960

Van der Weegen, F. active 1912–1928, *View of Anstey Lane, Alton*, gift, 1960

Van der Weegen, F. active 1912–1928, *View of Cottages in Alton*, gift, 1960

Van der Weegen, F. active 1912–1928, *Road Leading into Alton from the Upper Windows of Eggar's Grammar School*, gift, 1960

Watt, George Fiddes 1873–1960, *Francis George Baring, Second Earl of Northbrook (1850–1929), Chairman of Hampshire County Council (1907–1927)*, gift, 1924

Watts, Frederick W. 1800–1862, *On the River Itchen*, purchased, 1993

Weedon, Edwin 1819–1873, *The Launching of 'HMS Royal Sovereign' at Portsmouth, 25 April 1857*, purchased, 2006

Whitehead, M. E. *Cottages at Throop*, gift, 1964

Williams, E. *View of Cams Mill and Delme Arms Public House*, gift, 2006

Wissing, Willem c.1656–1687, *Lady Catherine Shuckburgh of Hinton Ampner, Hampshire*, purchased, 1989

Wissing, Willem c.1656–1687, *Sir Charles Shuckburgh of Hinton Ampner, Hampshire*, purchased, 1989

Woods, Chris *Bodmin at Ropley, West Country Class Locomotive No.34008 on the Watercress Line near Alton*, purchased, 1991, © the artist

Wortley, Archibald J. Stuart 1849–1905, *Melville Portal (1818–1904)*, untraced find

Wright, E. A. *The Royal Yacht and 'HMS Victory'*, untraced find

Wright, Jack *Landscape*

Horsepower: The Museum of the King's Royal Hussars

Barker, Thomas Jones 1815–1882, *'The Girls We Left Behind', the Departure of a Troop of 11th Hussars for India*, purchased with the assistance of the Victoria & Albert Museum Purchase Grant Fund, 2002

Codner, Maurice Frederick 1888–1958, *General Sir Charles Gairdner (1898–1983)*, on loan from the Regiment

Cuneo, Terence Tenison 1907–1996, *Presentation of the Guidon by HM Queen Mother, 1965 (11th Hussars)*, on loan from the Regiment, © reproduced with kind permission of the Cuneo estate

Giles, Godfrey Douglas 1857–1941, *Charge at El Teb, Sudan*, on loan from the Regiment

Giles, Godfrey Douglas 1857–1941, *The Race for the Kopje*, on loan from the Regiment

Gwatkin, Joshua Reynolds active 1831–1851, *Samuel Fisher, 11th Light Dragoons*, gift, 1991

Hall, John 1739–1797, *Captain Edward Hall, Earl of Ancrams Dragoons*, bequeathed by A. G. Miller, 1988

László, Philip Alexius de 1869–1937, *Field Marshall Julian Byng, 1st Viscount Byng of Vymy*, on loan from the National Portrait Gallery

G. M. *HRH Duke of Gloucester*, on loan from the Regiment

unknown artist *Lieutenant General Charles Vane, Lord Stewart (later Marquis of Londonderry)*, on loan from the Regiment

unknown artist *Sergeant Major Kilvert*, on loan from the Regiment

unknown artist *Major General John Coombe*, on loan from the Regiment

Wanklyn, Joan active 1956–1994, *Auld Lang Syne (10th Hussar Guidon Parade)*, on loan from the Regiment

Wanklyn, Joan active 1956–1994, *10th Royal Hussar Guidon Parade March Past HRH Duke of Gloucester, Colonel-in-Chief*, on loan from the Regiment

Winterhalter, Franz Xaver 1805–1875, *Major General Sir John Douglas*, on loan from the Regiment

Wollen, William Barnes 1857–1936, *The Scouts*, purchased by an anonymous benefactor on behalf of the museum, 1981

The Adjutant General's Corps Museum

Cremona, Emanuel Vincent 1919–1987, *Field Marshall Montgomery of Alamein (1887–1976)*, gift from the Command Pay Office, Malta, 1971

A. G. J. *Royal Hibernian Military School Prize Giving Day, 1911*, donated by Mr Cusack, 1980

Lytton, Neville Stephen 1879–1951, *Auxiliary Territorial Service Band*, untraced find

The Gurkha Museum

Beadle, James Prinsep 1863–1947, *General Frederick Young (1786–1874), Who Raised and Commanded the Sirmoor Battalion (later King Edward VII's Own Gurkhas (The Sirmoor Rifles) (1815–1842)*, on loan from the Trustees of the Sirmoor Rifles Association (UK) Trust

Boden, Leonard 1911–1999, *HRH Princess Mary, the Princess Royal (1897–1965)*, on loan from the Trustees of the 10th PMO Gurkha Rifles Regimental Association Trust, © the artist's estate

Cousins, Derek b.1928, *Field Marshal the Lord Bramall of Bushfield, KG, GCB, OBE, MC, JP (b.1923), Colonel 2nd King Edward VII's Own Gurkhas (The Sirmoor Rifles) (1976–1986), President of the Gurkha Brigade Association (from 1987), HM Lord Lieutenant of Greater London (from 1986)*, on loan from the Trustees of the Sirmoor Rifles Association (UK) Trust

Cuneo, Terence Tenison 1907–1996, *The Action at Labis*, on loan from the Trustees of the 10th PMO Gurkha Rifles Regimental Association Trust, © reproduced with kind permission of the Cuneo estate

Doig, Desmond 1921–1983, *Naik Dilbahadur Rana, Orderly to Major Geoffrey Maycock of the 5th Royal Gurkha Rifles (Frontier Force)*, gift from S. Carroll Esq., 2002

Douglas, G. *Gurkha Mangale Limbu, Supper in '68: Gurkha Field Squadron in Traditional Dress*, donated by Major T. Spring-Smyth

Edwards, Lionel D. R. 1878–1966, *Crossing the Tigris, Mesopotamia, 23 February 1917*, on loan from the Trustees of the Sirmoor Rifles Association (UK) Trust

Festing, Andrew b.1941, *Field Marshal Sir John Lyon Chapple, GCB, CBE, MA, DL, Colonel 2nd King Edward VII's Own Gurkhas (The Sirmoor Rifles) (1986–1994), Governor and Commander in Chief Gibraltar (1993–1995)*, on loan from the Trustees of the Sirmoor Rifles Association (UK) Trust, © the artist

Fildes, Denis 1889–1974, *HRH The Duke of Edinburgh (b.1921)*, gift from the Trustees of the 7th DEO Gurhka Rifles Regimental Association Trust

Fildes, Denis 1889–1974, *HM Queen Elizabeth II (b.1926)*, on loan from the Trustees of the 6th QEO Gurkha Rifles Regimental Association Trust

Noakes, Michael b.1933, *HRH The Prince of Wales (b.1948)*, on loan from the Trustees of the Sirmoor Rifles Association (UK) Trust, © the artist

Ram, Jayun active 1824–c.1840, *Captain John Fisher (1802–1846), Killed in Action while Commanding the 6th Sirmoor (Rifle) Battalion (later 2nd King Edward VII's Own Gurkhas) at the Battle of Sobraon, India, 10th February 1846*, bequeathed by Mrs E. M. Dixon (great-granddaughter of Captain Fisher), 1995

Sheldon, Harry 1923–2002, *A Young Garhwali Man in Traditional Dress*, donated by Paul E. Sheldon, the artist's brother, 2002

unknown artist *Lance Corporal Bhimlal Thapa DCM, 1st Battalion 2nd King Edward VII's Own Gurkha Rifles (The Sirmoor Rifles)*, on loan from the Trustees of the Sirmoor Rifles Association (UK) Trust

unknown artist *General John Adam Tytler, VC, CB (1825–1880)*, gift from Beatrice Louisa Frances Skelton (great-granddaughter of General Tytler), 2005

unknown artist *Major General Sir Charles H. Powell, KCB, Colonel 1st King George V's Own Gurkha Rifles (1916–1943)*, acquired, 2003

The Light Infantry Museum

Birley, Oswald Hornby Joseph 1880–1952, *Sir John Moore, KB (1761–1809)*, © the artist's estate

The Royal Green Jackets Museum

Atkinson, John Augustus 1775–1833, *Lieutenant Colonel Macleod at Badajoz*, purchased, 1976

Aylward, James D. Vine d.1917, *The Morning of Waterloo*, gift, 1952

Baines, Thomas 1820–1875, *Camp Scene*, gift, 1955

Baines, Thomas 1820–1875, *Captain Lord Russel's Coy with a Six-Pounder Detachment of the Royal Artillery Skirmish against the Kaffirs*, gift, 1955

Baines, Thomas 1820–1875, *Landing in Surf at Algoa Bay, Cape of Good Hope, 30 March 1852*, gift, 1955

Baines, Thomas 1820–1875, *River Crossing*, gift, 1955

Baines, Thomas 1820–1875, *The Battalion Embarks at Dover on HM Steamship 'Magaera' on 2 January 1852*, gift, 1955

Béjar Novella, Pablo Antonio 1869–1920, *Prince Maurice of Battenburg (1891–1914)*, gift, 1965

Bodley, Josselin 1893–1974, *Polygon Wood, Ypres*, gift from the artist's wife, 1975

Bodley, Josselin 1893–1974, *Shelley Farm, St Eloi*, gift from the artist's wife

Breun, John Ernest 1862–1921, *Lieutenant Colonel Hutton*, gift, 1961

Crofts, Ernest 1847–1911, *The Capture of a French Battery by the 52nd Regiment at Waterloo*

Fildes, Denis 1889–1974, *General Sir David Lathbury, GCB, DSO, MBE (1906–1978)*, gift, 1971

Green, Kenneth 1905–1986, *General Sir Bernard Paget (1887–1961)*, © the artist's estate

Hollebone, Sarah *General Sir Montagu Stopford, GCB, KBE, DSO, MC*

Holt, Herbert 1891–1978, *Brigadier General Henry Bouquet (1719–1765) (after John Wollaston)*, gift, 1964

Jones, George 1786–1869, *Captain George Napier*

Kitson, Ethel M. active 1920–1972, *Cromac Square, Londonderry*, acquired, 1972

Lawrence, Thomas 1769–1830, *Sir John Moore (1761–1809)*, gift

Lawson, Cecil active 1913–1923, *Iron Bridge at Lucknow*, acquired, 1958

Miles, John C. active 1839–1850, *Lieutenant Edward Welch Eversley*, purchased, 1997

Moseley, Henry 1798–1866, *Lieutenant General Sir Henry Smith (1805–1837)*, gift, 1956

Pickersgill, Henry William 1782–1875, *Major General Sir George Ridout Bingham (1777–1833) (detail)*, purchased, 1960

Risdon, A. W. *Rifleman Tom Plunkett (after N. Payne)*

Trotter, John (attributed to) active 1756–1792, *Lieutenant Colonel George Etherington (served with the 60th, 1756–1787)*, acquired, 1994

unknown artist *Captain Francis Charteris Fletcher (served 1846–1864)*, purchased, 1961

unknown artist *Captain Isaac R. D'Arcy*

unknown artist *Colonel John Philip Hunt, CB (1799–1814)*

unknown artist *Colonel Thomas Lawrence Smith (1792–1877)*, on loan from an anonymous individual

unknown artist *Colonel Willoughby Verner (d.1943)*

unknown artist *Duke of Connaught (d.1942)*

unknown artist *Governor General Sir George Prevost (1767–1816)*, purchased, 2003

unknown artist *John Colborne, 1st Baron Seaton (1778–1863)*, gift

unknown artist *Lieutenant Anthony Francis Macleod Paget (1924–1945)*

unknown artist *Lieutenant Colonel Boyd Manningham*, bequeathed, 1976

unknown artist *Lieutenant Colonel James Fullerton (d.1834)*, gift, 1966

unknown artist *Lieutenant Colonel W. Humbley (served with the Rifle Brigade, 1807–1854)*, gift, 1961

unknown artist *Lieutenant General Robert Beaufoy Hawley (1821–1898)*, presented by Lieutenant General Sir Edward Hutton, 1965

unknown artist *Lieutenant General Sir Thomas Beckwith (d.1831)*

unknown artist *Major General Coote Manningham (1765–1809)*, bequeathed, 1976

unknown artist *Major General Sir Alexander Cameron of Inverailort (1770–1850)*, gift, 1994

unknown artist *Robert Craufurd (1764–1812)*

unknown artist *Russian Icon*

unknown artist *The Honourable Henry Robert Molyneux*

The Royal Hampshire Regiment Museum

Cuneo, Terence Tenison 1907–1996, *Tebourba Gap*, commissioned by the Regiment to commemorate the award of the Victoria Cross to Major H. W. Le Patourel in the action at Tebourba Gap, Tunisia, in December 1942, © reproduced with kind permission of the Cuneo estate

Holroyd, John Newman active 1909–1947, *General Sir Richard Haking (1862–1945)*

Stadden, Charles & Wilcox, Leslie Arthur 1904–1982 *Presentation of the Colours to 1st Battalion, by Earl Mountbatten of Burma at Münster, Germany, August 1963*

unknown artist *Ceremony of the Presentation of the Colours of the 4th/5th Battalion, the Hampshire Regiment, by Earl Mountbatten of Burma at Broadlands, Hampshire, June 1963*

unknown artist *Colonel Mordaunt Cope Commanding the Hampshire Militia*

unknown artist *Major John Rutledge Kell, 37th Foot (1825–1836)*, presented by Brigadier General C. Winton, CMG, 1917

Waring, Dawn *The Battle of Minden, 1 August 1759*

Wilcox, Leslie Arthur 1904–1982, *D-Day, 6 June 1944*

Wilcox, Leslie Arthur 1904–1982, *Monte Cassino*

Winchester Museums Service

Appleyard, Frederick 1874–1963, *The Devil's Pool, Glen Trool, Galloway, Scotland*, bequeathed by Bernard Osmond, 1998

Appleyard, Frederick 1874–1963, *The Merrick Group and River Dee, Galloway, Scotland*, bequeathed by Bernard Osmond, 1998

Appleyard, Frederick 1874–1963, *Geoffrey Walton as a Young Boy*, gift from Geoffrey Walton, 1997

Appleyard, Frederick 1874–1963, *View over Lovington House*, bequeathed by Bernard Osmond, 1998

Appleyard, Frederick 1874–1963, *Itchen Valley Landscape with Figure*, gift from Geoffrey Walton, 1997

Appleyard, Frederick 1874–1963, *Avington Park, Looking North towards Itchen Down*, bequeathed by Bernard Osmond, 1998

Appleyard, Frederick 1874–1963, *Garden at Lane End, Itchen Stoke*, gift from Geoffrey Walton, 1997

Appleyard, Frederick 1874–1963, *Moonrise over the River Itchen from just below Itchen Stoke*, bequeathed by Bernard Osmond, 1998

Appleyard, Frederick 1874–1963, *The Ford at Chilland, Martyr Worthy*, bequeathed by Bernard Osmond, 1998

Appleyard, Frederick 1874–1963, *Itchen Abbas Church*, purchased from Andrew Smith & Son, 1993

Appleyard, Frederick 1874–1963, *Landscape with Trees*, purchased from the Bruton Gallery, Somerset, with the assistance of the Victoria & Albert Museum Purchase Grant Fund and the National Art Collections Fund, 1979

Appleyard, Frederick 1874–1963, *Village Green, Itchen Stoke*, purchased from the Bruton Gallery, Somerset, with the assistance of the Victoria & Albert Museum Purchase Grant Fund and the National Art Collections Fund, 1979

Arnald, George 1763–1841, *Cromwell's Troops Entering Winchester from the South*, purchased from John Corbett with the assistance of the Victoria & Albert Museum Purchase Grant Fund, 1985

Baigent, Richard 1799–1881, *Boys Going to Hills*, purchased from Michael Green, 1991

Bird *Richard Baigent (1799–1881)*, gift from Richard Coventry Baigent, 1934

Christie, Tessa *Interior of Winchester Cathedral*, purchased from the artist, 1972

Cooper, William Sidney 1854–1927, *Tanquerary Island, Kent*

Darley, William Henry active 1836–1850, *Head of Christ*, gift from Miss Jessie M. Baigent, 1973

Darley, William Henry active 1836–1850, *Louisa Baigent*, gift from Richard Coventry Baigent, 1934

Delamorte *Versailles, the Garden Front*

Donaldson, Andrew Brown 1840–1919, *King Alfred and the Danes*

Dyck, Anthony van (copy after) 1599–1641, *John Paulet (1598–1675), Fifth Marquis of Winchester, Defender of Basing*, gift from the 16th Marquess of Winchester, 1919

Griffier, Jan II active 1738–1773, *Winchester from the South-West with an Encampment in the Foreground*, gift from W. Bailey, the

351

Town Clerk, 1905

Halliday, Edward Irvine 1902–1984, *Queen Elizabeth II (b.1926)*, gift by public subscription, 1957, © the artist's estate

Hart, Thomas Gray 1797–1881, *Westgate from the West*, purchased from Bell Fine Art, 1994

Heathcote, Thornhill B. active 1880–1890, *Richard Harpur*, acquired from Winchester City Library, 1973

Ladbrooke, John Berney 1803–1879, *Landscape with Trees, Cottage, Winding Lane and Pond*

Ladbrooke, Robert 1770–1842, *Landscape with Trees, Cattle, and Stream*

Lely, Peter 1618–1680, *King Charles II (1630–1685)*, gift from King Charles II, 1683

Lely, Peter (after) 1618–1680, *King Charles II (1630–1685)*, gift from Dorothy Margaret Stuart, 1963

Liddell, George *Edward Page Clowser (1795–1860)*, gift from C. E. Clowser, 1956

Locke, Henry Edward 1862–1925, *Statue of King Alfred (849–899) in the Broadway*

Maclise, Daniel 1806–1870, *Cardinal Wolsey Refusing to Deliver up the Seals of His Office*

Marks, Henry Stacey 1829–1898, *The Odd Volume*, gift from Mrs C. Lyndon, 1935

Merrick, Emily M. b.1842, *Richard Moss (1823–1905), MP for Winchester*

Moore, Annie Osborne active 1888–1909, *Alderman Thomas Stopher (1837–1926)*

Mornewick, Charles Augustus active c.1826–1874, *The First Viscount Eversley, Charles Shaw-Lefevre (1794–1888)*

Opie, John 1761–1807, *Lady Elizabeth Woodville Pleading for Her Children before Edward IV (detail)*, gift from the Baring family of Stratton Park

Osmond, Edward 1900–1981, *Eight Acres Corner on the Avington-Littledown Road*, bequeathed by Bernard Osmond, 1998

Reinagle, Ramsay Richard 1775–1862, *Landscape in Italy*, gift from Mr Holdaway

Salisbury, Frank O. 1874–1962, *Marchioness of Winchester (1902–1995)*, gift from the Marchioness of Winchester, 1972, © estate of Frank O. Salisbury/ DACS 2007

Sparkes, T. Roy active c.1960–1989, *Cheyney Court*, gift from the artist, 1989

Sparkes, T. Roy active c.1960–1989, *College Hall, Winchester College*, gift from the artist, 1971

Sparkes, T. Roy active c.1960–1989, *The Old Chesil Rectory*, gift from the artist, 1971

Stewardson, Thomas 1781–1859, *The Children of the 13th Marquess*, on loan from Lady Pamela O'Leary

Stewardson, Thomas 1781–1859, *Anne, Wife of the 13th Marquess of Winchester (b. before 1785–1841)*, on loan from Lady Pamela O'Leary

Stewardson, Thomas 1781–1859, *Charles Paulet (1764–1843), 13th Marquess of Winchester*, on loan from Lady Pamela O'Leary

Till, Tobias b.1969, *Footbridge*, purchased from the artist, 2005, © the artist

unknown artist *Ralph Lamb (1518–1558)*

unknown artist *Edward Cole (d.1617)*

unknown artist *Sir Thomas White (1492–1567)*

unknown artist *Sir William Paulet (c.1483–1572), First Marquis of Winchester*, gift from Nathaniel Atcheson, 1815

unknown artist *George Pemerton*

unknown artist *King Charles I (1600–1649)*, gift from Mrs Thomas Fleming

unknown artist *King Charles II (1630–1685)*, gift from Mrs Thomas Fleming

unknown artist *George Morley, DD (1597–1684)*

unknown artist *Lancelot Thorpe (b.c.1532)*

unknown artist *Bishop Sherlock (1677–1761), Bishop of Salisbury*, gift from Mrs A. B. Sole, 1905

unknown artist *Colonel Brydges of Avington (1678–1751)*

unknown artist *Sir Paulet St John, Bt (1704–1780)*

unknown artist *Classical Landscape with Ruined Building, River and Pastoral Scene*

unknown artist *James Cooke*

unknown artist *Woodland Scene*

unknown artist *John Doswell (1740–1792), Mayor of Winchester*

unknown artist *Seascape with Sailing Ships and White Cliffs*

unknown artist *Seascape with Sailing Ships near Harbour*

unknown artist *The Westgate from the East*, gift from W. E. Deverell, 1897

unknown artist *Portrait of a Young Man*

unknown artist *Viscount Eversley, GCB (1794–1888), Aged 91*

unknown artist *Winchester from the South*

unknown artist *Alderman Thomas Stopher (1837–1926)*, gift from Mr A. Philip, 2003

unknown artist *The Old Chesil Rectory*, gift from R. J. Hedderwick, 1963

unknown artist *Alderman John Silver*

Walton, Henry 1875–1969, *Old Wooden Bridge over the River Itchen*, gift from Geoffrey Walton, 1997

Walton, Henry 1875–1969, *Trees in Avington Park*, gift from Geoffrey Walton, 1997

Young, Tobias c.1755–1824, *Winchester from the South*, purchased from Peter White with the assistance of the Victoria & Albert Museum Purchase Grant Fund, 1998

Facing page: Northcote, James, 1746–1831, *George III (1738–1820)* (detail), 1797, Royal Marines Museum, (p.184)

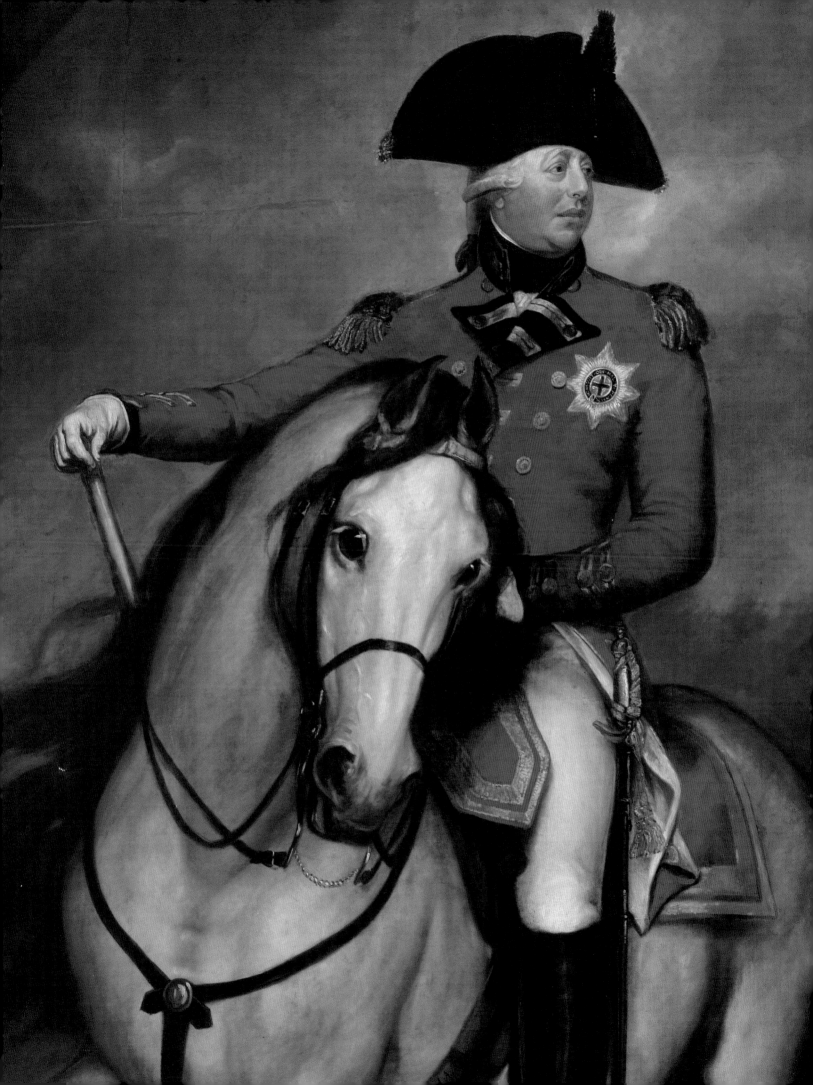

Collection Addresses

Aldershot

Aldershot Military Museum & Rushmoor Local History Gallery*
Queens Avenue, Aldershot GU11 2LG
Telephone 01252 314598

Army Physical Training Corps Museum
Army School of Physical Training, Fox Lines
Queens Avenue
Aldershot GU11 2BU
Telephone 01252 347168

Alton

Curtis Museum and Allen Gallery*
High Street, Church Street, Alton GU34 1BA
Telephone 01420 82802

Amport

The Museum of Army Chaplaincy
Amport House
Amport, near Andover SP11 8BG
Telephone 01264 773144

Andover

Andover Museum and Museum of the Iron Age*
6 Church Close, Andover SP10 1DP
Telephone 01264 366283

Test Valley Borough Council
Beech Hurst, Weyhill Road, Andover SP10 3AJ
Telephone 01264 368000

Basingstoke

Basing House*
Redbridge Lane, Basing RG24 7HB
Telephone 01256 467294

Basingstoke and Deane Borough Council
Civic Offices, London Road, Basingstoke RG21 4AH
Telephone 01256 844844

Basingstoke and North Hampshire NHS Foundation Trust
North Hampshire Hospital, Aldermaston Road
Basingstoke RG24 9NA
Telephone 01256 473202

Milestones: Hampshire's Living History Museum*
Basingstoke Leisure Park, Churchill Way West
Basingstoke RG21 6YR
Telephone 01256 477766

Willis Museum*
Old Town Hall, Market Place, Basingstoke RG21 7QD
Telephone 01256 465902

Beaulieu

National Motor Museum
John Montagu Building
Beaulieu, Brockenhurst SO42 7ZN
Telephone 01590 614650

Bishop's Waltham

Bishop's Waltham Museum
Barclays Bank Mews, Brook Street
Bishop's Waltham SO32 1AX
Telephone 01489 894970

Bursledon

Bursledon Windmill*
Windmill Lane, Bursledon SO31 8BG
Telephone 023 8040 4999

Chawton

Chawton House Library
Chawton House, Chawton GU34 1SJ
Telephone 01420 541010

Jane Austen's House
Chawton GU34 1SD
Telephone 01420 83262

Christchurch, Dorset

Red House Museum and Gardens*
Quay Road
Christchurch, Dorset BH23 1BU
Telephone 01202 482860

Eastleigh

Eastleigh Museum*
The Citadel, 25 High Street
Eastleigh SO50 5LF
Telephone 023 8064 3026

Hampshire Fire and Rescue Service
Leigh Road, Eastleigh SO50 9SJ
Telephone 023 8064 4000

Emsworth

Emsworth Museum
10B North Street, Emsworth PO10 7DD
Telephone 01243 378091

Fareham

Fareham Borough Council
Civic Offices, Civic Way, Fareham PO16 7PU
Telephone 01329 236100

Royal Armouries, Fort Nelson
Fort Nelson, Down End Road, Fareham PO17 6AN
Telephone 01329 233734

Westbury Manor Museum*
84 West Street, Fareham PO16 0JJ
Telephone 01329 824895

Farnborough

Rushmoor Borough Council
Council Offices, Farnborough Road
Farnborough GU14 7JU
Telephone 01252 398398

Fleet

Hart District Council
Civic Offices, Harlington Way, Fleet GU51 4AE
Telephone 01252 622122

Fordingbridge

Fordingbridge Town Council
The Town Hall, 63 High Street
Fordingbridge SP6 1AS
Telephone 01425 654134

Rockbourne Roman Villa*
Rockbourne, Fordingbridge SP6 3PG
Telephone 01725 518541

Gosport

Explosion! The Museum of Naval Firepower
Priddy's Hard, Gosport PO12 4LE
Telephone 023 9250 5600

Gosport Museum*
Walpole Road, Gosport PO12 1NS
Telephone 023 9258 8035

Royal Navy Submarine Museum
Haslar Jetty Road, Gosport PO12 2AS
Telephone 023 9252 9217

SEARCH*
50 Clarence Road, Gosport PO12 1BU
Telephone 023 9250 1957

Hamble

Hampshire Constabulary
Southern Support Headquarters, Hamble Lane
Hamble SO31 4TS
Telephone 023 8074 5450

Hartley Wintney

Hartley Wintney Parish Council
Appleton Hall, West Green Road
Hartley Wintney, near Hook RG27 8RE
Telephone 01252 845152

Havant

Havant Borough Council
Civic Offices, Civic Centre Road, Havant PO9 2AX
Telephone 023 9247 4174

Havant Museum*
56 East Street, Havant PO9 1BS
Telephone 023 9245 1155

Lee-on-Solent

The Hovercraft Museum Trust
Argus Gate, Chark Lane, Broom Way
Lee-on-Solent PO13 9NY
Telephone 023 9255 2090

Lymington

St Barbe Museum and Art Gallery
New Street, Lymington SO41 9BH
Telephone 01590 676969

Lyndhurst

New Forest District Council
Appletree Court, Lyndhurst SO43 7PA
Telephone 023 8028 5000

New Forest Museum and Library
High Street, Lyndhurst SO43 7NY
Telephone 023 8028 3444

Middle Wallop

The Museum of Army Flying
Middle Wallop SO20 8DY
01264 784421

Petersfield

East Hampshire District Council
Penns Place, Petersfield GU31 4EX
Telephone 01730 234103

Flora Twort Gallery*
Church Path Studio, 21 The Square
Petersfield GU32 1HS
Telephone 01730 260756

Portsmouth

HMS Excellent
Whale Island, Portsmouth PO2 8ER
Telephone 023 9272 2351

HMS Victory
Victory Gate, HM Naval Base, Portsmouth PO1 3NH
Telephone 023 9272 2124

HMS Warrior 1860
Victory Gate, HM Naval Base, Portsmouth PO1 3QX
Telephone 023 9277 8600

Portsmouth Museums and Records Service:

Charles Dickens' Birthplace Museum
393 Old Commercial Road
Portsmouth PO1 4QL
Telephone 023 9282 7261

D-Day Museum
Clarence Esplanade, Portsmouth PO5 3NT
Telephone 023 9282 7261

Eastney Industrial Museum
Henderson Road, Eastney
Portsmouth PO4 9JF
Telephone 023 9282 7261

Natural History Museum and Butterfly House
Cumberland House, Eastern Parade, Southsea
Portsmouth PO4 9RF
Telephone 023 9282 7261

Portsmouth City Museum & Records Office
Museum Road
Portsmouth PO1 2LJ
Telephone 023 9282 7261

Southsea Castle
Clarence Esplanade, Southsea
Portsmouth PO5 3PA
Telephone 023 9282 7261

Portsmouth Royal Dockyard Historical Trust
19 College Road, HM Naval Base
Portsmouth PO1 3LJ
Telephone 023 9282 0921

Royal Marines Museum
Eastney Esplanade, Southsea, Portsmouth PO4 9PX
Telephone 023 9281 9385

Royal Naval Museum
Victory Gate, HM Naval Base, Portsmouth PO1 3NH
Telephone 023 9272 7562

The Mary Rose Trust
College Road, HM Naval Base, Portsmouth PO1 3LX

Treadgolds Industrial Heritage Museum*
Bishop Street, Portsmouth PO1 3DA
Telephone 023 9282 4745

University of Portsmouth
University House, Winston Churchill Avenue
Portsmouth PO1 2UP
Telephone 023 9284 8484

Romsey

Romsey Town Council
The Town Hall, 1 Market Place, Romsey SO51 8YZ
Telephone 01794 512837

Selborne

Gilbert White's House & The Oates Museum
The Wakes, Selborne GU34 3JH
Telephone 01420 511275

Winchester

Hampshire County Council's Contemporary Art
Collection
Mottisfont Court, High Street, Winchester SO23 8ZF
Telephone 01962 846966

Hampshire County Council Museums and Archives
Service
Chilcomb House Chilcomb Lane
Winchester SO23 8RD
Telephone 01962 826700

Horsepower, The Museum of the King's Royal Hussars
Peninsula Barracks, Romsey Road
Winchester SO23 8TS
Telephone 01962 828541

The Adjutant General's Corps Museum
Peninsula Barracks, Romsey Road
Winchester SO23 8TS
Telephone 01962 877826

The Gurkha Museum
Peninsula Barracks, Romsey Road
Winchester SO23 8TS
Telephone 01962 842832

The Light Infantry Museum
Peninsula Barracks, Romsey Road
Winchester SO23 8TS
Telephone 01962 828550

The Royal Green Jackets Museum
Peninsula Barracks, Romsey Road
Winchester SO23 8TS
Telephone 01962 828549

The Royal Hampshire Regiment Museum
Serle's House, Southgate Street
Winchester SO23 9EG
Telephone 01962 863658

Winchester Museums Service:

> Guildhall Gallery
> Broadway, Winchester SO23 9LJ
> Telephone 01962 848289
>
> Westgate
> High Street, Winchester SO23 8ZB
> Telephone 01962 848269
>
> Winchester City Museum
> The Square, Winchester SO23 9EX
> Telephone 01962 848269
>
> Winchester Museums Service
> Hyde Historic Resources Centre, 75 Hyde Street
> Winchester SO23 7DW
> Telephone 01962 848269

* Collections managed by Hampshire County Council Museums and Archives Service.

Index of Artists

In this catalogue, artists' names and the spelling of their names follow the preferred presentation of the name in the Getty Union List of Artist Names (ULAN) as of February 2004, if the artist is listed in ULAN.

The page numbers next to each artist's name below direct readers to paintings that are by the artist; are attributed to the artist; or, in a few cases, are more loosely related to the artist being, for example, 'after', 'the circle of' or copies of a painting by the artist. The precise relationship between the artist and the painting is listed in the catalogue.

Supporters of the Public Catalogue Foundation

Master Patrons

The Public Catalogue Foundation is greatly indebted to the following Master Patrons who have helped it in the past or are currently working with it to raise funds for the publication of their county catalogues. All of them have given freely of their time and have made an enormous contribution to the work of the Foundation.

Peter Andreae *(Hampshire)*

Sir Henry Aubrey-Fletcher, Bt, Lord Lieutenant of Buckinghamshire *(Berkshire and Buckinghamshire)*

Sir Nicholas Bacon, DL, High Sheriff of Norfolk *(Norfolk)*

Peter Bretherton *(West Yorkshire: Leeds)*

Richard Compton *(North Yorkshire)*

George Courtauld, DL, Vice Lord Lieutenant of Essex *(Essex)*

The Marquess of Downshire *(North Yorkshire)*

Jenny Farr, Vice Lord Lieutenant of Nottinghamshire *(Nottinghamshire)*

Mark Fisher, MP *(Staffordshire)*

Patricia Grayburn, MBE DL *(Surrey)*

The Lady Mary Holborow, Lord Lieutenant of Cornwall *(Cornwall)*

Tommy Jowitt *(West Yorkshire)*

Sir Michael Lickiss *(Cornwall)*

Lord Marlesford, DL *(Suffolk)*

The Most Hon. The Marquess of Salisbury, PC, DL *(Hertfordshire)*

Phyllida Stewart-Roberts, OBE, Lord Lieutenant of East Sussex *(East Sussex)*

Leslie Weller, DL *(West Sussex)*

Financial Support

The Public Catalogue Foundation is particularly grateful to the following organisations and individuals who have given it generous financial support since the project started in 2003.

National Sponsor

Christie's

Benefactors (£10,000–£50,000)

City of Bradford Metropolitan District Council

Deborah Loeb Brice Foundation

The Bulldog Trust

A. & S. Burton 1960 Charitable Trust

The John S. Cohen Foundation

Christie's

Mr Lloyd Dorfman

The Foyle Foundation

Hampshire County Council

Peter Harrison Foundation

Hiscox plc

ICAP plc

Kent County Council

The Linbury Trust

The Manifold Trust

Robert Warren Miller

The Monument Trust

Miles Morland

National Gallery Trust

Stavros S. Niarchos Foundation

Norfolk County Council

Provident Financial

P. F. Charitable Trust

The Pilgrim Trust

RAB Capital plc

Renaissance West Midlands

Saga Group Ltd

The Bernard Sunley Charitable Foundation

University College, London

University of Leeds

Garfield Weston Foundation